D0161805

The Arts of Intimacy

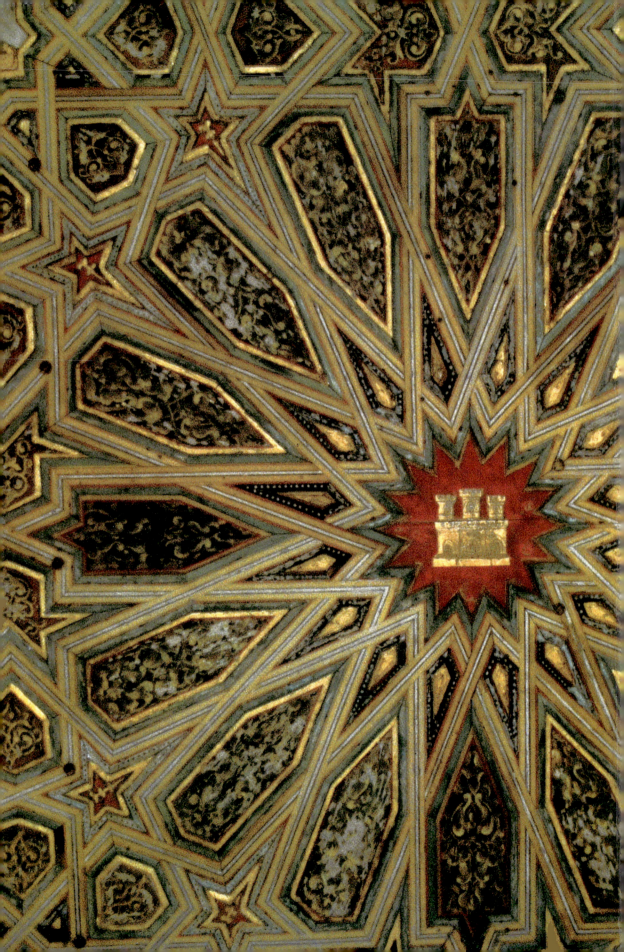

The Arts of Intimacy

✳

CHRISTIANS, JEWS, AND MUSLIMS
IN THE MAKING
OF CASTILIAN CULTURE

✳

JERRILYNN D. DODDS

MARÍA ROSA MENOCAL

AND

ABIGAIL KRASNER BALBALE

✳

YALE UNIVERSITY PRESS

NEW HAVEN AND LONDON

Published with assistance from the
Ronald O. and Betty Miller Turner Publication Fund
and from the Program for Cultural Cooperation between
Spain's Ministry of Culture and United States Universities.

Copyright © 2008 by Jerrilynn D. Dodds, María Rosa Menocal, and Abigail Krasner Balbale.
All rights reserved.
This book may not be reproduced, in whole or in part, including illustrations, in any form (beyond that
copying permitted by Sections 107 and 108 of the U.S. Copyright Law and except by reviewers for the
public press), without written permission from the publishers.

Designed and typeset by Katy Homans
Set in Gill Sans and Joanna type
Printed in China by C&C Offset Printing Co., Ltd.

Library of Congress Cataloging-in-Publication Data

Dodds, Jerrilynn Denise.
The arts of intimacy : Christians, Jews, and Muslims in the making of Castilian culture /
Jerrilynn D. Dodds, María Rosa Menocal and Abigail Krasner Balbale.
p. cm.
Includes bibliographical references and index.
ISBN 978-0-300-10609-1 (hard cover : alk. paper) — ISBN 978-0-300-14214-3 (pbk. : alk. paper)
1. Castile (Spain)—Civilization. 2. Castile (Spain)—History—Alfonso VIII, 1158–1214.
3. Castile (Spain)—Ethnic relations. I. Menocal, María Rosa. II. Balbale, Abigail Krasner. III. Title.
DP135.D63 2008
946′.302—dc22
2008010986

A catalogue record for this book is available from the British Library.

10 9 8 7 6 5 4 3 2 1

For Sandy and Theo
(J.D.D.)

For Harold, and his godson Harry
(M.R.M.)

For Musab
(A.K.B.)

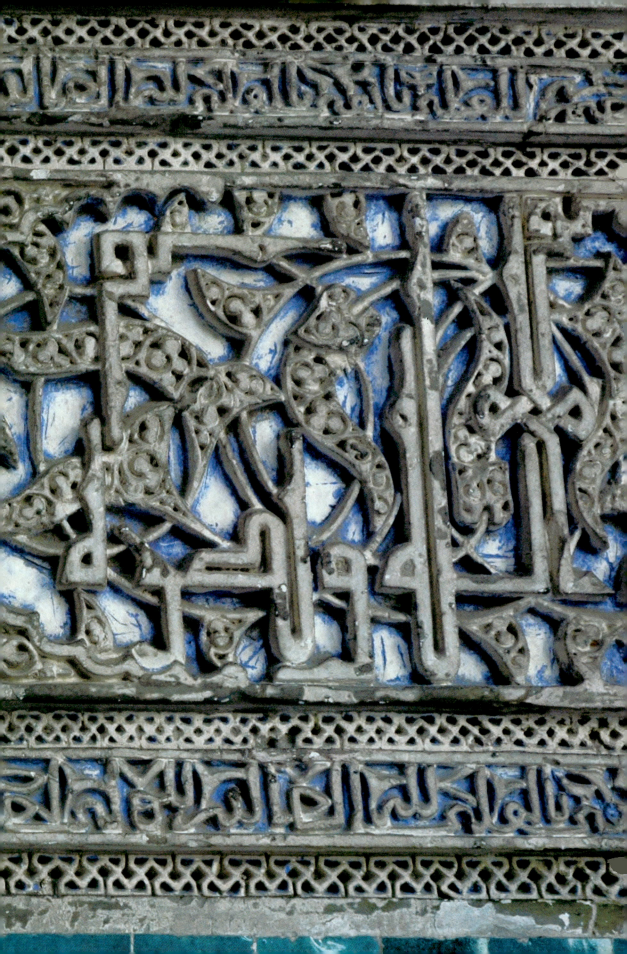

Contents

Preface

In a book about a world so conspicuously multilingual, one in some measure devoted to revealing the wonderful medleys of languages of the peoples of medieval Spain, the challenges of translation of every sort have been considerable. The process of trying to render this polyphonous universe in accessible language that is at the same time of some use to scholars who will know the original texts has prompted some difficult editorial decisions.

Proper names (people and places) are by and large given as they are in the modern Romance languages or Latin, although in some cases more familiar English forms are given, thus Cordoba rather than Córdova, Saragossa rather than Zaragoza, William rather than Guilhelm of Aquitaine, Frederick II rather than Federico II. We have also used a simplified system for transcribing words taken from the Arabic or Hebrew, giving common English equivalents whenever possible and avoiding all specialized diacritics. In a handful of cases where published translations we use have more complex transliteration systems, we have simplified these as well. All dates are given according to the common era.

In order to make this book accessible to as broad a range of readers as possible we have reduced the conventional scholarly apparatus to a minimal number of citational notes for each chapter. The text, however, is indebted to the research of scores of scholars who are acknowledged in an extensive bibliographic essay, which discusses all sources and readings. It is followed by a comprehensive bibliography of all works cited and discussed—both primary and secondary—as well as those generally indispensable for this study. We have also provided a chronology and genealogies of diverse rulers; both are meant to facilitate following what is at times a complex political narrative.

We have included a limited selection of Arabic and Hebrew texts to serve as a graphic demonstration of the complex languages and identities of nascent Castilian culture. For readers of these languages, these selections also offer a taste of the cadences of the poetry and the historical voices of the region, although they represent a mere sample of the riches of that world. In a number of cases we have used other scholars' published translations of primary Arabic texts. We have been especially glad to be able to cite translations of poetry that are the work of poets. Some of the translators we have relied on—Michael Sells and Peter Cole especially, for Arabic and Hebrew poetry respectively—possess that rare and invaluable combination of profound philological expertise and brilliant poetic sensibility, and our book is richer for being able to rely on their masterful renderings of the poetry that is one of the crowning aesthetic achievements of this time and place. In some cases

we have relied on translations themselves based on other translations—especially in the case of poetry, where despite their distance the translations capture the essence of the originals—but in most cases we have verified these texts with the original Arabic. All translators are cited when their work is used throughout the text, and many of the volumes containing their translations are discussed in the bibliographic essay. Above and beyond, and especially in a book that focuses on a historical moment in which translation was a highly valued and influential cultural practice, we would like to acknowledge here the many translators whose work has been indispensable to this book: David Assouline, Amila Buturovic, Peter Cole, Olivia R. Constable, Cola Franzen, Oleg Grabar, L. P. Harvey, Kathleen Kulp-Hill, Jeremy Lawrance and Jim Marchand, W. S. Merwin, Christopher Middleton and Leticia Garza-Falcón, James T. Monroe, Richard Terry Mount and Annette Grant Cash, Sarah Pearce, T. A. Perry, Franz Rosenthal, D. Fairchild Ruggles, Michael Sells, Devin Stewart, and Rafael Valencia.

Acknowledgments

We have incurred many debts in writing this book and it is a pleasure to be able to acknowledge them. Research for this book has been conducted with support from the Metropolitan Museum of Art, the American Philosophical Society, the City University of New York Research Award Program, and the Council for Cultural Cooperation between American Universities and the Spanish Ministry of Culture. Over the years we have worked on this project, a number of devoted students and research assistants have provided invaluable aid that has touched every aspect of this book: at City University of New York, Mitra Abbaspour, Miguel Arisa, Holly Kalman, and Sean Weiss; at Yale University, David Assouline, Camilo Gómez-Rivas, Shialing Kwa, Hillá Meller, Sarah Pearce, Geoffrey Shamos, and Ryan Szpiech. We are especially indebted to both David and Sarah for their substantive collaboration on a number of texts. Vital support that made this assistance possible has been generously provided by the Graduate Center of City University and the Provost's Offices of Yale University and City College of the City University of New York.

This complex project was able to come to fruition only because of the various gifted bookmakers at Yale University Press, and our first thanks thus go to our agent Alice Martell for her customary matchmaking wisdom. This is a book that simply would not exist without our editor, John Donatich of Yale University Press. He has been a wise and patient reader of the book as it has evolved over the years, and the evolution is in great measure his handiwork. He has also been singularly generous with the incomparable resources of the press, providing us other first-rate professionals to work with: Kim Hastings, who read and reread and helped organize the manuscript with a meticulousness and devotion that has no equal in the editing universe; Julianne Griffin, who, with unflappable good humor, struggled to make sure that all the many parts of this puzzle could actually come together, even when it was not obvious they could, and lavished the book with an intelligent understanding that has enhanced not only its form but its meaning; Katy Homans, who produced a beautiful coherent design out of so many disparate parts, and drew the book's themes into her art; and last but far from least Janyce Siress, who has quietly watched over everything, and made sure so many i's were dotted and t's crossed in the process.

Although throughout the book we hope to have acknowledged our considerable intellectual and scholarly debts to colleagues whose work is central to our own, we are especially pleased to be able to thank a number of individuals who have directly, and unstintingly, shared their expertise and wisdom during these last several years: Howard

Bloch was a perceptive and generous reader for the Yale Press of an early version of the book and his various suggestions for strengthening the manuscript were encouraging and wise. We also thank Paul Freedman, who so kindly shared his thoughts about contemporary historians and historiography of medieval Spain. Crucial to our enterprise in more ways than he may know is Peter Cole, whose greathearted support for this project has long been sustaining, and whose generosity and expertise were vital to the meditations on poetry, and to the inclusion of Hebrew poetry. F. E. Peters was always cheerfully at our disposal as Latin consultant extraordinaire, as well as an intrepid travel companion on more than one trip through Spain and, from the outset, a provocative interlocutor on many of the book's concerns. Juan Carlos Ruiz Souza generously shared his encyclopedic understanding of monuments, visited sites with us, and drew us into a long conversation about medieval Spain that has had a profound impact on this narrative. Also part of those splendid collegial conversations and visits were Susana Calvo Capilla, who particularly helped us to understand the fabric of Islamic Toledo; Teresa Pérez Higuera, the doyenne of Toledo's Mudejar world; and Isidro Bango Torviso, who offered venerable guidance from the wide territory of art history he commands. With open hand and heart many other scholars shared their work to the enormous profit of this book: we thank Lucy Pick for feedback that significantly shaped our vision of Rodrigo Jiménez de Rada; Francisco Prado Vilar, for his brilliant readings of the *Cantigas* among many other things; Constancio Martínez del Alamo and Elizabeth Valdez del Alamo and D. Fairchild Ruggles for constant collegial generosity on a host of topics; Cynthia Robinson, for stimulating dialogues, and especially those she engineered at a seminal conference at Cornell, where we rehearsed a number of our arguments; and Toledo's master archaeologist Juan Manuel Rojas, who led us beneath the city's streets to places where the twelfth century still hides. Cynthia Poulton worked long designing maps that are both scholarly and beautiful.

We are grateful to Rafael García Serrano of the Museo de Santa Cruz in Toledo and Ana Maria López Alvarez of the Museo Sefardí for assistance in visiting and photographing monuments. And thanks to Pep Escoda, lyrical photographer, for several beautiful photos, and the chance to see Toledo through an artist's lens. Special thanks are due to George Beech, Julio Navarro, and Sebastian Heath for heroic efforts in obtaining photos. At the Metropolitan Museum of Art, particular thanks are due to Marcie Karp, Senior Manager for Academic Programs, and her attentive staff, as well as to Charles Little and Peter Barnet of the Medieval Department; Michael Barry, Navina Haidar, Stefano Carboni, and Rina Indictor in the Department of Islamic Art; and Dorothea Arnold, for the chance to work so peacefully and productively in the Egyptian Department. Julie Zeftel and Gwen Roginsky were helpful in obtaining images, and thanks to Christopher Noey for a host of other things.

Jerrilynn Dodds offers thanks to all of the denizens of the Provost's Office of City University for support both material and spiritual; to Charles Gifford for holding down the fort; to the acute and generous traveling companion in Peter Wolf; and to Steve Kossak and Sue Mele, for the sustenance of true friendship. And she is grateful above all to her wonderful sons, Sandy and Theo, for their patience, inspiration, and love.

María Rosa Menocal is deeply indebted to the staff of the Whitney Humanities Center at Yale, a second family that has patiently tolerated the many distractions provoked by work on this project, and in all too many cases expertly, and lovingly, filled in for her; thanks especially to Norma Thompson, an anchor in her life in a thousand and one different ways. Above all, she is grateful to her perfect daughter, Margaux, who provided every kind of sustenance over these last several years, making her own work possible.

Abigail Krasner Balbale thanks her parents, Deborah and Michael Krasner, for their continual support, and, most of all, her husband, Musab, for understanding.

And the authors wish to pay tribute to their long and extraordinary collaboration, in which they have learned so much from one another that they, too, have been transformed.

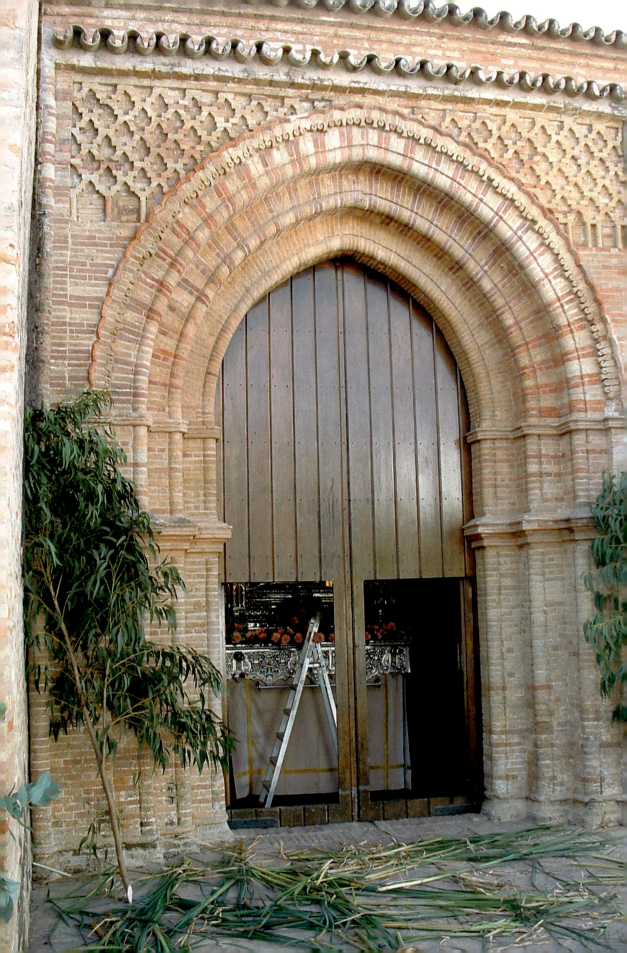

Palos

On the third of August of 1492, the morning of their celebrated voyage, Christopher Columbus and his men heard a last mass at the church of San Jorge Mártir in the little port city of Palos de la Frontera. They emerged from San Jorge's arched doorway to see their own ships, moored on the Tinto River only a few meters from where the church looked bravely off to sea. From church, to river, to estuary, they would spill into the ocean on a journey that would transform the world from which they came, and the world they would find: two old worlds would become new worlds in that chance encounter at the end of the fifteenth century.

For Spain, another process of transformation was well underway: Columbus's voyage was made beneath the flag of a new nation, one constituted that very year, and one borne on a carefully minted religious identity. The wonders these men would find, the riches they would claim, and the peoples they would subdue; all the works of exploration and conquest this voyage would initiate would occur in the name of the Catholic faith. Fourteen ninety-two was the year Queen Isabella and King Ferdinand defeated the kingdom of Granada, the peninsula's last Islamic polity, and in 1492 they also expelled the Jews living in the kingdom of Castile. Throughout the next century, a savage inquisition would be dedicated to eradicating those suspected of deviating from the Catholic faith. The process was set in motion whereby the Iberian Peninsula would be violently cleansed of its Muslims and Jews, populations that had been essential parts of its history for more than seven centuries. The new nation-state of Spain would find her conscious identity in the notion of divine right nestled at the heart of religious absolutism. Ferdinand and Isabella would become the Catholic monarchs, and Columbus, who would receive the authority to begin his voyage from the queen herself in her camp at the gates of Granada, would assail the new world with their cosmic entitlement.

Yet as the men turned back to gaze on the church from which they had come—the last vision of the land they no doubt feared they would never see again—what they saw was the trace of a different part of their own world. The façade of the church of San Jorge was a tall and exuberant portal arched with bands of red and pink brick, framed by a delicate net of interlacing ornament tied like fluttering ribbons to tiny decorative columns. The decoration probably was not in any way unusual to them. Such intricate nets of puzzlelike ornament were familiar to all who lived throughout Spain; they graced the palaces in which the

Palos de la Frontera, church of San Jorge Mártir, portal.

Catholic kings held court, covered the Torah niches of synagogues wrenched from ancient Jewish communities and now serving as churches, and adorned the façades and pulpits of churches from which the ideology of Christian conquest was preached. And yet at the root of those designs, seamlessly part of the Spanish landscape, was another, more surprising set of Iberian buildings: among them the Great Mosques of Cordoba and Seville, the palaces that had been built by Muslim rulers in Saragossa and Toledo, and the Alhambra in Granada itself. Just months after the taking of Granada, in the midst of the Inquisition, at the dawn of Spain's heady Catholic conquest, Columbus and his men would remember home as a church portal whose language of forms was rooted in an Islamic civilization now vanquished but still at Spain's very heart. Very soon, the powerful alliance of church and state would attempt to excise Spain's layered and diverse identity, to create the illusion of a single distilled entity, in which religion, culture, and political ambition were unambivalently aligned. But culture doesn't lie; it survives, slipping beneath the surface of national consciousness, becoming for us the recovered memory of a tangled, vibrant, hybrid world.

✳

This book is about that lost memory of Castile, about the history that created churches like San Jorge Mártir and made them the products of Castilian culture. Because this memory goes counter to so many received truths, it is also an attempt to restore to the general image of Castilian culture some of its disorder, to recognize its changing and evolving meanings. Our stories revolve around the city of Toledo, itself a complex weave of meanings for the Christians of León and Castile who coveted it, and won it in 1085. Possession of Toledo expanded the borders of the northern Iberian kingdom exponentially, and opened up a broad plain for settlement, providing security and further expansion. But its symbolic value was also potent. As the ancient capital of the Visigothic empire—the last Christian polity on the Iberian Peninsula before the advent of the Islamic Umayyad emirate—Toledo embodied the dream of a Christian empire. That dream of Visigothic renewal, however, was impeded by far more than the presence of Muslims. It was also the dream of a number of other feisty and competing Iberian Christian kingdoms, such as Aragon, Galicia, Navarre. Christian unity was a dream as fantastic as Visigothic renewal. And then, beyond the romanticized memory of Visigothic Toledo was the myth of the eleventh-century city, Tulaytula of the Muslim rulers of the Dhu al-Nunid family. Here was another meaning: Tulaytula as a cosmopolitan city with an urban economy, including a hive of markets for imported goods scarcely seen farther north, all manner of produce and livestock, luxuries, precious arts, and exotic products that evoked wonder and cupidity among the Castilians. And from this contemporary, Islamic Toledo flowed images of palaces and gardens, arts, poetry, science, song, and learning, aspects of a civilization that had already begun to affect the Castilians' notion of what courtly life and kingly virtue ought to be before they possessed the city itself.

The Castilians' possession of Toledo is often hailed as the beginning of what would

be known as the *reconquista* or the reconquest: a war fought to eject Muslims from territory that was believed to belong by right to Christians, a war rooted in religious identity and intrinsic confessional hostility. The eleventh-century Castilians would certainly flirt with the language of Christian destiny, but the idea of reconquest comes from a later century and from another place. The actual taking of Toledo was—diplomatically, militarily, socially, and culturally—a vastly more complex matter. At the most basic level, what the Castilians encountered in Tulaytula was a city in which social relations among Muslims, Christians, and Jews were negotiated in a less confrontational fashion than in the north, or in the papal imagination of the eleventh century. The *dhimma*—the pact by which Christians and Jews lived in an Islamic polity—had provided for the protection of those religious minorities in return for an acknowledgment of Islamic authority and payment of a special tax. So the Castilians would inherit a city that had incorporated the notion of religious and cultural difference into its very structure. And though their approach to governing religious minorities would diverge from that of the Muslim rulers who preceded them, their strategy

for possessing the city intact would also be something new, a supple yielding to the reality on the ground.

A century after the taking of Toledo, its Castilians and Latins newly arrived from other parts of Europe would brandish notions of Christian manifest destiny at the same time that the city fabric exposed a stratigraphy of creative interaction among its diverse religious groups: two languages and two voices in the same poem; buildings that advertise military and cultural domination but betray an unmistakable artistic intimacy between the supposedly opposed cultures. Not that an ideology of religious polarization did not exist: rather, the encounter of peoples—including Muslims, Jews, and Christians—that occurred in eleventh-century Toledo was felt in ways that left all parties transformed and interconnected regardless of their religion, their language, their power within the matrix of society, or even their conscious receptiveness to change. For from the beginning, Castilians and other Christians revealed ambivalence—both attraction and resistance—toward the different cultural expressions that the dhimma had created in Tulaytula. The churches constructed in twelfth- and thirteenth-century Toledo were intended by their very existence to embody a unified political and religious authority. Instead, they bear witness to the breaking down of the absolute cultural authority of the church, in both the conscious and unconscious complicity of the buildings' artistic expression. Latin culture began to be estranged from the ideas of absolute dominion and purity that had long fueled its spread. From this chink in the armor of Catholic cultural hegemony something new arose. In Toledo Castilian culture began to emerge.

These multiple and incremental transformations inflicted tiny momentary shocks to a utopian ideology of Christian absolutism, because the appearance of a bipolar opposition—between Christians and non-Christians—was not possible to maintain for very long in Toledo. Here, Castilian Christians found not only Toledan Muslims and Jews but also Mozarabs, Toledan Christians who had long lived under Islamic rule. And Toledo was a city where not only the Muslims but also the Jews and the Mozarabs were speakers—and readers and writers—of Arabic. But Castilians and Toledans of all three religions also came face to face with yet other groups of Christians, among whom were the Franks and Latin clerics who came from elsewhere in Europe, eager to profit from this prosperous Christian expansion, often at the expense of Iberia's indigenous Christians.

Dynamic transformations occurred in practical, quotidian ways and in public, official ones as well. They became part of Castile's cultural subconscious and part of its monarchs' conscious invention of their own identities. Words and goods, medical care and produce, the spaces of homes and the decoration of places of worship, military strategies and fashion passed effortlessly across religious frontiers in the intimate space of the city. And Arabic—although we sometimes forget this—was much more than the language of a religion; it was the language of shared poetries, ancient philosophy, science, agriculture, medicine, and the most modern technologies. In Toledo the cathedral itself would become the site of an industry of translation, as teams of Mozarabs, Muslims, Jews, and Latins from throughout Christendom translated and interpreted its Arabic libraries of science and phi-

losophy. But beyond language was also the notion, observed over centuries in the many Islamic polities of the peninsula, that kingship—and sovereignty—found its roots in the production of language, literature, and learning. The thirteenth-century monarch Alfonso X el Sabio, "the Learned," knew Arabic himself, but he is better remembered for constructing a corpus of Castilian writings in admiration of and in competition with the great Arabic libraries of the peninsula. And this new library of national identity would have at its heart translations of works of secular prose from Arabic. Castilian, in fact, might be seen to have been nurtured as an official and national language in this fecund environment of assimilation and appropriation.

By the fourteenth century, when Toledo's star was fading, and Seville's rising, synagogues and palaces in both cities would bear the traces of an artistic language that sought an image of absolute monarchy for Castile—artistic styles shared with its Muslim allies. The written, verbal, and artistic languages that were shared by Muslims and Christians, the meanings attached to these forms and styles, became the cultural bedrock of the Castilians, and of the Spanish nation-state that followed. Castile had learned from its common space with Islam and Judaism how to create an identity through culture. In the words of Antonio de Nebrija's dedication of the first Castilian grammar to Queen Isabella in 1492, "language was always the companion of empire."

✳

Complex, geometric arts like those Columbus and his crew saw on the portal of the church of San Jorge Mártir grew from Islamic traditions that restricted the use of images of humans and animals, favoring abstract and meditative arts over figural, narrative ones. But how these artistic values came to that church of Palos is another question. We are accustomed to think of the arts, of language and literature, as being irrevocably attached to the religious and political context in which they were created. So that, from the beginning, linguistic or artistic forms that go on to cross political or religious borders seem anomalous. We have come to call decorative traditions like those we see at Palos "influence," which suggests separate self-contained cultures, Christian and Islamic, defined by the interests of their own political and religious hierarchies, half consciously receiving exotic words, foods, or artistic motifs and styles across clear and defended frontiers. But that is no more tenable than its mirror image, the notion that there existed on the Iberian Peninsula a single cultural world, in which political and religious frontiers evaporated in the face of a shared language of forms. Both of these points of view suggest that culture is stable and fixed, particular to a time frame and a group of people. The first assumes that there is an Islamic culture and a Christian culture that are discrete, closed systems that only interact as separate unified entities. The second assumes a single artistic and literary culture detached from politics and religion as if the active intervention of religious and political tensions would make a hybrid culture impossible. It is in fact the shared assumption that religious difference, if allowed its potential to polarize peoples, would make cultural hybridity impossible that links these ostensibly opposed ideas.

But what if, in the Iberian Peninsula, religion, politics, language, and art never quite align? What if, like electrons, they revolve in different constellations, forming and reforming new bodies, each with different properties, evanescent attractions and repulsions? And as with electrons, one can never quite measure the location and movement of these parts of history at the same time. They are dynamic; intervention freezes the action. The Iberian Peninsula in the Middle Ages might be seen as scores of kingdoms attempting, through war, diplomacy, and law, to stop the action; to create the illusion of a stable entity in the face of kaleidoscopic change, stimulated even more intensely by the multiple kinds of difference the peninsula offered.

Even in 1492 the artistic traditions found at the church of Palos might have had intelligibly Islamic roots, while they were, at the same time, recognizably part of a local landscape. These traditions were assimilated into local identity without irony or disjuncture, even while their users were insisting on a pure cultural ideology aligning with religion. Toledo reminds us that interaction transforms all parties, the visual comfort, the linguistic home of both victors and vanquished, and that transformation is constant and dynamic, its changes occurring incrementally over time. Toledo's multiple cultures help us see that hybridity was not a historical anomaly; it was, throughout medieval Spain, the ideologically inconvenient norm, one tucked beneath a surface of triumphal chronicles and a fierce iconography of conquest.

Culture can bear the cherished scar, the suppressed memory of a civilization's unacknowledged parentage; it can coexist with religious difference and even with ideologies of dominance and opposition. The path by which tenth-century Castile traveled to fifteenth-century Spain was not a straight one, occasionally crossed by various enriching "bridges" and "intersections" with "Islamic" and "Judaic" cultures, as it is often represented. Perhaps Castilian culture did not develop along a path at all, but instead in a series of spaces—castles, cities, battlefields, courts, mosques, synagogues, and cloisters—spaces destroyed and redrawn scores of times over the centuries. It was formed from the competition, dominion, envy, and assimilation that occurred in those places shared with different Christians, Muslims, and Jews. Far from a juggernaut driven by the force of reconquest, Castile was the product of its own countless tensions, desires, and struggles for authority. What if the Catholic kings, in their public insistence on a national identity unsullied by Islam and Judaism, were only whistling in the dark?

✳

We hope in this study to bring to a broader audience some of the work of scholars who have turned toward the study of hybridization in medieval Spanish history, thereby uncovering untold riches. It is a fragmented story that follows the elusive evidence offered by culture: culture at times half erased, at times invisible in its many conscious and unconscious agendas. The historical narrative of this work, which we recount with an enormous indebtedness to our colleagues, is the structure, the backdrop, for the palimpsest of cultural history. Our work can also be seen to complement an ongoing trend that recognizes the

importance of Spain's regional differences, a useful reaction against the imposition of a heavy-handed cultural centrism that has long served to harden a notion of Castilian cultural single-mindedness. Our own goal, in our focus on the formation of Castilian culture, is not to reify the old paradigm within which "Spanish" is synonymous with "Castilian" in the Middle Ages. Nor do we wish in concentrating on Castile's absorption of Islamic and Judaic cultures to ignore or minimize the painful losses of the Iberian Peninsula's Muslim and Jewish peoples. Recognition of Castilian indebtedness to these cultures is in no way offered as a counterweight to Castilian oppression of the same peoples. We hope rather to reconstitute fragments of different memories of medieval Castilian culture, recollections more intimately implicated in the Arabic and Hebrew cultures to which it has been assumed to have been implacably opposed.

Though many of the ideas developed in this work are new, this is less a work of original scholarship than a different narration of cultural history. It is deeply dependent both on the work of our colleagues, old and new, and on our own earlier work—separately, as scholars of the history of art and architecture, and of language and literature. We have tried to assemble a vision of medieval Castilian culture that draws together strands of a fabric that in their complex and often paradoxical coexistence were vital to each other, but that have often been studied and written about in a kind of theological isolation. This is true for the study of the cultures of the different religious communities—Muslims, Christians, and Jews—and it has until recently been no less true in the segregation of the particular fields of language and literature, from art and architecture.

Though contemporary scholars are fast transforming the history of the medieval Iberian Peninsula, it is still popularly seen through the lens of Columbus's eyeglass, his steady gaze on the Catholic kings who had launched the new Spanish nation-state. Their conquests, expulsions, and inquisitions—the powerful branding of Spanish identity with Catholic absolutism—has been projected backward onto the peninsula's complex, plural medieval journey. Many of our conventional memories of medieval Castilian culture have been refracted through the lens that tells us that the Castilians—who would eventually unify the peninsula by conquering all their Christian rivals—were by definition anti-Muslim. And an anti-Arabic posture intermingles with an ideological enmity assumed to have emerged from fundamental and unambiguous polarities that tethered all cultural expression to religious identity. Cultural interaction is too often represented as "cultural diversity," in "margins" as opposed to "centers," or in terms of "borrowing" as if groups defined by religion or nationality, even when they occupy the same terrain, are fixed and self-contained. When we allow this to happen, we turn and project those polarities onto the present; they affect our assumptions about the capacity of peoples to reconcile or live together; they teach us strategies of anticipatory aggression. We hope, instead, to offer here one attempt at repositioning the popular vision of the ways in which religion, culture, and society can interact. Our goal is to create a willingness to see the different constituents of societies not as fixed and monolithic but as "between domains, between homes, and between languages."[1]

Frontiers

Quando mio Çid el castiello quiso quitar,	When My Cid came to leave the castle
moros e moras tomáronse a quexar:	the Moors and their women fell to lamenting.
"¿vaste, mio Çid; nuestras oraçiones váyante	"Are you leaving us, my Cid? Our prayers go before
delante!	you,
Nos pagados fincamos, señor, de la tu part."	We are well content, sire, with what you have done."
Quando quitó a Alcoçer mio Çid el de Bivar,	When My Cid of Bivar left Alcocer,
moros e moras compeçaron de llorar.	the Moors and their women fell to weeping.
Alço su seña, el Campeador se va,	He raised the banner, the Campeador departed,
passó Salón ayuso, aguijó cabadelant,	rode down the Jalón, spurred forward.
al exir de Salón mucho ovo buenas aves.	As they left the Jalón there were many birds of good
	omen.
Plogo a los de Terrer e a los de Calatayut más,	The departure pleased those of Terrer and still more
pesó a los de Alcoçer, ca pro les fazié grant.	those of Calatayud;
	it grieved those of Alcocer, for he had done much for
	them.

Trans. W. S. Merwin

The notion that Spain might ever have a pure indigenous identity unsullied by outsiders can be put to rest by consulting Spanish history in about 1100 BC. That is when diverse Iberian tribes encountered the Phoenicians, who were followed in time by the Greeks and the Carthagenians, all of whom established trading colonies on the eastern and southern coasts of the peninsula. It was the Romans, though, who would possess and define the peninsula as a place, transforming it into Hispania, a group of Roman provinces that would develop into a prosperous cosmopolitan part of the empire. The source of vast shiploads of wheat, olive oil, and minerals to Rome; the birthplace of Trajan, Hadrian, Seneca, and Martial; and the retirement choice of many an old Roman soldier, Hispania was the most Roman of Roman provinces outside Italy. The sites of its political and literary sophistication were elegant estates and villas, as well as dozens of important cities that sprouted the aqueducts, forums, theaters, baths, and colonnaded streets that marked the cosmopolitan identity of a Roman territory.

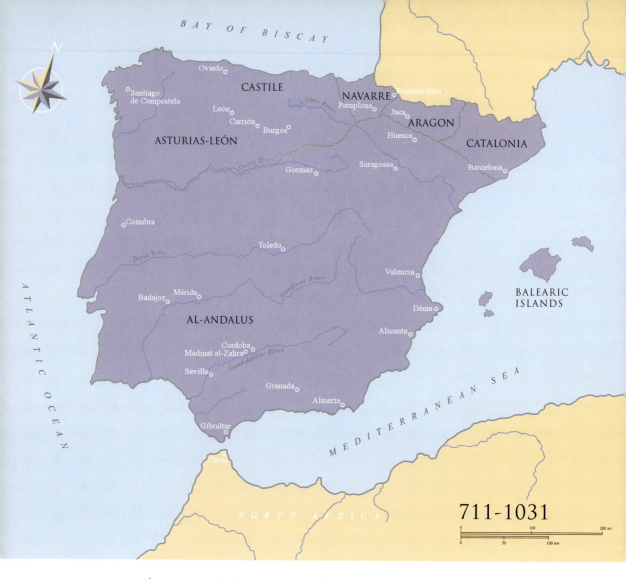

BAY OF BISCAY

Oviedo

Santiago
de Compostela

CASTILE

NAVARRE

Roncesvalles

León

Pamplona

Ebro River

Jaca

ARAGON

Carrión

Burgos

Huesca

CATALONIA

ASTURIAS-LEÓN

Duero River

Barcelona

Gormaz

Saragossa

Coimbra

Tagus River

Toledo

Valencia

BALEARIC
ISLANDS

Guadiana River

Badajoz

Mérida

Dénia

AL-ANDALUS

Alicante

Cordoba
Madinat al-Zahra

Guadalquivir River

Seville

Granada

Gibraltar

Almería

Ceuta

ATLANTIC OCEAN

MEDITERRANEAN SEA

NORTH AFRICA

711-1031

0 100 200 MI

0 50 100 KM

Christianity reached Hispania in the first century and from the third century a lively
Christian community can be chronicled there. A bishop of Cordoba, Hosius, became a
close advisor on religious affairs to the emperor Constantine, to portentous effect. Hosius
was one of the architects of the Council of Nicea (325), which in a sense defined ortho-
doxy for the newly powerful religion, and with Constantine, Hosius fought to tie Catholic
orthodoxy—as the new official religion—to imperial authority and control, an association
that would remain particularly potent in Spain. For as the authority of Rome waned, the
church appropriated its local structure, territorial divisions, and a number of its civil and
legal functions, as well as certain of its imperial pretensions.

Thus the church served as a unifying institution on the Iberian Peninsula in the fifth
and sixth centuries, as Byzantines, Basques, Visigoths, and Suevi clawed at parts of the
frayed garment woven by the Roman empire. The Visigothic king Leovigild (r. 569–586)
finally united the peninsula again, creating a centralized state with a consistent legal code
and compelling royal ceremony: a Regnum Gothorum, the legend and image of which
would long survive the rule of the Visigoths.

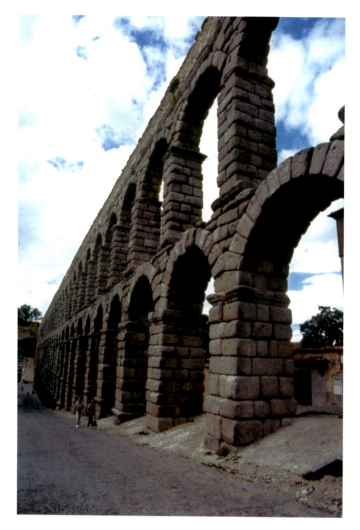

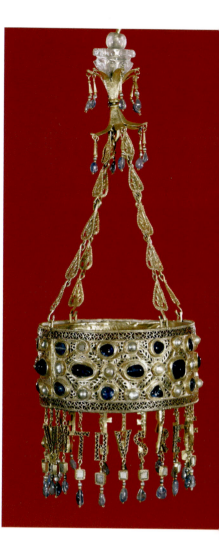

Leovigild, like King Athanagild before him, would establish his capital in the city of Toledo, perched on a hill over a strategic bend in the Tagus River, "raising the place from nothing to lord it over more ancient provincial centers," in Peter Linehan's inimitable words.[1] Located at the

Aqueduct of Segovia, end of 1st century CE.

Crown of Recceswinth, 2nd half of the 7th century. Museo Arqueológico Nacional, Madrid. The gold letters spell out "Recceswinth offered this." The crown, made of gold, pearls, sapphires, garnets, and other decorations, was meant to be suspended over the altar of a church as an offering from the king, and as an advertisement of both his piety and his power.

very heart of the peninsula, Toletum had been the capital of the Carpetani, one of the Celtic pre-Roman peoples of the Iberian Peninsula, a city that the Romans had folded into the province of Hispania Tarraconensis. Like most provincial capitals on the peninsula, Toletum had an aqueduct and an impressive hydraulic system, as well as a Roman circus, traces of which can still be seen in the city fabric today. But now, in the Visigothic period, Toletum became the center of an entire kingdom. And Leovigild, ruling from the city that was also the site of the great church councils of Toledo, would begin to shape the legend of the city in concert with the opulent and authoritative display of his new regnum.

But the regnum shrouded enormous tensions between the Visigothic rulers, who

Church of San Juan de Baños, 661.

were Arian Christians, and the indigenous Spanish church, which represented about six million Orthodox Hispano-Romans. The church would finally exact the conversion of the Visigothic oligarchy of two hundred thousand from Arian Christianity to Catholicism in 589, during the reign of Leovigild's son Recarred. Now the Regnum Gothorum looked pleasingly like the Christian Roman empire for which both the Spanish church and the Visigothic rulers ostentatiously yearned. Accounts of their joint cultural pillaging of the Roman empire—in palaces, churches, coins, vestments, liturgical objects, and court protocol, including the ecstatic unity protested in the writings of Isidore and other Visigothic church fathers—created an image of a sovereign Christian empire ruled in collaboration with a powerful church that would survive hundreds of years after the demise of the Visigothic empire.

In later times, Toledo of the Visigothic period would be remembered for its "church of Santa Leocadia, a wondrous work," and the Visigoths for a time "radiant in wonderfully constructed basilicas."[2] The churches of Toledo appear again and again in manuscripts that record the city's important church councils. In Toledo, these were likely to have been larger versions of basilicas like San Juan de Baños, constructed by King Recceswinth in the seventh century near hot springs he favored. There, aisles separated by arcades supported by Corinthian capitals continue the tradition of Roman Christian basilicas, as we might expect on the Iberian Peninsula, which had such close ties to Rome. But in the Visigothic period, basilicas would be constructed with horseshoe arches, arches that continue beyond the

semicircle of the canonical Roman arch, making a more mysterious space. As offerings, Visigothic monarchs hung crowns over church altars to signify their dedication to Catholicism (so recently adopted), golden jeweled symbols of the sharing of sovereignty with the Hispano-Roman church.

But in fact there was significant jostling for position between the church and the Visigothic state, in particular during the reign of King Wamba (672–680), who attempted to absorb the church under royal authority in Toledo. He established an archbishop in the city, Julian of Toledo, and now both secular and spiritual primacy glowed at the heart of the peninsula. Julian, however, would oppose the king's attempt to capture the church beneath the royal cloak, and by the time of the reign of his successor, Ervig, the church exercised unusual authority in secular as well as spiritual matters, and the archbishops of Toledo showed as much by anointing new kings at their coronations. Yet, perhaps because of just those images, tales of an ideal alliance between church and state would be associated with the city of Toledo under the Visigothic kingdom. Toledo was the city not only of the Visigothic monarchy and church councils but also of a powerful archbishop with primacy over all the churches of the peninsula, and it became the site of a utopian image of a state blessed by collaboration with the church, and a church whose authority extended far beyond the spiritual realm.

Of course, this vision of unchallenged power and peaceful unity of ecclesiastical and royal factions is disturbed by plentiful accounts of hastily poisoned monarchs, royal meddling in ecclesiastical affairs, and the unrepentant manipulation of the Visigothic succession by church officials during the seventh century. There was periodic and widespread persecution of the Jewish community, including, at times, forced conversion, confiscation of property, and slavery for those who resisted. And most influential to the destiny of the monarchy, hereditary succession could never be firmly established, so that the state was debilitated by chronic civil war. It was during one such scuffle that the Visigothic monarchy met its demise: Akhila, son of Witiza (r. 702–710), was proclaimed king, but a rival, Roderic, held the royal city of Toledo. Akhila's partisans turned to North Africa, to armies of Muslims garrisoned there by the Umayyads—the first dynasty of the Islamic caliphate—which had extended its arm to the far western reaches of the Mediterranean.

Umayyad Muslims had vanquished Byzantine rule from North Africa by the end of the seventh century, and the Umayyad governor of North Africa, Musa ibn Nusayr, occupied Tangier—for them, an exotic and remote frontier—by 708. Witiza's family found them there and appealed for help in regaining the throne. The Umayyad army was composed mainly of Berbers, the indigenous people of North Africa, and Musa would appoint one of them, Tariq ibn Ziyad, to lead the expedition to Spain solicited by the Visigothic pretender. In April 711 Tariq landed at the rock that bears his name (Jabal Tariq; Gibraltar) and engaged Roderic's army with an Umayyad force of twelve thousand. By the end of the battle, it was clear that this force was not brought to bear for the restoration of Witiza's regnum; the Umayyads had come to stay.

Combined Arab and Berber troops made their way quickly through an Iberian

Peninsula whose inhabitants were weary of war and disorder. One by one, the great cities built by Romans and Visigoths fell: Cordoba, Granada, Carmona, Seville; then north to Toledo, Saragossa, León, to Aragon and Galicia. Tariq's troops would take Barcelona in 718 and from there forces seized Carcassonne, and Nîmes in the south of France. In general, forays beyond the Pyrenees were discouraged by Umayyad leaders but raiding parties still followed the Rhone as far as Burgundy. Finally, in 732, Emir Abd al-Rahman al-Ghafiqi, who had sacked Bordeaux, was engaged by Charles Martel near Tours in a legendary battle that cooled the ardor of such expeditions, and concentrated Arab and Berber troops on the consolidation of the Iberian land they had won. It was called al-Andalus: perhaps an allusion to the wild Atlantic, the remote western corner of the Islamic world in which it was situated, though other explanations abound.

The Umayyads of Damascus

The Umayyads were the first dynasty to permanently move the center of the increasingly vast Islamic empire outside the Arabian Peninsula. Their rule began in the seventh century, in the period of immense upheaval after the death of the prophet Muhammad and the assassination of his son-in-law Ali. It was defined by a new set of social, artistic, and religious values created in new lands that were predominantly non-Muslim. Damascus, the city the Umayyads made their capital, was made up of a majority Christian and Jewish population and was full of structures and social institutions from the pagan and early Christian periods. Far from trying to eliminate this complexity, the Umayyads appropriated many of the pre-Islamic forms of Damascene society, incorporated the non-Muslims with a formal legal pact, and created a monumental landscape that demonstrated the extent to which they were part of the lively post-Roman world.

In dealing with the religious groups of the plural societies they ruled, the Umayyads relied on the dhimma, the pact governing relationships between the Muslim ruling class and their non-Muslim subjects. The subordinate religions were given protection and hospitality in return for the payment of a tax, and acknowledgment of the ultimate authority of Islam. Sometimes called the Pact of Umar (it may have been codified during Caliph Umar I's rule, 634–644), the dhimma was a revolutionary tool for

consolidation of conquered lands, allowing for varied cultural interactions.

In the earliest years of Islam, the first mosques had been reused buildings, sometimes churches shared with Christians or purchased from them. As new mosques were required, early Muslims exercised restraint in their construction, refraining from monumental forms or opulent decoration. But beginning with the Umayyad caliph Abd al-Malik (685–705), a new attitude toward building saw the Umayyads create luxurious monumental arts as a means of marking the cities they now governed. In Jerusalem, Abd al-Malik constructed the al-Aqsa mosque, and a commemorative structure, the Dome of the Rock, which was not originally used as a mosque. Instead, the dome seems to have been erected to honor a holy place common to Muslims, Christians, and Jews: the rock believed to be the site of Abraham's sacrifice, as well as the location of the ancient Jewish Temple. (Another building nearby commemorated the ascension of Muhammad.) The octagonal building with its central dome elevated on a drum is late antique or Byzantine in style, as are the brilliant mosaics and marble revetment in its interior. But unlike Byzantine or late Roman buildings, the decoration eschews images of humans or animals, in keeping with the aniconic nature of Islamic religious arts. It is the inscriptions that convey specific meanings, and here they suggest that the Dome of the Rock was intended to embody the

However, this first period of Islamic hegemony on the Iberian Peninsula was as fraught as the waning Visigothic monarchy had been. The Arab military aristocracy was divided into rival factions who warred bitterly, and the Berbers, aggrieved by the contempt with which they were treated by the Arabs, and disgruntled by the poorer northern lands they were allotted, revolted as well. These violent tensions contributed to the instability of a badly governed and remote territory of a caliphate on the edge of destruction.

In 750 the Umayyad caliphate was overthrown by the Abbasids—the second great dynasty of the caliphate, who moved its capital to Baghdad—in a dramatic and bloody slaughter of the Umayyad family. One young grandson of the caliph Hisham escaped, and made his way across the face of North Africa to the lands of his mother, a Berber. There, Abd al-Rahman was given an army by his maternal relations, and, entering the peninsula

glory of the new rulers of Jerusalem. The dome instructed Christians and Jews about the nature of Islam, explaining what was common and divergent about the three religions that now shared the city.

The same lavish ornamental style of mosaics and marble made the Great Mosque of Damascus an awe-inspiring center of Islamic worship. It was constructed at the heart of the Umayyad capital, in a place that had always signaled the convergence of religious and political power. The outer walls of the mosque, which measure more than five hundred by three hundred feet, are those of the old Roman temenos, or sacred enclosure, which had housed the Temple of Jupiter and, later, a church. The Muslims first shared the church with the Christians, but the Umayyads subsequently bought the entire space, and made it into a mosque that was also the principal open space of the city. A broad, lofty prayer hall hugs the *qibla* wall (the wall facing Mecca), and the rest of the vast space was transformed into a mammoth courtyard (*sahn*) embraced in a brilliantly decorated portico (*riwaq*). As at the Dome of the Rock, marble plaques cover the lower walls, and some decorative arches alternate colored and white marble. The vast upper walls were entirely covered with gold, green, and blue mosaics of houses, rivers, and trees, like the settings for paradise in Byzantine churches, but without the images of saints who appear in the Christian buildings.

The Umayyads were thus creating a capital in which artistic culture was shared, but the religious vision was new.

The Umayyads of Damascus governed through an Arab aristocracy and would fail in part because of the need for a more cosmopolitan rule in a rapidly expanding Islamic world. A coalition supporting Abu al-Abbas, a descendant of the prophet Muhammad's uncle, defeated the Umayyads, and, to prohibit them from regaining power, had the entire family put to death at an infamous banquet. Only a young prince, Abd al-Rahman I, and his brother Yahya escaped. Though Yahya would die at the hands of the Abbasids who pursued them, Abd al-Rahman would live on to found the Umayyad emirate of Cordoba.

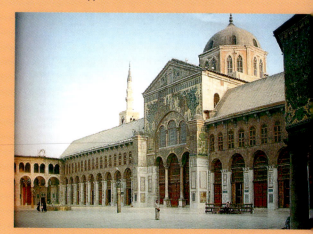

Great Mosque of Damascus, sahn, c. 715.

on the pretext of aiding a local cause, easily conquered the frontier forces in al-Andalus and was proclaimed governor, or emir, in the capital, Cordoba. Al-Andalus would now be an independent kingdom, but not a separate caliphate; it would be politically autonomous from the caliphate in Baghdad, although Abd al-Rahman would not claim to be a caliph himself.

From the outset, indigenous populations who accepted the authority of the Umayyad conquerors were more successfully integrated into the new social order than the Berbers had been. There was significant conversion of Christians, which created an additional social group, Muwallads, or indigenous converts to Islam. This was an ethnic category that followed an individual's family history for perpetuity, and carried a kind of secondary social status. But the treatment of unconverted Christians and Jews was unique under Islam. They were "Peoples of the Book" (*ahl al-kitab*) who had received the Torah, the Psalms, and the Gospels—revealed texts recognized by Muslims. It was held that a com-

The Treaty of Tudmir

The following letter from April 713 is the earliest preserved terms of capitulation from a Muslim commander to a Visigothic ruler in Iberia. Known as the Treaty of Tudmir, an Arabization of Theodemir, the name of the Visigothic ruler of Murcia, it displays many of the hallmarks of a dhimma arrangement. It provides the local Christian population with freedom to continue practicing their faith, in exchange for loyalty to the ruling Muslims and the payment of yearly taxes.

In the name of God, the merciful and compassionate.

This is a document [granted] by Abd al-Aziz ibn Musa ibn Nusair to Tudmir, son of Ghabdush, establishing a treaty of peace and the promise and protection of God and his Prophet (may God bless him and grant him peace). We will not set special conditions for him or for among his men, nor harass him, nor remove him from power. His followers will not be killed or taken prisoner, nor will they be separated from their women and children. They will not be coerced in matters of religion, their churches will not be burned, nor will sacred objects be taken from the realm, [so long as] he [Tudmir] remains sincere and fulfills the [following] conditions that we have set for him. He has reached a settlement concerning seven towns: Orihuela, Valentilla, Alicante, Mula, Bigastro, *Ello, and Lorca. He will not give shelter to fugitives, nor to our enemies, nor encourage any protected person to fear us, nor conceal news of our enemies. He and [each of] his men shall [also] pay one dinar every year, together with four measures of wheat, four measures of barley, four liquid measures of concentrated fruit juice, four liquid measures of vinegar, four of honey, and four of olive oil. Slaves must each pay half of this amount.*

Names of four witnesses follow, and the document is dated from the Muslim month of Rajab, in the year 94 of the Hijra (April 713).

Trans. Olivia R. Constable

بسم اللّه الرحمن الرحيم كتاب من عبد العزيز بن
موسى بن نصير لتدمير بن غبدوش انه نزل على
الصلح وان له عهد الله وذمّته وذمّة نبيه صلّى اللّه
عليه وسلّم الا يقدّم له ولا لاحد من اصحابه ولا يؤخر
ولا ينزع عن ملكه وانهم لا يقتلون ولا يسبون ولا
يفرق بينهم وبين اولادهم ولا نسائهم ولا يكرهوا على
دينهم ولا تحرق كنائسهم ولا ينزع عن ملكه ما تعبّد
ونصح وادى الذي اشترطنا عليه وانه صالح على
سبع مدائن اوريوالة وبلنتلة ولقنت وموله وبقسره واية
ولورقة وانه لا يؤدى لنا إبقاء ولا يؤوى لنا عدوا ولا
يخيف لنا آمنا ولا يكتم خبر عدو علمه وان عليه وعلى
اصحابه دينارا كل سنة واربعة امداد قمح واربعة
امداد شعير واربعة اقساط طلاء واربعة اقساط خل
وقسطى عسل وقسطى زيت وعلى العبد نصف ذلك

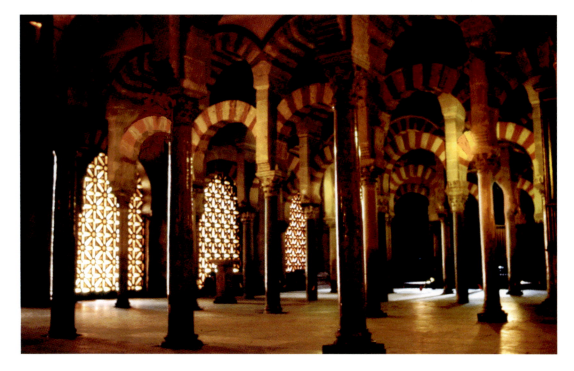

Great Mosque of Cordoba, prayer hall, 8th century.

munity of faith existed between these posses-
sors of earlier scriptures and Muslims, who
had received the ultimate revelation of the Quran. In early Islamic societies, Christians and
Jews were governed by the *dhimma*, the contract by which the Muslim community granted
them protection and freedom to practice their religion. In such pacts, the conditions for
tolerance were political submission and the payment of a special tax for non-Muslims, the
jizya, as well as measures aimed at assuring a Muslim hierarchy. Among these were strict
prohibitions to proselytizing or Muslim apostasy through conversion or marriage, and the
careful stratification of society and political institutions. Still, the dhimma constituted a
protected legal status for religious communities. It was a marked improvement for the
Jews, who had suffered repeated persecution in the Visigothic period. And it offered a kind
of autonomy for communities of Christians, called Mozarabs, because Islamic governance
provided for a separate civic authority, including a Christian judicial system for cases in
which only Christians were involved. Indeed, the church was the organizing body of
Christian internal rule in al-Andalus.

Arabized Christians, like Arabized Jews, were by law subordinate citizens in the
Islamic polity of al-Andalus, but the conditions of life and worship were good enough that
assimilation largely triumphed over rebellion, even among those for whom conversion was
out of the question. Mozarabic Christians and Jews would become, in very little time, Arabic
speakers who participated in the economy and cultures of the Umayyad cities of al-Andalus.

Abd al-Rahman I proclaimed the change in order to the new Umayyad emirate in
several ways. He put down revolts, and made peace with his enemies. He also brought a
number of northern governors, who had acted independently for generations, under his

aegis. One of these incidents has penetrated into European myth: Saragossa's governor, Sulayman ibn Yaqzan, had appealed to Charlemagne, pledging allegiance to the Frankish monarch if he would keep Abd al-Rahman from incorporating Saragossa into the emirate. Charlemagne himself traveled to Sulayman's aid, but was unable to take the city; and to add insult to injury, the Franks' rear guard was decimated by the Basques as they crossed the Pyreneean pass of Roncesvalles on their way home. Of such ignominious beginnings the *Song of Roland* would be wrought centuries later.

Abd al-Rahman used architecture as a way of creating an image of his new emirate: a sprawling mosque at the center of Cordoba, a broad prayer hall spilling into a courtyard that became the most important open space of the city. Its eleven aisles created a hypostyle plan: a forest of columns that could hold more than five thousand faithful. This open, dispersed plan connected it to the earliest Umayyad mosques of Egypt and Iraq, and red and white banded arches meant to evoke the grand Umayyad monuments of Damascus and Jerusalem. But the mosque was also marked by horseshoe arches, and classical orders, that were profoundly Hispanic forms. Abd al-Rahman and his architects used those indigenous forms to conceive a whole language of ornamentation devoid of people or animals, in keeping with Islamic restrictions against representations of animate beings in religious art. In that way they brought a new Spanish Islamic art into being.

The Umayyad rulers of the emirate of al-Andalus would build a prosperous and powerful dynasty with a dynamic economy and culture. Agriculture, trade, and manufacture of luxury goods would serve not only to create wealth but to bolster the image of kingship. The Umayyads imported new agricultural methods to the peninsula, introduced new foods and plants, created perfumes and incenses, silk textiles and clothing, ceramics, ivories, jewelry, and metal objects, all of which would perpetuate an image of courtly privilege and luxury and increase the prestige of the court while enriching it. For the Umayyads of Spain, high culture was part of the politics of ruling. Abd al-Rahman II (r. 822–852), who admired the urbane court culture of Baghdad, famously brought the Iraqi court musician Ziryab to Cordoba, and along with him the great refinements of the Baghdad court: new music, and novel fashions for cosmetics, clothing, and cuisine. But above all, Ziryab marks for us Cordoba's intense encounter with classical Arabic poetry, which would become a profound part of the culture of al-Andalus.

As the glory of Cordoba's culture accelerated conversion of the city's Mozarabs, one dissident group staged what is known as the Cordoban martyrs' movement, engaging in dramatic acts of civil unrest. The movement, composed of clergy and laymen, acted in response to a fear that their cultural identity, which in the past had been intertwined with the power of the church, would evaporate in the blinding luster of Umayyad Cordoba's golden age. Eulogius of Cordoba, a priest and apologist for the voluntary martyrs, who would himself eventually join their ranks, worked to advertise their actions with Christians in the north, attempting to associate them with early Christian martyrs who resisted Roman persecution. He saw his role, historian Kenneth

Codex Conciliorum Albeldense, 976. El Escorial, Madrid. Also called the Codex Vigilanus, after the scribe Vigila, pictured at the bottom of the center row of figures.

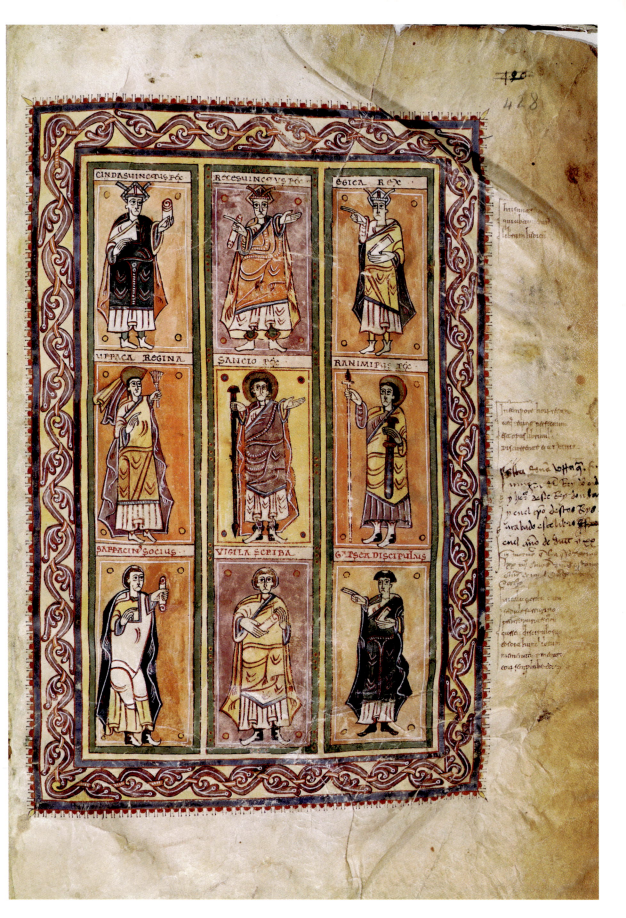

428

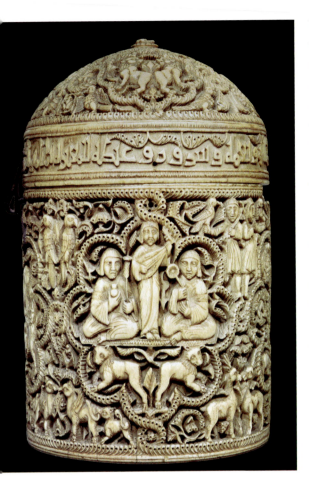

The al-Mughira casket. Probably made at Madinat al-Zahra, the casket's depiction of seated courtiers recalls the description of John of Gorze, the ambassador of Emperor Otto I to Abd al-Rahman III at Madinat al-Zahra: "There, in the midst of the most splendid luxury, the monarch reclined on a cushion, because they do not use thrones or chairs like other countries, but bolsters or cushions, on which they recline, one leg over the other."

Wolf tells us, as "promoting their cult when so many Cordoban Christians seemed inclined to reject the would-be martyrs as suicides whose actions jeopardized their day-to-day relations with the Muslims."[3] Indeed, the revolt was condemned by Cordoba's church hierarchy, and offers a view of the divergent attitudes of resistance and assimilation that reigned in the Umayyads' Christian community.

A quite different Christian community was developing in the far north of the peninsula. In the years that al-Andalus was a frontier outpost, and in the early years of the emirate, two small centers of Christian rule sprang up in lands that had been bypassed by Islamic forces: first, the mountain kingdom of Asturias, and, soon after, the kingdom of Navarre. At the same time, nascent Christian polities were developing in Aragon and Barcelona, to the east.

The kingdom of Asturias lay in a part of the Iberian Peninsula that had most resisted Roman and Visigothic authority and culture. The different inhabitants of these mountains and the coast were geographically remote and free of the powerful Islamic polity, just as they had remained largely aloof from Roman rule. Historian Gabriel Jackson called the first kings of Asturias and Navarre "wealthy cattlemen who doubled as guerilla war captains"[4] and it was, indeed, Basques from Navarre who had demolished Charlemagne's rear guard when the king of the Franks was returning home, through the mountain passes just north of Pamplona, from his ill-advised siege of Saragossa. And while the Umayyads ruled the rest of the peninsula from Cordoba, Oviedo was created as a new northern Christian capital, making a kingdom of Asturias at a time when the rural economy in the north began to sustain large family estates and monasteries.

It was in Oviedo or León that the myth of Toledo as the capital of a utopian Christian kingdom was first nurtured, a palliative for a scruffy mountain kingdom; Toledo of the Visigoths, where the church was believed to have all but reigned over a Christian empire. But the myth of Toledo was more programmatically a part of the spin of the kingdom of León, a myth that would long hold powerful implications for Spanish kingship. Alfonso III, king of Asturias and León at the end of the ninth century, encouraged the repopulation of

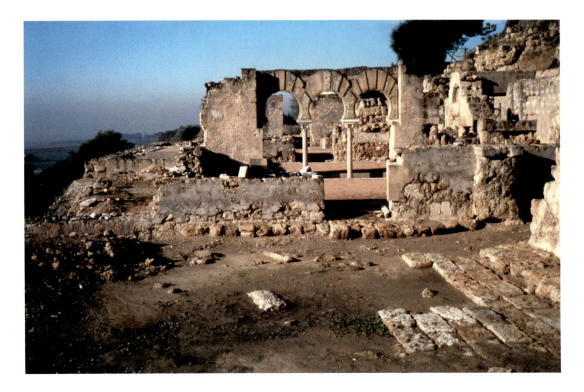

a broad strip of frontier lands north of the Duero **Madinat al-Zahra, view of palace ruins, 10th century.**
River, and he urged monasteries with resistant

politics from Umayyad lands to come north, enticing them with donations of land, local
authority, and privileges. And so the late ninth and tenth centuries saw monasteries of
Mozarabs, who had never known life except under Umayyad rule, staking a claim to
Christian territories in León, and bringing with them their distinctive ways, material cul-
ture, and native Arabic language.

It was perhaps these more politicized Mozarabs who introduced a militant tone into
the Leonese yearning for a renewal of the Visigothic monarchy. In the Codex Conciliorum
Albeldense, a manuscript collection of decrees of church councils and legal codes, an
extraordinary miniature depicts the Leonese investment in Visigothic conciliar laws that
prompted the manuscript's creation. On a page divided into nine parts, the Visigothic
kings Chindaswinth, Recceswinth, and Egica reign over the top three divisions, their robes
vibrating against backgrounds of complimentary colors, in an intense, saturated chromatic
scheme. Below them, in direct lines, are the Leonese rulers Urraca, Sancho I, and Ramiro
III, pictured as the direct and rightful heirs of a Visigothic peninsula that had vanished into
myth two centuries before them. And below the rulers, in surprisingly comparable scale,
the scribe Vigila and his disciples illustrated their own importance in perpetuating the idea
of Visigothic kingship through the creation of such a text. This remarkable grid envisions
a kind of ideological frame for Leonese identity, one that sanctified and justified territorial
expansion at the expense of their neighbors, both Christian and Muslim. For some, this
moment appears to signal the beginning of what would be known as "reconquest": a war

meant to evict Muslims from territory that by right belonged to Christians, a war founded on religious difference and sectarian animosity. But the yearning pictured is far from one rooted in religious ideology.

As Leonese monarchs repopulated abandoned frontier lands, al-Andalus prepared for its brilliant golden age. This was in part prompted by Abd al-Rahman III's determination to "hispanize" his rule,[5] as a means of uniting its disparate ethnic Muslim factions. Abd al-Rahman's greatest burdens at the outset of his reign in 912 were revolts of Muwallads, Hispano-Muslim families like the Banu Hafsun and the Banu Qasi. After putting down their rebellions, he empowered Hispano-Muslims in his realm and decreased the authority of the Arab aristocracy, while building his royal palace guard of Franks and Leonese merce-naries. Then in 929 Abd al-Rahman III took the extraordinary step of establishing his com-plete independence from the Abbasids in Baghdad by proclaiming himself caliph, or true successor of Muhammad. His claim was buttressed by a breathtaking new court ceremonial, and by an expansive new diplomacy: he took North African holdings to secure his caliphate against the new Fatimid regime in Tunisia, and established diplomatic relations with the Byzantine empire, as well as with Christian kings in Italy and Germany, whom he approached with the help of his ambassador Recemund, the Mozarabic bishop of Elvira. Abd al-Rahman thus achieved peace within al-Andalus and enormous prestige in the wider world.

Part of the genius of Abd al-Rahman III's rule was the creation of a remote and potent mystique, and he would use artistic patronage to provide a fitting setting for his new caliphal authority, and exercise control over a volatile court. He conceived a palace city, Madinat al-Zahra, at one of the royal estates on the outskirts of Cordoba, a visual essay on the scope of his power. There were fountains where gilded animals spewed water, workshops where precious objects were fashioned from a king's ransom of North African ivory, and a *tiraz*, a royal textile factory, where silks of incomparable quality and legendary reputation were manufactured. Here the stuff of mythic kingship was displayed in a labyrinthine palace sprawled across broad terraces, with courtiers lodged according to their position, and open arcades and gardens all oriented to the view of agricultural lands that were the source of caliphal wealth, views organized, in the words of landscape histo-rian D. Fairchild Ruggles, "to naturalize social hierarchy and serve state ideology."[6]

But we ought not to forget that Abd al-Rahman's Hispanic—rather than pan-Islamic —identity for al-Andalus must have grown to some extent from his personal experience. He was himself irrevocably Spanish, not only by virtue of his ethnically and religiously diverse population, but by his own genealogy. In his poetic treatment of life and love at the end of the caliphate, *Tawq al-hamama* (*The Dove's Neck-Ring*), Ibn Hazm, the best-known writer of all of Islamic Spain, remarked that the Umayyad caliphs and children were blonde and blue-eyed. They might have traced their paternal and political roots to Umayyad Syria, but they were bilingual and ethnically mixed, as a glance at their complete family tree makes abundantly clear. Hispano-Umayyad rulers consistently produced their heirs with women from the northern Christian kingdoms. The implications here are not merely ethnic; they cut deep into the notions of culture and identity. Abd al-Rahman III's mother,

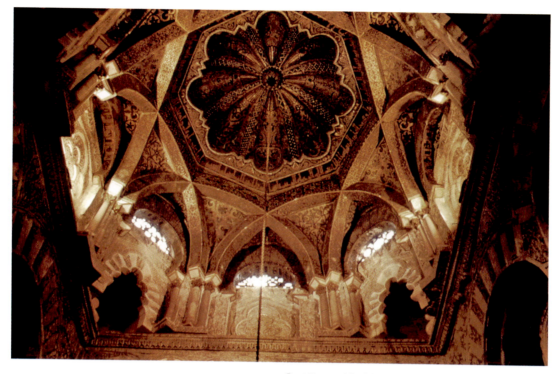

Great Mosque of Cordoba, maqsura dome of
al-Hakam II, 961.

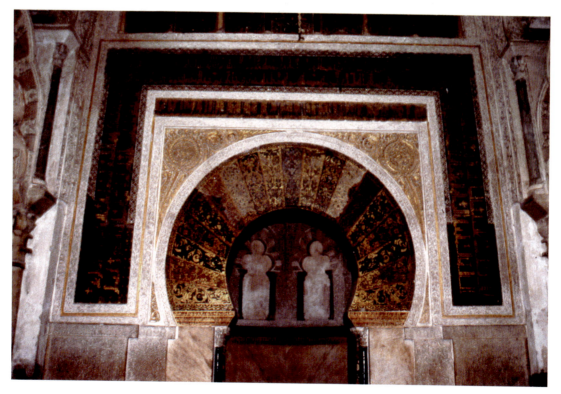

Great Mosque of Cordoba, mihrab of al-Hakam II, 961.

Muzna ("Raincloud"), was Basque. The mother of the caliph, one of the most powerful forces in the royal harem and the person most intimately associated with the ruler, would, Ruggles reminds us, "speak the romance tongue of Navarre or Catalonia, remember the sweet taste of well cured ham, and occasionally sing a colloquial song remembered from her childhood, particularly when rocking the cradle of her newborn."[7] No wonder the caliphs also spoke Romance, the vernacular language derived from Latin; and no wonder the diplomacy of the caliphate seldom confused politics and culture with religion.

Abd al-Rahman III's son was al-Hakam II (r. 961–976), a pious scholar who extended the use of architecture and patronage to support caliphal dignity through an enlargement of the Great Mosque of Cordoba. The prayer hall was a faithful continuation of the one begun by Abd al-Rahman I, reminding the devout of the direct line between al-Hakam and the first Spanish Umayyad ruler. And it culminated in a sumptuous and monumental *maqsura*, a part of the prayer hall set aside immediately preceding the qibla, the wall facing Mecca. The *mihrab*, the niche that marks the qibla, or the direction of prayer, was decorated with lavish gold, green, and blue mosaics meant to recall those of the Great Mosque of Damascus, the eighth-century mosque of the old Umayyad capital, and thus to legitimize the Cordoban Umayyad's claim, not just to the Umayyad past, but to caliphal authority.

A scholar in his own right, al-Hakam II followed his father in inviting poets, artists, mathematicians, and astronomers to court, a phenomenon that stimulated similar acts of intellectual patronage among the aristocracy. With more than four hundred thousand volumes, his library excited envy throughout Europe. Conservative theologians, like those associated with the Malikite school of law, were powerful in Cordoba, but under Abd al-Rahman III philosophers influenced by more wide-ranging thinkers from eastern Islam found a foothold in al-Andalus. And court physicians, like Hasdai ibn Shaprut (a Jew who served as the caliph's personal physician and performed diplomatic duties for Abd al-Rahman III), advanced the science of medicine.

Though often absorbed in subduing internal strife, Abd al-Rahman III had engaged in several significant territorial battles with the kings of León and Navarre. In retaliation for raids on his strongholds, he delivered a decisive blow to the kingdom of León at Valdejunquera. When the raids continued, he sacked Pamplona and decimated Navarre's regenerative powers for over a century. But in 939, King Ramiro II of León routed him at Simancas, making room for increased Leonese repopulation of the frontier. Al-Hakam II, however, was able to patrol his borders with little challenge: he subdued Navarre, León, Castile, and Barcelona, and the rulers of those northern kingdoms spent a large part of al-Hakam's reign ingratiating themselves with the Umayyad ruler. But, though religious ideology could infuse the glorious rhetoric of these conflicts, we would be mistaken in assuming that these were holy wars, conflicts that grew from ideological values.

In fact, relationships between Christian and Muslim monarchs were intertwined, and if there were often tensions, there was also close interaction and intimacy. Few stories better illustrate the intricate relations between the barely choate Christian monarchies of the tenth century and the Umayyads than the legendary Cordoban sojourn of the unfortunate

king remembered by the Cervantine name of Sancho the Fat. The obese Sancho I inherited the throne of León in 956, and then spent his entire lifetime defending it, involved in little else besides the murderous politics of succession and power that often led Christian princes and kings to seek protections and strategic alliances with the Umayyads. Sancho's journey to the great metropolis of Cordoba took place in 958—during the reign of Abd al-Rahman III—and was engineered by one of Pamplona's most formidable figures: his grandmother, Toda, queen mother of the royal Navarrese house. Toda had both personal and political interest in finding a cure for her heir's obesity, which, among other things, prevented him from riding a horse—essential to military, and thus political, leadership, as well as honor, where mobility was a cardinal virtue. But her net spread even wider; Toda, queen mother of Navarre, was also great-aunt of Abd al-Rahman III himself.

In refined, urban Cordoba Sancho was apparently transformed, rendered if not thin at least more able-bodied, and able to ride again, and in some accounts this was thanks to Hasdai ibn Shaprut, the caliph's physician and head of the Jewish community of the Islamic capital. But whether or not the advanced medical establishment of the newly declared caliphate managed to cure Sancho's morbid obesity, Sancho came away with useful political ties to the Cordoban leadership, and they helped restore him to the throne he and his brothers and half brothers had violently disputed throughout their lives. The Umayyads had no particular sentimental attachment to Sancho himself, and when he did not relinquish the castles that were the payment for the treatment he had received in Cordoba, his favor in Cordoba vanished. Now his half brother Ordoño appealed to the caliph for help in regaining his brother's disputed throne. Because Sancho was uncompliant, Ordoño received what he asked for, with the uncontested support of the Umayyad caliph.

The dynastic and geographic ties that constantly crossed political and religious frontiers continued to be knotted in the unions between Cordobans and Navarrese. Among these none is more dynastically significant than the mythologized love of the caliph al-Hakam II for a young Navarrese woman from Pamplona, Aurora, better known by her Arabic name, Subh. Subh's son with al-Hakam was the heir to the Umayyad line, but Hisham was only a child when his father, the caliph, died in 976. And it was in the denouement of the succession of the son of al-Hakam and Subh that the political landscape of the peninsula was radically redefined. The balance of power of the great Islamic metropolis and the budding and querulous Christian kingdoms of the north, Navarre among them, was upended with the breaking of that Umayyad line. Subh formed an alliance with Muhammad ibn Abi Amir, an intelligent and ambitious civil servant who rose to power quickly with her aid. He helped her thwart a conspiracy against her son, and was appointed *hajib*, or chamberlain. From this position, he eventually assumed power over the entire state. Ibn Abi Amir would become al-Mansur, "the Victorious," and, Ibn Hazm suggests, the lover of Subh as well.

Al-Mansur transformed the physical and social landscape of Cordoba itself, doubling the size of the Great Mosque, the visible cornerstone of his attempt to establish his own dynastic legitimacy. The mosque's design also declares his restraint, and conservatism, by

expanding the prayer hall eight full aisles to the east, mitigating the authoritative axis of al-Hakam's long mosque plan into a more traditional, dispersed plan. It is a challenge to the palacelike hierarchy of al-Hakam's luxurious addition, and thus proclaims al-Mansur's piety. The mosque was expanded in part to provide for the Berber mercenaries who supported his thinly veiled dictatorship.

Simultaneously, and in equal measure, al-Mansur transformed Cordoban relations with the northern Christian kingdoms, with his relentless, often gratuitously punishing raids of even the farthest northern reaches of the peninsula. He covered his dubious legitimacy with zealous and dramatic acts of militant piety. One of the foundational dramas in later narratives of implacable religious warfare between Muslims and Christians is al-Mansur's infamous sacking of the pilgrimage site of Santiago de Compostela in 997 and his ordering the bells of the church taken to Cordoba—on the backs of Christian prisoners-of-war—to be made into lamps for the Great Mosque. But even as he systematically undermined Cordoba's cosmopolitan spirit by burning books from al-Hakam's magnificent libraries, and even as he practiced a scorched-earth policy with his northern neighbors, al-Mansur, the Victorious, reinforced the notion of dynastic ties with the great Christian families of Pamplona. When the king of Navarre Sancho Abarca concluded a peace treaty with al-Mansur in 992, he gave the Cordoban tyrant his daughter as a bride. She bore al-Mansur an heir ambitiously named Abd al-Rahman, who was known both in his own lifetime and by Arab historians as Sanjul, an Arabization of "Sanchuelo" or "little Sancho," after his maternal grandfather, Sancho the king of Pamplona.

But before Sanjul could take possession of his kingdom, an uprising and disastrous civil war ripped through the caliphate. A succession of caliphs were enthroned and toppled by palace interests, Berber troops, or the Arab aristocracy, at times with the help of allies from the Christian kingdoms. In 1009 Madinat al-Zahra, the palatine city that had embodied the mystique of the caliphate, was sacked and destroyed. This was the *fitna*, the time of troubles, of civil wars. The rule of the Hispano-Umayyads was dead, and al-Andalus was dispersed into more than twenty Taifas, "party states," or petty kingdoms.

It was at such a moment that another Sancho, a man whose full name was Sancho III Garcés of Navarre but who is remembered as "el Mayor," or "the Great," became the dominant figure of his lifetime in the north of the peninsula. During the destructive last years of the reign of al-Mansur, an ambitious young Sancho inherited what was a diminutive realm in Navarre. But his long reign—from his accession within a year or two of the death of al-Mansur in 1002 until his own death in 1035, four years after the official dissolution of the caliphate in 1031—coincided almost exactly with the three decades of chaos and civil wars that were the swan song of Cordoba. These events gave him the opportunity to convert a tiny kingdom among many into a powerful union of Christian polities.

The collapse of the centuries-old Umayyad state provided the politically astute Sancho exceptional opportunities. And he had the skills and the vision to make a great deal of the circumstances: he largely ignored Cordoba and focused instead on what the squabbling Christian kingdoms might become. His debauched Cordoban cousin, Abd al-Rahman

(al-Mansur's son "little Sancho") had reigned disastrously for about a year, before being murdered in 1009, thus bringing to an ignoble end the Amirids, as al-Mansur and his heirs were known. But Sancho of Navarre was, quite unlike Sanjul, able to cobble together a new kingdom of his own from the long-feuding principalities of Aragon, León, Navarre, and Castile. Through diplomatic and cultural efforts, looking beyond the *mesetas*, the high plains, of an ever-larger Castile, he tied his own scarcely defined kingdom to yet other Christian courts, including Catalonia and other, Frankish ones beyond, and across the Pyrenees. From all of this followed unprecedented traffic in ideas and languages, including those of architecture, and liturgies. The cobbling was ultimately not as enduring as his imagination of a future that went beyond the merely territorial. His wider vision led him to cultivate affinities with the previously little-recognized Latin Christendom to the north, and to actively promote the pilgrimage to the Galician city of Santiago de Compostela, in the far west, beyond even his own newly expanded borders.

Sancho had a palpable desire not only to connect with an imperially Christian Visigothic past but to make something culturally distinct of what he had won through brute force, something that transcended the León, Castile, Aragon, and Navarre that composed his new kingdom. Through clever military alliances and politically astute marriages, he was legitimately able to declare himself *rex Dei gratia Hispaniarum*, in 1034, from León. In that title, as well as in the inscription *imperator totius Hispaniae* on the coins of his realm, are distinctly visible the glimmerings of a notion of what might be the first post-Umayyad empire in the peninsula. (*Hispaniarum* and *Hispaniae* both speak loudly to the plurality of groups in the realm, to the transcendence of regions, to the trumping of the local.) And what better way to codify this collective than to celebrate the Christianity that was the binding aspect of their loosely defined culture? So Sancho responded to al-Mansur's punitive, pious warfare, conceived to legitimize his usurped throne, with a vision of a unified Christian imperium.

An innocent observer of this scene in Iberia in the 1030s, when the stability and well-being of the caliphate were already a sentimentalized memory, and the lands under Islamic control were splintered and at violent odds with each other, would be forgiven for predicting a rapid supplanting of the old Islamic order by this ascendant and unified Christian polity. But Sancho's bellicose energies were almost completely aimed at enlarging his territories at the expense of other Christian kingdoms. And at his death Sancho explicitly dismantled that hard-won and still-nascent empire by dividing the realm among his sons, each of whom received his own kingdom. Although the relative sizes and primacies of the different territories had been reshuffled, with Aragon emerging as a newly distinct and relatively powerful entity, and the young Castile poised to absorb the older León into itself, this was a return to the status quo ante that provided an echo and a parallel universe, rather than an alternative and a challenge, to the state of political feuding among the Islamic city-states.

This undoing of protoimperial unity would become Sancho the Great's dubious legacy to the monarchical traditions of the Iberian Christians: a pattern of virtually constant civil wars among the hereditary rulers of the various kingdoms—men, and the occasional

woman, who were rarely strangers from strange lands but far more likely brothers or cousins or even spouses—engaged in often murderous struggles with each other in the attempt to establish an overarching dominion. But whatever success any individual ruler might have, no matter how brilliant, was unlikely to survive beyond his own lifetime. Whatever expanded and unified realm had been achieved, at whatever cost, might well be dismantled among the heirs.

The ultimate winner of this debacle would not be known for a century or more. It was the smallest of Sancho's bequests: the newly minted kingdom of Castile. Sancho had received Castilian lands as part of his Leonese wife's dowry, and he was probably obliged to pledge that Castile would not be absorbed into the kingdom of Navarre before he could possess it. Until then only a county, Castile's status was raised upon Sancho's death, so that he could offer a realm comparable to the others to his son Ferdinand I. And so the kingdom of Castile was born.

<p style="text-align:center">✳</p>

At the eve of the millennium, when Sancho the Great was forging his short-lived kingdom, Toletum had become Tulaytula: a northern frontier town of the Umayyad caliphate, a city with large Muwallad, Mozarab, and Jewish populations in addition to its Arabs and Berbers. Before 1030 Toledo would begin its golden age under the Taifa kingdom of the Dhu al-Nunid family. More than eighty years would pass before Toledo became part of Castile, years that saw both the city and the young kingdom transform, and grow close in unexpected ways.

In the beginning, Castile took its name from the Latin *castellae*, the fortified castles that speckled the vast plain just south of the Cantabrian Mountains and north of the Duero River valley. We mark the birth of Castile in the eleventh century for many reasons, but perhaps most fittingly because it was when the number of those emblematic castles, the fortifications in the rugged and sparsely populated tableland, became a defining presence of the landscape. Frontier Castile was remote, volatile, and hearty. And yet, long before the move into Toledo would completely redefine Castilian—both what it meant geographically and what its styles and loves were—the peoples whose fortified castles provided the culture with its name and defining characteristics were themselves a provocative mix, and the most equivocal of legendary warriors, the Cid, Rodrigo Díaz de Vivar, its not altogether surprising icon.

Castile's political history is easily rehearsed: it first emerged as a frontier county of the kingdom of Asturias in the eighth century. As part of Asturias it joined León in the ninth century and, as part of León's attempts to repopulate the frontier, the kingdom of Castile found its capital in a fortification (*burgus*) that would become the city of Burgos. Castile's borders extended south to the Arlanza and the Duero rivers, and the scruffy county had attained a kind of virtual autonomy by the tenth century, before Sancho III of Navarre annexed it, making it into a kingdom for his son, Ferdinand I, in 1035. From there Castile would alternately merge and separate from León for two hundred years. Ferdinand would

unite Castile with León in 1037 through his marriage to a Leonese princess, but he would ultimately split them to provide separate kingdoms for his sons Sancho, Alfonso, and García. Alfonso, through various unfilial acts, would unite them once again in 1072, but not until 1230, during the reign of Ferdinand III, would León and Castile be definitively joined. Castile expanded to include Toledo under Alfonso VI (extending it to the south, to what we now call New Castile) and Seville under Ferdinand III, as Castilian monarchs annexed Islamic lands and absorbed new populations. But often the struggles of Castilian monarchs for territory and authority were with nobles of their own courts, or with their own sons, sisters, and brothers. Ultimately, in 1479, the kingdoms of Castile and Aragon were joined under Isabella of Castile and her husband, Ferdinand II of Aragon, and the kingdom of Castile would both dominate and be subsumed into the Spanish empire born in 1492.

But in many ways, the distinctions between Asturias or León, Navarre or Castile, were evanescent in the early years: political history can be deceiving. And the topography of this history reminds us of the extent to which political changes often do not transform the essential workings of a place very quickly. The northern reaches of the peninsula, from the Duero River to the approach to the Bay of Biscay, through the Cantabrian Mountains, were always a hinterland. These lands were all united by history and experience. The long arm of Roman civilization barely reached there, and converted far fewer of its inhabitants to its ways than in the southern and central reaches of the peninsula, and the Basques long remained entrenched in both mountain strongholds and neighboring plateaus. At the end of the day—when the Visigoths gave up the ghost, and the arrival of the Umayyads transformed the peninsula—it was a region less Latinized—or Romanized—than the south. Its lands were less fertile and thus had been less coveted, its cities less layered with Roman culture, and it was still filled with speakers of Basque. The Umayyad Muslims were, at this moment, in ways conscious and unconscious, the new Romans, their cities palimpsests of Roman urban centers, their laws and administration part of their colonial strategy, their language the new imperial tongue. But they only sporadically tried and finally never brought this stubborn corner of the peninsula into their orbit.

By the eleventh century, these Castilian peoples and their leaders were still a rough-and-tumble multilingual tribe, marked by a certain self-conscious rebelliousness that had already been enshrined as a distinctive cultural characteristic in the tiny kingdom of Asturias. The independence—or at least the obvious departures from the norms of the rest of the peninsula—was also linguistic: the vernacular spoken here, as opposed to elsewhere, in regions originally more heavily Romanized, was relatively unfettered by Latinate traditions, and much affected by their unique and long period of Romance-Basque bilingualism. It was this first part of their frontier and mixed-peoples history, this complex internal concoction of Basques and Visigoths and other lightly Romanized peoples, that would eventually bequeath the Castilian vernacular most of its many singular phonetic features—this only one of the various ironies involving what would one day be made into the national tongue.

Even as Castile began to be defined as a place, it was a constantly moving frontier: mobility would long remain a cardinal virtue and Castile a highly moveable and adaptable state by definition. The much-celebrated frontierism of the Castilians codified the myth that they might be natural warriors, an image invaluable for their scholarly enshrinement as the front line of the crusade that would eventually be called the reconquest. But at the same time, it also was the source of their cultural mobility, a fitting complement to their geographic free-spiritedness. This combination has often seemed paradoxical as historians have peered across the abyss of the taking of Granada in 1492, and the subsequent homogenization of the peninsula. In the popular imagination of both Spaniards and others, "Castile" is a fixed, northern, and Christian point, the opposite and opposed pole of what "Andalusia" evokes, the Islamicized south.

But in fact theirs was a culture for hundreds of years on the move: their roots are found in that earliest northern polity, Asturias, among settlers who then moved on to León, and from there to Burgos, and on to the densely populated and thoroughly Islamicized metropolis that was Toledo, the new heartland from which they launched the expansion that would win them most of the peninsula. And, at the end of the story we tell, they believed Seville—the sentimental and political homeland of Alfonso X, uncontested patron and patron-saint of Castilian itself—to be the ultimate and best capital of what at that point they still thought of, without hesitation, as Castile. In this universe, and in this culture, not just borders were eminently moveable, but centers as well.

✳

Castile's political history begins in earnest with Sancho the Great. The Sisyphus-like cycle played out like a well-scripted drama in the generation following the dismemberment of the imperium that would result in the creation of the kingdom of Castile. The most successful of Sancho's heirs was his second son, Ferdinand, first king of Castile. Ferdinand assimilated León into his kingdom when he defeated and killed his brother-in-law in 1037; and he proceeded to absorb his own elder brother's portion, Navarre, by defeating and killing him in battle as well. Ferdinand followed in his father's footsteps along the broader and more complex cultural paths, too, cultivating Frankish ties, for example, and especially a relationship with that intellectual and colonial force to be reckoned with, the French monastery of Cluny, which during Ferdinand's reign became entrenched in the peninsula. Unlike his father, Ferdinand had the time and wherewithal to turn his attention and ambitions to the south, as well as to the north: once he had consolidated the power and territories that had been dispersed to his brothers, Ferdinand became a key player in the reversal of fortunes between Christian and Islamic petty kingdoms that we can easily say is what the history of the eleventh century is all about, and what led straight to the pivotal taking of Toledo in 1085.

Ferdinand's successful raids into the territories of various Taifas, during the 1050s and 1060s, starkly reveal the debilitated military state of the nearly two dozen independent and feuding Islamic city-states. The entrancing paradox of this moment is that mercurial

and competitive political circumstances proved a fertile breeding ground for virtually every aesthetic and intellectual endeavor. The small Taifa courts vied with one another for scholarly and artistic achievement, as a way of emulating the lost court culture of Umayyad Cordoba. Seville excelled in poetry, Saragossa in song, Toledo in science, agriculture, and astronomy, though learning, poetry, and song resonated in them all. And each vied with the memory of the Umayyad caliphate, and the legend of Madinat al-Zahra, to create opulent palatial settings in which the fabrics and foods and scents of court life became the symbols of sovereignty. But none of that extraordinary Taifa culture—the great new love songs of the moment, the scientific studies, botanical research, and philosophical treatises, the exquisite palaces of Taifa cities like Saragossa—was able to keep these Islamic city-states stable, especially when they were often and viciously turned against each other. And especially when most Christian kingdoms were, for the moment, not turned against each other, and instead allied under the absolute purposeful leadership of Ferdinand. The king of Castile, León, and Galicia was able not only to take a number of territories outright but also to bring a number of the Taifas under his indirect control.

It was not Ferdinand's purpose to decimate or colonize the Taifa kingdoms. Rather, he conquered to enlist them as allies and retainers, while plundering them economically. By the time of his death in 1065, Ferdinand had prominently reshaped the political landscape through his efficacious implementation of a system of *parias*, or tribute payments, from vulnerable Taifas. As with much else in the long history of Muslim-Christian relations in the peninsula, this development bears witness to the complexities it intensified. The vassalage of some Islamic cities to the Christian state of Ferdinand meant, among other things, that they were bound to seek the support of Christian armies in their struggles with other Islamic cities, while Christians of many stripes, from long-isolated territories in the north, became ever more familiar with the polished and urbane metropolises forged and embellished over centuries of Islamic rule. And of great cultural and political significance was the Taifa of Toledo, which became Ferdinand's tributary, and its brilliant ruler al-Mamun his unlikely ally, a few years before the Castilian monarch's death.

But with Ferdinand's death Sisyphus's rock rolled back down the mountain, and the united Christian kingdom was once again willingly sundered, so that the northern kingdoms were again turned Taifa-like against each other, and brothers set murderously against each other. Just like his father before him, Ferdinand divided his hard-won realm into three, a share for each of his sons. Sancho, the oldest, received Castile, and the youngest, García, inherited the westernmost kingdom of Galicia. And in another, perhaps less conscious imitation of his father, Ferdinand favored his own second son and gave León, the richest share by many measures, to Alfonso. But in the end Castile would be far larger, and greater. In the words of his biographer, the historian Bernard Reilly, Alfonso's "active and successful statecraft" would, by the end of his reign, "direct a political leviathan . . . half again the size of England." "Spain," Reilly reminds us, "was destined to emerge from the dream of Leon-Castilla."[8]

The complex tale of bad fraternal blood that followed the partition of Ferdinand's

kingdom among his three sons echoed that of the generation before. Here, in this generation, the two oldest brothers—Sancho of Castile and Alfonso of León—coveted the lands of the youngest—García—and sought to run him out of his kingdom, but eventually turned against each other as well. In 1071, in response to Alfonso's growing influence in Galicia, Sancho invaded León, and defeated his brother Alfonso at the battle of Golpejera. Sancho thus fleetingly reunited León and Castile under his scepter, and he sent Alfonso to Burgos in chains. Sancho consolidated his power by vanquishing his youngest brother, García, king of Galicia, whom he packed off in exile to the Taifa of Seville. And that is how García became the guest of the great Taifa ruler—and poet—al-Mutamid. He sat in elegant colonnaded courts on silk cushions, each textile worth a fortune by Castilian standards; he walked in irrigated gardens near the Guadalquivir River with what must have seemed like wondrous fountains. And he heard an entire court spar, negotiate, jest, and make love in poetry.

Alfonso was imprisoned because he had posed far more of a threat to Sancho's growing power than García. But as Sancho managed to appease the denizens of the kingdom of León, which he had appropriated from his brother, he relented to the pleas and council of his sister Urraca and Abbot Hugh of Cluny, and sent Alfonso from his prison in Burgos into exile in Tulaytula, the Taifa of Toledo. And how Alfonso must have marveled, emerging from a dark bastion in Burgos into the brilliant palaces of Toledo. With al-Mamun, the king of the Dhu al-Nunid family, Alfonso experienced a Toledo far more cosmopolitan and glorious than the celebrated Toletum of the Visigothic monarchy. He attended court banquets in columned palaces where guests received silk perfumed robes, or played a game like *manqala* with priceless carved ivory gameboards.

Like his younger brother in Seville, he also heard poetry, and wandered in pleasure gardens on the edge of town that were planted with exotic flowers and fruits studied and nurtured by court botanists and agronomers. The exiled Alfonso, an ex-king without portfolio, watched Mozarabic craftsmen, Jewish physicians, and Muslim astronomers interact in a lively court culture with al-Mamun—his old feudal client—the uncontested ruler of a city where sovereignty meant authority over multiple peoples and a multitude of arts and sciences as well. And thus, ever more distinctively part of the Castilian story too were the Taifa cities, and increasingly commonplace in everyday life were entanglements with Muslims, in war and love and a great deal in between.

Alfonso's brief Toledan exile, like his brother's in Seville, bears witness to the fungibility, and volatility, of political alliances and enmities, as well as shared cultural values and latent cross-religious intimacies. These were already manifest when Sancho the Fat trekked to Cordoba, desperate to lose enough weight to be able to ride his horse. But now, decades after the scattering of the old caliphate, and with the consequent unfurling of a Christian presence, fraternization was exponentially more accessible, frontiers far more porous. Alfonso's fugitive stay in the great Islamic metropolis of Tulaytula also provides a poetic augury, a kind of dramatic antechamber, to what would be the cardinal event of the century: his conquest of that same Toledo some fifteen years later. To master one of the great

Taifas was an ambition some medieval historians believed Alfonso first dreamt of while he was al-Mamun's guest, in the great Taifa king's exceptional palaces. This may have been true—although in 1071 Alfonso was hardly in a position to aspire to anything so audacious, scarcely more than his brother Sancho's political prisoner, even if it was in the supremely gilded cage of Tulaytula where he was confined.

These, however, turned out to be fleeting circumstances and within a couple of years that political landscape was transfigured by two theatrical political assassinations. In 1072 the ascendant and powerful brother Sancho—whose liegeman was Rodrigo Díaz de Vivar —was betrayed and murdered outside the walls of the city of Zamora. In the aftermath, with his brother and principal rival for control of the Christian kingdoms dead, Alfonso emerged from his Toledan exile within spitting distance of the kind of unified control his father, and grandfather before him, had carved out. Indeed, Alfonso commanded the loyalty of nobles from all three kingdoms before García could ride north from Seville. Alfonso's kingdom was a prize darkly compromised, trailed by the whispered suspicions that Alfonso had himself been involved in the royal murder. In some recountings, he was aided and abetted by Urraca, the brothers' sister of whom, in the tabloid version of the story, Alfonso was accused of having been more than fond. Out of the shadows cast by these suspicions, by one more treacherous struggle between brothers, by one more bloody resolution to the internecine Christian rivalries, Sancho's most loyal vassal, Rodrigo Díaz, from the small town of Vivar, near Burgos, began to move onto the center stage of this history, and of Spanish literature.

Just a few years after Alfonso supplanted his brother, in 1075, this already mercurial historical setting was intensified with yet another melodramatic political murder: the canny and long-successful ruler of Toledo, the same al-Mamun who had been Alfonso's protector and host when his brother Sancho had exiled him, was assassinated. Al-Mamun's long and prosperous reign over Toledo had made that Taifa a real contender for an elusive and desired prize, leadership over some sort of reunited Islamic realm. Al-Mamun of Toledo had managed to take Cordoba itself, and did so by defeating his most bitter rival, the great Taifa poet-king al-Mutamid of Seville. For a brief moment at least, as Alfonso was consolidating his own power over both Castile and León, it must have seemed that here, finally, was a worthy and able successor to the prosperous caliphate, someone who might subdue the internecine politics of feuding Taifas.

But such a return to the past was not to be: once again, and echoing conditions and attitudes in the equally fractious Christian north, the rivalries and enmities within the Islamic orbit trumped anything like a sense of religious solidarity. Indeed, al-Mamun's murder led to much more severe splintering and weakening of the Taifas than was already the case, and especially so in Toledo, where he was ultimately succeeded by a grossly corrupt and ineffective grandson named al-Qadir. Al-Qadir would be the last Muslim ruler of Toledo, although perhaps even that is an exaggeration since he depended from the start on Alfonso's military protection to keep his territories reasonably intact from the predations of rival Taifas. He struggled to maintain credibility or respect even within his own polity,

where he behaved with increasing cruelty, earning the enmity of most. Before long, in fact, al-Qadir was little more than Alfonso's puppet.

Toledo itself, while still nominally a Taifa, was practically speaking completely dependent: it was a vassal of the kingdom of Castile and León, to which it paid tribute. Leonese and Castilian troops were installed within the city to prevent civil war, troops perhaps more loyal to al-Qadir (since they were being paid to be) than any of his own. Alfonso's eventual "conquest" of this multilayered metropolis—the ancient Visigothic capital and one of the jewels of Taifa culture, thriving home to proud and Arabized Christian and Jewish communities—was from most points of view the full-dress playing out of what was a virtual fait accompli, Alfonso's taking complete and open control of what he already possessed behind the thinnest of veils.

Despite the obvious watershed at hand, and despite the momentous changing of the religious guard, the transfer of power was desired within Toledo, even by many of the city's most prominent Muslims, who did not want to be subjected to the acquisitive Taifa of Badajoz, waiting in the wings, and who saw no other way of ridding themselves of al-Qadir, far more odious and difficult than Alfonso, in their eyes. There were others, less pragmatic and more ideological, who believed that any Christian was worse than the worst Muslim, and who began to speak about appeals to Muslims from beyond the peninsula. But the endgame itself speaks to the ways pragmatic politics trumped virtually everything else: al-Qadir himself, politically and militarily besieged, appealed to Alfonso directly to bail him out of his own city. In the summer of 1084, he offered Alfonso his kingdom in exchange for the Castilian's help so he could escape to an alternative kingdom, the lovely little Valencia, on the eastern coast, which several decades before his grandfather had taken and made a part of the Taifa's holdings. Alfonso no doubt thought it an excellent exchange, and within a year of al-Qadir's ignominious retreat, Toledo, which would always thereafter be understood as the cardinal trophy of the "reconquest," was officially and openly his. Toledo was Castilian and everything going forward would be dramatically altered.

In and through the acquisition of this brave new capital Alfonso became something beyond a mere Christian king: he and his successors would rule over a far more complex citizenry, and he eventually declared himself *imperator constitutus super omnes Hispaniae nationes*, emperor of all the peoples of Hispania. Or, as this translates into the Arabic documents of the moment, *imbratur dhu al-millatayn*, emperor of the two faiths. And it did not take long for the disunited Taifa kings to fully realize, and finally react to, a situation of such magnitude, inconceivable a generation before: a Christian king who had united what had been three major kingdoms of the Christian north was now the confident possessor of the once great Tulaytula, a worthy capital for a new empire. In some desperation, and with justified trepidation, a number of Taifa rulers appealed for military help from the Islamic regime that had recently consolidated considerable power across the Strait of Gibraltar, the Almoravids. The beginning of the end of the Taifas was at hand. Enter Castile's most legendary hero.

The Cid's story as told in the poem that carries his name, from the Arabic *sayyidi*, does not begin until a few years after 1085, and it does not bother to rehearse the most basic elements of his previous life or the dramatic historical backdrop. Rodrigo Díaz was born just north of Burgos in the heart of Castile, and as an adult he became an accomplished commander and loyal courtier in Sancho II's court. During the years that Sancho was intent on usurping his brothers' thrones, Rodrigo was a key player in Sancho's entourage, perhaps his *alferez*, or standard bearer. His master's suspicious death produced an antagonistic relationship with Alfonso VI, his new lord, whom he no doubt suspected of complicity. But at the time of Sancho's murder, in 1072, Rodrigo had little choice but to pass into the service of the suspect Alfonso. And Alfonso, for his part, can hardly have seen his dead brother's notoriously faithful retainer as anything less than dangerous, so the relationship undoubtedly bristled with frictions and suspicions. These tensions came to a head in one of those acts of independence and defiance that reverberates in later fantasies about the Castilian character: Rodrigo openly challenged Alfonso's authority, and undermined his diplomacy, by leading a highly destructive raid in the lands of the Taifa of Toledo, which was then under Alfonso's protection. He was exiled by the monarch in 1081 and became a soldier of fortune.

During the years that Alfonso was engineering his momentous acquisition of Toledo, and when he entered the city triumphantly in 1085, the Cid was elsewhere—despite a later mythology that had him enter the city with Alfonso. In the version of the legend told by the romantic Spanish writer Gustavo Adolfo Bécquer, the Cid's horse, called Babieca, fell to its knees as they passed a tiny unpresupposing mosque just beyond the gate into the city. It was said that the horse sensed that beneath the mosque lay the vestiges of an ancient Visigothic church, destroyed by Muslim rulers, and that a miraculous light bore witness to its survival. But the Cid (and presumably his horse) was nowhere near; indeed he was instead fighting very different battles. After a number of initial expeditions, Rodrigo had entered the service of al-Muqtadir, the king of the Taifa city of Saragossa and a member of the Muslim clan called the Banu Hud. At the old king's death Rodrigo continued to serve the king's son al-Mutamin in his dynastic dispute against his brother, al-Mundhir, in battles that saw Rodrigo face off against al-Mundhir's Christian allies, Sancho I of Aragon and Ramón Berenguer II. These conflicts, which led Rodrigo at one point to take the Catalan Berenguer as prisoner, were fought for the Taifa king, but they also indirectly supported the complex interests of Alfonso, whose alliances and competitions with both Muslims and Christians in the north they ultimately served. Here at the intersection of Castilian history and myth is a diplomatic cloth from which it would be impossible to draw the Christian or the Muslim thread.

Rodrigo was readmitted to Alfonso VI's service in December 1086, under circumstances of some duress for the Castilians: the momentous invasion of the Almoravids, provoked by the conquest of Toledo. The political landscape was dramatically altered by the arrival of Muslim forces from across the Strait of Gibraltar, forces different, in so many

The Monastery of San Pedro de Cardeña

*Have the tent struck and let's go quickly, let the cock's
crow greet us in San Pedro de Cardeña . . .*

—from the *Song of the Cid*

Today one enters the austere walls of the Castilian
monastery of San Pedro de Cardeña from beneath a
densely sculpted baroque façade, a dramatic eques-
trian statue at its center. Framed by an elaborate
red and white striped niche, the Cid wields his
sword against a host of Muslims who cower in the
wake of his horse's flailing hooves. The monastery
of Cardeña likely began to advertise its connection
with the Cid as early as the twelfth century, as part
of its attempt to enliven a failing economy during a
period of decline in monastic income in Old Castile,
as its center of power migrated south with Castile's
frontier. Also during this period, monks from the
Castilian monastery of San Pedro de Arlanza
embroidered their connection to another Castilian
hero, Fernán González, as Toledo's archbishop
Rodrigo Jiménez de Rada cemented hero and
monastery in his historical writings. In this way
Castilian monasteries sought to create a kind of
collective identification with the legendary heroes
of Castile, and to reignite interest in their cults
and support for their work. It was likely at the
monastery of Cardeña that the Cid began to be
transformed from the historical and poetic figure of
complex social and political alliances into the war-
rior for the faith that he would become for later
popular culture.

Cardeña was founded in the late ninth or early
tenth century, and had strong connections with the
counts of Castile from its beginnings. When in 934
its buildings and lands were destroyed by an expedi-
tion of the Umayyad caliph Abd al-Rahman III, Arab
chroniclers marveled at its riches. When San Pedro
was rebuilt scarcely a year later, monks and frontier
statesmen brought the body of Count García
Fernández there to be buried, a ceremony meant to
solidify the monastery's importance to the identity
of the young county of Castile. For over a century
San Pedro de Cardeña would continue its steady

role at the heart of Castilian monasticism, and when
the Cid's widow, Ximena, fled Valencia with the
hero's body, she brought it to Cardeña to be
interred. Eventually she would be buried there, too,
along with a number of family relations and the
Cid's legendary horse Babieca.

But in the years following Alfonso VI's taking
of Toledo, the center of gravity of Castile moved
south and with it the economic and political for-
tunes of the monastery. In 1142, however, an inter-
action with French monasticism might have spurred
a desire to connect the monastery to the idea of a
cosmic fight for the Christian faith. Cardeña was
briefly given to the abbey of Cluny by King Alfonso
VII, perhaps on the occasion of the visit of Cluny's
abbot Peter the Venerable to the Iberian Peninsula.
Peter hoped to find a translator for the Quran with
the idea of properly refuting the error of Islam, but
he also hoped to extract financial support from the
Castilians, who had ceased a lucrative tribute upon
which the abbey depended. Cluniac monks moved
into Cardeña, whose monks strenuously resisted
the takeover but were ultimately expelled by the
Frenchmen. The Cluniacs made their mark immedi-
ately: sculptors from Burgundy came to decorate a
new cloister at San Pedro with sculpture that related
to work at Auxerre and Cluny, as José Luis Senra
has shown. But they also built a curious cloister
arcade: the arches are banded with red and white
masonry, a motif that would recall, with startling
clarity to twelfth-century eyes, the arches of the
interior of the Great Mosque of Cordoba. These
arches had become a reminder of Islam as the
mythic enemy against which the church fought. As
at the Cluniac church of Sainte-Marie-Madeleine at
Vezelay in Burgundy, where the Second Crusade
would be preached on Easter of 1146, this motif—
colorful, exotic, and out of the ordinary—was likely
meant to advertise the raison d'etre of the church
as mankind's defense against a foe it hoped to
depict as remote and vilified.

Cluny would be able to retain Cardeña for only
a few years, but its monks and the architecture of

its cloister would continue to embroider such meanings for centuries. In later times, the memory of the destruction of the monastery by the Umayyads in the tenth century would be embellished with a legend that monastic martyrs were burned and interred in this same cloister. The banded red and white arches, so like the Great Mosque of Cordoba, intensified the importance of the monks as defenders of a faith by evoking the mythic enemy against whom the church had begun to define itself. But it was finally in the manufacture of a new image of the Cid—one in which he fought against Muslims in a holy struggle for the faith—that Cardeña would find its most potent myth.

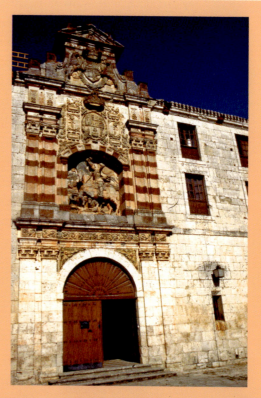

Monastery of San Pedro de Cardeña, baroque façade.

Monastery of San Pedro de Cardeña, cloister, 12th century.

ways, from the Andalusians of the Taifas who had called in their coreligionists for help, though with some trepidation. The pivotal battle of Zallaqa was a decisive defeat for the confident Castilians, scarcely a year after Toledo was virtually offered to them. Back in Alfonso's fold, Rodrigo served in campaigns against the Almoravids for the next several years. Even then, though, the bad blood between the monarch and the Cid meant that the reconciliation and the Cid's tenure in good standing was short-lived. In 1088 the Cid failed to appear at the king's summons to help relieve the Castilian post at Aledo and was definitively exiled by Alfonso.

In 1089 the Almoravids mounted another campaign in the peninsula, this time not only unbidden but unwelcome by the Taifa kings, who understood now that their erstwhile allies aspired to become their overlords. Out of favor once again, the Cid was now not only leading his own armies but taking his own cities. He eventually subdued and ruled Valencia as a lord with nearly regal prerogatives. He would deal the Almoravids a significant reverse in 1094, and for five years he governed Valencia uncontested. Rodrigo died there in 1099, and was buried in the cathedral. In 1102, as Almoravid destruction of the city seemed inevitable, his wife and heir Ximena took his body north to the monastery of San Pedro de Cardeña, whose monks would begin to weave myth from already legendary historical threads.

The *Cantar de mio Cid*, the *Song of the Cid*, begins with the hero's lamented exile from Burgos and the territories of Castile by Alfonso, repeatedly declared by the poem's weeping Greek chorus as unworthy of so loyal a vassal. It concludes with an ending as satisfying as that of any Shakespearean comedy: the personally and politically happy marriages of the Cid's two daughters to the kings of Navarre and Aragon. From start to finish, the poem unabashedly celebrates the values of the late eleventh century, when Alfonso's ability to make Toledo his meant the end of the era of the Taifas, and the beginnings of an imperial Castile. In the unique version in which it comes down to us—a single mutilated manuscript—the poem likely dates from at least a half century after the Cid's death in 1099 or, even more likely, from a full century later. Possibly the poem crystallized during the intensely ideological run-up to the thirteenth-century battle of Las Navas de Tolosa. But even though the poem may well have been given its definitive shape in a different time and place, one hundred years or more after the events it narrates, it vividly captures the ethos of a crucial moment in Castilian history.

As the poem opens, then, the Cid has been banished from Castile—it must be sometime just after 1088. The scene evokes the painful rupture of exile, the mourning of all at hand, the distinct sense of the enmity with Alfonso:

De los sos ojos tan fuertemientre llorando,	His eyes, grievously weeping,
tornava la cabeça i estávalos catando.	he turned his head and looked back upon them.
Vío puertas abiertas e uços sin cañados,	He saw doors standing open and gates without fastenings,
alcándaras vázias sin pielles e sin mantos	the porches empty without cloaks or coverings
e sin falcones e sin adtores mudados.	and without falcons and without molted hawks.

Sospiró mio Çid, ca mucho avié grandes cuidados.	He sighed, My Cid, for he felt great affliction.
Fabló mio Çid bien e tan mesurado:	He spoke, My Cid, well, and with great moderation.
"grado a tí, señor padre, que estás en alto!	"Thanks be to Thee, our Father Who art in heaven!
"Esto me an buolto mios enemigos malos."	My evil enemies have wrought this upon me."
. . . exien lo veer mugieres e varones,	They crowded to see him, women and men;
burgeses e burgesas, por las finiestras sone,	townsmen and their wives sat at the windows
plorando de los ojos, tanto avien el dolore.	weeping from their eyes, so great was their sorrow.
De las sus bocas todos dizían una razóne:	And one sentence only was on every tongue:
"Dios, qué buen vassallo, si oviesse buen señore!"	"Were his lord but worthy, God, how fine a vassal!"

The Cid leaves Burgos, with a group of loyal men, a group that will increase with his wanderings in exile, as the poem goes along, and as his successes in battle and his extraordinary generosity with his men win him more converts. He goes first to Cardeña, where he is leaving his wife, Ximena, and his two daughters in the care of the abbot Don Sancho. From this early moment, the true heart of the poem, and its dramatic axis, is laid bare: the fate of the Cid's daughters, to whom they might be married, under such difficult circumstances. And shortly thereafter the poem's characteristic ambiguity about political loyalties and dividing lines is revealed as well: the Cid enters territories that are still in Muslim hands but are dependencies of Alfonso, and although tempted by their wealth he warily walks away.

"Moros en paz, ca escripta es la carta,	"Let us leave these Moors in peace for their treaty
buscar nos ie el rey Alfonsso, con toda sue	is written; [says the Cid]
mesnada. . . .	King Alfonso will seek us out with all his host. . . .
"Lo que yo dixiero non lo tengades a mal:	Let no one take amiss what I have to say:
en Castejón non podriemos fincar;	We cannot remain in Castejón;
cerca es el rey Alfonso e buscar nos verná.	King Alfonso is near and will come seeking us.
Mas el castiello non lo quiero hermar;	But as for the castle, I would not lay it waste;
çiento moros e çiento moras quiero las i quitar,	I wish to set free a hundred Moors and a hundred
por que lo pris dellos que de mí non digan mal.	Moorish women,
Todos sodes pagados e ninguno por pagar.	that they may speak no evil of me since I took it
Cras a la mañana pensemos de cavalgar,	from them.
con Alfons mio señor non querría lidiar."	You have a full share, every one, and no one is still
Lo que dixo el Çid a todos los otros plaz.	unrewarded.
Del castiello que prisieron todos ricos se parten;	Tomorrow in the morning we must ride on;
los moros e las moras bendiziéndol están.	I do not wish to fight with Alfonso my lord."
	All are contented with what My Cid spoke.
	All went away rich from the castle they had taken;
	the Moors and their women are giving them their
	blessings.

Revealed here as well is another core value of the Cid himself, at least in this strong poetic manifestation: the warrior's interest is rarely in capturing territory, let alone in spreading anything like an ideology to those territories. Who is on whose side is a matter of treaty and power rather than religion. The Cid seeks instead the abundant wealth to be had through raiding and battles and the capturing of territories where ransoms and tribute will then be paid. But the continuous acquisition of this wealth is invariably followed by minute descriptions of the Cid as a river to his men, his generous distribution of the bounty to his followers. And his always dutiful compliance with the code requires him to send a portion of that wealth to his king, in part so we understand how superior the loyal and giving vassal is to his liege.

Esta albergada los de mio Çid luego la an
 robado
de escudos e de armas e de otrós averes lar-
 gos;
de los moriscos, quando son llegados,
ffallaron quinientos e diez cavallos.
Grand alegreya va entre essos cristianos,
más de quinze de los sos menos non
 fallaron.
Traen oro e plata que non saben recabdo;
refechos son todos essos cristianos
con aquesta ganancia que y avién fallado.
A so castiello a los moros dentro los an
 tornados,
mandó mio Çid aun que les diessen algo.
Grant a el gozo mio Çid con todos sos
 vassallos.
Dio a partir estos dineros e estos averes
 largos;
en la su quinta al Çid caen cient cavallos.
¡Dios, qué bien pagó a todos sus vassallos,
a los peones e a los encavalgados!
Bien lo aguisa el que en buen ora nasco,
quantos él trae todos son pagados.
"Oíd, Minaya, sodes mio diestro braço!
D'aquesta riqueza que el Criador nos a
 dado
a vuestra guisa prended con vuestra mano.
Enbiar vos quiero a Castiella con mandado
desta batalla que avemos arrancado;

My Cid's men have sacked the Moors' encampment,
seized shields and arms and much else of value;
when they had brought them in, they found they
 had taken
five hundred and ten Moorish horses.
There was great joy among those Christians;
not more than fifteen of their men were missing.
They took so much gold and silver, none knew where
 to put it down;
all those Christians were made rich
with the spoils that had fallen to them.
They have called back the Moors who lived in the
 castle;
My Cid ordered that even they should be given
 something.
My Cid rejoiced greatly, and all his men.
He bade them divide the money and those great
 spoils;
in the Cid's fifth there were a hundred horses.
God, they were well content, all his vassals,
both the foot soldiers and those who rode horses!
He who in good hour was born deals with them
 justly;
all who came with him are well content.
"Hear me, Minaya, who are my right arm!
Take from this treasure, which the Creator has given,
as much as may please you; take it with your own
 hand.
I wish to send you to Castile with the news
of this battle which we have won.

al rey Alfons que me a ayrado	I would send a gift of thirty horses
quiérole enbiar en don treínta cavallos,	to King Alfonso, whose anger is turned against me,
todos con siellas e muy bien enfrenados,	each with its saddle and lavishly bridled,
señas espadas de los arzones colgando."	each with a sword slung from the saddletree."

Eventually, after some time in the territories of Saragossa, the Cid and his much-expanded (and infinitely enriched) army approach the territories of Valencia, and it takes years and great effort before he is able to fully make it his own. But as soon as he does, he turns immediately to his truest concern, the fate of his daughters, which becomes inextricably bound to the greed incited by the tremendous fortune he has amassed. The Cid arranges to bring his wife and daughters to Valencia, which, in his exile from Castile, he now sees as his inheritance. For this vital task the Cid ultimately relies on a Muslim ally:

El moro Avengalvón, quando sopo el menssaje,	When the Moor Abengalbón knew of the message
saliólos reçibír con grant gozo que faze:	[that the Cid's men were approaching]
"¿Venides, los vassallos de myo amigo natural?	he rode out to receive them with great rejoicing:
A mí non me pesa, sabet, mucho me plaze!"	"Have you come, vassals of my dear friend?
Fabló Muño Gustioz, non speró a nadi:	It does not sadden me, believe me, it fills me with
mío Çid vos saludava, e mandólo recabdar,	joy!"
"con ciento cavalleros que privádol acorrades;	Muño Gustioz spoke, he waited for no one:
su mugier e sus fijas en Medina están;	"My Cid sent you greetings and asked you to pro-
que vayades por ellas, adugades gelas acá,	vide us
e ffata en Valencia dellas non vos partades."	with a hundred knights to ride with us at once;
	his wife and daughters are in Medinaceli;
	he would have you go and escort them here
	and not go from them as far as Valencia."

Ximena and their two daughters do eventually rejoin the jubilant Cid in his glorious Valencia, and in the middle of the poem the social harmony ruptured by Alfonso's banishment appears to be restored. But the idyll is short-lived, disrupted by Almoravids from across the sea—who attack Valencia and force a momentous battle—and by Alfonso, who marries off the Cid's daughters to a singularly unworthy pair of brothers, both greedy and cruel. In relatively short order the Cid is able to rout Yusuf of Morocco—an unambiguous reference to Yusuf Ibn Tashufin, the Almoravid emir who led his armies in the great battles of the Iberian campaigns. The encounter with Yusuf ends with Rodrigo enriched many times over again, and he eventually repels yet another attack from across the Strait of Gibraltar. But it requires the remainder of the poem to rectify the near tragedy of the daughters' terrible marriage to the infantes—the younger sons of kings, destined to never ascend to power—of Carrión.

The *Song of the Cid* exemplifies the age, not by reducing the values of the story to the implacable enmity between "Christian" and "Moor" and touting its hero as embodying

the Castilian "reconquest" (as in a *Roland*-like narrative), but by revealing ambivalence between religious groups. One of the great surprises for the unsuspecting reader of the epic poem that bears the hero's name is to discover that the only committed "Moorslayer" is not a Castilian, but a Frenchman, a certain Jerome, the Cluniac bishop of Valencia in the Cid's time. What better hero for such an era than a Christian warrior whose life-drama hinges on being exiled by his king, Alfonso, and who ends his life as the successor to none other than al-Qadir, as ruler of the Taifa of Valencia? What better name for such a hero than *sayyidi*, "my Lord," which in this profoundly multilingual universe is so readily transposed from Arabic into the Castilian equivalent, *mio Cid*? What better incarnation of the complex values of this old Castile than a man whose handful of trusted friends prominently includes a Muslim named Abengalbón, to whom on various occasions he entrusts his beloved and precious family for sage escort? The Cid's true enemies are Abengalbón's corrupt and treacherous counterparts, two brothers from the old Castilian nobility, the infantes of Carrión, a town between Burgos and León on the road to Compostela. The central interests and conundrums are really those of family and, by extension, nobility and personal worth: in this fierce universe of unpredictable loyalties, are dignity and nobleness inherited, or earned?

In the transfiguration from the legendary exploits of a gifted warrior into this poignant and direct work of art, the historical facts of Rodrigo Díaz's life and times are adroitly distilled, the exploits of a lifetime compressed into less than a half-dozen years. The dramatic historical events are everywhere: the narrative is driven by the perturbations of Rodrigo's constant and inscrutable political exile, an exile in which the Cid's generosity and dignity are vividly revealed. It is an exile redeemed, beginning in the second of the poem's three *cantares*, or divisions, by what he earns himself. It is through his own efforts —and the kindness toward those who fight for him, and sometimes those against whom he has fought, all of which win him loyal followers—that he establishes his own kingdom. Valencia is his antidote to exile and his earned inheritance, and he must ultimately defend it against Almoravid attack. But the real heart of the poem's drama is personal and familial: the story of how Alfonso (whose poor judgment in virtually every arena is another running theme) marries off the Cid's daughters to two contemptible young aristocrats. Through Rodrigo's great restraint and craftiness—his wisdom stands in striking contrast to Alfonso—the infantes of Carrión are eventually revealed to be frauds and cowards, and the Cid is then able to exact their public humiliation.

The grand finale is the new marriage of the long-suffering, but much loved, daughters to two reigning monarchs, publicly consecrating what was obvious to the commoner on the street—and the poem's audience—from the outset: that Rodrigo is no less a king in this Spain than any other.

Fizieron sos casamientos don Elvira e doña Sol;	The wedding is performed of Doña Elvira and Doña Sol;
los primeros foron grandes, mas aquestos son mijores;	the first marriage was noble but this much more so;
a mayor ondra las casa que lo que primero fo.	to greater honor he weds them than was theirs before.
Veed qual ondra creçe al que en buen ora naçió,	See how he grows in honor who in good hour was born;
quando señoras son sues fijas de Navarra e de Aragón.	his daughters are wives of the Kings of Navarre and Aragon.
Oy los reyes d' España sos parientes son . . .	Now the Kings of Spain are his kinsmen . . .

Beyond the Cid's personal honor, and that of his daughters, the tension in the poem grows, not from the threat of a mythic Islam, but from a desire to unite warring Christians, something his daughters' marriages accomplish. Thus anxiety grows not from an association of deleterious values with Muslims, but rather with those who disrupt the ties of trust and honor within their own kingdoms. If this is the epic poem of Castile's heroic age, the Cid of the poem is a man of his times: a Castilian hero with an Arabic epithet, his judgments of other men individual—not ideological or religious—and his triumph rooted more in the growth and opportunity of the frontier, in the possibility of personal honor attached to social and economic mobility, than in battles fought over confession. Both the history and the poem of Rodrigo Vivar, the Cid, speak to us about Castile at this crossroads, when a sense of identity materialized as part and parcel of the expansion into lands long Islamic. It was in this wide, arid plain, this ambivalent terrain with its promise of growth, mobility, and possibility, that an energetic, enterprising, and receptive Castile would begin the battle to both preserve and expel that powerful plural identity.

Dowry

(The guests) were conducted into . . . a great patio with flowers and then
brought into a room that was covered with brocaded tapestries of Tustar,
worked in gold, and with curtains that hung from the arches of the same fab-
ric, which dazzled the eyes with the impression of its colors and the brilliance
of the gold. Al-Mamun was seated on one side of the room and his grandson
on the other side. . . . Servants offered unguents and perfumed powders in cups
and silver trays of impressive finish. . . . Then they were conducted to the room
of the perfumes, which was placed on high, over the river, and was the most lux-
urious of the salons. The aroma of silver incense burners filled with aloe from
India, mixed with amber from Fustat, began to perfume them; next their clothing
was impregnated with rose water, while cut crystal flasks sprinkled perfume on
their heads. . . . With so many fragrances, their mustaches were dripping with
perfume and their grey hairs recuperated their original color.

The city of Toledo was both a myth of Taifa luxury and learning, and a thriving metropolis
unlike anything the Castilians had ever known, something like Oz to a girl from Kansas.
And it became even more remarkable over the next several centuries, redefining itself as
Castile embraced its new land and peoples, absorbing and transforming what it had won.

This was the much-coveted city that awaited the leader of the Castilians in the fall of
1084, as he settled into its outskirts. A brave mount emerging from a wide, vast plain; a
lone peak that sprouted minarets and bell towers like cypresses, all nestled in the crook of
the arm of the Tagus River—it was a place Alfonso already knew well. He marked his terri-
tory by moving into a *munya*, or country residence, built by al-Mamun, the ally who had
sheltered him, in this very city, during Alfonso's exile at the hands of his brother. The Taifa
monarch was now more like a lost friend than an exotic foe.

The popular recounting of Alfonso's acquisition of Toledo as reconquest masks a
more nuanced and, for many, unbearably contradictory memory. By the early eleventh cen-
tury, the fall of the Umayyad caliphate brought a sea change in the relationship between
the northern kingdoms and their Muslim neighbors. Al-Andalus

Toledo, view from the south. was now divided into Taifas: small rich kingdoms with brilliant

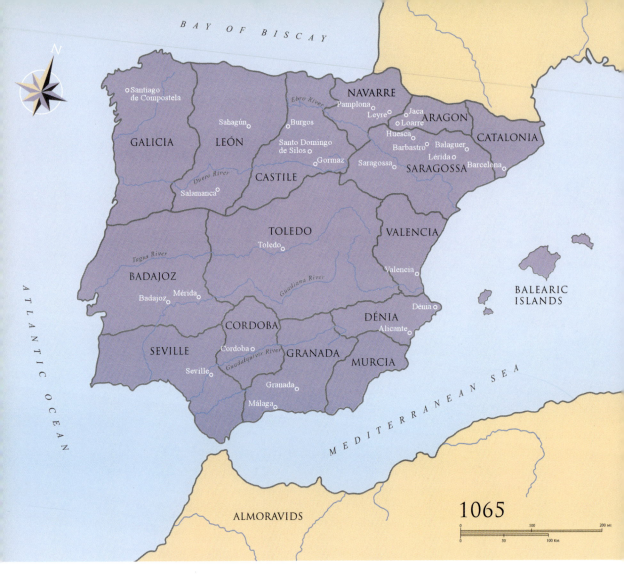

court cultures protected by fragmented and limited military apparatus. And rather than pursue a policy of annexing and settling the lands of submitted kingdoms, the bellicose energies of eleventh-century Castilian and Leonese rulers were as intensely engaged with warfare with other Christians as they were with Taifa city-states. They preferred to submit Taifa kingdoms to tributary status, exacting large amounts of gold and goods (*parias*), enlisting Taifa kings as allies in their own, at times incestual, conflicts, and encouraging divisiveness among them. In his memoirs, King Abd Allah (r. 1073–1090) of Granada gave voice to Alfonso VI's strategy, one that echoed that of Alfonso's father: "It is better for me to set one against the other and extract tribute from all. Eventually they will become so weakened as to surrender to me of their own will and I will gain my ends without any effort."[1]

In claiming Toledo Alfonso did just that. In fact, for many Toledans, the taking of Toledo was nothing more than a shrouded surrender to an ally. Through the ineptness of al-Qadir, Toledo had seen Cordoba pass into the hands of al-Mutamid, the poet-king of the Taifa of Seville, and the Toledans finally ejected their old king's grandson and put themselves

under the protection of al-Mutawakkil, the king of Badajoz. But at that point Alfonso, his own interests in the foreground, restored his vassal al-Qadir to power in 1081, in return for tribute and control over the estates that guarded the approach to the city. There might even already have been an implicit understanding that Alfonso would ascend to the throne of Toledo himself before long. In any event, when he finally took Toledo in 1085, it was with the complicity of the ineffective al-Qadir, and also with a significant faction of the city politic, for while one party of Tulaytula hoped to ally itself with an Islamic state, believing it was wrong to submit to a non-Muslim, others felt a familiarity and safety in submission to Alfonso, to whom they had been tributaries for so long. A short symbolic siege was negotiated, a kind of theatrical resistance to appease more conservative factions, for whom voluntary submission to a Christian monarch was not acceptable.

Some Muslim writers—wounded as Toledo passed from Islamic to Christian rule—voiced frustration at the lack of resistance to Alfonso's authority. Abd Allah, king of Granada, remembered that "the fall of Toledo sent a great tremor through al-Andalus and filled the inhabitants with fear and despair of continuing to live there." David Wasserstein has chronicled the widespread feeling that the Taifa rulers, in the decades leading up to the fall of Toledo, had betrayed Islam in their complicity with Christians, a sentiment voiced by Ibn Hazm, chronicler of the demise of the caliphate and the chaos of the Taifas. "By God," he would exclaim, "I swear that if the tyrants were to learn that they could attain their ends more easily by adopting the religion of the cross, they would certainly hasten to profess it! Indeed we see that they ask the Christians for help. . . . Frequently they protect them in their attacks against the most inviolable land, and ally themselves with them in order to gain security." And yet, as Wasserstein has noted, "we have virtually no evidence to suggest that the taifa rulers, or their subjects, or even the *fuqaha'* and other men of religion, sought to arouse anti-Christian support on the basis of such religious feelings."[2] It did not occur to the Taifas to advocate holy war, even in the face of what seemed to be their imminent demise on the peninsula.

In May of 1085 Alfonso VI took possession of the city of Toledo without resistance. As part of the terms of surrender, he sent his own troops to install his predecessor, the hapless al-Qadir, on the throne of Valencia, and he also promised the Muslim inhabitants of Toledo physical security, freedom of worship, the right to their own properties, and the unmolested use of their Friday mosque. What Alfonso had negotiated in this elegant dance of shifting power was a pact drawn from important parts of the dhimma, a way of subduing a plural city learned from his Muslim allies.

Although these terms represented the transfer of power after a symbolic siege, they were also the marker of a kind of tolerant rule that Alfonso had known firsthand, since he had lived in Toledo under al-Mamun, worshipped with Mozarabic Christians there, and so been protected by the dhimma when exiled by his own brother. Alfonso had finally taken Toledo not so much because of his military prowess, which was considerable, but rather thanks to his intimate understanding of the workings of the Toledan Taifa. It was his position as an insider, a familiar, that allowed him to negotiate this surrender and cast himself

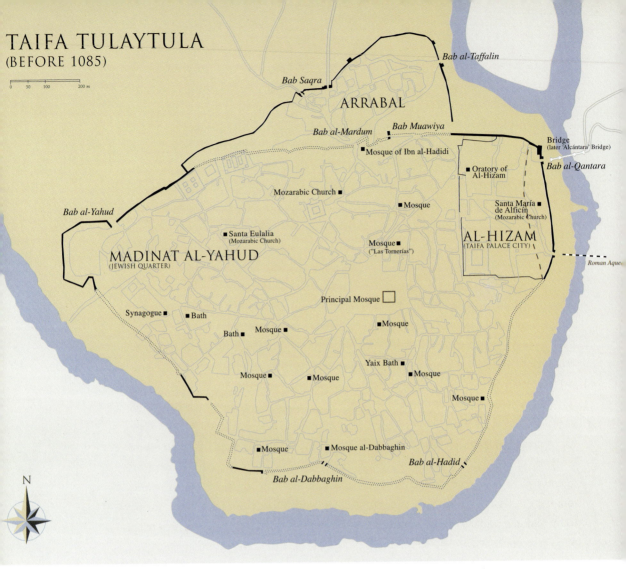

TAIFA TULAYTULA
(BEFORE 1085)

0 50 100 200 M

ARRABAL

Bab al-Taffalin

Bab Saqra

Bab al-Mardum Bab Muawiya

Bridge
(later 'Alcántara' Bridge)

■ Mosque of Ibn al-Hadidi

Bab al-Qantara

■ Oratory of
Al-Hizam

Bab al-Yahud

■ Mozarabic Church

■ Mosque

Santa María
de Alficín ■
(Mozarabic Church)

■ Santa Eulalia
(Mozarabic Church)

Mosque ■
("Las Tornerías")

AL-HIZAM
(TAIFA PALACE CITY)

MADINAT AL-YAHUD
(JEWISH QUARTER)

Roman Aque

Principal Mosque □

Synagogue ■ ■ Bath

■ Mosque

Bath ■ Mosque ■

Mosque ■

Yaix Bath ■

Mosque ■ ■ Mosque

■ Mosque

■ Mosque

Mosque ■

■ Mosque ■ Mosque al-Dabbaghin

Bab al-Hadid

Bab al-Dabbaghin

N

as an ally whose links to the Toledans outweighed the inconvenience of his faith and that shrouded the religious spin attached to his military conquest, or to the Toledans' confessional solidarity. Alfonso, al-Mamun, and al-Qadir experienced themselves as Christian and Muslims, but those were only fragments of their identities, and not the ones that prevailed in the transfer of Toledo. Alfonso VI had negotiated his rule of Toledo with people who were part of his complex political family.

But Alfonso had not just taken the city of Toledo; he had conquered the memory—the political ideal—of Toledo, the last capital of Visigothic Hispania, the seat of the Visigothic king and the powerful Hispano-Roman church that had forged an alliance with the monarchy. Although the Umayyads had made Cordoba—far to the south and beyond the mountain passes of the Sierra Morena—their capital, few Christians ever forgot what Toledo had once been, nor underestimated its importance, symbolic and strategic. The city never really fell from grace. Toledo was remembered as the site of a Christian authority and influence in the political arena much lamented in the Mozarabic church, whose

power, as a tolerated religion under Islamic rule, was restricted uniquely to the spiritual and legal concerns of a shrinking local community.

Silk textile from the Taifa period, 11th century. This textile was later used as an altar frontal at the monastery of San Juan de las Abadesas. Museu Episcopal de Vic, Barcelona.

Beyond this evocative legacy, this city that rises up dramatically from the stony gorges carved by the Tagus River had become, in the fifty years leading up to 1085, one of the real contenders for the mantle of leadership among the Taifa city-states. Through Toledo's capture, Alfonso and the Castilians hoped the metropolis would reclaim some of the semimythological power that came with the memory of its ancient Christian dominion; but those visions were now merging with an image of kingship inscribed in the physical world into which Alfonso would move. As part of his attempt to conserve this economy, Alfonso used the existing city mint to make dirhams shortly after his entry into the city in 1085. The coins, which feature Arabic inscriptions, were an imitation of the Taifa coins that had been made in the city before Alfonso's ascension, but they are not blind copies. The Arabic inscription from the Taifa coin is edited on Alfonso's dirham so that only the part appropriate to a Christian ruler remained: the name of the Prophet was removed, and replaced with the Arabic for the Father, the Son, and the Holy Spirit. Alfonso VI wished not just to appear to continue the Taifa rule of Toledo but to be understood by those who spoke Arabic, Christians, Jews, and Muslims.

In the pact that gave him Toledo, Alfonso had appropriated the places that excited wonder in the minds of the Castilians—the palace of the Taifa kings, the treasury of al-Qadir, and the royal gardens—while ceding to the Muslim population their principal mosque. That is, he subsumed the buildings and places that signified the vision of royal authority evoked by the reputation of al-Mamun, while following the lead of the dhimma in protecting at least one Muslim place of worship. That place of worship would become more significant to the Castilians than they knew. Even if the core of Tulaytula seemed to conquering Castilians to be its palaces, those sites of legends purposefully generated by their builders, Toledo's urban center had in fact formed around its Great Mosque. A

Bilingual capital, with inscriptions in Arabic and Hebrew. Museo Sefardi, Toledo.

Street in Toledo.

formidable rectangle nearly two hundred feet wide and half again as long, the mosque sat not at the edge of the city like the palace but at its heart and sprawled with all the authority of spatial ubiquity. A hypostyle mosque—a hall with a forest of columns—like the Umayyad touchstone, the Great Mosque of Cordoba, its roof was supported by perhaps eleven aisles of horseshoe arches, probably supported by columns with Corinthian capitals that linked them not only to late Roman tradition but also to their Umayyad forebears.

The mosque was a vast space in which the faithful might feel the breadth of the community during Friday prayer. Its power came not from the external monumentality offered by height, or a massive façade, but from the way it occupied and intermingled with the other functions of the city around it. There at the city's center, the principal mosque was surrounded by commercial zones so that its doors opened onto different markets, different streets. In Toledo, as in all the old centers of al-Andalus, Islam served as the nexus of urban life, and was intermingled with it.

The commercial sectors around the mosque, and those located in other parts of the city, were vast and organized by function. Near the mosque were luxury markets called

Mosque of Bab al-Mardum (mosque of Ibn al-Hadidi) from the Calle de las Descalzas.

Mosque of Las Tornerías, interior.

Arches from a bath near the street of Pozo Amargo.

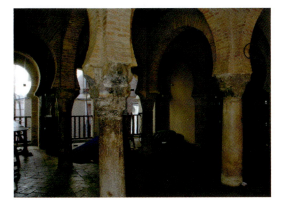

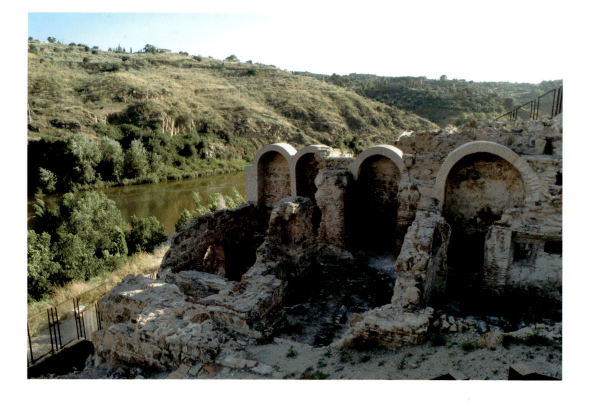

Ruins of a bath at the southern perimeter of Toledo.

alcaicerías to which access was restricted and where one could purchase incense, jewels, silks, and perfumes. There were commercial streets for manufactured goods, clothing, leather goods, metalwork and jewelry, and ceramics. Near the residential neighborhoods were the food markets and services: tailors, shoemakers, butchers, herbalists, and apothecaries, and in the perimeter of the city, closer to the suburbs that supplied them, produce, grain, and meat markets. Lodged in temporary stalls, or in permanent shops with a counter open to the street, the economy that Alfonso VI sought to stabilize and keep alive was a dizzying theater of goods wondrous and exotic, and now they were Castilian as well.

The urbanism of Tulaytula, as Alfonso found it, would yield no domestic chasm between Christians and Muslims: there was no distinct housing type that differentiated those religious groups. The residential streets in which Muslims and Mozarabs both lived were mute, austere, guarding family life behind unassuming walls in strict privacy. Two-storied homes were organized around interior patios, entered indirectly from the street. Homes and palaces were punctuated here and there by a small mosque, an ancient church, or a public bath. Scattered throughout the city were neighborhood oratories: the compact yet stately neighborhood mosque of Bab al-Mardum; its delicate cousin, a nine-bay mosque now called Las Tornerías; a mosque in the quarter of Santa María that would be sold to an archpriest named Nicholas in the twelfth century; the lost mosque that would later be converted to the church of El Salvador; the mosque of al-Dabbaghin built by Fath ibn Ibrahim al-Umawi in the tanners' quarter, to the south near the river; and a mosque

near the street of Pozo Amargo, near a handful of ornamental arches that might have come from a bath associated with it.

Beyond the Great Mosque, following the winding streets that tumbled down toward the western edge of the city, Toledo's Jews had lived in a separate sector of the city since the ninth century. Madinat al-Yahud, the city of the Jews, was a walled quarter that hugged the Tagus River and embraced about a tenth of the city's topography, housing between two thousand and three thousand people. It included the institutions of Jewish internal administration, schools, hospitals, public ovens, mikvahs—ritual baths—and kosher butchers, with a number of synagogues, though the ones that remain today were rebuilt in later periods. But its homes, the circuitous streets, cul-de-sacs, markets, and public baths were the same types as those shared by Christians and Muslims in the rest of the city. Like the Mozarabs, Jews were required to build their synagogues and homes below a certain height, so that their observances did not distract from Muslim prayer or attract attention. Despite these external restraints, the powerful intellectual energy of the rest of the city was alive here as well.

Though many Jews and Muslims left Toledo in the wake of the conquest of 1085, this city in which the Castilians made their new capital was far from an empty shell. One of Alfonso's first goals was, in fact, to retain its population, in order to stabilize its demography and economy, while carving out a place for the Castilians and the Franks who swept in with him. What they found was a metropolis with a mix of all of the children of Abraham, who intermingled in those civic and commercial spaces. Some Christians and many Jews had held governmental posts in Taifa kingdoms, and they commingled with Muslims socially and even in education. They had seen each other in the streets, the markets; and as James Powers has observed, they could even use the same public baths.[3]

The first step in this process of keeping and remaking was Alfonso's transformation from intimate tourist into full-time resident: the making of a home, and the contingent embrace of a world long desired and now possessed. Al-Mamun had constructed a magnificent palace in the quarter of al-Hizam, the seat of power perched high on the edge of the eastern sector of the city, and reaching, behind its high walls, down to the banks of the Tagus. Al-Hizam would later be known as alficen. The part dedicated to military activities was called alcazaba by the Castilians, from the Arabic al-qasaba, the word that yields the English "casbah." This entire royal quarter had been the site of palaces in Visigothic and early Islamic times as well, but it was the sumptuous Taifa palaces that most quickened the desire of the Castilians. Art historian Clara Delgado Valero, who resurrected Taifa Toledo from fragments hidden in the densely built city, sees this placement of al-Mamun's palace as "obeying the politics of continuity of Umayyad power, an inheritance, of which the Taifas felt themselves trustees."[4] This was an exclusive enclave whose high walls enclosed public rooms and intimate chambers, linked by courts and enclosed gardens and pavilions.

Like the Aljafería, the palaces of the Banu Hud in Saragossa, Toledo's palace was probably structured around enclosed rectangular courtyards onto which porticos and long reception rooms opened. The palace of al-Mamun is largely lost to us today, but we can see

Cloister of the convent of Santa Fe in Toledo. This arcade was built at the location of the entry to the palace of al-Mamun in al-Hizam, the palatial enclosure of the city.

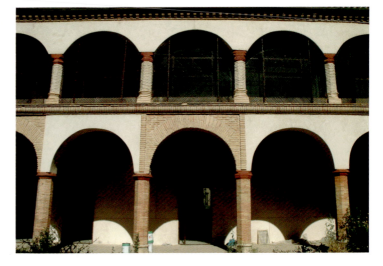

Palace of al-Mamun in Toledo, stucco and glass decoration from the intrados of entrance arches, 11th century.

Palace of al-Mamun in Toledo, stucco decoration of hunting and fantastic animals from entrance arches, 11th century.

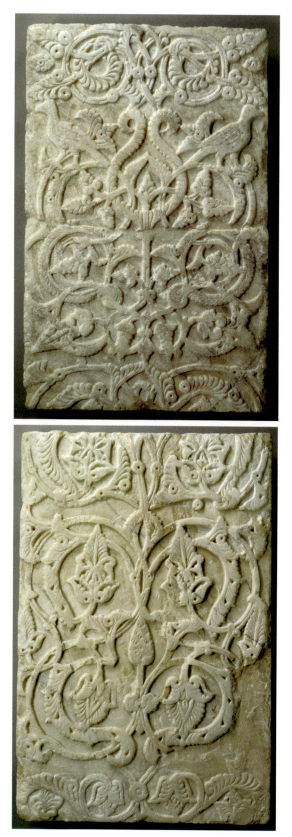

Palace of al-Mamun in Toledo, capital. Museo
Taller de Moro, Toledo, Depósito de la Parroquia
de Santo Tomé.

Palace of al-Mamun in Toledo, marble relief of
the Tree of Life, 11th century. Museo de Santa
Cruz, Toledo.

**Palace of al-Mamun in Toledo, small oratory,
11th century with later painting.**

in the convent of Santa Fe, which has replaced it, an echo of the Taifa palace entrance that lies buried below it. Excavations have recently uncovered fragments of that arcade, including astonishing decoration. The underside of the high arches would greet visitors with pairs of robust stucco animals facing one another against a ground of vibrant colored glass. Their deep translucent hues of red, blue, and aquamarine must have contributed to the legends of opulence and wealth created by the palace. On one face of the arch, perhaps the exterior, hunters of all kinds pursue their prey —with horses, spears, and falcons—across a saturated lapis and gold ground. Hunting was a symbol of lordly comportment, and since hunting rights could define the possession of land in the Middle Ages, hunting scenes were powerful reminders of sovereignty. On the other face, animals both natural and mythic suggest astrological signs, and remind the visitor of the more cosmic powers of the palace's master.

The interior walls were plastered and painted and some were adorned with gracefully carved marble panels. One marble relief that survives looks at first abstract, because of the tangle of interweaving forms. But as we look closer, we see it is the Tree of Life, with eternally circling branches in which birds and fantastic leaves are hidden in an elegant puzzle. Following the Umayyads, al-Mamun continued an essentially Roman architectural vocabulary, using columns and Corinthian capitals to support arches and doors, but here too their style is new, brilliantly rich and complex, distinctly compact and abstract. Furnished with carpets, curtains, and silks of legendary quality and manufacture, the palace aroused the fantasies of many who lived beyond al-Hizam's walls, Christians, Muslims, and Jews alike.

A gate to the enclave survives, reconstructed now, an enormous horseshoe arch looming over a public market, suggesting both the formidable power and the exclusivity, the seclusion of those who inhabited the spaces that spilled below. The names of the rooms were calculated to overwhelm and inspire those who squinted from the marketplace to catch a glimpse of the world beyond those walls: "the ennobled one," "the chamber of intimacy," "the room of perfumes." Of what little remains, an elegant little *qubba*, a

centrally planned domed chamber open to three sides, might have served as a tiny oratory. Its complex geometric ribbed dome, which rotates squares to create stars, links this gemlike space to the nostalgia for the caliphate that fueled much of Taifa culture. And its unveiling of a court fascinated with geometry and the intellectualization of space reminds us of the lively society that created these spaces, and those who created within these spaces: poets and historians, scientists and musicians. But while the Taifa of Seville was the place remembered for the creation of poetry, Cordoba for history and geography, Toledo was a cradle, not only of poetry, but in particular for the study and practice of science.

Indeed, one of the venerable images of a powerful and sagacious ruler in the Islamic world called for the possession and promotion of science and mathematics, and it was this particular current of courtly culture that had found root in Taifa Toledo. Geometers and mathematicians like Ibn al-Attar, al-Waqqadi, and al-Tujibi were nurtured in Toledo, as was Muhammad ibn Assafer, who made an astrolabe there in 1029, an astrological instrument for measuring celestial altitudes, which was developed from Hellenistic prototypes in far-reaching

Celestial globe, perhaps made by Ibrahim ibn Said al-Sahli, c. 1085. Paris, Bibliothèque nationale de France, Département des Cartes et Plans.

and ingenious ways in the Islamic world. In al-Mamun's time, al-Zarqali (whose Latin name was Azarquiel) refined the astrolabe and built a water clock that emptied and filled two basins in unison with the stages of the moon, a machine that would remain a kingly possession through the twelfth-century reign of Alfonso VII. And we can still see today two of the astrolabes built in Toledo by Ibrahim ibn Said al-Sahli, as well as two glorious brass celestial globes he built with his son Muhammad, which show the positions of the stars relative to the annual path of the sun, including forty-seven constellations and more than a thousand individual stars.

Like the astrolabes, such globes were part of the vast transformation of Ptolemaic science in early Islamic courts like Baghdad, figures of intellectual regeneration and technological prowess. And eleventh-century Toledo possessed the kind of prosperity—the libraries and scholars—needed to finance its own transformation into the new Baghdad. Even a partial inventory of Toledo's scholars speaks to an intellectual wealth as exciting as any other: al-Bajunis taught philosophy, logic, and medicine in al-Mamun's court, while a civil court judge (*qadi*) in Toledo, Said, would write a much-cited history called the *Kitab*

Site near the Tagus River in Toledo where Taifa
pleasure palaces were built.

tabaqat al-umam (*Book of the Categories of Nations*). And
the prestige of the doctor, botanist, and agronomer
Ibn al-Wafid would lead him to become a vizier of al-Mamun. With a kind of elegant
authority he would write not only one of the most important medical texts to emanate
from al-Andalus but a treatise on astronomy, and important texts on agriculture, including
the *Majmua* (*Collection*) and a synthesis of the work of Greek authors Dioscorides and
Galen. The surrender of the Taifa of Toledo ceded to the Castilians, and thus, through them,
to the rest of western Europe, the raw materials required for the metamorphosis of the
Arabic athenaeum into the Latin library.

From the caliphal and Taifa conviction that gardening, control of water, and creation
of landscapes was part of the privilege and identity of kings came the countless gardens of
Toledo, described by the great geographer al-Idrisi as crisscrossed with canals and hydraulic
works. Among these was a botanical garden made for al-Mamun by Ibn al-Wafid. It likely
contained exotic specimens of fruits and other delicacies imported from the east, the con-
sumption of which were part of the very definition of courtly culture in Umayyad and
Taifa society. D. Fairchild Ruggles reminds us that the botanist Ibn Bassal, who left Toledo
for a position in the court of Seville as Alfonso entered the city, planted marvelous fig
trees there that bore half-green and half-white fruit, and "wild pomegranate trees that are

unlike anything else."[5] And from these gardens came oils and scents, the copious application of which was part of the conspicuous consumption that made a court celebration dazzling.

The city was surrounded with lofty walls punctuated by powerful gates. The Bab Muawiya gave entry into the madina from the northern suburbs; the Bab al-Yahud to the Jewish quarter. The Bab al-Dabbaghin opened to the southern edge of the city walls, and the Bab al-Qantara controlled access from the other side of the river over the Alcántara bridge. The bridge led travelers to the palace, and was the site of triumphal entry to the city for its rulers. Outside the city walls, a royal munya, or country estate, had been intended both for income and pleasure. Al-Mamun might receive visitors in the hall called Majlis al-Naura, named for the *nuria*, or water wheel, which raised the waters from the river to the munya's rivulets and fountains. The water wheel fueled gilded lions who spilled water into irrigation channels, and marvelous fountains and gardens. Before becoming the master of Toledo, when Alfonso VI spent his short exile as the guest of al-Mamun, he probably resided in the Munya al-Mansura, a place to which he would later return, and possess.

✳

Part of the bequest of those palaces was a culture of poetry and song, to which the Castilians, long before 1085, had hardly been strangers. Among other things, Count Sancho García of Castile had received a gift from the Umayyads of *qiyan*, female performers whose song repertory consisted of hundreds of lyrics. And in the Taifa city that became the trophy-bride for the Castilians, her fine homes and courtyards still resonated with the sounds of that immense poetic dowry. Yet long before Toledo's Taifa palaces and their gardens were lost by al-Qadir, and became a part of the very center of Castile, nostalgia and loss already permeated Arabic poetic culture. In the memory inscribed in Andalusian Arabic poetry no lost gardens are better remembered than those of the palace city of Madinat al-Zahra, sacked during the civil wars that brought the Umayyad caliphate to an end. In the efflorescence of poetry that made the Taifas a glorious literary era, and thus in the lingua franca of the Arabic-speaking citizens of the city the Castilians encountered, the memory and the ruins of the lost gardens of Cordoba play an elegiac role.

> With passion from this place, al-Zahra,
> I remember you.
> Horizon clear, limpid
> The face of earth, and wind,
> Come twilight, desists,
> A tenderness sweeps me
> When I see the silver
> Coiling waterways
> Like necklaces detached

From throats. Delicious those

 Days we spent while fate

 Slept. There was peace, I mean,

And us, thieves of pleasure.

 Now only flowers

 With frost-bent stems I see . . .

<div align="center">Trans. Christopher Middleton and Leticia Garza-Falcón</div>

Thus begins one of the many eloquent love poems—a formal *qasida*, or ode, the elemental poetic form in classical Arabic—by Ibn Zaydun, a Cordoban who was born into the crumbling Umayyad universe, in 1003, and died in Seville, in 1070, one of the most famous poets of an age famous for its poets. This was a culture in which, from pre-Islamic times on, to speak Arabic was no less to speak its poetry, to know the canon and its great figures, its clichés and its masterpieces. Even in such a poetry-besotted universe Ibn Zaydun was particularly revered for his love poems, as he is to this day inside the Arabic tradition. In the eleventh century, not only among the citizens of Taifas like Toledo, but far beyond, the Cordoban poet is the supreme craftsman of the particular branch of love verses that glorify longing itself, rather than consummation or fulfillment. The bed of this wide and deep poetic stream is defined by its cultivation of an aura of love as that which can never be possessed. Always just beyond reach, little matter whether in the future or in the past, in the imagination or in a memory, the beloved, the object of desire itself, is often ambiguous and layered, a rich melding of nostalgia and yearning.

Is Ibn Zaydun here, in this ode known as "From al-Zahra," really lamenting the loss of his beloved Wallada? Wallada was the brilliant and sharp-tongued Umayyad princess who was born toward the end of the caliphate and lived to be part of Taifa culture through her own life and poetry. Heir to the Umayyads' Navarrese white skin and blue eyes, Wallada refused to wear the veil when walking in the city, it was said, in order to flout her beauty. She was also notorious for the freedom of her amorous adventures, about which she wrote her own often scathing verses; the most famous of these liaisons was with Ibn Zaydun, charted in dozens of his poems, and mythologized as a species of Romeo and Juliet in the annals of Arabic literature. But Ibn Zaydun's lament also remembers the terrible loss of the Umayyad universe itself, evoked as the ultimate paradise lost through images of the fairy-tale-like Madinat al-Zahra, with its "silver coiling waterways, like necklaces detached from throats." In the ambivalence between place and beloved lies much of the force of the desire: there are perhaps always multiple loves and moments evoked by such a chimerical place of happiness and peace, now abandoned.

Ibn Zaydun's personal history, as it happens, presents us with a vivid example of this enmeshment of the political and the personal. The historical record speaks to his passionate political entanglement with Cordoba itself, in its painful last years, and his devotion to the lost Umayyad cause; and no less so to Wallada, who not only abandoned him but reviled him for infidelity in her own verses and then took his great rival, the court's vizier

Ibn Abdus, as her lover—which in turn led to Ibn Zaydun's imprisonment. It is a life story in this respect not unlike that of his equally famous Cordoban contemporary Ibn Hazm, who was not a poet of Ibn Zaydun's stature but who also crafted visceral evocations of passion, and its perils.

وددت بأنّ القلب شقّ بمدية
وأدخلت فيه ثمّ أطبق في صدري
فأصبحت فيه لا تحلين غيره
إلى مقتضى يوم القيامة والحشر
تعيشين فيه ما حييت فإن أمت
سكنت شعاف القلب في ظلم القبر

How I wish I could split my heart
with a knife
put you inside
then close up my chest

so that you would be in my heart
and not in another's
until the resurrection
and the day of judgment.

There you would stay while I lived
and after my death
you would remain buried deep in
 my heart
in the darkness of the tomb.

Trans. Cola Franzen

Ibn Hazm was the towering figure of Andalusian letters of his age: a polymath, an important legal scholar, and in general a prolific and powerful writer who in ways different but parallel to Ibn Zaydun's dominated the intellectual landscape of the Taifas. And like Ibn Zaydun, Ibn Hazm was born into the chaos of the final days of the caliphate, in 994; worked tirelessly for the hopeless Umayyad cause; and then spent the rest of his life in embittered exile, wandering through Taifa al-Andalus until he died in 1064, in Niebla, not far from Seville. His most famous book is a treatise on love and its poetry, *Tawq al-hamama* (*The Dove's Neck-Ring*), which serves also as a chronicle of the last gasp of Umayyad high culture. Ibn Hazm was actually raised inside Madinat al-Zahra, and he was the source of much of the court gossip of the period, not least the story of the affair between al-Mansur and Subh. But his most poignant chapter is the one titled "On Separation," with

Wallada

Famous for disregarding the social restrictions usually placed on noble women, Wallada is said to have embroidered the words of one of her poems along the hem of her robe, which she defiantly wore through the streets of Cordoba: "By God, I will hold my head high and follow my path freely. I will give my cheek to my lover and my kiss to whomever desires it."

If you did justice to our love,
you would not desire nor prefer my slave girl.
Nor would you forsake a fertile branch
in its beauty,
and turn to a branch devoid of fruit.
You know that I am the Moon in the sky,
but you burn,
to my chagrin,
for Jupiter.

Jupiter is a play on words Wallada uses to refer to her slave girl, since the Arabic *al-mushtara* or *al-mushtari* means both Jupiter and "the one who has been bought."

Trans. Devin Stewart

its descriptions of many kinds of losses, among the most searing that of a particularly cherished beloved, a slave girl named Num: "Destiny deprived me of my beloved when the nights carried her away and the days passed by, and she became one with the dust and the stones. . . . Life did not taste sweet to me after her, and I have not forgotten her memory. . . . My love for her obliterated everything that came before her, and nullified what came after her." Only a few pages after this, and very much a part of the same sentimental and poetic category, we discover his searing, and echoing, description of the loss of his childhood home in Cordoba: "Its traces had been erased, its signs obliterated, its location hidden. Now it was all rot: it had become a barren desert, having once been a flourishing land; a desolate expanse in the wake of happy companionship; the shattering of great beauty, fright-filled roads after safety; a refuge for wolves, a carousing spot for ghosts, a playing field for jinn, a lurking place for wild beasts."

But both Ibn Hazm's little book, better translated (as it is by Gabriel Martinez-Gros) as "On Love and Lovers," and Ibn Zaydun's corpus of sometimes breathtaking love poems achieved the broad power and influence they did because of a far-flung appetite for a copious language of love, an appetite powerfully aroused among neighboring Romance speakers, in the decades that followed. It is true that the conflation, in both Ibn Hazm and Ibn Zaydun, of love and history speaks with special pathos to the circumstances of their lives, and to a historical moment: the eleventh century into which the Castilians made their splashy entrance, where Cordoba was already a ruin—its precious Madinat al-Zahra literally so, and Umayyad political omnipotence and cultural supremacy figuratively so. But it is also true that this was already a tradition in al-Andalus, whose foundational poem can be said to be the nostalgic ode to a palm tree—to a country palace, and beyond that to a lost world—written by Abd al-Rahman I.

تبدّت لنا وسط الرصافة نخلة
تناءت بأرض الغرب عن بلد النخل
فقلت شبيهي في التغرّب والنوى
وطول التناءى عن بنّى وعن أهلي
نشأت بأرض أنت فيها غريبة
فمثلك في الإقصاء والمنتاى مثلي
شقاك غوادى المزن من صوبها الذي
يسحّ ويستمرى السماكين بالوبل

A palm tree stands in the middle of Rusafa,
born in the West, far from the land of palms.
I said to it: How like me you are, far away and
 in exile,
in long separation from family and friends.
You have sprung from soil in which you are a
 stranger;
and I, like you, am far from home.

Trans. D. Fairchild Ruggles

Exile, of course, is scarcely distinguishable from the separation of lovers, and from the longing for what cannot be recovered. Ibn Zaydun's poems evoke places and times that the human heart yearns for, delicious days while fate sleeps, and where one can steal unblemished pleasure. But the role of love poetry is not really to dwell in the satisfaction,

let alone wallow in those moments, which turn out, inevitably, to be fleeting, or perhaps illusory, but rather to evoke the longing itself, the homesickness. Perhaps all such places exist only in those traces that remain in the landscape of the imagination, the triggers of vivid memory of what is lost, the flowers a little damaged, with frost-bent stems. The ode "From al-Zahra" finishes like this:

> Such fresh memories
> > Of you these few things
> > > Waken in my mind. For
> Faraway as you are
> > In this passion's grip
> > > I persist with a sigh
> And pine to be at one
> > With you. Please God no
> > > Calm or oblivion
> Will occupy my heart,
> > Or close it. Listen
> To the shiver of wings
> At your side—it is my
> > Desire, and still, still
> > > I am shaking with it. . . .
> Pure love we once exchanged,
> > It was an unfenced
> > > Field and we ran there, free
> Like horses. But alone
> > I now lay claim
> > > To have kept faith. You left,
> Left this place. In sorrow
> > To be here again,
> > > I am loving you.

Ibn Zaydun's poetry is exemplary of many of the paradoxes of the cosmos of the Taifas, and his love songs—and the powerful traditions within which they are embedded —prominent among the cosmopolitan riches that lay inside Toledo. As a poet he occupies all sorts of privileged places at once, perhaps not least in the impartially written history of love poetry in Romance. At the historic center of that narrative sit the troubadours of nearby Langued'oc, who began writing their own passion-centered poems, in their own newly minted vernacular, in the wake of Toledo's absorption into the Castilian orbit. In that realm, the nature of ties and contacts between speakers of Arabic and Romance, and thus between their respective poetic traditions—the first at one of its marvelous peaks, in Seville, the other in its glorious infancy, a few hundred miles away—lies at the heart of

any attempt to imagine the universe from which modern western love poetry springs. It is a universe full of riddles, of which perhaps the most vexing is why the Castilians, who encountered this powerful and omnipresent poetic culture head-on, did not themselves cultivate lyric poetry.

Against the backdrop of the conspicuous absence of a love lyric in the vernacular of the Castilians, Ibn Zaydun's poems stand out as ghostly mementos, markers of a passage from Arabic into the western poetic consciousness, and its articulation, which is nothing like a straight line: this is more like a delta that spreads from the Taifas northward, hugging the Mediterranean as it spills beyond Valencia and Saragossa and Barcelona, beyond the Pyrenees, into the heart of what we used to call Provence. Although there are no written translations of Ibn Zaydun's poetry into Romance by his contemporaries, his body of work provides near-perfect examples of all the tropes and sentiments that become the hallmarks of troubadour poetry, and beyond that our own: the conceit of pure love; the lovesickness that follows, since satisfaction is never really there, but in a faraway place, the past, or a distant shore; the wallowing in whatever the opposite of calm is, which means the recognition that oblivion comes from contentedness, since satisfaction never leads to poetry.

What is indisputable, however, is that in the canon of Arabic poetry, which is filled from beginning to end with poetry of longing and passion, and with that seductive ambiguity and mutability of the object of desire, Ibn Zaydun is remembered as one of the greatest masters of such expressions of love. No monument in the whole panorama of Arabic love poetry is more revered than his long qasida commonly called the "Nuniyya" for the distinctive rhyme in n (or na, the first-person plural pronoun) that carries its full fifty-two verses. And perhaps no monument commemorates the time and place better than this poem, with its transcendent evocation of loss, which we cite only in fragments:

> Morning came—the separation—
> substitute for the love we shared,
> for the fragrance of our coming together,
> falling away.

> The moment of departure
> came upon us—fatal morning.
> The crier of our passing
> ushered us through death's door. . . .

> Keeping faith in you,
> now you are gone,
> is the only creed we could hold,
> our religion. . . .

Do not imagine
that distance from you
 will change us
as distance changes other lovers.

We sought, by God,
no other in your place,
nor do our hopes
turn us another way.

Night-traveler, lightning,
go early to the palace
and offer a drink to one
who poured us her pure love freely.

And ask if thoughts of us
trouble a lover
as the memory of her
possesses our troubled mind.

O fragrant breath of the east wind
bring greetings to one,
whose kind word would revive us
even from a distance. . . .

I am left sad, keeping the faith
though you have shut
me out. A phantom
will be enough, memories suffice.

Though in this world
we could not afford you,
we'll find you in the stations
of the last assembly, and pay the price.

A response from you
would be something!
If only what you offered
you gave.

God bless you
long as our love for you still burns,
the love we hide,
the love that gives us away.

Trans. Michael Sells

Inbred here are the deep and sometimes explicit resonances with the pre-Islamic poetry that had for centuries provided terra firma for culture in Arabic. First brought out of the pre-Islamic deserts of the Arabian Peninsula, the art of making great poetry was the cornerstone of culture itself, a culture of poetic champions, the men who were winners of the prestigious competitions at the heart of Mecca, where banners were embroidered with the winning poems and hung around the Kaaba. The signature motif and characteristic opening of this bedrock body of poems (qasidas called *muallaqat*, or "suspended ones," in an allusion to the annual ritual at Mecca) is the poet's discovery of the abandoned camp-site of the beloved's tribe, which has moved on, in the desert. No one describes their ethos better than the preeminent translator of much of the Arabic canon, Michael Sells: "Traces of an abandoned campsite mark the beginning of the pre-Islamic Arabian ode. They announce the loss of the beloved, the spring rains, and the flowering meadows of an idealized past. Yet they also recall what is lost—both inciting its remembrance and calling it back."[6]

The Prophet's own recitations of God's revelation—*Quran* literally means "Recitation" and its opening verse is the angel Gabriel's injunction to Muhammad to "Recite in the name of your Lord who created you"—were overflowing with hermeticisms and flights of poetic beauty. This was especially true of the early suras, or verses, from the years in Mecca, in the first, difficult years of his prophethood, before the flight to Medina (the *hijra*) in 622 CE. They earned Muhammad the accusation that he was just another poet. And although the Revelation he recited to the Arabian tribes soon enough led to the destruction of their old gods, and although the expansion of the Arabs out of the peninsula was a direct consequence of the conversion to that new faith, the old poetic universe was hardly left behind. "If as a revealed text the language of the Qur'an is divine or prophetic, it is at the same time poetic, using the very language of pre-Islamic poetry," as we are reminded by Adonis, the most influential Arab poet of our times.[7] Even though it is the most power-ful icon of the *jahiliyya*—the "age of ignorance" before Muhammad and the monotheism he preached—pre-Islamic poetry is fully absorbed into Islamic culture, which explicitly embraces as axiomatic the principles of the muallaqa, not just its formalities and its imag-istic language, but perhaps more importantly the very notion that language and poetry are at the heart of civilization itself.

Indeed, even the Quran, and its exegetical traditions, cannot avoid speaking to the provocative question of the relationship between its own poetic language and the forma-tive poetic tradition that precedes it and with which it is intertwined, just as the hanging of poetic banners precedes the circumambulation of the Kaaba. In sura 26, "The Poets," the distinction is drawn between the God-given eloquence of the Arabic of revelation and the poets, whose followers go astray. Most famously, out of sura 11 (which begins with the verse "This is a Book whose verses are indeclinable and distinct") and also sura 17 (which includes the verses "Surely if men and jinns get together to produce the like of this [Quran] they will not be able to produce the like of it") emerges the notion of the miraculousness of the Quran itself, its inimitability. In other religions prophets have prof-fered other kinds of miracles, but in Islam the miracle is the language of revelation itself.

Thus, the conquest of the Iberian Peninsula was military and religious, but it was no less the triumph of the "pennants of the champions," as one of the surviving anthologies of the poetry of al-Andalus and the Taifas is poetically, and allusively, called. And as far from pre-Islamic Arabia as late eleventh-century Toledo was, the streets in 1086 still echoed with the sounds of its poetry. One portion of that heritage was the rich poetry itself, and one part the notion of championship as rooted in how brilliantly a man (and the occasional woman) could add to the tradition that tied them directly to the desert poets of the centuries before the coming of Islam, and beyond them to other Islamic courts across time and space, from Umayyad Damascus to Abbasid Baghdad. And of course, most recently, most powerfully, to Cordoba, which was already an abandoned campsite, the ruins of Madinat al-Zahra its traces.

✳

Beyond poetry, the brave new world was filled with the bits and pieces of the treasure of Madinat al-Zahra and of Taifa courts scattered with the winds of the civil wars of the eleventh century, or dispersed in tribute to Christian kings: lavish and beautiful cloths,

Labid

"The Muallaqa" (excerpts)

The tent marks in Minan are worn away,
where she encamped
and where she alighted,
Ghawl and Rijam left to the wild,

And the torrent beds of Rayyan
naked tracings,
worn thin, like inscriptions
carved in flattened stones,

Dung-stained ground
that tells the years passed
since human presence, months of peace
gone by, and months of war,

. . .

Cut the bond
with one you cannot reach!
The best of those who make a bond
are those who can break it.

Give to one who seems to care,
give again,
but if the love goes lame and stumbles,
you can break it off

On a journey-worn mare,
worn to a remnant,
with sunken loins
and a sunken hump.

. . .

On one like that,
when shimmerings dance
in the forenoon
and hills are gowned in mirage,

I bring the issue to a close,
not held back by doubt
or by some critic's rummaging around
for something there to blame.

Or didn't you know, Nawar,
that I
am one who ties a love knot
and cuts it free?

Who abandons a place
that no longer pleases,
unless ill fate cleave
to that some certain self of mine.

. . .

Trans. Michael Sells

bridles and saddles, curtains and boxes, the scents and tastes that issued from Taifa gardens and elevated life from survival to pleasure. But more than pleasure, the stuff of this culture began to define the visual, aural, and sensual languages of power. The *Song of the Cid* overflows with scenes where the openhanded hero distributes the spoils of battle, not only *dineros*, coins, but horses, "each with its saddle and lavishly bridled, each with a sword slung from the saddletree," and all manner of finely crafted objects, "tents and arms and garments of value." And a large portion is sent to Toledo—to the estranged king Alfonso—as well as to the cathedral of Burgos and the monastery of San Pedro de Cardeña.

The objects found their way to courts from Seville to Poitiers, and penetrated not only secular halls but the most sacred spaces. At the monastery of Leyre in Navarre, a formidable ivory casket likely made in the royal Umayyad workshops of Madinat al-Zahra served as a reliquary. Deep into the eye-poppingly expensive ivory—brought north to Cordoba through trade routes that ran from sub-Saharan Africa through Tunisia and across the strait—was cut a maze of delicate and intricate vegetation. Images associated with kingship and courtly activities were tangled in those vine scrolls and acanthus leaves: a prince enthroned or hunting with a falcon. In the hills of Navarre for centuries after the fall of Cordoba, the material, the virtuoso craft, the dizzying quantity and quality of the carving evoked the legends of the Umayyad court.

But Toledo also had its own workshops, which produced works as sumptuous, if not as arresting in craft, and certain of its arts fell into the hands of the Castilians as their due in the taking of the city and its dependencies. An ivory casket made for al-Mamun's son, Husam al-Dawla, whose violent death would open the way for al-Qadir's ascendancy to the throne, was carved by the master craftsman Abd al-Rahman ibn Ziyad in the royal atelier of Cuenca. Here the artist employed only plaques of ivory on a wooden core yet the heir to the throne of Toledo received an object that both recalled caliphal court ivories and took on a new direction. In al-Mamun's time, there were no large medallions with images of kings but instead a casket covered with an intricate screen of vines in which are hidden tiny pairs of animals facing one another heraldically, deer and birds, along with diminutive hunters, reminders of a king's right to hunt, an occupation symbolic of his dominion over his land, as declared boldly on al-Mamun's palace façade. It was in fact the secular meanings of these courtly objects, their capacity to visualize the exclusive luxuries that were part of the image of kingship, that made them well received in cathedral treasuries, where they were transformed from spoils of war to trophies of faith.

Thus at times, the pleasure and power of these courtly objects required a kind of reinvention, a reactive adaptation, that would reconfigure their meaning by granting them to church treasuries as reliquaries or objects of wonder, and here the bishops and abbots who cultivated an ideology of crusade and reconquest found dazzling material to promote their spin. Within the space of the church, a luxurious object of clear Islamic manufacture acquired in war became a de facto image of Christian victory in a cosmic struggle over a reductive and vilified Islam. Works were taken as booty from cities like Toledo, spoils of

war that served as payment for the lords whose troops followed Castilian rulers in battle, and they were then dispersed throughout the kingdom by soldiers who returned to their realms. The Cuenca casket of Husam al-Dawla made its way to the cathedral of Palencia, another by the same artist went to the monastery of Santo Domingo de Silos in the heart of Castile, yet another to the cathedral of Narbonne.

Some objects seem to have been made for the tourist trade, for purchase by Christian pilgrims, seeking a testimony to their exotic voyages, like a silver reliquary in the church treasury of Saint-Jean in Liège. A tiny ivory reliquary box in León is carved with caliphal palmettes and coursing hares and hounds, courtly subjects, true, but in an awkward style that suggests it, too, was created for a popular market. Here the relics of Saints Cosmas and Damien are to be found, according to an inscription carefully made on the bottom of the box. Another tiny reliquary now in the church treasury of San Isidoro is a heart-shaped box of silver, carefully inscribed in Latin so that the elegant arabesque of the object's Taifa decoration is not obscured. The inscription reads, "These are the relics of Saint Pelagius," the Mozarabic voluntary martyr, killed under the Umayyad caliphate for publicly blaspheming the Prophet. In a startling confluence of meanings, the unmistakably Islamic style of the reliquary at once glorifies the holy body within by virtue of its unparalleled art and evokes Islam as the other in defiance of which Pelagius gave his life, and achieved victory over death as a holy martyr.

However vilified and oppositional the stage set in which these objects were displayed, they were also absorbed into the personal experience of those who saw them in the north. Artists of Santo Domingo de Silos, the Castilian frontier monastery whose traumatic transition from Mozarabic to Romanesque has been chronicled by Meyer Schapiro, carved capitals in the monks' cloister that resonate with the heraldic animals of the Cuenca caskets and Taifa textiles. They are lost in a mesh of vines; birds disembodied in the articulation of their own feathers and tails. And yet in her work on Silos's sculpture, Elizabeth Valdez del Alamo has shown that these very images are already, by the year 1100, integrated into the redemptive meanings of the monastery and its saints.[8] Castilians were ready for the wonders of Toledo, and they could embrace the culture of its world because they had learned to exploit the cover of the church, which had long before integrated Islamic objects into a fictive cosmos of Christian domination.

More ubiquitous and universally coveted were the silks manufactured on the Iberian Peninsula, the renowned product of Islamic ateliers, which would have a long and widespread history as the embodiment of luxury itself in courts throughout Europe. Jane Burns reminds us of the allegorical figure of largesse, or courtly generosity, from Guillaume de Lorris's immensely influential *Roman de la Rose*, who wears a "fresh new outfit" of Saracen silk.[9] On the Iberian Peninsula, textiles changed hands before and after the taking of Toledo, passed from court to court to church with diplomatic missions, as gifts and prizes, with wedding dowries, and as part of the tribute owed to Castilian and Leonese kings. Already in the tenth century the caliph al-Hakam II gave Ordoño IV, king of Asturias, León, and Galicia, a robe of honor with a tunic of gold silk, when the monarch came

Pamplona casket, sometimes called the Leyre casket, perhaps made at Madinat al-Zahra, 1004–1005. The ivory casket was made for Abd al-Malik, the son of al-Mansur, to celebrate his conquest of León. The warrior fighting lions might indeed represent him in an emblematic vision of that battle; the warrior's shield is inscribed with blessings and one of the numerous artists' signatures on the casket: Khayr. The casket seems subsequently to have been taken as booty or tribute and donated to the monastery of Leyre in Navarre, where it served as a reliquary for the bones of Nunilo and Alodia, two of the Cordoban Mozarabic martyrs whose story was told by Saint Eulogius in the 9th century. Thus, as Julie Harris has shown us, imagery conceived to celebrate Abd al-Malik's victory over the Leonese would finally be used to sanctify the war against Muslims at Leyre.

Pamplona casket, detail of warrior or hunter attacked by lions.

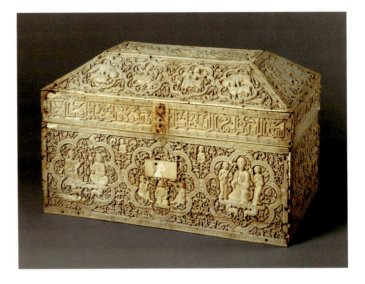

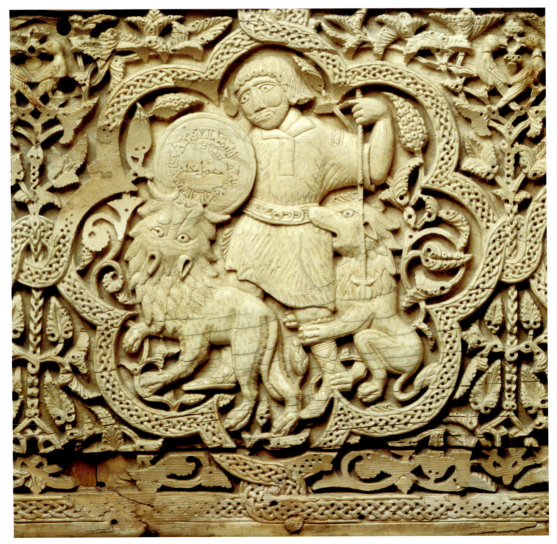

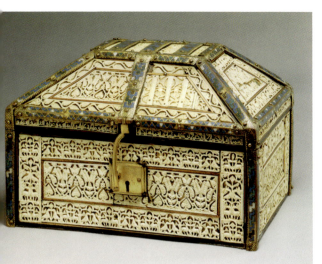

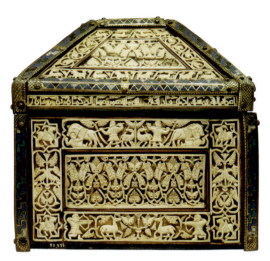

Palencia casket, made for Husam al-Dawla, son of
al-Mamun and successor to the throne before his
untimely death, 1049–1050. Museo Arqueológico
Nacional, Madrid.

Palencia casket, detail.

to Cordoba to ask the Umayyad for military aid.
And when in 1059 Alfonso VI's father, Ferdinand I,
gave a casket to the church of San Isidoro in León,
its lining—enveloping relics of holy martyrs in
one of the most sanctified Christian spaces imagi-
nable—was a priceless Taifa silk patterned in red, blue, and violet, with elegant inscriptions
in Arabic framing griffins, basilisks, ducks, eagles, and hares. The textile's capacity to signify
preciousness projected a kind of aulic importance onto the shards of relics and bore witness
to a shared series of visual values transmitted through material culture.

Ferdinand's gift constituted part of a vast enterprise of patronage and image-making
for the northern capital of León that culminated in 1063, on the occasion of the translation
of the body of the great Spanish father of the Visigothic church, Isidore. His holy relics
were sent from Seville as part of tribute due from the Taifa king al-Mutadid (the father of
Alfonso's contemporary, the poet-king al-Mutamid). Was Ferdinand's son Alfonso in atten-
dance when Ferdinand received the saint's bier in León, draped with a Taifa silk curtain
woven with disks and medallions? Ferdinand and Queen Sancha, in any case, marked the
occasion with gifts of other treasures to Isidore's Leonese church, including carved ivories
and a mantle of *gricisco*, or imported silk.

Silks of Umayyad and Taifa manufacture were prized throughout the Iberian Penin-
sula for their craft and their evocation of wealth and exclusivity. But they also carried
political meaning, for in al-Andalus as in many Mediterranean courts, the manufacture of
luxury textiles or certain kinds of silks could be a court monopoly, and a number of tex-
tiles carried royal honor and authority. Silk factories, known as *tiraz*, were an important
source of income and prestige for Umayyad, Taifa, and Almoravid monarchs. The word *tiraz*
also came to refer to particular royal robes with long borders of names, inscriptions, or
symbols (*alamat*) associated with the king. Such tiraz garments were reserved uniquely for
the ruler or for those he wished to honor or endow with authority, so that the famous

This casket was originally created by Muhammad ibn Zayyan in Cuenca in 1026, as its Kufic inscription relates. It was fashioned with plaques of ivory over a wooden frame, and carved with images of hunters, animals, and mythic creatures typical of Taifa court arts. But at some point the box was damaged and passed into the hands of the Castilian monastery of Santo Domingo de Silos, perhaps as the gift of a ruler or noble who had received it as tribute. On behalf of the monastery, an artist from France or Spain replaced a missing plaque in the 12th century with an enamel image of the monastery's patron saint—Dominic—between two angels, and decorated the top of the casket with an enamel of the Lamb of God. Perhaps the casket first came to Silos in 1076, when Alfonso VI himself was present at the northern monastery to witness the translation of Dominic's body. Elizabeth Valdez del Alamo and Constancio Martínez del Alamo have suggested that the presence of the image of the monastery's patron saint under the striking Kufic inscription on a recognizably Islamic box might have been meant to evoke Saint Dominic's reputation as the protector of Christian captives. Here is another way in which admiration and reverence for fine courtly objects can be shrouded by a political message, and enjoyed with impunity in a monastic setting.

Monastery of Santo Domingo de Silos, cloister capital, end of 11th century.

Arab historian al-Maqqari could explain the young caliph Hisham II's complete political impotence by declaring that he "was not left with any more insignia of the caliphate other than the prayer in his name on the minbars, the inscription of his name on the coinage, and the tiraz strips."[10] The most famous of these to survive from al-Andalus is a tiraz of the same unfortunate caliph, the "veil of Hisham." On either side of medallions woven in silk, linen, and gold thread is an inscription calling for "the blessings of God, and prosperity and long life for the Caliph, the imam Abdallah Hisham, favored of God and Prince of Believers."[11] The "veil" is in fact a long sash or band of delicate woven tapestry worn wrapped like a turban, its ends falling loosely over the wearer's shoulders. This one was likely given to a member of court as a mark of favor, and subsequently served as booty, for it was found hard on the frontier, serving as a reliquary cover in a church in the tiny town of San Esteban of Gormaz.

The particular kind of garment that bears the tiraz in the case of the veil of Hisham was both understood and admired in the Christian kingdoms of the north. An image from a tenth-century manuscript probably executed in Tabara, in the Duero valley, in 975 shows a turbaned rider on an opulently decked steed spearing a snake that rises before his horse. The image so bristles with awe for the gallant mounted warrior, that it was long interpreted as Christ or a saint vanquishing evil in the form of the snake, and indeed there is much that speaks of triumph and admiration in this image: the horse is elaborately caparisoned with ornaments and stirrups in the fashion introduced by the Umayyads, and sailing behind the rider are the ends of a long band of fabric, much like the veil of Hisham. And yet Karl Werckmeister discovered the text that identifies this rider as a Muslim soldier, impaling a rearing snake symbolic of the ninth-century martyrs of

Islamic textile lining the reliquary casket of Saint Pelagius, 1059 or before. Real Colegiata de San Isidoro in León.

Cordoba, who rose to challenge Umayyad authority.[12] In this most polarized of images, admiration for the Umayyad horseman, for his bridle and cape, and for the supple band of fabric that unfurls like a pennant from his turban, is far from disguised.

Alfonso VI's personal interest in the material culture of al-Andalus, both as it was learned from his forebears and as he understood it from his own more intimate interactions in al-Mamun's Toledo, is clear from a number of sources. The late twelfth-century historian Ibn al-Kardabus recounts that Taifa rulers courted Alfonso to support them in their wars, "lavishing on Alfonso costly presents, and giving him as many treasures as he chose to have." When his client Abd Allah, king of Granada, dismissed as exorbitant fifty thousand dinars of tribute exacted by Alfonso, the Castilian king agreed to accept little over half that amount, a large part of it paid in goods: textiles, rich clothing, and other luxury wares.[13] Not only Islamic objects but crafts, dress, and some of their original meanings as well would be absorbed into Castilian and Leonese life as Alfonso VI took Toledo. Among the eleventh- and twelfth-century Mozarabs to remain in Toledo after the fall of the Taifa were dealers in raw silk and a silk weaver, craftsmen who would continue old traditions, and begin new ones.

Toledo itself was lost to Islamic rule, but the city, and those inhabitants who remained, could still exact potent transformations. With its mythic history and vibrant present, both visible and familiar to Alfonso, Toledo was a persuasive teacher that contained the motive and the power to transform the Leonese and Castilians despite their

"Muslim Rider" from the Gerona Beatus, 975.
Gerona Cathedral.

military dominance and growing cosmic rhetoric.
The final conquest of the city—or rather the set-
tling into the city itself—was celebrated by the arriving Christians in terms of a return to
the past, as the restitution of Christian hegemony on the site of the Visigothic capital. But
the creation of Castile's plural cultural identity was already well underway, and had been
since Umayyad times, advancing with each incremental interaction: not only with each
political alliance, but with each meal shared, or bridle admired, each textile or ivory box
received in tribute. But now the overwhelming material and intellectual world of Toledo
was absorbed into the heart of Castile; now it would exercise its power over the Castilians
and Franks and other Latins who began to tread its streets.

ecat scm. uocabicatur filiuf dei

Others

Quod superius me libros legisse, linguam scire, nutrium fore semper inter Sarracenos dixisti,
non idcirco convenit ut illorum assequar legem.

I have read the books of the Muslims, written their language, and was
always nurtured by them, but it is not proper on that account that I
should follow their religion.
—Petrus Alfonsi

Alfonso VI entered Toledo with an army and an entourage that were anything but culturally
and linguistically uniform. His troops and his nobles were largely Castilians and Leonese,
some of whom, like the Cid, were the ambivalent remnants of Alfonso's late brother's
entourage. Among themselves, they undoubtedly conversed in their vernaculars—the local
varieties of spoken Latin that varied slightly from each other and from place to place.
These spoken vernaculars, which we often call "Romance," were not yet the modern
Romance languages but were already remote from Latin itself. The handful of local clerics
who could write in Latin probably composed the official documents for the realm, but
they were by now few and far between. The Castilians were also accompanied by other
Romance speakers, from beyond the Pyrenees: Franks, among them Cluniacs, as well as
papal emissaries, and assorted mercenaries. Each of these added to the variety of Romance
vernaculars that would now be heard on the streets of Toledo. But the clerics brought with
them something more: a connection to a Latin Christendom from which the Spanish
church had been partially insulated, and they brought a divergent and far more dynamic
Latin culture. These Latins, as we refer to the clerics, had come to claim authority to this
brand new slice of frontier territory in the name
of the church. That an indigenous church—the
Mozarabic church—already existed in Toledo was
a fact these ecclesiastical interests hoped to sweep
under the rich Taifa carpet of Toledo's conquest.

The Annunciation to Mary, from Ildefonsus's Treatise
on the Virginity of Mary, now in the Biblioteca
Medicea Laurenziana, Florence. This treatise was
written by the famous Visigothic bishop and archbish-
op of Toledo Ildefonsus, who would become a saint.
But this manuscript was painted by a Mozarab in
Toledo under the rule of al-Mamun, in 1067. Note
that Mary is seated on a throne beneath an arch
framed with an alfiz, and topped with crenellations.
Both details recall the Great Mosque of Cordoba,
and perhaps the lost Great Mosque of Toledo as well.

Of course, there was a formidable indige-
nous population to contend with as well. Toledo,
when Alfonso took possession, was roughly the

same size as his kingdoms of Castile and León combined. And what a remarkable population it was, this kaleidoscope of peoples that were now, overnight, members of the Castilian state: Muslims, Jews, and Mozarabs, those Christians who had long lived under Islamic rule. These three groups spoke Arabic, though at varying levels of competence, just as all three spoke a Romance vernacular, although, if asked what language they spoke, they would all have said Latin. Spoken Arabic and the varieties of Romance were all explicitly shared across confessional lines: Arabic was as much the language of the indigenous Christians of the metropolis as Mozarabic, which was the Romance of the homes and the streets and of the bilingual poetry of the day, and which, in that urban social space, was the companion of the Arabic of the educated man.

So the eleventh-century Toledans inherited by Alfonso all knew how to speak to each other in at least one language, more likely two, and they all shared in the visible and audible signs of a culture that united them, even as they were divided in their places of worship. The very concept of the coexistence of different Laws—as the religions were pragmatically conceived—within the larger polity was no odder than the varieties of languages in the markets and in the palaces, or—as we will see—the different voices within the signature poems of the era, or the mix of historical layers in its architecture.

The first great challenge for Alfonso was how to deal with such diversity of peoples and confessions. And this was doubly true for all those with whom he ruled, many of whom, unlike Alfonso himself, had little previous experience of big city life or the dramatic difference between that and the texture and sounds of life in the military encampments of the *meseta* and inside its *castellae*. Alfonso early set to work concluding treaties and granting diverse *fueros*, or law codes, that recognized rights and customs of the different constituencies that composed his frontier realm. "In the city of cities which was Toledo," Ramón Gonzálvez reflects, "it is clear that a single, general *fuero* would be impossible."[1] The Muslims were governed by the pact Alfonso made with them before he entered the city in 1085, and separate fueros were granted to the Castilians and the Franks, newcomers who were rapidly using their spoils of war to become Toledo's new landed aristocracy. Indeed, the Franks even lived in their own quarter of Toledo, as a distinct group, as would the Latin clerics. But Toledo's native Christians, its Mozarabs, who had governed themselves as Toledo's minority Christian society for over three centuries of Umayyad and Taifa rule, were pushed aside in the initial granting of fueros. Toledo's Mozarabs were angered by the unequal distribution of properties after the taking of the city by the Castilians. It was not until sixteen years later that they, too, received their own fuero, the ability to govern themselves with their own laws.

As a result of this proliferation of individual law codes, and the privilege that each community retained to be judged internally by its own magistrates, centralized municipal institutions were slow to develop in Toledo. Instead, the city responded to its multiplicity of peoples by automatically perpetuating parts of the Islamic system in which, as Gonzálvez points out, "the city was not a political entity in itself but a collection of locales, each a community of believers," to whom the king granted privileges.[2] In some

sense the Muslims, the smallest of the flocks among the city's congregations, the rulers with whom power had long been covertly shared and from whom it was now publicly wrested, presented the most clean-cut solution. As part of the transfer of power, the Castilians without hesitation had agreed to a pact that allowed them to remain in the newly Christian city. The Muslims could govern themselves internally and keep their properties; they were given the freedom to come and go with their possessions and continue practicing their religion; and they were permitted to retain their principal mosque in the center of the city.

These terms were translated from the dhimma, which had long governed Christians and Jews who lived under Islamic rule, and had been the norm throughout al-Andalus. They had been adopted by Alfonso in some ways as if they constituted a fuero for the Muslims, out of political expediency, as a means of stabilizing the remaining population, no doubt with hopes as well of limiting trauma to the existing economy. In this way the dhimma was quietly woven into the shared language of the transfer of power from Taifa to Castilian rule. This conversion of dhimma principles from Islamic law to Castilian praxis, now to accommodate the unprecedented numbers of Muslim and Jewish citizens of Alfonso's new prize of Toledo, would be regarded as heterodox not so much by the Castilians as by Christians from beyond the Iberian Peninsula, which outsiders viewed as an exotic universe of religious untidiness.

✳

For the Castilians in Toledo the most difficult conquest was not that of the Muslims. The group Alfonso found surprisingly complex to govern was Tulaytula's Christian community, native Arabic speakers we have come to call Mozarabs. In their own historical and cultural moment they were referred to by Arabic speakers by other names: Rumi (Romans, or Byzantines) or Nasara (Nazarenes) or Muahid (covenanted, meaning they were protected by the covenant of the dhimma). These Christians of the Taifa of Tulaytula (and before that, of the provincial city of the Umayyad caliphate) had always been a sizable minority, perhaps a fifth of the whole city, some of whose families had lived in Toledo for three centuries, and some who had emigrated more recently from Islamic cities to the south.

We might have expected that the native Mozarabs would greet the conquering Christians of Castile with open arms. But this is an expectation derived in great measure from the powerfully revisionist history of this community crafted in the infancy of the Spanish nation-state, some four hundred years later, by Cardinal Francisco Jiménez de Cisneros. Cisneros is best remembered as confessor to Queen Isabella the Catholic and grand inquisitor, and thus to a great extent responsible for the iconic debacles of his own period: the expulsion of the Jews in 1492 and the revocation of religious freedom for the Muslims that had been guaranteed by the Catholic monarchs, capped by the infamous pyres of Arabic manuscripts that lit the night sky of Granada in 1499. But Cisneros was an immensely complicated character—not a mere philistine—and he understood to what extent a new Spain involved not only the exile of the old but the creation of a new history

to replace what was, at that point, in the process of being expelled. The revival of the memory and a history of the Mozarabs—a community that by the late fifteenth century was not only essentially gone but mostly forgotten—fell squarely into that category.

In fact, the original Mozarabs of Toledo were hardly insular Christian communities culturally intractable or hostile to their Muslim rulers. In Toledo Mozarabs did not live in an isolated quarter as the Jews did, but intermingled with Muslims, and could even live in the Jewish quarter. Under Taifa rule they worshipped in at least six parishes throughout the walled city, including one very close to the main mosque. Many were members of families that had lived for hundreds of years in Islamic territories, governed internally by their own church hierarchy, an independence spawned by the autonomous fragmentation of divergent groups typical of the Islamic city. In 1085 many Toledan Mozarabs had ambivalent feelings about the changing of the guard at hand—there were many reasons to fear Castilian governance more than the Islamic rule to which they were accustomed. The Castilians would bring with them other Christians: papal legates, and Cluniacs, both Frankish and Castilian, whose raison d'etre was the appropriation of the modest ecclesiastical structures the Mozarabs had kept alive for centuries.

But even Mozarabic cultural identity was itself far from unitary. There were old Christian families who had been Arabized over generations, but also recent converts from Islam who felt more culturally at home among the Arabic-speaking Mozarabs than among the Franks or the Castilians. Mozarabic immigrants came to Toledo from other cities in al-Andalus. And there were *conversos*, Jews who had converted to Christianity, like the Aragonese Petrus Alfonsi, whose remarkable text begins this chapter.

Although in their post-fifteenth-century canonization the Mozarabs would become the ultimate emblems of heroic Christian resistance to Islamic domination, the eleventh-century record reveals, far from a story of simple religious enmities, one of Mozarabic assimilation to the Arabized culture of al-Andalus. It is also a history of distinct identities among different groups of Christians. On one hand, the history of the Mozarabic church had separated it profoundly from the northern church that was reforming and uniting Europe under the eleventh-century papacy. During the centuries of Umayyad ascendance, the church in the Andalusian cities, protected by the dhimma, was far more conservative, understandably less changed in its structure than the church in the northern Christian world. More self-protective, the Mozarabic church was bereft of the possibility of exercising political power as it had in the Hispano-Roman and Visigothic periods, but it strove to survive, to conserve the internal powers and structures it was able to retain under successive Islamic rules. Metropolitan sees remained intact, ecclesiastical courts functioned largely unmolested, and the ancient Hispanic rite known as the Mozarabic liturgy (although it actually dated from the Hispano-Roman church of the Visigothic period) was assiduously conserved and practiced.

Arabized Christians, like Arabized Jews, were second-class citizens in Taifa Toledo. But the church itself profited from its designation by the dhimma as the administrating body of Christian self-rule under Islamic government. In 950, Bishop John of Cordoba

explained to an astonished John of Gorze, ambassador of Otto I: "We are more conde-scending with the Muslims. In the midst of the great calamity that we suffered for our sins, we still owe to them the consolation of letting us live under our own laws and of living very closely and diligently the cult of the Christian faith, and they treat us with respect, and cultivate our acquaintance with affability and pleasure."[3]

There were also revolts among Christian minorities; the voluntary martyrs of ninth-century Cordoba would resonate historically. But even that revolt cannot be seen as a global action within the Mozarabic community of Cordoba: it was dutifully condemned by the more conciliatory bishops of Cordoba in 852. And even in that most extreme case, political and cultural resistance should not be mistaken for cultural impermeability. Resistance was, on the contrary, a defensive stance in the face of powerful assimilation. As Thomas Burman makes clear, even the line between linguistic acculturation—Arabization—and subtle religious assimilation—Islamicization—is a fine one. The Mozarab Ishaq ibn Balashk, for one, began each of the Gospels in his Arabic translation with the *basmala*—"In the Name of God, the Merciful, the Compassionate"—a phrase found in nearly all the Arabic documents concerning Mozarabs that issued from the Castilian chancery after 1085. The basmala even extends its blessing and authority over a Latin canon law collection of the eleventh century. In one case, the second person of the Trinity was described by its Mozarabic author in words taken directly from the Quran.[4]

The church, then, functioned productively and independently within Islamic polities, and fluidly within local linguistic culture, crossing even the most opaque cultural barriers. The historical moments that record Mozarabic resistance leave us not an image of isolated Christian communities nurturing separate cultures but a powerful picture of Mozarabic assimilation in day-to-day life that was threatening to those invested in the survival of a certain vision of church culture. The most lucid example of how acculturation is linked to resistance is also conveyed through language and literary expression. The ninth-century Mozarab Paul Albar of Cordoba (whose son called himself Hafs ibn Albar, "Hafs, the son of Albar," using conventional Arabic nomenclature) based his resistance to assimilation on the encroaching erasure of church letters in the face of Arabic literary culture.

> The Christians love to read the poems and romances of the Arabs; they study the Arab theologians and philosophers, not to refute them, but to form a correct and elegant Arabic. Where is the layman who now reads the Latin scriptures, or who studies the gospels, prophets or apostles? Alas, all talented young Christians despise Christians' literature as unworthy of attention. They have forgotten their own language. For everyone who can write a letter in Latin to a friend, there are a thousand who can express themselves in Arabic with elegance, and write better poems in this language than the Arabs themselves.[5]

Like many reactionary cultural stances, Albar's complaint is a call to arms against a force perceived as seductive and powerful—not simply alien or heterodox. Assimilation posed a threat to the survival not of Christianity but of the Latin Christian culture that had

Monastery of San Miguel de Escalada, exterior. 913 and late 10th century.

opposite, from left to right:

San Juan de Baños, 7th century.

Door to the fortification of Agreda, 10th century.

Door of Saint Stephen of the Great Mosque of Cordoba, 9th century.

Church of San Miguel de Celanova, 10th century.

Church of Santiago de Peñalba, 10th century.

Arches from the palace of Madinat al-Zahra, 10th century.

Arches from the Hall of the Ambassadors, Alcazar of Seville, 14th century.

Synagogue, now the church of Santa María la Blanca, Toledo, 13th or 14th century.

long supported the religion, and was a marker of its authority in society. Here Mozarabic resistance becomes potent evidence for Mozarabic assimilation. And at the heart of the call is the fear of the death of Latin letters. And indeed, Albar's son Hafs was the author of an Arabic translation of the Psalms, in which Burman found that "he consciously followed the conventions of good Arabic poetry."[6] In one Mozarabic family, the passage from Latin to Arabic Christian letters is betrayed in a father's anguished lament.

By the tenth century, resistance gave way to even greater assimilation. One need only think of the Mozarab Recemund, bishop of Elvira, also known as Rabi ibn Zayd. He would serve as the caliph's ambassador to Byzantium and the Ottonian court, while authoring manuscripts in both Arabic and Latin. Together with Bishop Abu Harith, he studied Arabic philosophy, part of the "broader intellectual horizon" Burman has revealed in the cultural ambience of Spanish Arabized Christians "so long as they continued to speak Arabic."[7] Even the most oppositional Mozarabs would

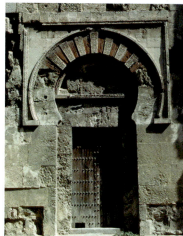

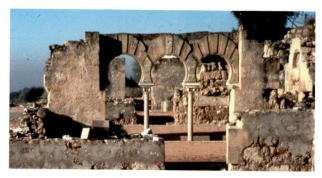

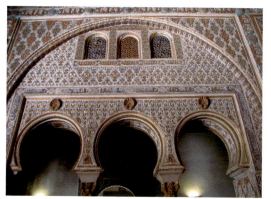

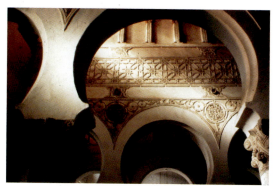

have their impact, albeit in an unexpected way. As the martyr movement of the ninth century was condemned by the compliant hierarchy of the Cordoban church, politicized monasteries looked instead to the northern kingdoms for their ideology of polarization. In 882 the bodies of Mozarabic martyrs from the Cordoban movement were received in León by King Alfonso III, new relics used as powerful political tools for the construction of a national identity in the nascent northern kingdom. Those Mozarabs who emigrated became willing participants in the expansion of the northern kingdoms, where their resistance to Islam and its culture found fertile ground.

Select monasteries from al-Andalus were also recruited by the northern kingdoms to leave their Umayyad cities to participate in the repopulation and administration of broad swaths of the unoccupied frontier at the edge of the caliphate. The monks received lands and a productive outlet for their ideological crisis: local authority that answered their yearning for ecclesiastical influence in political affairs. In the fledgling Christian kingdoms of the ninth and tenth centuries, Mozarabs became the Arabic-speaking advisors to northern kings, and began to cultivate a culture that straddled resistance with assimilation in the rugged north.

Once established in lands on the frontier, these Mozarabic monks could enact a nostalgic fantasy of Visigothic Christian authority. Indeed, these so-called repopulation monasteries built a number of self-consciously conservative buildings, of which the church of San Miguel de Escalada is a key example. "This place . . . long lay in ruin," its dedicatory inscription recounts, "until Abbot Alfonso, coming with his brethren from Cordoba, his fatherland, built up the ruined house."[8] We can hear two voices: the triumphant voice of Mozarabic monks who left Umayyad lands and allied themselves with the Leonese king, and the voice of those same monks who still saw Cordoba as their homeland after decades of voluntary exile.

Within their church we read the point more clearly. Escalada is an archaic basilica with a wooden roof and simple horseshoe-arched arcades. Today we often think of the horseshoe arch as a characteristic of Islamic architecture, but in early medieval Spain it resonated with the Visigoths, nearly all of whose churches used the horseshoe arch in arcaded basilicas or intimate cross-shaped churches to create an elegant partitioned space. We can see this in churches built in the Visigothic period that have survived to this day, like San Juan de Baños, built by the Visigothic king Recceswinth in the seventh century. The horseshoe-arched arcade at Cordoba had continued many building traditions of the Visigoths, whose power they subsumed. A pedestrian in a tenth-century Umayyad city like Cordoba would have seen horseshoe-arched arcades both in surviving Visigothic basilicas and in contemporary Umayyad mosques and palaces. At the same time, the horseshoe-arched arcades of San Miguel de Escalada were a means of visualizing the idea that the Christian kingdoms of the north might initiate a reinstitution of Visigothic rule. They created a new historical landscape of Mozarabic and Leonese desire, in which the Christian hegemony of the Visigoths might be reborn on the frontier.

The history of the horseshoe arch on the peninsula is serpentine and deeply ambiva-

lent. The distinctive horseshoe arcade was taken up as a hallmark of Hispano-Roman architecture of the Visigothic period, and was then adapted in Spanish Umayyad buildings like the Great Mosque of Cordoba, both as part of a local tradition and as emblematic of the purposeful melding of identities of the early years of al-Andalus. The form solidified at Madinat al-Zahra, with a more exaggerated profile, as an emblem of Umayyad court taste. That same Umayyad profile then ricocheted to later "Mozarabic" buildings in the north like Santiago de Peñalba, or San Miguel de Celanova, churches that superimposed Visigothic plans and elevations with the latest style in Cordoban court arches and decoration. Such forms could embody a kind of Visigothic nostalgia; but, like a slip of the tongue, the same horseshoe arch might expose a complicity, through an *alfiz*—a rectangular molding that frames an arch—or a circling vine, recalling the great Cordoban monuments. At Celanova and Peñalba, then, there is a layering of admiration and resistance, of assimilation and a reactionary embrace of a pre-Islamic past.

Here was a cultural interdependence that bubbled to the surface of consciousness, before being tucked neatly back into a fictive image of pre-Islamic purity. And these ambivalences in form extended far beyond the horseshoe itself. Alternating voussoirs, the red and white bands that make arches appear almost candy-striped, are one powerful example. Sometimes called banded arches, this distinctive use of color was immediately identifiable with the Great Mosque of Cordoba, where the ornamental technique had been created to evoke the opulent marble decorations of the great Umayyad mosques of Syria and Palestine. These were, in turn, Roman in origin, part of the Umayyads' cosmopolitan heritage.

We know from a tenth-century manuscript that banded arches could be directly associated with Cordoba and Umayyad rule, even with a fabricated vilification of Cordoban decadence. Consider a depiction of the story of Daniel from the Morgan Beatus, a manuscript in which a banded arch of red and white stones becomes the palace of Balthassar. On this arch God writes his warning of the impending doom of an impious kingdom. Eating and drinking in the company of multiple female companions, King Balthassar becomes the archetype of the Muslim ruler. The monastic artist Maius used the biblical story and his contemporaries' sure association of the banded arch with the Great Mosque of Cordoba to moralize the certain end of Islamic Spain. Indeed, in the miniature, Daniel reads the prophetic writing on the wall on the very voussoirs that bind Balthassar to the Umayyads.

Yet the association, like the Mozarabs' relationship with Islam, is far from universal or stable: the same banded ornament is painted onto horseshoe arches at San Cebrián de Mazote and Santiago de Peñalba—other Mozarabic churches built as part of the effort to repopulate the frontier. And even more specific references to the architecture of al-Andalus can be found, for instance, in evocations of the distinctive vaults of Cordoba's great mosque, the complex ribbed structures that divided its small domes into geometric forms. At the church of San Baudelio de Berlanga on the frontier, a space covered by one vast ribbed vault that grows from the center like an enormous palm tree used Umayyad Cordoba as a model that might excite a sufficient sense of awe, of wonder and splendor, to

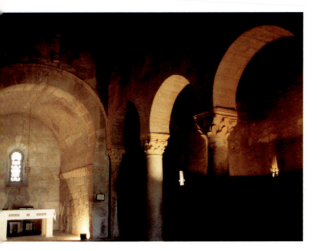

Church of San Juan de Baños, interior, 661.

Monastery of San Miguel de Escalada, interior, 913.

opposite: Banquet of Balthassar, from the Morgan Beatus, 2nd quarter of the 10th century. The Morgan Library & Museum, New York.

imagine a Christian paradisiacal setting. These are sites that resonate with pride in a shared visual language at the same time that they draw a line in the sand. Horseshoe and banded arches, painted decorations, and ribbed domes carried the memory of the Cordoban homeland and its mosque, a suppressed part of a place, a shared experience lost, a kind of collective identity hovering between yearning for an Andalusian homeland and a battle-scarred body formed in opposition to a demonized Islam.

✳

Let us return to 1085, to the event that has been seen as the liberation of the Mozarabs of Toledo. Many Muslims left the city as Alfonso entered; not surprisingly, this included members of the factions that had opposed Alfonso's takeover, members of the ruling classes, those involved with the government and the court of al-Qadir, as well as other important and wealthy families. Alfonso immediately appointed a Mozarab, Sisnando Davidiz, governor, to demonstrate his commitment to continuity in the diverse city, and to discourage further emigration.

But the Castilians' confrontation with Mozarabic Christians was spectacularly polyvalent, and ultimately destructive to any delusions of pure confessional identity. Their ancient and particular Christianity would incite the ravenous interests of other powers that accompanied Alfonso to Toledo. One of those powers was the papacy, with whom Alfonso had an uneasy alliance. The papacy was an institution dynamically focused since the mid-eleventh century on the extension of its authority, as well as its autonomy from secular rulers. The height of these changes had occurred under Pope Gregory VII (1073–1085), who not only fought to free the papacy and church from lay control but believed that as the successor of Saint Peter, the pope had the authority to compel monarchs throughout Europe to make war, at his command, in defense of the interests of the Holy See. Gregory's intense interest in Alfonso's progress to Toledo is not surprising: the opening up of new parts of the

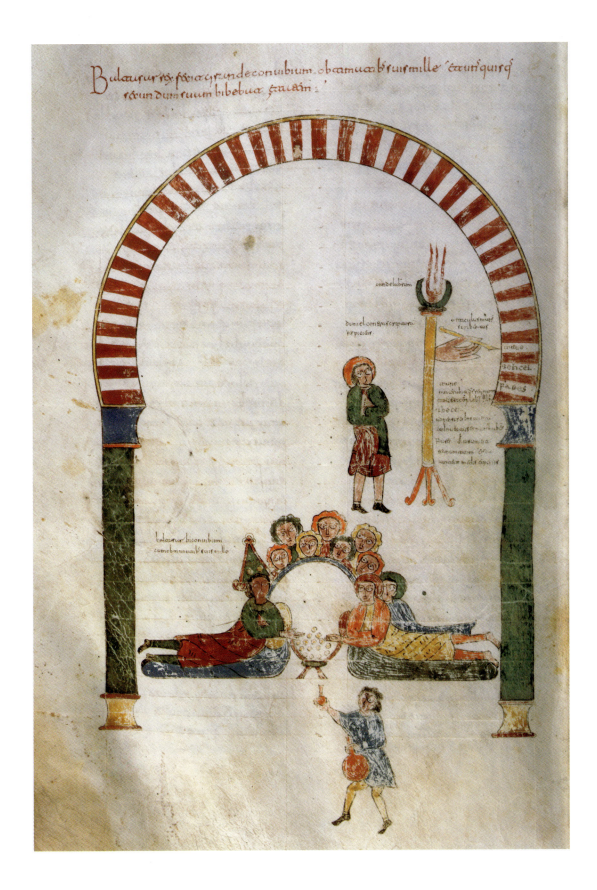

Balcasur rex fecit grande convivium obcamuca bi suismille cecurisquisq
recundum suum bibebat atatem.

Alternating Voussoirs

There are times when the most prosaic detail of ornament can take on weighty meaning, and this is surely the case with alternating voussoirs. Voussoirs are the trapezoidal stones that make up an arch; if they are fashioned in different colors, the construction of the arch is clearly articulated. Voussoirs decorated with alternating dark and light marble plaques were common in late Roman architecture. They could be seen as part of a larger system of marble revetment that created a regal and rational organization of the lower parts of the church. They probably also appeared at Charlemagne's palace chapel at Aachen in the Carolingian period, as a reflection of that king's wish to be considered a new Christian Roman emperor.

Because early Umayyad buildings in Damascus and Jerusalem were constructed in late antique and Byzantine traditions, marble revetment is featured as part of the lavish programs of the Dome of the Rock and the Great Mosque of Damascus. When the Umayyads fell, Abd al-Rahman I fled to Spain with the memory of those buildings. Without the materials or means to reproduce the marbles of his native Syria, alternating bricks and stone could reproduce one of the vivid effects remembered from Damascus. But here the banded arches are the dominant effect in the mosque's interior, and they contributed to the impression that the Great Mosque of Cordoba was like nothing else on the Iberian Peninsula.

Since most of the forms of the Great Mosque of Cordoba were common to all of Spain's monumental architecture, and hard to view as exotic—horseshoe arches, Corinthian capitals, and columnar supports—the red and white voussoirs began to represent, for those outside al-Andalus, what was different about Islam. They could be used critically, as in the Morgan Beatus, or as reminders of the assimilation of Christians and their pride at having been part of a brilliant Andalusian culture, as at San Cebrián de Mazote and Santiago de Peñalba.

The alternating voussoirs we see at the Great Mosque of Cordoba would have a curious afterlife in the Romanesque architecture of France. There, in the years following the First Crusade, they would be used in a number of churches. At Vezelay and Le Puy, the vivid carnivalesque ornament was meant to evoke the exotic Holy Land that the church sought to subdue and possess, but this was achieved through the practical architectural language of red brick and white stone created at Cordoba. It was likely a dual illusion: crusade against Muslims both in the Holy Land and in Spain that inspired the banded arches of the cloister of San Pedro de Cardeña where the legend of the Cid as a fighter for the faith was nurtured. The Dome of the Rock in Jerusalem, by the twelfth century, was in the hands of Christians who had declared that it was actually the site of the Temple of Solomon, part of the Old Testament history that preceded and prefigured Christ's revelation. Alternating voussoirs, first late Roman, then Umayyad, then Spanish, would take on new meaning once again. They were now a reminder of the holy heritage of Jerusalem at the same time that they evoked the exotic Muslim enemy the crusaders had gone to fight.

Mosque of Bab al-Mardum, 999.

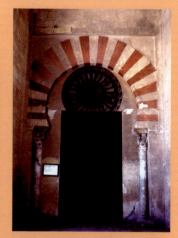

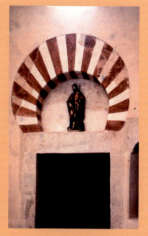

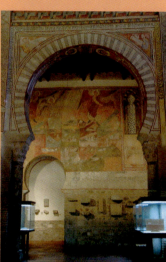

from left to right:

Great Mosque of Damascus, c. 715.

Great Mosque of Cordoba, 8th century.

Church of San Cebrián de Mazote, 10th century.

Madinat al-Zahra, 10th century.

Church of San Román, Toledo, 13th century.

Church of Sainte-Marie-Madeleine at Vezelay, 12th century.

Great Mosque of Cordoba, 8th century.

Cloister of San Pedro de Cardeña, 12th century.

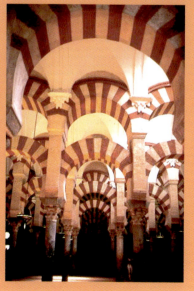

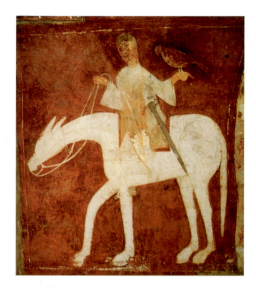

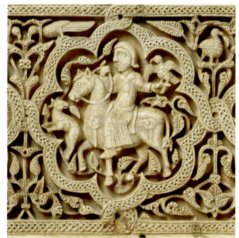

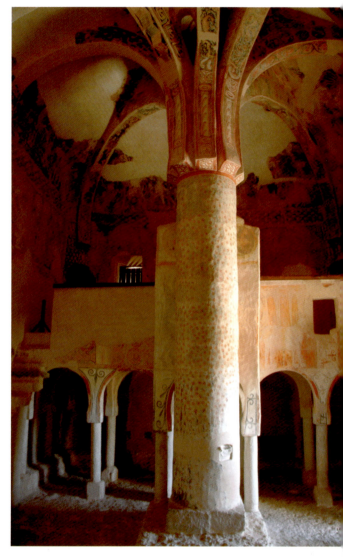

above: Church of San Baudelio de Berlanga, painting of a falconer.

below: Pamplona casket, detail of a falconer.

Monastic church of San Baudelio de Berlanga. The centrally planned ribbed vault of San Baudelio de Berlanga, perhaps built c. 1000, recalls the ribbed vaults of the Great Mosque of Cordoba, those of smaller mosques like Bab al-Mardum, or the little oratory from the palace of al-Mamun in Toledo. About a hundred years after it was built, Berlanga was restored and painted with scenes from the life of Christ on its upper walls, but with bold monumental images of hunters, warriors, and exotic and fantastic animals on its lower walls and vaults. The images of hunting that decorated the entry arches of the palace of al-Mamun in Toledo are here in enormous scale, perhaps transmitted from the caliphal or Taifa courts through precious portable arts received as tribute or booty by royal patrons, and given to monasteries and churches as offerings.

Iberian Peninsula to Christian rule meant the creation of new bishoprics, cities under the authority of bishops who became powerful extensions of the church's arm into the affairs of these rapidly growing kingdoms. The annexation of new lands over which monastic and ecclesiastical interests might hold sway created opportunities for the church that Gregory, his predecessor Alexander II (1061–1073), and his eventual successor Urban II (1088–1099) were eager to exploit.

The legendary churchmen of Cluny, the intellectually and economically potent French monastery that answered directly to the pope, had begun to interact with Spanish monarchs as early as the turn of the millennium. When Alfonso was imprisoned by his brother Sancho in Burgos, it was in part through the intercession of Abbot Hugh of Cluny that he was released into exile, and allowed to go to the palace of al-Mamun in Toledo. Small wonder that, upon leaving the prison, Alfonso gave four Leonese monasteries to Cluny in thanks for the "Cluniac prayers" that had saved him, then doubled the extravagant donation of one thousand gold pieces his father had formerly pledged the monastery. Nor is it extraordinary that he made ties with the monastery even more powerful in 1079 by marrying Constance, daughter of the duke of Burgundy and niece of the same Hugh of Cluny.

Though Cluny often represented the interests of the papacy, its envoys came to understand the complexities of the frontier more subtly than those in Rome. As Cluniacs anchored themselves with monastic and ecclesiastical authority on the frontiers of Castile, they had firsthand exposure to the intricate realities on the ground. Unlike the pope, who was dependent on envoys and eager to impose authority, the Cluniacs reformed from within the peninsula. Although they often had the same ostensible agenda of imposing Roman monastic, ecclesiastical, and liturgical norms, their long presence in the monasteries and cities of the peninsula made them not only more adept negotiators of change but also part of the indigenous weave themselves. Thus Cluniac interests could also split off from papal interests, creating a second Latin constituency, and a third Christian one. The central cultural and religious crisis following the conquest of Toledo did not pose Muslim against Christian, but rather pitted the various Christian groups against each other: diverse Mozarabs and indigenous churchmen against the papacy and Cluniac interests.

It might have been this looming struggle for power that prompted many Toledan Mozarabs to flee from the prospect of life under Alfonso and to instead follow al-Qadir to Valencia in 1085. Some of those Mozarabs might have been associated politically with al-Qadir, but what many must have feared—correctly, as it turned out—was that the pressures of the papacy on the new Castilian state would rob them of their traditional and distinctive practices, and with these, the autonomy they had nurtured during centuries of isolation under various Islamic polities. Mozarabs from different frontier cities who were resettled in Toledo after Alfonso took over were reported to be unenthusiastic concerning the prospect, and these appear to have been "obliged to do so by force," as Gonzálvez recounts.[9] The Mozarabs' investment in the dhimma under which they had lived, and their understanding of the extent to which their collective identity was part of the social system

it engendered—the autonomy the Islamic city offered individual groups—was something fueros attempted to recreate in Castilian Toledo. But Alfonso would ultimately sacrifice the Mozarabs' ecclesiastical autonomy to papal approbation. This betrayal began with a mosque and a cathedral.

The pact agreed on by the Muslims of Toledo and Alfonso in 1085 had included the stipulation that the city's principal mosque would remain in the hands of the Muslim community, dedicated to Muslim worship. But less than two years after the transfer of power, the mosque was seized and converted to a cathedral, its central position in the city appropriated by the new archbishop of Toledo, the Cluniac Bernard of Sedirac, former abbot of Sahagún, and before that, confidant of Abbot Hugh of Cluny. Some sources maintain that the seizure took place unbeknownst to the king, while he was away, part of the designs of his Burgundian queen, Constance, and Bernard, who had already supplanted the Mozarabs' own bishop. Since Constance was the niece of Abbot Hugh, the supposition is tempting, but unlikely.

The appropriation of the mosque was not part of Alfonso VI's original conciliatory agenda, and it upset his goal of stabilizing and retaining as much of the remaining Muslim population of Toledo as possible, and of calming the fears of his other Taifa clients, who teetered dangerously on the edge of alliances with the Almoravid empire of North Africa. But Alfonso, who would soon make a stand against Almoravid troops, was surely party to the seizure of the mosque, and his absence and subsequent dismay was likely staged, as he struggled to remain the "emperor of the two religions" while appeasing Roman interests.

As it turned out, the conversion of the mosque was not only the symbolic replacement of Islam as the authoritative religion in Toledo; it was even more a statement of the authority of the Roman church over the Mozarabic church in this newly acquired land. For the creation of this new cathedral was in fact the decisive blow in the usurpation of the city's entire ecclesiastical hierarchy. Bernard of Sedirac had been given a bishopric that had been occupied for more than three hundred years by Mozarabs, who had, until 1085, presided over the survival of Christianity in Toledo while practicing the Mozarabic liturgy. It was Bernard who took the mosque into possession, built altars in it for mass, and installed bells to announce the new predominance of Christianity in this former Taifa city. After three centuries as faithful custodians of the ancient see of Toledo under successive Islamic governments, Mozarabic churchmen were thus deprived of what might have been their moment of glory, the restoration of the ancient Visigothic see of Toledo with the advent of Alfonso VI in 1085. The new episcopal seat would instead now be in the hands of the Frank Bernard, who promoted the Roman liturgy.

The conversion of the mosque to a new cathedral was not only lamented by the Muslims of Toledo but opposed by the Mozarabs, who understood the dangerous destabilization of this usurpation of the Muslims' promised rights. But far more anguishing for the Mozarabs was the understanding that this new cathedral would replace and disenfranchise their own, Santa María de Alficín, which had survived since Visigothic times. In the

endowment deed of the new mosque-turned-cathedral, Alfonso implied that the mosque had been built on the site of the ancient Visigothic cathedral of Saint Mary. But Linehan has shown that this assertion was a boldfaced betrayal of the Mozarabs, whose own cathedral of Saint Mary still functioned in the eastern heights of the city.[10] The foundation of the new cathedral was staged as a renewal of the Visigothic church, an act of triumph of Christianity over Islam, when in fact it was the evisceration of one Christian institution by another.

Alfonso boldly took the initiative to seize the prize he had bought in part with the sacrifice of Toledo's Mozarabs: he named Bernard archbishop of Toledo. Every kingdom needed an archbishopric, a city of high ecclesiastical authority to echo the power and dignity of the king in his realm. He sent Bernard to Rome to confirm the appointment after the fact, with a stop at Cluny to obtain the blessing of Abbot Hugh, whose council and alliance Alfonso leveraged in his tense balance of power with the pope. But what Alfonso sought and received in 1088 was much more than confirmation of Bernard's appointment. The new pope, Urban II, was far more of a realist than the ardent Gregory VII had ever been. Not only would Toledo now be restored to the ancient authority it had legendarily enjoyed in Visigothic times, but the new archbishop would also have authority over all Spain ("in totis Hispaniarum regnis," Pope Urban II conceded)[11] and over unconquered parts of the peninsula until their own bishoprics were restored. Here, indeed, was an ecclesiastical structure to match Alfonso's imperial ambitions; it carried the implication that Alfonso was more than the king of a handful of disparate polities; it suggested, instead, that he was the heir to the Visigoths, the emperor of Spain.

By 1099, with Alfonso's complicity, Toledo's Mozarabs were even deprived of their old cathedral as well. The church of Santa María de Alficín was taken from them, and given by Alfonso to the monastery of San Servando, which he had previously donated to the Roman church. Like San Servando, Santa María de Alficín would now be administered by the papal legate to Spain. The Mozarabs had been handed over to an institution regarded as far less conciliatory in the Romanization of the Mozarabic church than the Cluniacs, who were more moderate in their imposition of the reforms that had become the terms of Rome's only real authority over Castile. That legate was now the administrator of papal tough love over the ancient church of Santa María de Alficín. "The Mozarabs of Toledo," Linehan comments, "discovered that they had exchanged one set of alien rulers for another. The Muslims, who for centuries had permitted them to retain their distinctive customs, culture, and religion, had been replaced by new masters who within little more than a year were already threatening to deprive them of all three."[12]

It is intriguing to consider that Castilian culture might not, finally, have been forged in the battle between frontier Christians and urban Muslims, but rather in a struggle between multiple groups, most of whom were Christians, all of whom feared loss of distinctive cultural, economic, and political authority at each others' hands. The greatest threat to the survival of the Mozarabic Christians as a cultural force was the papacy, a power kings like Alfonso VI might on occasion harness in the quest to expand dominion,

but never quite control. The myth that Castilians were frontier warriors whose identity was shaped through battle against an exotic Muslim foe was the later spin, the ritual explanation, for an internal struggle among Christians.

<div style="text-align:center">✳</div>

Iberian Christian identity had, in fact, long been contested from within. At the turn of the millennium, more than three-quarters of a century before the Castilian conquest of Toledo, struggles for land, power, and souls between competing Christian institutions can be read in arts and architecture. The process began in the very years that the northern kingdoms took form, in the time of Alfonso VI's grandfather, Sancho the Great. One hundred and fifty years after the foundation of San Miguel de Escalada in 913, it was no longer possible to associate horseshoe-arched churches with the notion of opposition to Islam. A new architectural style was imported, and with it, a new political orientation for the kingdom of Sancho the Great. The new style, Romanesque, would come to express the authority of the Roman church. In the nascent northern kingdoms of the peninsula that style came to visualize the idea of a unified Christian Spain in concert with a host of other cultural practices. It was an idea politically attractive to rulers like Sancho—and, no less, to the Cluniac churchmen who became their allies, who in turn gave them a foot in the door into this lucrative new slice of Christian Europe.

On one level, the Cluniacs must have been attracted to the possibilities of the pilgrimage to the tomb of Saint James, at Santiago de Compostela, in the northwest corner of the peninsula. As part of Sancho's works of political and economic consolidation, he changed its route both to ease the passage of pilgrims from across the Pyrenees and to connect its social and economic stimuli to the center of his kingdom. Because Saint James was an apostle of Christ, the miraculous discovery of his body in eighth-century Spain had early attracted pilgrims from all of Europe. These were pilgrims who would otherwise have had to visit Rome or Jerusalem to find an "apostolic witness," a relic as powerful and as closely related to Christ. Like the contemporary economic euphoria surrounding the hosting of Olympic games, the eleventh-century pilgrimage had begun to promise an economic boon for the communities and monasteries that lined the road along which pilgrims passed.

Even more central to Sancho's strategy for redefining what it meant to be an Iberian Christian kingdom were direct ties with Cluny, first suggested in a correspondence with Abbot Odilo. Sancho's interest in Cluny was part of a larger plan to use monastic reform as a tool of political consolidation in his broad collective of Christian polities dotted with unruly monasteries. He would "Navarrize" San Millán de la Cogolla, giving it the bishoprics of Najera and Pamplona, in a concentration of favor and power meant to sweep it into royal control.[13] And he asked Odilo to send a Spanish monk from Cluny to be the new abbot at the monastery of San Juan de la Peña, and is thought to have invited Cluniac reform at the monasteries of Oña and Leyre, imposing the Benedictine rule, the monastic rule that had a particular association with the sovereignty of the Roman church. Sancho

cemented his relationship with Cluny by giving the monastery significant donations drawn from the tribute he had begun receiving from Taifa kingdoms.

And with reform came building. The Romanesque style, at first evident only through cut-stone masonry and Roman—semicircular—arches, would be the terms through which a competition with the indigenous and Mozarabic church would be visualized. Already in the early eleventh century, important alliances between the kings of the northern kingdoms and the Latin church—at first monks from the monasteries of Cluny—would begin to suggest that the indigenous church as represented by horseshoe-arched architecture was a renegade Spanish identity, an other to the universal church of Rome. At both monasteries reformed by Sancho, the new monastic rule was accompanied by a new building type. At San Millán de la Cogolla the horseshoe-arched church with its traditional wooden roof was restored under Sancho by the addition of a Romanesque round-arched stone arcade and vaulted nave. The meaning of the change in style is made clear by the way the early, horseshoe-arched arcade is subsumed by the Romanesque one: it redirects the nave of the church slightly to the north, following the site's mountainous topography, and so gives the impression that the Romanesque addition sets a new course for the basilica. A very similar restoration occurred at the monastery of San Juan de la Peña, which had been reformed with the help and presence of Cluniac monks. Here a horseshoe-arched nave is also extended by two vaulted Romanesque bays, and here again the rupture between the original and the addition. What is interesting is not only the change in styles introduced by Sancho but, as Janice Mann points out, the fact that "little effort was made to harmonize" the demonstrably different arcades, which link "the vital new order of his kingdom with the venerable past."[14]

The building campaigns of Sancho the Great would begin the process of staging a new identity for the horseshoe-arched arcade, transforming the way those traditional forms were read by society. Whatever his attempt to link with the past as he effected change, Sancho introduced the notion that those horseshoe-arched arcades throughout the kingdoms of the north, like the Mozarabic liturgies, represented an old order. And, though the old order was politically useful to him, evoking, as Mann has noted, the Visigothic past, it was targeted for obsolescence by reforming churchmen. Next to Romanesque arcades, the horseshoe-arched arcade and the basilica type it accompanied appeared too insular and too ambivalent, no matter how consciously resistant to Umayyad culture it had seemed a century before at Escalada. The importance of Escalada's message about the Visigothic past was unreadable to the Franks who made their way to Spain as papal legates, or as early Cluniacs. In fact, as late as 1074, during the reign of Alfonso VI, Pope Gregory VII would write a version of Spanish history that would show him oblivious to the Castilian kings' historical and ideological attachment to the Visigoths.[15]

But however canonical Romanesque forms seemed, bereft as they were of exotic architectural formulas, the political reality behind them was not cleansed of cultural ambivalence. In the eleventh century, with the Umayyad caliphate gone, the Taifa states were neither monolithic nor powerful militarily, and they fought as often with one another

as with the growing Christian kingdoms. The Taifas' vulnerability not only filled Sancho's coffers with tribute but also promoted a vast complexity of alliances and rivalries not dictated by religious polarity. It might be useful to imagine that Sancho was constructing an identity, not in defiance of Islam, but in opposition to contemporaries like Count Sancho García of Castile, who aided Berber allies in installing Sulayman, a great-grandson of Abd al-Rahman III, on the throne in Cordoba in 1010, during the death throes of the caliphate. Sancho García was known to favor Islamic dress, and to receive audiences while he reclined on cushions, wearing Arab robes. The complexity, the messiness of Iberian architectural identity, might be seen as analogous to that kind of cultural ambivalence, an untidiness the Franks were eager to mask. Already in the first years of the eleventh century, it would seem to slip into hiding soon after Sancho the Great, behind a wall of ashlar masonry. Like an elaborate set for a ritual purification, his identity would be linked to the fate of the papacy and to Cluny with an arcade of Roman arches.

The heirs of Sancho the Great persisted in promoting Romanesque style in tandem with the reforms of the Latin church in Spain. In Aragon, Ramiro I began the Romanesque cathedral of Jaca, a monumental cut-stone basilica with Roman arches and wildly inventive figural sculpture. And his son, Sancho Ramírez, would use the dome and exaggerated profile of a Romanesque church to proclaim the presence of Christianity at the frontier castle of Loarre.[16] This was an architectural gesture that surely was meant to embody his extraordinary act of making Aragon a feudal client of the Holy See, and to express a confrontation with Islam echoed by his participation in the ill-fated "crusade of Barbastro," to which we shall return.

Sancho the Great's son Ferdinand I joined his inheritance, Castile, with that of his bride, Queen Sancha of León. They continued the process of harnessing Cluniac alliances, but without accepting the feudal relationship to which Ferdinand's Aragonese nephew would submit himself. And they concentrated their patronage in a monumental capital in León, where they built a small church to receive the relics of Saint Isidore, sent by Ferdinand's feudal client, King al-Mutadid of Seville. Under Ferdinand's daughter Urraca, as John Williams has demonstrated, a western portico would be added to that church, constructed of cut stone with robust Roman arches and sculpted figural capitals. Romanesque, then, would be the style of the new kingdom of Castile and León, as well.[17]

As Castile became the most important of the northern dynasties, links to Cluny were strengthened by Alfonso VI. Only two years after recovering his rule at the death of his brother in 1072, Alfonso presided over a portentous council in Santiago de Compostela, one that would have the twin effects of establishing Gregorian reforms on the peninsula (in particular the imposition of the Roman liturgy) and initiating a great new Romanesque church over the tomb of Saint James. The council's declaration that its goal was "the restoration of the faith of the church" clearly bound the act of imposing the Roman liturgy on the peninsula with the act of a new building, in this particular style. Bernard Reilly suggests that at this time Alfonso made a lavish gift intended to finance the construction of the new cathedral, part of the thirty thousand gold dinars he had received in tribute from

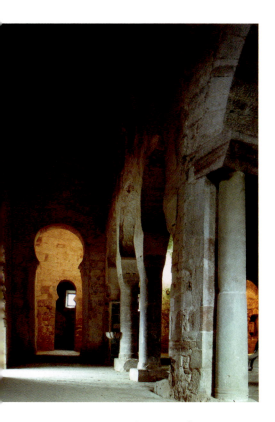

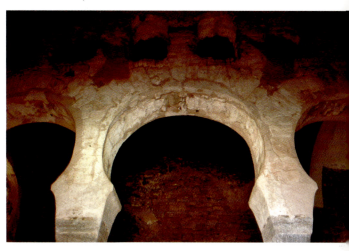

Church of San Millán de la Cogolla. The pier at the right marks the change from the 10th-century horseshoe-arched church to the early 11th-century Romanesque addition.

Church of San Millán de la Cogolla, horseshoe arch from the 10th century.

King Abd Allah of Granada.[18] Here in Santiago, which would become, ten years before the taking of Toledo, Spain's de facto primatial see, an enormous Romanesque church was begun. When it was completed, it would be an immense three-aisled basilica with nine towers, its barrel vault a breathless sixty-eight feet. The cathedral of Santiago would be both a celebration of a site that was the culmination of the pilgrimage roads and a grand statement about Santiago's place in a monarchy that had not yet obtained Toledo. Santiago shares immense size, ingenious circulation, and expressive, figural sculptural styles with a number of near-contemporary churches in France, but it initiated developments as well, inspiring architecture and sculpture in France as often as it received inspiration, over decades of different building campaigns.

Here we see Romanesque architecture—the style associated in Spain with church reform and the wider dominion of the church—as a statement of Alfonso's commitment to Roman reform. Indeed, Alfonso's only contemporary portrait is found on a capital of one the columns of the chapel of San Salvador, in the bits of the east end that composed the first completed parts of the new cathedral. Hardly a likeness, Alfonso appears as a frontal iconic image bearing a banner with the inscription that dates the beginning of the construction of Santiago to his reign: REGNANTE PRINCIPE ADEFONSO CONSTRUCTUM OPUS [This work was constructed by the reigning king Alfonso]. He seems to be presented to the viewer by two enormous angels who dwarf him in scale, steadying the king, each with a hand on his shoulder while they receive the weight of the world on the capital's corners. Santiago's bishop Peláez appears in a near-identical composition, balancing

Castle of Loarre, late 11th century. The dome of the church can be seen rising above the walls of the fortress.

church and state in the delicate work of construction and reform.

The Great Council of Santiago was one step in Alfonso's uneasy dance with Pope Gregory VII, who was intent on establishing authority in this rapidly expanding frontier, with their new lands and riches. Following the efforts of his predecessor Alexander II, Gregory had tried more than once to mount a crusade in Spain, with the hope of gaining temporal as well as spiritual power there. In a 1073 letter to "all the princes wishing to go to Spain," he wrote, "the kingdom of Spain belonged in ancient times to St. Peter and, though occupied for a long time by the pagans, since the law of justice has not been set aside it belongs even now to no mortal, but solely to the apostolic See."[19] It was clearly not merely conversion or dominion over the too-long independent Mozarabic church that Gregory VII had at first sought; it was a foot in the door, sovereignty over lands that had not been in Christian hands for three hundred years. He had been encouraged in his expectations by Alfonso's cousin, Sancho Ramírez I, king of Aragon, who went to Rome, and who had submitted himself later as a vassal of the chair of Saint Peter.

The Council of Santiago occurred as Alfonso VI himself began to confront Gregory VII's crusading aspirations. Alfonso was not about to rule new lands as a vassal of the pope, although he knew he was not in a position to openly defy the papacy. Instead he calculated just what it was he was willing to concede to the pope, while the pope calcu-

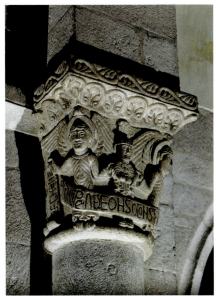

Cathedral of Santiago de Compostela, interior, 11th–13th centuries.

Santiago de Compostela, capital with Alfonso VI between two angels, last quarter of the 11th century.

lated how his authority might practically be felt in Castile, where the monarch was less acquiescent than in Aragon. Alfonso's military power and his own agile diplomacy would result in reduced expectations for Gregory. Observance of the Roman office in Spain became the terms in which Roman authority would be acted out on Castilian soil.

But even that was difficult. The king still revealed a reticence to deliver the entire Spanish ecclesiastical structure over to papal control, pleading for a delay in the adoption of the Roman rite in León and Castile. Spanish bishops who had promised the pope to impose the liturgy found more resistance, and less will for change, than they had anticipated. Alfonso himself was hard pressed to bring the autonomy and diversity of his native monastic and ecclesiastical establishments under the yoke of the Roman church. He complained bitterly to Abbot Hugh in 1077 that "our realm is wholly desolated on account of the Roman office which, on your command, we accepted."[20] The *Crónica najerense* recounts that on April 9 of that same year Alfonso submitted the two liturgies—Roman and Toledan, or Mozarabic—to a trial by fire, with the idea of justifying the reform he would inevitably be obliged to put into place. "But when the Toledan liturgy took a great leap out of the flames, the angry king kicked it back into the fire, saying: 'Let the horns of the laws bend to the will of kings.'"[21] Impertinent and mythic, the tale underlines the frustrations that faced Alfonso and bishops who attempted to impose Roman rule, and its

Santiago Matamoros

Saint James the Greater, son of Zebedee, was one of the apostles of Christ. There is no biblical record of his ever having been to the Iberian Peninsula, but a lively local tradition attests to his having preached in Caesaraugusta—the Roman town that would become Saragossa—before returning to Judea to be decapitated by Herod in 44 CE. From Judea James's body was said to have been transported to the western coast of the Iberian Peninsula, where a hermit discovered it amid bright lights and the singing of angels. There it would be venerated in the shrine that came to be known as Santiago de Compostela (Saint James of the Field of Stars, *campus stellae*, but more likely from *compostum*, suggesting an association with a cemetery). Because Saint James was an apostle of Christ, his shrine at Santiago de Compostela would become a powerful draw for pilgrims from throughout Europe. The road to Santiago was a powerful socioeconomic force, and one of the principle avenues through which an exchange of culture occurred across the Pyrenees. And the apostle Saint James was finally so associated with his Galician shrine that he would often appear in painting and sculpture as a pilgrim himself. In these images, he wears a traveler's cloak and hat, and carries the staff and the scallop shell that marked pilgrims to Santiago, who would gather shells as souvenirs of their voyage to the edge of the Atlantic.

Saint James was eventually recruited to serve medieval political goals as well. Although the biblical Saint James would die more than five centuries before the birth of Muhammad, he appears in the arts of medieval Spain as "Santiago Matamoros," Saint James the slayer of Moors, astride a white charger with the supine bodies of Muslims beneath his horse's hooves. In his *De rebus Hispaniae*, Toledo's archbishop Rodrigo Jiménez de Rada recounted the legend of Saint James's bellicose persona in the time of Ramiro I, king of Asturias (842–850):

And so the Saracens moved against (Ramiro) with infinite troops. The army of King Ramiro, for its part, . . . took refuge in a fortified place called Clavijo. And since Ramiro was unsure the night before the battle, Saint James appeared to him, and encouraged him that he could be sure of his victory, and should confront the Arabs the next day. At first light of day he told the bishops and magnates about his vision; giving thanks to God, they quickly rallied together to battle, comforted by the promise of the apostle. But on the other side the Saracens, too, joined the combat confident because of their superior numbers. But, once the battle had begun, the Saracens, shaken and disconcerted, turned their backs to the swords of the Christians, so that almost seventy thousand of them died. They say that in this battle, Saint James appeared on a white horse, waving a white pendant.

In the end, it was not Ramiro at all who fought at Clavijo but Ordoño I, and the earliest account of the battle is likely a forgery of the twelfth century. Nevertheless, from that era on, Santiago Matamoros would become something very close to the militant patron saint of the empire, "the natural enemy or supernatural Nemesis of Islam," in the words of Francisco Márquez Villanueva. Thus Saint James, the Iberian Peninsula's apostolic witness, is galvanized with contemporary crusading politics. The image of the "Moorslayer" on a valiant horse would eventually become a linchpin for Catholic Iberian identity, and it would influence representations of the Cid and Fernán González, as these Castilian heroes were reimagined in the crusaderlike image of Santiago Matamoros.

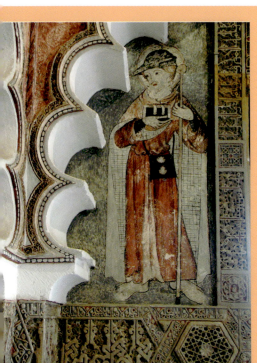

clockwise from top left:

Saint James as a pilgrim, monastery of Santa Clara in Tordesillas, 14th century.

Saint James as Santiago the Moorslayer, church of Santiago de Compostela, 12th century.

Juan Vallejo, Saint James as Santiago the Moorslayer, cathedral of Burgos, chapel of Santiago, 16th century.

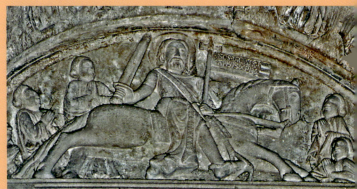

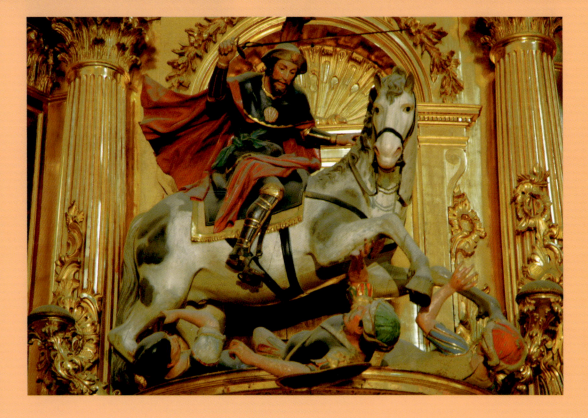

"Mozarabic" antiphonary, from the monastery of San Juan de la Peña, c. 1000. Biblioteca Universitaria de Zaragoza. This antiphonary also has musical notation. It is part of the "Mozarabic," or Visigothic, or Hispanic liturgy, which was replaced with the Roman liturgy at San Juan de la Peña in 1071. It is written in Latin in Visigothic minuscule text, and the illuminated figure is linear and calligraphic, repeating some of the patterns of the script itself.

"Roman" antiphonary, from the monastery of San Millán de la Cogolla, c. 1200. Real Academia de la Historia, Madrid. This page also has musical notation, but it is part of the Roman mass and is written in the more easily deciphered Carolingian minuscule. The illuminated initial of a human and a serpent intertwining is typically Romanesque with solid but edgy expressive forms that are bound within a frame yet transgress its borders.

Images from the exhibition catalog *Edad de un reyno*.

survival celebrates the strength of the indigenous church's resistance to Roman reform, and slyly suggests Alfonso's cynicism in complying with papal demands.

Abbot Hugh and Cluny's legion of brethren eager to be the advisors of kings were key intermediaries who guided Alfonso's diplomacy along the perilous frontier that separated errant emperor from papal pawn. As early in his reign as 1077, Alfonso doubled his subsidy to the monastery of Cluny, an annuity financed by the tribute he received from the Taifa of Toledo. Alfonso, in Reilly's words, could "appreciate that French abbots and French bishops could be turned to peculiarly royal purposes since they had no family ties to the magnate houses of his realm and he and his dynasty were major patrons of the mother house itself."[22] It was a Cluniac, Robert, whom Alfonso placed in the abbacy of his new royal monastery of Sahagún, and a niece of Abbot Hugh, Constance,

whom he married at the death of his wife Agnes of Aquitaine. The Cluniacs to whom he turned in Castile understood the difficulties in imposing the Roman rite by force. Robert in fact seems to have slowed the process, becoming a "champion of the Mozarabic cause"[23] and invoking the ire of the papacy.

In 1080, Alfonso joined a council of Castilian bishops and abbots in definitively adopting the new Roman rite in all his lands. By extending the ecclesiastical and monastic power of Rome, Alfonso was able to forestall the papacy's attempt to establish a feudal relationship between Rome and Castile. In the erasure of Mozarabic culture, the pope had his consolation prize. Liturgical and ecclesiastical reform—the "restoration of the faith of the church" that was the theme of the Santiago council—would culminate, in the decades that followed, in the usurpation of the Mozarabs' authority over the church of Toledo. And Alfonso codified this position by declaring himself *imperator totius Hispaniae*, emperor of all the Spains, a title Gregory VII finally would not challenge.

$$*$$

But Gregory had hoped for something very different. Pope Gregory VII, and Alexander II before him, had swathed desire for the conquest of Islamic cities with the idea of crusade, a holy war sanctioned by the pope, in which the remission of sins was offered to those who fought against an enemy of the church. The linking of the universal idea of crusade with the local territorial idea of reconquest would constitute a significant part of the Latin church's contribution to Castilian politics of the next few centuries. Though the Castilians paid lip service to the idea that Umayyad or Taifa lands were theirs by right, Ferdinand I and Alfonso VI were far more concerned with exacting lucrative tribute and useful alliances—including military assistance—from the Taifas than on cleansing and colonization. The word "reconquest" was not yet employed in Spain, even in the eleventh century, though it was used in France before it surfaced in Spanish documents. Interlocking ideological tools capable of arousing armies and justifying bloodshed and the usurpation of land, these twin ideas of crusade and reconquest linked by the papacy became part of the dance between Spanish ruler and Roman pontiff for another four hundred years.

And others were drawn into the mix as well, prominent among them the Franks, hungry for the unencumbered lands and spoils enveloped in sanctity and indulgences that crusade offered up. In 1064, Pope Alexander II, in concert with a large contingent of the nobility from both Normandy and the southern French kingdoms of Aquitaine, Poitiers, and Gascony, promoted a crusade to the city of Barbastro in the kingdom of Saragossa. A large army led by William of Montreuil, a mercenary in the service of the pope (and known as "Le Bon Normand") besieged the city in the name of the pope for forty days with the help of Aragonese and Catalan troops, including Alfonso's cousin Sancho Ramírez I.

Upon taking the city, the conduct of these foreign soldiers would stand in stark contrast to Alfonso VI's in taking Toledo: William's forces promised the city's Muslim inhabitants safe conduct, only to slaughter them as they left the city, raping Muslim women and selling the young as slaves. Joseph O'Callaghan points out that the massacre of Barbastro

"exemplified the difference in the attitudes of those Christians who had continual contact with Muslims and those who did not. The zeal and fanaticism displayed by the latter contrasted sharply with the comparative tolerance of the former."[24] The victors glutted themselves in the city with luxuries and refinements unknown to them in the north, until al-Muqtadir, the same king of Saragossa who would one day employ the Cid as a leader for his own troops, recovered it within the year.

Even the papacy's disastrous crusade of Barbastro, though hostile to any understanding of the Aragonese Muslims as a people or a culture, could not help but have an impact on the life of the mind of Europe. The much-recounted 1064 "crusade" also speaks in unusual detail to the attractions of the powerful song culture of the Taifa world, and the long Arabic traditions of poetry and singing behind it. We are left with detailed narratives by two major contemporary, eleventh-century chroniclers of the events of Barbastro, one the Cordoban historian Ibn Hayyan, a Muslim, the other the Christian Amatus of Monte Cassino, a historian of the Norman expansions of the same years. These together paint a

The Crown of Aragon

During key periods in the formation of Castile, the Crown of Aragon was its major Christian rival and competitor, at times its closest ally and at others its fiercest enemy. Dominating the Mediterranean coast of the peninsula, the kingdom had its roots in the historic unity of the region. The eastern-flowing Ebro River cut a swath through the region and acted as a conduit for people and ideas that connected the inland hills of modern-day Navarre, Catalonia, and Aragon to the Mediterranean. The river joined these disparate areas into a geographic entity with a fairly consistent culture as early as the Roman period. Under the Muslims, the territory was known as al-Thaghr al-Aqsa, or the "Furthest March."

The areas that would become Aragon and Catalonia began as administrative divisions under the early caliphate. As a Christian county, Aragon began to take form in the ninth century, at roughly the same time that Catalonia—the eastern territory that would eventually become part of Aragon—passed from Umayyad into Carolingian hands. At the turn of the millennium, the counts of Aragon and those of Barcelona were vassals of Sancho the Great, part of his ephemeral, unified northern kingdom. At his death in the eleventh century, Aragon would be transformed: Sancho the Great distributed

his realms, making each into a kingdom to bequeath to his sons. Thus Aragon would emerge as a major player among the Christian kingdoms at the same time, and in the same way, as Castile.

In the second half of the eleventh century the young kingdom of Aragon developed a rivalry with the kingdom of Saragossa, the splendid northernmost Taifa with which it shared a border. King al-Muqtadir (1046–1081) would offer tribute to Ferdinand I of Castile to protect himself from the Aragonese, and thus initiate a dance of changing alliances—between Aragon, Castile, and an indentured Islamic kingdom—that would replay for years to come. Alfonso I the Battler (1104–1134) would capture the Taifa of Saragossa, and make it part of Aragon, opening the way for a vast kingdom.

But the Aragonese princes would, in the end, show more taste for papal alliances and crusades than the Castilian monarchs: Sancho Ramírez I of Aragon would visit Rome in 1068 and commend himself to the pope as a vassal of Saint Peter, after participating in the crusade of Barbastro. His son Alfonso I the Battler, whose tempestuous marriage with Queen Urraca of Castile would be annulled, was by all accounts a pious and earnest crusader, who would unsuccessfully attempt to leave the entire kingdom to monastic military orders at his

vivid picture of the ways this attempted crusade was unwittingly instrumental in creating a dynamic new culture of interaction in Aquitaine.

Among the military leaders of the various troops fighting under papal banners was William VIII of Aquitaine (as well as of Poitiers and of Gascony). His troops were among those decamping Barbastro almost immediately, carrying with them as much as they could. Perhaps the greatest prize they hauled back across the Pyrenees with them was an extraordinary number of qiyan, enslaved women who sang for a living, young and attractive and very well-trained entertainers. Prized in the Taifa courts, and already a presence in the Christian courts of the peninsula—Sancho García of Castile, for example, had received gifts of such performers from the Umayyads—these women, with their repertoires of hundreds (some sources say thousands) of songs, transformed the culture of poetry and music in Aquitaine, and thus eventually much of Europe. They introduced songs that echoed the styles of Taifa poets like Ibn Zaydun, songs of yearning, ambivalence, and unrequited love that would be the source of a whole culture of courtly love; and their

death. And Peter II (1196–1213), who joined Alfonso VIII of Castile in the crusade of Las Navas de Tolosa, would die defending the interests of the church in the Albigensian crusade.

The combined territories of Catalonia and Aragon became a united kingdom in 1137 with the betrothal of Petronilla of Aragon and Ramón Berenguer IV of Barcelona. Their descendants would govern until 1410 as counts in Barcelona and as kings in Aragon. Aragon had become a trans-Pyreneean kingdom, often including lands on the other side of the mountain range, alternately fighting with and making alliances with Frankish kingdoms to the north, Castilians to the west and south, and Islamic kingdoms even farther south. At various times during the kingdom's history, it expanded, through marriage or conquest, to include Sardinia, Sicily, the Balearic Islands, Roussillon, Provence, Montpellier, Naples, Athens, and parts of Tunisia. Castile and Aragon alternated wars and alliances, as James I of Aragon made Majorca part of his kingdom, and conquered Valencia after taking crusaders' vows, and his son Peter III (r. 1276–1285) would conquer Sicily. It was a powerful federative state of Aragon that faced Peter I of Castile in the fourteenth century, and the Castilian Trastámaras who followed. After the heirless death of the last of

Ramón Berenguer and Petronilla's line, rule passed to Ferdinand of Antequera of the Trastámara family. Ferdinand the Catholic, Ferdinand of Antequera's descendant, would officially unite Castile and Aragon by marrying Isabella of Castile in 1469.

Aragon's three major cities—Barcelona, Saragossa, and Valencia—differed considerably in the makeup of their populations and languages, as well as in their cityscapes and histories. While Barcelona was officially the capital of the whole of the Crown, the rival cities within the kingdom long retained their distinctive heritage and influence, as well as considerable autonomy. Saragossa, capital of the Taifa of the Banu Hud, first passed to Christian leadership in 1118 under Alfonso I of Aragon, and was then held as Castilian territory from 1134 to 1162. When it came back to Aragonese control, Saragossa became one of the Crown's most important cities, serving as the location of the cortes, where kings were crowned. Saragossa's palaces, the Aljafería, which were first built by the Banu Hud during Taifa years, remained the palaces of their new rulers and informed the aesthetic of Christian court architecture and decoration.

sophisticated cultivation of the performance of such songs became as central to the rites of poetry as musicians, and their instruments, and the lyrics themselves, which were in every sense not just interpreted but translated by them. Thus the qiyan, slaves and trophies of war, created an appetite in the courts of nearby Aquitaine for the Arabic love songs that were at their height in al-Andalus at the moment of the brutal crusade. They brought both the bilingual *muwashshahat*, the popular songs that joined Arabic and Romance, and those in classical Arabic, as seductive a treasure as any of the sumptuous material trappings that left these eleventh-century Franks astonished at the wonders of the Taifa world, so utterly different from their own.

On the other side of the failed crusade, the cosmopolitanism and the varieties of prosperity of the Taifa world are truly revealed, and transformative. As would soon enough be true for the crusades proper, in the Holy Land, military aggression and ideological stridency led to a certain intimacy, and from that, desire and miscegenation. Along with the acquisition of hundreds, perhaps thousands, of nubile female performers of both the popular and the canonical songs of the Hispano-Arabic tradition, the chroniclers of Barbastro leave us further vivid testimony of the allure and power of Arabic culture as a whole. What is extraordinary is how little formal translation it took for the qiyan to become a part of the world of Christians from far beyond the precincts of bilingual and multiconfessional Spain, the world of the Normans and the Aquitainians.

Among the stories told by the contemporary chroniclers is that of the Jewish merchant from Barbastro, friend of one of the city's thousands of Muslims who had fled after the forty-day siege, when the cruel terms of surrender had forced the men to leave their wives and children behind, as part of the households then ransacked, and raped, by the Franks. This Jew was commissioned by his wealthy friend—apparently the Muslim in question was one of the former commanders of the fort—to enter Christian-held Barbastro and go to his former dwelling, to try to ransom his daughters. But the scene the intermediary discovered astonished him: the Christian who had taken over his friend's household was one of the leaders of the papal forces, and there he was, mere months after the brutal slaughter of so many of Barbastro's inhabitants, sitting on the floor in Arab robes, enjoying a meal of local foods, chatting in pidgin Arabic with the members of the household who had stayed behind, including the women, one of whom he appeared to have taken as a wife. The after-dinner entertainment was, of course, singing by the girls of the household, a performance that moved the Frank first to tears, and then to informing the envoy that no fortune would be great enough to induce him to give up these pleasures he now enjoyed.

After Barbastro the qiyan became a significant presence in the courts of southern France where, among other monumental events, the influential first troubadour, William IX of Aquitaine, was born. The son of William VIII, one of Barbastro's leaders, was born in 1071—the year after Ibn Zaydun died in Seville. William IX was thus born into, and himself cultivated, a distinctly

Pillow cover of Queen Berenguela. This pillow, fashioned from an Almohad textile of crimson silk, belonged to Berenguela, a capable and powerful diplomat who was the daughter of Alfonso VIII and Eleanor of England. In the pillow's center is a rondel in which two qiyan dance and play musical instruments. One makes a gesture that suggests singing. A band around the medallion bears the Arabic inscription "There is no deity but God."

post-Barbastro world, out of which he emerged to be enshrined as the first poet of the European lyric tradition, the first lyricist audacious and self-assured enough to use the vernacular rather than Latin as a language of cultural prestige. Long emblematic of the early twelfth-century rise of this revolutionary European literary culture is a new love lyric—once referred to as that of "courtly love." Thanks to Barbastro, William's life began in courts intimate with the sounds—the rhythms and rhymes, the tempos and at least some of the images—of Arabic singing. These songs, in turn, like music in other peak

William of Aquitaine

Ab la dolchor del temps novel
foillo li bosc, e li aucel
chanton, chascus en lor lati,
segon lo vers del novel chan:
adonc esta ben c'om s'aisi
d'acho dont hom a plus talan.

With the sweetness of the new season
woods fill with leaves and the birds sing
each of them in its own tongue (en lor lati)
set to the verse of a new song,
then is the time a man should bring
himself to where his heart has gone.

De lai don plus m'es bon e bel
no vei mesager ni sagel,
per que mos cors non dorm ni ri
ni no m'aus traire adenan,
tro qu'eu sacha ben de la fi,
s'el'es aissi come u deman.

From my best and fairest to me
no messenger nor seal I see
so my heart neither laughs nor sleeps
nor do I dare take further steps
until I know that we agree
it is as I want it to be.

La nostr'amor va enaissi
com la trancha de l'albespi,
qu'esta sobre l'arbr'en creman,
la nuoit, ab la ploi'ez al gel,
tro l'endeman, quel sols s'espan
per la fueilla vert el ramel.

The way this love of ours goes on
is like the branch of the hawthorn
that keeps trembling upon the tree
in the night in the rain and ice
until the sun comes and the day
spreads through the green leaves and branches.

Enquer me menbra d'un mati
que nos fezem de guerra fi
e que'm donet un don tan gran;
sa drudari'e son anel.
Enquer me lais Dieus viure tan
qu'aia mas mans soz son mantel!

I can still recall one morning
when we put an end to warring
and how great was the gift she then
gave me: her love and her ring.
God, just let me live to getting
my hand under her cloak again!

Qu'eu non ai soing d'estraing lati
que'm parta de mon Bon Vezi;
qu'eu sai de paraulas com van,
ab un breu sermon que s'espel:
que tal se van d'amor gaban,
nos n'avem la pessa el coutel.

What do I care for the strange way
they talk to keep my love away?
I know how words are, how they go
everywhere, one hint is enough.
They talk of love, what do they know?
We have the morsel and the knife.
Trans. W. S. Merwin

moments—one need only think of American jazz when it became chic in Paris, or rock when it spread beyond Anglophone shores—came embedded in an intricate network of style: musical instruments, the clothes of the performers, the intellectual life and luxury goods that came from the same world.

The world of love songs and their singers was an ephemeral and yet solid building block of what would be the famous "courtliness" and high secular culture of William's generation, and of the twelfth century. William fit well into the complex world that had long characterized Iberia, and that the Castilians were intent on preserving, after Toledo became the heart of their dominion. But then, Aquitaine was not so far from Toledo after all. William's half sister, Ines, was one of Alfonso VI's six wives, and the second of William's own four wives was Philippa, the young widow of Sancho I of Aragon. But family ties are only the beginning: William had fought for the pope in the First Crusade but he was also excommunicated by the pope for an infamous extramarital affair. And even more contradictory to the rhetoric of crusade, he was a friend and ally of the king of Saragossa, Imad al-Dawla, who was among the Muslims who fought with the Aragonese against the Almoravids. Indeed, the historian George Beech has established that it was this memorable

Eleanor vase. Late antique or Sassanian with later additions. Its inscription reads: "As a bride, Eleanor gave this vase to King Louis, Mitadolus to her grandfather, the King to me, and Suger to the Saints."

Saragossan king who presented William with a vase of luminous honeycombed rock crystal. This vase then made a pilgrimage much like that of the qiyans' songs. It was given by William to his son, who in turn passed it on to his daughter, Eleanor: the heiress of Aquitaine who would sweep its cosmopolitan culture before her as she became queen first of France and later of England. The "Eleanor vase," as it came to be known, passed in turn into the hands of Abbot Suger, who made it an essential part of his new Gothic vision of the French monarchy at the abbey of Saint-Denis. The gift from William's Saragossan ally is thus a precious object in the French patrimony. It is emblematic of the less visible dowry Eleanor took with her to the courts of both her husbands, Louis VII of France and Henry II of England: that taste for vernacular love songs inherited from her grandfather.

The vase is also a tangible memento of the complexity of relations between Christians and Muslims, even beyond that body of love songs that William first launched in Occitan,

the vernacular of the south, popularly known as Provençal. This history stands in stark contrast to the *Song of Roland*, which presents a cartoonish opposition between "Christians and Pagans," as the poem has it. But the Roland is only one poem in a much larger canon, part of the copious literary history of the eleventh and the twelfth centuries, when the great northern French epic and romance traditions were being crafted in the shadow of the crusades. And in much of that literature the engagement with the "Saracen" world is richly complicated by evocations of the much-coveted material universe of al-Andalus and other Islamic worlds of the Mediterranean. Ambivalence and desire toward this same world emerge in the shape of love matches and even marriages across divides that were revealed to be remarkably porous, sometimes loving: Cligès and Fenice, Jaufre Rudel and his "faraway love" in Tripoli, Aucassin and Nicolette, Floire and Blanchefleur. William and others like him were part of a world in which religion was not the gatekeeper of intimacy. A crusader like William, a mercenary like the Cid, and a Castilian king like Alfonso could fight either alongside or against Muslim kings and armies. And the material and intellectual and musical cultures that were the distinct commodities of an Islamic society could be transformed into part of the Christian world, with little more than the wave of a hand.

✳

Unlike the hapless and short-lived victors of Barbastro, Alfonso ruled Toledo as a place both different and familiar, its peoples both submitted and tolerated. He would eventually have six wives whose diversity reminds us of his ability to survive in a high-stakes contest with powerful competing interests. Among them was Ines, half sister of the crusader and troubadour William; another was the formidable Burgundian Constance, niece of Hugh of Cluny and reportedly a promoter of liturgical reform. But he also had, the *Chronicon Regnum Legionense* tells us, "two concubines, although they were most noble."[25] The second of these was Princess Zaida, former daughter-in-law of al-Mutamid of Seville, who would become Alfonso's favorite, and his wife, after she bore his only male heir. Recalling Ruggles's recreation of the world of the Navarrese concubines of the Umayyads, we ask, in which language did Zaida sing lullabies to the young Castilian prince?

And then there is the cathedral in which one would worship in Toledo in 1087, the place wrested from Toledo's Muslims by Archbishop Bernard. The cathedral of Toledo in the eleventh and twelfth centuries, the center of Christian Toledo and the site of church authority, was the physical structure that had been the city's principal mosque. The irony was not lost on later Muslims: centuries later, al-Maqqari would recount that, when the Christians came to take the building to consecrate it as a cathedral, a pious *faqih*, a jurist, was praying. He is remembered as having completed his prostration, eyes filled with tears, before a respectful and silent crowd of "awaiting Christians." Those "awaiting Christians" were the eleventh-century Toledans, who attended mass in that forest of columns and arches, the eleven aisles of arcades of horseshoe arches, some perhaps scalloped and covered with Arabic inscriptions like the fragments of Taifa Toledo that survive. It would be

more than a century and a half before this hypostyle hall was replaced by the Gothic cathedral that dominates Toledo today. The reuse of the broad columned prayer hall of Toledo's principal mosque to serve as the city's cathedral would affect how three generations of Toledans, people born and educated in the Castilian frontier city, would conceive of the idea of a church, a cathedral. The conversion of the mosque would, in the end, transform them all.

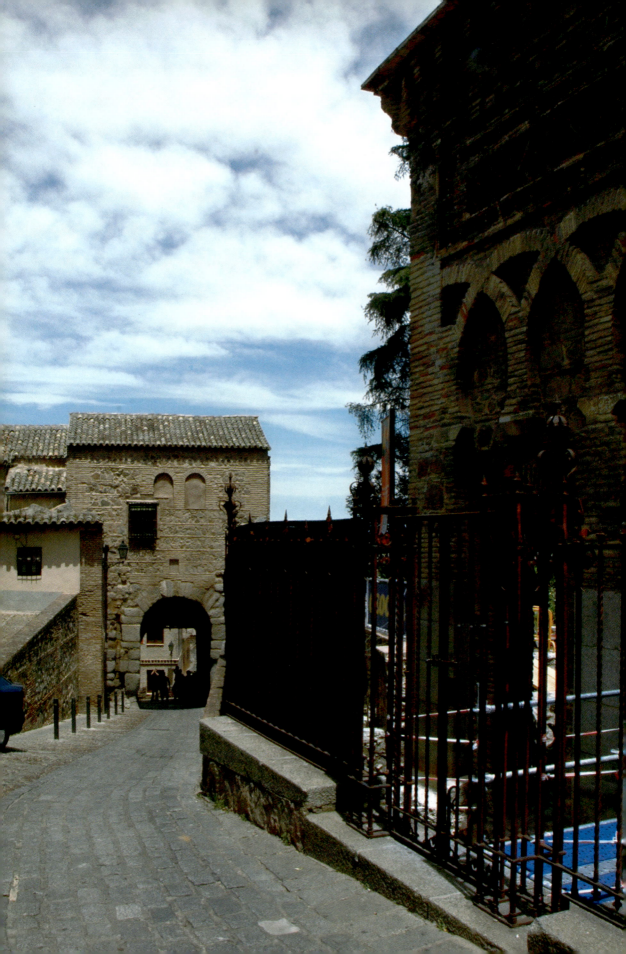

CHAPTER FOUR

Union

اشترى الارسربشت دون بيطره بن مقيال... الامام بمدينة طلبيرة في كنيسة شنتة مرية بها من
الارسديقن دون دمنغه غنصالبه ومن دون اندراش بن عبد الله... ومن دون طومي شطرنين اوصيا
الارسبرشت دون نقولاش الذي كان من آئمة قاعدة شنتة مرية بطليطلة حرسها الله وهم البايعون عن
انفسهم وعن الارسديقن دون غنصالبه الوصي معهم ايضاعلى انفاذ عهد الارسبرشت دون نقولاش
المذكور جميع الدار والاصطبل الذي قبالة للدار المذكورة وكان مسجد في القديم المعلوم ذلك كله
لموصيهم والاسبرشت دون نقولاش المذكور بحومة القاعدة شنتة مرية داخل مدينة طليطلة حرسها
الله وحد الدار المذكور في شرق دار لورثة القايد دون شبيب رحمه الله وفي الغرب الطريق الهابط
من القاعدة الى جهة البير المر واليه يشرع باب الشوطر الذي من جملة هذا المبيع المذكور وفي
القبلة الطريق النافذ من هذا الطريق المذكور الى الطريق الثاني واليه يشرع باب الدار المذكورة
وفي الجوف دار لقبشقول قاعدة شنتة مرية وحد الاصطبل المبيع المذكور... وفي جوف الطريق
والباب اليه شارع بثمن مبلغه مايتان مثقالا و مثقالين من الذهب الفنشي

From the Chancery of the Cathedral of Toledo:

The Year 1178. June.

Authorized by the archdeacon Don Domingo Gonzalbo, Don Andres ibn Abd
Allah . . . and Don Tome Saturnin, executors of the archpriest Don Nicolas, of
the regular clergy of the cathedral . . . in favor of the archpriest Don Pedro, son
of Micael . . . , imam of the church of Santa María de Talavera: the sale of a
house and a stable that used to be a mosque, in front of the church, in the
neighborhood of the cathedral, in Toledo. To its east is a house that belongs
to the heirs of Said Don Sabib; on the west is the street that runs between the
cathedral and Pozo Amargo . . . ; to the south is another street . . . where the door
of the house is found, and to the north is the house of the cathedral choir leader.
. . . For the price of 202 mizcales of Alfonso gold.

Another tiny mosque, just a few steps up the steep hill from the nearby city gate, was
built by the architect Musa ibn Ali on the eve of the millennium. Founded by Ahmad ibn
al-Hadidi, a pious gentleman of a prestigious family, it was meant to serve a local neigh-
borhood of prosperous citizens in the northern part of the thriving provincial city of
Tulaytula at the end of the Umayyad caliphate. Though Ibn al-Hadidi's family were "men
of science and religion, dedicated to teaching and to politics,"[1] their name, which appears

Mosque of Bab al-Mardum, with the Gate of the
Majordomo (Bab al-Mardum) in the distance.

in brick on the mosque's street façade, would be for-
gotten over time. Instead the building came to be

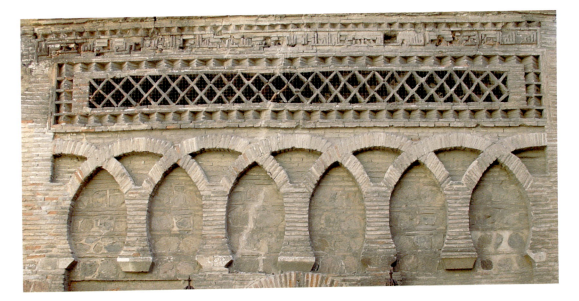

Dedication Inscription, Mosque of Bab al-Mardum

Basmala. Ahmad ibn al-Hadidi caused this mosque to be built, with his own funds, hoping through this to receive eternal compensation from God. It was completed with the aid of God, under the direction of the architect Musa ibn Ali, and of Saada, concluding in Muharram of the year three hundred and ninety [999].

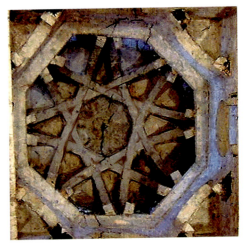

Mosque of Bab al-Mardum, façade detail with interlacing arches and inscription.

Mosque of Bab al-Mardum, ribbed dome.

Mosque of Bab al-Mardum, detail of scalloped arches with alternating red and white voussoirs.

opposite:

Mosque of Bab al-Mardum in Toledo, 999.

Mosque of Bab al-Mardum, interior.

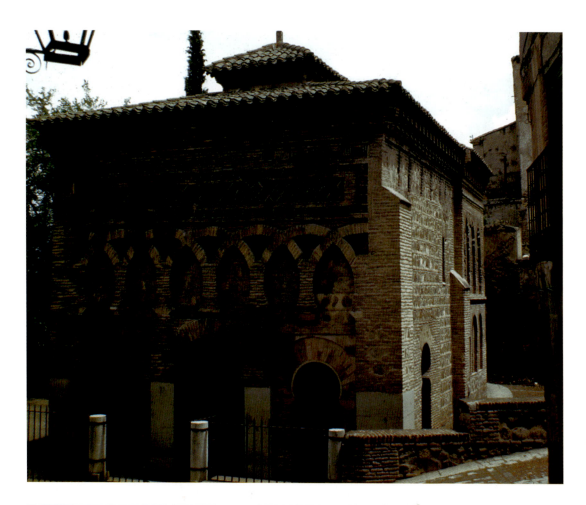

named for the nearby city gate known as Bab al-Mardum—the Gate of the Majordomo, or perhaps the Blocked Gate.

In 1085, when Alfonso VI entered Toledo, the little mosque, perhaps along with its *waqf*, or endowment, probably passed into private hands, the transaction part of the economic realignment of lands and goods that accompanied the Castilian's taking of the city.[2] At that moment, the mosque of Bab al-Mardum looked very much as it had at the time of its construction in 999. The neighborhood oratory was, on three sides, an open pavilion, like a delicate pierced cube, a miniature version of that plan in which worshippers pray in a forest of columns. Above its four columns, square bays concealed nine diminutive ribbed domes that paid homage to the grand vaults of the Great Mosque of Cordoba. Like Cordoba, too, was its ingenious array of different arch types: horseshoe arches divided the mosque's interior, interlacing arches wove in and out of one another on the exterior façade, and little trefoil arches alternated red and white bands. This lively vocabulary recalled the great mosque of the Umayyad capital at its height. The little mosque's typology—a nine-bay plan for a private oratory—reflects mosques in North Africa, and even Iran, but the language of expression here is distinctly Andalusian.

Though constructed under the waning reign of the Umayyads on the Iberian Peninsula, the neighborhood oratory can hardly be considered part of the Umayyad court style. It lacks the insistent classicism of grand Umayyad patronage as seen in Andalusian mosques and palaces in Cordoba or Madinat al-Zahra, which uses ornament in compressed, abstracted riffs on late antique styles. Instead, this rational, geometric little jewel box of a mosque uses the module of the brick to create multiple planes, as if the wall were composed of layers that could be peeled back to reveal its thickness. Bricks also fashion the donor's inscription that hails pedestrians bound for the city gate, and bricks generate the illusionist ornamentation of interlacing arches that echoes the court buildings of the Cordoban capital. It is brick that reminds us that, though this tiny mosque aspires to the grand ornamental gestures of Umayyad Cordoba, it is constructed in an independent tradition, rooted in a local practice that has had a life of its own for centuries here in Toledo.

Today, however, we see the mosque of Bab al-Mardum through the cloak of a physical transformation that took place in the late 1100s, nearly two centuries after its construction, and a century after Alfonso VI became the ruler of Toledo. In 1183 Domingo Pérez and his wife Juliana gave the military order of the Knights of Saint John the building "which was a mosque of the Moors in the parish of San Nicolas," now a "house" associated with a place called Santa Cruz. The couple hoped the knights would keep that name for the "chapel and oratory" they would make from this building.[3] In 1186, one hundred years after the Castilian takeover of Toledo, Gonzalo, archbishop of the city, consecrated the chapel, exhorting the knights not to let the people of the neighborhood pray there, as it was intended for their use alone. The 1186 document was no doubt necessary to affirm the rights of the Order of Saint John and those of the archbishop, at a time when scuffling for the lands and resources of the frontier town created sharp tensions between these competing Catholic institutions.

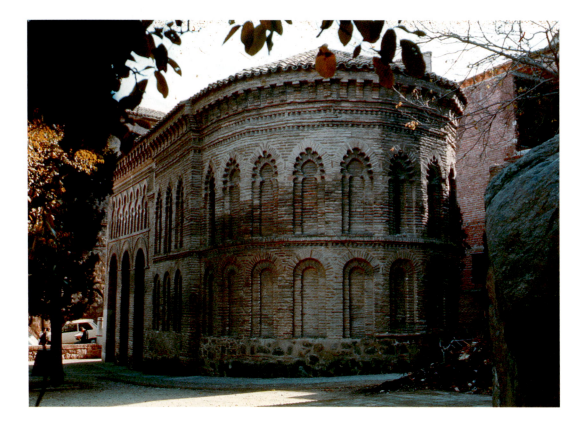

Around this time, the little mosque's mihrab was destroyed and an enormous apse was grafted

Church of Santa Cruz in Toledo, apse added to the mosque of Bab al-Mardum in 1186.

onto the eastern side of Bab al-Mardum's fragile nine-bay pavilion, subordinating the entire original oratory into a kind of portico for the new church. This made for an unusual building. Santa Cruz did not become the kind of longitudinal basilica typical of twelfth- and thirteenth-century church-building in Toledo. Instead, the apse, where the altar would be located, was dislodged from its usual place in the dramatic narrative of the basilica. It was isolated and overfed to become not only the interior space necessary for the Christian cult but also the exterior marker of the mosque's Christianization, of its absorption into a world that wished to be seen as Christian.

The message seemed appropriate to the goals and identity of its new owners. The Knights of Saint John of Jerusalem, also known as the Hospitalers, were the first of a series of military religious orders founded in the eleventh century to protect pilgrims to the Holy Land and to fight the "enemies of Christ." Knights of Saint John led ascetic lives, taking monastic vows of poverty, chastity, and obedience, but they also took to the battlefield with shields, banners, and capes on which a Maltese cross, their symbol, was emblazoned. Their headquarters in the Holy Land was the formidable castle of Krak des Chevaliers (in modern-day Syria), but they came to Spain to confront the enemies of Christ on yet another frontier. The establishment of military orders like the Knights of Saint John and the Templars gave rise to Spanish military orders: Calatrava, Alcántara, and the most power-

Interlacing Arches

To mark the mihrab aisle of his addition to the Great Mosque of Cordoba, the caliph al-Hakam II created two screens of bewildering arches. The lower arches are polylobed: the single arch has been broken into a series of smaller ones, so that the arch appears scalloped, and loses some of its rational credibility. But logic is thrown to the winds in the second level of this screen. There, arches appear to do the impossible: they overlap and slip behind one another. These intertwining arches challenge our expectations that architecture ought to stand up, and they engage the viewer in their puzzle like optical illusions.

In the Taifa period these baffling forms were taken up and propelled to new heights of mystifying complexity, with whole systems of interlacing arcades hidden like tiny twisted worlds within large palace arcades. Polylobed arches would also enjoy great favor in Almohad architecture, but were cooler, less ornamented, fashioned of brick and whitewashed, prized for their sharp profile and flat unadorned surface. Both polylobed arches and interlacing arches were tamed by this more restrained attitude toward ornament, and they were miniaturized and converted into two-dimensional patterns, controlled within rectangular recesses on minarets or walls. In this way polylobed arches and interlacing arches would become the decorative patterns known as *sebka*.

from top to bottom:

Great Mosque of Cordoba, 961.

Convent of Santa Fe in Toledo, 13th century.

Puerta del Sol in Toledo, 14th century.

opposite, clockwise from top left:

Great Mosque of Cordoba, 961.

Convent of Santa Clara in Tordesillas.

Aljafería in Saragossa, 11th century.

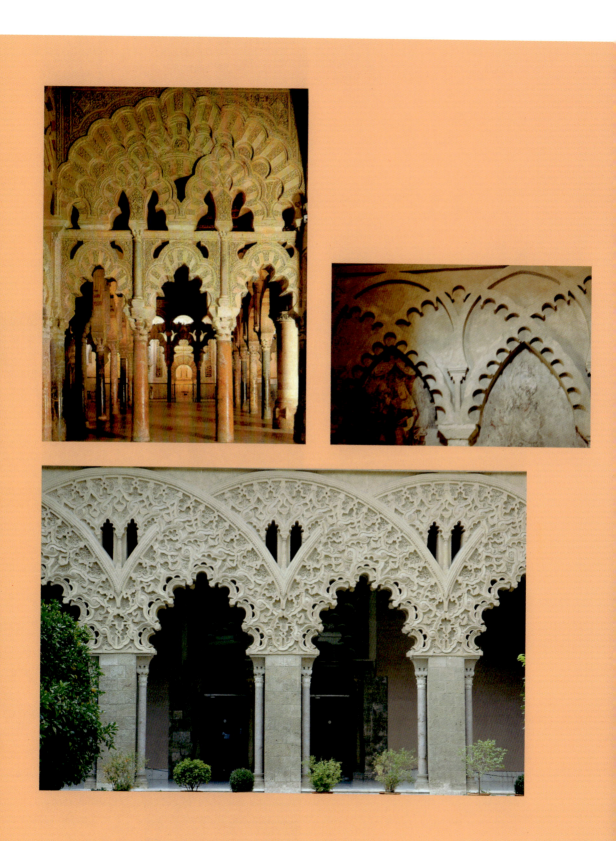

Seam between the mosque of Bab al-Mardum and the church of Santa Cruz.

ful of all, the Order of Santiago. In the last quarter of the twelfth century, the chivalric orders brought Castilian kings heavy cavalry, and encouraged and protected frontier settlements, all at the moment that armies from North Africa launched shattering attacks against León, Portugal, and Castile. Because their warriors were monks, the military orders' presence lent a cosmic meaning to battles against Muslim foes that pleased the papacy as well.

The year 1183 was a particularly important one for the Knights of Saint John, as Susana Calvo Capilla has shown in her masterful analysis of Bab al-Mardum's passage from mosque to church. The order had been part of a hopeful series of military initiatives for the Castilians, and their prior, interested in focusing bellicose energies away from fellow Christians and toward Muslim foes, had intervened to create a peace between the kingdoms of León and Castile.[4] The knights' agenda dovetails with their additions to Bab al-Mardum. Out of scale with the compact mosque to which it clings, the wide apse opens to envelop the nine-bay pavilion with its unpierced fortresslike wall, so different from the open arcades of the mosque to which it is attached. The effect is that of a little mosque slipping into the giant apse, as if the newer building were slowly consuming the older one. Santa Cruz seems frozen in time: poised an instant before it devours the fragile mosque.

If they wished to show ideological domination of Christianity, a world within the control of the church, why did the Knights of Saint John not simply destroy the little

mosque? Perhaps because this particular way of creating a church transformed the mosque of Bab al-Mardum into the symbolic spoil of war of the Knights of Saint John. It became a trophy, which, like the taxidermed head of a hunted animal, is poised in the final moment of its conquest for monks whose raison d'etre was to conquer in the name of Christ.

And yet, our suspicion that the absolute polarity of victor and vanquished is illusory at Santa Cruz is confirmed by the very language in which that architectural gesture of domination and triumph is made. The mosque of Bab al-Mardum itself had been constructed with spolia from a Toledan church of the Visigothic period: the columns and capitals reused to make the neat geometric plan of the little mosque. And the gesture was repeated when the apse of the church of Santa Cruz was appended to the mosque. But what is remarkable is that the new apse was made in a parallel tradition of construction: rubblework foundations, composed of stones set in cement, giving way to brick walls. Even more vivid is the visual language that the church of Santa Cruz presents to its public: blind arcades that use the thickness of the brick to create multiple planes. Rows of scalloped arches, like those of the earlier mosque, round-headed arches, and keel-shaped arches that draw the horseshoe arch into an elegant point are layered against the opaque mural surface to create a lively textured skin. It is true that the church's walls use individual motifs that diverge from the specific ornamental forms of the mosque, but more binds the expression of these two styles than separates them. For the tradition in which Santa Cruz was built is a twelfth-century variant of the same local language in which Bab al-Mardum was constructed at the end of the first millennium. It is in this already hybrid dialect that the church speaks to Castilian Toledo.

In an attempt to account for the Islamic taste apparent in the churches of Castilian Toledo and in other cities of the conquest, scholars would name them Mudejar, after muda-jjan in Arabic, meaning "one left behind," referring to Muslims who remained in cities newly governed by Christians. The term at first suggested that the style was in fact a building tradition, adopted for expediency and propagated because the workforce of the recently conquered territories was assumed to be composed of Muslims, the Mudejares who were now the Muslim citizens living under Christian rule. Later, the likelihood of a multiconfessional workforce was accepted, and the adoption of this local style was assumed to reflect the victor's admiration for the architectural culture of the Islamic polities they had vanquished.

But the term "Mudejar" is problematic because it assumes that a style or architectural tradition shared by divergent religious groups is an anomaly, as if architecture and ornament must be identified foremost with a predominant religion. Scholars at times have fetishized what they saw as the irony of its use by Christians. But what if that irony was lost on twelfth- and thirteenth-century Toledans? What if, like Mozarabic Christians' use of the Arabic language and song forms, it might at times have been more natural than contradictory to share an artistic language? What if important parts of visual and literary culture had little to do with religious difference at all?

If we call the little church of Santa Cruz Mudejar, it is because both the church and the term challenge us to understand that it embodies one part of a new collective taste

that not only survived the conquest of Toledo but grew and transformed under Castilian rule. It is a taste developed and disseminated hand in hand with the Christian conquest. Created through indigenous traditions of construction, and ornamental strategies shaped by Hispano-Muslim abstract tastes and ancient Roman conventions, there is nothing about Toledan Mudejar as a construction technique and ornamental style that is symbolic of religion, or of ethnicity. What we call Mudejar after 1085—a building continuing Islamic forms and traditions constructed under Christian dominion—is part of the same development as buildings begun in 1084, a year before Alfonso's triumph, or even in 999, nearly a century before that, when the mosque of Bab al-Mardum was first built, and the end of Tulaytula was unimaginable.

Buildings like Santa Cruz retain recognizable typologies and forms of the Romanesque architecture that was simultaneously developing throughout the north of Castile. Its voluminous apse, the distribution of space and decoration within, even the semicircular arches of the abstract exterior skin of the church belong to established church-building tradition. Mudejar is a hybrid, a reflection of assimilation and transformation. Yet specific, conscious political messages can coexist with this assimilated expression and they often do. In fact, the tension between political messages of domination (like those at Santa Cruz) and a style that suggests assimilation drives us to the heart of what is complex and fecund about Toledan life, about any plural place. If the church of Santa Cruz was meant at first to create an architectural image of a sacred struggle—Christianity as the victor, consuming the tiny vanquished mosque—this palimpsest of church and mosque in the fabric of Toledo also betrays an unspoken truth: how intertwined collective visual values in Toledo were, both before and after the conquest. There was clearly discomfort with this conflation of mosque and church in Toledo's later history, a tension that led to mythic explanations. The legend of a lost Visigothic church revealed by a miraculous surviving light would give both mosque and church yet another name for centuries: Cristo de la Luz.

<p align="center">✳</p>

This culture of assimilation had developed over a century of changing winds for Castilian rule. Thirteen months after the taking of Toledo, the armies of a North African empire, the Almoravids, landed in Algeciras and made their way to Seville. They had been invited to al-Andalus by al-Mutamid of Seville in an alliance with the Taifa kings of Granada and Badajoz, kings who felt their sovereignty severely threatened by the loss of Toledo the year before. The taking of Toledo had been a benchmark not only for the Castilians. In October the Almoravids had routed Alfonso VI at Badajoz, but by 1094 they had turned against their Andalusian allies and proceeded to depose all the major Taifa kingdoms except Saragossa and Valencia. They would take Seville as the capital of what was now their colony. Al-Mutamid, Seville's remarkable poet-king—and the man who had reluctantly called the Almoravids to help him in the first place—thus found himself exiled and imprisoned by his erstwhile allies, and part of his legacy are the heartbreaking poems that lament this fate.

By 1109, the year of Alfonso's death, the Almoravid emir Ali ibn Yusuf was making

raids deep into the Tagus River valley, the frontier region of Toledo. Taking advantage of the period of transition in Castilian power, he assailed the towns that circled Toledo, including Talavera and Madrid (*majrit*, from the Arabic *majra*, a reference, perhaps, to the Manzanares River), and tested the walls of Toledo itself. The cosmopolitan city, on which so many Castilian hopes were pinned, would become something of a frontier outpost. By the time the great king died, the Almoravids had established an empire that would change the face of Islam on the peninsula.

Alfonso's only son and heir, Sancho—the son of Zaida—would die at the age of fifteen fighting the Almoravids at Ucles, just nineteen miles south of Toledo. At this devastating turn of events, the old king took the unusual step of naming his daughter Urraca monarch of Castile. The extraordinary twenty-nine-year-old daughter of Alfonso and Constance of Burgundy seems to have gleaned substantial diplomatic and military skills

Gustavo Adolfo Bécquer
Legend of the Cid and Bab al-Mardum

No pararon aquí los milagros de esta divina imagen, pues que en la pérdida de España, cuando la perdió el Rey D. Rodrigo, que fue el año tercero de su reinado, y de setecientos catorce del nacimiento de nuestro Salvador, temerosos los cristianos de los árabes y judíos no ultrajasen a estas divinas imágenes del Santísimo Cristo de la Luz y Virgen de la Luz, las escondieron en unos nichos que están a mano derecha de la ermita, dejando una lámpara encendida con una panilla de aceite. Fue Dios servido que el Rey D. Alonso el Santo ganase a Toledo el día de San Urbano a veinticinco de mayo de mil ochenta y tres. Entró en Toledo acompañado de la nobleza de España, y viniendo el Cid Ruiz Díaz a su lado, entrando por la puerta Aguileña, que está frontera de la iglesia del santísimo Cristo, el caballo del Cid se arrodilló delante de la iglesia, y desmontando, abrieron las paredes, y al son de música del cielo, vieron (prodigioso caso) al Santísimo Cristo de la Cruz y Virgen de la Luz, con la lámpara encendida, dando luz a los que lo son del Cielo y la tierra, la cual estuvo ardiendo con una panilla de aceite todo el tiempo que estas divinas imágenes estuvieron ocultas, que fueron trescientos y setenta y nueve años. Entró S. M. a adorar las divinas imágenes, y mandó que el arzobispo dijera en esta Santa Casa la primera misa, y dejó, como David, el alfanje en el templo, S. M. el escudo de la Santa Cruz con que alcanzó la victoria.

The miracles of this divine icon did not stop there. King Rodrigo lost Spain in the third year of his reign, the year 714 of Our Lord; and the Christians, fearing that Muslims and Jews would not worship these divine images of the Most Holy Christ of the Light and the Virgin of the Light, hid them in some of the niches that are on the right-hand side of the hermitage, leaving one lamp lighted with a small amount of oil. God granted that King Alonso [Alfonso] the Saintly would win back Toledo on the feast day of Saint Urban, the 20th of May, 1083. In the company of Spain's nobility, and with the Cid, Ruy Díaz, at his side, he entered Toledo through the Aguileña gate, which abuts the church of the Most Holy Christ. The Cid's horse knelt before the church. Dismounting, the men broke open the walls, and to the sound of heaven's music, they saw the Most Holy Christ of the Cross and the Virgin of the Light, with their lamp still lighted and giving light to the inhabitants of heaven and earth; it had burned with that small amount of oil all the time that the divine images were hidden, which was 379 years. His Majesty entered to venerate the divine images, and ordered that the archbishop celebrate the first Mass in that holy place; and as David had in the Temple, he left his cutlass and the shield of the Holy Cross which had brought him victory.

Trans. Sarah Pearce

from her parents, but she was forced to expend most of her bellicose energy defending her reign from numerous challenges to her sovereignty, including those posed by her actual husband, her sister, and even Alfonso, her own son by her first husband, Raymond of Burgundy, who had died in 1107. The child Alfonso, who had already been crowned king of Galicia at the age of six, was in custody of a Galician count and the ambitious Diego Gelmírez, the bishop of Santiago de Compostela, who meant to use him as a pawn in their own quest for power.

Part of the problem was Urraca's second marriage. In the year of her father's death, 1109, Urraca married Alfonso el Batallador, "the Battler," king of Aragon, in what had initially seemed a powerful alliance, for it united all the Christian states of the peninsula except Catalonia. But it was a tempestuous and obsessive match, the couple alternately waging war on one another and reconciling, until they accepted the pope's nullification of

Al-Mutamid of Seville

On being exiled from Seville

Oh to know whether I shall spend one more night
In those gardens, by that pond,
Amid olive-groves, legacy of grandeur,
The cooing of the doves, the warbling of the birds;
In the palace of Zahir, in the spring rain,
Winking back at the dome of Zurayya,
As the fortress of Zahi, with its Sud al-Suud,
Casts us the look of the waiting lover.
Oh that God might choose that I should die in
 Seville,
That He should there find my tomb when the last
 day comes!

Trans. Rafael Valencia

On his imprisonment in Aghmat, near Fez, where he died in 1095

I say to my chains,
don't you understand?
I have surrendered to you.
Why, then, have you no pity,
no tenderness?

You drank my blood.
You ate my flesh.
Don't crush my bones.

My son Abu Hasim sees me
fettered by you and turns away
his heart made sore.

Have pity on an innocent boy
who never knew fear
and must now come begging to you.

Have pity on his sisters
innocent like him
who have had to swallow poison
and eat bitter fruit.

Some of them are old enough
to understand and I fear
they will go blind from weeping.

The others are now too young
to take it in and open their mouths
only to nurse.

Trans. Cola Franzen

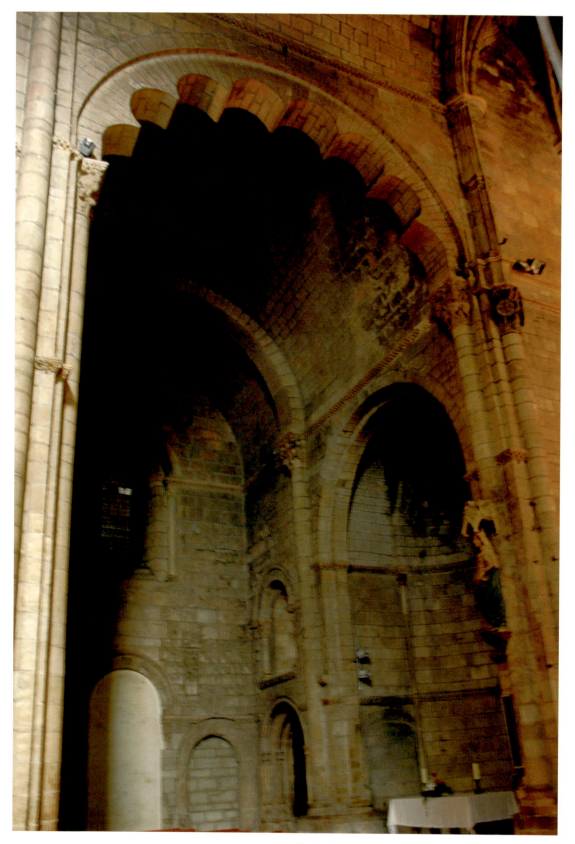

Church of San Isidoro de León, scalloped arch in the
crossing, 12th century.

their marriage on the grounds of consanguinity. The failed marriage of nations erupted into a civil war between Aragon and Castile, and a number of important Castilian cities and fortresses would remain in Alfonso's hands until after Urraca's death. But in 1116 the queen looked to the future. If she would not have an heir to a united kingdom of Castile and Aragon with Alfonso the Battler, she must move to empower her young son by Raymond of Burgundy, a legitimate grandson of Alfonso VI, by separating him from his powerful and divisive guardians in Galicia, and associating him with the Castilian throne. Urraca accomplished this by giving the world-weary eleven-year-old Alfonso authority over the lands south of the Duero River, and those that centered on Toledo, the city of the child's birth. Toledo had teetered perilously on the edge of the kingdom of León-Castile since Alfonso VI had first faced the Almoravids. In 1117 the young king and his entourage would enter Toledo, which until recently had been in the hands of his crusading stepfather and surrounded by Almoravid forces.

Though Urraca herself would not reside there, the actual and symbolic repossession of Toledo was an essential part of her image as the monarch of Castile. Therese Martin has shown how Urraca evoked Toledo in her building works in León. In the austere Romanesque church of San Isidoro, in which ashlar construction, vaulting, and figural

The Almoravids (1056–1147)

The founders of the Almoravid kingdom had been nomads in the Sahara and modern-day Mauritania, who stopped their itinerant lifestyle to settle at the foot of the Atlas Mountains. The Almoravids were from the Sinhaji tribal group, and initially won power through their control of the lucrative salt-gold trade between Iberia and East Africa. Though they were among the Berber tribes who had converted when the Islamic empire first stretched across North Africa, they sought a deeper understanding of their new religion. They asked Abd Allah Ibn Yasin al-Nafisi, a Berber Muslim scholar, to teach them about Islam, and he led them to a military monastery, called a *ribat*, on an island off the coast of Mauritania for a spiritual retreat. They thereafter became known as *al-murabitun*—the people of the ribat. Ibn Yasin inculcated desire for conquest and for spreading Islam in his followers. Before his death in 1059, they had conquered many of the non-Muslim Berber tribes of Morocco and held significant territory. The Almoravids were traditionalists, following the Malikite school of law and swearing allegiance to the Abbasid caliphate in Baghdad. They lived simply and austerely, basing their lives on the guidelines set forth by Malikite legal scholars.

The first request from an Andalusian Muslim leader for assistance from the Almoravids may have come as early as 1079, and in 1083 Seville's leader al-Mutamid helped the Almoravids capture the North African coastal city of Ceuta, which had been part of the Cordoban caliphate and subsequently a Taifa. In 1086, after Alfonso VI's conquest of Toledo, al-Mutamid requested that the Almoravids help defend the fragmented Taifas of Islamic Spain from further Christian advances. So the Almoravids entered the peninsula, crossing the seven short miles that separate Africa from Europe at the Strait of Gibraltar. According to the memoirs of Abd Allah of Granada (written while he was a prisoner of the Almoravids in Morocco), the Taifa kings had promised to finance Yusuf Ibn Tashufin's expedition and provide him with assistance from their armies if he came. In October of 1086, in the battle of Zallaqa (also called Zalaca or Sacralias) just north of Badajoz, the Almoravids and their Andalusian allies soundly defeated Alfonso VI. Yusuf and his armies left after the battle of Zallaqa, but in 1090, they

sculpture all proclaim a northern Romanesque vision, the queen included horseshoe-shaped and scalloped arches in key places to emphasize "her position as heir through her father . . . by evoking the fabled city."[5]

In Toledo the young Alfonso would learn to rule, under the tutelage of its archbishop, the Cluniac Bernard, the old ally and friend of his grandfather Alfonso VI. So it was in Toledo that the boy was first acclaimed king in 1118, a dress rehearsal for his real assumption of power, which would not take place until his mother's death in 1126, in León, the city that had served as the center of her rule.

At the time of Alfonso VII's ascension to the throne in León, the Almoravids had renewed attacks on the lands surrounding Toledo, as he was still gathering the parts of his Castilian birthright. Many castles in the surrounding region fell, but the Toledans themselves defended their city. Alfonso's ambitions could not be supported by centering his kingdom on such a frontier. At the death of Alfonso the Battler, the curious crusader whose marriage with the young Castilian king's mother had gone so wrong made an extraordinary will. He left the kingdom of Aragon to monastic military orders: to the Templars, to the Order of the Hospitalers of Saint John of Jerusalem, and to the Canons of the Holy Sepulcher. Few took the will seriously, but the ensuing struggle for the kingdom

returned, this time uninvited, lured by the wealth of the peninsula and no doubt tempted by the political weakness and disunity of the Taifa kings they had observed firsthand. The dramatic turning point saw a reversal of alliances: none other than Alfonso VI himself was called on to help al-Mutamid attempt to save Seville from the very warriors the Andalusian ruler had invited to confront the Castilian king after the fall of Toledo. But Alfonso, already defeated by the Almoravids, could do little to stop their rapid expansion. It was sometime in 1091 or 1092 that Alfonso took al-Mutamid's former daughter-in-law Princess Zaida as a concubine, in an attempt to ally himself more closely with Seville. And al-Mutamid, along with Abd Allah of Granada, was taken prisoner by the Almoravids. The proud Andalusian Taifa kings spent the rest of their lives in unhappy exile in North Africa. By the time Yusuf died in 1106, his army was well entrenched in the south of the peninsula and was able to exert considerable pressure on the kingdom of León-Castile by besieging cities along its southern and eastern borders. The era of the Taifas was effectively finished, although a number of them would continue to struggle against Almoravid domination for years.

Under Yusuf's son, Ali ibn Yusuf, the Almoravids and the Castilians, Leonese and Aragonese, negotiated and continually redrew a border between Christian- and Islamic-ruled areas that ran across the middle of the peninsula. Although this new presence of a foreign Islamic power in the peninsula at times introduced a strident religious tone into the political language of the moment, this history too is full of alliances formed across confessional lines. At the same time, the Andalusian experience affected the Almoravids themselves. Ali ibn Yusuf, the last Almoravid king, burned the works of al-Ghazali (d. 1111), the preeminent Persian theologian who was also a Sufi mystic and who would come to be known as Algazel in Latin Christendom, where his anti-Neoplatonism earned him pride of place among many thinkers. Nevertheless, the Andalusian music, poetry, and philosophy the North Africans originally disdained became, to a certain extent, a vital part of their court and culture.

The Almohads (1130–1269)

The conservative Almoravids were themselves eventually criticized for too lax an interpretation of Islam. In their home territories of North Africa, a new movement gained force, one that based its legitimacy on a different approach to the Quran and accused the Almoravids of corruption. The Almohads, from *al-muwahiddun*, or "unifiers," were a sect founded by a theologian named Abu Abd Allah Muhammad Ibn Tumart (1078/81–1130). From their base in the upper Atlas Mountains, the Almohads set out on their campaign of religious debates, conversion, and battles, with the goal of winning the Almoravid empire for themselves. Ibn Tumart, who had studied Islamic theology in the East, transmitted his knowledge to his followers in the Berber language, and called himself al-Mahdi, or one who is guided by God. Though the Masmuda tribal federation, which was the Almohad base, had converted to Islam generations earlier, al-Mahdi's new approach to Islam, based on a stricter following of the word and a rejection of bodily luxuries, led him and his followers to oppose Almoravid rule.

Al-Mahdi's successor Abd al-Mumin (r. 1130–1163) conquered Marrakech in 1147 and effectively deposed the Almoravids in North Africa. Across the Strait of Gibraltar, the Muslims of al-Andalus had begun a series of modest rebellions against Almoravid rule. Continuing attacks from Alfonso VII and his allies began to loosen the Almoravid hold on the Muslim territories of al-Andalus. In 1145, Sayf al-Dawla, a descendant of Abd al-Malik of Saragossa and ally of Alfonso VII, briefly took control of several Almoravid cities: Cordoba, Jaén, and Granada. By the late 1140s, most of the Islamic cities of the south and the east had won independence and briefly became something like Taifas once more. With the resulting unrest, and the continuing threat of Christian conquest, a number of Muslims yet again appealed to their coreligionists across the Mediterranean for support. By 1157 the Almohads had won nearly all of the former Almoravid territory for themselves, with the notable exceptions of

Valencia and Murcia, which remained Almoravid Taifas until 1172. The Almohads, like their predecessors, chose Seville as their Andalusian base and their colony's capital, and thereafter ruled between the twin capitals of Marrakech and Seville.

The Almohads, like the Almoravids, approached al-Andalus with some contempt for what they viewed as religious and moral laxity, as well as a cultural extravagance inappropriate to their own understanding of Islam. However, the period of their control over their Andalusian colony is hardly devoid of lasting and influential cultural achievement. Ibn Quzman transformed the poetic scene with his vernacularized zajals, adding a new form to the inventory of the Arabic songbook, in use to this day. And during the same period the bilingual muwashshah flourished. Ibn Arabi, whose work has become one of the cornerstones of Sufism, or Islamic mysticism, was born in Murcia in 1165, shortly after the Almohad takeover of al-Andalus. After a spiritual awakening, he abandoned his worldly ways and became a wandering ascetic, writing a vast number of works on mysticism, the esoteric sciences, and the philosophy of religion. His early life took him from Murcia to the court of the Almohads in Seville, and after his spiritual transformation he traveled to North Africa, Mecca, and finally Damascus, where he would teach and write until his death in 1240. His most widely cited poem ends with an ode to the varieties of religious forms:

> A white blazed-gazelle
> Is an amazing sight,
> Red-dye signaling,
> eyelids hinting,
>
> Pasture between breastbones
> And innards.
> Marvel,
> A garden among the flames!
>
> My heart can take on
> Any form:
> Gazelles in a meadow,

A cloister for monks,
For the idols, sacred ground,
Kaaba for the circling pilgrim,
The tables of a Torah,
The scrolls of the Qur'an

I profess the religion of love;
Wherever its caravan turns
Along the way, that is the belief,
The faith I keep.

Trans. Michael Sells

Besides poets, several important philosophers thrived in the court of the Almohads. Ibn Tufayl of Almería wrote his famous philosophical parable "Hayy ibn Yaqzan" (Alive, Son of Awake) while serving as a physician and advisor in the court of Almohad Abu Yaqub (r. 1163–1184). He also acted as the patron of a young philosopher from Cordoba, Ibn Rushd, better known as Averroes in the Latin West, where he was an influential Aristotelian, seated by Dante next to Aristotle himself in the Limbo of the virtuous pagans in the *Divine Comedy*. After his introduction from Ibn Tufayl in 1169, Averroes also became prominent in the Almohad courts, serving as a *qadi* or judge in Cordoba and Seville and then as a court physician in the Almohad court in Marrakech. It was Abu Yaqub who encouraged Averroes to write commentaries of Aristotle that would make the philosopher's work more understandable, commentaries that would soon thereafter transform Christianity's understanding of the Greek philosopher. However, under Abu Yaqub's successor al-Mansur, Averroes's fortune changed: he was briefly exiled to Lucena and his books were burned. He died in 1198 in Marrakech, under murky circumstances.

Though the Almoravids and Almohads became more tolerant of art and philosophy once these were a part of their everyday life in al-Andalus, they remained fundamentally opposed to religious dissent, and their harsh policies toward the Peoples of the Book resulted in waves of emigration of both Mozarabs and Jews out of Almohad territories.

Indeed, Almohad persecutions caused a mass exodus of non-Muslims to Christian territories that resulted in both a loss of religious diversity in cities like Seville and a concomitant efflorescence of cultural and linguistic diversity in twelfth- and thirteenth-century Toledo. This in turn contributed to the flourishing of translation activity in the Christian city. Some important scholars left the Iberian Peninsula altogether, most famously the Jew Musa ibn Maimun, known as Maimonides (1135–1204). Maimonides, a contemporary of Averroes, and like him an Aristotelian, was the author of immensely influential philosophical texts in Arabic that, like those of his fellow Cordoban, would help transform intellectual life in Latin Christendom in the thirteenth century.

But the Almohads' political and territorial position in Iberia was not stable for long: in 1195, they won their last major victory against Alfonso VIII in the important battle of Alarcos. Even though the Almohads trounced the Castilians, they did not advance upon Toledo—returning to Seville immediately thereafter—and their victory and the subsequent peace treaty would not last long. In 1212, outside the small town of Las Navas de Tolosa, about seventy-five miles north of Granada and in the southern foothills of the Sierra Morena mountain range, the Almohads were decisively defeated. Combined Christian forces destroyed the Almohad army, and the defeat made their eventual retreat from the peninsula appear inevitable.

A dispute over the succession to Almohad leadership weakened them further and led rivals to ally themselves with the Castilian king Ferdinand III. The Taifa-like city-states that remained in the 1220s were claimed, one by one, over the next decade by the Castilian monarch, who completed his full takeover of once-Almohad territories in 1248, when he took possession of the territorial capital, Seville. This he did with the help of his ally, and vassal, Muhammad ibn Yusuf ibn Nasr, known as Ibn al-Ahmar, who as Muhammad I would become the founder of the Nasrid dynasty that would bear his name.

allowed Alfonso of León-Castile to submit Navarre and Aragon to his own vassalage. Now ruler of Galicia, León, and Castile and sovereign over Aragon and Navarre, Alfonso would be crowned "emperor of all the Spains" in the cathedral of León in 1135.

The military success of the Almoravids that had placed Toledo on such a precarious frontier had also transformed the nature of warfare in Iberia, and with it, the political relationships between Castilians and the peninsula's Islamic polities. Where the Taifas had been independent city-states with separate diplomatic and political alliances, the Almoravids united much of al-Andalus into a single colony. From their beginnings as a seminomadic Berber tribe, they had become extremists who followed conservative observance of Islamic doctrine, including a literal reading of the Quran as well as restricted interaction with non-Muslims. Young men were often trained in a military monastic setting, a *ribat*, where they led an ascetic life alternating prayer and military drills.

The Almoravids from the outset had been contemptuous of the opulent lifestyle and political laissez-faire of the Taifa kings, and they promoted hostile relations with Christian states, much as papal envoys sought to instill a crusade mentality among the Castilians. The Almoravids indeed made common cause with the conservative Malikite theologians of al-Andalus in their severity toward Christians and Jews, so that it seemed the crusaders among the Castilian churchmen had found their Islamic other. A zealous church intent on an Iberian crusade now faced, for the first time, a zealous Islamic empire that, unlike the states that preceded them in al-Andalus, conceived of *jihad* as a struggle against Christian kingdoms, which now began to be represented uniquely as enemies of the faith.

The ideology of the Almoravids was echoed by Alfonso VII in his quest to unite the northern Christian kingdoms under his own aegis. He thus became the first of the Castilian monarchs to convert his territorial wars into a crusade, an act that had been rehearsed in Aragon numerous times since the disastrous crusade at Barbastro. Alfonso I of Aragon, the Battler, whose ardent faith appears to have harbored genuine crusading zeal, had enlisted French lords to aid him in taking Saragossa, and Pope Gelasius (r. 1118–1119) would offer absolution for all who participated in the action. And in 1123 Pope Callixtus II would promote a Catalan crusade that was paired with one to the Holy Land to simultaneously assail Islam on two fronts. In 1147 Alfonso VII is thought to have followed this lead, asking Pope Eugenius III for crusading privileges in the conquest of Almería. But for all the flourish of empire and crusade, his gains against the Almoravids were not spectacular, and he could not overcome the power of the Almohads, the North African empire that would supplant the Almoravids, first in North Africa, and then in their Andalusian colony.

Once again conservative and reforming, the Almohads attempted to incorporate Spanish Muslims into their own fold. But the city-states of Murcia and Valencia remained stubbornly independent. Murcia was ruled by the legendary king Muhammad ibn Mardanish (called "el Rey Lobo," the Wolf King, by the Christians), who allied himself with Alfonso VII in opposition to the North African empire, undercutting the Almohad claim to represent a unified Islam, and betraying the plural nature of Alfonso VII's imperial alliances. Yet the Almohads still created a powerful and mythic presence, above all when

their caliph al-Mansur landed in Tarifa with an immense army in 1195 and proclaimed a holy war. The Almohads pushed north to Alarcos, where they dealt Alfonso VII's grandson, the young king Alfonso VIII, a shattering defeat, and ominously took control of the road that led from Cordoba to Toledo.

The notion of jihad—the struggle, within an individual or a community, to reform oneself, to live the way God had intended—is central to Islam, as is its second meaning—war in the service of religious reform. Under the Almohads, political rhetoric had begun to line up more consistently along ideological frontiers without the political and cultural entanglements of the Taifa kingdoms. And yet, there was significant dialogue between the most opposed of Christian and Islamic societies. While the conscious agenda might have been polarized, the dialogue often masked a kind of competitive admiration, linked by a common need. A number of scholars, the legendary Américo Castro among them, suggested that much about the idea and practice of sacred military monastic orders—dedicated to ridding the peninsula of Muslims—was itself appropriated from Islamic practice, in which the notion of the ribat had been rooted since the seventh and eighth centuries.[6] Thomas Glick and Oriol Pi-Sunyer recognize the process whereby this institution came to be appropriated in Spain as what anthropologists call stimulus diffusion: that is, the spread of an idea through an encounter between two groups, but "reinvented" by the appropriating group, for whom there is a taboo to borrowing across a frontier.[7]

<div align="center">✳</div>

And yet, borrowing across an invisible frontier—the frontier between religions, and the political identities that had ossified around them—is exactly what was happening in Toledo as the ideas of crusade and jihad took hold on the peninsula. In the heady years after Alfonso VI took possession of Toledo, there was clearly some confusion as the novel terms of capitulation offered to the Toledan Muslims were implemented. We have seen the ways in which Alfonso avoided the depopulation of the city by granting its Muslims security, their property, practice of their religion, their own language, judges, and use of their principal mosque. But for Alfonso this agreement was more of a fuero than a sacred pact like the dhimma, and when he allowed Toledo's Great Mosque to be appropriated by his new archbishop for use as a cathedral, it demonstrated how tenuous these privileges were. So we can imagine that during the first generation following Alfonso's arrival in Toledo, property changed hands quickly and the identity of buildings was transformed with the interests of their new landlords. According to Calvo Capilla, by 1089 Alfonso would make over to the cathedral "those churches that the Muslims call Great Mosques, where they have always had the custom of praying on Fridays," that is, all the principal mosques from his newly conquered territories. The donation obviated the expense of constructing new churches immediately, and he ceded the buildings together with the lands and industries that had provided them financial support: vineyards, mills, and gardens.[8] It is likely that he gave the church many other, smaller mosques as well, but some might have passed into private hands as part of the estates of wealthy Muslims purchased or received as booty: a

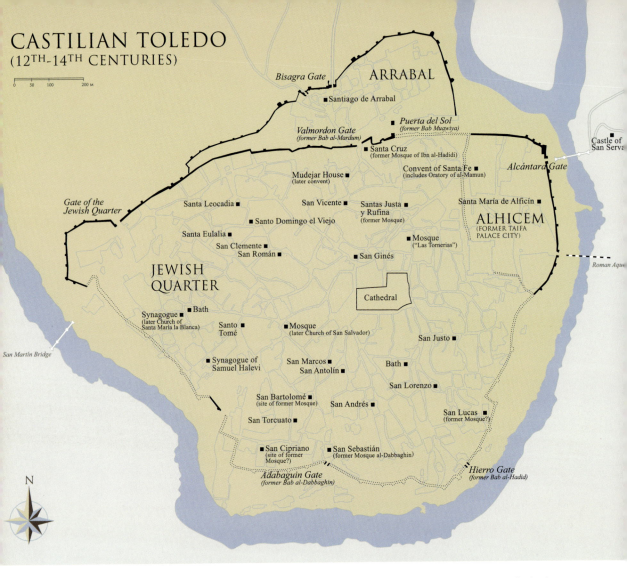

CASTILIAN TOLEDO
(12TH-14TH CENTURIES)

0 50 100 200 M

Bisagra Gate

ARRABAL

■ Santiago de Arrabal

Puerta del Sol
(former Bab Muqwiya)

Valmordon Gate
(former Bab al-Mardum)

■ Santa Cruz
(former Mosque of Ibn al-Hadidi)

Convent of Santa Fe ■
(includes Oratory of al-Mamun)

Alcántara Gate

Castle of
San Serva

Mudejar House ■
(later convent)

Santa María de Alficín ■

Santa Leocadia ■ San Vicente ■ Santas Justa
 y Rufina
 (former Mosque)

ALHICEM
(FORMER TAIFA
PALACE CITY)

*Gate of the
Jewish Quarter*

■ Santo Domingo el Viejo

Santa Eulalia ■ ■ Mosque
 ("Las Tornerias")

San Clemente ■
San Román ■ ■ San Ginés

Roman Aque

JEWISH
QUARTER

Cathedral

Synagogue ■ ■ Bath
(later Church of
Santa María la Blanca)

Santo ■ ■ Mosque
Tomé (later Church of San Salvador)

San Justo ■

San Martín Bridge

■ Synagogue of
Samuel Halevi

San Marcos ■
San Antolín ■

Bath ■

San Lorenzo ■

San Bartolomé ■
(site of former Mosque)

San Andrés ■

San Lucas ■
(former Mosque?)

San Torcuato ■

■ San Cipriano
(site of former
Mosque?)

■ San Sebastián
(former Mosque al-Dabbaghin)

Hierro Gate
(former Bab al-Hadid)

Adabaguin Gate
(former Bab al-Dabbaghin)

N

mosque south of Toledo's cathedral was divided and sold as two houses, one of which would become a stable. Two other mosques in the north of the city met the same fate; one was the mosque of Ibn al-Hadidi, the mosque of Bab al-Mardum that would become the church of Santa Cruz a century later.

There were new constructions as well. On a site across the river, commanding the eminently strategic Alcántara bridge, Alfonso built a fortified castle, but one that would be administered by monks: the castle of San Servando. It was to this monastery that he would give the Mozarabs' church of Santa María de Alficín, under the authority of the papal legate, and now it would stand to represent the Roman church's investment in the monarch's military success. Indeed, the story of the Castilian opening to Islamic culture was clearly not an extension of a particularly tolerant ideological vision. On the contrary, it would happen in spite of the most expedient and self-interested actions of Toledo's new Castilian and Frankish ruling classes. For them, Toledo was a symbolic and strategic goal. But there, on the other side of the river from that fortified monastery, was also a new kind of conquest for the Castilians: a city, with a far more complex urban economy than they had known before,

one that brought new prospects and prestige to the burgeoning king- **Alcántara bridge in Toledo.**
dom. And because that urban life had been structured by Umayyad
and Taifa societies, their embrace of urban economy, urban pleasures, and urban cosmopoli-
tanism would unwittingly also become a leap into a new vision of self for the Castilians.

This process began with the practical appropriation of the urban structure of the Taifa
city by its new Castilian lords. Castilian kings would enter the city in triumph from the
northeast, across the Alcántara bridge and through the Alcántara gate as Umayyad and
Taifa rulers had before them; the Bab Muawiya in the north continued to be the principal
access to the madina, the public and commercial city. The Bab Saqra would be steadily
used to visit the cemetery from the northern suburbs, and when it was eventually rebuilt,
care was taken to neither harm nor obscure the powerful statement of its caliphal arch
embedded with Visigothic spolia. The palace, the markets, the residential neighborhoods,
and the Jewish quarter all kept their original place in the city, positions that continued to
structure much social interaction. Muslims were now sold in the slave markets, but docu-
ments remind us that the diminishing number of Muslims in the city were also mer-
chants, potters, weavers, butchers, and bricklayers. With Muslim neighbors and a larger
and more influential Jewish population than the Castilians had ever seen, they went to the
same public baths that had served the Taifa population of the city, creating new laws that
governed when a Jew, a Muslim, or a woman could use them. The new denizens of Toledo

Convent of Santa Clara in Toledo, vestiges of a 12th-century house.

took possession of houses and neighborhood mosques, used the same markets, held court in the same halls.

With these social and economic changes tensions could run high. Alfonso found himself relying in part on the administrative structure in place from the time of the Taifas, and he depended at times on distinguished Toledan Jews, who were adept in Arabic and in local social and political customs, among them Arram ben Isaac ibn Shalib, physician, private secretary, and administrator of the armies, whom Alfonso sent to collect tribute from al-Mutamid of Seville. Joseph ibn Ferruziel, known as Cidellus, or little Cid, was physician and counselor to Alfonso himself, and also the *nasi*, or leader, of the Jewish community of the city. Alfonso was severely rebuked by Pope Gregory VII for elevating Jews to public office. The city's Muslims were not relegated to a separate neighborhood; they were dispersed throughout the city and participated in most aspects of its economy, though the rights they were accorded in their initial pact eroded with time. The Mozarabs, for their part, still followed the old Visigothic law codes and did not originally participate in the fueros of the Castilians or those of the Franks. They were driven to protest their exclusion from the new, Roman ecclesiastical hierarchy and its sudden new wealth, and in 1101 Alfonso was obliged to confront serious property disputes between different groups and appoint a series of judges to mediate between Mozarabs and Castilians. Unwittingly, the Castilians had begun by governing Toledo as the Taifa kings had, as a series of separate groups, each with their own separate laws. But this structural idea was not accompanied by the same legal protections. The Muslim population of the city steadily diminished, and, in 1108, in the anxiety following Alfonso's defeat at Ucles, a Christian mob—almost certainly Castilians and Franks—united in a violent attack of the Jews of Toledo, whose privilege in the city was blamed for the disaster.

In the terms of Toledo's capitulation, Alfonso had designated that al-Mamun's palaces should pass to him, including the alcazaba, the palatial zone of the al-Hizam, the palaces of al-Mamun later called "Palacios de Galiana" by the Castilians, and the retreats outside the walls with their fountains and gardens. The pleasure palaces between the river and the city walls would come to be known as the "Huerta del Rey"—"the Garden of the King,"

the palace in which Alfonso had lived during his exile in Tulaytula. Even the Castilians' primary place of worship—the principal mosque of the city—held its ground as the center of worship for the Castilians, supplanting the surviving Mozarabic cathedral. There were, of course, sound economic and social motivations for this remarkable continuity in Toledo's urban fabric, and dramatic symbolic reasons for the appropriation of the palaces, or for the change of site of the cathedral to the Friday mosque. But the preservation of these urban forms, like the preservation of art, literature, and social customs, would begin to broaden and transform the experience of the Castilian victors, in ways they had perhaps not envisioned when they first walked Toledo's streets. A century later, when the Castilians and Franks were the predominant landowners in the city—second only to the cathedral—and they came to build new houses, they would fashion homes and palaces that mimicked those of the Taifas: an open rectangular courtyard with porticos leading to long rooms on either side. Like Taifa palaces, some incorporated fountains, pools, and flowing water, new pleasures learned in the frontier city. We can see a twelfth-century patio from just such a house, preserved in the convent of Santa Clara, with an elegant, sharp, double horseshoe-arched doorway, ornamented with carved stucco and Arabic epigraphy.

But even more surprising is the style through which the new Castilian identity would be expressed in sacred architecture. The churches of the surviving Mozarabic parishes were probably among the first to be rebuilt or embellished. And new churches were briskly accommodated in confiscated mosques, as during the reign of Alfonso VII, when the "Christians took the church of San Salvador of the Moors on the Day of Saint John the Baptist." According to one account, Alfonso VII's queen, Berenguela, seems to have followed in the apocryphal footsteps of her husband's grandmother, Queen Constance, in depriving Toledo's Muslims of yet another mosque. Some believe this mosque, located near the cathedral, to the southwest, had been conceded to the Muslims of Toledo in the 1080s as recompense when Toledo's principal mosque was converted to the cathedral. The legend of its appropriation in fact suggests the Castilians felt the need to enlist a higher authority to justify the conversion of this neighborhood mosque into a church. As the story goes, during a violent storm in the city of Toledo, Queen Berenguela took refuge in this "mosque of the Moors," which stood near the center of town, and prayed there to God for protection. When the storm abated, she convinced "the King, her husband, that this mosque be made a church for Christians dedicated with the title of San Salvador."[9] The new church of San Salvador would disguise the mosque building very little: the minaret served as a bell tower, and part of a horseshoe-arched arcade from the mosque's prayer hall now forms its south nave arcade. The arcade is oriented not east-west as one would expect in a church but toward an absent qibla, in the direction of Mecca. But that arcade also incorporates late antique and Visigothic spolia as its capitals and supports, including a pillar with reliefs depicting the miracles of Christ, precious fragments of an ideologically charged past, which were either reused in the mosque or added in its conversion to a church. Exposed, even highlighted in the new church of San Salvador, this spolia served as a kind of visual justification for the appropriation of the mosque, as the city's Muslims were pushed into smaller and more rudimentary prayer halls.

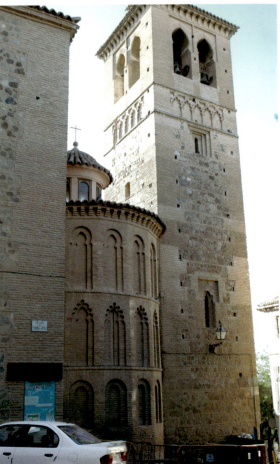

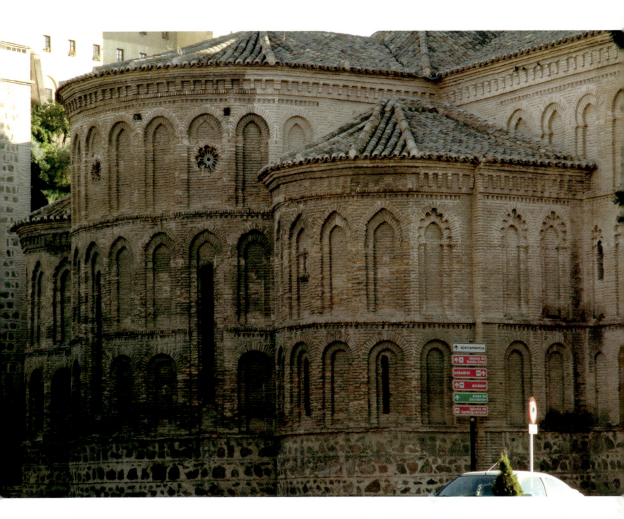

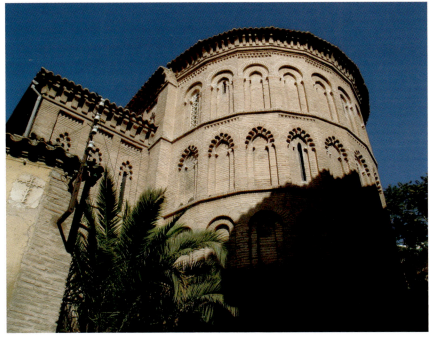

opposite, clockwise from top:

Church of San Eugenio.

Church of Santa Leocadia.

Church of San Vicente.

above: Church of Santiago de Arrabal.

left: Church of Santas Justa y Rufina, Toledo.

Among those buildings that continued to function as mosques, Las Torneras (named for the street of workshops on which it was located) was the most central, in the vibrant market neighborhood just to the east of the cathedral, in the heart of the Frankish quarter. Toledo's eminent historian of Islamic architecture, Clara Delgado Valero, believes the small mosque owed its survival in part to the importance of the affluent Muslim merchants who conducted business in this area of town. In the late twelfth century, while the mosque of Bab al-Mardum was being subsumed by a voluminous apse, Muslims could still leave their shops or stalls in the markets, weaving through hawkers and servants of all faiths, or past knots of Frankish and Castilian soldiers, to enter Las Torneras through a patio that served as its courtyard, to pray beneath its nine ingenious geometric cupolas.

By the third quarter of the twelfth century, swelling semicircular apses like those of northern Romanesque churches began to be appended to converted mosques as at Santa Cruz and Santas Justa y Rufina, but with a lively textured decoration quite at home in the vestiges of old Tulaytula. The skin of these apses was enveloped in row after row of decorative blind arcades, some doubled horseshoe arches, some scalloped or pointed from Islamic tradition, and others something new to Toledo: semicircular Roman arches, the immigration of an idea from Castilian Romanesque buildings in the north. On their interiors, these new apses combine the organization of a Romanesque church with the technique and ornament of Toledo's Mudejar art: horseshoe and scalloped arches harbor niches in which portraits of saints are tucked. Here is an architecture assimilating in more ways than one; its identity is evolving in a process far more layered and nuanced than a dance between two religions. Toledan Mudejar churches were not an exotic style preserving a frozen moment of cultural encounter. They are the expression of what has been called "Mudejarismo," in the words of María Teresa Pérez Higuera, "the process by which medieval Hispanic society is Islamicized, and comes to use Mudejar art to express its cultural identity, distinct from the European identity represented by Romanesque or Gothic."[10]

Even as the acts of domination and the rhetoric of crusade increased, Toledan Mudejar continued to be a series of evolving styles by which that new Castilian identity was expressed. By the mid-thirteenth century, the churches, and their apses—their way of presenting themselves to the public in Toledo's urban theater—became loftier, and began to betray the impact of Gothic style. Just outside the old city walls, not far down the hill from Bab al-Mardum, Santiago de Arrabal has abandoned the horseshoe arch in a soaring, elegant basilica with pointed arches, and a Gothic vault at its crossing. And it commanded the suburban neighborhood in which it was built with three round apses, and three corresponding aisles, an idea that had reverberated from Castilian "Mudejar" churches farther north. But it retains the dramatic exterior decoration of earlier Mudejar churches, horseshoe or scalloped arches cut sharply into the surface of the building, as if this were a part of Santiago's traditional identity its patrons were not willing to abandon, even in the face of a new Gothic fashion.

Toledan Mudejar would transform through renewed contacts with the different artistic traditions of al-Andalus, as well, despite political hostilities. With the social upheavals

Muqarnas

Muqarnas is one of the few architectural forms created within Islam. A kind of nonfigural sculpture, it is an abstract three-dimensional architectural motif that responds to the taste for intricate cerebral ornament driven by geometry and meditative complexity. Often compared to stalactites, muqarnas is composed of the stacking and layering of sections of cones, nichelike forms that move in and out of space. Muqarnas is thought by some to derive from the division of squinches, or the decorative rationalization of the transition between a round dome and the square room on which it rests. Muqarnas appears as a transition between different layers or planes of a wall, but can also envelop entire domes with its dizzying, confounding logic, as at the Alhambra.

Muqarnas at the Great Mosque of Seville, 12th century.

Muqarnas at the church of San Andrés in Toledo, 12th century.

Muqarnas dome at the Alhambra palace in Granada, 2nd half of the 14th century.

instigated by Almoravid and Almohad rulers, Toledo's position on the frontier made it the destination, the port of entry for immigrants and refugees from the south. The chronicle of Alfonso VII tells us of Mozarabs deported by the Almoravid emir Ali ibn Yusuf, and during Almohad rule in al-Andalus, whole communities of Mozarabs settled in the province of Toledo with their bishops: Mozarabs from Ejica, Niebla, and Madina Sidonia. These immigrants from southern lands are credited with the introduction of Almohad and Almoravid artistic forms that began to appear in the city in the late twelfth and thirteenth centuries, like the muqarnas vaults at San Andrés, an echo of those still to be seen in the vestiges of the Great Mosque preserved in Seville's cathedral cloister.

If we were to travel from Santa Cruz, slowly circling up from the low streets that hugged the northern city walls in the late thirteenth century, we would pass through a neighborhood peppered with churches and convents. This northern area had been the site of the homes of prominent Muslim families, with its covered passages and small privately built mosques, and now it held new Mudejar homes with patios and horseshoe arches, as well as this small village of churches. The church of Santa Eulalia is banked against a steep incline, hidden in a knot of houses and convents as we come upon it on our way toward the center of the city. It is in part a survivor, and its interior looks archaic: though the nave includes one pillar on each side, most of the nave arcades are composed of freestanding columns supporting horseshoe arches, making Santa Eulalia's interior resonate with memories of the Visigothic period, like those renewed and preserved by Mozarabic patrons, as at the church of San Miguel de Escalada near León. Santa Eulalia's east end is even screened by a wall creating a space darker and more mysterious than an open apse, and though the present wall is almost completely reconstructed, we can still see the compartmentalization of spaces typical of churches that followed the ceremonial of the Mozarabic liturgy. Santa Eulalia's construction is fine and sure, and yet the nave arcade of horseshoe arches is awkwardly composed of reused columns and capitals that vary in size and style. Many of these are fragments from the Visigothic period used as spolia. Spolia in Roman architecture was often meant to recall a vanquished foe. But here, these scarred and mismatched capitals and columns, sustaining an old-fashioned arcade of horseshoe arches like the beleaguered heroes of a long siege, are emblematic of the passion and resurrection of Visigothic Christendom and its long Mozarabic travail.

But Santa Eulalia is not a Visigothic church; it is probably a Mozarabic church rebuilt under Castilian rule, one then disastrously restored in the last century, in all cases with a certain tendency to fetishize the ghosts of Toledo's Visigothic past. But for all its triumphal and survivalist spin, Santa Eulalia still betrays its more complex history despite itself. The horseshoe arches of its arcade are each encased in a square frame, the Umayyad invention called the alfiz, like those that structure each door of the Great Mosque of Cordoba. The alfiz is not just a motif: it is a way of conceiving architectural forms as part of a system of decoration, in which the entire wall is alive with geometric play. The upper parts of the wall are also broken into parts, as a series of false windows open onto the side aisles, lightening the arcade wall while they break up the monotony of the high broad surface.

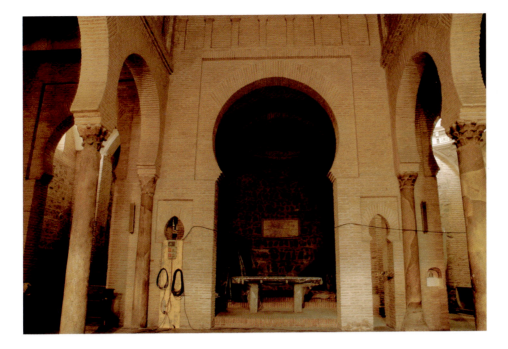

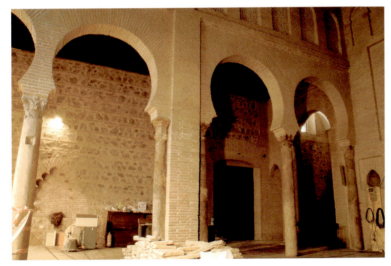

Church of Santa
Eulalia in Toledo, per-
haps 10th century,
reconstructed in the
12th century and
highly restored in the
20th century.

These openings might ultimately derive from Umayyad tradition remembered in a lost
mosque of Toledo, for they echo those at the Umayyad mosque of Damascus. But now
they are part of a kind of design dedicated to the construction of churches, and they are
thus windows into the complex identity both of the Toledans who fashioned them and of
those for whom they were fashioned.

Up the hill from Santa Eulalia is the church of San Román, whose bell tower, looking
for all the world like a minaret, was taller than any other structure in the city, at a time
when the cathedral was a Taifa mosque that spread low and wide throughout the center of
what Mozarabic documents still called the *madina*. Its architects lovingly crafted a horseshoe-
arched arcade on its interior, recessed so that each arch is framed by an alfiz, as well as the

same line of broad false windows as at Santa Eulalia, and lively scalloped windows and blind arches in brick. But now the horseshoe arches are all engaged to square brick piers, as is the habit in Romanesque buildings, and vertical pilasters, stretching to the ceiling from each pier, divided into vertical sections or bays, as at the church of Santiago de Compostela. On one hand, the vertical pilasters are a natural part of the Toledan system of construction in which the wall itself is enlivened with moldings and frames and shifts in planes; but on the other hand, that tradition is guided in such a way that it also answers a more northern Romanesque taste for rational vertical forms that trace the passage of weight from the roof, to the piers, to the ground. What we see at San Román is a Toledan Mudejar architecture that had both a powerful core tradition and one that changed with time. Its hybridity is not the fixed circumstance of a conquest but the evolving identity of a people who both transform and are transformed by the city they have conquered.

Steps away from Santa Eulalia, down a short narrow path, the church of Santa Leocadia was built nearly a century later. Its bell tower still mimicked a minaret, with a square plan and a little frieze of interlacing arches that traces its ancestry from the Umayyad Great Mosque of Cordoba to the Almohad minaret of the Great Mosque of Seville. The church culminated in three apses with taller, more elongated proportions than the one added to Santa Cruz, and they stacked three layers of blind arcades in brick: keel-shaped, scalloped, and semicircular arches, creating striking curved fields of severe, textured brick planes, an architectural calligraphy drawn by the sharp shadows of Toledo's afternoon sun. Santa Leocadia's apse is echoed in that of San Vicente, a short distance away, a church that seems entirely defined by its swelling, encrusted apse, a marker for all who pace the serpentine streets of this arduously steep city that weaves former mosques with new church foundations in a unified urban vision.

If we continue beyond the high ground of San Román, we can descend, beyond the cathedral, to the south, where Toledo's streets become steep again, this time plunging toward the Tagus River. We might pass the baths of Pozo Amargo, with their elegant ornament of pointed, keel-shaped arches, and a mosque turned into a house and a stable. As we descend into the old quarter of the dyers, toward the neighborhood of San Antolín, a familiar apse, belonging to another ruddy brick church, projects into the space between converging streets, textured shadowed arches riveting our gaze as they appear from between the mute walls of the dark city alleys. Here in the south of the city can also be found the church of San Lucas, with its horseshoe-arched naves made from brick piers, as well as San Sebastián, which might originally have been the mosque called al-Dabbaghin, built by Fath ibn Ibrahim al-Umawi in the tanners' quarter near the river at the city's southern limit.[11] The arcades of San Sebastián probably reused columns harvested from the mosque of al-Dabbaghin. But more surprisingly, it has also retained the southern orientation of the original mosque through successive rebuildings and additions, though churches built for Christian worship constructed arcades that reached from a western door to an apse in the east. San Sebastián faced the river, from which Toledo's southern slope rose like a forest of bell towers, slender and square-planned like so many minarets: the

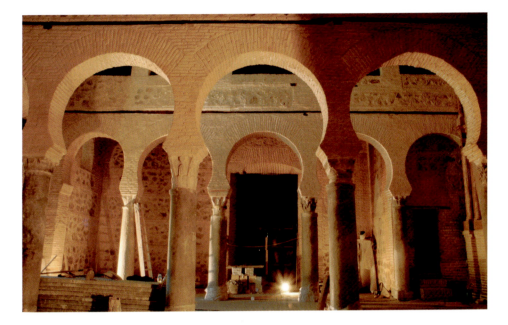

towers of San Cipriano, San Lucas, San Sebastián, and that of San Bartolomé, which, with its perfect caliphal window like a miniature mihrab from

Church of San Sebastián in Toledo, arcade of the 12th-century church, retaining the orientation of the mosque it replaced.

the Great Mosque of Cordoba, was surely an actual minaret at its inception, like others with which it stands.

Throughout Toledo, the imbrication of periods and styles bears witness to a reality that would only be obscured if we insisted on dissecting each monument's parts, segregating each capital or arch by chronology, reign, or religion. Toledo teems with churches that carry in their fabric undisguised intimacy with the mosques of Tulaytula, or that fold ancient spolia into their naves, fragments that conjured a Visigothic past for the building that made the eleventh-century taking of the city look, in the twelfth and thirteenth centuries, like an act meant to complete a divine plan for Christian hegemony. To attempt to disentangle the converging and contradictory historical artifacts that compose the history —real and imagined—of Santa Cruz, Santa Eulalia, San Salvador, San Bartolomé, or dozens of other Toledan churches—to attempt to draw the confessional stratigraphy, the layers of religious identities of these monuments—is to lose their primary message as envoys from a hybrid world. The bell tower of San Bartolomé, created as a minaret, or the Visigothic capitals of Santa Cruz, reused serially in a mosque and a church, cannot be properly understood through a retrospective segregation of parts. Organize these monuments chronologically, pull them apart, and we are left with a sad pile of historical detritus. The point of this sly historical rebus is precisely its indecipherability, its indecipherability despite itself. It no longer makes sense to separate the threads of Castilian, Taifa, Umayyad, and Visigothic culture in these works of architecture, disentangling the roots of each fragment or motif through an inquiry into style, religion, or political history. Castilian culture, Castilian identity, is now something more than the sum of its parts.

Far more than the sum of its parts, too, is the great poetic monument of the age, the distinctly Andalusian form called *muwashshah* in Arabic. Behind that seemingly inscrutable Arabic word lies the principle of vital entanglement so visible on the streets of Toledo. The name of this enduringly popular song form literally means something like "sash" or "circle" or (in a very old-fashioned vocabulary) "girdle," and these images from the world of fashion suggest the encircling and ornamentation of the song's stanzas. The poems begin with a number of stanzas in formal classical Arabic—or in Hebrew—which circle around to its final lines, the *kharja*, an impertinent refrain in a completely different language, the vernacular. These final verses could be in either of the common street languages of the moment: spoken Arabic or that form of spoken Latin we call Romance. This quintessentially Andalusian song tradition—it is invented here and is still known in the Arabic world as Andalusian—is explicitly built on the dialogue between the divergent sounds, styles, and spirits of two languages: the venerable classical Arabic pillars and the vernacular refrain. If we translate *muwashshah* as "ring song," we appreciate vividly that the role of the song's final verses (in Arabic, *kharja* means "going-out") is fundamentally irreverent: the upstart local language, more often than not in the voice of a woman, playing with and running rings around the canonized classical Arabic poetic tradition, with its formal and authoritative male voice.

One can feel the play between the two traditions, even in translation, in the voice of Ibn Quzman, one of the most celebrated Andalusian poets, a towering figure during the first half of the twelfth century:

> Disparagers of love, now hear my song;
> Though you be of a mind to do love wrong,
> Believe me, moonlight is the stuff whereof
> My lady's limbs are made. I offer proof.

So begins the poem, only to end with the startling voice of the Lady herself singing:

> *Easy does it, not too quick,*
> *I like it slow, and nothing new.*
> *Custom knows a thing or two,*
> *It's to custom we should stick:*
> *Festina lente, that's the trick—*
> *Come at me slow, I'll come with you.*
>
> Trans. Christopher Middleton and Leticia Garza-Falcón

The colloquial language of the refrain varies from poem to poem. In some cases, including those that show evidence of having been the primordial ones, the refrain is in Mozarabic, sometimes now called Andalusi Romance. Not formalized as an independent written language, Mozarabic is distinctively the indigenous language of the Christians of

the caliphate and the Taifas. But it is also a mother tongue of countless Muslims. And in other cases the kharja is the mirror image of that popular Romance: the Arabic of the streets, the informal and spoken variant of highly formal poetic Arabic, another language that easily tied the faith communities to each other, the language of markets and harems and kitchens, side by side with the Latin-based vernacular. Indeed, in a number of poems the language of the kharjas has become infamous, and endlessly—at times bitterly—scrutinized by scholars, precisely because it is not clear whether the language is really one or the other: for some it looks like Arabic with inflections of Romance, but for others it is more obviously Romance saturated with Arabic.

A further layer of inscrutability comes from having to actually read these bits of a poetic language that were distinctive precisely because they were not a part of a written tradition. The presence of the oral was the purposeful counterpoint to the written lyrical forms. Because these refrains are most often in a female voice, which further marks the voice and its language as not-classical, the kharjas are emblematic of that whole universe of mother tongues, speaking and singing that lay explicitly outside the rules and formality of the courts, and their culture. But by necessity this song culture has been transmitted to us in Arabic script. Or, in a significant number of cases, in Hebrew: the eleventh century witnessed a historic efflorescence of poetry in Hebrew, which had long been a merely liturgical language, as the Arabized Jews of al-Andalus reinvented a poetic tradition that had not seen its like since the era of David and Solomon. The Jewish poets also relished the muwashshah, part of a whole poetic canon in the brand-new lyrical Hebrew they were inventing out of their intimacy with the Arabic poetic tradition. They cultivated the contrast between the Hebrew of the principal strophes and the vernacular kharja, sung in either Mozarabic or the vernacular Arabic. Most of the poets of what is dubbed the golden age of Hebrew poetry, among them its most famous and influential, Judah Halevi, a sometime-citizen of Toledo, tried their hand at this poetic form, and its play of tones and voices.

The modern-day deciphering of the kharjas, long assumed in academic circles to be gibberish at the tail end of these perplexing poems, came about via the work of a scholar studying not so much Arabic but principally Hebrew examples of this lyrical form. The distinguished and extensive body of muwashshahat of the great Halevi himself—who spent years in Toledo and who was almost certainly a part of the circles close to Alfonso VI —was central to the mid-twentieth-century insights about the multilingual nature of this song form, as were those of other Jewish luminaries, among them Moses ibn Ezra, whom some would consider the very embodiment of the Andalusian Jewish golden age, and its intellectual and poetic achievements. Even in thirteenth-century, long-Castilian Toledo the muwashshahat would remain alive and well, and one of the songs of Todros Abulafia speaks to the vigor and continuing life of this half-blood form, where Arabic love poetry lives in its various communions: with Mozarabic street songs, and the Christian women who are their archetypical singers, and with a Hebrew lyrical voice that has remade itself in this community of thoroughly Arabized Jewish poets.

above, clockwise from left:

Church of San Bartolomé, bell tower made from a minaret.

Church of San Bartolomé, window with alfiz.

Church of San Bartolomé, Visigothic reliefs reused in the minaret and subsequently in the bell tower.

below:

Bell tower of Santiago de Arrabal in Toledo.

Bell tower of Santiago de Arrabal in Toledo, window with alfiz.

opposite, from left to right:

Bell tower of San Lucas in Toledo.

Bell tower of San Sebastián in Toledo.

Bell tower of San Román in Toledo.

Bell tower of Santa Leocadia in Toledo.

Bell tower of Santo Tomé in Toledo.

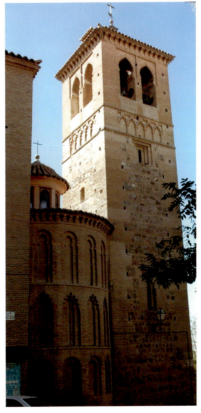

Judah Halevi

Born in northern Spain around 1075, Judah Halevi
was an itinerant poet who spent much of his youth
in the southern lands of Islamic Spain. He found his
way to the kingdom of Castile sometime around
1100 and settled in Toledo, where he worked as an
associate of Cidellus (Joseph ibn Ferruziel), the court
physician and advisor to Alfonso VI. A true master of
Hebrew language and prosody, Halevi was versatile
in incorporating biblical imagery and Arabic poetics,
and he is revered as one of the greatest poets of al-
Andalus both for the power of his sacred verses—
part of the Jewish liturgy to this day—and for what
his translator Peter Cole has called his "quietly
haunting" secular lyric.

If only I could give
 myself in ransom for that fawn
who served me honeyed wine
 between two scarlet lips . . .

I think of all that pleasure
 the best of months gone by,
a time when in my arms
 the sun's brother would lie;
my chalice was his mouth—
 I drained its ruby dry.
 And love's hand between us
 sustained me in my love;
 love's hand brought us near
 and never did me harm.

The blame then is mine,
 not his who stole my heart,
and yet my pain was great
 the day that I departed
from his tents despite
 his pleas that I stay on.
 But Time's thread led me out,
 and onward to another;
 Time despised me so,
 it saw to my departure.

The Red Sea, my friends,
 was parched beside my weeping,
and for my heart, my eyes
 had not the least compassion,
from the day my footsteps
 fell on foreign soil . . .
 Sorrow in my eye
 formed a second sea—
 I feared that it would drown me
 and no one pull me free.

In David I forgot all this,
 and thinking of his favors,
I offer up these verses
 a necklace in his honor,
rebuking Time, which hounds me,
 increasing now my power.
 My sword grows drunk with Time's
 blood which leaves me thirsty—
 Time would drive me out,
 but clearly doesn't know me.

 A dove nesting there
 in the myrtle now is watching,
 as I prepare my song,
 as I complain of Time;
 her voice gently calls—
 like a girl who's singing:
 In the end I'll win—
 loving once was fun;
 leave Time to Ibn
 al-Dayyeni's son.

Trans. Peter Cole

מִי יִתְּנֵנִי כֹּפֶר לְעֹפֶר יַשְׁקֵנִי
צוּפִי וְיֵינִי מִבֵּין שְׁנֵי שְׂפָתוֹת שָׁנִי:

אֶת־שַׁעֲשׁוּעַי אֶזְכֹּר וְטוֹב יַרְחֵי קֶדֶם
עֵת בֵּין זְרֹעַי הָיָה אָחִי שֶׁמֶשׁ רֹדֶם
מִפִּיו גְּבִיעִי אֶמְצֶה בְדֹלַח עִם אֹדֶם
בֵּינוֹ וּבֵינִי יַד אַהֲבָה תִּסְעָדֵנִי
וּתְחַבְּרֵנִי אֵלָיו וְלֹא תַחְטִיאֵנִי:

עָשַׁק לְבָבִי עֲלֵי חֲמָסִי לֹא עָלָיו
עֵת רַב כְּאֵבִי יוֹם רָחֲקִי מֵאֹהֳלָיו
וַיִּפְגְּעָה בִי אוּלַי יְשִׁיבֵנִי אֵלָיו
וַיְמַשְׁכֵנִי חוּט מִזְּמָן זָר יוֹרֵנִי
כִּי יִשְׂטְמֵנִי דַּרְכֵי פְרִידָה יוֹרֵנִי:

יַם סוּף יְדִידִי מוּל יַם דְּמָעַי כַּצִּיּוֹת
כִּי עַל־כְּבֵדִי עֵינַי בְּלִי רַחֲמָנִיּוֹת
מִיּוֹם צְעָדִי דָּרְכוּ אֲרָצוֹת נָכְרִיּוֹת
עוֹנִי בְעֵינִי יִתֵּן לְפָנַי יָם שֵׁנִי
פֶּן יִשְׂטְפֵנִי אֶפְחַד, וְאֵין מִי יַמְשֵׁנִי:

אֶשְׁכַּח בְּדָוִיד כָּל־זֹאת וְאֶזְכֹּר טוֹבוֹתַי
לָתֵת כְּרָבִיד עַל־מַהֲלָלָיו שִׁירוֹתַי
אֶגְעַר בְּמַכְבִּיד אֶבְלִי וְאַרְבֶּה צְבָאוֹתַי
אַשְׁכִּיר אֲזֵנִי מִדַּם זְמָן יַשְׁכִּירֵנִי
וּלְגָרְשֵׁנִי נֵכָר, וְלֹא יַכִּירֵנִי:

יוֹנָה תְקַנֵּן בֵּין הַהֲדַס בִּי תִתְבּוֹנֵן
עֵת שִׁיר אֲשַׁנֵּן אוֹ עַל־זְמַנִּי אֶתְאוֹנֵן
קוֹלָהּ תְּחַנֵּן אֵלַי כְּעַלְמָה תִּתְרוֹנֵן
בִּין סירי ביני אלקרדש תאוה ביני
דשה אלזמאן כן פליו בן אלדיין

I take delight in my cup and wine
and go down to the garden and spring—
and hearing the song of doves and swifts,
 I, too, begin to sing . . .

I tell plainly of all my loves,
despite my jealous friends' concern.
I sing with a beautiful doe whose cheek
 is like the crescent moon—
the melody rises up in the groves
and my lips there in the garden move
 and like the birds above me call,
 as from the branches they respond.

I hold the goblet in my hand—
a graceful girl is at my feet;
I take in the fragrance of the cinnamon's scent
 and eat thin slices of roasted meat.
I taste her lips and drink the wine,
and waken my flute, as desires rise—
 and drink my fill of nectar with her,
 until my thirst is wholly quenched.

My friends speak and plead with me
to loosen myself from the grip of that girl:
"How could you let that daughter of Canaan
 hold you in desire's spell?"
And I, in turn, answer them:
"If love of that girl is a burden to me,
 I'll wear it on my head like a crown—
 or around my neck like a string of pearls."

Now like a miser, she holds back.
In my largesse, I scatter tears.
I look at my plight, and think "Just maybe,
 she'll have mercy and see my ordeal."
I'm wearing away in my desire—
if only I would grow so thin
 that to the spies I'd disappear,
 and never be seen by them again.

Come back, my doe, and sit by my side.
With the balm of your mouth, heal my pain.
"I can't," she says, "I'll be reproved
 if they see us," and I respond:
"Within my illness I've been consumed
and so no longer possess a body—
 and in my thinness if a man
 stared at me he wouldn't find me." Trans. Peter Cole

אשמח בכוסי

אֶרֵד וְאָבוֹא לְגַנִּי אֶשְׂמַח בְּכוֹסִי וְאָשִׂישׂ
כִּי אָז תְּרַנֵּן לְשׁוֹנִי. אֶשְׁמַע זְמִיר תֹּר וְקוֹל סִיס

עַל אַף מְקַנֵּא וְנִרְגָּן דִּבְרֵי אֲהָבַי אֲבָרֵר
לֶחְיָהּ כְּסַהַר וְאָגֵן עִם יַעֲלַת חֵן אֲשׁוֹרֵר
אֶפְתַּח שְׂפָתַי בְּתוֹךְ גַּן וּזְמִיר בְּפַרְדֵּס אֲעוֹרֵר
אָשִׁיר וְהֵם יַעֲנוּנִי. וּכְסִיס וְעָגוּר עֲלֵי צִיץ

וּלְיַעֲלָה עַל שְׂמָאלִי מִזְרָק אֲשׂוּ עַל יְמִינִי
אֹכַל מְבֻשָּׁל וְצָלִי אָרַח בְּמֹר קִנְּמוֹנִי
אֶשְׁתֶּה, וְאָעִיר חֲלִילִי אָמַץ שְׂפָתָהּ וְיֵינִי
עַד כִּי אֲרֵו צִמְאוֹנִי. אָרִיק וְאֶשְׁתְּ רֹק וְעָסִיס

אָמְרָד בְּחֶשְׁקָהּ וְאָמְעָל: אוֹמְרִים מְרִיבִים, לְמַעַן
תַּעֲשֶׂה כְחֶפְצָהּ וְתִפְעַל? אֵיךְ בָּךְ, גְּבִיר, בַּת כְּנַעַן
אִם אַהֲבָתָהּ כְּמוֹ עֹל – וַאֲנִי אֲשִׁיבֵם וְאַעַן:
מִצְחִי, עֲנָק צַוְּרוֹנִי. עַל אַהֲבָה הוּא אֱמֶת צִיץ

אֶבְזֹר כְּנָדִיב דְּמָעַי תִּמְנַע חֲפָצֵי כְּכִילַי
תַּחְמֹל בְּשׁוּרָהּ נִגְעַי אֶרְאֶה נְגָעַי וְאוּלַי
אֶדַּל עֲדֵי כִי לְרֵעַי – סַפְתִּי בְּחֶשְׁקָהּ וְאַחְלַי
צוֹפֶה וְלֹא יֶחֱזֵנִי. אֶהְיֶה כְנֶעְלָם, וְיָצִיץ

רְפָאִי בְּרֹק פִּיךְ כְּאֵבִי יַעֲלָה, שְׁבִי נָא לְמוּלִי
פֶּן יֶחֱזֶה מְרִיבִי וַתַּעֲנֶה: אִירָאָה לִי
סַפְתִּי, וְגוּף אֵין כְּבָר בִּי וְאָמְרָה: הֵן בְּמָחֳלִי
מִן אַלְנַחוּל לַם יַרְאָנִי. וְאִן שַׁ'ץ פִי' שַׁאכְ'ץ

Here we find virtually every trope of the love-song traditions—the poet who is part of the community of birds, and sings like and with them; the wasting away that comes with love, and its sufferings, deprivations that are the ornaments and markers of love, and worn proudly; the beloved's likeness to does and moons—which the muwashshah takes out of the classical Arabic universe and makes its own. And the metamorphosis provoked by this union and communion with non-Arabic poetry makes this a lyric tradition that is a part of the other traditions of the peninsula as well, of Romance and of Hebrew. The mixture of languages and poetic dictions, the overlapping of various voices, the will to confound categories—all lie at the heart of this heterodox form emblematic of Andalusian culture. The description of the muwashshah by the great fourteenth-century historian and historiographer Ibn Khaldun in his *Muqaddimah* is still its most telling and most eloquent:

> Poetry was greatly cultivated in Spain. Its various ways and types were refined. Poems came to be most artistic. As a result, recent Spaniards created the kind of poetry called muwashshah. Like the qasidah, the muwashshah is used for erotic and laudatory poetry, and its authors vied to the utmost with each other in this kind of poetry. Everybody, the elite and the common people, liked and knew these poems because they were easy to grasp and understand. . . . Muwashshah poetry spread among the Spaniards. . . . As a result the common people in the cities imitated them. They made poems of the muwashshah type in their sedentary dialect, without employing vowel endings. They thus invented a new form, which they called zajal. They have continued to compose poems of this type down to this time. They achieved remarkable things in it. The zajal opened a wide field for eloquent poetry in the Spanish-Arabic dialect, which is influenced by non-Arab speech-habits.[12]

The *zajal* is, indeed, the counterpart and sister form to the muwashshah, a song in which Romance and Arabic do not even pretend to be separated into different kinds of strophes in the same poem, but are thoroughly interwoven. The master poet of the form was Ibn Quzman, whose single muwashshah we began with, and to which we now return, to observe more closely the intricate intermarriage of languages and voices. Although the kharjas appear only once at the end of the written version of the full poems, their sounds—their rhymes and rhythms—give shape to the whole of the poem. As in much modern lyric, this refrain may seem small in its written traces but it is the unifying and recurring thread woven through the song, the insistent response of the vernacular to the call of the classical.

> Disparagers of love, now hear my song;
> Though you be of a mind to do love wrong,
> Believe me, moonlight is the stuff whereof
> My lady's limbs are made. I offer proof.

Something I saw, full moon in her, alive,
Cool in her balanced body, took me captive;
Her beauty, young, her anklets, with a thrill
They pierced my heart, to cause every ill.
"Easy does it, not too quick,
I like it slow, and nothing new . . ."

A lover is a man amazed. Desire
Can drive him mad the moment he's on fire;
Heartsick, when he has the thing he wants;
Worse, if he's deceived by what enchants.

A lover knows he's not the only one.
His lady's garden gate, she keeps it open:
A challenge—passion hurts him even more.
Whom will she choose? Whom will she ignore?

I'm of a kind a woman's body charms
So to the quick, it's Eden in her arms:
Absolute beauty being all we seek,
We can be melted by a touch of magic.

As for the moon, so for the sun: from both
She draws her power; moon pearls grace her mouth,
Solar fire crimsons her lips, and yet
She's not ambiguous when her heart is set.

Burning in my reflections, day by day,
In every act of mine she has her say;
Even when, if ever, she's at peace,
You'll never find her supine in the least.

Such is my proven moon, my lady love.
Yet of myself she did once disapprove:
Pointing to the marks my teeth had made
Across her breast, then eyeing me she said:
"Easy does it, not too quick,
I like it slow, and nothing new.
Custom knows a thing or two,
It's to custom we should stick:
Festina lente, that's the trick—
Come at me slow, I'll come with you."

Here the magic of the music and lyrics lies in the wedding of opposites and some-time antagonists, the Arabic and Romance strands that are also courtly and vulgar, male and female, lover and beloved. And the arts of Toledo and the songs shared not just the historical moment but also an aesthetic of desired entanglement that goes beyond the cliché that the whole is greater than the sum of the parts. Understanding the whole has been among the most exacting tasks in the literary history of the Arabic, Hebrew, and Romance worlds, the distinct universes to which these poems belong in different meas-ures; or, rather, to none of which they really belong since their whole is profoundly dependent on the dialogues. What, after all, is the lover's voice without the beloved's response? How different is it to hear the beloved actually answer—beloveds in poetry being notorious for their complete silence—and to take measure of the sound of her voice, her tone and attitude? The poetic and historical puzzle has everything to do with what can be heard only when both languages are heard alongside each other.

The lover, in the poetic voice of Ibn Quzman, is itself a wonderful concoction: one heaping measure of the omnipotent tradition of classical Arabic poetry, with its veneration of love and the object of desire at its very center. But in Ibn Quzman's hands this honored tradition, with some of its many tropes lovingly rehearsed (the moon- and sun-ness of her beauty, the all-consuming obsession of love), is also infused with a healthy dose of impu-dence and near-pornographic wit, which find their fullest expression in his songbook of zajals. But in the muwashshah here, the woman's voice in the kharja, her straight-shooting and disarmingly unromantic voice, is right out of a broad and popular tradition of female songs in the Romance vernaculars, a vulgar tradition—vulgar in all the different senses of the word—distant indeed from that courtly tradition to whom, as it turns out, she is giv-ing instruction on how to make love and thus, in effect, on how to make love poetry.

In many of the songs of this tradition, when the fresh and brassy beloved appears, since she is explicitly singing in Mozarabic, she is the strand in the poem that alludes unmistakably to the Christians who kept their spoken-Latin linguistic tradition alive side by side with their absorption of Arabic. And simultaneously she personifies all the Christian women who were the lovers—and the mothers!—of Muslims. And she is in charge here: the distinctiveness of the ring songs, and what makes the muwashshah a renegade poetic genre in the Arabic canon, is that the almost shockingly unclassical female voice rules; she has literally made the seemingly omnipotent male poet, and his tradition, dance to her very different beat. The courtly poet's stanzas turn out, on closer inspection, to be not so classical after all, to be set to the beats and rhymes of the little kharjas. The Arabic verses are, first of all, shaped in poetic meters that are more like those of Romance than of the Arabic canon. But, even more strikingly, they use rhyme patterns—alternations of rhyming sounds—which are wholly alien to the classical Arabic tradition, in which a single rhyme unifies an entire poem.

Who, here, is the victor, who the vanquished? What meaning can conventional notions of linear influence have in such a universe, where the aesthetic point is to dance rings around linearity itself, to mirror the remarkable alliances and consanguinity of the

sort that bound Umayyads to Navarrese in the tenth century or Alfonso VI to Zaida, and his son and heir? And what does it tell us about the aristocracy of Arabic letters in the eleventh century, when this thoroughly unclassical ring-song tradition can count among its devotees and authors the likes of the great poet-king, al-Mutamid of Seville? That prominent political figure of the last decades of the Taifas, and in the events culminating in the arrival of the Almoravids, is no less powerful or princely in the history of the ring song.

من يغش
أو يهجر خلّه
كيف ينعش؟

علقت ظبيى
مسودّ السوالف
شمسيّة المحيّى
غصنيّة المعاطف
إذا قام يعيى
بحمل الروادف
كأنّ الحميّى
من تلك المراشف
من يرش
من فيه ببلّة
كيف يعطش؟

منّي بالتمنّي
لمن يتمنّاك
ورضي المتمنّي
وجودي بعتباك
عليه ومنّي
برشفي ثناياك
قالت بتجنّي
اخشى لائم في ذاك
قلت لش؟
والسمح بقبلة
ليس يفحش

متى أستريح
من هجر الحبائب؟
اغدو وأروح
منه في كتائب
والهجر قبيح
إذ لست بتائب
عن شمس تلوح
من تحت الذوائب
كالحنش
يكسو الجسم حلّة
هين يفرش

غزال بفرّد
بالحسن الحصين
حسن ليس يوجد
إلا بالظنوني
بلحظ تقلّد
حسام المنون
وخدّ تورّد
بالورد المصون
في غبش
أن تلحظه مقلة
فيخمّش

وليل توالت
علينا الملاهي
إذ نمت فقالت
تريد انتباهي
سنتك طالت
فكم انت ساه؟
ولمّا استمالت
قلت أش
تحيّي بكله
حلو مثل أش

You are abandoned by a friend:
What will console you? Or, again,
A friend cheats on you, what then?
What can calm you, what be done?
How now to take things as they come?

I quit, but I'll be back
With him, his troops of horsemen
Draw me. Though
Splitting up is rough, I know
A sunrise I'll for certain never lack
Or think of it, "I've had enough."
The way it surges from below
Tufts of hair attract me so.

A snake puts on new fancy threads
And they are not the ones it sheds.

Captive I am of a gazelle,
Her black hair, sun-tinted face,
So delicately branched her limbs,
How do they lift her full hips?
Wine's fire, shot from those lips,
Her mouth's light moisture—well, I think
You'd not be thirsty, drinking it.

A beauty, chaste, like none
Other, save in imagination.
But then her gaze: clear it foresees
The slash of death. Her cheek's rose,
Carnage, with darkness
Like a dawn it blushes.
A mere look, you think, will hurt her.

Give him what he wants, I told her,
Let him kiss your teeth.
She said she was afraid of such a sin.
A kiss was not abominable, I told her.

Then many pleasures in the night
Made many more for us, until,
When I was sleepy,
She woke me, said: "Why sleep at all?
Have you forgotten me or something?"
And over me she leaned, told me:

"See how a little mouth to bliss
Restores so sweet a thing as this."

Trans. Christopher Middleton and Leticia Garza-Falcón

We inherit these poems through opaque historical veils that make their appreciation an act of various and complex kinds of translation. For anyone other than the rare reader of both classical Arabic and medieval vernacular Romance, or of both the eleventh-century poetic Hebrew concocted by the Andalusian Jewish poets and vernacular Arabic and Romance, there are almost insuperable difficulties. None is more crucial than grasping the dramatic about-face of tone and accent that takes place between the classical stanzas and the refrain, although this vacillation and exchange can be vividly captured in musical performance. But literary translations of these complicated poems are scarcer than one might predict, knowing that this is the form that elevated Andalusian songs to stardom throughout the Arabic-speaking world and whose chic was coveted, and ultimately acquired, by the singers later known as troubadours. An Andalusian who found himself writing about the ring songs in thirteenth-century Baghdad bragged that "the muwashshah is the cream of poetry and its choicest pearl; it is the genre in which the people of the West excelled over those of the East."[13]

No one today would dispute that the muwashshah is the quintessentially original literary form of the Andalusians, nor that its genius resides in its embodiment of the multilingual and multiconfessional landscape that characterized medieval Spain, from Umayyad Cordoba through the Toledo of the first Castilians. But for hundreds of years, despite the pride and praise of prestigious Arab historians such as Ibn Khaldun, the ring songs lay virtually unknown. Their decisive decipherment did not come until the middle of the twentieth century, and out of the Hebrew exemplars. It was Samuel Stern who had the earthshaking insight that it was the "sedentary language"—to quote Ibn Khaldun now—of the whole range of "common people" of medieval Spain, with their integrated song traditions, that was the key to understanding this poetry. Nevertheless, the poems continue to suffer both isolation and segregation, torn asunder: the body of the poem in classical Arabic or Hebrew studied separately from the vernacular refrain. The classical stanzas are read so as to make sense inside the Arabic or Hebrew poetic canons, while the little refrains are worked into Spanish literary history, by treating the Romance kharja as if it were an autonomous poem.

But pull these monuments apart—the classical stanzas and the kharjas—and we are left with an incomprehensible pile of shards, out of context, uncomfortable in isolation, incomplete without their other. What is remarkable is to see the aesthetic values of Arabic poetry in Spain setting aside the most basic formal rules of the

Todros Abulafia

A native and denizen of Toledo, Abulafia (1247–sometime after 1300) was an ambitious poet who worked in the Alfonsine courts and commanded both the Arabic and incipient Castilian literatures of the day. One of his short poems records the audience he was granted with the king, Alfonso X:

Faith's vengeance on falsehood was taken
the day Alfonso was crowned as King—
and so, coming to serve you, I bring
a cup for your glory, with this small hymn.

For the Lord commanded in Scripture: Ascend
to sacred feasts with a gift in the hand.
Trans. Peter Cole

His "I take delight in my cup and wine" (on p. 150) has its kharja in Arabic, written in Hebrew script along with the rest of the Hebrew poem.

Ibn Quzman

Muhammad ibn Abd al-Malik ibn Quzman (1078–1160) was a native of Cordoba, and among its most illustrious and notorious poets in the age of the Almoravid domination. Much of his life was apparently spent wandering from one city to the next, either seeking patrons or fleeing troubles that may have been caused by his authority-defying poetry. In addition to producing a sizable corpus of classical poetry, he fashioned a revolutionary poetic style in the *zajal*, a poem written in the colloquial Arabic of al-Andalus, interlaced with words and expressions in Romance, sometimes in elaborate and lewd puns. His strong poetic rebelliousness is emblematic of the Andalusians' discontent with Almoravid puritanical standards, and his use of the various Andalusian vernaculars—the mixture of Arabic and Romance—was an eloquent and sophisticated challenge to the new rulers, for whom those languages were both alien and "corrupt." Ibn Quzman often wrote provocative verses with an eye explicitly on the difficult politics of the stricter religious authorities of the Almoravid period. In one poem he comments explicitly on the troubles his poetry creates:

I said what I had in mind: that is my excuse
 Here I make a stop and my zajal ends.
You are the Almoravids, so I know the story,
 You have never liked any extravagance.

Trans. Amila Buturovic

Indeed, in many of his zajals, including some of the most famous, we are treated to that "extravagance," the boastful poetic persona—a willful drunk and letch—who seems to be thumbing his nose at the Almoravids, taking the free-spiritedness of Andalusian social and poetic mores to extremes of both form and imagery:

My life is spent in dissipation and wantonness!
O joy, I have begun to be a real profligate!
Indeed, it is absurd for me to repent
When my survival without a wee drink would be certain death.

Vino, vino! And spare me what is said;
Verily, I go mad when I lose my restraint!
My slave will be freed, my money irretrievably lost
On the day I am deprived of the cup.
Should I be poured a double measure or a fivefold one,
I would most certainly empty it; if not, fill then the
 jarrón!
Ho! Clink the glasses with us!
Drunkenness, drunkenness! What care we for
 proper conduct?
. .

I, by God, was seated, when there came to me with a
 garland on her head,
A Berber girl; what a beauty of a *conejo!*
"Whoa!" [Said I, "she] is not a *sera* of *cardacho*,
But don't pounce [on her] for neither is she a *grañón!*"
"Milady, say, are you fine, white flour or what?"
"I am going to bed." "By God; you do well!"
I said: "Enter." She replied: "No, you enter first, by
 God."
(Let us cuckold the man who is her husband.)
Hardly had I beheld that leg
And those two lively, lively eyes,
When my penis arose in my trousers like a pavilion,
And made a tent out of my clothes.
And since I observed that a certain "son of Adam"
 was dilated,
The chick wished to hide in the nest.
"Where are you taking that *pollo*, for an immoral
 purpose?
Here we have a man to whom they say: 'O what
 shamelessness!'"
I, by God, immediately set to work:
Either it came out, or it went in,
While I thrust away sweetly, sweetly as honey,
And [my] breath came out hotly between her legs. . . .

Vino is Romance for "wine"; *jarrón*, "jug"; *conejo*, "rabbit"; *sera,* "basket"; *cardacho*, "thistle"; *grañón*, "porridge." *Pollo* is from Latin *pullus*, for "young animal," probably not from Spanish *pollo* for "chicken."

Trans. James T. Monroe

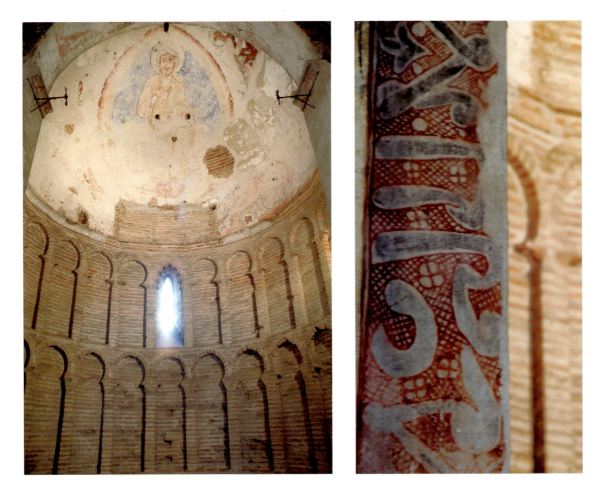

Church of Santa Cruz in Toledo, apse interior.
Church of Santa Cruz, inscription.

classical tradition. The kharja might indeed once have been part of an autonomous and popular tradition of women's songs, and perhaps intelligible inside some hypothetical purely Christian (and presumably purely female and purely Latinate) universe. Yet it is alive today not as part of such a separate state but rather as an integral and formative part of a poetic tradition that reveled in the ambiguity of high and low, of male and female, and, perhaps most to the point, of Muslim and Christian, or Jewish and Christian, or Jewish and Muslim, of Arabic and Hebrew and Romance.

Like Bab al-Mardum itself and the polyglot architectural traditions of which it is a part, the muwashshah, the cultural trophy of the Taifas, brought the vernacular language of the native Christians of old Hispania directly and explicitly into the orbit of the classical Arabic of the Muslims. Or was it the other way around, in this rocklike song tradition, where the unlettered local and indigenous popular traditions breathed new life and originality into more staid and respectable poetic forms? The classical Arabic poems, with their powerful male poetic voices in formal courtly language, bear the unmistakable marker of literary and social status, the tie that binds the poet to hundreds of years of canonical traditions. At first sight it would seem to have swallowed nearly whole the untutored voice

that pipes up only at the end, clearly tied to the ephemeral world of women's songs in maternal languages like Mozarabic, far below anything like written status. From certain perspectives what is at stake here is an appropriation of sorts, an easy citation, the classical male poets of wealthy al-Andalus plucking the flower of early Romance literature. Perhaps benign, perhaps misogynist and culturally prejudiced, perhaps indifferent, its value ends up being something like historical preservation, which is how the Spanish literary tradition casts the ring songs when it plucks out their kharjas for its own purposes—and how the Arabic literary tradition casts it when it sees that same kharja as little more than a token, a nod the long-established poetic tradition can afford to make to the locals.

But on closer inspection it turns out that the transaction—what literary historians all too often speak of with the reductive term "influence"—is more complicated than either citation or derivation. This is a lyric, and its music, from a universe where the pull of gravity is ambiguous, and both planets are ultimately reshaped. And in the cosmos of rampant metamorphoses, some sought, others forced, the question surely arises: Just who is converting whom when classical Arabic poetry is reshaped by the street language of Christian women, and when their once-popular songs thus become a characteristic part of the courtly culture of refined Muslims? And what did the Castilians who entered the universe where the ring song reigned make of this child of a mixed marriage? Whose triumph, whose songs, whose culture?

If we return to the little church of Santa Cruz, we find that the same ambiguities, between victor and vanquished, between restricted and unrestricted voice, are present even in the most triumphal and conscious part of its conversion. As if to remind us of the layers of linguistic and confessional identity present in this converted church, the decorative program of the apse interior, its most sacred part, bears the burden (or wears the crown) of cultural ambivalence at Santa Cruz. It presents us with two statements. The first is an authoritative Christ Pantocrator against a blue sky and a field of stars, an arresting statement of the church's indisputable role as mediator; arbitrator of divine authority on earth. The message of domination in the transformed Santa Cruz is lucid and immediately understandable. And it is more triumphal for being a forceful figural image of the divine in a mosque, where figural representation would have been unthinkable a century before.

The looming Christ is painted in a style related to clerical manuscript illumination, as the art historian David Raizman has shown.[14] But a second powerful statement is evident as well: a barely legible Arabic inscription that frames the triumphal arch, in much the same way inscriptions frame architectural members on the exterior of the tenth-century mosque in Cordoba, or any number of others in al-Andalus. Whereas those are often Quranic quotations or tributes to buildings' patrons or builders, this one says only "prosperity" (al-iqbal) and "good fortune" (al-yumn), in an awkward jumble of letters and shapes that weave in and out of legibility. These are the kind of greetings one might expect on a ceramic bowl or a bronze object made for sale to a more general clientele, a generic greeting appropriate for any Toledo burgher, regardless of religion. Such inscriptions were part of a craft tradition formed before 1085, and they can be seen on Toledan objects of the Taifa period.

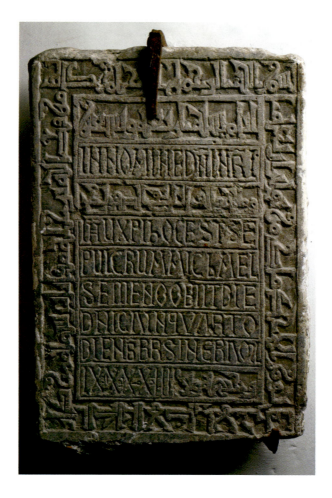

Bilingual tomb slab from Toledo, 1194. Museo Taller del Moro, from the Parroquia de Santas Justa y Rufina. This is the tomb monument of Michael, son of Semeno, a Mozarab who died in 1194. The Arabic inscription begins: "In the name of God, the Merciful, the Compassionate. It was by God's foreordainment that the date [was] fixed for [the death of] Michael ..." The beginning of the Latin inscription reads: "In the name of our Lord Jesus Christ. This is the tomb of Michael ..."

Inscriptions in Arabic were understood by all to be a kind of artistic expression in themselves, both subtle abstract design and hidden message.

At Santa Cruz, then, it seems that copybooks once in the hands of Toledo's craftsmen had now passed to its builders and painters, who were directed to include Arabic writing in one of the most important parts of this triumphal painting campaign. The awkwardness of the writing, which alternates legible and illegible words, does not represent the religion of the workforce. It suggests, rather, an unsurprising general illiteracy among these painters. But here the fact of writing was more significant than its meaning. A biblical Arabic inscription, or one alluding to its patrons, would have required a literate painter or author, a much more expensive enterprise, and the resulting inscription would have been understandable only to the Mozarabic or Muslim population, whom these patrons, newcomers to Toledo, were not expected to accommodate in their chapel. Instead, the need to use an inscription that simply appeared to be Arabic responded to a value system to which these militant monks subscribed—one that gave high priority to aesthetic values that emerged from Arabic culture, in the senses of

both triumph and prestige. Its ornamental function was to frame the image of Christ; this structuring ornament parallels the function of inscriptions in Taifa and Almoravid palaces, and yet it also repeats the way Arabic inscriptions frame the battle banners captured from Almohad foes.

The inscription, in a context that bristles with the triumph of the Christian church, still embraces in its forms as much as it rejects. In some ways the inscription of Santa Cruz might be seen as an attempt to politicize Toledo's persistent cultural hybridity as it could be read in the patterns of quotidian patronage. Consider a bronze ewer, or pitcher, in the shape of a peacock, very likely made in twelfth-century Spain, that belongs to a group of useful objects in the shape of animals associated with Islamic tradition. It carries two inscriptions: one is in Arabic, proclaiming that the object was "made by Abd al-Malik the Christian"; the other is in Latin and reads, "it was

Bronze ewer in the shape of a peacock.

the work of Solomon," suggesting a legendary level of artistic value. "The market for the object would have been Latin," Oleg Grabar concluded. "But value is provided by the artist's name written in Arabic, yet identified as a Christian." [15]

Like ring songs, these are languages, and languages of form, understandable through their fragmentation, not in spite of it. What makes this combination of forms seem anomalous, at Santa Cruz or in the muwashshah, is not the fact that churches might be built by Muslims or that Christians might speak Arabic. It is the integration of a paradigm for the formal use of an inscription or the formal structure of poetry that yields openly to an ambivalent, hybrid world.

Santa Cruz was built at a moment in which the conquest of Toledo by Alfonso VI in 1085 is already a memory, from an almost legendary and distant century. The tiny mosque-turned-church and the many brick churches by which late twelfth-century and thirteenth-century Toledo would eventually be known are instead a vital part of a triumphant Castilian universe under Alfonso VIII, Ferdinand III, and Toledo's archbishop Rodrigo Jiménez de Rada. The Toledo that lies at the center of the mythologized history of the Castilians and their reconquest is a triumphant, polarized one, its ambivalences glossed over. The Toledo of heroic Visigothic survival, of mosques dominated and submitted to the yoke, would long serve as a template for the official memory of medieval Spain. But culture reveals other truths. The unifying artistic and poetic thread woven through that history recalls a more complex interaction: the languages of its songs and the conversion of the little mosque hard by the old city gate that led into the old madina.

CHAPTER FIVE

Babel

rei q te plaze he nos venidos. i traedes uostros escriptos. rei si traemos los meiores que nos avemos. pus catad dezid me la vertad. si es aquel ome naçido que esto tres rees man dicho. di rabi la vertad si tu lo as sabido. por veras vo lo digo: que nolo escripto. hamihala cumo eres enartado. por que eres rabi clamado. non entedes las profecias las que nos dixo ieremias par mi lei nos somos erados. porque non somos acordados: porque nõ dezimos vertad.

Rabbi

King, what is your pleasure? Here we are.

Herod

And have you brought your books?

Rabbi

Yes, king, we have them,

The best that we have.

Herod

Then look,

tell me the truth,

whether that man is born,

whom these three kings have told me about.

Tell the truth, rabbi, if you have found it out.

Rabbi

In truth I tell you,

I do not find it written.

Rabbi 2

Al-hamdu li-llah, how crafty you are!

Why are you called rabbi?

Do you not understand the prophecies

that Jeremiah told us?

By my Law, we have gone astray.

Why haven't we come to our senses,

why don't we tell the truth?

Trans. Jeremy Lawrance and Jim Marchand

—from *Auto de los reyes magos*

In 1157, a Castilian ruler once again divided his united empire. Upon his death Alfonso VII would leave Castile to his eldest son, Sancho III, and León to Ferdinand II, an act that would usher Toledo into a period of tension and unrest for a generation. Sancho died only a year after his father, leaving the throne to his own son, the two-year-old Alfonso VIII, whose mother had died in childbirth. The infant heir was sheltered in Toledo during much of his perilous minority, and his vulnerability loosed in his uncle tempting visions of a united kingdom of Castile and León under his own rule. In 1162 King Ferdinand of León seized Toledo, made a member of the powerful Castro family its mayor, and attempted to gain custody of the orphaned

Towers of Toledo, with San Román.

king. He failed to do so, in part, because of the loyalty of the city's Mozarabs to Alfonso. And so, as a later tradition has it, the child prince Alfonso was proclaimed king from the highest tower in the city in defiance of the pretensions of the Castros, a proclamation that was said to be the work of Toledo's Mozarabic *aguacil*, or sheriff, Esteban Illán. Upon retaking Toledo when he was barely fifteen, the young king would change the city's political balance. He marginalized old members of the Castilian oligarchy, whom he believed had aligned themselves with his uncle, and reshuffled the composition of the municipal government, dramatically increasing the number of Mozarabs, who had been largely alienated from the city's civic and ecclesiastical hierarchy for more than a century.[1]

Alfonso VIII's reign was nevertheless difficult, and it was at first a tenuous time for the fortunes of Toledo. Alfonso suffered a disastrous defeat at the hands of the Almohads in the battle of Alarcos in July of 1195, and he ordered the walls of the city reinforced, a testament to its still-vulnerable position at the southern edge of Castile. It was not until his brilliant victory over the Almohads seventeen years later, at the battle of Las Navas de Tolosa in 1212, that Alfonso secured Toledo; in that year it ceased to be a frontier city for the first time since it had been taken by Alfonso VI in 1085. But the same events that assured Toledo's safety and geographic centrality moved it to the margins of royal attention, and ultimately to the margins of Castilian authority. Greedy to push the Castilian frontier south to the brilliant cities of Cordoba and Seville, Castilian monarchs would have other sites at which to assimilate the Islamic culture of regal authority and it was those southern Andalusian capitals that became the focus of their cupidity.

Transformations in Toledo in the thirteenth century provide a melancholy echo of Castile's expansion south. The great palaces of al-Mamun, the al-Hizam, had since the time of Alfonso VI remained largely in the hands of the monarch, and the royal presence there symbolized Toledo's centrality to Castilian monarchal prestige. But now Alfonso VIII would begin to cede parts of the royal enclosure in donations, to monastic orders and to families who had aided him, and finally to military monastic orders. The military orders had been instrumental in aiding him in the control and repopulation of lands to the south of the city, and they would soon offer enthusiastic collaboration in the pivotal battle of Las Navas. Small wonder that the mosque of Bab al-Mardum fell into the hands of the Hospitalers early in Alfonso's reign; it might well have been the donation of a member of court, following the royal lead. And Alfonso's own donations to the military orders were so extensive that one territory south of Toledo would be known as "Fields of the Orders." So their incursion into the palatial precinct of the city marks not only the king's increasing gaze toward Seville but the ascending authority of these bellicose and prosperous monks at the very heart of Toledo.

Alfonso would give the Order of Calatrava a part of the al-Hizam for the convent of Santa Fe, which would rise on the ruins of the palace of al-Mamun. The little domed oratory from the Taifa palace that had survived the destruction of the rest of the palace would become the "Bethlehem chapel" of the convent. Its central plan and ribbed vaults, a little eleventh-century replica of the much-admired maqsura vault of the Great Mosque of

Cordoba, were now reinvented, given a new meaning as an evocation of the Holy Sepulcher, the ultimate domed symbol of the original crusading goals of the military orders. The possession

Vault of the small oratory of the palace of al-Mamun, later the chapel of Belen, 11th century with later painting.

Vault of the church of Torres del Río in Navarre.

of just such little oratories can be seen to have stimulated the use of this Cordoban-style ribbed vault in northern churches built to recall Holy Jerusalem and the crusades that were the orders' raison d'etre. At the Navarrese church of the Holy Sepulcher at Torres del Río in the north, a small centrally planned chapel simultaneously recalled the goal of the crusades—the domed church of the Holy Sepulcher in Jerusalem—as well as Iberian Islam, through the geometric puzzle of its vault, which was passed from Cordoba to Toledo, there to be grafted onto a triumphant vision of Christian war.

One of the early gestures in this age of triumphal rebuilding is the site from which the heroic proclamation of the young Alfonso VIII had been made. Wedged tightly in the quarter where the Illán family had lived for centuries, the tower of the church of San Román stood at the crown of this stepped metropolis, the highest point in Toledo. San Román had probably existed as a Visigothic parish before the eighth century, and an early church of San Román might have been used as a mosque during the years of Umayyad and Taifa Toledo. In the time of Alfonso VI, an eleventh-century ancestor of the Illán family, Pedro Illán, described himself as a member of the parish of San Román. The need for a new church was felt sometime in the late twelfth century, as all of Toledo seemed to

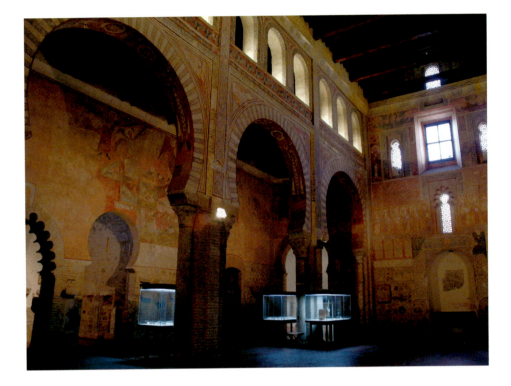

San Román in Toledo, nave, late 12th century; apse and paintings, c. 1221.

bloom with textured brick apses and lean square bell towers. The new church was a wooden-roofed basilica that used a contemporary version of a horseshoe-arched arcade reminiscent of Visigothic and Mozarabic churches and that connection was purposefully underscored by the use of spolia, old capitals from Visigothic and late antique monuments that suggested an ancient history of the parish. The reused stones hint at a mythic, constructed archaeology, a fictive continuous link with a romanticized Visigothic Toledo.

The church of San Román would receive another impressive renovation at the beginning of the thirteenth century, one that would make its meanings even more inscrutable. Construction was begun on a new apse, and it was unified with the older nave by an extraordinary cycle of paintings. Monumental images from the Apocalypse—the resurrection of the dead, elders and apostles seated in a heavenly court in paradise, an apocalyptic beast assailed by a heavenly warrior—animate the walls of the church in vibrant scenes that are combined with the more formal figures of confessors and fathers of the church. The church fathers are so authoritative, and the apocalyptic imagery so dynamic and palpable, that on some level the whole seems to celebrate the figural representation. Images of animate beings become the way by which revelation is announced in a religious structure: they challenge the whole basis of mosque ornamentation, its intellectual, abstract structure and ideology. This forceful and turbulent decoration of San Román's interior proclaims a new order.

But in the nave of the church, and in much of its west end, these paintings are structured by a kind of ornament that would have been familiar to those who frequented mosques or palaces of Taifa Toledo. San Román's hallmark horseshoe-arched arcade is

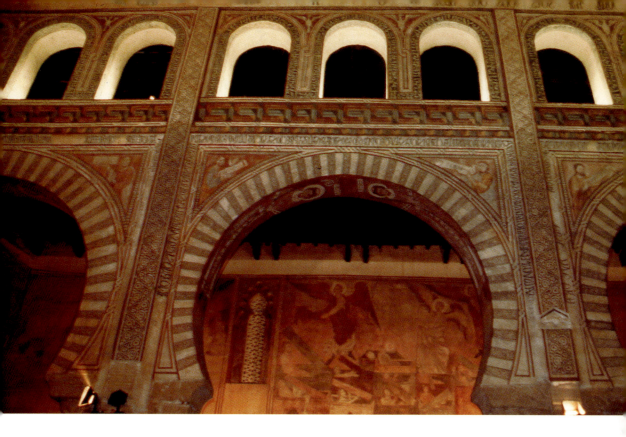

wrapped in Latin and Arabic writing and ornament reminiscent of that of an Islamic palace:

arches and scalloped windows of the Mudejar construction tradition are framed by painted moldings, pilasters and capitals in trompe l'oeil, and alfizes, while smaller scalloped windows alternate painted red and white voussoirs, like those of the mosque of Bab al-Mardum. Most strikingly, the horseshoe-arched arcade of the nave harbors vine scrolls and interlace found in Umayyad and Taifa carving. The same language of decoration can be seen in Toledo today, in a stucco horseshoe arch with Taifa decoration preserved in the Plazuela del Seco, where banded arches are inhabited by the same play of palmettes and vine scrolls. In San Román, windows are embraced by Arabic calligraphy that occasionally yields a platitude, *al-yumn wa al-iqbal* ("good fortune and prosperity"), much like the inscriptions at Santa Cruz. And perhaps most striking of all, the horseshoe arches of the naves are painted with alternating decorated and smooth voussoirs, evoking both local Taifa and Umayyad tradition, and ultimately the Great Mosque of Cordoba.

The power of this ornamental scheme, with its Islamic forms, is so manifest in San Román's nave that at first glance it seems to struggle with the lively apocalyptic themes it frames. The divergent languages of these two cycles of painting have led to the suggestion that they might represent different moments in the history of San Román, under the assumption that the ornamental paintings must belong to an Islamic or Mozarabic campaign in the building's history that precedes the figural images.[2] But analysis of the paintings by the conservator Carmen Rallo Gruss has shown them to "correspond to the same moment"; they are part of "a unitary whole."[3]

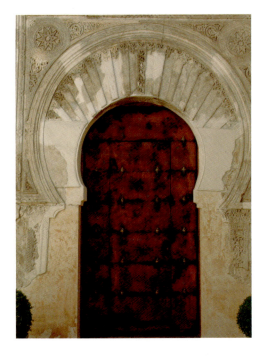

clockwise from top left:

Eleventh-century arch preserved in the Plazuela del Seco.

Detail of arch from the Plazuela del Seco.

Detail of arch from the Plazuela del Seco.

San Román in Toledo, decorative detail.

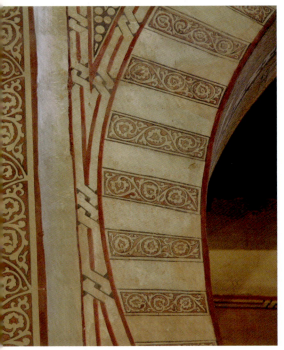

The Arabic Inscriptions of Islamic Spain

From China to Spain, the buildings of the Islamic world are drawn together with a calligraphic thread of religious quotations, aphorisms, secular or mystical poetry, historical documentation, and political propaganda. In the Islamic world, writing functions both as a carrier of meaning, through a text, and as an abstract form of ornamentation. Arabic writing on the walls of the Iberian Peninsula began soon after the arrival of Abd al-Rahman I in the eighth century and continued long after the fall of the Cordoban caliphate. Its uses ranged from selections from the Quran, as on the mihrab of the Great Mosque of Cordoba, to straightforward dedication inscriptions, as on Bab al-Mardum, and even, in the case of the Alhambra, poetry composed in the voice of the room it adorned.

The earliest surviving Arabic inscriptions from the Iberian Peninsula are poorly cut and roughly formed archaic *kufic*, a simple and geometric script. In the ninth and tenth centuries, the increasing refinement of the Umayyad court brought new forms of kufic, with elegantly proportioned letters that sometimes ended in bursts of leaves and flowers. In the Taifa period, courts engaged in fierce competition, as architects and craftsmen tried their hands at new kinds of calligraphy that formed not only letters but geometric patterns. When the Almoravids came to the peninsula, a new kind of script, called *naskhi*, or cursive, arrived on the scene. Already used in North Africa and the rest of the Islamic world, naskhi was easier to read than kufic and could often incorporate longer texts on the walls of buildings. The Berber regime used this script to propagandize, and continued to use kufic for decorative purposes. But when the Almohads supplanted the Almoravids, they limited calligraphy on religious buildings and restricted it in most cases to religious texts, though over time their severity relaxed. Almohad craftsmen also worked for Christian patrons, and would decorate the cloister of the monastery of Las Huelgas with kufic bands praising Christ.

Under the Nasrids, Iberian epigraphy reached a high level of sophistication at the palace of the Alhambra, incorporating multiple scripts and vegetal ornaments into a distinctive royal aesthetic. The letters of kufic phrases extended into geometric panels, sometimes reversed onto themselves in mirror image, and were often surrounded by clusters of smaller secondary inscriptions. Using both kufic and naskhi scripts, the Nasrid court calligraphers made elaborate patterns out of phrases praising God and their rulers, and giving voice to the building itself. Long poems in naskhi describe everything from the kings' martial exploits to the young princes' circumcisions. The inscription on the Lion Fountain describes the mechanism by which water is made to spout and drain.

Simple Kufic inscription from the mihrab of the Great Mosque of Cordoba, late 10th century.

Naskhi inscription from the Alhambra, 14th century.

This apparent confrontation of divergent artistic languages draws us into the politically and intellectually charged world of thirteenth-century Toledo, and it provides us, as a guide, with one of Castile's most fascinating historical figures. "This church was consecrated," an inscription over San Román's entry once recounted, "by Archbishop Jiménez de Rada, on Sunday, the 20th of June, Era MCCLIX (1221)." It is hard to imagine that Rodrigo Jiménez de Rada, Toledo's most outspoken archbishop, most passionate advocate, and most manipulative historian, would not have had a hand in the renewal of the ancient church whose inscription bears his name. But San Román's decoration sits uncomfortably with Rodrigo's other reputation: his role as Castile's premier crusader, who effectively combined the ideas of crusade and reconquest.

Rodrigo had come to Toledo from Burgo de Osma in 1209. The new archbishop was a Romance speaker from Navarre, and upon arriving at the great metropolis he was at first disdainful of the Mozarabic Christians he encountered, whose "diversity of customs and languages" seemed suspect. Harking back to the eleventh-century reforms, he suggested that their ancient Hispanic liturgy, preserved since Visigothic times, had been tainted by their interaction with Muslims centuries before.[4] This stance surely fueled his interest in initiating his most urgent act of patronage as archbishop, laying the first stone of the new cathedral of Toledo, a project begun under an earlier archbishop, John of Castelmaurum. The old Taifa mosque, which had served as a makeshift cathedral for nearly a century and a half, "still had the form of a mosque, since the time of the Arabs," Rodrigo reminded the readers of his famous history, *De rebus Hispaniae* (On Spain).

The physical place in which Toledo's church had found its identity for almost a century and a half was still a hypostyle hall, eleven aisles of columns crowned by horseshoe arches and elegant, attenuated Corinthian capitals. The center of Toledo's famed church, "which," Rodrigo declared, "once noble and famous, had been prisoner under the tyranny of the Saracens for a long time," would be "transformed from a mosque into a church (*a forma mesquite in formam ecclesie*)."[5] A desire to transform the long-ago converted mosque was shared by Toledan archbishops since the time of Alfonso VII, and it is possible that some demolition had already begun. Rodrigo's ardent determination to transform it into a Gothic structure can be seen in part as an extension of those same artistic values, in which anxiety concerning cultural hybridity creates a yearning to construct a central image of imagined purity in the service of religious and ideological authority. And it fit well, also, with the image of Rodrigo as crusader.

For Rodrigo is best known in history as a promoter of the great battle of the age: the crusade of Las Navas de Tolosa, in which Alfonso VIII dealt the Almohads a powerful and decisive blow. It was probably Pope Innocent III who initiated the crusade, but he found in Toledo's new archbishop an energetic and willing partner. At the pope's request, Rodrigo encouraged Alfonso to engage in a holy war, an act about which the king was very likely both ardent and reserved, haunted as he was by the battle of Alarcos, where the Almohads had decimated Alfonso's troops seventeen years before. In promoting this new crusade, Rodrigo would demonstrate his energy for the power he saw embodied in the

archbishopric of Toledo: he laced his episcopal acts with regal authority by mustering kings and prelates alike to the battle, brandishing papal indulgences and exhortations. The archbishop swung into action, journeyed to Rome to secure crusading indulgences from the pope, and then flew across the face of Europe, recruiting armies in Italy, France, and Germany. Rodrigo instilled a sense of united crusading purpose in Spanish Christian monarchs for whom the pragmatics of power struggles had only rarely been subservient to ideology. A native of the Iberian Peninsula, Jiménez de Rada was the Spanish church-man who would finally bring Castile in line with papal desire. ("Born though he had been on the right side of the Pyrenees," Linehan remarks, Rodrigo "was for all of that a carpetbagger.")[6]

As this new crusading army assembled in Toledo in the spring of 1212, it created an image unlike any that town had seen: Rodrigo, the archbishop, sword brandished, led papal legates, the rapier-wielding archbishops Arnald of Narbonne and William of Bordeaux; the amazing alliance of three Iberian kings, Alfonso VIII of Castile, Peter II of Aragon, and Sancho VII of Navarre; troops from lands beyond the Pyrenees; and the mili-tant monastic orders of the Templars, Hospitalers, and Calatrava. Rodrigo himself marveled at the chaotic, lively, and international throng, so diverse, united only by Christian faith, "their arms made ready, provisions stored, and more than anything, their hearts prepared for combat."[7] In the end, the French would make little showing at the battle, but Alfonso VIII and his archbishop would score a resounding victory. The Castilian king sent Pope Innocent III spoils of war, symbols of victory, in the form of the Almohad commander's tent and standard with a proclamation of his triumph: "O what happiness! O what thanks-giving! Though one might lament that so few martyrs from such a great army went to Christ in martyrdom."[8]

Rodrigo's commitment to the crusade of Las Navas was deep, but his alliance with the pope was symbiotic, and masked other ambitions for himself and his city. Rodrigo dedicated significant energy toward unambiguously establishing for Toledo the dignity of primatial see of Hispania, the highest ecclesiastical authority in the realm. His justification was fixed in the idea of Toledo as the city that had, in the golden moment of the reign of King Wamba at the end of the seventh century, bound ecclesiastical power and secular authority. Rodrigo hoped to see his own authority as primate echo that of the ancient Visigoths; Toledo must be an *urbs regia* that would replicate a utopian relationship between church and state, in which Castilian kings nodded to the authority of the archepiscopate in fashioning an empire. But this primacy could be awarded only by the pope. The con-cern of Innocent III, in contrast, was to maintain active ecclesiastical authority over newly conquered lands, and to encourage the polarity between Christians and Muslims, which increased papal prestige. "The language of the Reconquista is the language of the reformed papacy," Damian Smith reminds us,[9] and the transformation of reconquest from an ideal of peninsular renewal of the Visigothic monarchy into an international crusade that pitted Christians against Muslims on a cosmic battlefield had been the consistent message of the papacy since the second half of the eleventh century. It placed conquered lands in a spiri-

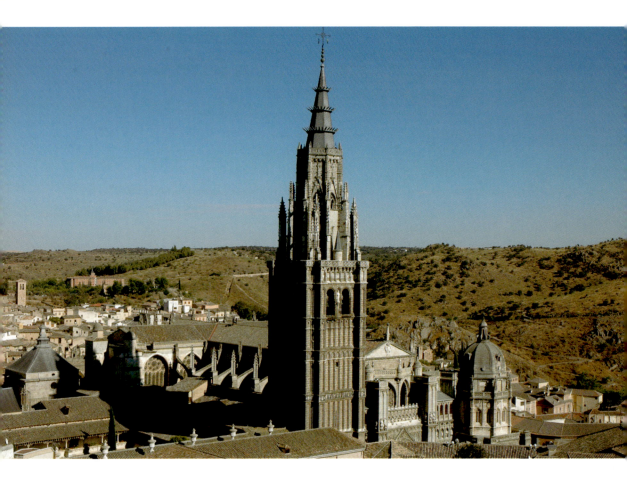

Cathedral of Toledo.

tual realm that augmented papal authority, and painted the actual conquest of Iberian territory with the veneer of papal sanctity.

When, fourteen years after the triumphant battle of Las Navas, Rodrigo joined Castile's new monarch, Ferdinand III, in laying the first stone of the new cathedral of Toledo, he was pursuing several objectives. In beginning the transformation of Toledo's mosque-turned-cathedral into the city's first Gothic building, he was throwing down the gauntlet to its former ambivalent and layered identity, adopting a style from a distant place that seemed always to have been entirely Christian, a style unladen with the kind of cultural ambivalence that reigned in the Toledo of Taifa palaces, and Mozarabic and Mudejar churches. In a temporal sleight of hand, Jiménez de Rada would now build a physical emblem of reconquest, Toledo's pre-Islamic, Visigothic church, renewed on the ruins of the Taifa mosque. But he also wanted to create a place where Castilian kings might be crowned, one that owed as much to Bourges or Saint-Denis as to Visigothic Toledo. This seems entirely in keeping with the man who first wed the ideas of Visigothic renewal and holy crusade in a pragmatic and effective way.

But how, then, do we fit the church of San Román, consecrated by Rodrigo, into this vision of his culture, his ambitions? The Islamicizing decoration of San Román, initiated some five years before the laying of the first stone of the new cathedral, would seem at

first to fly in the face of Rodrigo's strategy of patronage as it is embodied in that building. But the Apocalypse of San Román's figural program, rooted in biblical and liturgical texts, would not. The apocalyptic vision of the resurrection of the dead materializes from behind the south arcade of the church in a frameless cinematic drama. Large-as-life dead burst from a maze of coffins, their lids askew. The immediacy of this image is striking: three angels awaken the dead, a trumpet straining to the left, a dramatic flourish of drapery to the right, six wings akimbo. The dead tug and push at their coffin lids; one impatient mortal extracts a pale emaciated leg before his tomb lid is fully elevated, one stretches his hand toward heaven while still supine. The coffins are clearly depicted in different shapes and materials, tipped slightly so the viewer can grasp their deep, obscure interiors, into which one might step. The dead include not only the usual man and woman, lay and cleric, but variations in age, dress, and gestures that combine with the resurrection's significant scale and lack of frame to intrude into the viewer's emotional and temporal space.

The decoration of the nave end confirms the notion that the space of the church was a kind of stage set for an experiential Apocalypse: the resurrection of the dead, and the second coming of Christ. Prophets gesture from the spandrels of alfizes, and on the west wall twenty-four figures sit in two neat rows in paradise—whether apostles and twelve of the elders or a conflation of the two is unclear—the tangled branches of enormous paradisiacal trees behind them. They surely faced an enthroned Christ in the central apse, as María Concepción Abad Castro has suggested, one demolished to make way for the choir and east end designed by the sixteenth-century architect Alonso de Covarrubias.[10] In the north aisle, an enormous, arching, apocalyptic beast is speared by an angel, while another angel crouches below.

The apocalyptic paintings of San Román were rooted in a long-standing Iberian tradition giving the book of Revelations a special place in the liturgy from Visigothic times until the abolition of the Mozarabic liturgy with the Roman reforms of the late eleventh century. Here at San Román, models are drawn from many sources: Byzantine art, the Roman Breviary, and local painting traditions, to name just a few. The discrete lines of apostles and elders at San Román's west end recall the clear, orderly lines of the sacred court as it appears in tenth- and eleventh-century Beatus manuscripts, like an image of the heavenly court from the Gerona Beatus. Many of these copies of the well-known commentary on the Apocalypse of the eighth-century monk Beatus are associated with monasteries in Spain from before the time of Roman reform, and some have been shown to reflect values particular to the Mozarabic communities. And yet, the San Román paintings do not seem to directly copy such a manuscript, and they are organized in a completely different way. For here the elders are not gathered around Christ; they look toward an image of Christ that once faced them from the apse, a painting lost in the sixteenth century.

Because Christ was in the east, and the elders, apostles, and trumpeters in the west, San Román's nave space is embraced as part of the heavenly court; the congregation is included in the drama. And the theatrical nature of the viewer's experience is increased with other, hidden images. Tiny angels who lurk in the splayed thickness of the wall

San Román in Toledo, The
Last Judgment, c. 1221.

Heavenly court from the
Gerona Beatus, 976. Gerona
Cathedral.

opposite:

San Román in Toledo, Elders
and Apostles, c. 1221.

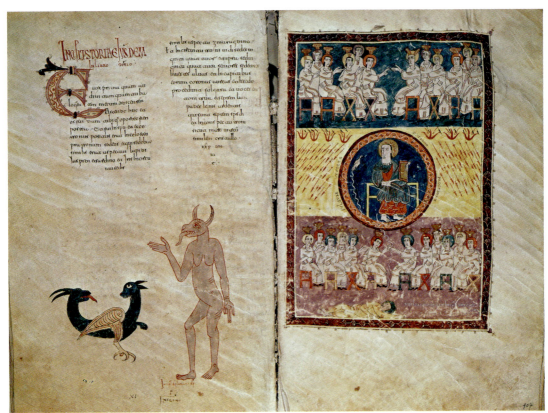

San Román in Toledo, angel, c. 1221.

behind apse windows peer into the church from behind scalloped arches and Arabic writing. They provide a visceral experience of the divine in this world, small surprises, illusionistic interventions of the cosmic into the earthly consciousness of the faithful. At San Román the magic of the divine is here and now; the Apocalypse becomes a public drama in which the faithful participate, by virtue of being Christians in Toledo in the age of Rodrigo.

It may be this detail that first suggests Rodrigo Jiménez de Rada's personal intervention in the painting program at San Román, for the archbishop was quite interested in the didactic and emotive value of theater. Historian Lucy Pick believes Rodrigo to be the author of the *Auto de los reyes magos* (Drama of the Three Kings), perhaps meant to have been performed in 1212, at the Christmas court of Alfonso VIII. The earliest vernacular version of the story of the three wise men, it also provided a clear metaphor for Rodrigo's day: evil Herod was presented as the archetype for the Almohad king, and the voyage of the three kings likened to the activities of the three Iberian kings (of Castile, Aragon, and Navarre) who traveled from afar to famously unite in the battle of Las Navas, which had been fought and won that very year.[11] The play was in keeping with Rodrigo's affection for constructing a sacred metaphor for contemporary events. The dramatic presentation of the *Auto*, and the repeated reference to Alfonso's crusade from within the structure of divine history, gives us insight into Rodrigo's way of addressing an audience through art.

The image of the paradisiacal court is also found in another manuscript associated with Rodrigo's desire to revive Toledo's Visigothic heritage: the *Notule de primatu* (On Primacy). This manuscript is dedicated to the evidence, voraciously compiled by the archbishop (as well as highly edited and nuanced), that proved his claim that Toledo ought to have primacy over all the churches in Spain. Its eighteen illustrations picture the councils of the Visigothic church and in each, king and archbishop sit at the top of three ranks of bishops and clergy, in order of hierarchy. In an image of the Third Council of Toledo, for instance, we see the seated ecclesiastical court: beneath the monarch and archbishop (who see eye to eye) are rows of clergy, at the higher levels mitered bishops, and at the lower levels sit tonsured clergy, just as they do on the west wall of San Román. Perhaps the paradisiacal

Auto de los reyes magos

Most likely written in the early thirteenth century in the Toledan Mozarabic dialect, the *Auto de los reyes magos* is a short theatrical work based on a version of the three kings narrative (Matthew 2:1–12) and concluding with an amusing dialogue between Herod and two rabbis.

qui vio numquas tal mal. sobre rei otro tal. aun ñ so io morto. ni so la t'ra pusto. rei otro sobre mi. nuquas atal ñ ui. el seglo va acaga. ia ñ se que me faga. por vertad nolo creo: ata que io lo veo. venga mio major do q mios averes toma. idme por mios abades. por mis podestades. i por mios scrivanos. i por meos gramatgos. i por mios streleros. i por mios retoricos: dezir man la uertad. si iace i escripto. o si lo saben elos. o si lo ã sabido. rei q te plaze he nos venidos. i traedes uostros escriptos. rei si traemos los meiores que nos avemos. pus catad dezid me la vertad. si es aquel ome naçido que esto tres rees man dicho. di rabi la vertad si tu lo as sabido. por veras vo lo digo: que nolo escripto. hamihala cumo eres enartado. por que eres rabi clamado. non entedes las profecias las que nos dixo ieremias par mi lei nos somos erados. porque non somos acordados: porque nõ dezimos vertad. io nõla se par caridad. porque nola avemos usada. ni en nostras vocas es falada.

Herod […]
Who ever saw such evil,
one king over another!
I am not yet dead
or buried in the earth:
another king over me?
I never saw such a thing!
The world is upside down,
I no longer know what to do;
I won't believe it's true
until I see him.
Summon my chamberlain
who collects my money.
Go fetch my abbots
and my potentates
and my scribes
and my magicians
and my astrologers
and my orators:
they will tell me the truth
if it is written down,
or if they know it
or if they have heard it.

Rabbi
King, what is your pleasure? Here we are.

Herod
And have you brought your books?

Rabbi
Yes, king, we have them,
The best that we have.

Herod
Then look,
tell me the truth,
whether that man is born,
whom these three kings have told me about.
Tell the truth, rabbi, if you have found it out.

Rabbi
In truth I tell you,
I do not find it written.

Rabbi 2
Al-hamdu li-llah, how crafty you are!
Why are you called rabbi?
Do you not understand the prophecies
that Jeremiah told us?
By my Law, we have gone astray.
Why haven't we come to our senses,
why don't we tell the truth?

Rabbi 1
I don't know the truth, for charity's sake!
Because we have never used it,
and it isn't found in our mouths.

Trans. Jeremy Lawrance and Jim Marchand

Al-hamdu li-llah (*hamihala* in the Mozarabic) is an Arabic phrase meaning "praise be to God," used in the Islamic world in response to everything from a sneeze to a safe return from a journey.

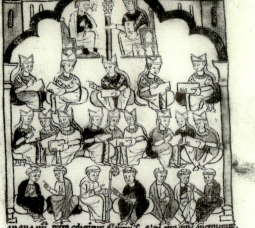

Notule de primatu, image representing the Third Council of Toledo of the 6th century in the Visigothic period, c. 1240. Biblioteca Nacional, Madrid.

court at San Román, which represents the last days, is also an allusion to the great Toledan councils of the past, of their revival by Rodrigo in the present, and their celestial parallel in the final days. By representing the councils of the present, the past, and the court of the future in the same way, Rodrigo bound them in the cosmic drama that sanctified his contemporary acts in the Toledo of his day, and made his attempts to connect Toledo's authority to the Visigothic past something like sacred history.

But in yet another work of the prolific Rodrigo we find the philosophy that brings us closer to the Islamic-style decorations of San Román. The Apocalypse is the subject of chapters of Rodrigo's *Dialogus libri uite* (Dialogue on the Book of Life), a refutation of Jewish doctrine also written soon after the victory of Las Navas.[12] Rodrigo had entered the fray of a lively polemic within Judaism, one that had revolved for decades around the resurrection of the body. The polemic touched on a key theme in the archbishop's work, a school of thought that sought an "understanding of the relationship between unity and plurality (that) left a place for non-Christians to live among Christians."[13] Pick sees Rodrigo's polemics as a way to create a theological structure, a hierarchy in which interactions between Christians and those of other religions might safely occur. *Dialogus libri uite* as well as the *Auto de los reyes magos* were first and foremost polemics, meant to refute the Jews effectively, and to establish boundaries between their religion and that of the Christians. They are similar to the process whereby, just before the battle of Las Navas, Rodrigo commissioned a translation of the Quran from Mark of Toledo, one in which the translator linked the act of translation to the act of holy conquest.[14] Reconquest was the perfect cover for assimilation.

Yet Rodrigo is also known for protecting the Jews of Toledo, who were important to the financial well-being of the city, and he sought to shield them from the oppressive dictates of Rome. He employed Jews as property managers to the distress of cathedral canons, and interacted with them in scholarly capacity, in particular as translators. And he is famous for having called out the militia of the city of Toledo to protect the city's Jews when French crusaders began a spontaneous massacre in the frenetic days of preparation for the crusade of Las Navas, when foreigners, unused to the entitled plurality of Toledo, crowded its streets. Rodrigo's polemic works against Jewish thought became one way of

defining difference and hierarchy, assuring his own authority and that of Christianity while still interacting in a peaceful context. He was able, through these works, to construct a secure religious space in which Christians and Jews could interact more freely.

It is possible that San Román is just such a space, one that makes statements of authority to create a structure in which interaction might safely and fruitfully occur. It is not, however, one for interaction with Jews. On one level, the building demonstrates an encounter with everyday Arabic culture as it existed in Toledo, and there is a way in which the Islamic forms are thus domesticated. The inscriptions evoke wishes that might be found on secular objects belonging to any Arabic-speaking Toledan, which still meant most of the city's Jews and Mozarabs, including Mozarabs from old Toledo families, as well as those who had more recently come from Almohad lands to the south, and also new Mozarabs (the so-called neo-Mozarabs) who were in fact recent converts from Islam. And the horseshoe-arched arcade echoed the Visigothic and Mozarabic past as easily as an

The "Synagogue of Santa María la Blanca"

A grand columned synagogue in the Jewish quarter of Toledo has long provided an enigma for visitors and scholars. Its original name was lost when it was converted to a church, and so it is known incongruously today as the "synagogue of Santa María la Blanca." Some believe it dates from the twelfth or thirteenth century, for its complex geometric ornamental reliefs that resemble Almohad decoration; more recently it has been seen as part of Toledo's fourteenth-century artistic flowering, in which Islamic taste became part of Castilian style. The synagogue is not only decorated in a tradition of Islamicizing ornament, but it is built as a hall of five aisles of white stuccoed horseshoe-arched arcades. Its plan and the disposition of its interior space recall the experience of a hypostyle mosque. The synagogue appears to be part of a group built in a similar style: before it was destroyed in 1899, the old synagogue of Segovia and that of Toledo shared jutting horseshoe arches, blind arches, stuccoed reliefs, and massive capitals, though that of Segovia appears to have had only three aisles. We have no information concerning the original orientation of the synagogue that became the church of Santa María in Toledo, nor of the placement of its ark niche. The synagogue, however, reminds us of the extent to which a shared culture bears witness to permeable boundaries between Muslim and Jewish communities. It also bears witness to more anguishing changes in the condition of Jews who suffered brutal pogroms in 1391. In 1411, the renowned anti-Semite Vicente Ferrer delivered a sermon at the church of Santiago de Arrabal in which he incited furor and hate against the Jews of Toledo. At his instigation, the congregation followed him to this synagogue, which he seized and converted to a church.

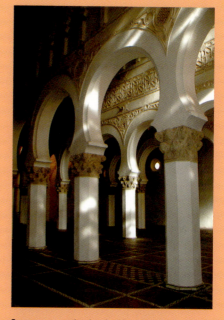

Synagogue, now the church of Santa María la Blanca in Toledo, 13th or 14th century.

San Román in Toledo, Saint Bernard, c. 1221.

Islamic one in Toledo. Even the painted voussoirs of the delicate scalloped windows of the choir were a real part not only of the architectural landscape of Taifa Toledo but also of the twelfth-century city under Christian rule. They were found in the mosque of Bab al-Mardum, which had been converted into the church of Santa Cruz by the Hospitalers of Saint John thirty-eight years before San Román's dedication. Rodrigo must have been witness to the ways in which not only the Mozarabic community but the entire Christian community of Toledo could at once vilify and absorb Islamic cultural values, changing their own visual identity in the process—so that even Islamic culture might become part of that world, its absorption part of a theology of unity under the hierarchy of the church.

It is probably the incorporation of the Mozarabic community, in fact, that is played out in the paintings at San Román. A clue is provided by that series of rather monotonous figures, hierarchical and repetitive, that serve to temper the raucous cosmic dance of the nave and south aisle: the confessors and fathers of the church. They include near-contemporary reformers like Bernard of Clairvaux, the strident advocate of crusade canonized as recently as 1172. But they also pointedly include Spanish fathers (Isidore, Leander) and Romans (Stephen, Lawrence), a detail of integration of the traditional Spanish church within a Roman hierarchy. Why would the integration of the Spanish church, so long oppressed by Rome, be part of the agenda at San Román?

The old Mozarabic families like the Illáns had gained significantly in civic power under Alfonso VIII. Upon retaking Toledo, the young king had marginalized old members of the Castilian ruling class, and reshuffled the composition of the municipal government, dramatically increasing the number of Mozarabs. Esteban Illán (d. 1208), the young Mozarab *aguacil* who would become mayor, was particularly credited with aiding Alfonso

in his recapturing the city, and his family's prominence in the parish of San Román suggests a direct connection to the renovation and painting of the building in the thirteenth century. Illán's tomb resides in the south aisle of San Román and it is likely that San Román was refurbished in part thanks to his sons' patronage. And those sons bring us back to Rodrigo: García Illán would become the treasurer and later archdeacon of the cathedral during Rodrigo's archiepiscopate, and Micael Illán became a canon and later dean. And these connections further muddy the waters of culture and religion: Esteban Illán, who signed his name to municipal documents in Arabic, would certainly not have felt that the Islamicizing decoration at San Román was anomalous to his culture or faith, and it is unlikely his sons would, either.

Rodrigo's attitude toward the Mozarabs, and toward their cultures, seems to have involved a learning curve. In the decade after the battle of Las Navas, as the Navarrese cleric had come to interact with the strange new world of Toledo, his thought had evolved. Consider the following passage from the *Dialogus,* which seems to refer directly to the practice of the Mozarabic rite:

> They live with Christ under the unity of the Church although they are distinguished by different signs and forms of worship; and just as a variety of curtains once decorated the inside of the tabernacle, so now does a variety of religious practices decorate the church of Christ.[15]

This passage can, in one way, be used to explain the images of church fathers at San Román. The images are numbingly similar and repetitive, and yet that might be the point: they succeed in representing the Spanish fathers of the church, even Leander, the author of the Mozarabic liturgy, as part of a new, reformed Roman church. They are unified in appearance and aspect, equal in sustaining the structure as a whole. These words were written in the decade following the crusade of Las Navas de Tolosa, a period in which Rodrigo was both employing Jews and composing polemics against them. In this same moment Rodrigo was also presiding over Toledo's influential translation movement, in which he commissioned a polemical translation of the Quran, on one hand, and translations of Arabic scientific and philosophical texts that had the power to challenge his very faith, on the other. And at the same time, in 1221, Rodrigo consecrated the church of San Román.

In fact, the Mozarabs supplied Rodrigo with a host of theological ideas that helped him craft a vision that conflated the crusade against Islam with the battles of the end of days described in the Apocalypse. Paul Albar, the ninth-century Mozarab who wrote in defense of the Cordoban martyrs, was the author of the *Indiculus luminosus* (Illuminating Evidence), written with a copy of the Beatus commentary at hand.[16] It allies Muhammad with the Antichrist of Revelations and the Beast of the Book of Daniel, connections that gave Rodrigo's crusade the force of a cosmic battle like that of the final days. Mozarabs had been instrumental in imbuing apocalyptic themes with contemporary history when certain of their monasteries emigrated to the northern kingdoms. And these had an impact on the imagery of manuscripts of Beatus's commentary made in the north. Not only is the palace

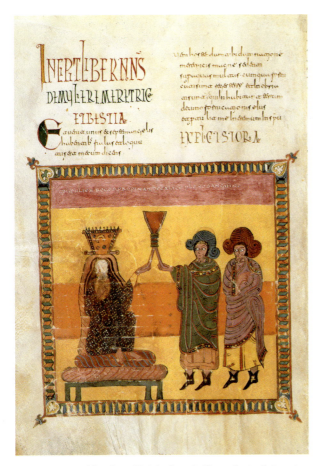

The whore of Babylon from the Morgan Beatus, 2nd quarter of the 10th century. The Morgan Library & Museum, New York. In the Bible, the whore of Babylon is described as "the great harlot who sits upon many waters, with whom the kings of the earth have committed fornication, and the inhabitants of the earth were made drunk with the wine of her immorality." Apocalypse of Saint John 17:1–3.

of the evil king Balthassar made into the Great Mosque of Cordoba in the Morgan Beatus, but in other Beatus pages, the whore of Babylon is seated, like Islamic rulers, on a pile of cushions, and the Muslim rider of the Gerona Beatus is both a hostile Herod ordering the Massacre of the Innocents, and an Umayyad persecutor of Mozarabic martyrs. It seems possible that in the thirteenth century, Jiménez de Rada had by political necessity discovered common ground between himself and Toledo's indigenous Christians in the unquestioned capacity of apocalyptic themes to picture Muslim-Christian relations in cosmic terms.

It was not just a cosmic battle that was evoked at San Román but the battle of Las Navas itself, described through apocalyptic metaphors. Pope Innocent III, who received the spoils of war from Alfonso VIII, used the success of the battle to promote the Fifth Crusade. In the summons of April 1213, he recalls the victory of Las Navas and concludes that "God has now given us this good sign that the end of the beast is approaching." [17] He is referring to the Beast of the Apocalypse. The phrase conjures the overscaled, isolated image of the death of the Beast at San Román: with dramatic movement, larger than life, it might be read as an illustration of Innocent's exclamation, one certainly known to Rodrigo.

In making the idea of reconquest apocalyptic, and the Apocalypse in turn about contemporary reconquest, Rodrigo unified his concerns with those of the still-divided Christian community of Toledo. Without yielding to the surviving Mozarabic liturgy, the archbishop could harness the Mozarabs' apocalyptic metaphor to his own great crusade, all the while cementing alliances with Toledo's increasingly influential Mozarabic oligarchy. The crusade of Las Navas elevated the present to a prophetic image of the last days, uniting the variety of Christians of Toledo.

If we do not assume, at the outset, that the nave paintings must represent only an exoticized Islam, we can see them as part of this larger vision of inclusion. The ubiquitousness of the particular Islamic forms at San Román is striking: the vine scrolls of the

nave arcades, made famous at the Umayyad palace of Madinat al-Zahra, are also visible in Taifa ruins from the Plazuela del Seco. But those decorative palmettes are also clearly recognizable in the carving of the altar screens of the church of San Miguel de Escalada, a monastery founded by Mozarabic monks who had emigrated from Cordoba to León. Scalloped arches with alternating voussoirs of red and white are found at the mosque of Bab al-Mardum, but that building had also been, for decades, the church of Santa Cruz. And the alternating red and white banded arches of the Great Mosque of Cordoba, as politicized as they seemed in the Morgan Beatus, and as Islamicizing as they seem to us today, could be found in churches associated with the Mozarabs as early as the tenth century. This is not to say that these forms were uniquely understood as part of a homogenous Islamicizing culture shared by Christians and Muslims alike. It is rather that the meanings of these forms were in constant flux, just as Rodrigo's understanding of the Mozarabs and their culture was. Such images could hold multi-

San Román in Toledo, Beast of the Apocalypse, c. 1221.

ple meanings simultaneously: spolia from a vanquished enemy, pride in a glorious shared Arabic culture, pride in a resistant Christian culture, pride in an ancient Visigothic culture. All of these meanings were superimposed, and Rodrigo ran to concretize them, to incorporate them into a theology of unity as fast as his paintbrush would allow him.

Language is key here: the Latin of San Román was the language of the church, while the Arabic in the inscriptions was still, in thirteenth-century Toledo, one of the everyday languages of the Mozarabs, as much as of Toledan Muslims and Jews. For all that it was quite evident that these were arts rooted in Umayyad and Taifa culture, they were not exclusively bound to Islam, either as a religion or as the rival of the reconquest. In his influential *De rebus*, Rodrigo suggests that the multiplication of languages in the world was a punishment Christians had to endure for the construction of the Tower of Babel.[18] Rodrigo thus found a theological justification for the plurality he was daily accepting and in which he was participating in Toledo. Multiple languages, and the divergent peoples who spoke them, are present by God's choice. How far are multiple languages from multiple artistic styles?

As much as it might have served the pope's purpose to promote a wall that neatly separated religion, ideology, politics, and culture, it was hardly a myth that could be perpetuated

in the Toledo of Rodrigo, where the dominant hostilities were between different groups of Christians: between Castilians and Leonese, Franks and Spanish Christians, Castilians and Mozarabs, even between the pope and Rodrigo himself. In fact, we can see the nave of San Román as part of an incorporation of the visual culture of Mozarabic Christians, both their Islamicized secular culture and the Visigothic history they perpetuated, into the fold of the Roman church. San Román mirrored Toledo clearly, in its messy hybridity. After the battle of Las Navas, Rodrigo understood that there was no way to make an end run to reconquest, around Toledo's plurality.

<div align="center">✳</div>

Even within Castilian forces, the years of cultural interaction and kaleidoscopic shifting of alliances had created cynicism concerning crusader values and political fealty. The career of Alvar Pérez de Castro, chronicled by historian Simon Barton, followed that of his father and grandfather in unrepentant shifts from mercenary in the service of the Almohads, to loyal vassal of both Leonese and Castilian kings. His grandfather was part of the Castro family expelled from Castile during the minority of Alfonso VIII. After a period of serving the king of León, he fell out of favor with that monarch, and so rode with his followers to Seville, pledging himself to the Almohads. He could be found, in one moment, defending an Almohad fortress against a Castilian king, and in the next, fighting as a crusader for the same king. The son followed in his father's footsteps, in a career that saw him alternately serving the Castilians, Leonese, and Almohads, even finding himself in 1194 in the Almohad army that would defeat Alfonso VIII at Alarcos. Alvar, the grandson, seems to have been in the service of the Almohad caliph before pledging himself to Ferdinand III, becoming one of his most valued vassals and lords. It is not a surprise that both Pope Innocent III and Rodrigo railed against knights, who, "abandoning their people and native land, have allied themselves with the Saracens, in order, if possible, to attack and defeat the Christian people with them."[19]

Near the end of his life, Rodrigo would tell the story of laying the stone of the new Gothic cathedral of Toledo, together with King Ferdinand: "the king and the archbishop Rodrigo placed the first stone of the cathedral of Toledo, that still conserved the form of a mosque since the time of the Arabs, and which building rises by the day with formidable work, to the enormous admiration of the people."[20] Though the mosque building had served as Toledo's cathedral for more than 140 years, Rodrigo tells the story in the language of conversion. He reminds us that the cathedral was still in the form of a mosque evoking the day of its original conversion by Bernard of Sedirac in 1086: the occult nocturnal purification of the appropriated mosque with holy water described by Rodrigo himself earlier in the *De rebus*. The mosque building itself did not offend because the act of transformation took the pride of place. Julie Harris notes that mosques were often spoken of in positive terms as buildings. This aesthetic opinion was cushioned by the act of purification in mosque-to-church conversion, which provided an important ceremonial link with reconquest ideology.[21]

Las Huelgas

At the end of the twelfth century, before the battle of Las Navas de Tolosa, Alfonso VIII would join with his queen, Leonor Plantagenet, to create a visual image of their Castilian royal dominion. The royal monastery of Las Huelgas near Burgos would be endowed with incredible wealth, and placed directly under the authority of the pope. By 1199 Las Huelgas was a royal pantheon: the burial site of the Castilian royal family. And it was also a monastery for nuns, whose abbesses were given extraordinary privileges. As a royal pantheon of the Cistercian monastic order, Las Huelgas was modeled after the abbey of Fontevrault, where Leonor's mother, the formidable Eleanor of Aquitaine (who in her time had been both queen of France and queen of England) was buried. And like Fontevrault, it would have a church begun in the Angevin Gothic style, with tall delicate pillars spreading into high Gothic vaults.

After the death of Alfonso and Leonor, the project of Las Huelgas would be abandoned for a generation. Ferdinand III was the son of a king of León, and was probably not overly enthusiastic about completing such a monument to Castilian dignity, even if he had incorporated Castile into his kingdom. Gema Palomo Fernández and Juan Carlos Ruiz Souza have recently shown us, in fact, how Las Huelgas was taken up and completed by Alfonso X, renewing its function as a burial place for Castilian kings at the death of his son, the infante Ferdinand de la Cerda. Alfonso X would link his ancestor's coat of arms with his own, combining the castles of Castile with the lions of León. But an entirely different artistic tradition was then in use. The same study has revealed that Alfonso X covered the oldest parts of Las Huelgas—those not completed in the Gothic style—with a thrilling variety of fine stucco carvings. These include many motifs that might be found at the Alcazar of Seville or the Nasrid kingdom of Granada, and a qubba, or square chapel, was given a vault that was a reminder of Cordoba, taken by Ferdinand III in 1236. But many of the stucco carv-ings copy the actual Islamic textiles in which Castilian nobles were buried, including those that wrapped the body of Ferdinand de la Cerda himself. These stuccos are a precious glimpse into some of the ways that the earlier association of Islamic material arts with ideas of kingship and luxury become assimilated until they are ideas about Castilian identity.

Monastery of Santa María la Real de Las Huelgas, Burgos, cloister, 12th–13th centuries.

Ribbed vault from the Assumption Chapel.

But Rodrigo's account of laying the first stone, and his report of the new cathedral's progress, is followed by a remarkable account of another, different purification that often escapes notice. Immediately following his comments concerning the cathedral, Rodrigo introduces "a certain Abenhut . . . in the lands of Murcia" who "began to confront the Almohads, who oppressed the Arabs of the peninsula with such a severe yoke that they supported Abenhut without difficulty." Abenhut here is the great Murcian leader Ibn Hud, who defied the Almohads and became a Castilian ally in the fight against the North African empire. Rodrigo recounts how Ibn Hud seizes Murcia, how he then "cuts off the heads of all the Almohads" he could get his hands on, after which Toledo's archbishop describes Ibn Hud as doing an extraordinary thing: "considering that all of the mosques were infected by the presence of the Almohads, he had his priests purify them, sprinkling water, and painted over their coats of arms."

What Rodrigo described was a Christian ceremony of purification and consecration, like those he must have seen in the principal mosques of many cities that had fallen into Castilian hands during his long tenure as archbishop. The mosque of Murcia, however, remained the mosque of Murcia when wrested from the Almohads even if Ibn Hud painted over a coat of arms. The key here is Rodrigo's attempt to create a trope, to echo his conversion of Toledo's mosque with Ibn Hud's "conversion" of Murcia's mosques. Rodrigo was trying to fold the Castilian ally, Ibn Hud, into that same diverse cosmos where Franks, Castilians, Jews, Mozarabs, and crusading archbishops lived in peace under the cloak of one realm, under the eye of one church; to distinguish between good Muslims and bad Muslims; between Spanish Muslims who worked from within the authority of Castile, and Almohads, vilified reductive other to the sacred crusader.

Consider once more the Arabic inscription "good fortune and prosperity" (al-yumn wa al-iqbal) from San Román, wishes from the same list of politically correct platitudes that adorned countless secular objects used for centuries, no doubt, by Toledans of all three religions, epithets that flowed effortlessly across political and religious frontiers. For Toledo's Mozarabs they would be religiously neutral; signs of a world that was being ideologically erased, but culturally incorporated, by, of all people, a crusading archbishop. The same wish, al-yumn, is written on a tunic, part of a set of pontificals in which Rodrigo would be buried in 1247, on the eve of the Castilians' momentous capture of the Almohad capital of Seville. Of either Almohad or Nasrid manufacture, it was probably a gift from King Ferdinand III, who had himself received it from his feudal client, another "Good Muslim," Muhammad ibn Yusuf ibn Nasr ibn al-Ahmar, founder of the new dynasty of Granada that would bear his name. The place of the robe in Rodrigo's world is as complex as the political alliance that brought it into being. As Rodrigo promoted crusade, and spoke of frontiers separating Christians and Muslims, he was creating a myth of a Christian West that we still take for granted today. But even as he brandished his crusader's sword, he himself was transformed, through language, material culture, and interaction with Muslims, Jews, and Mozarabic Christians, incorporating a more layered, plural vision of the Christian cosmos into his reformed Toledo.

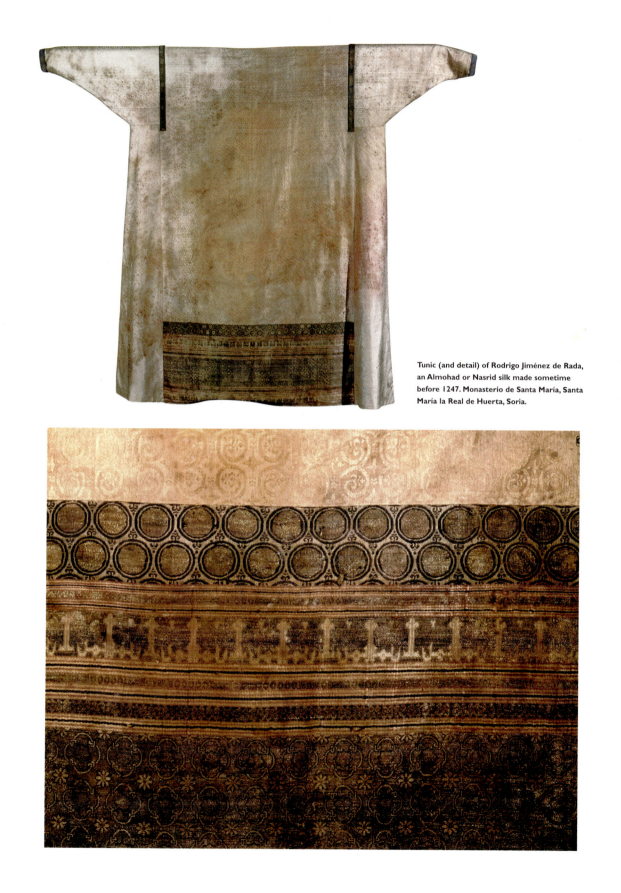

Tunic (and detail) of Rodrigo Jiménez de Rada, an Almohad or Nasrid silk made sometime before 1247. Monasterio de Santa María, Santa María la Real de Huerta, Soria.

The Arabic Inscriptions of Christian Spain

In the years after the fall of the Cordoban caliphate, Arabic calligraphy continued to be used as ornamentation throughout Spain, in constructions initiated by Muslim, Christian, and Jewish patrons, often beside inscriptions in Hebrew, Latin, or Castilian. At times, alongside these legible inscriptions, more inscrutable Arabic inscriptions can be found. The use of Arabic-like patterns without linguistic meaning as a form of Islamic ornamentation, sometimes called illegible or "pseudo"-Arabic, occurs throughout the Islamic world, with a separate set of meanings and decorative purposes. In a Christian or Jewish context, the use of Arabic writing has traditionally been considered out of place because scholars have tended to fetishize the presence of Arabic in a non-Islamic context.

The question of Arabic and pseudo-Arabic inscriptions in Castilian buildings is full of contradictory readings. The technical difficulty of reading any Arabic monumental inscription, especially those that are painted on crumbling plaster walls or carved stucco, means that what one person may see as legible Arabic another might regard as illegible. This is further complicated by the restoration of many buildings, which often (as in the case of San Román) means the inscriptions are painted over in darker colors, potentially changing their original forms.

Despite these difficulties, there often appears a common pattern, suggesting a particular Arabic phrase, which at times accompanies quite legible inscriptions in Arabic, Latin, or Hebrew. The text of this ornamental line can yield diverse readings; on one hand, it can be read as pseudo-Arabic, while on the other, an Arabic phrase can be deciphered in the tangle. In fact, the script lies someplace between the two, in an intermediary zone of allusive, nearly comprehensible script. Though its level of legibility varies in each of the buildings mentioned below, the same repeating phrase can often be read: the aphorism "good fortune and prosperity" (*al-yumn wa al-iqbal*). The letters are crudely shaped and stylized almost to the point of illegibility, with anomalous features like the floating Arabic letter *waw*. The consistency of

this pattern in a number of Castilian buildings from the thirteenth and fourteenth centuries suggests the use of a pattern book, surely one originally formulated for the decoration of objects in minor arts. It is found on textiles, ceramics, enamels, and other portable objects coveted across political and confessional boundaries.

In the church of Santa Cruz in Toledo the copybook inscription surrounds the principal apsidal arch. At San Román, it embraces angels in scalloped arches, windows on the main wall, and the nave arcade. At Las Huelgas in Burgos, peacocks nest in a stucco bower of the same elusive Arabic. The inscription at the convent of Santa Clara in Tordesillas weaves through legible kufic inscriptions, surrounding images of the Holy Family and saints. And at the synagogue of Samuel Halevi, it ribbons through the center of a dense panel of stucco interlace, bordered above and below by Hebrew calligraphy of selections from the Torah. The Hebrew inscriptions yield to the logic of the architecture the same way Arabic inscriptions do in these and earlier monuments.

The same inscription is found on a ceramic box preserved in the Royal Pantheon of San Isidoro, dating from the mid-thirteenth century, and a vase from the Alhambra.

Like the Nasrid motto "There is no victor but God" (*la ghalib illa allah*), inscribed as authoritatively on the walls of the Alcazar of Peter the Cruel as on the surfaces of the Alhambra, these invocations of prosperity gain new meaning in a Christian context. As a supplication for good fortune from God as well as an allusion to the immense richness of Islamic court aesthetic, this inscription's multiple implications cannot have been lost on its Castilian viewers.

In balancing between legible and illegible, holy and mundane, appropriation of spolia and assimilation of Andalusian Arabic culture, these inscriptions embodied the Castilian ambivalence toward the Islamic world they were both imitating and replacing. Like the silks and ivory boxes that found new homes in churches and Christian courts, these inscriptions speak in the multivalent Castilian languages of luxury and victory.

Clockwise from left:

Church of San Román in Toledo.

Monastery of Santa Clara in Tordesillas.

Monastery of Santa María la Real de Las Huelgas.

Ivory box from San Isidoro de León with reused panels from a Taifa box and new panels with "pseudo-Arabic" calligraphy on one of its sides, a design meant to imitate Arabic calligraphy but without linguistic meaning. Its use shows admiration for Arabic calligraphy and understanding of its importance even among those who did not read Arabic. Ivory plaques of animals and Arabic inscriptions, 11th century; panels with pseudo-Arabic calligraphy, 11th or 12th century? Museo Arqueológico Nacional, Madrid.

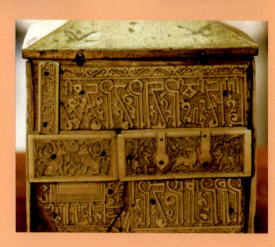

CHAPTER SIX

Adab

Hic est liber magnus et completus quem Haly Abenragel summus astrolugus compusit de Judiciis Astrologi[a]e, quem Juda filius Mosse de precepto domini Alfonso illustrissimi regis Castelle et Legionis transtulit de Arabico in ydeoma maternum, et Alvarus dicti illustrissimi regis factura eius ex precepto transtulit de ydeomate materno in latinum.

This is the large and all-inclusive book composed by the great astrologer Ali ibn abi al-Rijal On *Astrological Judgments,* which Yehudah, son of Moses, translated from Arabic into his mother tongue at the command of Lord Alfonso, most illustrious king of Castile and León, and which, at the command of the same illustrious king that it should be done, Alvaro translated from his mother tongue into Latin.

—Preface to the treatise *De judiciis astrologiae*

A few months after the archbishop Rodrigo consecrated the church of San Román, in 1221, a new heir to the Castilian throne was born in Toledo. On the twenty-third of November of that year, Beatrice of Swabia gave birth to the son of Ferdinand III, who had been king of Castile since 1217. It is likely that the child Alfonso, whom some say was named after the conqueror of Toledo, was born in one of those old palaces of al-Mamun that, in 1085, his namesake ancestor had taken over as the royal residences of the Castilian monarchs in their new metropolis. Within a few months the baby was taken to Burgos, where the Castilian *cortes,* the assembly of nobles, could formally recognize him as heir to his father, Ferdinand—a throne, as it turned out, he would not occupy for another thirty years. But at the time of the birth of the man who would one day be Alfonso X it was vital to establish the groundwork for a peaceful succession to the throne of the dominant Christian kingdom of the peninsula and especially to a unified throne of Castile and León, which had been bitterly and violently contested in so many generations.

Before leaving Toledo, the newborn was baptized there, and it is hard to imagine that Rodrigo did not preside over the ceremony himself, as he had over almost everything else of significance in the realm of Castile in the preceding decades, down to and including the writing of the histories that would for centuries tell the

Toledan dinar of Alfonso X, 1213. American Numismatic Society. The coin's Arabic inscription around the outside echoes the basmala, beginning: "In the name of the Father, the Son, and the Holy Spirit." In the center, another Arabic inscription referring to the pope as the "imam" of the Christian church hovers between a cross and ALF in Latin letters.

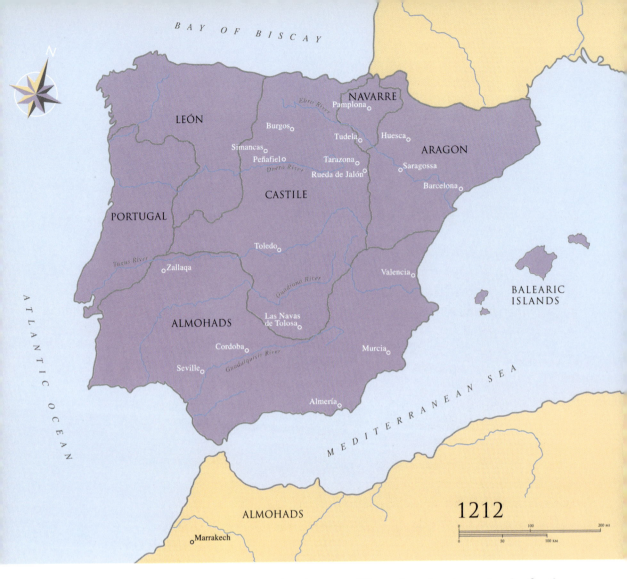

story of this kingdom. Some say that the prince Alfonso, born less than a decade after the battle of Las Navas de Tolosa, was in fact named not after the conqueror of Toledo but rather for the Castilian hero of that turning-point battle, Alfonso VIII, who was also the founder of several of Castile's most prominent cultural institutions: the convent of Las Huelgas, outside Burgos, as well as the university of Palencia, Christian Spain's first university. The evocation of Alfonso VIII would resonate powerfully in the formative years of Alfonso X, in so many ways the child of the denouement of Las Navas. His life, virtually until the moment he ascended the throne at age thirty-one, was lived in the slipstream of his father Ferdinand's remarkable military successes against the Almohads, who were left mortally wounded after Las Navas. These decades, from many perspectives, constitute the heartland of the reconquest: between the battle of Las Navas in 1212 and the climactic taking of Ishbiliya, the capital of Almohad al-Andalus, in 1248, with the final defeat of the Almohads and their abandonment of the peninsula. The dazzling and venerable Islamic city of Ishbiliya became Seville, the new capital of the kingdom of Castile. Alfonso's inheritance, when his father died just a few years later, in 1252, was a kingdom and, indeed, a

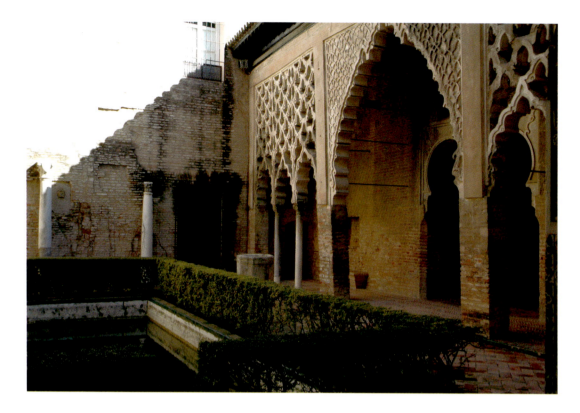

whole world, starkly transformed by this Christian expansion and Islamic retreat whose unambiguous tipping point was that battle of Las Navas.

Patio del Yeso, a 12th-century Almohad garden and portico in the Alcazar of Seville.

Most later historians would rely on the archbishop Rodrigo's own meticulously crafted account of the great battle, cast down to the finest detail as the story of a miraculous crusade that pitted a united assembly of Christians against an enemy spiritual and eternal rather than territorial and contingent. Thus too we mostly imagine its momentous sequel, easily evoked by the dominolike series of Almohad cities that fell into Ferdinand's hands: Mérida and Badajoz in 1230, Cordoba in 1236, Valencia in 1238, Jaén in 1246, and finally Seville in 1248. But the reality on the ground was, in dozens of ways, scarcely less equivocal and complex than it had been two centuries before. The archbishop's writings were meant to be persuasive, and were pitched to future generations, as much history is; and it can scarcely be doubted that Rodrigo, let alone the savvy and skilled King Ferdinand, and his heir-in-training Alfonso, understood just how thick the veneer of wishful thinking might lie on the historical realities of their times. Who, after all, knew better than Rodrigo himself that it had been only through his own genius for manipulation that a momentary patching-together of the bitterly warring Christian kingdoms had been effected, to achieve Las Navas?

And who was more aware than Ferdinand—and the young prince and heir to the throne often by his side, learning all the skills of arms and warfare essential for the king-to-be of an expansive Castile—that in the years and then decades that followed Las Navas

the Christian kings and nobility had returned immediately to all their old ways? These were decades in which the Christians of the peninsula also fought among themselves and cut advantageous deals across the often fictive lines of reconquest, with Almohads and Andalusian Muslims alike. It was through a mutually advantageous alliance with a Muslim —that oldest of Castilian political traditions—that Ferdinand was able to achieve his final and decisive victories, first over Cordoba, and then over Seville. Muhammad ibn Yusuf ibn Nasr, known as Ibn al-Ahmar in his lifetime and as Muhammad I in histories of Granada, became Ferdinand's vassal and ally in 1236. For years Ibn al-Ahmar—who prided himself on his old Andalusian lineage—had been involved in anti-Almohad uprisings in the outskirts of Granada. The bargain he struck with Alfonso allowed him to finally take this city that sits dreamlike on the River Darro, in the shadows of the Sierra Nevada, with its fortified acropolis of reddish earth dramatically looming over its center. Thus was born the independent Nasrid kingdom of Granada, issue of the cross-religious coupling that allowed the ultimate Castilian triumph over the Almohads.

From Ibn al-Ahmar's patronymic, Ibn Nasr, came "Nasrid," the name given to the long line that succeeded him, as well as the glorious artistic styles that would flourish in Granada, as part of the fruit borne of the protection provided by vassalage to the Castilians. Later Muslim historians were discomfited by the spectacle of Ibn al-Ahmar's decisive role in the Castilian conquest of both Cordoba and Seville. Returning from the campaigns against fellow Muslims—taunted in some versions, praised but embarrassed in others—Ibn al-Ahmar supposedly deflected attention from the Christian victory he had made possible by proclaiming, "There is no victor but God." And thus *wa la ghalib illa allah*, which is carved endlessly on the white-plaster walls of the Alhambra, the palace city on Granada's fortified hill built in relative peace and prosperity during the century after the Castilians drove the Almohads from the peninsula.

As had Alfonso VI generations before him in Toledo, Ferdinand would move to possess the palace of the Muslim rulers who preceded him. The Alcazar of Seville was a military stronghold and governor's residence in the Umayyad period; it became the gracious Qasr al-Mubarak, or "Blessed Palace," under the Abbadids, who ruled Seville during the Taifa period, and subsequently the palace of the Almohads. Poets walked on paths between gardens and pools, flanked by gracious apartments, or in large sumptuous ceremonial halls. The Castilians would preserve an Almohad courtyard, the delicate Patio del Yeso, as it came to be called. This rectangular patio, nearly square, barely contains a broad, placid pool at its center, in which are reflected screens of lacy plasterwork that fall on frail marble columns. Horseshoe arches, scalloped arches, and stucco designs based on *sebka*, the puzzlelike intersection of rhomboids, would provide Castilian artists with new models for a generation.

Another memorial to this universe survives, hidden away inside the immense Gothic cathedral of Seville. But the building was far different in Alfonso's time. For in Seville, as in Toledo, a cathedral of Saint Mary was housed in a converted mosque, in this case the Almohad Great Mosque of Seville. Austere and restrained in their use of architecture, the Almohads had eschewed the use of luxurious mosaics as at Cordoba, or the plastic,

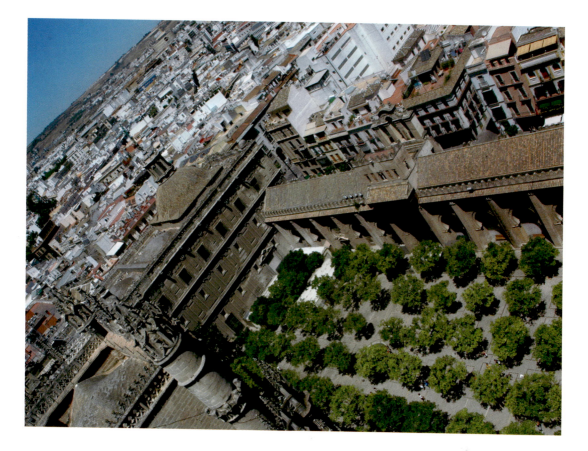

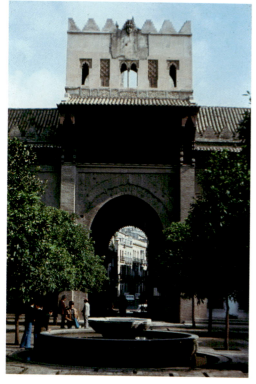

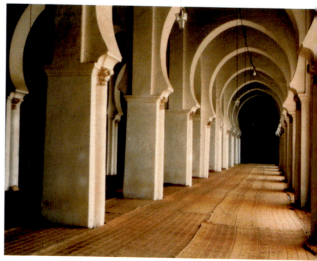

clockwise from top:

Great Mosque of Seville, parts of the sahn later incorporated into the cathedral of Seville.

Kutubiyya mosque in Marrakech as rebuilt by the Almohads in the 1160s. It gives an idea of how the Great Mosque of Seville might have looked originally and when it was used as a cathedral during the reign of Alfonso X.

Great Mosque of Seville, parts of the sahn later incorporated into the cathedral of Seville.

Decorations on the door of the Great Mosque of
Seville, preserved today in the cathedral.

visceral plaster carving of the Taifas and Mardanis
of Murcia. Instead, they built a conservative
hypostyle mosque of brick piers covered with plaster, in which the sharp profile of a keel-
shaped arch—a pointed horseshoe arch—created a simple elegance repeated throughout
the enormous prayer hall. In the cloister of the cathedral today arches from the mosque's
sahn, or courtyard, still survive, and over the entrance, a muqarnas vault, the Almohad's
complex and cerebral response to the sensual forms of the Taifas. But the Castilians had
particular admiration for the minaret of the Great Mosque, which "could not be matched
in all the world." Alfonso so valued it that he threatened with death anyone who would
destroy "even one brick."[1]

When Ferdinand died in 1252, and Alfonso ascended to the throne of Castile, the
new king built a memorial in which to bury his father. Ferdinand's simple marble tomb
was installed in that mosque, recently consecrated as the new cathedral of Seville. And the
story of the "Conqueror of all of Spain"—who would much later be canonized for his
role in the reconquest—is carved on the sepulcher. The epitaph appears not once but four
times, once in each of the languages of the empire that was Ferdinand's and became
Alfonso's: Latin front and center; Arabic and Hebrew on the right, separated from each
other by the intertwined lions of León and the castles of Castile; and to the left, for con-
temporaries, an irreverent surprise, Castilian. Here is Alfonso's elegy to his conqueror
father's plural kingdom, and to a Castilian universe in which the public presence of Jews
and Muslims was a matter of course, peoples of the realm with their own monumental
languages in which the king himself could inscribe their versions of the life of Ferdinand.
No less, though, this was Alfonso's proclamation of his own imperial vision and ambitions,
especially those that arose from the culture of translation his father's tomb immortalizes.

Bell Towers and Minarets

The first tower minarets on the Iberian Peninsula appeared in the ninth century, and by the tenth century, Abd al-Rahman III would build a tower at the Great Mosque of Cordoba to celebrate his sovereignty as caliph. A curious dialogue had already developed, however, between Christians and Muslims, concerning visual and aural authority in plural cities of al-Andalus. Though they were free to worship, the Mozarabs missed the ability to advertise their faith. "And what persecution," Paul Albar of Cordoba would declare, "could be greater, what more severe form of suppression . . . when one cannot speak by mouth in public what with right reason he believes in his heart?" "We have become," he lamented, "dumb dogs, unable to bark." At some point, this competition began to be worked through in architecture and the sounds that called the faithful to prayer, with bell towers and minarets as the symbolic terms of the dispute. Speaking of the Muslim reaction to Christian bells in Cordoba, Paul Albar remarked in his *Indiculus luminosus* that "when they hear the sign of

the basilica, that is, the sound of ringing bronze, mouthing their derision and contempt, moving their heads, they wail out repeatedly unspeakable things." In speaking of the muezzins, who gave the call to prayer from the minarets, however, he returned the sentiment, protesting that they "howl daily from their smoky towers."

By 850, Eulogius, the leader of the ninth-century Mozarabic martyr movement, reported that the emir Muhammad I had ordered that the church towers be pulled down. The dhimma protected the places of worship of Christians and Jews under Islamic rule, but it did not permit the embellishment or monumentalization of Christian or Jewish places of worship, and guarded against any behavior that would threaten the authority of Islam in plural societies. Abd al-Rahman III's tower minaret, built a century later, was surely part of this competitive dance between bell towers and minarets. This heated dialogue had a long afterlife. When al-Mansur conducted punitive raids in the north of Spain, he burnt the church of Santiago de Compostela, while respecting

Great Mosque of Cordoba, minaret, later converted into a bell tower, 10th century.

Minaret of the Kutubiyya mosque in Marrakech, 1160s.

Minaret of the Great Mosque of Seville, 12th century, later converted into a bell tower, often called "La Giralda."

Minaret converted into a bell tower at Santiago de Arrabal in Toledo, 13th century.

the sanctity of the saint's tomb. He then sent the bells of the church of Santiago to Cordoba, carried by Christian prisoners, where they were converted into lamps for the mosque. And in the thirteenth century, the Castilian king Ferdinand III is said to have returned those same bells to Santiago on the backs of captured Muslims.

Bells themselves were recruited in this struggle for rhetorical domination. During Almohad raids, aimed in particular at correcting the laxness of dhimmi relations in al-Andalus, bells were captured from churches and sent to North Africa. There, as in Cordoba under al-Mansur, the clappers were removed, and they were sequestered in cages of bronze filigree designed to hold oil lamps. Bells that had once called the Christian faithful to prayer now lit the prayer halls of devout Muslims.

But a great deal of the contentious dialogue between bell towers and minarets shrouds admiration as well. The Almoravids did not leave minarets, but the Almohads constructed lofty square-planned towers visible from afar, and these were conceived,

Jonathan Bloom has demonstrated, as major political statements during the Almohad offensive. The minaret of the Great Mosque of Seville was constructed by the architect Ahmad ibn Baso more than a decade after the completion of the Almohad's severe and enormous hypostyle mosque. It was originally more than 260 feet high, a dizzying statement of "Islam Triumphant." And yet it was greatly admired by the Castilians when they took Seville. Alfonso X appropriated it as the tower of the cathedral of Santa María, and called it the most beautiful building in the world. In 1568 its pinnacle was redesigned by the architect Hernán Ruiz, and it became a symbol of the city, taking on the name "La Giralda," the weather vane. Its pinnacle carries the allegorical figure of "faith" as if to proclaim the final domination of Christianity over Islam. Now the minaret of the Great Mosque of Seville was a symbol of Christianity triumphant.

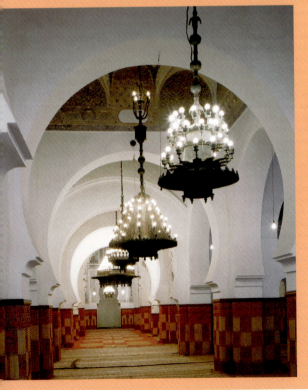

Qarawiyyin mosque in Fez, bell lamps in the mihrab aisle.

Lamp from the Qarawiyyin mosque in Fez, Almohad period, late 12th–early 13th century. The lamp is made from a bell taken from a church on the Iberian Peninsula.

The Tomb of Ferdinand III

Ferdinand III (r. 1217–1252) was buried in the cathedral of Seville, alongside his first wife, Beatrice, and the son who would eventually succeed him to the throne, Alfonso X the Wise (r. 1252–1284). Just a few years before his death, Ferdinand had taken Seville from the Almohads, whose Andalusian capital it had long been; the vast Great Mosque was consecrated and began serving as the cathedral of the city, which in turn had become the de facto capital of the Castilians and would long remain Alfonso's favorite home. The tomb he built for his father was originally a part of the converted Almohad mosque, a building that remained in Christian use until the early fifteenth century. At that point it was demolished and replaced by the Gothic cathedral that fills its footprint, leaving only a handful of traces of its predecessor: the gates leading to the ablutions court and the court itself, as well as La Giralda, the distinctive minaret-turned-bell tower. Today the original tomb sits mostly unremarked as the "base" of the altar of the Capilla Real (royal chapel) considerably obscured by the gilt baroque superstructure that was added in 1771.

The original marble tomb, a rectangular sarcophagus of approximately six feet by seven feet, was commissioned by Alfonso X and bears the king's epitaph in four languages. Although Castilian had already begun to appear in a limited number of texts, few would have imagined it as literally comparable to Arabic, Hebrew, and Latin, languages long consecrated as those of laws and letters. But it was precisely Alfonso's translation work and dedication to recasting the vernacular of his kingdom—a project that was about to begin in earnest as he took over the throne—that would fully transform Castilian, and elevate it to the status of a legitimate literary language distinct from Latin.

The inscriptions themselves provide particularly striking markers of the Castilians' intimacy with the communities they represent on the king's tomb. The four inscriptions are not mechanical translations but rather, each version reflects, to some degree, the cultural and religious sensibilities of speakers of the particular languages. In the Arabic text, for example, the formula *radi allahu anhu,* "may God be pleased with him," the epithet usually appended to the names of the companions to the prophet Muhammad, is here used for Ferdinand, who is nevertheless described as the victor over a series of Islamic cities. In these broadly cultural renderings of the same description of Ferdinand and his achievements, there was no particular reliance on cognates in the Arabic and Hebrew versions of the epitaph, and there was no shying away from the use of culturally distinctive concepts. Remarkable—and poignant, given that later historical perspective from which we now read them, knowing that Jews and Muslims would be expelled from Spain and from the memory of what had ever constituted the Castilian community—is the use of the place-names Sefarad and Andalus to mean Spain. In each inscription, the date is marked on the calendar that would have been used by speakers of that language: the Latin inscription follows the Gregorian calendar, the Arabic inscription follows the Hijri calendar, the Hebrew follows a biblical calendar, and the Castilian follows its own, distinct from the Latin. The dates themselves resonate with the polyphony of sounds and words of Ferdinand's kingdom: the last day of May 1252; the twentieth day of First Rabia 550; the twenty-second day of Sivan 5012; and the last day of May 1290.

By confirming that each of these four dates points to the same day, May 31, 1252, Enrique Flores (also given as Henrique Florez), the theologian who published the first transcriptions, translations, and pictures of the inscription in the initial volume of *España sagrada* (1754), noted in the accompanying article that Ferdinand's saint's day had been celebrated incorrectly on May 30, and appealed for this to be changed based on the overwhelming evidence provided by the Hebrew and Arabic inscriptions. The work of Enrique Flores remains the best source for the inscriptions.

The general sense of the epitaph is as follows:

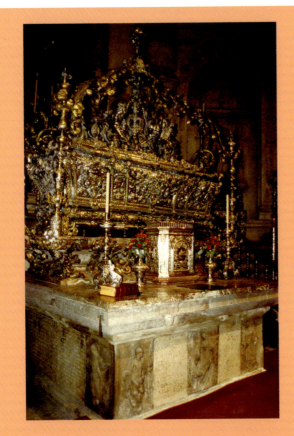

Latin

Here lies the most illustrious king Ferdinand of Castile, Toledo, León, Galicia, Seville, Cordoba, Murcia, and Jaén, who conquered all of Spain (Hispania), the most loyal, the most veracious, the most constant, the most just, the most energetic, the most tenacious, the most liberal, the most patient, the most humble and the most effective in fear and in the service of God. He conquered and all but exterminated the arrogance of his enemies, protected, raised up, and exalted the men who were his friends; he captured the city of Seville, the capital of all of Spain, from the hands of the pagans and restored it to the Christians, and that is the city where he paid his debt to nature and passed to the Lord on the last day of May in the year of the Incarnation, 1252. Trans. Sarah Pearce

HIC : IACET : ILLVSTRISSIMVS : REX : FER
RANDVS : CASTELLE : ET : TOLETI : LEGION
IS : GALLIZIE : SIBILLIE : CORDVBE : MVRCIE: ET
IAHENI : Qᵎ : TOTAM : HISPANIĀ : CONQVISIVIT :
FIDELISSIMVS : VERACISSIMVS : CONSTANTI
SSIMVS : IVSTISSIMVS : STRENVISSIMVS : DETEN
TISSIMVS : LIBERALISSIMVS : PACIENTISSIMVS : PII
SSIMVS : HVMILLIMVS : IN : TIMORE : ET SERVICIO : D
EI : EFFICACISSIMVS : Qᵎ : CŌTRIVIT : ET : EXTERMIN
AVIT : PENITVS : HOSTIVM : SVORVM : PROTERV
IĀ : Qᵎ : SVBLIMAVIT : ET : EXALTAVIT : OMNES :
AMICOS : SVOS : Qᵎ : CIVITATĒ : HISPALĒ : QVE : C
APUD : EST : ET : METROPOLIS : TOCIVS : HISPANIE :
DE : MANIBVS : ERIPVIT : PAGANORṼ : ET CVL
TVI : RESTITVIT : ẊTANO : VBI : SOLVENS : NAT
VRE : DEBITṼ : AD : DOMINṼ : TRĀSMIGRAVIT : V
LTIMA : DIE : MAII . ANNO : AB : INCARNACIONE : DO
MINI:MILLESIMO:DVCENTESIMO:QVINQVAGESIMO:II:

Latin text transcribed

Here lies the most honorable king Don Ferdinand, lord of Castile, Toledo, León, Galicia, Seville, Cordoba, Murcia, and Jaén, conqueror of all of Spain. He is the most loyal, truthful, and forthright; the strongest, most handsome, and most illustrious; the most modest; the most humble and God-fearing. He is God's greatest servant. He destroyed all of his enemies and honored his friends. He conquered the city of Seville, capital of Spain, and died there on May 31, 1252.

The language-specific texts illustrate the finer differences between the four, and we present them here in Flores's transcriptions and in literal translations intended to give a sense of the cultural variants and expressions:

Arabic

Here is the tomb of the great king Don Ferdinand, lord of Castile, Toledo, León, Galicia, Seville, Cordoba, Murcia, and Jaén, may God be pleased with him, who ruled all of Spain (Andalus), (who is) the most faithful, the most veracious, the most enduring, the most just, the most valiant, the most propitious, the most noble, the most forbearing, the most visionary, the greatest in modesty, most suitable to God and His greatest servant. He died (God had mercy on him) on the Friday night and God raised him. He honored and ennobled his friends and took possession of the city of Seville, which is the capital of all of Spain, and in which he who broke and destroyed all of his enemies died on the twentieth of the month of First Rabia of the year 550 of the Hijra. Trans. Sarah Pearce

Arabic text transcribed

Hebrew

In this place is the tomb of the great king Don Ferdinand, lord of Castile, Toledo, León, Galicia, Seville, Cordoba, Murcia, and Jaén—may his soul be in paradise—who seized all of Spain (Sefarad), the upright, the righteous, the enduring, the mighty, the pious, the forbearing, the one who feared God and served Him all of his days, shattered and destroyed all of his enemies, praised and honored all of his friends, and took the city of Seville which is the capital of all of Spain, in which he died on the night of Friday, the twenty-second of the month of Sivan, of the year 5012 since the creation of the world. Trans. Sarah Pearce

Hebrew text transcribed

Castilian

Here lies the most honored king Don Ferdinand, lord of Castile and Toledo, of León, of Galicia, of Seville, of Cordoba, of Murcia, and of Jaén, he who conquered all of Spain (toda España), the most loyal and most truthful and the most forthright, the strongest and most decorated, the most illustrious and the most forbearing and the most humble and the one who is most fearful of God, and the one who did the most service to Him; who broke and destroyed all of his enemies, who praised and honored all of his friends, and conquered the city of Seville which is the capital of all of Spain and died in it on the last day of May in our era, the year of 1290. Trans. Sarah Pearce

Castilian text transcribed

His most breathtaking aspiration is brazenly inscribed, prefigured, on his father's tomb: to transform the common speech that was Castilian into a written language to rival and even replace Latin. This is a revolution written in stone. And its beginnings, as the tomb itself whispers to us, lay in a proud moment in the not-so-distant Castilian past: that time and place when Toledo's embrace of its Jewish and Islamic heritage brought the cream of Latin culture to its own doorstep, hat in hand.

<p style="text-align:center">✳</p>

In 1142 Peter the Venerable, abbot of Cluny, went to look for a Quran. For him this was the most vital book in the Arabic libraries of the new Christian frontier of his age, the textual proof of the errors of Islam. Peter's interest in the sacred texts of the Muslims was part and parcel of his dispute with Bernard of Clairvaux, the great champion of crusade whose image would appear on the walls of San Román years later. Peter, against Bernard, believed the polemic with Islam ought to be conducted intellectually, and thus his extraordinary efforts to have the Quran in Latin. His arduous trip south of the Pyrenees and into the territories controlled by Alfonso VII would have brought some comforts and pleasures, since the abbot had dozens of Cluniac monasteries to stay at along the way. And once he arrived in Toledo he would be received by a fellow Frenchman and Cluniac: the archbishop Raymond, who was only the second archbishop of Toledo after 1085. Raymond had succeeded Bernard of Sedirac in 1125, and like him wished to see Toledo as the center of the Spanish church, a view he continued to promote vigorously until his death in 1152. And it was a view he shared with Alfonso VII, who ruled from 1126 until 1157, and whose advisor and confidant he was for the many years of their nearly overlapping reigns.

Although there is much dispute about Raymond's actual role in the creation of a burgeoning industry of translators and translations, there is a certain proof in the pudding: Toledo, in the middle of the twelfth century, was poised to become the charismatic center of European intellectual life. Latin Christians from beyond the Pyrenees had been arriving in Spain for decades: churchmen and other literate clerics, and more and more, as time went by, the independent scholars, men in search of specific books rumor had it might be found in the libraries of this Christian land so different from their own. Herman of Corinthia, sometimes called Herman the Dalmatian; Peter of Poitiers; Robert of Ketton . . . the annals of the first half of the twelfth century afford us a glimpse of the growing international attraction of Spain, through the names of these men who made the intellectual pilgrimage from all corners of Latin Christendom. Charles Homer Haskins, who first revamped our notions of the Middle Ages in his still-classic *Renaissance of the Twelfth Century*, called Spain, in this pivotal moment, "the land of mystery, of the unknown yet knowable, for inquiring minds beyond the Pyrenees. The great adventure of the European scholar lay in the Peninsula."[2]

But the truth is that in the first decades of the century it was not only the new Castilian metropolis that beckoned with a treasury of books to study, and translators, or those who might teach Arabic to someone who did not read it. Many of the early scholars

were peripatetic, and worked in smaller cities up and down the Ebro valley. And although we often reflexively call them translators, they were translators in the service of their own intellectual interests, as we sometimes are, and then their translations served others. The most powerful rival to Toledo as a center of knowledge, and as a warehouse of the great books of mathematics and the sciences that Latin Christendom was just beginning to realize were within their reach, was the kingdom of Aragon, long dominated by the illustrious Banu Hud, the family that had created and ruled the ultracivilized Taifa of Saragossa.

The first purveyor of Saragossan intellectual goods beyond the Pyrenees was Petrus Alfonsi, the converted Jew from nearby Huesca who ended up as one of England's intellectual luminaries in the early decades of the twelfth century. Petrus—whose Jewish name was Moses and who is sometimes referred to as "Moses the Spaniard"—left the Taifa's precincts sometime shortly after his public baptism in 1106, taking some of its great book learning with him. Among these were the influential collection of tales he slyly called the *Disciplina clericalis* (the Jewish convert's "Priestly Tales" are explicitly the nuggets of wisdom and stories taken from the traditions of the Arabs, for the edification of novice Christian clergy) as well as translations of a number of key works of astronomy, including al-Khawarizmi's astronomical tables.

But, in considerable measure because of Petrus's teaching and influence in the England of Henry II, his revelations of scarcely imaginable wealth in the libraries of his homeland, the treasure seekers began to travel to places where they could themselves have direct access to the libraries. And many of the earliest known translators worked in cities like Tudela, which sits on the banks of the Ebro in Aragonese territories, or Tarazona, whose bishop, Michael, had a number of early translations dedicated to him. The translations dedicated to Tarazona's bishop—including the important books of Hugh of Santalla, such as his *Liber Aristotilis* (Book of Aristotle), were based on manuscripts that had been acquired from the Saragossan libraries. When the Banu Hud abandoned Saragossa in 1110, deposed by the Almoravids, they took themselves and their famous libraries to a small fortification called Rueda de Jalón, less than thirty miles to the west of their old Taifa capital. It was Michael's fortune that his bishopric of Tarazona, in turn, lay some thirty miles to the west of Rueda, and its exiled Taifa library.

So when Peter the Venerable began his search in Spain for a translator to turn the Quran into Latin, Toledo was not quite yet the center of the Arabic library universe it would soon be. The abbot of Cluny was himself pulled, albeit indirectly, by the gravitational field that was the great Saragossan library, and he had to travel through the Ebro valley to find the first-rate translator who had been most highly recommended to him for the unusual job at hand. He was Robert of Ketton, an Englishman who had come to Spain to study in her Arabic libraries, and who was already becoming one of the great translators of scientific and mathematical texts. It was his translation of al-Khawarizmi's algebra that would affect the course of mathematical understanding in Latin Christendom. There is much dispute about where it was, exactly, that Peter found Robert: perhaps it was as far north as Pamplona, where Robert would eventually end his career as an archdeacon; or

perhaps it was as far west as Tarazona, or even closer to Rueda, since we know that Robert collaborated with Hugh of Santalla in the compilation of the *Liber Aristotilis*; or perhaps it was farther east and closer to the heart of Castile, somewhere along the Ebro River.

But find him he did, and he was able to persuade him, with the offer of what Peter later reported was an extortionist sum, to undertake the translation of the Quran, a text in which this intellectual adventurer and pioneer in fact had no particular interest. Although Robert was a man of the church, like most others involved in this hunt for the treasures that lay in the magic cabinets of Arabic books of Spain, he was searching for knowledge that lay far indeed from religion or its ideology. Many inside his own faith would eventually maintain that this knowledge went counter to revelation, and a slightly different way of telling the story of the twelfth-century "renaissance" is through the prism of the struggle between reason and revelation that sooner or later became manifest in each of the three monotheistic communities.

Even in this most unusual project undertaken for the abbot of Cluny, one exceptionally focused on a religious text in Arabic, Robert behaved as he did in his more scientific work, and as most other translators of his age did. This meant, first and foremost, that he worked not alone but as part of a collaborative enterprise, just as, in the very recent past, he had worked with Hugh of Santalla and Herman of Corinthia on the *Liber Aristotilis*. Many surviving translations name only the lead figure in the project—most likely the Latin scholar whose interest in the text provoked the effort—but all manner of evidence suggests that virtually all projects not only were collaborative but also involved the striking mixture of languages and religions that made the Christian territories of Spain distinctive. Robert's Quran is the version not just of Robert but also of a Mozarab identified as Petrus Toletanus, and of a Muslim named Muhammad. And beyond this, Robert also brought to bear the same very broad concept of "translation" that he and others brought to most, if not all, such projects: his work was that of a scholar and intellectual who knew and used the history of the texts with which he worked. He is better understood as a guide or a go-between, a concept poetically called *turjuman* in Arabic, a word that gave modern Spanish the equally evocative *trujamán*.[3]

Robert's translation of the Quran provides us an extraordinary example of how easily this fundamental quality of the twelfth-century transformations has been misjudged, more often than not viewed with disdain, because of its obvious "inexactitude," and belittled with the tag of "paraphrase." But in a brilliant piece of close-textual detection, Thomas Burman has documented Ketton's extensive use of local, contemporary *tafsir*—the exegetical tradition on the Quran that Muslims use to guide their own readings and understandings of what is a difficult and often opaque text of revelation. From the late fourteenth century on, the Ketton Quran was widely criticized for being (at best) a "loose and misleading paraphrase." "Juan de Segovia," the earliest and, Burman argues, the fairest of his critics, "not only objected to Robert's redivision of the Quran into more than the standard 114 surahs, but also decried the God-like way in which he had translated: he had moved what was at the beginning of many Quranic passages to the end, and vice versa; he had

altered the meaning of Quranic terms as he translated them; he had often left out what was explicitly in the text, but incorporated into his Latin version what was only implicit in the Arabic original."[4] What Peter the Venerable took away with him, when he returned to Cluny with a version of the scripture of the Muslims—and assorted other texts together called the *Collectio Toletana* (Toledan Collection)—was not a freewheeling paraphrasing by an English mathematician whose Arabic was not up to snuff, or who was perhaps too detached from the job at hand and anxious to get back to what he no doubt thought of as his real work. No, Robert's version of the Quran was crafted with extraordinary care, a text created explicitly for the novice Christian reader, a translation that had worked commentary into the original and that had incorporated contemporary Muslim understandings of the text into the text "itself."

The translation of texts from Arabic often involved magic-seeming transfigurations, and translators were very often seen as alchemists, or sorcerers. Dante cast Michael Scot, the most renowned Arabist and translator of the early thirteenth century, a man who studied both Arabic and translation in Toledo, as a necromancer. Behind this casting lie all sorts of enduring images of the translators themselves, of the libraries they worked with, and perhaps especially of Toledo itself. The Taifa of Toledo had in fact specialized in the study of the stars, sometimes astronomy, but just as often its inseparable partner, astrology. Toledo's image as Spain's magical center, the place where the arts of necromancy and divination flourished, would become even more entrenched under Alfonso X, the first Castilian monarch to take direct control over the translation enterprise, and make scholarship itself vital to the image of kingship. In many cases, as Charles Burnett makes clear, the intertwinements between the magic arts and the scholarship at the heart of the translators and their translations were explicit, and unembarrassed: "In our first encounters with the transmission of Arabic science we find the exact sciences inextricably mixed up with astrology and magic and their transmission hedged with language redolent of a mystery religion. The same scholar would see nothing incongruous in solving a quadratic equation one moment and predicting from the stars whether a man might be killed by falling masonry the next: he might even make a talisman to prevent such a contingency."[5]

For us, Robert of Ketton's transmutation of the Quran of the early 1140s, worked somewhere along the Ebro, or perhaps even as far as the precincts of Saragossa, stands at a different but equally alchemical crossroads: although there would be translators and translations out of Arabic and into Latin elsewhere, Toledo in the second half of the twelfth century became the undisputed center of this new cultural empire, one explicitly dedicated to the metamorphosis of the legendary wealth of Islamic Spain into what would become the foundations of modern European thought. Writing toward the end of the twelfth century, in his dedication of the *Philosophia* to the bishop of Norwich, Daniel of Morley tells his personal story of discovery, which stands as representative of the age:

> When, some time ago, I went away to study, I stopped a while in Paris. There I saw asses rather than men occupying the Chairs and pretending to be very important.

They had desks in front of them heaving under the weight of two or three immovable tomes, painting Roman Law in golden letters. With leaden styluses in their hands they inserted asterisks and obeluses here and there with a grave and reverent air. . . . When I discovered things were like this, I did not want to get infected by a similar petrification, and I was seriously worried that the liberal arts, which illuminate the Bible, were being skipped over, or read only in exam cribs. But when I heard that the doctrine of the Arabs, which is devoted almost entirely to the quadrivium, was all the fashion in Toledo in those days, I hurried there as quickly as I could, so that I could hear the wisest philosophers in the world.[6]

An air of mystery has long hung over many of the essentials of this crucial chapter in intellectual history: why was the translation of the Arabic library into Latin not undertaken before, or elsewhere, or by others? Adelard of Bath, along with Petrus Alfonsi (with whom he may have collaborated on some translations in England), reportedly took a seven-year journey to the Middle East, Magna Grecia, and Sicily, all in pursuit of what he famously dubbed the *studia arabum*. Any one of those places, where there was access not only to Arabic but also to Greek, might have served as the intellectuals' pilgrimage site. Why was it only Castilian Toledo, and principally in the second half of the twelfth century, that harbored, on such a scale, Latin translations of what we quite misleadingly call the Greek philosophical corpus? For the Latins it was distinctly the learning of the Arabs, the studia arabum, and even more specifically the libraries and learning of the Andalusians.

It is not merely a question of Arabic being rendered into Latin. The central question concerns Castilian: Castilian as the shared language of translators, and Castilian Toledo, as the nurturing culture. From the multilingual and multireligious teams of translators easily drawn from the substantial communities of Mozarabs and Jews and Mudejares, to that sense of Castile as an empire that could replace both the Romans and the Umayyads, it was the complex Castilian ethos that made Toledo into the antechamber to the long-secret knowledge of the Arabs. Here was a unique place, where the *ydeoma maternum* was the lingua franca of the clusters of scholars and their guides, their turjumans, where the key to the Arabic libraries was Castilian.

So we pause briefly to rehearse the beginnings of the story of the Arabic libraries of al-Andalus, and thus Toledo itself. These libraries were the legacy, first and foremost, of the Abbasid caliphs of Baghdad, patrons of the first "translation movement," as it is normally called. There they created a mythic image of kingship to buttress their legitimacy, an image supported by extensive acts of cultural patronage. In their soon-to-be legendary capital, the round city sometimes called Madinat al-Salam, or the "City of Peace," the Abbasids began collecting Greek and Roman texts, many of which had been shunned by the authorities of Christian learning in Rome and Constantinople. In the course of the two centuries that followed their rise to power—from the middle of the eighth until the end of the tenth—a vast portion of the storehouse of knowledge and thought of classical antiquity metamorphosed, from Greek into Arabic. "Subjected to the transformative magic of the translator's pen," as Dimitri Gutas puts it, were nearly all secular Greek books, and his inventory of

clockwise from left:

Arabic astrolabe of Ahmad ibn Muhammad al-Naqqash, 1079–1080. Nuremberg, Germanisches Nationalmuseum.

Latin astrolabe, 1498. Adler Planetarium, History of Astronomy Collection, Chicago.

Hebrew astrolabe, mid-16th century. Adler Planetarium, History of Astronomy Collection, Chicago.

these is sobering: "astrology and alchemy and the rest of the occult sciences; the subjects of the quadrivium: arithmetic, geometry, astronomy, and the theory of music; the entire field of Aristotelian philosophy throughout its history: metaphysics, ethics, physics, zoology, botany, and especially logic—the *Organon*; all the health sciences: medicine, pharmacology, and veterinary science; and various other marginal genres of writings, such as Byzantine handbooks on military science (the *tactica*), popular collections of wisdom sayings, and even books on falconry—all these subjects passed through the hands of the translators."[7]

It has long seemed odd that no significant translation into Latin or vernacular languages took place earlier, or in other places despite the fact that these vast Arabic libraries of Baghdad were available in Cordoba by the middle of the tenth century, and despite the fact that these libraries and some of their scholarship were known by Latin-Christian scholars from other parts of Europe since at least the turn of the millennium. During the second half of the tenth century, Gerbert of Aurillac, the Frankish cleric who would become Pope Sylvester II, had spent years studying in Catalonia, and some believe in al-Andalus as well. Gerbert took back to northern Europe bits and pieces of the advanced mathematics and technology of al-Andalus, including his knowledge of the navigational wonder of the age, the astrolabe. But a translation movement is not an abstract intellectual enterprise, even when many of its most renowned and influential texts are. The opportunities had long been there in theory since Umayyad Cordoba, and beyond Cordoba the Taifas had the libraries, of course. But they had no need; theirs was a universe in which all civilized and literate people—Jews and Christians included—could read Arabic. In the Umayyad worldview, the barbarians to the north, despite the occasional interest of a rara avis like Gerbert of Aurillac, would hardly have seemed like a promising market for Latin versions of books on the theory of music or botany.

Only in the aftermath of the 1085 conquest of Toledo did there come into being a large and vigorous Christian kingdom with a body politic that went far beyond the tribal and isolated. Toledo's cosmopolitanism replicated a number of the social and cultural conditions that had once provoked and sustained the dynamic efforts of the Abbasids: abundant libraries and skilled and literate native speakers of all relevant languages. Plus desire, amorphous but all-powerful, and desire among those in a position to organize and fund and sustain this expensive and complicated business: teams of translators, Arabic tutors and scholars sitting at desks with Latin scholars, often with a third or fourth bilingual guide to the language and the texts. The transformation of this from the occasional one-man show, as was the case with Gerbert of Aurillac, and a trickle of translations into the kind of imposing enterprise it became, was already beginning to take place in the 1140s, when Peter the Venerable nevertheless had to go searching for a first-rate translator outside the walls of Toledo.

Just a few years later, an adventurer-scholar named Gerard from the Italian city of Cremona made the trip to Toledo because he had heard that there he could find Ptolemy's *Almagest*, which he and many others considered a text of transcendental value. There, Gerard discovered not only the *Almagest* but a burgeoning enterprise housed in the precincts of the

cathedral of Toledo, where Toledans still prayed in the hypostyle hall of the Great Mosque. There, he found the vital support of influential men within the church, not least his fellow Christian Arabist known as Dominicus Gundissalinus, Domingo González. And there he would also find, over the next several decades, that the translation of Greco-Arabic texts was being encouraged and facilitated by Toledo's French archbishop, John of Castelmaurum, who was simultaneously involved in raising funds for a new cathedral building. Gerard never left Toledo: he died there in 1187, after a long and brilliant career, which made him the superstar translator of the age, with dozens of major works to his credit, beginning with the *Almagest*. Gerard's accomplishments are generally attributed with providing the

The Number Zero

In early medieval Europe, Roman numerals were used to express numbers in writing, but this system had no numeral for the number zero. This made mathematics difficult, for though medieval scholars understood the concept of zero (called *nullus* in Latin), there was no placeholder for complex computation. It was probably this limitation that made medieval scholars turn from Roman to Arabic numerals, a system of numbers developed in India but brought to Europe by Islamic scholars. Along with the rest of the Arabic numerals that we use today, zero traversed the medieval world, from India, through the Middle East, to Europe. And like many scientific and mathematical ideas, a vital stop in zero's journey from east to west was Toledo.

By the end of the eighth century, the use of Indian numerals was adopted at the Abbasid court of al-Mansur. These numbers, particularly the zero, allowed mathematicians to make more rapid and precise computations. Important mathematicians at the Abbasid court wrote several books about the virtues of the Indian system, most notably al-Kindi and al-Khawarizmi (whose name, in addition to being the root of the mathematical term "algorithm," would also form the word for books about Arabic numerals, "algorism").

The ninth-century works of mathematicians working in the east made their way to Spain along with the rest of the philosophic and scientific corpus of the Abbasids. By the twelfth century, homegrown scholars in al-Andalus were hard at work using this science for their own purposes. Abraham Ibn Ezra, a rabbi born in Toledo in 1097, wrote books on astrology and astronomical tables, and an arithmetic, in which he described the numerical system in vogue. This system, with nine numerals and a zero, quickly caught the attention of scholars to the north. Gerard of Cremona (1114–1187), who traveled to Toledo to learn from and translate the great works of astronomers and mathematicians in the Arabic libraries, is believed to have used this numerical system in his Latin translation of Ptolemy's *Almagest*, which would be the first appearance of zero in northern Europe. Another Spanish scholar, John Hispalensis of Seville, who had converted from Judaism to Christianity, wrote a book that used the Arabic numerals to extract the square root of numbers.

Most frequently credited for introducing the Arabic numerical system into Europe is Leonardo Fibonacci, an Italian merchant who published a translation of al-Khawarizmi's work on algebra (*al-jabr*) in 1202. It was, however, a work completed in Spain that helped bring the Arabic numerals to common usage in Latin Europe. In 1248, King Alfonso X commissioned the translation of an astronomical table that used Arabic numbers including zero in its notation. Known as *zephirum* in Latin, zero entered intellectual circles, where it would be taught and debated alongside other concepts newly arrived from the Arabic world at the nascent European universities. By the year 1300, Arabic numerals were in widespread use throughout Europe.

raw materials for the philosophical work of the great Latin thinkers of the thirteenth century. These are also the accomplishments of the Toledan world of those decades, a moment apart in the history of translations. Gerard's work, like that of his contemporary and sometime collaborator Gundissalinus, was the work of those Toledan teams, although often the names of what Gutas has called the "shadow translators" do not survive.

But enough of the time they do, and even a few lines can paint a vivid picture, as does this passage from the preface to Ibn Sina's *De anima* (On the Soul), in the famous translation of Gundissalinus and one of his frequent partners, identified as Iohannes Hispalense, the Mozarab John of Spain. It is the latter who speaks in the preface and succinctly describes the everyday translation method: "Me singula verba vulgariter proferente, et Dominico archidiacono singula in latinum convertente, ex arabico translatum."[8] John, a Mozarab and a native speaker of Arabic, first renders the text, word for word, from Arabic into the vernacular, the Romance of Toledo; and then the archdeacon Gundissalinus turns that vernacular into the formal Latin of the written translation.

John the Mozarab is only one of the many Toledan shadow translators who made possible the work of scholars, both indigenous and peripatetic. Gerard himself was early on lionized by the many scholars for whom his dozens of translations were the basic building blocks of their education. Perhaps as a result of his fame, very little is known about his indispensable collaborators, the Mozarabs and Jews and Mudejares with whom he sat and worked. Notice of a Mozarab assistant of Gerard's, variously referred to as Ghalib, or Gallipus, is one of the rare exceptions. His work is mentioned by Daniel of Morley, another prominent twelfth-century scholar who made the pilgrimage to the Iberian libraries. Daniel also gives us precious confirmation of the centrality, in the whole process, of that *lingua toletana*, the Toledan vernacular. But we know a great deal more about those who worked with Gundissalinus. He collaborated with John of Spain on translations of the work of Ibn Sina—known in Latin as Avicenna—and also of al-Ghazali—known as Algazel. Gundissalinus's cohorts further included one of the major Jewish scholars of the age, Abraham Ibn Daud—his name appears as Avendauth—a Jewish philosopher who ended up in Toledo, along with many others, in the wake of the Almohad persecutions that began in the Andalusian cities in the middle of the twelfth century.

A century after the Castilian conquest of Toledo, the presence there, in the cathedral district, of an exiled Jewish intellectual speaks volumes. Although the Castilian monarchy rarely played a direct patronage role in the translation enterprise, it was from the beginning their patronage of Toledo itself that must be seen as the primum mobile of the transformation of the mid-twelfth century. The conditions necessary for translation were fostered by the kings of Castile from Alfonso VI on. The circuitous road to empire, which found the Castilians embracing a plural city, depending on Jews and Arabic-speaking Christians for their cultural and economic survival, even living among Muslims, paved the way to a metropolis of translation. What is more, it was not only these social circumstances that laid the foundation for translation but also the tumult caused by social instability and political change throughout the peninsula, the movement of ground beneath

everyone's feet. Castile's ability to solidify translation as its cardinal industry hung on two historic episodes caused by the upheaval of the middle of the twelfth century: the displacement of a library and the displacement of a people.

The first of these was the transplanting to Toledo of the celebrated library of the Banu Hud of Saragossa, whose books had already played key roles in whetting the appetite for Arabic-Spanish treasure. Since the first decade of the twelfth century, both the library and the last members of the Banu Hud had been living in what must have seemed a particularly cruel exile, a backwater on the river Jalón. But in 1140, an extraordinary opportunity arose for the aging Sayf al-Dawla, the son of Imad al-Dawla, the Saragossan ruler who had made the gift of a crystal-rock vase to his comrade William of Aquitaine. The old Muslim aristocrat was offered the possibility of moving to Castilian Toledo, to exchange his private little city of Rueda de Jalón for lands near Toledo, and substantial property inside Toledo itself, what the historian Ibn al-Abbar would refer to as "half the city of Toledo."[9] Sayf al-Dawla and his preeminent library were thus transported to Toledo and right into the middle of the cathedral quarter, this the remarkable exchange for the tatters of his old kingdom. The deposed Muslim king—a refugee from his coreligionists the Almoravids, living out his life in Toledo of the Castilians probably died, a half dozen years later, in 1146, in that cathedral quarter. His library, however, did more than live on: it became a vital and transformative part of the resources of the various denizens of the cathedral quarter. The value of this Taifa legacy to Toledo and the rewards to Castilian Toledo for its complex hospitality were incalculable.

The 1140s were, at the same time, years of upheaval in the remaining Islamic territories of Spain, controlled for a half century by the Almoravids. But in the 1140s the Almoravids had had to contend with powerful rivals, back in the heart of their empire, and in 1146, the same year that Sayf al-Dawla died, they began to be supplanted by the Almohads. Far less tolerant of what seemed to them the corrupt ways of their Andalusian colony, the Almohads began a series of persecutions and expulsions of the Jews of their lands. The most famous victim and refugee from those years is certainly Musa ibn Maimun, later known as Maimonides, who had been born to an old Cordoban family that emigrated first to Morocco—where they lived a dangerous life of pretend conversion to Islam—and later farther east, to more hospitable Egypt, then under the rule of the Fatimid dynasty. But most Jewish families did not take such an arduous path out of the old Andalusian cities, and emigrated north instead, to Christian lands, and especially to the great metropolis of Toledo, a city particularly tolerant of Jews. This was a policy long at the heart of the Castilian struggle with the church, and one it would eventually lose, but at that midcentury point when the Almohads began to provoke Jewish emigration, it was still firmly in place. There is thus considerable historical irony in this moment: thanks to the repressive policies of the Almohads who had taken control of what remained of al-Andalus, the heart of Christian Castile experienced a surge of Andalusian immigrants. Some were Mozarabs who brought fresh new architectural forms from their homeland, al-Andalus. Others— Abraham Ibn Daud is exemplary—became central to the translation enterprise or, rather, to the very transformation of translation into Toledo's most vigorous industry. Among

these new Toledans were a number already intimate with the Arabic libraries the Christians in the cathedral quarter were just discovering, here a whole community that could help in grasping what it might all mean, not just the texts themselves but the whole universe of philosophical study and commentary from which they came.

It was thus, in the nearly direct aftermath of these large-scale Jewish emigrations to Castile, and alongside the inheritance of the Banu Hud's library, that a critical mass of resources, attitudes, and skills was achieved in the next half century in the art of translation from Arabic to Latin. This was an art in which the city's growing and thriving Jewish community played standout roles, and their presence in the central cathedral quarter is attested in myriad ways, not least the complaint against the archbishop Rodrigo, accused of favoring Jews in the ranks of those he chose to administer archepiscopal properties. Both the Jewish community and the Arabic library were vital parts of what was increasingly the business of the church of Spain, a complex enterprise where cross-confessional teams worked with everything from mathematics to metaphysics. Reading Arabic, and being able to work with texts from the Arabic library, became an essential part of the definition of being a scholar—whether the scholar came from as far as Scotland to train, or from as nearby as the Jewish quarter, a short distance away, or from inside the cathedral itself. By the end of the century, the archbishop and primate of Spain, Rodrigo himself, may have been working with Arabic sources, when he wrote his *Historia Gothica* and his *Historia Arabum*. It was under Rodrigo, as well, that a second Latin translation of the Quran was executed, as part of the run-up to the campaign of Las Navas. This translation, by Mark of Toledo— a canon of the cathedral who eventually also translated one of the treatises of Ibn Tumart, the founder and spiritual guide of the Almohads—is considered relatively unbiased and accurate. But the preface to the translation masks this scholarly restraint, revealing unambiguously the aggressive and conversionary desires of the church and most of its clerics.

These ideologically motivated translations were a drop in the bucket that was the still burgeoning and intellectually driven exploration of Arabic texts, not just the transplanted Saragossan library but new work coming out of al-Andalus, producing new philosophical thought. Fueled by the demand for scientific and philosophical texts—there was still unsatiated hunger for the *studia arabum* that Adelard of Bath had begun to promote nearly a century before—the translation enterprise was so vigorous by the beginning of the thirteenth century that it was able to capture almost immediately the contemporary flowering of philosophical thought in late Almohad al-Andalus. This was the moment when Aristotle would make his tumultuous entry into western Christendom. The key texts of the Aristotelian revival were translated in Toledo shortly after being written in Cordoba or Seville. Sometime in the early 1220s, within a few years of the birth of Alfonso X, Michael Scot—who would eventually move to the court of Frederick II and succeed Gerard of Cremona as the West's preeminent translator—was already translating the work of Ibn Rushd, Averroes. At the time, Scot was studying Arabic and working in Toledo in league with one Abuteus Levita, a Jew, and probably in the midst of other teams of translators, and he took the method with him when he set up shop in Frederick's Sicily.

If we could somehow reenter Toledo in these years, and sit at a table where men of all three of the Abrahamic religions worked together on Arabic texts, we would witness how, in the very heart of the see of Spain, intellectual traditions long cultivated by Muslims and Jews were intensely desired, acquired at such expense of time and funding, and painstakingly transformed into the foundations of Christian Latin culture. Many of these texts would fuel the controversies surrounding the relationship between faith and reason that ignited in northern cities in the centuries that followed. Yet the heart of the matter here was not religion, but language. In Toledo, within these elite scholarly groups, and among the most literate men, discussions about the most abstruse and difficult concepts did not take place in either Arabic or Latin. Instead, as many different sources tell us, the language at the table, the common ground, was the *ydeoma maternum*, the *vulgarum*, or local vernacular. But not for long. The great trick of what was almost immediately known as the *era alfonsí*, the Alfonsine age, was to transfigure the street language of Toledo into the new language of the Castilian empire. Out of Arabic translations, Latin itself would be replaced by the Castilian of Toledo.

<p style="text-align:center">✳</p>

Knowledge of Latin in the peninsula had for centuries been both limited and relatively poor. As elsewhere in the world that had emerged after the collapse of Rome and the rise of Christianity, knowledge of Latin was largely limited to the clergy, which thus had something of a monopoly on literacy, so that *litteratus* meant not "literate" in the far broader sense we are likely to mean it but rather more specifically "Latinate." At times difficult to fathom, especially in hindsight—when the ascendance of the vernaculars seems inevitable —is the degree to which the relationship between a written language and what people speak is a matter of perception. Throughout the "Latinate" world, the perception was, for many centuries after the fall of Rome, that one was speaking Latin. This is true even though we know, from secondary evidence of all sorts, that if we had heard people speaking we would have described their language as something altogether different from what we understand to be Latin. In most vital ways it would sound to us far more like what we now call the Romance languages. But, despite our sometimes powerful notions about where languages begin and end, there is nothing at all inevitable that requires what Roger Wright has felicitously called an otherwise unnecessary conceptual break between Latin and Romance.

Indeed, it was not until the reign of Charlemagne that the perception of the difference between a codified written language and the ways such a language is spoken crystallized anywhere in the far-flung territories that had once belonged to Rome and spoke the language of the Romans. Wright, whose innovative scholarship in the last several decades has completely shaped how we understand the historic rift between Latin and her daughters, collaborated with the late Colin Smith in drawing a crisp picture of the convoluted (and counterintuitive) historical sequence of this discovery. The effort of Charlemagne's religious and educational advisors to impose good standards in the performance of the liturgy throughout his empire first triggered the profound linguistic changes of the

moment. This because Alcuin insisted on each Latin letter being given a clear phonetic value in chanting and in recitation, according to what were assumed to be classical values. "The unintended consequence," Wright and Smith conclude, "was to 'create' what is usually known as 'medieval Latin' as a language to be firmly marked off from the spoken vernaculars—early Romance—with their elisions and lack of synthetic case-endings and abundant post-classical vocabulary."[10]

But for several centuries all of this affected only the territories north of the Pyrenees that had been part of Charlemagne's domain, and none of it had any effect in Iberia until the twelfth century. It was then that the influx of Cluny-trained clerics helped bring to a head in Spain consciousness that Latin was a different language from what people spoke.

For the Iberian Christian communities this was an explicitly foreign intervention, and one that hardly came value-free or free-floating. Local pronunciation practice was tied both to the script that Iberian Christians had been using to write Latin since Visigothic times as well as to the very divisive abolition of the Mozarabic rite itself. Mozarabs and non-Mozarabs alike had for centuries used a writing form called Visigothic or Mozarabic or *littera toletana*, but when the Cluniacs and other Christians began to arrive in Toledo after 1085, they began the imposition of their own script, a script born of the same Carolingian reform that had established their pronunciation of Latin. The Latin Christians in the Cluny orbit had for centuries been using this different pronunciation and this different script, called Carolingian, suitable for writing this long-since "reformed," that is to say "modernized," Latin.

The native Visigothic script, and the indigenous manner of pronouncing Latin, was seen by the outside Christian world as one more instance of Spanish backwardness. Their old-fashioned ways of reading and writing the language that had long united western Christendom were to be reformed, much like the use of horseshoe arches and the Mozarabic rite itself. The arrival of these reforms shattered the delusion that people spoke Latin. The introduction of the new script and pronunciation

Gonzalo de Berceo
"Vida de San Millán de la Cogolla" (excerpt)

Qui la vida quisiere de Sant Millan saber,
E de la su ystoria bien çertano seer,
Meta mientes en esto que yo quiero leer,
Verá a do énvian los pueblos so aver.

Secundo mia creençia que pese al pecado,
En cabo quando fuere leydo el dictado,
Aprendrá tales cosas de que será pagado,
De dar las tres meaias non li será pesado.

Çerca es de Cogolla de parte de orient.
Dos leguas sobre Nagera al pie de Sant Lorent
El barrio de Berçeo, Madriz la iaz present:
y nació Sant Millan, esto sin falliment.

Whoever wishes to know of the life of San Millán and to be certain of his history should pay attention to what I intend to read, and he will see the place where he lived.

According to my belief—let the devil judge it—in the end, when the dictum is read, you will learn things that are so marvelous that it will be no burden for you to pay three *meaias*.

Two leagues from Nájera at the foot of San Lorent is Berceo's neighborhood. Madrid is located there now, and that is where San Millán was born, without a doubt.

Trans. Sarah Pearce

began to affect the fate of Latin almost immediately, so that in very short order those who were Latin-literate (always, of course, a minuscule portion of the population) in Toledo shared that same self-consciousness of the deviation between written and spoken languages. And it was thus that in Castile, as elsewhere in the peninsula—as in most other parts of western Christendom beyond the Pyrenees—sporadic but growing instances of the writing down of one vernacular or another began throughout the twelfth century.

Early signs of the need for some sort of transformation, some reckoning with the chasm, are particularly significant at San Millán de la Cogolla, the monastic center associated with several of what are considered the earliest surviving written texts in Castilian: first, a series of glosses to a Latin manuscript called the "Glosas Emilianenses," from the late tenth or early eleventh century. And then, over two centuries later, in the same monastery, we have the evidence of the monk-poet Berceo, most of whose poems are hagiographies involving saints associated with the monastery, not least of which is the "Vida de San Millán" (Life of Saint Millán). Here, for many, is the birth of Castilian literature.

Gonzalo de Berceo left a legacy of pious religious narratives in Castilian, much of it in a verse form called *cuaderna vía*. This versification is central to what is called *mester de clerecía*, the "ministry" or art of the clergy. In the universe of vernacular verse forms this seemingly monastic style is understood as a contrast, formal and functional, to the alternative narrative style, *mester de juglaría*, the oral art of minstrels whose greatest example is the *Cantar de mio Cid*, the Song of the Cid. The contrast was probably not so stark, and the styles and their universes considerably entangled: a whole school of scholars believe that the Cid is not so much performance art as a written and learned composition, a part of the monastic universe, and contemporary with Berceo. Other scholars note that Berceo's mester de clerecía is in fact affected by the style of epic narrative of the moment, and may have been an effort to transform and yoke that popular style into something useful for the monasteries.

But whereas virtually any discussion of the composition of the Cid—who, where, when, how—will be argued and disputed, Berceo's life and works mostly lie in a seemingly quieter terrain. This bucolic contemporary of the urbane Rodrigo Jiménez de Rada was probably born toward the end of the twelfth century but composed all of his work in the first half of the thirteenth. His work springs from the fertile swath of the Ebro valley, the Rioja, then in the heart of old Navarre. Berceo and his various recountings of saints' lives —besides the story of San Millán, he wrote of Santo Domingo de Silos, Santa Oria, and the martyrdom of San Lorenzo, as well as his most famous work, *Milagros de Nuestra Señora* (Miracles of Our Lady)—were part of the local struggles among different monasteries. His work acquires foundational distinction in the modern history of medieval literature principally because we know who Berceo himself was, rather than thanks to any exceptional literary merit. In post-nineteenth-century literary historiography, authorship per se is distinctly associated with a certain kind of modernity. A name to attach to a work, and something of a personality to go with it, seem to us part and parcel of the identifiable beginnings of a literary history that more resembles our own. It is easier to identify with than the abundant

anonymous traditions, or the "merely" translated, although the *Milagros de Nuestra Señora* were likely translations into Castilian from an existing Latin miracles collection.

The great difficulty lies, however, in writing the history of a literature before literature was written, but when it may have been no less literary, its aesthetics no less complex. The long-controversial issue of the composition of the *Song of the Cid* falls squarely into this predicament: is the sole survivor of the Castilian epic tradition a written Castilian text from the first years of the thirteenth century? Or is that mutilated text just one avatar of what was a tradition of performances, when the vernacular thrived on its status as a language of performance, and had no need to acquire a written form to be understood as dramatically different from Latin? Other cardinal cultural spheres that had little or nothing yet to do with writing were affected by that growing self-consciousness of the vernacular. And these were far more pervasive in society, and in performance. This was, indeed, a piv-

Gonzalo de Berceo
Milagros de Nuestra Señora

"La casulla de San Ildefonso" (excerpt)

En España cobdicio de luego empezar,
en Toledo la magna, un famado logar,
ca non sé de qual cabo empieze a contar
ca más son que arenas en riba de la mar.

En Toledo la buena, essa villa real,
que yaze sobre Tajo, essa agua cabdal,
ovo un arzobispo, coronado leal,
que fue de la Gloriosa amigo natural.

Diziénli Ildefonso, dizlo la escriptura,
pastor que a su grey dava buena pastura,
omne de sancta vida que trasco grand cordura,
que nos mucho digamos, so fecho lo mestura.

Siempre con la Gloriosa ovo su atenencia,
nunqua varón en duenna metió mayor querencia;
en buscarli servicio metié toda femencia,
facié en ello seso e buena providencia.

Sin los otros servicios, muchos e muy granados,
dos yazen en escripto, éstos son más notados,
fizo d'ella un libro de dichos colorados
de su virginidat contra tres renegados.

"The Chasuble of Saint Ildephonsus" (excerpt)

In Spain I desire at once to begin:
in the great city of Toledo, a famous place,
for I do not know where else to begin
because there are more miracles than the sand on
the seashore.

In fair Toledo, that royal city
which lies above the Tagus, that mighty river,
there was an archbishop, a loyal cleric
who was a true friend of the Glorious One.

According to the text, they called him Ildephonsus,
a shepherd who gave his flock good pasture,
a holy man who possessed great wisdom,
all that we may say his deeds reveal.

He was always partial to the Glorious One,
Never did man have more love for lady,
he sought to serve Her with all his might,
and did so sensibly and most prudently.

Besides his many other great services
there are two in the writing which are most notable:
he wrote a book of beautiful sayings about Her
and Her virginity, contradicting three infidels.

Trans. Richard Terry Mount and Annette Grant Cash

otal moment for the crystallization of that conceit still with us, that a vernacular could become a highly specialized lingua franca: an art-language, a koine. This is the age of the two great vernacular languages of song cultures: what we used to call Provençal (and now refer to as Occitan), and what is called Galician-Portuguese, the peninsular language of troubadour lyric. These flourished as performed languages but are preserved in much later collections, sometimes far removed in time and space from the moments of the original performances and the eras of their great success and popularity.

But neither vernacular art traditions, with their ambiguous relationships to any "recorded" forms, nor small-town clerical efforts to instruct the locals, constitute the kind of purposeful and broad effort involved in the creation of a wholly new written language. And this creation is like translation in many ways, perhaps not least in that it means leaving one language behind—in this case declaring Latin transcended, replaced. It is more useful to understand the cradle of a new written Castilian as something only the most powerful could undertake, and to see that the pursuit of a new written language was part of the cultural insurgency of the Castilian monarchy itself, their generations-long turn away from Latin as the unique language of scholarship and erudition.

Alfonso X was not the first of the Castilian monarchs to grasp the problem: widespread illiteracy in Latin coupled with the recognition of Castilian as an alternative language of literacy. His grandfathers and father, alongside their political and military ambitions and pursuits, had been involved in reinventing education itself, one institution and book at a time. Shortly after the turn of the thirteenth century, in 1204, Alfonso VIII had founded Europe's first largely secular university. The university at Palencia is a *studium generale* brought into existence by the fiat of royal authority—rather than by the church—and with professors and students invited by the Crown—rather than by the clergy. One of the first products of that institution—or at least of the intellectual climate it nurtured—was the anonymous *Libro de Alexandre* (Book of Alexander), a versified narrative in Castilian and also in cuaderna vía, of the life and education of Alexander the Great. At first glance it is a text closely allied with the Berceo universe: the tag *mester de clerecía* comes from one of the opening quatrains of the *Alexandre* poem, and the question of whether Berceo himself was the author of the *Alexandre* was much discussed for some time.

But this attribution is now generally discounted and in virtually every other key respect the *Libro de Alexandre* stands a pole apart from Berceo's monastic evangelizing: it belongs to the universe of fundamentally secular texts whose fountainhead is a body of narratives that are about education in and of itself, not about any kind of sure truth but rather about the paradoxes and difficulties of the whole process. "Didactic" has long been used to describe a wide gamut of medieval literature, and the word suggests that these kinds of texts, and the attitudes that lay behind them, were moralizing and sermonizing. While these are not unfair characterizations of works like Berceo's, they misrepresent the principles of the constellation of texts from which the *Alexandre* emerges, where what teaching itself might mean is a central preoccupation.

The new vernacular texts emerging from these largely secular contexts—and these

were some of Alfonso X's teachers, books that lay at the heart of his own education—were based on different underlying notions of what constituted education itself. The prince Alfonso's education was thus often innovative and surprisingly secular, its defining feature distant from the monastic (or Parisian) schooling that would have been the more conventional choice of the age. And the word "didactic," with its powerful suggestion of the

The *Libro de Alexandre*

Written by an anonymous cleric at Palencia in the early thirteenth century, the *Libro de Alexandre* tells the life of Alexander the Great—his intellectual, political, and military exploits—in a new poetic form called the cuaderna vía, verses containing fourteen syllables. The *Alexandre* thus initiates a tradition of vernacular literature centered on the figure of Alexander and on the aesthetic and ethical synthesis of Greek and Persian antiquity; it depicts a king not unlike Alfonso X, passionate about learning despite being beset with political difficulties. The *Alexandre* represents the first exemplar of a vibrant genre in medieval Spanish letters, the work of poets engaged in the mester de clerecía, the "craft of the clergy," as opposed to the mester de juglaría, the more popular narrative form of the minstrels, and of works such as the *Cid*. Despite the "clerical" label, the poets and poems of the mester de clerecía were not necessarily orthodox or even Christian: the versatile meter and the humanist temper of the mester opened the reception of classical and late antiquity in medieval Spain and would find expression in the works of Jews— Santob de Carrión's *Proverbios morales*—and Muslims —the *Poema de Yuçuf*—and in such classics as the legendary Archpriest of Hita's *Libro de buen amor* (*Book of Good Love*), frequently described as the most Mudejar work in the medieval Castilian canon.

El infant al maestro no l'osava catar;
daval grant reverençia nol queriá refertar;
demandóle liçencia, qu le mandás fablar;
otorgóla de grado e mandól' enpeçar.

"Maestro, tú m crïeste, por ti sé clerezía;
mucho me as bien fecho, graçir non tel sabría;
a ti me dio mi padre quand siet' años avía,
porque de los maestros aviés grant mejoría.

"Assaz sé clerezía quanto m'es menester,
fuera tú non es omne que me pudiés vençer;
connosco que a ti lo devo gradeçer,
que m' enseñest las artes todas a entender.

"Entiendo bien gramática, sé bien toda la natura,
bien dicto e versífico, connosco bien figura,
de cor sé los actores, de livro non he cura;
mas todo lo olvido, ¡tant'he fiera rencura!

"Bien sé los argumentos de lógica formar,
los dobles silogismos bien los sé yo falsar,
bien sé a la parada mi contrario levar;
mas todo lo olvido, ¡tanto he grant pesar!

"Retórico so fino, sé fermoso fablar,
colorar mis palabras, los omes bien pagar,
sobre mi adversario la mi culpa echar;
mas por esto lo he todo a olvidar.

"Aprís toda la física, so mege natural,
connosco bien los pulsos, bien judgo 'l orinal;
non ha, fuera de ti, mejor nin ome tal;
mas todo non lo preçio quant'un dinero val.

"Sé por arte de música por natura cantar;
sé fer sabrosos puntos, las vozes acordar,
los tonos com'empiezan e com deven finar;
mas no m puede tod'esto un punto confortar.

"Sé de las siete artes todo su argumento;
bien sé las qualidades de cad'un elemento;
de los signos del sol siquier del fundamento,
nos me podría çelar quanto val' un açento.

"Grado a ti maestro, assaz sé sapïençia,
non temo de riqueza aver nunca fallençia;
mas bivré con rencura, morré con repentençia,
si de premia de Dario non saco yo a Greçia."

passing on of basic and self-evident truths, is a far cry from traditions that seek to inculcate wisdom, more likely to be a matter of knowing how to ask questions than a litany of specific answers. The *Libro de Alexandre* exemplifies the reconfiguration of intellectual life that followed Toledo's outpouring of translations of the Arabic philosophical library into Latin. The philosophical and experiential education of Alexander the Great became a simulacrum

The prince dared not look at the master, so great was his reverence and fear of rebuke. He requested permission to say a few words, which was given outright, and so he began:

"Master, you reared me and taught me to compose verses, such good have you done that I know not how to give thanks. When I was seven, my father gave me to you, the greatest of masters.

"When the occasion arises, I nimbly compose verses that are matched by none except you. I know full well that you deserve gratitude, for teaching me to understand the arts.

"I understand grammar and the laws of nature, and I know well how to produce verses and figures of speech. I know the great authors by heart and can never read enough—yet I retain nothing, for I am consumed by rancor!

"I can formulate logical arguments, collapse a false syllogism, and force my opponent to agree—yet I retain nothing, so great is my hardship!

"I am a fine rhetorician, an eloquent speaker; with colorful speech, I may please an audience, I can even confound my adversaries—yet for all this, I retain nothing.

"I became an expert in medicine, and a natural healer. I've learned the pulses and how to analyze urine. In these matters there is none better than you. But I do not value these things more than a penny.

"Through the art of music, I have learned to sing naturally, with pleasing accents and tuned voice, caring for the way tones begin and end—yet none of this brings more than a pittance of comfort.
"I have learned the arguments of all seven arts, the properties of the four elements and the signs of the sun and heavens—yet I do not value this more than a fraction.

"Thanks to you, master, I have attained wisdom, and I shall never be wanting; and yet I shall have lived fiercely, and died with regret if I am unable to wrest Greece from the hands of Darius."

Trans. David Assouline

for many of the broad intellectual issues that came together in this moment of intellectual realignments, and the concerns at hand were better couched as questions than answers: How is wisdom inculcated in a man who will be king? What knowledge does he need and where does he find it? Should princes be educated by philosophers? Will their travels to lands where other religions and languages and customs prevail teach them things they will not learn otherwise—but which may nevertheless be vital for the art of governing their own people?

The rise in popularity of Alexander texts throughout Europe in the Middle Ages is a complex phenomenon, and in a post-Roman universe that did not know Plutarch's famous Greek account of the life of Alexander, it was known through a series of later Latin fragments and translations. The Castilian *Libro de Alexandre* is part of a far-reaching European fascination with the life of the Macedonian prince who was educated by the ultimate philosopher, Aristotle, and then went out and conquered the wide world, full of wonders—and went at least partially native in the process. But the Castilian *Alexandre* is also a work whose very existence speaks to immediate and local concerns, with an unmistakable bearing on the explicit questions that hover about the education of the future monarchs of Castile, at the turn of the thirteenth century. Most obvious of these, arguably, is the matter of the social and educational role to be played by philosophy and science, and beyond them, just around the bend now, all the new arts of fine living, not so different from those Alexander discovered, and adopted, in his eastward passage. It is easy to forget how startling and even prickly many of these questions were as they were, in effect, first being asked, staking out territory that belonged to neither Latin nor the church, and how much of a challenge they posed to institutions like the church, with which the Castilian monarchy had long had an irascible relationship.

But even as the number of written Romance documents began to grow, in the first half of the thirteenth century, this language was still a far cry from having the legitimacy of Latin. More and more types of documents began to be written down in these approximations of the spoken language: in the early part of the thirteenth century there were vernacular chancery documents coming out of Rodrigo's Toledo (the Treaty of Cabreros of March 1206 between Castile and León, for example, is in Castilian only) as well as works like the *Libro de Alexandre* at the university in Palencia. Nevertheless, it is hard to imagine any language other than Latin for Rodrigo's historical masterpiece, *De rebus Hispaniae* (On Spain), which he finished in 1243, toward the end of his life. And yet within a generation—the generation of Alfonso's ascendance to the throne—that same Latin text became the basis for a book whose very hallmark is its being written in Castilian, the *Estoria de España* (History of Spain).

The transfiguration lies in Alfonso's own growing understanding, through his unusual education, of the importance of a secular culture to the idea of empire, and of the pressing need, in his kingdom, for a language that, unlike Latin, could serve as its vehicle. It is hardly coincidental that the other vernacular Castilian text directly involved in the education of the young Alfonso was the *Libro de los doce sabios*, best translated as "Book of the

Arch from the Qasr al-Saghir in Murcia, 2nd quarter of the 13th century, now in the convent of Santa Clara la Real.

Twelve Sages," which also—again, no coincidence—ties itself explicitly to the persona of Alexander. It was his father, Ferdinand III, who compiled this miscellany of "wisdom" materials translated from Arabic into Castilian prose for the education of his sons. Its alternative title is *Tractado de la nobleza y lealtad* (Treatise on Nobility and Loyalty), which reflects directly on those same difficult questions about the nature of the secular and intellectual apprenticeship required for a successful kingship. This was a book so prized by Alfonso that he returned to revise and finish it himself some years later, when he was already king, and when he was in the process of transforming the principles and texts of his own personal education into the mirror of what he wanted to achieve for his kingdom, for Castile as a whole.

The substantive details of this cultural enterprise, the answers to all those questions about what kings and commoners alike should know and how they should behave, were still to be found in the Arabic library. But this, now, was a different part of the library, a distinct section called *adab*, or what we translate as belles lettres. And its many texts had previously been of virtually no interest to the Latin translators. But the young Alfonso had no particular need for the Latin translators, since he could work with Arabic and Arabists directly, and in any event he understood that what the prodigious bellettristic Arabic library offered were the foundations for a way out of Latin, and into Castilian. And so just a few years before the death of his father, Ferdinand III, before he ascended the throne, before he carved his father's tomb in the four languages of his realm—the vernacular given equal status with the languages of literacy—Alfonso translated his first work out of the adab tradition. Out of Arabic, and into Castilian, *Calila e Dimna* is the foundational text of Castilian prose, the bedrock of a new empire.

Some of the uniqueness—what Francisco Márquez Villanueva has called the mudejarización—
of Alfonso's education came because of his direct involvement with his father's campaigns
to subdue and subjugate the remaining Islamic territories, in the period after the battle
of Las Navas de Tolosa. It was during the years of the conquest of Murcia, and at a famed
madrasa, or school, there that Alfonso probably began to learn the rudiments of reading
Arabic, and perhaps also to understand something about adab. And Alfonso must have
frequented palaces like the Qasr ibn Sad in the Arrixaca, a ghetto created to contain
Murcia's Mudejares. There, the walls were worked in stucco carved with ataurique, stylized
vegetal forms painted in vibrant colors, and Arabic inscriptions framed porticos and
doorways. At what point, one wonders, did the young Alfonso find he could read the
carved inscriptions that embraced these arches and hugged the moldings that belted
each room?

Besides Toledo, the Castilian capital where Alfonso was born, and Seville, the Castilian
capital where he would die, no part of the peninsula meant as much to Alfonso as Murcia,
once the brilliant Taifa that dominated the eastern coast of al-Andalus. But during the half
century of Almohad rule, and especially in the fallout after Las Navas de Tolosa, Murcia's
location made it a frontier kingdom desired and disputed among three greater surround-
ing powers: the expansive New Castile to the west, Valencia—and thus the Crown of
Aragon—to the north, and Granada to the south. Murcia, the eponymous capital city
of this fertile region of huertas (irrigated fields), is not quite on the coast itself but lies
roughly halfway between two strategic coastal cities, Almería to the south and Valencia
to the north. The difficult annexation of Murcia to Castile was one of the signal events
of Alfonso's lifetime, and beyond, and for years much of the political and cultural life of
Castile was intertwined with that of Murcia.

Alfonso would tell the story of his time in Murcia in his Cantigas de Santa María, the
fecund cancionero—songbook—of 420 poems. In verse and image, Alfonso lays out his
ambivalent and at times contradictory role of ruling a multiconfessional society, evoking
a pragmatic tolerance modeled after the dhimma, while at the same time conquering
Islamic polities in the name of Christianity, often under the banner of a holy crusade.
This collection of cantigas—songs—is not composed in Castilian, although by the end of
Alfonso's life he had thoroughly established Toledo's vernacular as the new legitimate writ-
ten language. But, perhaps because of the enduring prestige of Arabic song forms in cities
like Toledo and Seville, perhaps because it was being honed as adab, prose, Castilian was
not the language of song. Instead, Alfonso chose the troubadour koine of the peninsula,
Galician-Portuguese. In this fashionable song language, Alfonso presented himself as the
Virgin's own troubadour, submitted to her in a kind of spiritual vassalage.

Alfonso's personal intervention is particularly evident in cantiga 169, which has
been deftly elucidated by Joseph O'Callaghan. We
see Alfonso, who narrates the cantiga in the first

Illustration to cantiga 169 of the Cantigas de Santa
María, 13th century. El Escorial, Madrid.

person, still a young prince who wears, in place of a crown, a biretta or flat-topped hat bearing the symbols of Castile. "I shall tell a great miracle," Alfonso tells us, "which I saw when God granted me Murcia."

The miracle happened to an ancient church of the Peerless Queen which stood there in the district of La Arrijaca. . . . [T]he Moors had no power to do any harm whatever in that holy place, nor to remove the church from there, although it lay in their domain.

Although many times they begged me to have the church removed, showing me that it would be a good thing if I did so, and their request was granted, it availed them nothing.

The young prince is pictured before a host of bearded, turbaned Muslims who approach him on their knees as supplicants. Castilian knights in birettas with swords stand behind them, and one of the Murcian Muslims gestures to the previous image of the city, in which the image of the Virgin waits implacably within a lofty basilica. Alfonso's gesture of acquiescence underscores the fulfillment of the pact between the Muslims and their Christian lord. Because Murcia was still an independent kingdom tied by feudal obligations to Castile, Alfonso supported the petition of these Muslims to repossess the church of the Virgin. It was their "domain" and Alfonso is pictured as the just prince who understands that the productive interaction of peoples and polities demands binding obligation and legal protection, despite the fact that the protagonists are not Christians. It is thus not Alfonso but a miraculous force that keeps them from destroying the church.

The scene of supplication is repeated at various moments in Murcia's history. The Muslims are shown next petitioning King James I of Aragon, Alfonso X's father-in-law, who would come to his aid following an uprising of Mudejares in Murcia in 1264.

Cantiga 187 of the *Cantigas de Santa María*. El Escorial, Madrid. Cantiga 187 tells the story of an *alcaide*, a commander, of the castle of Chincoya who is very good friends with the Muslim alcaide of a neighboring castle. But his Muslim friend betrays him, and delivers him to the king of Granada. The small defending force, in the end, is saved only by the Virgin. In the second panel on the first page, the Muslim and Christian lords exchange a "kiss of peace." The miniature, which emphasizes their friendship in order to build pathos for the treachery that follows, presents us with a scene of powerful intimacy: each knight leans forward in his stirrups, clutching his spear in one hand and reaching forward to embrace his friend with the other, their horses' bodies overlapping, their hooves planted for the embrace. The Muslim's and the Christian's profiles are poised in the moment before the embrace, the only parts of their bodies not already intertwined, so that the impending kiss is powerful and dynamic, silhouetted against a blank sky. Encased in this image are both the pain of conflict and treachery, and the familiarity and ambivalence of intimacy.

Following the rebellion, the cantiga recounts, James "made the cathedral out of the great mosque" as part of the treaty that ensued. It was surely in exchange for this usurpation of the Muslims' primary place of worship that they again asked permission to have the church of the Virgin removed. But now, because of the treachery of the Murcian vassals, the legal climate was transformed: the city was partitioned, and its indigenous Muslim inhabitants had been given forty days to relocate to the suburb of Arrixaca so that the city proper could be repopulated with Christian settlers, as both a security measure and a means of granting lands and goods to loyal vassals.

Displaced from their original homes, their territory decreased by more than half, Murcian

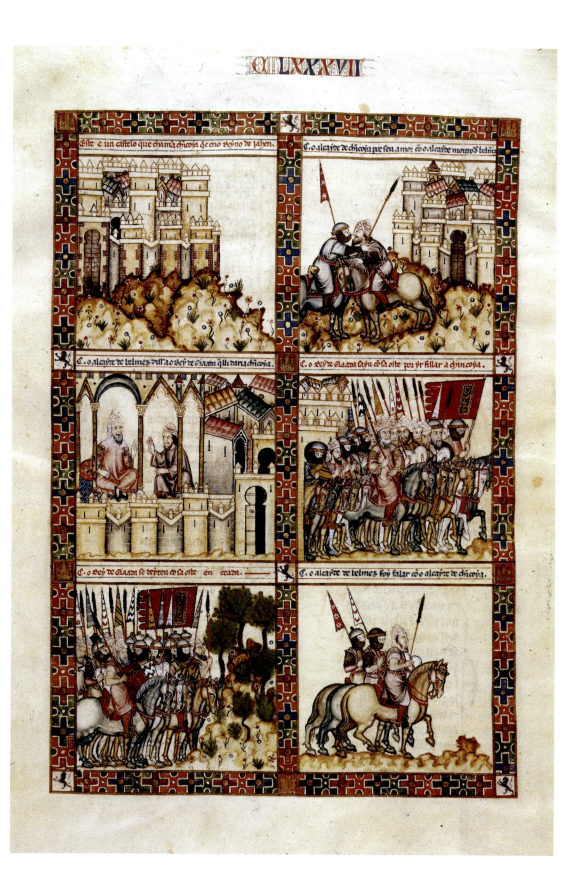

Alfonso X
Cantiga 169, from the *Cantigas de Santa María*

ESTA E DUN MIRAGRE QUE FEZO SANTA MARIA POR
HUA SA EIGREJA QUE E ENA ARREIXACA DE MURÇA, DE
COMO FORON MOUROS ACORDADOS DE A DESTROIR E
NUNCA O ACABARON.

A que por nos salvar
fezo Deus Madr' e Filla,
se sse de nos onrrar
quer non é maravilla.

E daquest' un miragre direi grande, que vi
des que mi Deus deu Murça, e oý outrossi
dizer a muitos mouros que moravan ant' y
e tĩian a terra por nossa pecadilla,
 A que por nos salvar . . .

Dũa eigrej' antiga, de que sempr' acordar
s' yan, que ali fora da Reỹa sen par
dentro na Arreixaca, e yan y orar
genoeses, pisãos e outros de Cezilla.
 A que por nos salvar . . .

E davan sas ofertas, e se de coraçon
aa Virgen rogavan, logo sa oraçon
deles era oyda, e sempre d' oqueijon
e de mal os guardava; ca o que ela filla
 A que por nos salvar . . .

Por guardar, é guardado. E porende poder
non ouveron os mouros per ren de mal fazer
en aquel logar santo, nen de o en toller,
macar que xo tĩian ensserrad' en sa pilla.
 A que por nos salvar . . .

E pero muitas vezes me rogavan poren
que o fazer mandasse, mostrando-mi que ben
era que o fezesse, depois per nulla ren,
macar llo acordaron, non valeu hũa billa.
 A que por nos salvar . . .

E depois a gran tempo avêo outra vez,
quand' el Rei d' Aragon, Don James de gran prez,
a eigreja da See da gran mezquita fez,
quando ss' alçaron mouros des Murç' ata Sevilla;
 A que por nos salvar . . .

Que enton a Aljama lle vêeron pedir
que aquela eigreja fezessen destroir
que n' Arraixaca era; e macar consentir
o foi el, non poderon nen tanger en cravilla.
 A que por nos salvar . . .

Depo[i]s aquest' avêo que fui a Murça eu,
e o mais d' Arreixaca a Aljama mi deu
que tolless' a eigreja d' ontr' eles; mas mui greu
me foi, ca era toda de novo pintadilla.
 A que por nos salvar . . .

Poren muit' a envidos enton llo outorguei,
e toda a Aljama foi ao mouro rei
que a fazer mandasse; mas diss' el: "Non farei,
ca os que Mariame desama, mal os trilla."
 A que por nos salvar . . .

Depois, quand' Aboyuçaf, o sennor de Çalé,
passou con mui gran gente, aquesto verdad' é
que cuidaron os mouros, por eixalçar ssa fe,
gãar Murça per arte. Mais sa falss' armadilla
 A que por nos salvar . . .

Desfez a Virgen santa, que os ende sacou,
que ena Arraixaca poucos deles leixou;
e a sua eigreja assi deles livrou,
ca os que mal quer ela, ben assi os eixilla.
 A que por nos salvar . . .

E porend' a eigreja sua quita é ja,
que nunca Mafomete poder y averá;
ca a conquereu ela e demais conquerrá
Espanna e Marrocos, e Ceta e Arcilla.
 A que por nos salvar . . .

This is about a miracle which Holy Mary performed for a church of Hers in La Arrijaca of Murcia and tells how Moors had decided to destroy it and never succeeded.

It is no wonder that She whom God made Mother and Daughter in order to save us wishes to be honored by us.

Concerning this, I shall tell a great miracle, which I saw when God granted me Murcia. I also heard it told by many Moors who formerly lived there and held the territory, to our dismay, and who often remembered this.

The miracle happened to an ancient church of the Peerless Queen which stood there in the district of La Arrijaca. The Genoese, Pisans, and others from Sicily went there to pray,

and they made their offerings. If they prayed with all their hearts to the Virgin, their prayer was heard at once, and She always protected them from mishap and harm, for whoever She takes under Her protection

is protected. Therefore the Moors had no power to do any harm whatever in that holy place, nor to remove the church from there, although it lay in their domain.

Although many times they begged me to have the church removed, showing me that it would be a good thing if I did so, and their request was granted, it availed them nothing.

Then some time ago it happened again, when the king of Aragon, the worthy don Jaime, made the cathedral out of the great mosque, that the Moors rebelled from Murcia to Seville.

The Moorish community came to him to ask that that church in La Arrijaca be destroyed. Although he consented to it, they could not touch a single nail of it.

After this, it happened that I went to Murcia, and most of the Moorish community asked me to remove the church from their midst, but I was loathe to do so, for it had been freshly painted.

However, very reluctantly, I granted their request, and all the Moorish community went to the Moorish king to ask him to have it done, but he said: "I will not, for Mariame deals severely with those who displease Her."

Later, when Aboyuçaf, lord of Salé, passed by with a great army, it is true that the Moors thought to take Murcia by trickery, in order to exalt their faith. However,

the Holy Virgin undid their treacherous plot, for She drove them out of there and left very few of them in La Arrijaca. Thus She freed her church from them, for in that way She banishes those She despises.

Therefore, Her church is now free, for never can Mohammed hold power there because She conquered it, and furthermore, She will conquer Spain and Morocco and Ceuta and Asilah.

Trans. Kathleen Kulp-Hill

Muslims were now separated by a physical wall from the city that had been theirs. The dense, crenellated jumble of walls and buildings of the first and last miniatures of this page take on more meaning, as we imagine the Virgin's church in the tense embrace of a compressed and displaced community bereft of its own mosque. Alfonso X seems to acknowledge this hardship in the story and in the miniatures as well. King James finally acquiesces, allowing the destruction of the church of Arrixaca, as does Alfonso X, now crowned king, in the panel that follows. It is finally the Virgin who protects her church by magically prohibiting its demolition. The acts of the Virgin are seen as superseding the laws, treaties, and accommodations of Alfonso and James, who are subject to earthly laws. Her direct intervention is needed to ensure a cosmic order that cannot be easily reflected in the daily acts of rulers of a world so diverse, in which so many interests intertwine.

The repeated composition of leader before prostrated Muslims culminates in an inverted image: the Murcian Muslims plead with a different ruler behind the same Gothic arcade as before, elegant columns and tracery that signify a palace, but also, we can now see, the sure, consistent structure of Castilian rule, Castilian law. Having been given permission by Alfonso X to destroy the church, the Muslims of Murcia must now petition their own king for the church's destruction. We must read the image from right to left, as if it were Arabic, a compositional gesture both polarizing and empathetic, full of subconscious understanding and at the same time an urgency to distinguish, to create oppositions and frontiers between Muslim and Christian experience. And this ambivalence yields the most surprising inversion of all. The ruler seated on a throne to the right of the image is the Muslim king, probably Abd Allah.[11] Only Abd Allah will refuse to consent to the church's destruction, saying, "I will not, for Mariame deals severely with those who displease Her." The Virgin proceeds to possess Murcia altogether.

We are thus propelled into the palimpsest of tolerance and domination that formed Alfonsine colonial cities. Cantiga 169 provides us with one of those problems that fall between the master narratives of politicians on one hand and churchmen on the other. Alfonso required the Virgin's miracles to mediate between real life on the frontier and the expectations of sacred history. In the *Cantigas* it is the Virgin, entering the everyday life of Alfonso's kingdom, who intercedes for Alfonso, spreading her cloak over the impossible twin agendas of plural state and Christian absolutism.

Beyond the politics of domination and annexation, Murcia offered cultural wealth to which Alfonso, both as a young prince and as the more mature king, had privileged access. In Murcia he was far from the Toledo of the translators, now a cosmopolitan crossroads of Latin Christendom, and instead in a frontier town that more resembled Toledo as it had been for the Castilians at the end of the eleventh century. And in this world still nearly universally Arabophone, at the madrasa of Muhammad al-Riquti, a school known for accepting both Jewish and Christian students, the heir to the Castilian crown was likely introduced to written Arabic. This was an Arabic far beyond the street vernacular that had been a commonplace skill for warriors and princes since before the time of the Cid. And it may well have been in Murcia, perhaps at al-Riquti's school, perhaps elsewhere, that

Alfonso began to appreciate that there was a whole precinct of Arabic libraries virtually untouched by the Latin translators of the city of his birth.

Alfonso's own project of translation connected him with Toledo, and with Castilian monarchs who had preceded him. And it involved him in a kind of cultural and even political rivalry with his older and more powerful cousin, Frederick II Hohenstaufen, emperor of Sicily, Holy Roman emperor, and king of Jerusalem, and thus himself the Christian ruler of more than one plural land with indigenous Muslim populations. Frederick, to whom Alfonso was related through his mother, Beatrice of Swabia, had seen that to rule an empire it was necessary to embrace and maneuver a broad swath of culture; to amalgamate the learning and languages of the places he had brought together with the sword. His interest in translation might have grown from his own position between languages and cultures. He founded libraries and universities and was a great patron of Arabic translation. Arabic was, in fact, one of Frederick's native languages, learned as a child in Norman Sicily, and he knew both street Arabic and the scholarly language. The great translator Michael Scot traveled from Toledo to Palermo to become a favorite in Frederick's vibrant court, where the king fostered exchanges with intellectuals from throughout the Mediterranean.

For Alfonso as for Frederick, such cultural projects were not only about integrating knowledge but about creating a culture of empire, language, and literature as the hand-maiden to a political idea. And Alfonso's ambitions of empire would become even more intertwined with Frederick when his cousin was deposed as Holy Roman emperor in 1245, and Alfonso himself emerged as a candidate.

Alfonso began working on his own trans-lation project sometime in the decade before his father's death in 1252, and what he tackled were texts distant from those of the Toledan intellectuals. Somewhere along the line, some-where between Murcia and his ascension to the throne in Seville, Alfonso had the insight that the basis for a Castilian library might lie in the considerable body of "profane belles-lettres"—to quote now from the elegant entry on *adab* in the first edition of the *Encyclopaedia of*

"ADAB, a term meaning, in both the heathen and the Islamic times, the noble and humane tendency of the character and its manifestation in the conduct of life and social intercourse. . . . Parallely to this practi-cal designation of this word there is also a metaphori-cal one: the knowledge that leads to an intellectual culture of a higher degree and enables a more refined social intercourse, especially the knowledge of Arabic philology, poetry and its explanation, and the ancient history of the Arabs. The latter application of the word *adab* arose from the influence of the cultural tendency, after the Persian model, towards a more refined tone and the growth of profane literature since the second and third centuries of the Hidjra. . . . The different branches of *adab*, being profane belles-lettres, are strictly distinguished from *ilm*, which sums up the religious sciences. . . . Besides the real attain-ments sometimes also social qualities and skill in sport and in ingenious, mostly imported games, are included in the term *adab*. Persian influence on *adab* is reflected in the following maxim of the vizier al-Hasan b. Sahl: 'The arts (*al-adab*) belonging to fine culture are ten: Three Shahradjanic (playing lute, chess, and with the javelin), three Nushirwanic (medi-cine, mathematics and equestrian art), three Arabic (poetry, genealogy and knowledge of history); but the tenth excels all: the knowledge of the stories which people put forward in their friendly gatherings.'"

From E. J. Brill's *First Encyclopaedia of Islam, 1913–1936*

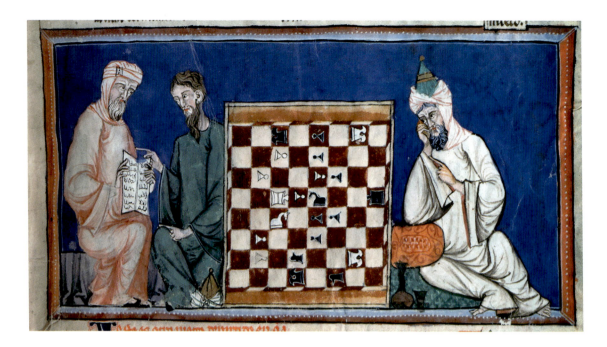

A Christian consults an Arabic text during a chess game with a man who is presumably a Muslim. Such delight in the exchange of information and erudition is typical of the *Libro de ajedrez, dados y tablas* (Book of Chess, Dice, and Tables) of Alfonso the Learned. 1283. El Escorial, Madrid.

Islam, written by Ignaz Goldziher. During the first several years in Seville, after the Castilians had triumphed over the Almohads in 1248 and before his father's death made him king four years later, Alfonso embarked on the translation of two texts, both iconic works of the Arabic adab tradition, and both eventually widely imitated: the *Kitab al-jawarih* (Book of Hunting Animals; *Kitab al-yawarih* in the Spanish transliteration of Arabic) and the *Kalila wa dimna*.

The first work of adab that Alfonso had translated into Castilian was a long-admired treatise on falconry and other hunting practices, the Baghdadi *Kitab al-jawarih* (a book that had not long before inspired the famous treatise on falconry, *De arte venandi cum avibus*), one of the masterpieces of the court of Alfonso's cousin, Frederick II). Called the *Libro de las animalias que caçan* (Book of Animals That Hunt) in Castilian, it deals with both the theory and the practice of hunting with animals such as birds and dogs and it has an even more rarefied reading public than others in the collection of seemingly idiosyncratic books from this original chapter of written Castilian. And yet it is almost perfectly paradigmatic of the whole project: the original Arabic text comes from the very heart of the adab tradition, in which hunting manuals spoke to the refined courtly life and to the possession and control of land. These matters of both etiquette and skill extended as far back as the Umayyad hunting lodges in Syria, with later incorporations of the natural historical material that followed from Aristotelian-based scholarship.

The Castilian text also speaks to the different concepts of translation itself, which distinguish Castilian adab from the Latin philosophical and scientific gestalt, as the Persian was distinguished from the Greek. The necessarily contingent nature of culture created

attitudes about translation necessarily different from those of the philosophical and scientific traditions, explicitly concerned with universality. This distinction points rather precisely to the linguistic tension in early thirteenth-century Castile, between the local and highly contingent vernacular, and a Latin with claims of universality. Adab in fact involves more practical rather than abstract truths, and thus the tradition of "wisdom" texts—like the *Libro de los doce sabios* and then the *Calila e Dimna*, and then dozens in their wake. Here is a body of prose focused on providing always translatable guidance, and general modes and attitudes about living. Translation, here, is the conversion or transplanting of cultural values from one group to another.

Although we have traditionally understood the Castilian translation movement as the logical, if not natural, consequence of the preceding Latin translation movement, that relationship is not really linear. The tension between the Latin and the Castilian movements is, instead, intrinsic to the internal dynamics of the Arabic library itself, divided between science and philosophy, on one hand, and adab, on the other. The relationship between the Latin and the Castilian translation projects thus is rooted in the ninth-century rivalry between Baghdad's translations of the Greek philosophical corpus and the roughly simultaneous cultivation of adab in the far east of the Abbasid empire. Broadly speaking, that rivalry could be described as classical versus vernacular: the translation of the Greek canon in Baghdad versus the incorporation of a whole range of traditional or semipopular materials about daily life and how it may be more finely lived, drawn from a range of disparate linguistic cultures from the eastern end of the Islamic empire. As was true in Alfonso's project, the dichotomy can also be understood as that between scholarship, or the philosophical tradition with its natural ties to both the sciences and theology, and secular culture, including much of what we today would call literature. It is an old truism that the Arabic translation movement conspicuously did not include literary texts, and numerous scholars have puzzled over why that might have been so. The more accurate truth, however, is a far more restricted and simple one: Greek literary texts were not translated in Baghdad. If there was one thing that did not need to be imported during that expansive moment in the formation of a big-tent Islamic civilization, it was certainly verse, the Arabic art form par excellence. But, as Goldziher's delightful definition of adab makes clear, prose texts of all sorts, those "stories which people put forward in their friendly gatherings," were in fact absorbed into the Arabic canon from elsewhere. They lie at the heart of the broad cultural movement that is adab, a culture very different from that of the more precise scientific translations and scholarly commentary characteristic of Baghdad. Adab as a cultural practice revolved instead around the concepts of intermediaries and cultural adaptations. The Persians were intent on integrating themselves, along with their courtly refinements and their own literature, much of which was already self-consciously translated from Indian traditions, to the nascent imperial culture of Islam.

Adab was thus not a mediation between two essentially alien cultures but rather between already overlapping and entangled peoples. This kind of cultural traffic marks moments of historical passages, when one empire aspires to replace another, in part

through the naturalization of older communities, and of at least some parts of their cultures. In contradistinction to the powerful philosophical ethos of Baghdad's translation enterprise, the Persians brought vast quantities of narrative prose into the Arabic universe. These texts included both what we would call prose fiction as well as a variety of kindred works and genres as diverse as histories and hunting manuals—the whole range of genres that would be written under Alfonso's direction. Toledo's Latin translation movement of the twelfth century is the obvious heir, or the second iteration, of Baghdad's. It was a scholarly endeavor intently focused on the intellectual traditions bound up with philosophy and with philosophy's relationship to theology. But the Alfonsine project, and thus the creation of Castilian, is not derivative of Toledo's Latin translation movement, but rather rivalrous and complementary, as adab was to philosophy.

Within this broad landscape, Alfonso's transformation of Castilian into the language of his empire is, indeed, the culmination of the political aspirations of the Castilian monarchy, from the time of Alfonso VI on. It began when Castilians moved into Toledo and Toledo transformed Castile. With its explicitly cosmopolitan culture, Toledo was their "cabeça del reinado" ("head of the empire"), to use the language of the *Alexandre* poet, who conjured up for us a world that also perfectly mirrored the intellectual and linguistic dichotomy: the competing empires in Alexander's universe are the Greek and the Persian. The powers of a mighty magician were required to metamorphose the local vernacular into the vehicle of a cosmopolitan culture, rather than a merely local or scholarly one. It was Alfonso X who had the vision and the profound understanding of the libraries of his realm to make his project mirror that of the Arabo-Persian adab tradition.

The seminal text of that Arabo-Persian adab tradition is the collection of stories called *Kalila wa dimna*; and Alfonso's *Calila e Dimna* would play precisely that role in the transfiguration of Castilian. *Kalila wa dimna* had a complicated and telling past life before becoming the foundational text of Castilian prose fiction. Sometimes known as the *Book of Bidpai*—the fables of a philosopher who is counselor to a king—they contain stories that particularly address problems of authority and moral dilemmas. The stories were first recounted and collected hundreds of years before, as something generally described as a Buddhist preaching or wisdom text, also known as the *Panchatantra*. From that Sanskrit masterwork the volume moved into other manifestations: its Pahlavi avatar was converted by a young Islamic culture still inventing itself, and the eighth-century Arabic version tellingly involves a prefatory narrative accounting for the migration of the text from India to Persia, and holding up the stories as advice for kings.

The translator of that Arabic *Kalila wa dimna* was the architect of adab in its most expansive and literary chapter: the writer Ibn al-Muqaffa was a convert to Islam, an Iranian who, in turn, devoted his career to converting the cultural heritage of his native Persia into the language of the conquering empire. A man for whom the differences between originals and translations seemed fatuous, Ibn al-Muqaffa belonged to a whole coterie of non-Arabs who were fundamental to adab, and who thus became major figures in the Arabic literary tradition. And the Castilian translator, in turn—Alfonso himself—played an even more

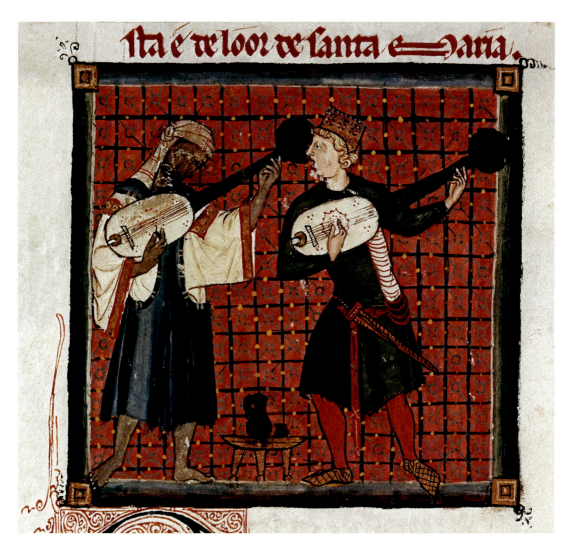

A Muslim and a Christian play and sing together in the *Cantigas de Santa María*. El Escorial, Madrid.

transformative role for his own new imperial culture. Through his choice of this tradition, and this text, the newly minted Castilian king revealed his distinct sense of the complex *translatio imperii* he was hungry to engineer. His ambition was to transform Castile into the successor to the great empires that preceded him in history, including both Umayyad Cordoba and the Holy Roman empire. For this he needed a new cultural language for his kingdom, one that could be distinct from and supersede both Latin and Arabic.

The first of the five books of this masterpiece involves two jackal brothers, Kalila and Dimna, whose names give later versions of the book its title. The jackals inhabit a realm in which the Lion is king, but into which has wandered a noble Bull—lost in some versions, stuck in the mud or wounded in others—whose distant bellowing disconcerts the Lion. In the Lion-king's fears of the unknown noise, the crafty Dimna sees an opportunity to advance himself, and to raise his status at the king's court by becoming the advisor able to soothe those fears and become a liaison with the Bull. The Bull is eventually brought to the

court and, much to Dimna's frustration, an unexpected friendship develops between the carnivore-king and the huge but ultimately pacific "grass-eater," as the Bull is sometimes referred to. This terminology underlines the presumed natural incompatibility between the two beasts, each at the head of a kingdom inimical to the other. And yet, the text is clearly, in this case, sympathetic to the notion that natural enemies easily become natural friends when cast into a circumstance of intimacy. And Dimna's resentment of both the friendship and his own commensurate loss of standing with the Lion leads him—against the advice of Kalila—to sow such discord and suspicion between the two friends that they eventually turn on each other, and the Lion kills the Bull. But it is not long before the Lion realizes the injustice and tragedy of what has happened, that he was lied to and manipulated by Dimna. In some versions he then simply kills the conniving courtier outright; in others, including in Alfonso's Castilian, there is a trial that leads to Dimna's conviction, imprisonment, and death.

But what this most basic recounting of the story fails to convey is that the plot is carried forward through the telling of dozens and dozens of stories—a sea of stories, as Salman Rushdie would one day title his own work so explicitly a part of this tradition, as is its cousin, the *Thousand and One Nights*. So much so that it would be fair to describe the real plot as something like "the art and uses of storytelling." Few conversations take place between any of the animal characters that are not, in fact, the recounting of stories within the story; sometimes these are tales about animals but sometimes they are, more amusingly, stories about people. And it is always explicit that the story recounted is meant to elucidate a quandary or provide a warning about pursuing a certain path, even though the "moral of the story" can be ambiguous. Precisely because they are delivered as particular stories—something that happened to someone once—these are not predigested morals but narratives in need of interpretation.

These collections are conventionally called framed tales: the frame is the outermost layer, where the first story is told and within which all the others are embedded. The most famous of these frames is the story of Sheharazade in the *Thousand and One Nights*: how the heroine comes to tell a story every night. In the framed-tale tradition the portrait and behavior of the listener is at least as central as that of the storyteller. The role of the listener —who may or may not have explicitly asked for advice, or asked to hear a story—is the key one: to learn how to interpret wisely, to figure things out in one's own life from choices others have made. The paradigmatic listener is a king, or a king-to-be: Alexander, or the Lion-king, or the Persian shah who kills a new wife every night before becoming entranced by Sheharazade's stories. Or Alfonso himself, on the eve of becoming king when he took on the project to translate the *Kalila wa dimna*.

As with the framing story of the Lion-king and how he deals with a corrupt advisor, many stories might be of special interest to those who rule. But these rich and complex stories transcend any narrow definition of manuals-for-rulers. It is clear that Alfonso believed that through him and beyond him these texts provided a broad secular foundation for his heirs, the Castilians who had too long been without a culture of refinement

and wisdom in their own language. And the *Calila e Dimna* was only the slightest hint of what was to come, the very beginning of an outpouring of writing by him, or supervised by him, or commissioned by him, in the vernacular, all in the Castilian of Toledo except the *Cantigas*. Much of this new body of regal Castilian writing was produced by the coterie of polyglot and multireligious translators of Alfonso's court. And much of it—like the *Calila*—followed Arabic models, sometimes yielding translations, sometimes using texts as a more general model.

No rudimentary sketch of the new Castilian library created by Alfonso can do it justice, although it can hint at the vast ambition of his enterprise: lavishly illustrated books of chess and other pastimes; several different monumental histories, recounting the history of civilization from biblical times into the Castilian era; treatises in many of the sciences—astrology and astronomy, geology—many of these, too, stunningly beautiful in their complex illumination; handbooks of practical philosophy; and in a class altogether of its own, the *Siete partidas*, the massive and still influential "seven-part code" of law that is far more, a sweeping portrait or encyclopedia of life and society in Castile in the thirteenth century. Most of this was produced during Alfonso's thirty-two difficult years as king, years of constant political upheavals and bitter disappointments. His reign saw a costly and ultimately failed campaign to succeed his cousin Frederick II as Holy Roman emperor, the execution of his own brother, and a rebellion among his nobles, led by his own son Sancho. But although nearly all his short-term and personal political ambitions ended up badly, his cultural ambitions—political in different and more visionary terms—were an unmitigated success, no less than the establishment of Castilian as a viable alternative to both Latin and Arabic.

The *Calila* thus stands at the very inception of Castilian as a written culture. There are a handful of important precedents; most significant and influential among these is the framed-tale collection written by the Jewish convert to Christianity Petrus Alfonsi. The *Disciplina clericalis*, written in Latin, was also based on the traditions of storytelling and wisdom literature long a part of basic culture for those literate in Arabic. But it is only in the wake of the royal endorsement of the high cultural standing of such stories, and of the popularity and success of the Castilian *Calila*, that the river of vernacular framed-tale collections central to what we call prose fiction begins to flow. In Castile itself several notable collections follow, each with powerful family ties to both Alfonso and to the adab heritage exemplified by the *Calila*. The first of these is the *Sendebar* (the name is taken from that of the counselor to the king in the frame story, but the collection is also known as the *Book of the Wiles of Women* or the *Book of the Seven Sages*; in Spanish it is the *Libro de los engaños o asayamientos de las mugeres*), written or translated by Alfonso's own brother Fadrique, whom Alfonso executed in 1277. And the second, written sometime between 1335 and 1340 by Alfonso's nephew Don Juan Manuel, is the *Libro de los exemplos del Conde Lucanor y Patronio* (Book of the Stories of the Count Lucanor and Patronio), usually referred to more simply as the *Conde Lucanor*.

The *Sendebar*'s frame involves a false accusation against a prince, and a trial follows in which the accuser, one of the king's wives, and his advisors, the "seven sages," argue the innocence and guilt of the prince through a veritable battle of stories. Typically, the stories

Mudejar Churches of Old Castile

Old Castile, the northern territories where Castilian lands were centered before the conquest of Toledo, is dotted with brick churches, many of which betray a connection to the Toledan Mudejar tradition. In the eleventh through the fourteenth centuries, churches covered with a lively skin of blind arcades, like Toledan Mudejar churches, appear in the zone between the Duero and the Tagus rivers, in country monasteries and small towns where the colonization of the lands between Burgos and Toledo triggered new settlements. But the process of spreading Toledo's hybrid architectural culture seems to have begun even earlier in Old Castile. Sources document the presence of Mudejar workmen from Toledo as early as 895 in Zamora, and 1051 in Sahagún, suggesting the cities imported their accomplished brick masons already in the Umayyad and Taifa periods. And several churches in Sahagún date before the second half of the twelfth century, when many of the Toledan churches that survive today were built. Toledan Mudejar, as a brick architecture, was less expensive than cut stone, and could be accomplished more rapidly, and it was easily assimilated in the north, where there were already indigenous brick traditions.

In both Old Castile and Toledo, Mudejar buildings were transformed through encounters with stone Romanesque, and then in turn transformed the appearance of Romanesque churches, in a constant conversation as complex as Castilian identity itself. Endless marriages and progeny are to be found among the churches of that broad swath of Castile, churches that combine Romanesque and Mudejar structure, ornament, and materials. This has led to increasingly complex terminology that attempts to sweep buildings like San Salvador de Toro into either the "Romanesque" or the "Mudejar" camp. The brick churches of Old Castile—often referred to as the cradle of Castilian culture—are brave mixed marriages between the architecture of interaction and that of reform.

In 1324, the infante Don Juan Manuel, nephew of Alfonso X and the author of the canonical Castilian *Conde Lucanor*, built the monastery and the church of San Pablo in the town of Peñafiel, hard on the banks of the Duero River. It was to this monastery that he bequeathed his manuscripts, and he was buried there, as he had wished. The swelling apse that survives is covered with rows of brick arches: scalloped arches, keel-shaped arches, and horseshoe arches, antiquated memories of Toledo that obscure the Gothic windows they embrace. Here, one of the key sites associated with the birth of Castilian prose is self-consciously the site of an explicit wish to preserve hybrid Castilian culture.

Church of San Lorenzo in Sahagún.

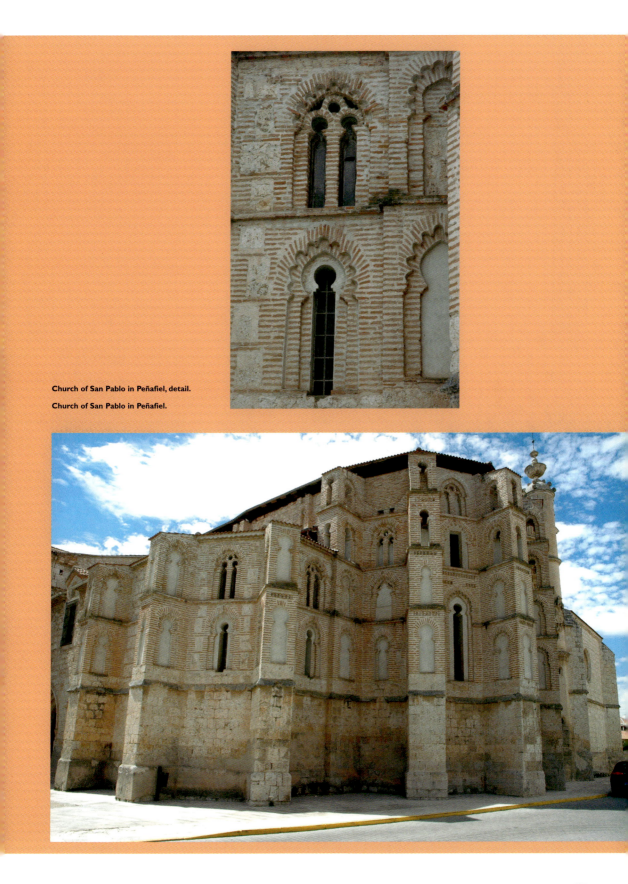

Church of San Pablo in Peñafiel, detail.

Church of San Pablo in Peñafiel.

themselves come from the wealth of sources that the Arabic imperial traditions of adab had absorbed, including, in this case, several of Greek and Hebrew provenance. In real life, Alfonso's brother and fellow devotee of the framed tales, the prince Fadrique, was summarily executed by his brother rather than tried. In Fadrique's uncannily prescient text, however, where stories are meant to elucidate the potential tragedy of false accusations, the prince is vindicated. Although there is a convoluted history of the *Sendebar*'s translations into other languages, and although many of its stories reappear in later European story collections, the Castilian *Sendebar* itself eventually fell out of the mainstream of literary history. The *Conde Lucanor*, on the other hand, stands at the very beginning of that mainstream, firmly entrenched in the Spanish canon in a pivotal and foundational position, much like that of Chaucer's *Canterbury Tales* in English and Boccaccio's *Decameron* in Italian. Its frame is simple: the count asks his counselor Patronio for advice, which is then offered in the form of stories. And many of these are twice-told tales, stories already in the *Disciplina*, the *Sendebar*, or the *Calila e Dimna*.

Alfonso's initial choice of the fertile *Calila e Dimna* invigorated virtually all the new European cultures. It is in the vanguard of the far-flung and densely interconnected body of stories in the vernaculars that would constitute one of the pillars of European literature. These medieval collections—and many that are intertwined with them in later European fiction—share a great deal, even when they differ substantially in time and place and language. They all seem to carry something of the DNA of Toledo: the palimpsest of sources and languages. Sometimes the same stories are retold or reworked, but in some sense that is less key to their complex kinship than the fundamental attitudes they share about storytelling itself. Here the cardinal virtue is that a story requires listeners (and, increasingly, readers) to figure the morals of the story out themselves, to interpret.

The new education of Castilian princes—or lion-kings or pilgrims to Canterbury—now involved neither rote didacticism nor straightforward commandments; those were the methods and attitudes of the Latin church, not those of the newly literate secular societies of the thirteenth and fourteenth centuries. The literary tradition of adab had offered a different model: complex and often perplexing, or even discouraging, stories—stories with no obvious moral at all, although sometimes a great deal of entertainment—provide the opportunity to acquire wisdom. The many overlaps in stories from one collection to another opens a window onto a world in which authors were encouraged to share and rewrite stories without embarrassment. Here we are still far from the modern conceit of originality, in a universe in which what is prized, instead, is the skill of the storyteller, as well as the versatility of basic stories. What matters is how well the tales lend themselves to being told again and again, and in circumstances as disparate as the Persian court where Sanskrit stories are retold in Arabic and the Florentine garden where Boccaccio's ten young women and men tell each other stories as refuge from the devastation of the plague.

The only text concerned with notions of originality and authorship is Don Juan Manuel's *Conde Lucanor*, the clearest progeny of the *Calila e Dimna*—and which includes a retelling of the Calila story itself. Perhaps understandably: Don Juan Manuel lived a personal

and political life in the shadow of his uncle Alfonso X, in an age of political tumult, much of it caused by the actions and fates of kings. He was both a beneficiary of Alfonso's cultural legacy and a victim of the political chaos the Castilian king left behind when he died in 1284. The son of Prince Manuel, one of Alfonso's brothers, Don Juan Manuel led a novelistic life, as even the most cursory accounting reveals. He was born during the terrible rupture between Alfonso X and his son Sancho, which resulted in a war between father and son, unhealed at the king's death. Juan Manuel was two years old when that same disinherited cousin, Sancho IV (r. 1284–1295), seized his father's throne, and Juan Manuel would live to experience the fractious minorities of the two Castilian kings who followed: Sancho IV's son Ferdinand IV (r. 1295–1312) and Ferdinand's son Alfonso XI (r. 1312–1350). Don Juan Manuel would in fact be among those who jostled for power during the minority of the young Alfonso XI, and he was for many years the governor, or *adelantado*, of Murcia, still a frontier city in the early fourteenth century, as it had been in Alfonso X's time. And when Alfonso XI later in life reneged on a promise to marry Don Juan Manuel's daughter Costanza and imprisoned her, the knight, author, and intellectual Don Juan Manuel offered both lands and his fealty to Muhammad, the Nasrid king of Granada.

But perhaps Juan Manuel's greatest burden, as a descendant of Alfonso, was following in his royal uncle's literary footsteps, yearning to become a foundational figure in Castilian letters, although he understood perfectly well he was not the pioneer, but a settler. In much of his writing—including dozens of volumes that are little studied today, compared to the *Conde Lucanor*, which is mandatory reading for all educated Spaniards—we feel his palpable obsession with questions of authority and originality, with the differences he wants to claim exist between translations and originals. The introduction to the *Conde Lucanor* hints at his anxiety about authorship: "And because Don Juan saw and knew that in copying books many errors occur . . . he beseeches people who read any book whatever which was copied from what he composed or wrote to read the very copy which Don Juan wrote, which has been corrected in many places in his own hand."

Perhaps he imagined that this would help draw a historic distinction between his uncle and himself, and in some sense by proclaiming it so loudly, he has made many believe it: conventional narratives of Castilian literary history place him as the first great writer of Castilian prose, a beginning. But in every way imaginable the *Conde Lucanor* is the offspring of the *Calila e Dimna*: in its recycling of many of the same stories, and in its most basic structure, the frame tale, with its conceit of a king listening to stories told by a counselor. And most of all in its language, Castilian, now the language of a sophisticated and literate culture, unambiguously the progeny of Alfonso himself. Antonio de Nebrija would one day, in his 1492 dedication of the *Gramática* to Queen Isabella, justly identify Alfonso X as his predecessor, noting that "siempre la lengua fue compañera del imperio" (language was always the companion of empire). Perhaps to this acknowledgment we can also add a more thorough appreciation of the deep cultural memory at work here: the extent to which Alfonso's concept of the cultural empire as the necessary handmaiden of a political one derives naturally from the adab of the Arabic cultural empire he dreamt Castile could succeed.

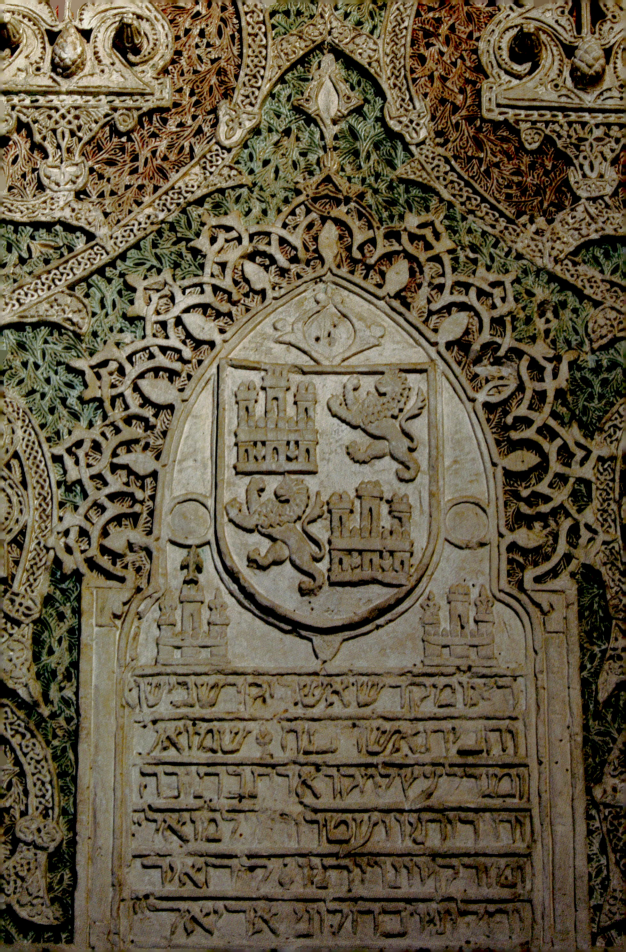

CHAPTER SEVEN

Brothers

Carved delicately in low plaster relief, a shield bears the arms of the kingdom of Castile and León: rampant lions—tails arched and paws extended—shadowbox two white stucco castles, each with towers bristling crenellations. If we step back a few inches, we can see that the coat of arms is caught in a thicket of stucco leaves, red and green with deep shadows; and that over these, delicate arches and knots intertwine with tangled ribbons of Arabic calligraphy and vegetation, layer upon layer, each matrix with its own interior logic, slipping over an infinite stratigraphy of branches and bands carved into the surface of the wall. What we have found is the arms of the kingdom of Castile woven into a web of ornament that easily recalls the great palace of the Alhambra built by the Nasrid monarchs Yusuf I and Muhammad V.

Now step back just a bit more. Below the arms of Castile is an inscription: six broad bands of Hebrew writing crowned with two more crenellated castles. The authority of those castles and the shield of arms over the inscription take on new meaning as we read a part of its message:

> Prince among the princes of Levi, R. Samuel Halevi, a man placed on high, may his god be with him and exalt him ! . . . He has found grace and mercy in the eyes of the great eagle of enormous wings, a warrior and champion . . . whose name is great among the nations, the great monarch, our lord and our master, the king Don Peter: may God aid him and magnify his power, glory, and fortune, and protect him as a Shepherd protects his flock. For the King has glorified and exalted him and has raised his throne above all other princes . . . without his consent, no person moves a hand or foot. . . . Throughout all the kingdoms his fame has spread and he (Peter) has become the savior of Israel.[1]

The inscription is one of a pair that flank the Torah niche of a synagogue in Toledo, and together they identify Samuel Halevi—the treasurer of King Peter I of Castile, his chief tax collector, and Castile's ambassador to Portugal—as its patron. The inscriptions describe Halevi as "a great man, pious, just, prince among the princes of Levi," who surpassed even himself in "building a house of prayer in the name of Yahveh."[2] The echoing rectangular prayer hall is breathtaking in proportion, seventy-five feet long but a full fifty-six feet high, and

Synagogue of Samuel Halevi in Toledo, 1360s, stucco decoration flanking Torah niche.

BAY OF BISCAY

La Coruña

Ebro River
Pamplona
NAVARRE

Burgos

ARAGON

Tordesillas
Duero River
Saragossa

Oporto

Barcelona

LEÓN-CASTILE

Madrid

PORTUGAL

Toledo

Valencia

Tagus River

Guadiana River

BALEARIC
ISLANDS

Lisbon

ATLANTIC OCEAN

Cordoba
Murcia
Guadalquivir River

Seville
Granada
GRANADA

Palos de la Frontera
Almería

Algeciras

MEDITERRANEAN SEA

NORTH AFRICA

1492

100 | 200 MI
50 | 100 KM

Synagogue of Samuel Halevi in Toledo, interior.

Synagogue of Samuel Halevi in Toledo, stucco decorating Women's Gallery.

culminates in an ornate Torah ark of three scalloped arches resting on slender marble columns. The monumental sanctuary includes adjacent rooms, and broad second-floor women's galleries to the south with openings that look down on the main sanctuary. The scale of Samuel Halevi's synagogue is palatial, as if the patron meant to construct his own palatine chapel as "prince among the princes of Levi." But the choice of the stucco style is a marker of his bond with his "lord and master" Peter I, king of Castile.

The arms of Castile in the synagogue of Samuel Halevi appear in an aesthetically politicized context. The architecture of the synagogue, with its lofty proportions and complex stucco relief carving, was constructed and ornamented in what had become the Castilian court style. That a Jewish member of the kingdom would construct in the court style was particularly appropriate. Indeed, in many juridical texts, Jews belonged to their king and were directly protected by him. But the synagogue of Samuel Halevi finds its Castilian identity, its royal identity, in a style that is identifiably Islamic as well: one that

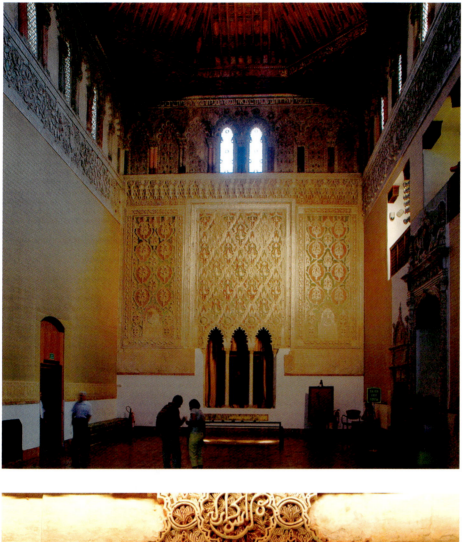

Sister Haggadah, Barcelona, 14th century.

Kennicott Bible, La Coruña, 15th century.

associated the arms of Castile with Nasrid ornament and Arabic inscriptions.

Isidro Bango Torviso has shown the subordination of religion in the creation of a civil artistic identity in a visual comparison as simple as it is lucid. He compares the folios of two Hebrew manuscripts produced within the kingdoms of Aragon and Castile: the "Sister" Haggadah, a manuscript giving the order of Passover from fourteenth-century Barcelona, in the kingdom of Aragon, and the Kennicott Bible, a famous Hebrew Bible commissioned in the fifteenth century in La Coruña, then in the kingdom of Castile.[3] The Aragonese page bears the arms of Aragon, in an illuminated initial of the Gothic style, gold-leaf Hebrew characters emitting a burnished glow against a backdrop of red and blue vine scrolls and finials immediately relatable to the French Gothic tradition of illumination. But the Castilian folio shows the castle of Castile with its three turrets caught in a maze of geometric interlace, a single gold band forming a continuous rebus of knots like those that weave throughout the stuccos at the Alhambra in Granada. We see here an assimilated style that signifies Castile as consciously as does the castle of the coat of arms itself.

Samuel Halevi, in fact, engaged the same atelier to construct his synagogue that had built his "lord and master's" palace at Tordesillas: one of many residences redecorated in his palatine style, with patios, courtyards, and dense stucco ornament. When Halevi used this style, he was expressing through visual language his connection to Peter, as his inscription clearly articulates. That dependence reminds us to what extent this style of decoration had become the expression of the Castilian monarchy, a style unapologetically identified with Islamic taste. And that concept of Castilian style pervades other cultural realms, defining some of the most characteristic writing of the period, including another

masterpiece explicitly a part of Peter's world. "Consejos y documentos del Rabbi Don Santo al Rey D. Pedro" (Advice and Texts from Rabbi Don Santo to King Peter) is the full title of the *Proverbios morales* (*Moral Proverbs*) dedicated to the Castilian king by Rabbi Shem Tov ibn Ardutiel ben Isaac, known by his nickname, Santob de Carrión. The *Proverbios morales* follow in this culture's long tradition of wisdom and advice literature, joining this fourteenth-century rabbi to Petrus Alfonsi, Alfonso X, and Don Juan Manuel. It is a text remarkable not so much because a rabbi is advising his king but because it is written in Castilian, a

Santob de Carrión
Proverbios morales

Dedicatoria al Rey Don Pedro I

Señor Rey, noble, alto,
Óy este sermon
Que vyene desyr Santo,
Judio de Carrion,

Comunalmente trobado,
De glosas moralmente
Dela filosofia sacado,
Segunt que va syguyente.

Quando el Rey Don Alfonso
Fynó, fyncó la gente
Commo quando el pulso
Fallesçe al doliente.

Que luego non cuydauan
Que tan grant mejoria
A ellos fyncaua,
Nin omne lo entendia.

Quando la rosa seca
En su tiempo sale,
El agua della finca
Rosada, que mas vale.

Asi vos fincastes dél
Para muncho turar,
E faser lo que él
Cobdiçiaua librar:

Como la debda mia,
Que a vos muy poco monta,
Conla qual yo podria
Bevyr syn toda onta.

Dedication to King Peter I

Lord King, noble and high, hear this discourse, which Santob, the Jew from Carrión, comes forward to speak:

[It is spoken] for the benefit of all, rhymed in the vulgar manner, and culled from glosses taken from moral philosophy, as [you will see from] the following.

When King Alfonso died, the people were left like a sick man when his pulse fails.

For at the moment they did not reflect that such a cure remained, nor could anyone [even] imagine that it was possible.

When the dry rose leaves the world in its appointed time, its rose water remains, of greater worth.

In the same way, you have survived him, in order to live a long life and do the things he wished to acquit:

As, for example, the sum promised me, which is of slight worth to you but with which [if acquitted] I could live without any shame [of hardship].

Trans. T. A. Perry

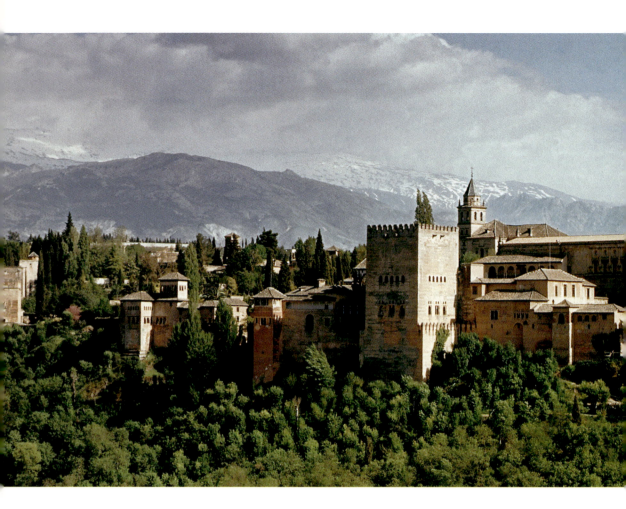

View of the Alhambra in Granada.

shared language now as flourishing and official as the court style of Peter.

The lofty spaces of Halevi's synagogue mark one of the last lavish Castilian buildings in the city of Toledo. By the time it was built, Toledo's archbishops had ceased to dream that Toledo would become their center of power. Seville, instead, had become the focus of royal interest and patronage for the Castilian kings. The synagogue of Samuel Halevi is one of the last great monuments to remind us that Toledo was nevertheless an indomitable metropolis in which a formative culture mitigated, enriched, eroded, and complicated Castilian identity. At the same time, the synagogue draws us deeper into the world of this Castilian court style, to Seville, where a "revolution in civil architecture" inspired by Islamic palaces was promoted.[4]

✳

Sometime after 1360, Samuel Halevi was taken to Seville, where he was tortured, and then executed by his "lord and master" Peter I. By all accounts Peter wished to force his tax collector, courtier, and ambassador to reveal the location of an alleged secret treasure. Halevi's large fortune, including money, lands, and some eighty Muslim slaves, was confiscated by

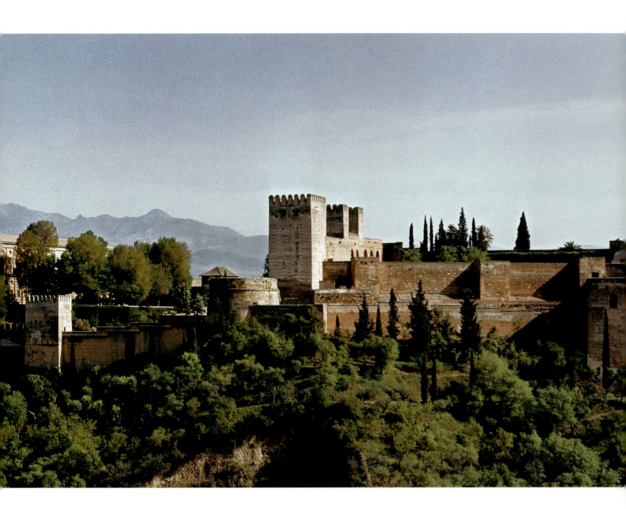

the king. This was but one of the summary and despotic killings for which Peter would come to be known as "the Cruel." During his reign Peter would execute untold numbers, including his two younger brothers, his half brother Fadrique, his cousin, Prince John of Aragon, his wife, Blanche of Bourbon, hostages, dinner guests, knights who fell short of their military goals, or, if any of these could not be found, he did not shrink from executing a fugitive's mother. A great deal of his rage was centered on his illegitimate half brother, Henry of Trastámara, oldest son of his father's beloved mistress, Eleanor of Guzmán. Peter's failure to make a strategic peace with Henry would be his downfall, and the enmity between them fueled and expanded a civil war that radically transformed the politics, and the royal line, of Castile.

The one player on the diplomatic stage of the Iberian Peninsula with whom Peter the Cruel had a stable relationship was Muhammad V, Nasrid king of Granada, and tributary of the kingdom of Castile. Like Peter, Muhammad V had come to the throne as an adolescent, and they shared the vulnerability of young monarchs opposed by members of their own family. Muhammad, the longest-reigning king of Granada, regarded by some as the greatest, promoted strong ties with Castile. In this he defied the prevailing Nasrid policy of peace with all parties. Muhammad's determination to honor his feudal obligations to

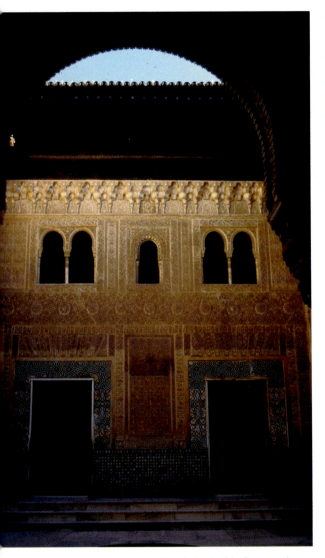

Alhambra in Granada, façade of the Comares palace, redecorated c. 1317.

Castile would oblige the Nasrids to take up arms against Aragon and others against whom Peter might have a rivalry. As Peter the Cruel pursued a war with the kingdom of Aragon, and demanded naval assistance from his tributaries, Muhammad's loyalty to Peter produced a palace coup. One hundred conspirators financed by Maryam, the mother of Muhammad's own half brother Ismail II and new contender for the throne, scaled the fortification of the Alhambra and took the royal palace by surprise in Ramadan of 1359. Before long, Muhammad was in Seville, where he was lavishly received in the royal palaces, the Alcazar, by Peter, with whose aid Muhammad would eventually repossess the Alhambra three years later, in 1362. Among Muhammad's first acts once he was restored to power would be to declare outright support of Peter against the Castilian king's half brother Henry, despite the fact that Henry's power was mounting. L. P. Harvey reveals the bond between the kings in a quote from one recension of the *Chronicle of King Peter*: "The word ran through the city that even when everybody else abandoned him [Peter], the Moors would not let him down, especially King Muhammad of Granada, whom he had caused to recover his kingdom."5

The Alhambra, already legendary, had been under construction for some time. It was probably the founder of the Nasrid dynasty, Ferdinand III's ally Ibn al-Ahmar, who first built on the imposing palace site, though other fortifications and palaces had previously existed against the Olympian backdrop of the Sierra Nevada. The Alhambra was a court city that included terraced gardens, palaces, military barracks, and fortifications all begun before the mid-fourteenth century. The royal palace that Muhammad V lost and then regained in 1362—the labyrinth of courtyard gardens and high-ceilinged halls of what is called the Comares palace—was primarily the work of Muhammad's father, Yusuf I. It was almost certainly unfinished at the time the adolescent monarch first came to power, and Muhammad would later make significant refinements and additions, to produce the palace we see today.

The façade of the Comares palace in the courtyard today called the Cuarto Dorado was his work, with its deep cornice of muqarnas and its symmetrical and equivocal doors.

The mystic designs of the *alicatados*, mosaic tile panels with a complex rationality that cannot easily be grasped, find a home in this elusive monumental place. The doors and the geometric designs are puzzles understood only by the monarch. It is an architecture that supports the monarch's omnipotence absolutely. The Comares façade was one part of the Alhambra completed by Muhammad V upon his return to the throne, and its inscriptions helped unfold its meanings:

> My position is that of a crown, and my door is that of a divergence,
> the west finds in me the east;
> al-Ghani bi-llah ["Contented with God," Muhammad's nickname] entrusted me to
> open the path to approaching victory;
> and I await his appearance like horizon welcomes the dawn;
> May God beautify his works just as He beautified his character and his form.[6]

These verses were composed by the poet and statesman Ibn Zamrak, who accompanied Muhammad to Seville and whose poems would cover the walls of the Alhambra. Ibn Zamrak is credited with articulating in words the meaning of the architecture of the Alhambra. The commanding palace overlooking Granada was intended to be a victory monument, a palace city in which a theater of power and control could be played out visually by the Nasrids, whose fate was in the hands of the Castilians.[7] The Nasrid motto,

Alicatados

Alicatados are mosaic panels composed of tiny pieces of ceramic chiseled from a fired tile and trimmed to intricate geometric shapes with *alicates*, or delicate pliers. These tile panels protected the lower portions of walls most likely to be abraded by daily use, and were cool to the touch, and luminous, reflecting light and water alike. Alicatados were fit together like a puzzle, to create designs in which deceptively simple geometric themes rotate, multiply, and divide, producing disjunctures in optical perception and multiple levels of reality. Their insistent liminality between the worlds of illusion and rationality provided a catalyst for the twentieth-century graphic work of M. C. Escher, whose optical rebuses were inspired by two visits to the Alhambra.

Alhambra in Granada.
Alcazar of Seville.

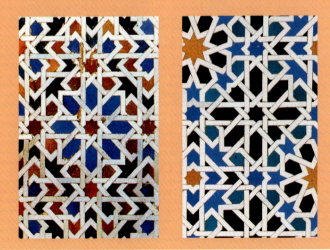

Ibn Zamrak

Considered the greatest poet of his age, Ibn Zamrak (1333–1393) was the eminent poet of the court of Muhammad V, as well as the king's private secretary. For many years involved in the byzantine and often violent court intrigues, he was both assassin and himself assassinated. He is believed to have arranged for the death of Ibn al-Khatib, the great polymath of the age, Muhammad's vizier, and ultimately our invaluable historian of al-Andalus. Ibn Zamrak's most famous poems survive in what has been called the most luxurious edition imaginable: engraved on the walls of the Alhambra palaces, speaking in the voices of the palaces themselves.

I am the garden appearing every morning with adorned beauty; contemplate my beauty and you will be penetrated with understanding;

I excel through the generosity of my lord the imam Muhammad for all who come and go;

How excellent is our beautiful building, for it certainly surpasses all others by decree of the stars!

How many joyful solaces for the eyes are to be found in it; in it even the dreamer will renew the objects of his desire!

The hands of the Pleiades will spend the night invoking God's protection in their favor and they will awaken to the gentle blowing of the breeze.

In here is a cupola which by its height becomes lost from sight; beauty in it appears both concealed and visible.

The constellation of Gemini extends a ready hand [to help it] and the full moon of the heavens draws near to whisper secretly to it.

And the bright stars would like to establish themselves firmly in it rather than to continue wandering about in the vault of the sky,

Were they to remain in its antechambers they would outstrip the handmaidens in serving you in such a way as to cause you to be pleased with them.

It is no wonder that it surpasses the stars in the heavens, and passes beyond their farthest limits.

For it is before your dwelling that it has arisen to perform its service, since he who serves the highest acquires merit thereby.

In [your dwelling] the portico has exceeded [the utmost limits] of beauty, while thanks to it the palace has come to compete in beauty with the vault of heaven.

With how many a decoration have you clothed it in order to embellish it, one consisting of multicolored figured work which causes the brocades of Yemen to be forgotten!

And how many arches rise up in its vault supported by columns which at night are embellished by light!

You would think that they are the heavenly spheres whose orbits revolve, overshadowing the pillar of dawn when it barely begins to appear after having passed through the night.

The capitals [or the columns] contain all sorts of rare wonders so that proverbs [composed about them] fly in all directions and become generally known.

In it there is burnished marble whose light has shone and thus illuminated the darkest shadows remaining in the gloom.

When they are illuminated by the rays of the sun you would think that they are made of pearls by reason of the number of celestial bodies in them.

Nor have we observed any palace higher in its lookout spots, clearer in its horizons, or ampler in its halls of assembly.

Moreover we know of no garden more pleasant in its freshness, more fragrant in its surroundings, or sweeter in the gathering of its fruits.

[The garden] gives double satisfaction for the amount which the judge of beauty imposed on it [as a fine]:

For if the hand of the breeze fills it with [silver] dirhams of light, he is satisfied with this [as payment];

Yet the [gold] dinars of the sun [also] fill the enclosure of the garden, filtering through its branches, leaving it embellished.

Trans. Oleg Grabar

يفوق على حكم السعود المبانيا	وللّه مبناك الجميل فانه
تجدّ به نفس الحليم الامانيا	فكم فيه للابصار من متنزّه
ويصبح معتلّ النسيم رواقيا	تبيت لهم كفّ الثريّا معيذة
ويدنو لها بدر السماء مناجيا	تمدّ لها الجوزاء كفّ مسارع
ولم تك في افق السماء جواريا	وتهوي النجوم الزهر لو ثبتت به
الى خدمة ترضيك منها الجواريا	ولو مثلت في سابقيه لسابقت
وان جاوزت منها المدى المتناهيا	ولا عجب ان فاتت الشهب بالعلا
ومن خدم الاعلى استفاد المعاليا	فبين يدى مثواك قامت لخدمة
به القصر آفاق السماء مباهيا	به اليهو قد حاز البهاء وقد غدا
من الوشى تنسى السابريّ اليمانيا	وكم حلّة جلّلته بحليّها
على عمد بالنور باتت حواليا	وكم من قسى في ذراه ترفعت
تظلّ عمود الصبح اذ بات باريا	فتحسبها الافلاك درات قسيّها
فطارت بها الامثال تجري سواريا	سواري قد جاءت بكلّ غريبة
فيجلو من الظلماء ما كان داجيا	به المرمر المجلوّ قد شفّ نوره
ارتنا دروعا يكسبتنا الاياديا	اذا ما جلت ايدي الصبا متن صفحه
وارفع آفاقا وافسح ناديا	ولم نر قصرا منه اعلى مظاهرا
واعطر ارجاء و احلى مجانيا	فلم ندر روضا منه انعم نضرة
اجاز بها قاضي الجمال التقاضيا	مصارفة نقدين فيه بمثلها
دراهم نور ظلّ عنها مكافيا	فان ملات كفّ النسيم بمثلها
دنانير شمس تترك الروض حاليا	فتملا حجر الروض حول غصونها

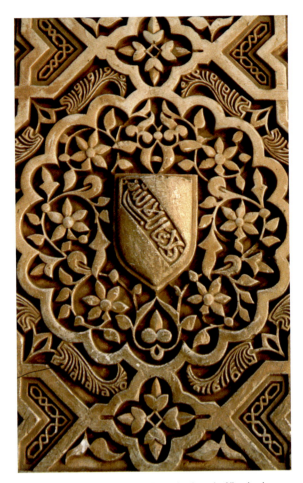
Detail of stucco decoration from the Alhambra in Granada.

conceived in the wake of the thirteenth-century victories that saw the founding of the dynasty, is here carved on ceilings and walls and over the thresholds of the palace. But now it takes on a new double meaning: *wa la ghalib illa allah,* "and there is no victor but God," might also echo a fantasy of Nasrid victory in the present. A palace isolated from the exterior world could become the setting for a utopian vision that served, as historian José Miguel Puerta Vílchez reminds us, to create an illusion of unchallenged power, within and without the Nasrid realm.[8]

The triumphal rhetoric of this redecoration of the Alhambra has been associated by art historian Oleg Grabar with Muhammad's retaking of the Nasrid throne from his own half brother in 1362, and with an unusual victory at Algeciras in 1369. Antonio Fernández-Puertas has described the Comares façade as a triumphal arch, like "arches and gates through which victors passed returning from military campaigns."[9] But in the poems of the palace, the internal struggle within the Nasrid court is shrouded, and only the victory against the "infidel" is voiced.

We need to pause to consider why Algeciras was an unusual victory. The battle was atypical because in the diplomatic atmosphere in which Peter I of Castile and Muhammad V of Granada moved, military conflict with the Castilians was out of the question. Peter and Muhammad were linked by feudal vows, and they had certain personal alliances; they honored and defended one another even against aggressions by their own relatives, so that their enemies on both sides exploited those loyalties as a means of suggesting they were unfit rulers. Peter in particular was accused of being too friendly with Muslims, too accustomed to their ways. "There were some who said they did not want to serve (Peter), and who said the Moors were coming, and that the king would welcome them into the city," reports the *Chronicle of King Peter*.[10] And Muhammad's strategic fealty to Peter, which did not falter until the end, had contributed to the loss of his throne early in his reign.

Muhammad did not fight Peter in the battle of Algeciras, but instead Peter's half brother Henry of Trastámara. Algeciras was the most significant of a series of cities seized by the Nasrids in the chaos that followed Peter's death in 1369 at the hands of his half brother. It was Henry's forces Muhammad opposed, taking advantage of Peter's death to

conduct lucrative raids. Muhammad used their modest success to create a new image in the Alhambra: one in which Castilians became infidels. Castilians, with whom he had taken refuge when in exile, and with whom he had allied himself in many wars, and with whom he shared artists and statesmen.

Yet the very notion of a victory monument might be seen as part of a long artistic conversation between Castilians and Nasrids. When Muhammad V was in exile, received regally in Seville as Peter the Cruel prepared to return him to the throne, he lived in an elaborate stage set for their shared courtly culture. The Alcazar of Seville included the courtyard known as the Patio del Yeso and a four-part garden, both built in the Almohad period with sunken gardens, standing pools, channels of water, and lacy arcades of stucco carving, some pierced like fragile stucco screens. Muhammad would also have seen the Gothic halls of Alfonso X, with their cool ribbed vaults, and he would surely have sat in the triumphant space built by Peter's father, Alfonso XI, a great room called the Hall of Justice connected to the Patio del Yeso. This grand chamber giving onto an enclosed Almohad garden was constructed by Alfonso to commemorate his victory

Alcazar of Seville, Hall of Justice of Alfonso XI, after 1340. The tall centrally planned hall is a typical form, often called a *qubba*. Here Alfonso XI links his hall with the garden of the Patio del Yeso from the Almohad period.

at Río Salado in 1340, a battle he fought as a crusade, in which the Marinids were definitively expelled from the peninsula and sent back to North Africa. Its high walls combined the coats of arms of Castile and León with those of the Christian Order of the Banda, and with legible Arabic inscriptions as well as *ataurique*, stucco carving of abstract vegetal forms. [11]

Perhaps Muhammad V's idea for transforming parts of the Alhambra into a victory monument was inspired by the Alcazar's Hall of Justice; by the way Peter's father—Alfonso XI—had appropriated and inverted the forms of Muhammad's father—Yusuf I—into a victory celebration in the Alcazar of Seville. Like the Hall of Justice, the victory iconography at the Alhambra concerns a single battle, and represents it in cosmic terms. Algeciras was thus transformed into the eternal battle between the faithful and the infidel, precisely the thematic structure in which the battle of Salado had been advertised, and fought by Alfonso XI.

But the levels of exchange and shared culture penetrate more deeply than iconographical appropriation. Recent scholarship suggests that Muhammad brought other ideas

back with him to Granada when he returned from exile: the architectural historian Juan Carlos Ruiz Souza has even proposed that the Court of the Lions might have found its predecessor in the Patio del Vergel, an enclosed court with pavilions on its short ends at the palace of Tordesillas, and that parts of that design derived, in turn, from earlier Nasrid tradition and local Cistercian monasteries.[12]

During the mid-fourteenth century artistic frontiers were so evanescent that terms like "interaction" and "influence" hardly seem to apply. The Castilian monuments built during Muhammad V's reign, his exile, and after—parts of the palace of Tordesillas, the synagogue of Samuel Halevi, and the Alcazar in Seville, to name just these few—share a style with the Nasrid court, and it grew, and was transformed with each new building, each new patron.

Muhammad, during his stay in Seville, probably did not see the great façade of the Alcazar, which marks the beginning of Peter the Cruel's extensive building campaign in 1364, for which he very likely used craftsmen who had worked with the Nasrids before

The Marinids (1269–1420)

The Marinids, so called for the tribe of Banu Marin, to which they belonged, were probably Berber though they claimed Arab ancestry. They had long resisted Almohad rule, and in 1216—no doubt taking advantage of the weakness and disarray that followed the defeat of Las Navas de Tolosa in 1212— they started moving northward, a conquest of Almohad territories that would continue for the next five decades. They first intervened in the Iberian Peninsula in the Mudejar revolts of 1264–1266, helping Ibn al-Ahmar defend the Mudejares of Murcia; over subsequent decades they regularly came to the aid of the Nasrids against the advances of later Christian kings, especially in the early fourteenth century, largely owing to the close relationship cultivated by Nasrid statesman Ibn al-Khatib (1313–1364). Their power base at Fez and their court at Marrakech became a great Islamic destination of the far west, drawing diplomats and scholars from the eastern side of the Mediterranean, many of whom would then cross to the Nasrid court at Granada.

But the patterns of intrareligious alliances in the service of territorial and personal disputes were far from finished: when the Marinid leader Abu Yusuf annexed the cities of Málaga and Algeciras to use as bases for his raids in Spain, Ibn al-Ahmar appealed to Alfonso X to save him from his rescuers, and a Muslim-Christian alliance managed to expel the Marinid leader in 1278. In an even more unexpected alliance, in 1282 Alfonso X asked Abu Yusuf for assistance in fighting against Alfonso's own son Sancho, who had rebelled against him in a bitter struggle over the succession to the Castilian throne. Not only did Abu Yusuf and Alfonso together besiege Sancho in Cordoba, but Alfonso took a loan of one hundred thousand gold dinars from the Marinid king, and gave him the Crown of Castile to hold as collateral. Alfonso was already ill and would die two years later, and the Crown would never return. Despite these alliances, the constant Marinid raids may have accelerated the deterioration of the relationship between the Muslim and Christian leaders of Iberia. The Marinids suffered a brutal defeat at the hands of the Castilians at Río Salado in 1340 and were forced to return to North Africa for good. In Granada, the Nasrids maintained contact with their southern neighbors and received visitors from Fez (including such luminaries as Ibn Battuta and Ibn Khaldun) until the ultimate dissolution of the Marinid state in 1420.

Muhammad V's exile. The façade, the Puerta de la Montería, might well be a copy of a lost façade of the Alhambra, as Ruiz Souza suggests.[13] It integrates ataurique, sebka, muqarnas, and Arabic inscriptions, including "The empire for God" and "There is no victor but God," the Nasrids' signature motto. This language, both artistic and linguistic, is in turn framed by a Latin inscription: "The highest, noblest, and most powerful conqueror, Don Pedro, by God's grace King of Castile and León, has caused these Alcazares and palaces and these façades to be built, which was done in the year [1364]."[14]

This façade was surely constructed by craftsmen from Granada, a group that had perhaps already spent five years in Castile during Muhammad V's exile: an atelier augmented by Castilians. Some of the craftsmen had fulfilled court commissions in Tordesillas and Toledo, and others were North African craftsmen who might have come with Muhammad to Seville from the Marinid court where he began his exile. But the theater of interaction penetrates more deeply than the sharing of craftsmen or even of symbolic meanings; it

Ataurique

By the fourteenth century stucco reliefs were often organized into arabesques, never-ending vine scrolls or ribbons that follow a circuitous path over the face of a wall, perhaps wrapping around an inscription before slipping behind a section of muqarnas, continuing beyond the field of our vision. Confounding and meditative, the arabesque, in its refusal to culminate, to begin or end, is often associated with mystic thought.

Its complex design is part of a larger order, which is suggested but cannot be fully controlled or known.

Ataurique is related to arabesques and sometimes derived from them. They are low-relief designs carved in stucco in which vegetal motifs intertwine in a multilayered web. They can include patterns of vines ending in leaves and palmettes but they are, at times, quite abstract, and often combined to create broad, repetitive, stylized stucco screens or walls. In the Nasrid and Castilian monuments of the fourteenth century, ataurique is at once complex, multilayered, and mannered, yet also restrained—caught within frames and grids, in low relief that does not break the wall surface.

clockwise from left:

Synagogue of Samuel Halevi.

Alhambra in Granada.

Patio de las Doncellas of the Alcazar in Seville.

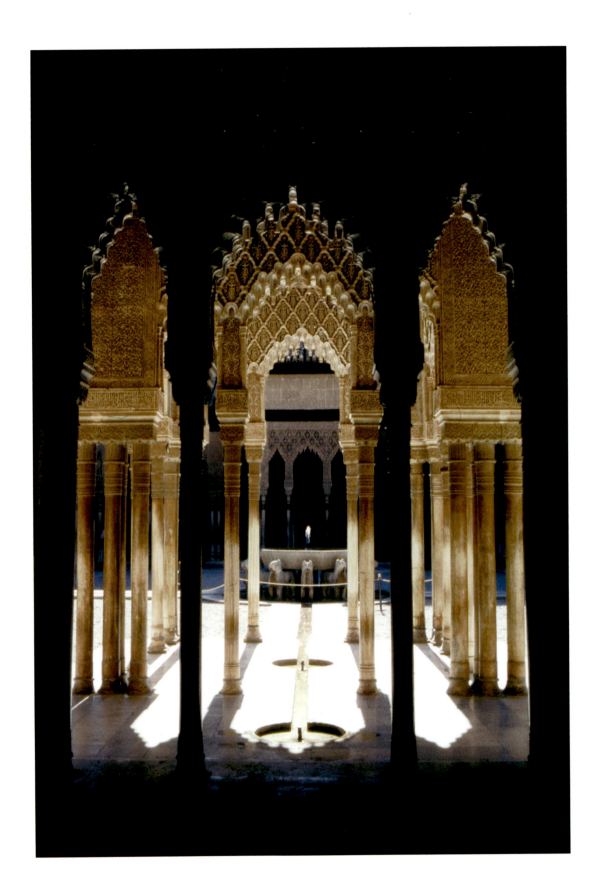

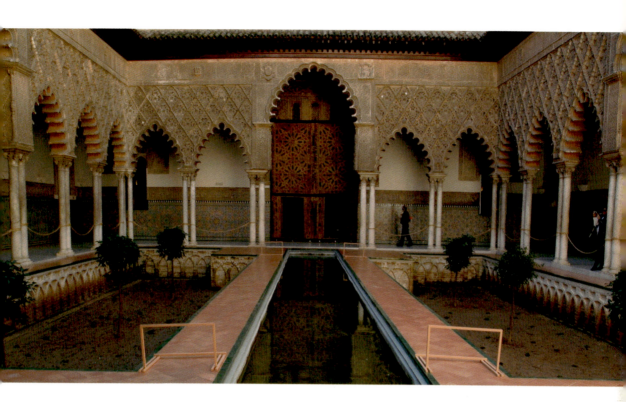

extends to the way architecture used text and even
sacred writing to mediate between religion and
secular authority.

Alhambra palace in Granada, Court of the Lions,
1370–1390.

Alcazar of Seville, Patio de las Doncellas, 1359–1369.

Consider the Hall of the Ambassadors, the
heart of the Alcazar as it was redecorated by Peter I. A lofty reception room, its elegant
triple horseshoe arches nurtured the memory of Madinat al-Zahra. We know in particular
about Peter's personal intervention in this part of the palace from an Arabic inscription on
the door, which begins: "Our exalted lord the sultan Don Peter, king of Castile and León—
may God grant him eternal happiness, and may it remain with his architect—ordered
that these carved wooden doors be made for this room (*qubba*) of happiness, made for the
honor and grandeur of his ennobled and fortunate ambassadors." The inscription, in bands
around the entry, goes on to state that in this door to the sultan's most magnificent recep-
tion hall "craftsmen from Toledo were employed, and this was in the exalted year 1404
[1366]. This work is like the twilight at evening and like the glow of dawn at morning, a
throne resplendent with brilliant colors and the intensity of its magnificence. . . . Praise
be to God!"

The craftsmen might have been from Toledo, but the language with which the
inscription exalts Peter also recalls that of the Alhambra. The use of Nasrid images of celes-
tial kingship in the inscriptions of the Alcazar becomes even more complex on the inside
of the door, the side facing the hall itself. It is here that we begin to see not only Nasrid
and Castilian visual languages but textual languages and meanings intertwining. Rather
than Arabic, the inner door bears a Castilian inscription in Gothic characters. The text

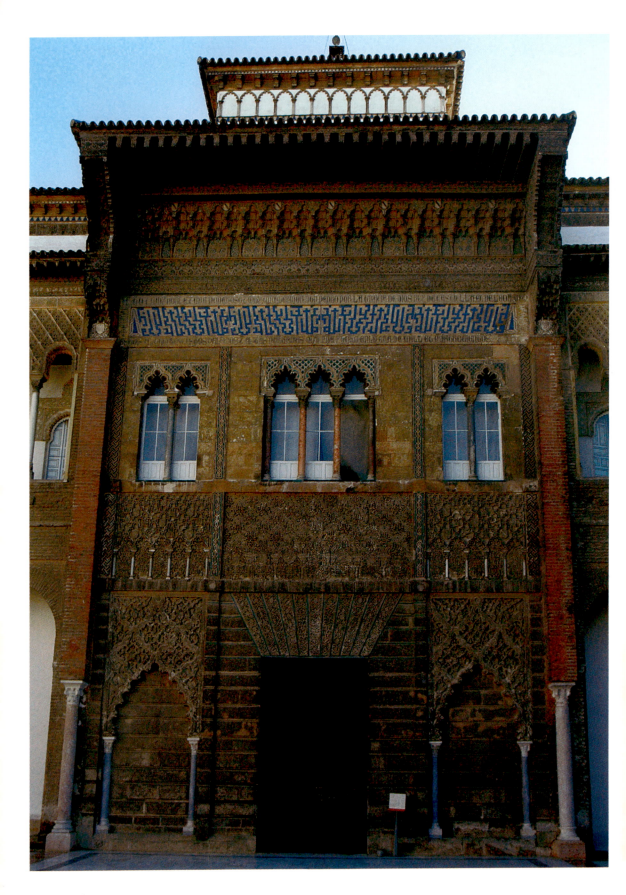

includes the first verses of Saint John's Gospel as well as extracts from Psalm 53. Biblical language creates a structural parallel to a Quranic text. The text in question is the one that greeted visitors to the Hall of the Ambassadors at the Alhambra: an introductory formula and five verses of sura 113, called "Daybreak."

> In the name of God the Compassionate the Caring;
> Say I seek refuge in the lord of the daybreak;
> From the evil of what he created;
> From the evil of the dark as it spreads;
> From the evil of those who cast their breath on knots;
> From the evil of an envier's envy.

The five verses from Saint John at the Alcazar echo the cadence of the inscription of the Nasrid doorway. And the imagery of an all-powerful God, creator of all things who balances the forces of dark and light, is mirrored here as well:

> In the beginning was the Word: and the Word was with God: and the Word was God;
> The same was in the beginning with God;
> All things were made by him: and without him was made nothing that was made;
> In him was life: and the life was the light of men.
> And the light shineth in darkness: and the darkness did not comprehend it.

Sebka

Sebka is a pattern that grows from the intertwining multilobed arches of Umayyad and Taifa architecture, which expand to fill the entire space of the wall above them. Tamer than the caliphal interlacing arches, sebka can begin at the base of a panel or wall with tiny columns launching interlacing arches, but they are then regularized into a pattern, locked within a rectangular field Still, sebka flirts maliciously with architectural forms to present multivalent realities in space and time. On a flat wall of the Alcazar at Seville, a blind arcade of columns, capitals, and arches intertwine impossibly, suspending the viewer in a world between two and three dimensions, tiny patterned descendants of those within the Great Mosque of Cordoba. But the field above the arches dissolves into a flat screen of rhomboids laid out across the wall like fish scales patterned with tiny carved arabesques, a design that links the synagogue of Samuel Halevi with the palaces of Peter the Cruel and the Alhambra palace of Muhammad V.

Minaret of the Great Mosque of Seville.

opposite:
Alcazar of Seville, Montería façade, 1364–1366.

Alcazar of Seville, door into the Hall of the Ambassadors, 1364–1366.

The texts from Psalm 53, which also appear on the door of the Hall of the Ambassadors of the Alcazar, seem to attempt a Christian recreation, a kind of reactive adaptation of the use, on buildings throughout Islamic world, of the *Fatiha*, the opening chapter of the Quran. Here it is the meaning, rather than the appearance of the text, that is reflected in the Alcazar. A portion of the *Fatiha* reads:

> Master of the day of reckoning
> To you we turn to worship
> and to you we turn in time of need
> Guide us along the road straight
> The road of those to whom you are giving
> not those with anger upon them
> not those who have lost the way

Trans. Michael Sells

Its reflections, scattered in Castilian inscriptions over the inner door of the Hall of the Ambassadors of the Alcazar of Seville, use Psalm 53 to focus on the same themes of the straight path and God as the master of the day of reckoning:

> All have gone astray; all alike are perverse. Not one does what is right, not even one. Will these evildoers never learn? They devour my people as they devour bread; they do not call upon God.
>
> They have good reason to fear, though now they do not fear. For God will certainly scatter the bones of the godless. They will surely be put to shame, for God has rejected them.

<center>✳</center>

The act of taking that which is shared and renting it, forcefully separating plants long grafted, roots held in common and intertwined, is a violent one. The courts of Peter I and Muhammad V were alive, and constantly transforming, each in the mirror of the other— so that even statements of separateness and domination bear the unmistakable marks of complicity, and of desire. Muhammad V seized on the death of his old ally to create mythic frontiers through the stage set of the Alhambra, acting out a ceremonial opposition to an "infidel," who was in fact a ruler with whom he had been personally and culturally enmeshed for his entire political life. That opposition is remote, and constructed; the artistic language of domination and sovereignty found its most immediate reflections not in struggles between "faithful" and "infidel" but in internal struggles for power among those of the same religious and political group.

In turn, Peter exploited the very concept of absolute, unquestioned monarchy imbricated in the Nasrid palace. In those buildings, in the words of Puerta Vílchez, an "iconography of historical and terrestrial power is displayed through the idea of divine power of the ruler."[15] It was far from just a style or motif; it was a language of form conceived to support an absolute monarchy and a centralized state. Ruiz Souza has shown us how Peter's dialogue with Muhammad answered the desires of a king attempting to integrate power into what would become the nation-state of Spain.[16] Imagine the power of this unquestioned image of cosmic kingship contained not in words but in an architectural language for Peter, and how serviceable it must have seemed in the face of his dissenting nobles and homicidal half brother. The Alhambra's high ceilings and lofty proportions, the king's throne beneath a muqarnas dome, with all its implications of divine power, provided Peter with meanings he needed in the true crisis of his leadership, which, like Muhammad's, was fraternal rather than religious.

Nasrid palatine style had become one with Castilian identity. Indeed, Peter's half brother Henry II scrupulously adopted his brother's artistic language two years after killing him, in the most crucial of political monuments. In the old Great Mosque of Cordoba, still being used as the cathedral of the city, Henry redecorated a Castilian funerary chapel with ataurique and a muqarnas dome. The palatine style was no longer merely Peter's: it was

The savage battles between the forces of Peter the Cruel and his half brother, Henry II of Trastámara, caused widespread destruction of the fortifications of Toledo. Peter's greatest contribution to the built fabric of the city were the repairs Archbishop Tenorio (1375–1399) made to the city after Peter's death. He rebuilt the castle of San Servando, the bridge of San Martín, and the old Bab Muawiya, a principal entry to the city from the north, which became the door now called the Puerta del Sol. Its keel-shaped arch, alfiz embracing interlacing arches, repeats the entry to churches like Santiago de Arrabal and Santa Leocadia, a triumphal entry arch wrought in a profoundly Toledan language.

clockwise:

San Martín Bridge in Toledo, 14th century.

Santiago de Arrabal in Toledo, 13th century.

Puerta del Sol in Toledo, 14th century.

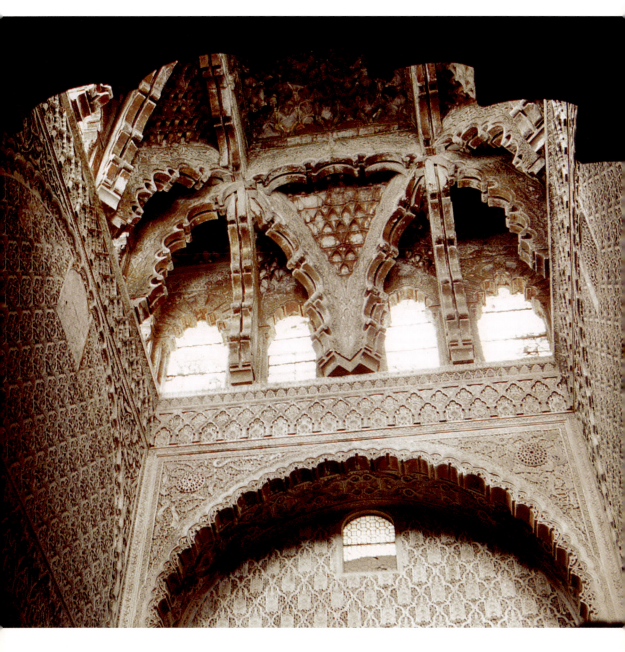

now Castile's. It was the culmination of thousands
of interactions, social and intimate, artistic and lit-
erary, cruel and compassionate, that marked the

**Great Mosque of Cordoba, royal chapel, also known
as the chapel of San Fernando, built by Henry II of
Trastámara in 1371.**

formation of Castilian identity since 1085. Peter the Cruel's court style is the product of a
common culture, in which meanings as well as motifs and craftsmen cross political and
religious borders; in which they all—artistic styles, typologies, iconographies, and the
people who made them—transform and mutate until their Christian, Jewish, or Muslim
origins, their beginnings and their ends, their ultimate realities intertwine like arabesques,
until they can no longer be disentangled.

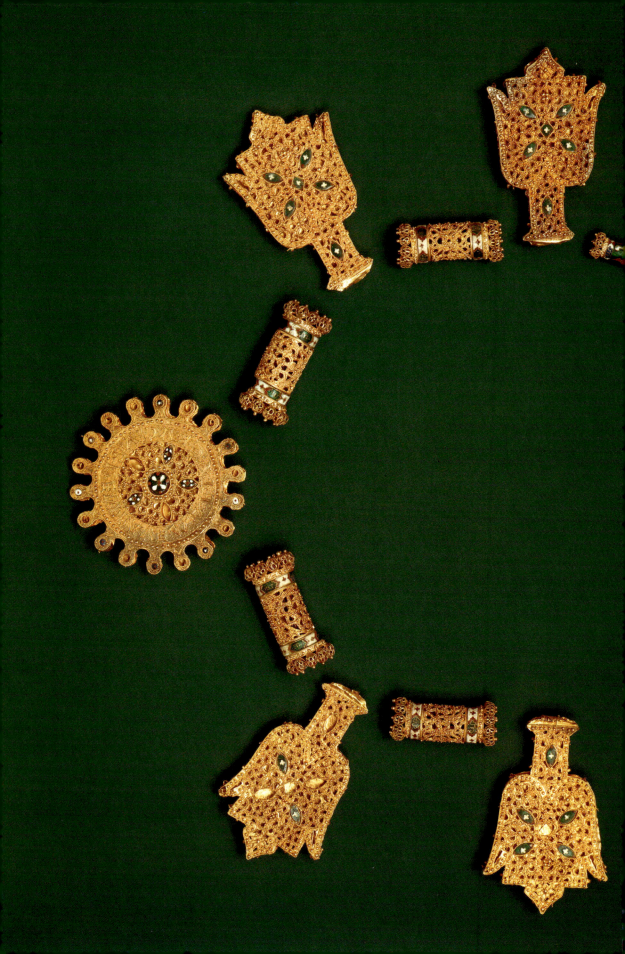

Postscript: Intimacy Betrayed

> . . . the love we hide,
> the love that gives us away.
> —Ibn Zaydun, "Nuniyya"

On the eve of their taking possession of Granada, in 1491, the Catholic kings Ferdinand and Isabella signed capitulation agreements with Muhammad XII, last of the Nasrids, known as Boabdil. These agreements in many ways followed centuries-old Castilian traditions: the Muslims of Granada were promised the right to "live in their own religion," and the new rulers would "not permit that their mosques be taken from them, nor their minarets nor their muezzins, nor . . . interfere with the pious foundations or endowments which they have for such purposes, nor . . . disturb the uses and customs which they observe." Those who decided to leave the newly Castilian territories were to be allowed free passage out, but those who chose to stay would do so on the same kind of terms of freedom of worship and self-governance for religious minorities that had first been established on the Iberian Peninsula in 711 by Muslims. Even in judicial matters, "the Moors shall be judged in their laws and law suits according to the code of the *sharia* [Islamic law] which it is their custom to respect, under the jurisdiction of their judges and *qadis*."[1] Traditional Castilian terms of capitulation, these were nevertheless soon abandoned.

Castilians had been granting such terms to newly acquired Muslim subjects for some four centuries, the conditions for the accommodation of Muslims into Christian society that had been established when Alfonso VI had taken the Taifa of Toledo in 1085. On one level these dhimma-like terms—alien to most of the rest of medieval Christendom—had provided some measure of political and legal infrastructure for social conditions that in turn begat the particularly hybrid culture of Castile, by retaining a religiously plural population, and the social and cultural conventions that each group nurtured and shared. But the Castilians' demography was doubly complex, for it also subsumed the layered Christian populations left from the Islamic kingdoms the Castilians had overcome. Religious plurality meant not just Muslims and Jews, but Arabized Christians, who were more difficult to exclude from the new social and political institutions of expanding Castile, and who thus brought their Arabized culture to the heart of the Christian kingdom. In the end,

Filigree necklace, late 15th or early 16th century. Metropolitan Museum of Art, New York.

the Arabization of Castile probably owed as much to new Mozarabic populations—the products of the dhimma under earlier Islamic rules—as it did to new Mudejares.

Of course, the Castilians' agreements were neither consistently respected nor always abided in good faith, if at all: over the centuries the Castilians had broken such promises as easily as they had made them, beginning with the usurpation of the Great Mosque of Toledo in 1086. But neither the dubious question of purity of intention nor that of righteousness or consistency in the highly variable practice of protecting those communities should cloud our vision of the cultural landscape that evolved over four formative centuries. The interactions that transformed all parties, that created new identities and roles for every actor in the urban drama, required neither good will nor a notion of equality, but only the proximity dictated by expediency.

The continued presence in the peninsula of both Muslim populations within Castile and Islamic kingdoms of various sorts provided an ongoing source of vital political, and thus cultural, engagement. What lies behind 1492 is not so much the history of an implacable opposition but rather a tense shuffle of convenient alliances and warfare, of alternating compliance and confrontation, in which the players became known to each other, at times despite themselves. The culmination of the Christian-Muslim competition for territory and political control vividly evoked by 1492 is thus the end not only of the struggle but also of centuries of ongoing renovation of often intimate ties to the rich world of Islamic and Arabic intellectual and artistic practices. The monuments of medieval Castilian culture inherited by the Catholic kings—from the very language of the Castilian empire, created by Alfonso X and his translators out of Arabic itself, to the palaces of Seville, with their Arabic writing in praise of the Christian monarch—speak loudly to an identity forged out of cultural praxis rather than ideological purity.

✳

In the summer of 1492, after the conquest of Granada and the edict expelling the Jews from Spain, and months before Columbus and his men left the port of Palos, Antonio de Nebrija wrote the first grammar of a European vernacular language. In the preface, with its dedication to Queen Isabella, Nebrija recognizes the centrality of a language of culture to the enterprise of empire, and honors Alfonso X, and his translations from both Latin and Arabic, as the progenitors of Castilian. This *Gramática de la lengua castellana* decisively establishes Castilian as Spanish, the successor-language to those of the empires that, in the peninsula, had been united and defined by Latin, and then Arabic. But neither Latin nor Arabic had yet lost its place in that still self-consciously complex culture. Nebrija was himself a humanist who wrote nearly everything else in his prolific outpouring in Latin. And Arabic was still tacitly understood as part of the Castilian repertoire: when Columbus and his men made landfall in a place called Cubanacán—what we came to call Cuba—they sent an official translator inland to find the Great Khan they believed ruled these Asian "Indies." That translator and diplomat was Luís de Torres, who traveled with Columbus's company as an intermediary and interpreter. Torres was a Jew who, like countless others,

had become a converso, or forced convert, as the price for remaining a part of Spain. In November of 1492 it was in Arabic that he held the first official diplomatic exchanges with the Tainos of Cuba. In the arts, too, the distinct traces of the hybrid medieval past were still visible, interwoven into the distinctive Castilian identity. A lady in Isabella's court might well have worn a gold necklace of filigree, fashioned in a style common to Nasrid craftsmen, like the one today displayed in the Metropolitan Museum. Its central medallion reads "Ave Maria Gratia Plena": the words the angel Gabriel used to address the Virgin Mary in the Annunciation. But that medallion is framed by four stylized hands of Fatima, good luck symbols, meant to ward off evil, assimilated from Islamic tradition and named for Muhammad's daughter. The hands are abstracted almost beyond recognition and they do not hold the authority of the Latin. Along with the style of the necklace, they were a part of the experience that had slipped into the cultural subconscious.

Thus, while the appropriation of monuments in the fifteenth and sixteenth centuries might have the same ambivalent meanings as in earlier centuries of conquest, those meanings are now far more deeply shrouded, nearly impossible to read within the prevailing ideology of purity. In 1523 a tall domed church rose from the center of the broad furrows of the hypostyle hall of the Great Mosque of Cordoba, which had served as the cathedral of the city since its conquest by Ferdinand III in the thirteenth century. This new cathedral inscribed within the mosque building was constructed by the architect Hernán Ruiz and his descendants at the behest of the canons of Cordoba, and after vigorous opposition of the city council, which had resisted any alteration of the original form of the mosque-turned-cathedral. A tall, stubby nave clings to the roofs of the long aisles, culminating in a dome that created an unmistakably Christian profile, like the dome of the cathedral of Loarre that had Catholicized its frontier castle in the eleventh century, for those who saw it from afar.

The new church at Cordoba is also triumphal, and in that way it reaches across three and a half centuries, to Santa Cruz in Toledo. The cathedral of Cordoba in fact is a kind of inversion of the creation of the church of Santa Cruz from the little mosque of Bab al-Mardum. Here in sixteenth-century Cordoba there is no continuation of the mosque's decorative traditions as there was in Toledo, nor of the more recent Castilian style of the thirteenth and fourteenth centuries that had adhered closely to Islamic convention. Instead, the architectural vocabulary is now punctiliously Gothic and classical: Gothic tracery, Corinthian orders, and visceral figural sculpture cover every inch of the interior of this addition to the mosque-cathedral. Even so, this church that was intended to unambiguously Christianize the mosque and to muster all of its seductive imagery to the single meaning of trophy and spoil of war nevertheless carries the recessive gene of its own alloyed past. The sculpture and ornament of its interior, along with the abstract patterning of its Gothic tracery and the horror vacui—the overall surface pattern created by its sculpture and decoration—suggest habits of thinking that favor abstract patterning and skins of complex, meditative ornamentation. While there are very few motifs that can be credibly related to Islamic roots, the whole system of decoration, the overall taste for the

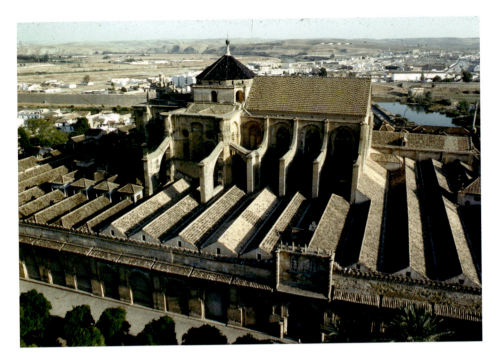

Great Mosque and cathedral of Cordoba. Additions made by the Hernán Ruiz family between 1523 and 1599, under Archbishop Alfonso Manríquez, were against the wishes of the Toledo town council and its mayor.

Great Mosque and cathedral of Cordoba, interior.

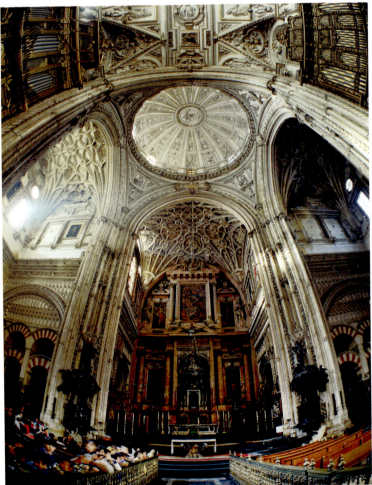

structure of its ornament, speaks as a silent gesture, and betrays a seven-century intimacy with Islam.

By the end of the fifteenth century there is a dramatic parting of the ways, and a tear in the fabric of our historical memory, that takes place in the historical moment for which the shorthand is 1492. Although it could perhaps more accurately be dated to 1369, the year that Peter of Castile was murdered by his Trastámara half brother, or to 1391, the year that widespread pogroms not only decimated the Jewish population but triggered widespread conversions to Christianity of many of the Jews who survived, it is of course 1492 that has pride of place in the historical imagination and in the communal memory. This is a memory shared, ironically, by the Christians and Muslims and Jews who before that parting of the ways shared a homeland, and broad swaths of culture. This is a crossroads in both history and its memory mostly defined in the going forward: into a Spain that would be dramatically delineated and colored by the expulsions of the Jews, in that same year; by the betrayal of those capitulation promises of religious and cultural protection for the Muslims, who would not be definitively expelled until 1614; and by that intervening century of often brutal effort to redefine Castilian—now Spanish—identity as something purely Christian in blood, belief, and cultural habit.

That new forging of Spanish identity in the early modern period can be remembered from myriad perspectives. One is the poignant and tragic perspective of those expelled—and those who remained behind as conversos, Jewish converts, and Moriscos, as the Mudejares and Muslim converts came to be known. Another is the triumphant and nationalistic perspective of the Spanish empire, seen as giving birth to the flourishing of literary and artistic culture of the sixteenth and seventeenth centuries, a chapter nearly universally known as the *siglo de oro* or golden age. That identity has sometimes—although not often—been remembered from the paradoxical perspective that tragedy and triumph here are somehow interconnected, that much of the outpouring of brilliant culture of the golden age was the result, direct or indirect, of the violent paroxysms involved in so dramatically redefining just who Spaniards were, and who they were not. This was an exercise in denying a remarkable medieval past.

In the creation of a new Spanish identity in the sixteenth century it was not just Muslims and Jews who were betrayed. The expulsion of the Jews, the reneging on the promises of the capitulation agreements of 1491, the stripping of the rights of Muslims, also eviscerated an ancient Castilian way of life, economy, and culture. The Castilians had betrayed themselves. What difference does it make to remember the Castilian culture that precedes 1492 in a way that more fully takes into account its fundamentally hybrid and multilingual nature? Restoring this memory makes us understand the ways a culture can betray itself, its own history and legacy. Recalibrating the past that lies behind 1492 extends beyond the contested question of Spain's own heritage, even as it was pivotal in transforming Europe through its provocative embrace of Arabic culture. The history of medieval Castile provides us with the rich story of our own modern world in the making, with many of our modern aesthetic and philosophical sensibilities uncannily on display.

Chronology

5th–6th cent. Byzantines, Basques, Visigoths, and Suevi settle the formerly Roman province of Hispania

569–586 Reign of King Leovigild; restoration of a unified Visigothic monarchy

570–632 Life of the Prophet Muhammad

580 Arian Synod of Toledo underlines differences between Arians and Catholics

589 Third Council of Toledo; formal conversion of the Visigothic kingdom to Catholicism

600– or 601–636 Isidore is bishop of Seville, compiles a universal encyclopedia as well as a history of Hispania, and encourages the establishment of seminaries in all of Hispania's cathedral cities

610 Muhammad's first revelations

622 Hijra, the flight from Mecca to Medina, and the first year in the Islamic calendar

632–661 Reign of the first four caliphs following the death of Muhammad: Abu Bakr (632–634), Umar (634–644), Uthman (644–656), and Ali (656–661)

649–672 Reign of Visigothic king Recceswinth, who constructs San Juan de Baños in the tradition of Roman Christian basilicas, with distinctive horseshoe-arched arcades

661 Muawiya, a member of the Umayyad family, establishes the caliphate at Damascus

672–680 Reign of King Wamba; archbishopric is established in Toledo

687–691 Caliph Abd al-Malik begins construction of the Dome of the Rock and the first al-Aqsa mosque in Jerusalem

708 Musa ibn Nusayr, Umayyad governor of North Africa, occupies Tangier

709–715 Construction of the Great Mosque of Damascus and renovation of the al-Aqsa mosque under Caliph al-Walid ibn Abd al-Malik

710–711 Roderic is proclaimed king of the Visigoths in a battle of succession with Akhila, son of Witiza (r. 702–710)

April 711 Berber army chief Tariq ibn Ziyad crosses the strait eventually named after him (Jabal Tariq; Gibraltar) with an army allied with Akhila; Roderic is defeated

711–720 Muslim conquests throughout peninsula

732 Emir Abd al-Rahman al-Ghafiqi, after sacking Bordeaux, is engaged by Charles Martel near Tours

750 Umayyad caliphate of Damascus is overthrown by the Abbasids; Abd al-Rahman, the sole survivor of the Umayyad royal family, escapes to the west

756 Abd al-Rahman I arrives in Cordoba and declares himself emir

756–929 Umayyad emirate of Cordoba

778 Charlemagne's expedition against Saragossa, followed by the battle of Roncesvalles

780 Abd al-Rahman I begins construction of the Great Mosque of Cordoba

late 8th cent. Use of Indian numerals is adopted at the Abbasid court of al-Mansur

late 8th cent.–early 9th cent. Discovery of the relics of Saint James in Galicia, which begin to attract pilgrims from all over Europe

9th cent. First tower minarets appear in Iberia

822 Ziryab, a court musician of the Abbasids in Baghdad, travels west to Iberia and becomes a staple of Abd al-Rahman II's Cordoban court, to which he introduces countless cultural innovations

833–852 Abd al-Rahman II expands the Great Mosque of Cordoba

850–859 Mozarab martyr movement in Cordoba, condemned by bishops in 852

866–910 Reign of Alfonso III of León, who consolidates Asturias, Galicia, and León into one kingdom, and fosters the idea of León as successor to the Visigothic kingdom

882 The bodies of the Mozarab martyrs of Cordoba are received in León by Alfonso III

late 9th–mid-10th cent. Foundation of Mozarabic monasteries across León, including San Pedro de Cardeña, San Cebrián de Mazote, San Miguel de Celanova, and Santiago de Peñalba

c. 900–950 The artist Maius produces his illustrated version of the 8th-century Commentary on the Book of the Apocalypse by Beatus, now known as the Morgan Beatus

905–925 Reign of Sancho I Garcés of Navarre, who expands the territories of Navarre in battles against the Umayyads

913 Foundation of San Miguel de Escalada in León

924 Abd al-Rahman III sacks Pamplona, capital of Navarre, temporarily reversing the advances of Sancho I Garcés

929 Abd al-Rahman III, previously emir, becomes the first caliph in Cordoba

929–1031 Umayyad caliphate of Cordoba

934 San Pedro de Cardeña is destroyed by Umayyad troops

935 Rebuilding of San Pedro de Cardeña begins

936 Construction of the palace city of Madinat al-Zahra begins under Abd al-Rahman III

939 Ramiro II of León defeats Abd al-Rahman III in the battle of Simancas

953 Mozarab Recemund, also known as Rabi ibn Zayd, serves as caliph Abd al-Rahman III's ambassador to Holy Roman emperor Otto I; upon his return, he is named bishop of Elvira, and later leads diplomatic missions to Byzantium and Jerusalem, as well as authoring manuscripts in both Arabic and Latin

958 Abd al-Rahman III has recuperated all lost territories

958 Sancho the Fat, king of León, makes a pilgrimage to Cordoba

961–976 Al-Hakam II follows his father, Abd al-Rahman III, in inviting poets, artists, mathematicians, and astronomers to court; he amasses an enviable library

962–966 Al-Hakam II builds additions to Great Mosque of Cordoba

967–970 Gerbert of Aurillac travels in the Crown of Aragon, studying mathematics and astronomy in Vic or Ripoll

981 Muhammad ibn Abi Amir, vizier of the young caliph Hisham II, takes the caliphal title al-Mansur, "the Victorious"

c. 987 The vizier al-Mansur expands the Great Mosque of Cordoba eight aisles to the east, nearly doubling its size

992 Sancho Abarca, king of Navarre, concludes a peace treaty with al-Mansur, offering the caliph his daughter in marriage

994–1064 Life of Ibn Hazm

994–1091 Life of the Umayyad princess Wallada

997 Al-Mansur sacks Santiago de Compostela; the bells of the church are brought to Cordoba

997–1074 Life of Ibn al-Wafid

999 The mosque of Ibn al-Hadidi, known as Bab al-Mardum, is built in Toledo

999 Gerbert becomes Pope Sylvester II

late 10th–early 11th cent. "Glosas Emilianenses" are produced at San Millán de la Cogolla

1000–1035 Reign of Sancho the Great, king of Navarre, who briefly unites León, Castile, Aragon, and Navarre through marriage, family alliances, and conquest; the kingdoms are divided among his sons upon his death

1000–1035 Sancho the Great of Navarre changes pilgrimage route to Santiago de Compostela, builds relationships with Cluny, and restores San Millán de Cogolla and San Juan de la Peña with Romanesque additions

11th cent. Golden age of Andalusian Hebrew poetry

1003–1070 Life of Ibn Zaydun

1009 Madinat al-Zahra is sacked by Berber mercenaries and destroyed

1009–1031 Civil war (fitna) in al-Andalus ends the reign of the Umayyad caliphate

1010 Count Sancho García of Castile aids Berbers in installing Sulayman, a great-grandson of Abd al-Rahman III, as ruler of Cordoba

c. 1025–1035 Benedictine rule is adopted at the monasteries of Oña and Leyre

1029 Muhammad ibn Assafer makes an astrolabe in Toledo

c. 1029 Sancho the Great requests that a Spanish monk from Cluny be appointed abbot of the monastery of San Juan de la Peña

1031–1091 Taifa kingdoms

1032 Marriage of Ferdinand I of Navarre, count of Castile, to Sancha of León; several areas of León pass to Castile as her dowry

1037 Unification of Castile and León after Ferdinand I kills his brother-in-law Bermudo at the battle of Tamarón, though Ferdinand is not crowned as king of Castile and León until 1039

1043 Al-Mamun becomes ruler of Dhu al-Nunid Toledo

1049–1082 Ahmad I, leader of the Banu Hud in Saragossa, builds the Aljafería palace

1054 Ferdinand I kills his elder brother García III of Navarre at the battle of Atapuerca and absorbs Navarre into his territory

1055–1138 Life of Moses ibn Ezra

1063 The body of Isidore of Seville is sent from al-Mutadid's Seville to Ferdinand I's León as part of the city's tribute

1064 Pope Alexander II promotes a crusade to Barbastro, and an army led by William of Montreuil and made up of French, Aragonese, and Catalan troops massacre and sell into slavery the city's Muslim inhabitants; the city is left in the hands of Sancho Ramírez of Aragon

1064 William VIII of Aquitaine and his troops decamp Barbastro, taking back with them across the Pyrenees qiyan, enslaved women singers

1065 Ferdinand I of Castile-León dies, dividing his kingdom among his sons and separating Castile and León once more

1068 Sancho Ramírez I, king of Aragon and cousin of Alfonso VI, goes to Rome to visit the pope, and submits himself as a vassal to Saint Peter

1071 Sancho II of Castile and Alfonso VI of León win the territory of their brother García of Galicia, who flees to al-Mutamid's Seville; shortly thereafter, Alfonso is deposed by Sancho and becomes an exile in al-Mamun's Toledo; Sancho briefly unites all three kingdoms

1071–1127 Life of William IX of Aquitaine

1072 Sancho II is murdered at Zamora; Castile and León are reunified under Alfonso VI; the Cid, Rodrigo Díaz de Vivar, becomes liegeman to Alfonso

1073 Pope Gregory VII tries to mount a crusade in Spain

1074 Alfonso VI and al-Mamun campaign together in Muslim territories in southeastern Spain; Alfonso presides over the Great Council of Santiago de Compostela that establishes Gregorian reforms on the peninsula

1075 Assassination of al-Mamun; his grandson and heir al-Qadir cannot stop Valencia from declaring its independence from the Toledan kingdom

1075 Construction of a Romanesque cathedral at Santiago de Compostela begins under Alfonso VI

c. 1075–1141 Life of Judah Halevi

1077 Alfonso VI of Castile-León begins calling himself *imperator totius Hispaniae*, emperor of all of Spain; he also doubles his yearly donation to the monasteries of Cluny

1078–1160 Life of Ibn Quzman

1079 A coup removes al-Qadir from power; al-Mutawakkil of Badajoz is acknowledged as ruler of Toledo; Alfonso VI marries Constance, daughter of Duke William of Burgundy and niece of Abbot Hugh of Cluny

1080 A council of Castilian bishops and abbots joins Alfonso VI in adopting the Roman liturgy

1081 Alfonso VI has definitively defeated al-Mutawakkil and reinstates al-Qadir as ruler of Toledo; the Cid is exiled by Alfonso and becomes a soldier of fortune

1083 Almoravids capture the North African city of Ceuta, which had been part of the Cordoban caliphate and then a Taifa, perhaps with the assistance of al-Mutamid's navy

1084 Al-Qadir retreats to Valencia, surrendering to Alfonso VI the principality of Toledo

May 1085 Alfonso VI of Castile-León enters Toledo, which becomes the largest city in his realm, and grants different communities their own legal codes; Muslims are governed by a pact, and the Castilians and the Franks are given fueros

1086 al-Mutamid, emir of Seville, summons the Almoravids to help Taifa kings defend against further Christian conquests; Almoravid forces from Morocco arrive in Iberia, defeat Alfonso VI at Zallaqa, and then return to North Africa; the Cid returns to Alfonso's service

1086–1125 Bernard of Sedirac is archbishop of Toledo

1086 Bernard of Sedirac appropriates the Great Mosque of Toledo as its new cathedral

1088 Pope Urban II grants the archbishop of Toledo authority over all of Spain

1088 The Almoravids return to Iberia and besiege the castle of Aledo with the armies of al-Mutamid's Seville, as well as Granada, Murcia, and Almería; the Cid is again exiled, this time for not coming to the aid of the Castilians at Aledo

1090 Almoravid armies return for a third time, this time to attack the Islamic Taifas; al-Mutamid calls on Alfonso VI to help save Seville

1091 Alfonso takes al-Mutamid's former daughter-in-law Princess Zaida as a concubine, in order to ally himself with Seville, which he tries unsuccessfully to defend; the Almoravids depose all the major Taifa kingdoms except Saragossa and Valencia, and make Seville their capital; al-Mutamid of Seville and Abd Allah of Granada are exiled to North Africa

1092 Al-Qadir is beheaded by the chief *qadi* (judge) of Valencia with the support of his subjects; the Almoravids then take the city

1094 The Cid defeats the Almoravids in Cuarte, just outside Valencia, and takes the city, which he rules as independent lord

1094–1104 King Peter I of Aragon unites the kingdoms of Navarre and Aragon

1097–1167 Life of Abraham ibn Ezra

1099 The Cid dies in Valencia

1099 Alfonso VI takes the old cathedral of Santa María de Alficín from the Mozarabs and gives it to the Roman church

1101 Alfonso VI grants Toledo's Mozarabs their own fuero

1102 The Cid's wife, Ximena, has his body taken to the monastery of San Pedro de Cardeña, in León, as the Almoravids burn Valencia

12th cent. Rise of the vernacular European love lyric

1106 Baptism of Petrus Alfonsi following his conversion from Judaism to Christianity

1106–1143 Ali ibn Yusuf is emir of the Almoravids

1107 Death of King Raymond of Burgundy, husband of Urraca of Castile, the daughter of Alfonso VI; their son Alfonso remains in the custody of Diego Gelmírez, bishop of Santiago

1108 Defeat of Alfonso VI's army by the Almoravids at the battle of Ucles; Sancho III, his only male heir, is killed; a Christian mob attacks the Jews of Toledo after the defeat

1109 Marriage of Queen Urraca to King Alfonso the Battler of Aragon; death of Alfonso VI, leaving his daughter Urraca as monarch of Castile

1110 Saragossa is taken by the Almoravids; the Banu Hud flee with their libraries to Rueda de Jalón

c. 1110–c. 1185 Life of Ibn Tufayl

1114 Annulment of the marriage of Alfonso the Battler of Aragon and Queen Urraca

1114–1187 Gerard of Cremona is active as a translator in Toledo

c. 1115–1130 Adelard of Bath translates Euclid, Abu Mashar, and al-Khawarizmi

1116 Queen Urraca gives her son Alfonso authority over lands south of the Duero River, including Toledo, the city of his birth

1117 Alfonso VII, son of Urraca and Raymond of Burgundy, enters Toledo

1118 Alfonso VII is declared king in Toledo; Alfonso the Battler of Aragon and French allies successfully besiege Almoravid Saragossa; Pope Gelasius declares the campaign a crusade

1122 Peter the Venerable is elected abbot of Cluny

1123 Pope Callixtus II allows Catalans to crusade in Valencia

1125–1152 Raymond of Sauvetot is archbishop of Toledo, and becomes the patron of numerous translations from Arabic into Latin

1126 Death of Urraca; Alfonso VII's full assumption of power

1126 Adelard of Bath completes a version of al-Khawarizmi's astronomical tables, translated from the astronomer Maslama of Madrid

1126–1198 Life of Ibn Rushd

c. 1130–1140 Establishment of the military religious orders of the Templars and Hospitalers in the Iberian Peninsula; Alfonso the Battler of Aragon bequeaths his kingdom to military orders, but his will is never enacted

1133–1142 John of Spain translates the *Secretum secretorum* (Secret of Secrets), a mystical text attributed to Aristotle, as well as texts by authors including Ibn Sina, al-Farabi, Ibn Gabirol, al-Khawarizmi, al-Kindi, and Thabit ibn Kurra

1134 Death of Alfonso the Battler of Aragon

1135 Alfonso VII declares himself emperor of all the Spains, after winning Navarre and Aragon

1135–1204 Life of Maimonides

c. 1136–1156 Robert of Ketton is active as a translator at Toledo

1137 Catalonia and Aragon become a united kingdom with the betrothal of Petronilla of Aragon and Ramón Berenguer IV of Barcelona

1140 Sayf al-Dawla, the exiled Saragossan Taifa ruler, is offered land in Toledo; he moves to the city with his family's libraries

1142 San Pedro de Cardeña is given by Alfonso VII to the abbey of Cluny; monks create a new cloister with red and white banded arches, recalling the Great Mosque of Cordoba

1142 Peter the Venerable, abbot of Cluny, meets Herman of Corinthia and Robert of Ketton "in the region of the Ebro"; he commissions Robert to translate the Quran and Herman to translate explanatory documents into Latin; in León, Herman of Corinthia completes his translation of a *Liber generationis Mahumet* (Book of the Life of Muhammad) for Peter the Venerable

1143 Robert of Ketton completes his Latin version of the Quran for Peter the Venerable; the text is delivered with the two tracts against Islam translated by Herman of Corinthia; Robert of Ketton is appointed archdeacon of Pamplona

1145 Robert of Ketton, in Segovia, translates al-Khawarizmi's *Algebra*

1146 Almohads enter al-Andalus

1146 Sayf al-Dawla dies in Toledo

1147 Pope Eugenius III issues a bull declaring that Iberia, along with the Levant and eastern Germany, is a field for crusading

1149 The basilica of San Isidoro in León is dedicated in the presence of Alfonso VIII

1152–1166 John II of Castelmaurum, formerly bishop of Segovia, is archbishop of Toledo

1152–1166 Ibn Daud translates, with Dominicus Gundissalinus, Ibn Sina's *De anima* for Archbishop John of Toledo

1157 Death of Alfonso VII; he divides his empire between his two sons, bequeathing Castile to Sancho III and León to Ferdinand II; Almohads have won nearly all former Almoravid territory and make Seville their capital

1157–1158 Sancho III rules as king of Castile

1158–1214 Reign of Alfonso VIII, son of Sancho III by Blanche of Navarre, king of Castile, orphaned at age two

1162 Ferdinand II of León seizes Toledo and attempts to gain custody of the orphaned king

1165–1240 Life of Ibn Arabi

1166 Alfonso VIII regains Toledo with the help of its Mozarab population and, according to legend, is proclaimed king from the tower of San Román; Alfonso grants a new fuero to the people of Toledo

1169 Alfonso reaches legal adulthood at fifteen and marries Leonor, daughter of Henry II of England and Eleanor of Aquitaine

c. 1175 Gerard of Cremona translates Ptolemy's *Almagest*

1175–1232? Life of Michael Scot

1183 The mosque of Bab al-Mardum is given to the Knights of Saint John, who convert it into the church of Santa Cruz and add an apse

1186 Gonzalo, archbishop of Toledo, consecrates Santa Cruz

1187 Gerard of Cremona dies; his team has translated seventy-one works from the Arabic

1195 Al-Mansur, ruler of the Almohads, arrives in Tarifa and declares holy war; Alfonso VIII of Castile, along with the knights of Santiago, Calatrava, and Alcántara, are defeated in the battle of Alarcos

1195–1197 Almohad attacks on Iberia reach as far north as Madrid; their harsh policies begin to send many Jews and Mozarabs north, spurring the translation activity in Toledo

c. 1196–c. 1264 Life of Gonzalo de Berceo

1198–1250 Reign of Frederick I, king of Sicily, known as Frederick II, king of the Romans from 1212 until his death, and as Holy Roman emperor from 1220 to 1245

1199 Alfonso VIII and his queen, Leonor Plantagenet, construct a royal pantheon at Las Huelgas

early 13th cent. Appearance of the *Libro de Alexandre*

1202 Leonardo Fibonacci publishes a translation of al-Khawarizmi's work on algebra

1204 Alfonso VIII founds the studium at Palencia

1206 The Treaty of Cabreros between Castile and León is written in Castilian only

1209 Rodrigo Jiménez de Rada arrives in Toledo from Burgo de Osma and becomes archbishop

1209 Mark of Toledo, canon at the Toledo cathedral, translates the Quran at the request of the archdeacon of Toledo and Archbishop Rodrigo

1210 Pope Innocent III encourages crusade against the Almohads, and threatens Alfonso IX of León with ecclesiastical sanctions if he continues to ally with the Almohads against the Castilians

1212 An alliance of Christian kings, including Alfonso VIII of Castile, Peter II of Aragon, and Sancho VII of Navarre, defeats the Almohads at the battle of Las Navas de Tolosa

1212? Dramatic presentation of the *Auto de los reyes magos*

1213 Summons to the Fifth Crusade issued by Pope Innocent III

1214 Ferdinand III decrees that only the vernacular should be written in the Castilian chancellery

1221 Birth of Alfonso X in Toledo

1221 The church of San Román in Toledo is consecrated by Archbishop Rodrigo Jiménez de Rada

1226 Rodrigo Jiménez de Rada and Ferdinand III of Castile lay the foundation stone of Toledo's Gothic cathedral

1230–1248 Ferdinand III triumphs over Almohad-controlled cities: Mérida and Badajoz (1230), Cordoba (1236), Valencia (1238), Jaén (1246), Seville (1248)

1230 Reunification of Castile-León under Ferdinand III

1236 Ferdinand III takes Ibn al-Ahmar, founder of the Nasrid dynasty, as a vassal and ally

1243 Rodrigo Jiménez de Rada finishes his *De rebus Hispaniae*, a history of Spain written in Latin

1247 Death of Rodrigo Jiménez de Rada

1247–c. 1300 Life of Todros Abulafia

1248 Alfonso X commissions the translation of an astronomical table using Arabic numbers, including zero, bringing this numerical system to common usage in Latin Europe

c. 1248–1252 Alfonso X undertakes translations from the Arabic adab tradition, producing the *Libro de los animalias que caçan* and *Calila e Dimna*

1250–1280 Composition of the *Cantigas de Santa María*, sponsored by Alfonso and written in Galician-Portuguese

1251–1265 Alfonso X commissions jurists to create a comprehensive legal code, which would be known as the *Siete partidas*

1252 Great Mosque of Seville is converted into a cathedral; Ferdinand III is buried there, in a tomb inscribed with Castilian, Latin, Arabic, and Hebrew

1252–1284 Alfonso X, the Learned, reigns as king of Castile-León and all regions conquered by his father

1264 After widespread Mudejar revolts, in Murcia, James I of Aragon takes the Great Mosque as a cathedral and forces Muslim inhabitants to relocate to the suburb of Arrixaca

1266 James I of Aragon comes to the aid of his son-in-law, Alfonso X, following the uprising of Mudejares in Murcia; together they reconquer the city; the Islamic kingdom of Granada becomes a tributary of Castile

1277 Alfonso X executes his brother Fadrique

1278 Ibn al-Ahmar of Granada appeals to Alfonso X against the Marinids

c. 1280 Last stages of the production of the manuscript of *Estoria de España*, commissioned by Alfonso X and written in the vernacular

1282 Alfonso X asks for aid from Abu Yusuf in fighting against Alfonso's own son, Sancho; he offers the Muslim ruler the Crown of Castile as collateral

1282–1348 Life of Don Juan Manuel

late 1200s–after 1345 Life of Santob de Carrión

1313–1375 Life of Ibn al-Khatib

1324 Don Juan Manuel, nephew of Alfonso X, builds the monastery and church of San Pablo in Peñafiel, on the Duero River

1332–1406 Life of Ibn Khaldun

1333–1354 Reign of Yusuf I, Nasrid ruler, who constructs parts of the Alhambra in Granada

1333–1393 Life of Ibn Zamrak

c. 1335–1340 Don Juan Manuel writes the *Conde Lucanor*

1340 The battle of Río Salado, where King Alfonso XI of Castile and Afonso IV of Portugal definitively defeat the Marinids

1340 Alfonso XI constructs the Hall of Justice at the Alcazar of Seville to commemorate his victory at Río Salado

1350 Peter I begins his reign as king of Castile

1353 Peter begins his construction on the old Almohad palace of the Alcazar of Seville

1354 Muhammad V begins his first reign as Nasrid king of Granada

1357–1360 Construction of Samuel Halevi Abulafia's synagogue in Toledo

1359 Muhammad V is ejected from power in a conspiracy involving his half brother, Ismail II; Muhammad flees to Fez, and eventually to Peter's Seville

1360 or 1361 Samuel Halevi Abulafia is put to death by Peter I

1362 Muhammad V regains power in Granada, with Peter's help

after 1362 Muhammad V's additions to the Alhambra, including renovations of the Comares palace and the Court of the Lions

1364 Ibn Khaldun, working as an envoy for the Nasrids, visits Seville to ratify a peace treaty with the Castilians

1364 Peter I begins an extensive building campaign at the Alcazar of Seville

1369 Peter I is assassinated by his half brother, Henry II of Trastámara; Nasrid victory at the battle of Algeciras against Henry of Trastámara and Castile

1369 Muhammad V recommences construction at the Alhambra

1371 Henry II of Trastámara redecorates a funerary chapel at the Great Mosque of Cordoba with ataurique and a muqarnas dome

1391 Death of Muhammad V

summer 1391 Mobs attack Jewish communities in cities across Iberia; hundreds are killed, and many more convert to Christianity

1469 Marriage of Ferdinand II of Aragon and Isabella of Castile

1479 Unification of Castile and Aragon under the Catholic kings, Ferdinand and Isabella

1483 The Inquisition is organized into a central council with jurisdiction over all of Castile and Aragon; Torquemada is appointed the first inquisitor general

1491 Ferdinand and Isabella sign capitulation agreements with Muhammad XII, last of the Nasrids

1492 Isabella and Ferdinand defeat the kingdom of Granada, the peninsula's last Islamic polity, and expel Jews living in Castile; Columbus and his men hear a last mass at the church of San Jorge Mártir in Palos de la Frontera and set sail for the new world

1492 Appearance of Nebrija's *Gramática de la lengua castellana*, dedicated to Queen Isabella

Genealogies

Cordoban Umayyads with Royal Mothers

Hisham (10th Umayyad caliph in Damascus)
r. 724–743

Muawiya = Rah, Berber

Abd al-Rahman I of Cordoba = Halal
r. 756–788

Hisham I = Khazraf
r. 788–796

al-Hakam I = Halawah
r. 796–822

Abd al-Rahman II = Buhair
r. 822–852

Muhammad I = Ailo, from a northern Christian region
r. 852–886

Al-Mundhir Abd Allah = Durr/Iñiga, daughter of Fortún Garcés of
r. 886–888 r. 888–912 Navarre

Muhammad = Muzna, Basque

Abd al-Rahman III = Murjana
r. 912–961

al-Hakam II = Subh, Navarrese
r. 961–976

Hisham II
r. 976–1013

* Upon the youthful succession of Hisham II to the caliphate, true power lay with his vizier, Ibn Abi Amir, who took the regnal title al-Mansur in 981. Hisham II was a figurehead, and all Umayyad caliphs after him were claimants to the throne without real power. See al-Mansur and his descendants.

Al-Mansur and His Ruling Descendants, Known as the Amirids

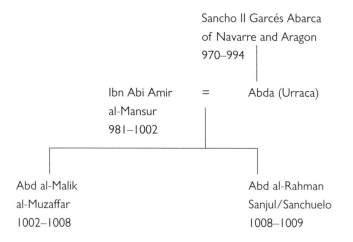

Sancho II Garcés Abarca
of Navarre and Aragon
970–994

Ibn Abi Amir = Abda (Urraca)
al-Mansur
981–1002

Abd al-Malik
al-Muzaffar
1002–1008

Abd al-Rahman
Sanjul/Sanchuelo
1008–1009

Almoravids, 1086–1145

Yusuf Ibn Tashufin 1086–1106
Ali ibn Yusuf 1106–1142
Tashufin ibn Ali 1142–1145

Almohads, 1121–1223

Ibn Tumart 1121–1130
Abd al-Mumin 1130–1163
Abu Yaqub Yusuf I 1163–1184
Abu Yusuf Yaqub al-Mansur 1184–1199
Muhammad al-Nasir 1199–1213
Abu Yaqub Yusuf II 1213–1223

Royal Family of Asturias, León, Castile, and Aragon

Alfonso III the Great
Asturias
866–910

García I
León-Castile
910–914

Ordoño II
Galicia
910–925

Fruela II
Oviedo, Asturias
910–925

Alfonso IV
León
925–930

Ramiro II
León
930–951

Ordoño IV
León
958–960

Ordoño III
León
951–956

Sancho I the Fat
León
956–966

Vermudo II
León
984–999

Ramiro III
León
966–984

Alfonso V
León
999–1028

Sancho III Garcés the Great
Navarre
1000–1035

Vermudo III
León
1028–1037

Sancha = Ferdinand I
Castile
1035–1065

García III
Navarre
1035–1054

Ramiro I
Aragon
1035–1063

Sancho II
Castile
1065–1072

Alfonso VI
León
1065–1109

García
Galicia
1065–1072

Urraca

Sancho I Ramírez
Aragon
1063–1094

Urraca = Raymond of Burgundy
León-Castile
1109–1126

Peter I
Aragon
1094–1104

Alfonso the Battler
Aragon
1104–1134

Ramiro II
Aragon
1134–1137

Alfonso VII
León
1126–1157

Ramón Berenguer IV = Petronilla
Barcelona, Aragon
1131–1162

Sancho III
Castile
1157–1158

Ferdinand II
León
1157–1188

Alfonso II
Aragon
1162–1196

Alfonso VIII
Castile
1158–1214

Henry I
Castile
1214–1217

Berenguela = Alfonso IX
León
1188–1230

Peter II
Aragon
1196–1213

Alfonso II
Provence
1196–1209

Ferdinand III
Castile-León
1217–1252

James I
Aragon
1213–1276

Alfonso X the Learned
Castile-León
1252–1284

Peter III
Aragon
1276–1285

Royal Family of León-Castile, 1217–1379

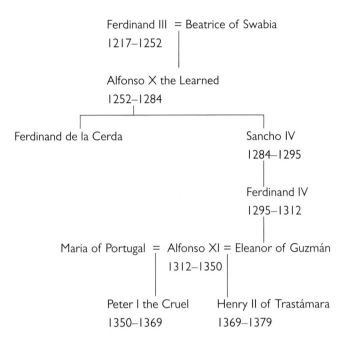

Ferdinand III = Beatrice of Swabia
1217–1252

Alfonso X the Learned
1252–1284

Ferdinand de la Cerda Sancho IV
 1284–1295

 Ferdinand IV
 1295–1312

Maria of Portugal = Alfonso XI = Eleanor of Guzmán
 1312–1350

Peter I the Cruel Henry II of Trastámara
1350–1369 1369–1379

Notes

Palos

1. Said, *Culture and Imperialism*, 332.

Chapter 1 Frontiers

Epigraph from Merwin's *Poem of the Cid*, Castilian text by Ramón Menéndez Pidal.

Arabic text of Treaty of Tudmir from al-Dabbi, *Bughyat al-multamis fi tarikh rijal ahl al-andalus*, 259.

1. Linehan, *History and the Historians*, 53.

2. Eulogius, *Apologeticus martyrum* and Eulogius, *Memoriale sanctorum*, quoted in Colbert, *The Martyrs of Córdoba*, 336 and 221–222 respectively.

3. Wolf, "Eulogius of Cordoba."

4. Jackson, *The Making of Medieval Spain*, 14.

5. Jackson, *The Making of Medieval Spain*, 32.

6. Ruggles, *Gardens, Landscape, and Vision*, 76.

7. Ruggles, "Mothers of a Hybrid Dynasty," 76.

8. Reilly, *The Kingdom of Leon-Castilla under King Alfonso VI*, xi.

Chapter 2 Dowry

Epigraph from the Arabic-to-Spanish translation of Ibn Bassam by Rubiera Mata, *La arquitectura en la literatura árabe*, 167–168.

Arabic text of Ibn Hazm from García Gómez, *al-Shi'r al-andalusi*, ed. Munis, 151.

Arabic text of Abd al-Rahman from Ibn Idhari, *Kitab al-bayan al-mughrib*, 2:60.

1. Quoted in Reilly, *The Kingdom of Leon-Castilla under King Alfonso VI*, 127–128.

2. All quotes here from Wasserstein, *The Rise and Fall of the Party-Kings*, 279–280; his own statement, 282–283.

3. Powers, "Frontier Municipal Baths."

4. Delgado Valero, *Regreso a Tulaytula*, 62.

5. Ruggles, *Gardens, Landscape, and Vision*, 22.

6. Sells, *Desert Tracings*, 3.

7. Adonis, *Introduction to Arab Poetics*, 42.

8. Valdez del Alamo, "The Saint's Capital"; Schapiro, "From Mozarabic to Romanesque."

9. E. J. Burns, *Courtly Love Undressed*, 187.

10. Quoted in Partearroyo, "Almoravid and Almohad Textiles," 105.

11. Partearroyo, in *Al-Andalus*, ed. Dodds, 226.

12. Werckmeister, "The Islamic Rider in the Beatus of Girona."

13. O'Callaghan, *Reconquest and Crusade*, 166–167.

Chapter 3 Others

Epigraph from Burman, *Religious Polemic*, 7.

Occitan text of William of Aquitaine from Kehew, *Lark in the Morning*.

1. Gonzálvez, "The Persistence of the Mozarabic Liturgy," 171.

2. Gonzálvez, "The Persistence of the Mozarabic Liturgy," 172.

3. Quoted in Dodds, *Architecture and Ideology*, 90.

4. Burman, *Religious Polemic*, 16–17.

5. Quoted in Dodds, *Architecture and Ideology*, 67.

6. Burman, *Religious Polemic*, 15 n. 5.

7. Burman, *Religious Polemic*, 15.

8. Quoted in Dodds, *Architecture and Ideology*, 50.

9. Gonzálvez, "The Persistence of the Mozarabic Liturgy," 169–171.

10. Linehan, *History and the Historians*, 217–218.

11. Linehan, *History and the Historians*, 210.

12. Linehan, *History and the Historians*, 218.

13. Linehan, *History and the Historians*, 181.

14. J. Mann, "A New Architecture," 239, 245.

15. Moralejo Alvarez, "On the Road," 175.

16. J. Mann, "San Pedro at the Castle of Loarre," esp. 172–183 and 195–200.

17. Williams, "León: The Iconography of a Capital," 248–251.

18. Reilly, *Kingdom of Leon-Castilla under King Alfonso VI*, 83–84.

19. Quoted in O'Callaghan, *History of Medieval Spain*, 201.

20. Quoted in O'Callaghan, "The Integration of Christian Spain into Europe," in *Santiago, Saint-Denis, and Saint Peter*, ed. Reilly, 107.

21. Quoted in O'Callaghan, *History of Medieval Spain*, 203.

22. Reilly, *Kingdom of Leon-Castilla under King Alfonso VI*, 114.

23. O'Callaghan, *History of Medieval Spain*, 203.

24. O'Callaghan, *History of Medieval Spain*, 197.

25. Quoted in Barton and Fletcher, *The World of El Cid*, 87.

Chapter 4 Union

Arabic text of epigraph from González Palencia, *Los mozárabes de Toledo*, no. 141.

Spanish text of Bécquer from *Historia de los templos de España*, ed. Arboleda.

Hebrew texts of Halevi and Abulafia courtesy of Peter Cole.

Arabic text of al-Mutamid from García Gómez, *Las jarchas romances*, no. 26.

1. Calvo Capilla, "Reflexiones," 338.

2. Calvo Capilla, "La mezquita de Bab al-Mardum," 299–330.

3. Document discovered by Calvo Capilla ("La mezquita de Bab al-Mardum," 324–326).

4. Calvo Capilla, "La mezquita de Bab al-Mardum," 300.

5. T. Martin, "The Art of a Reigning Queen," 1151.

6. Castro, *The Spaniards*, 472; Glick and Pi-Sunyer, "Acculturation"; Lourie, "The Confraternity," 159–161.

7. Glick and Pi-Sunyer, "Acculturation," 152.

8. Calvo Capilla, "La mezquita de Bab al-Mardum," 309–310.

9. Quoted in Delgado Valero, "Iglesia de San Salvador," in *Arquitecturas de Toledo*, 301.

10. Pérez Higuera, in *Arquitecturas de Toledo*, 71.

11. Delgado Valero, "Iglesia de San Sebastián," in *Arquitecturas de Toledo*, 243.

12. Ibn Khaldun, *Muqaddimah*, trans. Rosenthal, 458.

13. Quoted in Rosen, "Muwashshah," 166.

14. Raizman, "The Church of Santa Cruz."

15. Grabar, "The Crusades and the Development of Islamic Art," 242–243.

Chapter 5 Babel

Epigraph from Lawrance, http://www.art.man.ac.uk/SPANISH/ug/documents/AUTRRMAG_002.pdf.

1. Vann, "The Town Council of Toledo."

2. Abad Castro, *La iglesia de San Román*, fig. 2 and pp. 20–21.

3. Rallo Gruss, *Aportaciones*, 251.

4. Linehan, *History and the Historians*, 344; Hernández, "Language and Cultural Identity," 39–41.

5. Quoted in Pick, "Rodrigo Jiménez de Rada," 219.

6. Linehan, "The Toledo Forgeries," 669.

7. *Roderici Ximenii de Rada, Historia De rebus Hispaniae sive Historia Gothica*, ed. Valverde, bk. 8, pt. 3.

8. Quoted in O'Callaghan, *History of Medieval Spain*, 248.

9. D. Smith, "'Soli Hispani'?," 507.

10. Abad Castro, *La iglesia de San Román*, 20.

11. Pick, *Conflict and Coexistence*, 195–196.

12. Pick, *Conflict and Coexistence*, chap. 4.

13. Pick, *Conflict and Coexistence*, 17.

14. Tolan, *Saracens*, 183–184.

15. Quoted in Pick, *Conflict and Coexistence*, 101.

16. Williams, *The Illustrated Beatus*, 1:131.

17. Quoted in D. Smith, "'Soli Hispani'?," 510.

18. *Roderici Ximenii de Rada, Historia De rebus Hispaniae sive Historia Gothica*, ed. Valverde, bk. 1, pt. 1. Brought to our attention by Professor Lucy Pick.

19. Quoted in Barton, "Traitors to the Faith?" 25.

20. *Roderici Ximenii de Rada, Historia De rebus Hispaniae sive Historia Gothica*, ed. Valverde, bk. 6, pt. 24.

21. Harris, "Mosque to Church Conversions."

Chapter 6 Adab

Latin text of epigraph from Galmés de Fuentes, *Romania Arabica*, 158–159.

Castilian texts of Berceo from La *"Vida de San Millán"* and *Los Milagros de Nuestra Señora*, both ed. Dutton.

Castilian text of *Libro de Alexandre* from Cañas ed.

Galician-Portuguese text of Alfonso X from *Cantigas*, ed. Montoya.

1. Quoted in Cómez Ramos, *Arquitectura alfonsi*, 22–23.

2. Haskins, *The Renaissance of the Twelfth Century*, 285.

3. The dictionary of the Real Academia defines trujamán as "persona que aconseja o media en el modo de ejecutar algo, especialmente compras, ventas o cambios" [person who advises or mediates in the act of executing something, especially sales, purchases, or exchanges].

4. Burman, *"Tafsir and Translation,"* 705.

5. Burnett, "The Translating Activity in Medieval Spain," 1038.

6. Quoted in Burnett, *The Introduction of Arabic Learning into England*, 61–62.

7. Gutas, *Greek Thought, Arabic Culture*, 1.

8. Galmés de Fuentes, *Romania Arabica*, 159.

9. *Encyclopaedia of Islam*, 2nd ed., s.v. "Hudids."

10. C. Smith, "The Vernacular," 74.

11. O'Callaghan, *The Learned King*, 104.

Chapter 7 Brothers

Castilian text of Santob de Carrión from *Proverbios morales*, ed. Perry.

Arabic text of Ibn Zamrak adapted from Monroe, *Hispano-Arabic Poetry*, and Grabar, *The Alhambra*.

1. Hebrew text in Cantera Burgos, *Sinagogas de Toledo*, 107–108. Our translation.

2. Cantera Burgos, *Sinagogas de Toledo*, 109–110.

3. Bango Torviso, *Remembering Sepharad*, 147.

4. Ruiz Souza, "Castilla y al-Andalus," 27.

5. Quoted in Harvey, *Islamic Spain*, 214.

6. Adapted from Fernández-Puertas, "Inscripciones poéticas," 159–161.

7. Grabar, *The Alhambra*, 108–128; Fernández-Puertas, *La fachada del palacio de Comares*.

8. Puerta Vílchez, *Los códigos de utopia*, 123.

9. Fernández-Puertas, *La fachada del palacio de Comares*, 29–30.

10. Quoted in Harvey, *Islamic Spain*, 214.

11. Ruggles, "The Alcazar of Seville."

12. Ruiz Souza, "El Patio del Vergel."

13. Ruiz Souza, "El palacio de Comares."

14. Quoted in Ruggles, "The Alcazar of Seville," 91.

15. Puerta Vílchez, *Los códigos de utopia*, 81.

16. Ruiz Souza, "Castilla y al-Andalus," 27.

Postscript

1. Quoted in Harvey, *Islamic Spain*, 316.

Glossary

alfiz: a molding that traces a rectangle around the exterior of an arch, framing it

basmala: the common-use abbreviation of the Quranic *bismillah al-rahman al-rahim*, meaning "in the Name of God, the Merciful, the Compassionate," ubiquitous as an invocation in the Islamic world

caliph: literally, a successor or deputy; the name given to the single ruler of the Islamic community in the Umayyad and Abbasid periods; later used by various claimants to this position

dhimma: the pact that establishes the legal status of Christians and Jews under Muslim rule

dhimmi: Christians and Jews living under the dhimma; covenanted people

emir: governor in an Islamic polity

fitna: disorder; usually refers to a state of civil war

fuero: law code in medieval Castile

hypostyle: a building with multiple supports

jihad: the struggle to reform within an individual or a community, or war in the service of religion

kharja: the final couplet of a *muwashshah*, sung in a vernacular language

madina: a city or the city center

madrasa: an Islamic school of higher learning

mihrab: a niche in the *qibla* wall, indicating the direction of Mecca

Mozarabs: Christians living under Islamic rule in Spain

Mudejars: Muslims living under Christian rule in Spain

Muwallads: indigenous converts to Islam

muwashshah (pl. *muwashshahat*): Andalusian strophic song form in either Arabic or Hebrew that incorporates a vernacular in its final verses, the *kharja*

Peoples of the Book (*ahl al-kitab*): the Islamic term for Christians and Jews, those who have received prophetic scripture from God

qasida: an ode, the classical Arabic form that originated in pre-Islamic Arabia

qibla: the direction of Mecca, toward which all Muslims pray

qiyan (sing. *qayna*): young women trained as professional entertainers, especially as singers

qubba: a centrally planned room, often domed

sahn: courtyard

spolia: literally, the spoils of war, used to describe fragments of a previous building purposely used in a new structure

Taifas (from the Arabic *muluk al-tawaif*): factions; city-states that sprang up following the demise of the Umayyad empire

tiraz: workshop for silk production, often exclusively associated with a royal court; also the name for a fabric with a royal inscription given by the caliph to a favorite

Sources and Readings

Histories and Religions

Throughout our study we have relied on a number of fundamental general histories, some of which are also eminently readable introductions to the subject. "The religious history of the Iberian peninsula in the Middle Ages may be summarised," Richard Fletcher tells us in his highly readable *Moorish Spain*, "as the persistent and wilful failure of two faiths and cultures to make any sustained attempt to understand one another. Human enough; pretty bleak. The trouble with such a judgement is that historians in making it have to rely on the testimony of those who could write. For most of the period . . . that meant a small intellectual elite. Intellectuals are not renowned for their grasp of everyday reality, nor for cheerfulness and optimism. Judgements might have been rosier if one had found oneself spending the Easter vigil at a Mudejar pop concert in the local cathedral; or downing a few bottles of Valdepeñas with like-minded Muslim pals at one of Toledo's monastic wine-bars" (174–175). This accessible volume provides an overview of the history and culture of Islamic Spain in less than two hundred pages. Fletcher, whose recent tragic death cut his life of scholarship short, and saddened all who knew him, understood the difficulty of approaching the history of Islamic Spain given that the sources provide such an incomplete sketch of what life might actually have been like.

Joseph O'Callaghan, whom we have cited throughout the book, is particularly erudite in his works about Alfonso X, and has written the indispensable *History of Medieval Spain*, a useful introduction in its own right and one of our constant sources. J. N. Hillgarth's two-volume *Spanish Kingdoms, 1250–1516* is one of the major reference works for this period. Bernard F. Reilly's many books on León-Castile, to which we return later in this essay, are by far and away the best sources in English for the complex history of those kingdoms. His *Contest of Christian and Muslim Spain*, among his more general works, provides an excellent overview of the pivotal eleventh and twelfth centuries. Reilly is also the author of *The Medieval Spains*, arguably the best overall introduction available for the general reader, going from the Visigoths to the marriage of Ferdinand and Isabella. Pierre Guichard, writing originally in French, compiled a rather conventional general history called *Al-Andalus: 711–1492*, which was subsequently translated into Spanish and published in a lavishly illustrated edition, *De la expansión árabe a la reconquista: Esplendor y fragilidad de al-Andalus*.

Gabriel Jackson's deceptively slim volume, *The Making of Medieval Spain*, intended for general consumption, also surprises with original material and revelatory analysis. Teofilo Ruiz is another valuable historian whose focus is social history in the great tradition of

Jacques Le Goff and the *Annales* school; his most recent book-length contribution, *From Heaven to Earth*, sheds much light on the overall processes of vernacularization and secularization. Especially valuable are his chapters on the adoption of the vernacular and its impact on various forms of legal documentation, and on the role of kingship, definitively construed, from the time of Alfonso VI, as secular, in sharp contrast to other European monarchies. One of the leading scholars on the social and military history of medieval Spain, Angus MacKay offers a concise yet richly detailed narrative in *Spain in the Middle Ages*, which is divided into two parts: "The Age of the Frontier" and "From Frontier to Empire." Despite his focus on military history and the impact of the shifting frontiers of the "reconquest," MacKay also examines "processes of cultural change," including the relationship between the larger political tribulations and the translations of the twelfth century. MacKay views the late medieval period as an experiment in the formation of governmental, social, and economic institutions that constituted the extended ancien régime of Spanish politics from the fourteenth to the nineteenth century.

Thomas Glick has contributed several important works, including his 1979 *Islamic and Christian Spain in the Early Middle Ages* (now revised and expanded, in a 2005 Brill edition, incorporating the considerable scholarship published since the 1970s, which he characterizes as a "scholarly revolution") and his 1995 *From Muslim Fortress to Christian Castle*. The seven-hundred-odd pages of Peter Linehan's substantial book, *History and the Historians of Medieval Spain*, explore the nuances of medieval Spanish history and historiography. Both impeccably researched and eruditely witty, his information and jokes alike are splendidly suited for those already familiar with material, though they might be more difficult to comprehend for relative novices: "Properly brought-up house guests murmur appreciatively when their hosts invite them to admire their prized possessions, and Raimundo (who because he was archbishop of Toledo cannot have been lacking in courtesy) was presumably as little disposed to raise questions with Abbot Suger regarding the Passio S. Eugenii as he was liable by the merest movement of his semi-naturalized Spanish eyebrow to register the slightest trace of surprise on being informed that Saint-Denis was the capital of France, no less" (274–275).

Broad and synthetic histories written in Spain are almost inescapably involved in the powerful and competing orbits of Claudio Sánchez Albornoz and Américo Castro. The extended body of historical writings by Sánchez Albornoz—whose most fundamental work is certainly *España, un enigma histórico*, also available in an English translation—and Castro—whose training was as a literary scholar and whose masterpieces, such as *La realidad histórica de España*, are really works of historiography rather than historical narrative—were both shaped by and then in turn strongly shaped the historical and national identity crises of Spain that might be seen as beginning in 1898, with the loss of Spain's last colonies, Cuba and the Philippines. Their competing visions of medieval Spanish history are not ultimately separable from much larger, and often searing, national debates about the nature of Spain itself, and the Spanish character. Both the general and the scholarly reader can profit greatly from James T. Monroe's outstanding *Islam and the Arabs in Spanish Scholarship:*

Sixteenth Century to the Present. Although written in 1970, this intellectual history remains the best source for understanding the complex issues at stake in twentieth-century writing about medieval Spanish history, which inevitably takes place in the context of Spaniards' complex relationship with their medieval and especially Islamic past.

Histories in the post-Castro-Sánchez Albornoz era have been principally regional, but among the notable overviews and surveys published in Spain, and that can be consulted with profit, we note Luis García de Valdeavellano's *Historia de España: De los orígenes a la baja edad media.* Following on the work of his predecessors, Sánchez Albornoz and Hilda Grassoti, Valdeavellano provides a minutely detailed study of medieval Spain that remains an indispensable resource to those interested in the development of its social and institutional life. The last "libro" of this vast work, book 5, deals with our period (912–1212), the rise of the Cordoban caliphate and the kingdom of León; the foundations of the early agricultural economy; the rise of the nobility, magnates, counts, and other aspects of the class structure; the first political assemblies of "curias"; the legal system of fueros, or customary laws governing northern Castile; the counts of Castile and the beginning of the reconquest, and so forth. Most of all, his work gives a full picture of Islamic and Christian political and social developments from the rise of Abd al-Rahman III as caliph to the Berber invasions and the battle of Las Navas while providing parallel narratives of the rise of the Christian kingdoms. This is a work primarily for those already familiar with Spanish medieval history who wish to deepen their understanding of the basic changes that resulted from economic, social, and political shifts from one generation of Christian-Muslim conflict and coexistence to the next.

There is also the excellent *Epoca medieval* by José Angel García de Cortázar y Ruiz de Aguirre, which is volume 2 of the series *Historia de España alfaguara.* García de Cortázar y Ruiz de Aguirre manages an overview of Spanish medieval history covering the entire period from the Visigoths to the late fifteenth century, all within five hundred pages or so— a remarkable work of synthesis. It contains an extensive chapter on what is termed a "segundo estado español: la monarquía arabigoespañola de los omeyas" (second Spanish state: the Hispano-Arabic monarchy of the Umayyads), but the book focuses primarily on social and political history of the "sociedad hispanocristiana" (Hispano-Christian society) and implies a clear distinction between these "two Spains." *La península en la edad media* by José-Luis Martín is another overview, this one by a historian who in 1986 also wrote a small biography of Sánchez Albornoz (which, he confesses in the preface, he chose over the opportunity to write a biography of Alfonso X, in the same series).

Originally published between 1952 and 1959, Ferran Soldevila's *Historia de España* is an attempt to bridge the gap between what the prologue calls "castellanocentrismo" (Castilian centrism) and its opposite, the "fragmentación que destruye la visión del conjunto" (fragmentation that destroys the vision of the whole). Soldevila incorporates, to a greater extent, Catalan and Portuguese history. Each chapter presents the development of Spanish history as a series of conflicts and resolutions between Christian and Muslim lands, and among Christian kingdoms: for example, chapter 5, "La invasión musulmana

y el nacimiento de los pueblos hispanos"; chapter 6, "El esplendor califal y el crecimiento de los núcleos cristianos." This work is more accessible than Valdeavellano but more comprehensive than García de Cortázar y Ruiz de Aguirre, and directs the reader to the principal historical sources for further study.

Representing an extraordinarily wide range of approaches, the volume resulting from the quincentennial conference in Granada in 1991 and edited by Salma Khadra Jayyusi as *The Legacy of Muslim Spain* provides information on almost every specialized topic relating to Islamic Spain—from culinary culture to mysticism, hydraulic technology to the "linguistic interference between Arabic and the Romance languages"—as well as extended encyclopedic essays, including an immensely useful political history from 711 to 1492 by Mahmoud Makki. The more recent basic reference book *Medieval Iberia*, edited by E. Michael Gerli, interprets its subject broadly and is thus a distinctive and welcome break from many older such reference books within which "medieval Spain" tout simple meant Christian Spain; Gerli's entries do not neglect Arabic and Hebrew sources and topics.

Primary sources from this period from Latin and Arabic, as well as the vernaculars, are listed below. In addition, for the general reader there are two highly useful sources of primary documents available with English translations: Olivia Remie Constable's *Medieval Iberia: Readings from Christian, Muslim, and Jewish Sources*, and Colin Smith, Charles Melville, and Ahmad Ubaydli's three-volume *Christians and Moors in Spain*. Constable's collection brings together translations (which include informative introductory notes and references) from Latin, Arabic, Hebrew, Castilian, Catalan, Aljamiado, Portuguese, and even Italian, covering the full expanse from Isidore of Seville to Columbus. *Christians and Moors in Spain* is made up of two volumes of texts translated from Latin by Smith, covering the years 711–1150 and 1195–1614 respectively. The third volume is dedicated to texts translated from Arabic by Melville and Ubaydli, covering the period from 711 to 1501. All three volumes include transcriptions of the original texts on pages facing the translations.

<p style="text-align:center">✳</p>

For our short review of peninsular and Castilian history before 1085 we have depended both on the venerable general histories that form the backbone of the study of medieval Spain, and on more focused works. For the Visigoths, there is nothing like the erudite, dizzying, analytic account in Linehan's *History and the Historians of Medieval Spain*, but one will understand their history better by first reading E. A. Thompson's *Goths in Spain*. See also José Orlandis's *Historia del reino visigodo español*, P. D. King's *Law and Society in the Visigothic Kingdom*, and of course the studies of the legendary Claudio Sánchez Albornoz, two of which are particularly important for our purposes here: *Ruina y extinción del municipio romano en España e instituciones que le reemplazan* and his 1946 article "El aula regia y las asambleas políticas de los godos."

The study of the history of the caliphate in Cordoba was established by Evariste Lévi-Provençal with his monumental *Histoire de l'Espagne musulmane, 711–1031* and drawn into the present day by David Wasserstein in his *Caliphate in the West* as well as by Rachel Arié in her *España musulmana (siglos VIII–XV)*, part of the larger series *Historia de España* edited by Manuel

Tuñón de Lara. The conquest is chronicled by Roger Collins in *The Arab Conquest of Spain*, 710–797, and Janina Safran examines its literary representations in "From Alien Terrain to the Abode of Islam: Landscapes in the Conquest of al-Andalus." *The Second Umayyad Caliphate*, Safran's analysis of Umayyad Cordoba, is both a profound look at Umayyad political culture and a study of the complexity of Umayyad identity, a volume that thus complements Gabriel Martinez-Gros's now classic *Idéologie Omeyyade*. That complex identity of the Umayyads is also highlighted in D. Fairchild Ruggles, "Mothers of a Hybrid Dynasty: Race, Genealogy, and Acculturation in al-Andalus," which discusses the northern Christian-born mothers of many Umayyad caliphs and from which our genealogy is adapted. In *Islamic and Christian Spain in the Early Middle Ages* Glick has intricately and ingeniously traced the interactions in technology, agriculture, and cultural forms that accompanied the establishment of the caliphate and in the years that followed. For transformations in economy and trade, Olivia Remie Constable's *Trade and Traders in Muslim Spain: The Commercial Realignment of the Iberian Peninsula, 900–1500* is extremely valuable. Peter Scales has chronicled the demise of the Umayyad state in *The Fall of the Caliphate of Córdoba*.

Concerning the Mozarabs in al-Andalus and the martyrs of Cordoba, our primary references are Kenneth Baxter Wolf's *Christian Martyrs in Muslim Spain* and his "Christian Views of Islam in Early Medieval Spain," in the volume *Medieval Christian Perceptions of Islam* edited by John Tolan. Tolan is also the author of an especially illuminating study that includes the Mozarab martyrs, part of his recent highly accessible book *Saracens: Islam in the Medieval European Imagination*. In the Jayyusi volume, see "The Mozarabs: Worthy Bearers of Islamic Culture" by Margarita López Gómez, as well as the two-part article on the Mozarabs by H. D. Miller and Hanna Kassis in *The Literature of al-Andalus*, the *Cambridge History of Arabic Literature* volume edited by María Rosa Menocal, Raymond Scheindlin, and Michael Sells (hereafter cited as *CHAL*). All of these build on the foundational study of Isidro de las Cagigas, *Los mozárabes*. Thomas Burman's *Religious Polemic and the Intellectual History of the Mozarabs, c. 1050–1200* deepens our vision of their assimilation of Arabic culture. Richard Bulliet's *Conversion to Islam in the Medieval Period: An Essay in Quantitative History* is the now classic source of the "conversion curve" that reveals the leaps and bounds of conversions from Christianity to Islam from the eighth through the tenth century, and in doing so offers important data about the conversion of Mozarabs and its relationship to a changing political economy.

An understanding of the formation of the kingdom of Asturias begins with Roger Collins's *Arab Conquest of Spain* and *Early Medieval Spain: Unity in Diversity*. Because the first Christian kingdoms in the north, as a historiographical problem, have long carried the weight of signifying the origins of the sixteenth-century Christian nation-state of Spain, early studies struggled with the extent to which the notion of Visigothic revival and reconquest had shaped early Spanish identity; see, for example, Sánchez Albornoz in his three-volume *Orígenes de la nación española: Estudios críticos sobre la historia del reino de Asturias*. Among the issues of contention are the degree to which the revival of an "Ordo Gothorum Obetensium regnum" described in chronicles composed a century later is anything like a fair description of the Oviedo of Alfonso II or, instead, a reflection of the preoccupation of Alfonso III and

later Leonese kings. For this, see especially Kenneth Baxter Wolf, *Conquerors and Chroniclers of Early Medieval Spain*, and Jan Prelog in the preface to his critical edition of the *Chronicle of Alfonso III*. "In view of recent work on the 9th century sources and what may have happened to them in the 11th and 12th, can anything be regarded as certain or sacred?" is the haunting question asked by Linehan in this maelstrom. "Was the very notion of survival after 711 conceivable where there had been no existence before. . . . Was the ruler who established himself in the remote north also the successor of the last of the Visigothic rulers of Toledo?" (*History and the Historians*, 80–81). More directly to the point is Reilly: "Surely nothing in the organization of the Christian church of Asturias over the next three centuries will remotely resemble that of the Visigothic Kingdom. As for the new Asturian monarchy, it is fundamentally distinct from that of the Visigoths " (*Medieval Spains*, 76).

The depopulation and repopulation of the Duero basin is another key issue for this period, one that seeps into issues of cultural identity as well. On the extent of the depopulation of the Duero basin, see the classic studies by the two towering scholars, Claudio Sánchez Albornoz's *Despoblación y repoblación del valle del Duero* and Ramón Menéndez Pidal's "Repoblación y tradición en la cuenca del Duero." See also Salvador de Moxó's *Repoblación y sociedad en la España cristiana medieval*, as well as Linehan's reexamination of the subject, with his questioning of the romantic and nationalist strains that have survived in this argument (*History and the Historians*, 109–110). José María Mínguez Fernández has demonstrated the persistence of Muslim settlement from the eighth and ninth centuries in the Duero basin, thus cautioning us from assuming that the Mozarabs were the only source for Arabic place-names and vocabulary in the north, and making our vision of the surviving society there far more textured and diverse.

Finally, for the problems inherent in interpreting documents as the center of the Asturo-Leonese kingdom moved from Oviedo to León, see, of course, Linehan, who has dedicated a full chapter of his *History and the Historians* to the question, "Oviedo to Leon." See also Sánchez Albornoz's study "Sede regia y solio real en el reino asturoleonés," as well as *Historia urbana de León y Castilla en la edad media* by Jean Gautier Dalché and "La historiografía hispana desde la invasion árabe hasta el año 1000" by Manuel C. Díaz y Díaz.

Sancho the Great's relationship to Cluny is now recognized as more subtle and complex than depicted by Américo Castro, who accused the Cluniacs of wanting to create a "second Holy Land" in Spain in which they "could create a kingdom like that of Jerusalem . . . the Napoleon of that time was that abbot of abbots, Hugh of Cluny" (*Spaniards*, 433). See especially Carmen Orcástegui Gros and Esteban Sarasa Sánchez, *Sancho Garcés el Mayor* (1004–1035): *Rey de Navarra*, and Charles J. Bishko, "Fernando I y los orígenes de la alianza castellano-leonesa con Cluny." "As historians of other parts of Europe well know, the wide umbrella of 'reform' sheltered all manner of improbable reformers, and was as leaky as it was wide,'" Linehan reminds us in his inimitable way (*History and the Historians*, 182). For the extended history of Cluny, the Gregorian papacy, and Castile under Ferdinand and Alfonso VI, see Reilly, both in his *Kingdom of Leon-Castilla under King Alfonso VI* and in his "Chancery of Alfonso VI" in the extremely useful conference volume he edited, *Santiago,*

Saint-Denis, and Saint Peter, as well as Bishko's study and Linehan, in *History and the Historians*. And Simon Barton's dense, intriguing *Aristocracy in Twelfth-Century León and Castile* reminds us how far we must still go to understand the workings of secular society in the face of a world largely chronicled by churchmen.

For the history of the Taifa kingdoms of the eleventh century, Wasserstein's *Rise and Fall of the Party-Kings* is the essential source. For the history of the changing of the guard in Toledo, we depended especially on the fundamental framework of events revealed in the extended work of Reilly, both his most general and accessible works (*The Medieval Spains*) as well as the more specialized series of books on the history of Castile. For the complex chronology of the events leading to Alfonso's taking of Toledo, we have relied particularly on *The Contest of Christian and Muslim Spain: 1031–1157* and *The Kingdom of Leon-Castilla under King Alfonso VI*, in which Reilly pithily characterizes the final chapter in this legendary conquest as "a charade and an anti-climax" (170). O'Callaghan is the other indispensable historian of the political and military complexities of the time and place, and his 1975 one-volume history is an invaluable resource. More recently, his 2003 *Reconquest and Crusade in Medieval Spain* focuses on both the ideology and practical realities of the warfare of the peninsula. And finally, we are indebted to Linehan's exquisite sense of the different agendas involved in the layers of historical writing, in particular as regards the dense and endlessly revelatory *History and the Historians*.

On the Taifa of Toledo an unusual but useful source is Julio Porres Martín Cleto's *Historia de Tulaytula*, with considerable emphasis on the material realities of the city in its last years as an Islamic polity and on the transition—what made it and what didn't—to Christian rule. Also somewhat idiosyncratic is the openly apologetic Catholic vision of *La reconquista de Toledo por Alfonso VI* by José Miranda Calvo, which presents a decidedly sympathetic view of Alfonso's imperial (and dhimma-like) politics, as well as a reasonably even-handed view of the conflict between Mozarabs and Castilians in the aftermath of the Castilian takeover. *Tolède, XIIe–XIIIe: Musulmans, chrétiens et juifs; Le savoir et la tolérance* is an excellent collection of high-level scholarly articles covering virtually every facet of Toledo's culture, edited and with an elegant introduction by Louis Cardaillac. (A Spanish version of this book appeared a year after the original French publication of 1991.) A fine overview of Toledo and its conquest is also embedded in chapter 9 of Michel Terrasse's 2001 *Islam et Occident méditerranéen: De la conquête aux Ottomans*.

We are all indebted to the studies of Juan Francisco Rivera Recio, especially *La iglesia de Toledo en el siglo XII* and "La fundación de la iglesia de Toledo trás la conquista," in *El arzobispo de Toledo Don Bernardo de Cluny (1086–1124)*. Miguel Angel Ladero Quesada has interpreted documents to give us important overviews of Mudejar life in Castile; see especially "La population mudéjar, état de la question et documentation chrétienne en Castille," and *Los mudéjares de Castilla y otros estudios de historia medieval andaluza*. For Jewish life in Toledo, we depended in particular on Pilar León Tello, in her *Judíos de Toledo*, and Porres Martín Cleto, "Los barrios judíos de Toledo," in *Simposio 'Toledo Judaico.'* Of interest to a general reader is Angel González Palencia's *Mozárabes de Toledo en los siglos XII y XIII*.

Though the Almoravids and Almohads became more tolerant of art and philosophy once settled in their palaces in al-Andalus, they insisted, as Bernard Reilly writes, "on fundamentalist religious orthodoxy among Muslims, and were sometimes guilty of persecution, exile, and even judicial murder of religious deviants from it. If anything, the record of the Muwahhid [Almohads] is worse, in that they were also much less tolerant of the other 'people of the book.' However much they might patronize the Muslim artist or thinker, it is indisputable that they bore the responsibility for the increasing emigration of Mozarabs and Jews from Andalucia which resulted from their harsher policies. The loss of variety in cultural and intellectual life that ensued must be laid at their door" (*Contest*, 233–234). Above and beyond the considerable material available in the general histories of Spain already discussed, thorough and generally accessible sources for the Almoravids and Almohads include *Los almorávides* by Jacinto Bosch Vilá (with a foreword and updated bibliography by Emilio Molina López in the updated 1998 edition) and two relatively recent books by María Jesús Viguera, *El retroceso territorial de al-Andalus: Almorávides y almohades, siglos XI al XIII* and *Los reinos de taifas y las invasiones magrebíes (al-Andalus del XI al XIII)*. See also the extensive work by Vincent Lagardère, above all, *Les Almoravides: Le djihad andalou (1106–1143)*.

On the charismatic, influential, and highly complex character of Rodrigo Jiménez de Rada, we are deeply indebted to Lucy Pick and Peter Linehan. Pick's *Conflict and Coexistence: Archbishop Rodrigo and the Muslims and Jews of Medieval Spain* is an exciting new reading of the archbishop's attitude toward Muslims and Jews. In its analysis of Rodrigo's subtle negotiation of reconquest and assimilation, it helped shape a good deal of our argument concerning the archbishop and took us deeply into his reign. We also profited enormously from Pick's "Rodrigo Jiménez de Rada and the Jews: Pragmatism and Patronage in Thirteenth-Century Toledo," which provides an especially helpful bibliography of both primary and secondary sources, as well as extensive translations from Rodrigo's vast *Historia De rebus Hispaniae sive Historia Gothica*. Pick is interested in exploring the seeming contradictions in Rodrigo's historical persona as it is traditionally featured in histories—which can be seen as exemplary of the apparent contradictions throughout Castilian culture—and especially how a number of the texts of religious polemic served "to stabilize relations between Christians and others by defining the position of each group in relationship with the other. Firmly outlining the contours of belief and disbelief allowed Christians to permit themselves to live alongside non-Christians" (*Conflict*, 3).

Linehan's incomparably rich exposition in *History and the Historians* reveals the ways in which Rodrigo shaped the telling of all later versions of the conquest of Toledo and its aftermath, and is especially illuminating on the vital process of Castilianizing Toledo. See in particular chapters 10 and 11, and Linehan's 1988 article "The Toledo Forgeries c. 1150–c. 1300." A complementary view of the essential "Spanishness" of Muslims and Jews, in the eyes of Rodrigo, is ably developed in "'Sarazenen' als Spanier? Muslime und kastilisch-neogotische Gemeinschaft bei Rodrigo Jiménez de Rada," by Wolfram Drews. Like Linehan and Pick, Drews argues for a more complex view of Rodrigo, focusing on Rodrigo's clear distinction between the Muslims of Spain and those from elsewhere. Also supportive of a

general vision of the project of Castilianization (and its particularities) is Diego Catalán's book on the *Estoria de España*, a rich collection of that scholar's many contributions to the study of the historiography of the Alfonsine era.

The encyclopedic volume of H. Salvador Martínez, *Alfonso X, el Sabio*, has laid out Alfonso's years in Murcia, interweaving history with the education of the young prince. See also Juan Torres Fontes, "Los mudéjares murcianos en el siglo XIII" and "La cultura murciana en el reinado de Alfonso X." O'Callaghan, in his invaluable *Alfonso X and the "Cantigas de Santa Maria": A Poetic Biography*, makes a fascinating close reading of many of the cantigas as a way of understanding the history of Alfonso X. For further bibliography on most of these issues of the Alfonsine period and the king's work, see the Languages and Literatures section of this essay, below.

L. P. Harvey's *Islamic Spain, 1250–1500* was for us a decisive source for both the history of the Nasrids and the interaction of Muhammad V with Peter I of Castile. Harvey treats the history of Mudejar communities with the same depth that he treats the master political narrative, and that makes a history more revealing and complex than any other; we are grateful to have been able to work with and cite his translation of the capitulation agreements signed at the end of 1491. Concerning Muhammad V, we consulted the invaluable Arié, *L'Espagne musulmane au temps des Nasrides (1232–1492)*, as well as Ladero Quesada's *Granada: Historia de un país islámico (1232–1571)*, which offers an insightful analysis of the interactions between the Castilian and Nasrid rulers. An important historical and political argument about the nature of Nasrid patronage and rule is found in the acute interpretation of José Miguel Puerta Vílchez, both in his *Códigos de utopía de la Alhambra de Granada* and in his more recent *Historia del pensamiento estético árabe: Al-Andalus y la estética árabe clásica*. For Peter, see also Luis Vicente Díaz Martín's *Pedro I, 1350–1369* as well as the provocative study by Julio Valdeón Baruque, *Pedro I, el Cruel y Enrique de Trastámara: ¿La primera guerra civil española?* Valdeón Baruque makes the case for a major tear in the fabric of Spanish society—akin to that of the civil war of 1939—during the years of warfare between Peter and Henry. An elucidating psychological portrait of Peter is found in "Pedro the Cruel: Portrait of a Royal Failure," by Andrew Villalon; of particular interest for the identity of Peter's court is Abdesselam Cheddadi's "A propos d'une ambassade d'Ibn Khaldun auprès Pierre le Cruel."

The idea that Peter might have been attracted to the unquestioned sovereignty that radiated from Nasrid kingship, and the relationship of that development to the genesis of Spain as a nation-state we take from Juan Carlos Ruiz Souza's wonderful 2004 "Castilla y al-Andalus: Arquitecturas aljamiadas y otros grados de asimilación." Ruiz Souza has also guided us to recent studies concerning the formation of the modern state, including Adeline Rucquoi's *Génesis medieval del estado moderno: Castilla y Navarra (1250–1370)*, José Manuel Nieto Soria's *Iglesia y génesis del estado moderno en Castilla (1369–1480)*, and Gautier Dalché's "L'historie castillane dans la première moitié du XIVe siècle." Finally, to understand the particular context of Seville, we used Bosch Vilá's *Historia de Sevilla: La Sevilla islámica, 711–1248*, as well as Rafael Valencia's useful "Islamic Seville: Its Political, Social, and Cultural History."

The best general history of the Crown of Aragon is Thomas Bisson's *Medieval Crown of*

Aragon: A Short History, which covers the rise of the counts and the long reign of James the Conqueror (1213–1276), a political and literary giant of this period. Bisson eloquently phrases the politically and culturally autonomous Catalonia as "the Normandy of the late medieval Mediterranean. She did not give her name to the confederation. She was content to leave the Crown to others" (4). The other great synthesis of Aragonese history is José María Lacarra's *Aragón en el pasado*, which Bisson considered a "masterly sketch."

<p style="text-align:center">✴</p>

The term "reconquest" has come under much-merited scrutiny in the past decades. "The Reconquest has been depicted," O'Callaghan tells us, "as a war to eject the Muslims, who were regarded as intruders wrongfully occupying territory that by right belonged to the Christians" (*Reconquest*, 3). Consider its uses in scholarship: many medieval writers and certain contemporary writers subscribe to the notion of a "Christian" entitlement to the land, and examine the history of Christian expansion in that light. Other contemporary scholars, although not necessarily themselves invested in the ideology of reconquest, assume that medieval Spanish Christians ascribed that meaning to the large part of their warfare against Islamic states. Finally, there are those who view each instance of warfare between Christian rulers and Islamic adversaries as the product of a unique convergence of circumstances, among which commitment to reconquest at times figured either as a heartfelt ideology or as a Machiavellian strategy. Thus scholars like Jocelyn Hillgarth and Bernard Reilly put "reconquista" or "reconquest" in quotation marks, a pattern we follow here.

Though confessional right to the peninsula appears in literature as early as the ninth century as part of an aspiration to effect the renewal of Visigothic rule over the entire land, it cannot be seen as the beginning of a continuous peninsular war to recover "Christian" territories culminating in the taking of Granada in 1492. The renewal of Visigothic Spain would be a leitmotif for legitimizing Castilian warfare throughout the Middle Ages, but in the eleventh century only the Navarrese managed to unite most Christian monarchs and thus create even the illusion of a united Visigothic renewal. On the whole, the actual nature of warfare in the eleventh century (as opposed to the spin) did not reflect a "reconquista" but rather the submission of Taifa states to vassalage and their exploitation for tribute, points made authoritatively in Wasserstein's indispensable *Rise and Fall of the Party-Kings*. Other helpful discussions on the topic of reconquest and crusade include B. W. Wheeler, "Conflict in the Mediterranean before the First Crusade: The Reconquest of Spain before 1095," in the useful *History of the Crusades: The First Hundred Years*, as well as *The Reconquest of Spain*, by Derek Lomax. More recently the discussion has been taken up by O'Callaghan in *Reconquest and Crusade in Medieval Spain* as well as by Reilly in *The Contest of Christian and Muslim Spain* and by Richard Fletcher in "Reconquest and Crusade in Spain c. 1050–1150." See also, in *A History of the Crusades: The Fourteenth and Fifteenth Centuries*, Charles Bishko, "The Spanish and Portuguese Reconquest, 1095–1492," as well as José Goñi Gaztambide's *Historia de la bula de la cruzada en España*.

There is evidence that the very word "reconquista" began to be used not in Spain but in France, and that it does not appear in Spanish sources of the eleventh century or earlier (Wasserstein, *Rise*, 273). With the term came the idea that such warfare ought to be fought beneath the cloak of religious authority, a concept that subsumed earlier ideas of Visigothic renewal. "Reconquest" in the eleventh century thus comes to approach "crusade" in its meaning, though crusades were only those expeditions specifically authorized by the pope, in which indulgences were offered to participants (O'Callaghan, *Reconquest*, 20). "The language of the Reconquista is the language of the reformed papacy," Damian Smith reminds us in his article "'Soli Hispani'? Innocent III and Las Navas de Tolosa," and the transformation of warfare in Spain into an international crusade that pitted Christians against Muslims in a mythic bipolar opposition has a great deal to do with the intervention of the Gregorian papacy in affairs on the Iberian Peninsula after the second half of the eleventh century.

O'Callaghan sees the idea of crusade, the product of papal intervention in Spain, as supplanting and incorporating "reconquest." He makes a close study of papal strategies, and is able to demonstrate that the crusades in the Holy Land and the crusade on the Iberian Peninsula were simultaneous and related. In the twelfth and thirteenth centuries, crusades were more easily focused on Almoravids and Almohads, who were seen as different from Spanish Muslims, and more easily polarized, an idea also discussed in Wolfram Drews's article on Rodrigo and the archbishop's attitudes about different groups of Muslims. For some rulers, identification with the sacred mandate of "reconquest" was as important as the acquisition of land and cities; Alfonso I "the Battler" clearly fits this bill, a pious warrior who, upon his death, would leave his kingdom to the military orders of the Hospital and the Temple.

But there were more selective uses of the advantages of crusade, and arguably most extraordinary among these is the case of Alfonso X's crusade against the Muslims of the Marinid state in Morocco, newly led by emir Abu Yusuf ibn al-Haqq. It was a military expedition with sound defensive motives, for Alfonso needed to defuse the power of the growing North African state in order to deter its launching an invasion against his territories to the south. It was also, though, proclaimed an official crusade: Pope Innocent IV not only agreed to offer plenary indulgences to those taking the crusader's oath to fight with Alfonso but transferred the vows of Holy Land crusaders who wished to join him. And yet the mythic polarization of Muslims within the discourse of crusade disappeared for Alfonso X by 1282, when he forged an alliance with Abu Yusuf against his own son, Sancho II, and borrowed one hundred thousand dinars from his old enemy. As security for the loan, Alfonso X gave Abu Yusuf—the Marinid ruler against whom he had once led a "crusade"—the Crown of the kingdom of Castile, a prize that would never again return to the Iberian Peninsula. For a more detailed narrative, see O'Callaghan, *The Learned King*.

Clearly life in plural cities like Toledo undermined the ability to create a vilified Islam, or a bipolar opposition between Muslims and Christians. And the very battles celebrated as milestones in the "reconquest" often increased the intimacy that challenged its

central idea. Thus, for instance, the *Cantigas* and the *Siete partidas* show both the Castilian monarchy's need to integrate a lively plural population in Murcia and Seville that reconquest would have them convert or vanquish, and also the ways the consequent interaction was transforming Castilian custom, culture, and law.

Just as the myth of unrelenting and unambivalent Christian "reconquista" is far too monolithic and misleading for medieval Spain, any uniform or unambivalent understanding of *convivencia*, as a state in which Christians, Muslims, and Jews lived together in an atmosphere of harmony and equality, is without credibility. Some of our problem in interpreting the interaction of religious groups in a plural society stems from the projection of our present-day circumstances onto medieval Castile. We often view "equality" as a precondition for tolerance, and assume that fruitful and creative coexistence can only occur in an atmosphere of political détente. But to tolerate, F. E. Peters has pointed out, is literally to bear to abide the other. Peters is an outstanding source of clear and clear-eyed exposition of the relations and dynamics among the three Abrahamic faith communities on whom we have relied; see especially his monumental two-volume *Monotheists: Jews, Christians, and Muslims in Conflict and Competition*. Peters also provides the following introduction about the beginning of the dhimma, which provided the basis for the accommodation of other "Peoples of the Book" from the time of Muhammad on: "In 627 Muhammad and his raiders approached the oasis of Khaybar north of Medina. When he had overcome polytheists, the Prophet offered them no quarter: either they became Muslims or they perished, peremptorily. The dwellers in Khaybar were, however, Jews, many of them in fact refugees from Medina, and Muhammad offered them another alternative. If they submitted without resistance and agreed to pay tribute to the Muslim community, they might remain in possession of their goods and continue to live as Jews. Later and elsewhere Christians capitulated to Muslims arms and were offered the same terms in the name of a shared possession of the 'Book,' that, a genuine revelation" (*Children of Abraham*, 64).

Thus, as we have discussed, the Peoples of the Book who submitted to Muslim rule were offered a pact—the dhimma—in which they agreed to acknowledge the political authority of Islam and to pay a head tax (the jizya; Quran 9:29) in exchange for freedom of worship and specific limitations on activities that might expand the influence of their religion. These limitations varied in divergent times and places, but they could include prohibitions against enlarging places of worship or building new ones without permission; restrictions on public display of worship, attempts to convert Muslims, owning a Muslim slave, or marrying a Muslim woman (which might result in her conversion, or that of her children), though a Muslim man might marry a Christian or Jewish woman. Under the dhimma, Peoples of the Book might adhere to their own laws and traditions in religion and in those customs and social institutions related to religion, such as marriage and divorce. On the Iberian Peninsula, dhimmi might have been prosperous citizens who paid the jizya, worshipped in their own churches, governed themselves to a large extent, and might also have occupied important posts at court, or shared in business and intellectual pursuits as they did under the Umayyads of Cordoba or the Taifa kingdoms. But they might also,

under Almoravid or Almohad rule, have survived insult and alienation, the destruction of churches and synagogues, or persecution that contradicted the terms of the dhimma.

In recent years Américo Castro's influential notion of convivencia—which means, literally, "living together," referring to that coexistence of the three Abrahamic faiths in Iberia rooted in the dhimma—has too often been eviscerated to imply a utopian conflict-free coexistence. In fact, his original understanding was deeply rooted in an explicit appreciation of the superimposed powers of rivalry, fear, and admiration. As Thomas Glick has articulated it in his introduction to the 1992 exhibition catalog coedited with Vivian Mann and Jerrilynn Dodds, convivencia is a coexistence among the three religious communities that "carries connotations of mutual interpenetration and creative influence, even as it also embraces the phenomena of mutual friction, rivalry, and suspicion." Our study is profoundly indebted to Castro's theories and insights, from the most general—that the coexistence of the faith communities in medieval Spain affected and shaped all three of them profoundly, and ultimately created a culture that is the result of that coexistence—to many specifics, perhaps not least his observation that the Castilian practice of allowing Jews and Muslims to live in their territories is "alcoránica." A great deal of Castro's writing was part of an acerbic but productive polemic with his nemesis, Sánchez Albornoz, whose baseline position was that because the relationship among the religions was fundamentally oppositional it was thus not influential or shaping, and that a Spanish national character, which preceded the invasion of 711, was honed during the centuries of reconquest. For a sympathetic account of Sánchez Albornoz and his views, as well as a selection of excerpts from his prolific body of writing, see José-Luis Martín's *Claudio Sánchez-Albornoz*; and for an overview of the polemic between the two scholars—both exiled from their homeland for decades, thanks to the Spanish civil war—see the straightforward 1975 book by José Luis Gómez-Martínez, *Américo Castro y el origen de los españoles: Historia de una polémica*.

In great measure because of the strong reaction among many Spanish intellectuals—not just Sánchez Albornoz—Castro continuously rewrote his ongoing meditation on the nature of Spanish history and culture, in a series of works that were ultimately translated as *The Structure of Spanish History* (originally *La realidad histórica de España*) and *The Spaniards*. Readers may also want to consult some of the smaller pieces that first articulated some of his most provocative views, such as "El enfoque histórico y la no hispanidad de los visigodos" or "Español, palabra extranjera." An invaluable year-by-year detailed list of the complicated Castro bibliography is available in *Américo Castro: The Impact of His Thought*, edited by Ronald Surtz, Jaime Ferrán, and Daniel Testa, a volume that also includes studies by his most prominent and influential students and followers. Castro's books are returning in reprints in Spain, for example, the 2001 edition of the 1948 *España en su historia*, as well as the two volumes that have appeared in a projected six of his "collected works": *El pensamiento de Cervantes y otros estudios cervantinos*, introduced by Julio Rodrígues Puertolas, and *Cervantes y los casticismos españoles*, with a masterful prologue by Francisco Márquez Villanueva. Márquez Villanueva is arguably the most ferocious defender of the legacy of Don Américo, as well as of the use of Mudejar as a literary category (about which more below, under Languages and Literatures).

An excellent recent overview of the state of thinking and scholarship on these closely intertwined questions of tolerance and convivencia, intolerance and reconquista, is Alex Novikoff's article "Between Tolerance and Intolerance in Medieval Spain: An Historiographic Enigma." Novikoff's piece would make a good starting point for someone not already immersed in the field: he provides a succinct and intelligent analysis of the latest trends in this area and explores the enduring fascination with the concepts of tolerance and intolerance despite their obvious inadequacies. Novikoff also provides an in-depth historical overview, pointing out that "the historiography of medieval Spain is as old as medieval Spain itself" (11) but focusing principally on the nineteenth and twentieth centuries, and a fair presentation of the polemic between Sánchez Albornoz and Castro. Glick has also written extensively and usefully about convivencia in *Islamic and Christian Spain in the Early Middle Ages*, where he lays out the critical history of the term, and also discusses the ways in which the Castilian policies regarding Jews and Muslims is both a continuation of the Umayyad dhimma and yet more fragile: "The fact that the *dhimma* contract was a religious obligation upon Muslims provided those relationships with a solidity that the shifting sands of Christian administration and politics could in no way provide, although the *dhimma* model is clear. The Christians borrowed the model but implemented it as civil, not religious law" (7). More recently, in his "Interfaith Scholarly Interaction," Glick provides invaluable insights about interfaith polemics—what they do and don't mean, in terms of relations among the different religious communities—and about the extraordinary and often unappreciated depths of scholarly discourse among intellectuals—scholars, philosophers, translators—from the various communities. On that extensive body of interfaith debates and dialogues, and what they may or may not tell us about the relations among the faith communities, see also Cary Nederman's *Worlds of Difference*, as well as *Beyond the Persecuting Society*, a volume of essays Nederman coedited with John Laursen.

The existence of the dhimma, or of a state of convivencia, in no way precluded the civil unrest and paranoia that might erupt in the persecution of a minority, as occurred when the reputed misdeeds of Joseph Ibn Naghrela, the Zirids' powerful Jewish vizier, provoked hysteria that culminated in the massacre of Granadan Jews in 1066. But on the whole, Bernard Lewis tells us, in his essential *Jews of Islam*, such massacres "were a rare occurrence in Islamic history. In general, the dhimmis were allowed to practice their religion, pursue their avocations, and live their own lives, so long as they were willing to abide by the rules" (45–46). Thus, even those who incited the massacre of the Granadan Jews were careful in their writings not to contradict their right to live according to the dhimma, as it was a "contract established and sanctified by the Holy Law of Islam" (45). Mark Cohen's landmark *Under Crescent and Cross* explores the advantages for Jews inside a system that explicitly provided for their existence. Under the Umayyad and Taifa kingdoms, the tolerance mandated by the dhimma created restricted conditions of tolerance, within which deep interconfessional exchange—cultural, social, and political—nevertheless occurred. Indeed, it clearly took place at dizzying heights in Granada until 1066, as evi-

denced by the rise of Ibn Naghrela himself: Joseph's father, Samuel Ibn Naghrela, known as Samuel the Nagid, rabbi, statesman, and supreme poet of the age, was a Jew whose family had fled from the chaos of Cordoba to Zirid Granada, where he rose to the rank of vizier and gained sufficient authority to name his own twenty-year-old son his successor. The intensity of cultural interaction is at the heart of another iconic eruption of interfaith violence in al-Andalus: the power of the impact of Arab culture on the Mozarabs of ninth-century Cordoba had inspired the violent rhetoric of voluntary martyrdom among those who resisted cultural transformation and the creeping erosion of the prestige of the church, for which see Dodds's *Architecture and Ideology in Early Medieval Spain*, Jacques Fontaine's "Literatura mozárabe 'extremadura' de la latinidad cristiana antigua," and Kenneth Wolf's *Christian Martyrs in Muslim Spain*.

Sometimes, the greatest peril in interfaith relations—from the point of view of religious authorities—was the miscegenation—sexual as well as cultural—that was always eroding the differences among the communities, and this in turn could be quite threatening and volatile all around. On the many ironies and apparent contradictions stemming from the intimacy of contacts, see also Jonathan Ray's "Beyond Tolerance and Persecution," one of a growing number of studies in recent years that strive to fine-tune and reenergize convivencia, as a term and as a model: "I propose that it was specifically those aspects of medieval convivencia that are most frequently lauded as ideal—that is to say of an open and accepting society—that medieval Hispano-Jewish authorities found to be the most problematic. For Jewish spiritual and communal leaders, at least, the real problem was not the exclusion, but rather its acceptance of Jews . . . Christian and Muslim permissiveness presented these leaders with a [much thornier] problem. How do you prevent the social, economic, and political assimilation into non-Jewish society of the constituent members of your communities? How do you maintain social cohesion, religious identity, and a controllable tax-base, when Jews are allowed to settle outside of their designated quarters, dress like Gentiles, socialize with Gentiles, and even take Gentile lovers?" (4).

The question of intermarriage and miscegenation has also been taken up by David Nirenberg, among the most prominent scholars of the interaction of the three faith communities in Spain, in his characteristically subtle "Love between Muslim and Jew in Medieval Spain." Like Glick's study on "Interfaith Scholarly Interaction," this appears in a volume edited by Harvey Hames and dedicated to Elena Lourie that constitutes a treasure trove of studies on the Mudejares specifically and interfaith relations more generally. Nirenberg's *Communities of Violence* is, arguably, the most important recent study in the arena of how coexistence did, and did not, work. This landmark book reveals the contradiction perhaps most difficult to grasp in the history of the Jewish community's overall well-being in Spain: that it was predicated on ritualized occurrences of communal violence against them. Nirenberg's brilliant contribution to our understanding of the counterintuitive dynamics here is to lay out the "interdependence of violence and tolerance" (7). His other studies are all highly recommended reading; they invariably emphasize the double edges of interfaith relations. Although this kind of legal and social tolerance was restrictive and

did not prevent those eruptions of violence—Nirenberg would say that its success was in part predicated on that violence—it created enough stability and continuity for coexistence, and the social and economic interaction that made exchange and transformation of both parties inevitable. See also the wide range of studies and positions on these issues that appear in *Medieval Spain: Culture, Conflict and Coexistence*, a volume edited by Roger Collins and Anthony Goodman in honor of the historian Angus MacKay. Among the many illuminating essays from which we have profited, we signal particularly that of Collins, who notes that the concept of convivencia should also be applied to the relations among or between opposing groups *within* the faith communities which, as we have endeavored to show, were often the most dangerous rivals; and that of Simon Barton on Christian mercenaries working for Muslims, with its clear-eyed appraisal of the difference between the ideological posturing of "reconquista" and the historical reality: "the search for wealth, status and power, the chief motors of aristocratic behavior down the ages, was always likely to take precedence over religious or ideological considerations" (38).

The place of a religious minority under a Christian ruler on the Iberian Peninsula was considerably more tenuous than that of Islamic polities, principally because while the dhimma had been a religious contract, part of *sharia*, or Islamic canon law, the Christian rulers' pacts were, in contrast, political agreements. When a Castilian ruler allowed Muslims to remain in a conquered city, a Mudejar's position was that of "tributary status," Harvey reminds us in his "Mudejars" article in the Jayyusi volume, and their protection was only as secure as the local fueros or terms of capitulation negotiated by their previous ruler (178). From the rescinding of key elements of the terms of capitulation of the Taifa of Toledo—such as the protection of the principal mosque—we understand how evanescent those protections could be under Castilian rule, and how powerful the influence of the church outside the peninsula, which was uncompromisingly opposed to the existence of Muslims or Jews within Christian polities. We are grateful to have been able to read, ahead of its forthcoming publication by Yale University Press, Stuart Schwartz's illuminating *In Their Own Law: Salvation and Religious Tolerance in the Iberian Atlantic World*. This study reveals the extraordinary extent to which common people throughout the sixteenth century, and on both sides of the Atlantic, continued to believe that "cada uno se puede salvar en su ley" (each person can be saved in his own religion), an almost completely ignored chapter in the history of tolerance in European societies.

The sources consulted for the Jewish community of Toledo are discussed above. Among more general sources, Raymond Scheindlin's article "Merchants and Intellectuals, Rabbis and Poets: Judeo-Arabic Culture in the Golden Age of Islam" in *Cultures of the Jews*, edited by David Biale, is an excellent overview of this subject. Jane Gerber's *Jews of Spain: A History of the Sephardic Experience* remains the most accessible and comprehensive study of Jewish history in medieval Spain. The great Jewish historian Howard Sachar's *Farewell España: The World of the Sephardim Remembered* is a compelling narrative history. Yitzhak Baer's *History of the Jews in Christian Spain* remains a valuable resource for the late medieval period, in particular concerning the Jewish communities of Castile-León and Aragon. For the Crown

of Aragon, Nirenberg's *Communities of Violence* provides a powerful synthesis of Jewish communal and political conditions in the years leading up to the pogroms of 1391. Jonathan Ray's *Sephardic Frontier* examines Jewish involvement in the progress of the reconquest, and the impact of the southward expansion on the Jewish community.

Bernard Lewis's small book *The Jews of Islam* is still a valuable reference and introduction to the subject. Similarly, Norman Stillman's *Jews of Arab Lands*, a collection of documents with concise and insightful commentaries, should sit on the shelf next to Constable's *Medieval Iberia*. Haim Beinart's classic work, *Gerush sefarad*, has recently been translated and published by the Littmann Library of Jewish Civilization, at Oxford, under the title *The Expulsion of the Jews from Spain*. Beinart meticulously traced the sequence of events leading up to the edict of expulsion, and the development of Jewish communal, intellectual, and political life in late medieval Spain. Another recent volume, edited by Zion Zohar, *Sephardic and Mizrahi Jewry* contains an initial section with articles by Marc Cohen, Norman Stillman, Jonathan Decter, and Moshe Idel, a rigorous but surprisingly accessible introduction to the social, religious, and literary history of the Jews in Spain.

<div style="text-align:center">✳</div>

The term "Mudejar" was first used by fourteenth-century Christians to describe their Muslim vassals. The *Encyclopaedia of Islam* defines "Mudejar," from the Arabic word *mudajjan*, as tributary or "one who remains behind." This is consistent with the first known written use of the Arabic term, in Ramón Martí's thirteenth-century glossary, which defined *mudajjan* as "persons allowed to remain." This first and more traditional use of the term "Mudejar," meaning the Muslims as protected tributaries of Christian kingdoms, is discussed most succinctly in Harvey's "Mudejars." His *Islamic Spain, 1250–1500* integrates the Mudejares effectively into the political narrative of Christian and Muslim kingdoms from the thirteenth century until the fall of Granada. And his newly published continuation of that history, *Muslims in Spain, 1500 to 1614*, elucidates the complex relationship between Christians and Muslims in the time following the fall of Granada and the forced conversion of many Mudejares, and their subsequent new definition as Moriscos, for further discussion of which see below.

Isidro de las Cagigas published his influential *Los mudéjares* in 1948–1949, a story told, as O'Callaghan observes, around the "reconquest." In many ways the field has been structured by the powerful analytical studies of Robert I. Burns, the senior statesman of the community of scholars working in this area. Burns, who has primarily studied the Mudejares of Aragon, has forcefully reminded us of the variety of contexts and experiences of Mudejar life, thus cautioning us from the kind of reductive studies that see all Mudejar experience as comparable. "The Mudejar situation was differently experienced in the several realms of Castile and in Portugal," he tells us in "Muslims in the Thirteenth-Century Realm of Aragon." "Across time, the Mudejar complex evolved, as its Christian and Muslim contexts underwent change in all component elements. To interpret any Mudejar experience, even the 'same' experience of one region over different generations, one must insert

it into those contexts—for instance the local, the structural and the immediate as well as the wider European and Islamic, and the personal. A substratum of identity and continuity does not need to be discerned and appreciated, over geographical-human spaces as over time" (102). Many of the most captivating and useful studies of the Mudejares are in fact focused not on Castile but rather on the Crown of Aragon, because of the wealth of archival material preserved for that region, and the size and importance of its highly acculturated Mudejar communities. The legal status of capitulating Muslims is also discussed by Burns and Paul E. Chevedden in *Negotiating Cultures: Bilingual Surrender Treaties in Muslim-Crusader Spain under James the Conqueror*. Among other notable studies we note especially John Boswell's pathbreaking 1977 *Royal Treasure: Muslim Communities under the Crown of Aragon in the Fourteenth Century*. Brian Catlos's various recent studies, focused on the Mudejares of Aragon, aspire to modify Américo Castro's *convivencia*—and replace it with *conveniencia*, in the light of his own and others' studies of the last half century, and also hoping to remove the taint of utopianism that has crept into the usage of the terminology of *convivencia*.

The topic of Mudejar experience in Castile has been studied with dedication by a number of formidable protagonists, many of whom were mentioned in our discussion of Toledo. O'Callaghan, once again, offers an excellent overview, in particular of legal issues, in his "Mudejares of Castile and Portugal in the 12th and 13th Centuries," one of several valuable Mudejar studies collected by James M. Powell in *Muslims under Latin Rule, 1100–1300*. A consideration of the varied experiences of Mudejares throughout the medieval period can be found in David Nirenberg's chapter of Peter Linehan and Janet Nelson's *Medieval World* volume, "Muslims in Christian Iberia, 1000–1526." Other generally accessible sources that deal with the Mudejares include Fletcher's *Moorish Spain* and Reilly's *Medieval Spains*, each of which has small chapters devoted to the Mudejares. A great little section of W. Montgomery Watt and Pierre Cachia's now quite old but still-useful *History of Islamic Spain*, "The Muslims under Christian Rule" (pp. 130–133 in the 1967 edition), discusses the importance of Mudejar achievement in the history of Islamic Spain. Primary source material on the legal status of Muslims in Christian society (with its parallels to dhimmi status under Islam) is in the *Siete partidas*, which have been translated by Samuel Parsons Scott and recently reissued by the University of Pennsylvania Press, with a comprehensive and useful introduction by Burns. The *Siete partidas* can also be consulted in the facsimile editions of Gregorio López, whose version, completed in 1555, served as the basis for the edition of the Real Academia de la Historia of 1801. More recently, scholars have gone about editing individual sections of the work, but a complete critical edition remains a desideratum. The compilers of the Real Academia edition recognized that López's edition, although often differing from manuscript sources, carried a force of its own: the editorial decisions he made have literally determined the textual basis for specific areas of Spanish law. There could be no more poignant statement of the canonical nature of López's edition: it quite literally *was* the *Partidas*, with medieval parchment and the signatures from the king and his entire court, including the chancery, presiding magnates (presidentes), magistrates (oydores), and mayors (alcaldes), down to the "assistentes, gouernadores, corregidores . . .

y otros jueces y justicias." Arguably the greatest achievement of this work, beyond the gar-
gantuan task of editing the seven divisions of the legal code, was the gloss that the licenci-
ado added. An expert in canon law, López explains in highly formulaic but eloquent
Latin the key terms and phrases of the vernacular code. He makes reference, primarily, to
sources of canon law but also draws quite frequently on biblical sources, Aristotelian phi-
losophy, and numerous classical, late antique, and medieval sources including Gregory the
Great and Saint Thomas Aquinas. Beyond any reliance on sources, however, the lawyer's
erudition and his own explanations are the lasting legacy of this gloss. Through the gloss,
a text far exceeding the length of the *Partidas* themselves, López paints an intricate portrait
of the Renaissance Latin reception of a medieval law code. See also Francisco Fernández y
González's *Estado social y político de los mudéjares de Castilla*, in which the term *mudajalat*, "one who
entered into dealings with another," is preferred.

So, what would eventually become of the Mudejares, these Muslims whose guaran-
tees of religious freedom were slowly stripped away over the course of five centuries even
as they proved to be a dominant artistic and cultural force in the nascent nation-state we
now know as Spain? Where did they go and what did they do after the word *mudéjar* all but
disappears from the documentary evidence and conventionally agreed-upon historical nar-
ratives? The word *moro* appears in Castilian sources as early as the tenth century, where it
refers generally to all Muslims, according to Corominas's standard etymological dictionary.
And bearing the Mozarabic-derived suffix *-isco*, or "descended from," the word begins to
be applied to the descendants of the Mudejares in the last century of their collective, and
increasingly shabby, life on the peninsula. One of the major distinctions between Morisco
communities is frequently defined in terms of geography: the Granada Moriscos were the
last to lose their sovereign Muslim principality. But as the perpetrators of two uprisings
that spread from Granada to the foothills of the Alpujarra Mountains (1499–1501 and
1568–1570), they were the first to suffer the indignity of forced conversions and relocations
inland. The Aragonese and Valencian Moriscos, who were generally poorer and situated in
more rural areas than their Granadan counterparts, suffered the loss of their sovereignty
and religion more slowly and quietly. On the other hand—and perhaps paradoxically—
the Granadan Moriscos, owing to the length of time in which they were in full control of
their education system, were more knowledgeable in Arabic and Islamic tradition than
their counterparts were. Because of this, and because of their overall higher levels of edu-
cation and wealth, the Granadan Moriscos were not prohibited from using Arabic, as were
the Moriscos living in the Crown of Aragon, but instead were often encouraged to use
their knowledge of Arabic to scrutinize documents in the service of the Inquisition. Many
of these Moriscos held posts high enough in government and stations elevated enough in
society that their names are preserved even today: Miguel de Luna and Alonso de Castillo
are among the most famous.

Morisco literature is written generally in one of two languages: an Arabic dialect
or the Romance dialect referred to as Morisco-Aljamiado. The latter's distinctive and
distinguishing feature is confined exclusively to the page: it is written in Arabic script.

"Aljamiado" itself derives from an Arabic root that conveys the sense of foreignness the Moriscos must have felt, in the larger Christian society but also at home in their Arabic letters, even, most painfully, in their relationship to the Quran, as beautifully evoked by Consuelo López-Morillas in *The Qur'an in Sixteenth-Century Spain*. *Ajm*, which means incomprehensible, was used in the early years of Islam to refer to Persians, but gradually grew to mean any non-Arabic speaker, and is set up as the opposite of *arab*—meaning Arabic speaker. Aljamiado, then, has at its root a meaning opposed to the root meaning of Mozarab (*mustarib*). The major categories of Morisco-Aljamiado writings are first religious and second literary. Smaller categories include scientific and pseudo-scientific writing. Although the number of manuscripts preserved is relatively small, the cataloging efforts to date have been fairly thorough, particularly Vincent Barletta (on Alhadith: Resources for the Study of Morisco Language and Literature, visit his web site: http://www.colorado.edu/spanish/barletta/alhadith/) and Luis Bernabé-Pons's 1992 book. Bernabé-Pons has written an excellent introduction to the overall cultural situation, "La asimilación cultural de los musulmanes de España: Lengua y literatura de mudéjares y moriscos"; see also Barletta's *Covert Gestures: Crypto-Islamic Literature as Cultural Practice in Early Modern Spain*.

For a concise introduction to Morisco culture, see Luce López-Baralt's chapter in the *CHAL*, "The Moriscos," which considers the nature and problems of Morisco-Aljamiado, particularly in light of the use of the Apocalypse as a literary and cultural device. See also Francisco Márquez Villanueva's *El problema morisco (desde otras laderas)* and Alvaro Galmés de Fuentes's *Los moriscos (desde su misma orilla)*, two volumes in conversation about the treatment of Morisco historiography. Sarah Pearce's prize-winning study "Era Du l-Qarnain, que su nombre era al-Iksandar: Notes on the Morisco Alexanderroman" has provided us an invaluable guide to the complexities and oftentimes counterintuitive roles of Aljamiado literature in the sixteenth century. A succinct and impassioned overview on the expulsion of the Moriscos may be found in Roger Boase's 1990 article, which includes extensive further bibliography. Several editions and translations of Morisco-Aljamiado manuscripts exist, including Francisco Guillén Robles's *Leyendas de José, hijo de Jacob y de Alejandro Magno sacadas de dos manuscritos moriscos de la Biblioteca Nacional de Madrid*, and while the texts are far too heavily edited to be useful for scholarly purposes (Emilio García Gómez and A. R. Nykl would later comment on this frustrating fact), the introductory essay provides a useful summary of their language and content, and a detailed, if brief, social history. See also Guillén Robles's *Leyendas moriscas*, a series of Morisco legends, abridged and adapted into modern Spanish, for consumption by a general audience. This approach has been taken by some scholars as a major theoretical decision regarding the nature of Aljamiado as a translatable language. *Manuscritos árabes y aljamiados de la Biblioteca de la Junta*, a project directed by Miguel Asín Palacios, the one-time dean of Hispano-Islamic letters and culture, is a volume containing precious little commentary but facsimile copies of all but one of the Arabic and Aljamiado manuscripts that belong to the former Biblioteca de la Junta. The collection is available on CD from the CSIC-Filología, Madrid.

The most important new addition to the field is Harvey's *Muslims in Spain, 1500 to 1614*,

his much-anticipated companion volume to *Islamic Spain, 1250–1500*. As the title indicates, Harvey believes that the majority of the Moriscos in this period were actually Muslims—albeit crypto-Muslims, hiding under cover of nominal Christianity. As reviews of the book indicate, this is a controversial opinion much disputed by other scholars of the period.

Architecture and Art

The term "pre-Romanesque" can be nefarious. With one awkward and efficient gesture of homogenization, it can obscure all of the disparate, fecund movements that constitute the working through of regional collective identities in Europe after the fall of the Roman empire. And it marginalizes those monuments of art and architecture that do not roll, like a juggernaut, toward Romanesque, its international classical ideal. The vision evoked by "pre-Romanesque" is that of an apologetic band of polities limping with a blind and more or less maladroit fervor toward a transcendent trans-European style. When we organize the art of medieval Spain around the idea of Romanesque, we are in danger of promoting one of the medieval papacy's most successful spin campaigns. Romanesque was in many cases the monumental stage for the church at the time of the Gregorian reforms, from which it argued its authority to its constituency directly, loosed from the intervention of individual secular rulers. Romanesque churches were the stage from which the papacy sought to unite the diverse states of Europe under its spiritual, and at times temporal, authority.

Here is where we can be caught in our own yearning to see traces of Europe, signs of our contemporary notion of the West, in the fragmented body of the Roman empire we study as medievalists. That is the seduction of Romanesque as an organizing principle: we can find ourselves subconsciously acquiescing to its original agenda, conceived nearly one thousand years ago. The eleventh-century church was fiercely focused on claiming the scepter of the Roman empire in Europe, as the last pan-European institution to survive its fragmentation. If Romanesque is so easily seen as a European style, it is because it came to be used in the interests of establishing a vision of a united Europe: a uniform western realm under the authority of the church, one intent on suppressing alternative religions and ideologies. This meant the suppression of local styles, as would later happen on the Iberian Peninsula. But its ideology has also permeated the master narrative of architectural history, which has struggled in its own way over the suppression and manipulation of the local styles preceding the advent of Romanesque on the peninsula.

For scholars of medieval Spain, the stakes have been high. If Asturian architecture is "pre-Romanesque," what does it mean if it does not fulfill the promise of anticipating Romanesque, the future culmination of western classical identity? It came to mean, in the early part of the twentieth century, that Spain had always been destined to be marginal to the West, unless that architecture could be shown to make the link. Manuel Gómez Moreno's lament in *Iglesias mozárabes* reveals the brilliant Spanish scholar's bitter candor on the subject: "Mas de temer es que, sobre todo fuera de España, se defina como erroneo todo nuestro aparato de cronología, repitiendo lo que a la ligera sentaron Marignan y Enlart, a saber, que en España, no hay arte cristiano anterior al románico francés, o si algo

hay carece de valor y notoriedad salvo acidentes. . . . Aunque no dejen de doler las injusticias, estamos acostumbrados a que lo español se vilipendie sobre la norma de nuestra moderna inferioridad" (xvi). [One has to be concerned that, especially outside of Spain, our whole chronology for these (Mozarabic) buildings will be rejected, repeating the feelings of at least Enlart and Marignan, that is, that in Spain there is no Christian art before French Romanesque, or if there is something it lacks in value and importance, except for accidents. . . . Although the injustice of it is painful, we are accustomed to seeing that which is Spanish disdained on account of our modern inferiority.]

Even Gómez Moreno attempted to bridge the gap, however, desiring an architecture that was both a part of this European phenomenon and yet distinctly Spanish. But what was uniquely Spanish could not depend on Islam, the ultimate marker of Spanish identity as something alien from his concept of "Europe." Discussing Asturian monasteries, he calls them "tránsito de lo carolingio a lo románico e independiente de ambos representando una iniciativa puramente española, rama de andalucismo con ciertas peculiaridades que la despegan también de lo arabizado nuestro" (*Arte árabe*, 357) [transition between Carolingian and Romanesque and independent of both, representing a purely Spanish initiative, the branch of Andalucia with certain peculiarities that separate it as well from our Islamic past].

More recently, Isidro Bango Torviso has taken the bull by the horns. Warning against the tendency to categorize Spanish buildings in relationship to French models using the terms "pre-Romanesque" and "proto-Romanesque," he concludes:

"Mi visión de lo hispano resulta muy diferente. En primer lugar el devenir del arte peninsular no sigue el esquema europeo coetáneo. Bajo ningún concepto, ni los edificios asturianos, ni los llamados mozárabes o de repoblación, ni las artes figurativas de igual período son experiencias que terminarán conformando el románico. Las formulas del románico se introducirán en nuestro país perfectamente definidas y como efecto de un proceso de sustitución cultural de nuestras propias tradiciones" ("Crisis de una historia del arte medieval," 27). [My vision of Hispanic arts is very different. In the first place, the development of peninsular art does not follow the contemporary European scheme. Under no circumstances should Asturian buildings, or those labeled "Mozarabic" or "repopulation" structures, or the figurative arts of this early period be considered experiences leading to the Romanesque. The formulas of Romanesque architecture were already well defined when they were introduced into our culture, at which time they substituted our own architectural traditions.]

Though the age in which we struggled with Arthur Kingsley Porter's question "Spain or Toulouse?" is long past, we often subconsciously organize our studies in temporal orbits around styles like Romanesque. But each time we privilege the view that a uniform classicizing monumental style is the central expression of a collective medieval identity; each time we see local aesthetic and cultural complications of its unifying program as exotic or marginal, we are continuing to promote the same medieval ideology, or at least its Cartesian successor in secular Europe. And it becomes more difficult, by extension, to

distinguish that medieval sleight of hand from our contemporary one. For though the notion that the central identity of the West is Christian and classical is part of that medieval papal ideal, the brilliance of the campaign is that, as the authority of the church waned, its message of a western identity contained in a Christian empire has survived secularism and revolutions, hidden in the high moral ground of the rational classical architecture that was its expression. "Classical" and "anticlassical" became "western" and "nonwestern." It is perhaps this crisis of identity—one that claims to be secular, but which has a religious and racial memory, split off, tucked deep into the folds of its subconscious—that has set the stage for the many struggles concerning terminology and ideology that are at the heart of the study of medieval Spanish art.

For our short history of Spanish architecture and art before 1085, we wish to acknowledge essential texts, new and old. From the significant years of the foundation of the field, we mention here only the vital fieldwork, analysis, and documentation of Pedro de Palol, Helmut Schlunk, and above all, Gómez Moreno's *Iglesias mozárabes*. Arguments from a number of earlier studies by Dodds concerning architecture of the Visigothic and Asturian periods, in particular *Architecture and Ideology* and "Entre Roma i el romànic," are incorporated into our analysis, as are others from Dodds, Little, Moralejo, and Williams, *The Art of Medieval Spain*.

Any narrative of this period is today indebted to the work of Bango Torviso, both in synthetic analysis and because he consistently challenges thorny preconceived notions that inhibited understanding the arts of the Visigothic period, Asturian arts, and arts of the tenth century, sometimes called Mozarabic or "repopulation." His *Arte prerrománico hispano: El arte en la España cristiana de los siglos VI al XI* is sharply reasoned and beautifully documented. His close reading of meaning in Asturian architecture can be found in "De la arquitectura visigoda a la arquitectura asturiana: Los edificios ovetenses en la tradición de Toledo y frente a Aquisgran," among other publications. His "Arquitectura de la décima centuria: ¿Repoblación o mozárabe?'" and "El neovisigotismo artístico de los siglos IX y X: La restauración de ciudades y templos" set the study of tenth-century architecture on a new course. In addition, two of his recent exhibitions have constituted important contributions to the field, and their catalogs are important references for this work: *La edad de un reyno: Las encrucijadas de la Corona y la Diócesis de Pamplona* and *Maravillas de la España medieval: Tesoro sagrado y monarquía*.

Finally we have turned to the works of Joaquín Yarza, Manuel Núñez Rodríguez, Antonio Bonet Correa, and Xavier Barral I Altet, and to the catalog entries and essays of Gisela Ripoll, Sabine Noack, and Achim Arbeiter from Dodds, Little, Moralejo, and Williams, *The Art of Medieval Spain*. For the church of San Juan de Baños, we are indebted to Narciso Menocal, whose "Date of the Dedication of San Juan de Baños" confirms the centrality in history of a church we have long felt central to the history of art.

Our treatment of art and architecture under the Umayyad emirate and caliphate of Cordoba is brief, but it draws on several important studies. In our overview we are indebted to Oleg Grabar's *Formation of Islamic Art*, to the foundational studies of K. A. C.

Creswell, and to the insightful state of the question by Sheila Blair and Jonathan Bloom: "The Mirage of Islamic Art." For the Great Mosque of Damascus we looked to Finbarr Barry Flood's revelatory *Great Mosque of Damascus* and to Grabar's "Grande mosquée Omeyyade de Damas"; for the Dome of the Rock, as always to Grabar, *The Shape of the Holy: Early Islamic Jerusalem* and "The Meaning of the Dome of the Rock in Jerusalem," as well as to Nasser Rabat, "The Meaning of the Umayyad Dome of the Rock" and "The Transcultural Meaning of the Dome of the Rock."

The overview of the Great Mosque of Cordoba is primarily from Dodds, "The Great Mosque of Cordoba," in *Al-Andalus: The Art of Islamic Spain*. Our understanding of interlacing arches is drawn from Christian Ewert's *Spanisch-Islamische Systeme sich kreuzenden Bögen*; the history of the mosque has been documented by Manuel Nieto Cumplido in various works. Additional interpretations can be found in more recent studies, in particular those of Nuha Khoury and María Teresa Pérez Higuera. See also Jonathan Bloom's important "Revival of Early Islamic Architecture by the Umayyads of Spain" as well as Susana Calvo Capilla's study of the transformation of the urban context of Cordoba through political and social change in "El entorno de la mezquita aljama de Córdoba antes y después de la conquista cristiana."

The excavation of the palace of Madinat al-Zahra has been at the heart of the scholarship of Antonio Vallejo Triano. Felix Hernández Giménez and Antonio Fernández-Puertas's volume *Madinat al-Zahra: Arquitectura y decoración* provides a useful survey. The interactions between the palace spaces and the gardens of Madinat al-Zahra, and the relationship between the garden design and the ideology of the Umayyad caliphs is wonderfully revealed by D. Fairchild Ruggles in her *Gardens, Landscape, and Vision in the Palaces of Islamic Spain*, as well as in "The Mirador in Abbasid and Hispano-Umayyad Garden Typology." We also owe to Ruggles much of our information concerning agriculture and horticulture in this period, and on the way economy, culture, and political values are imprinted in the practical and pleasurable world of the landscape. Finally, Glaire Anderson has contributed to our understanding of the meanings of the munya, or country palace, in the Umayyad period in her recent dissertation: "The Suburban Villa (Munya) and Court Culture in Umayyad Cordoba."

Madinat al-Zahra figures as the center of production and consumption of opulent arts in Renata Holod's "Luxury Arts of the Caliphal Period," a work that places the ivories, ceramics, textiles, and precious objects in a setting that reveals their workings in society and kingship. Concerning ivories in particular, Anthony Cutler's *Craft of Ivory: Sources, Techniques, and Uses in the Mediterranean World, A.D. 200–1400* is of enormous value. The foundational reference for the study of the ivories of al-Andalus is Ernst Kühnel and Adolph Goldschmidt, *Die islamischen Elfenbeinskulpturen, VIII–XIII Jahrhundert*, while John Beckwith's *Caskets from Cordoba* provides a useful introduction. Finally, Francisco Prado-Vilar turned the study of caliphal ivories on its head with his brilliant analysis of a quite specific political interpretation of the images on the al-Mughira casket in "Circular Visions of Fertility and Punishment: Caliphal Ivory Caskets from al-Andalus."

Concerning textile production in al-Andalus throughout the Middle Ages, see the work of Maurice Lombard, and especially the classic studies of Florence Lewis May and R. B. Serjeant, respectively: *Silk Textiles of Spain: Eighth to Fifteenth Century* and *Islamic Textiles: Materials for a History up to the Mongul Conquest*. We looked to the more current documentation and analysis of Cristina Partearroyo, in her "Tejidos de al-Andalus entre los siglos IX al XV (y su prolongación en el siglo XVI)," as well as to her essay and valuable entries for individual examples in Dodds, *Al-Andalus*.

We are indebted to the extraordinary work of George Miles concerning numismatics. For the history and use of scientific instruments, we relied on David King's *Astronomy in the Service of Islam* and Leo Mayer's *Islamic Astrolabists and Their Works*.

The issue of fortifications, settlements, and strongholds is important and includes many values shared by Muslim and Christian populations. See Thomas Glick's *From Muslim Fortress to Christian Castle*, and the many publications of Juan Zozaya, in particular "The Fortifications of al-Andalus," "Islamic Fortifications in Spain: Some Aspects," and "Las torres y otras defensas." Zozaya's extraordinary exhibition and catalog, *Alarcos '95: El fiel de la balanza*, examines the objects, arts, and technologies of the life of Christians and Muslims, advancing our understanding far beyond the posturing of armies and kings. His archaeological studies and challenging theories have shaped the field in myriad ways.

In our study, we have given particular consideration to the art and history of the Mozarabs, both during the caliphate and within Toledo during the Taifa and Castilian periods. For the early period, Francisco Javier Simonet first introduced the study of Mozarabic arts as Arabized, a strategy to some extent intertwined with the term. As Mustarab, or Arabized Christians, the term "Mozarab" suggested an assimilation of Islamic art that is only occasionally characteristic of the arts of Mozarabs. In 1919 Gómez Moreno's *Iglesias mozárabes* became the touchstone for the study of Mozarabic arts, with its extensive and meticulous documentation of churches throughout Spain. Because there are few vestiges of Mozarabic architecture in southern Spain, he studied the entire corpus of northern churches for the witness of Mozarabic culture during the repopulation of the ninth through the eleventh centuries, when politicized, resistant Mozarabs were among the many who moved north to occupy borderlands in the new Christian kingdoms. Gómez Moreno saw the Mozarabs as the source of transmission of Islamic form, and chose his monuments not so much for their consistent Mozarabic patronage as for the presence of Islamic constructional or ornamental detail, which led to wide selection of monuments between the ninth and the twelfth century throughout the peninsula. This created a dilemma for future historians. In "Arquitectura española del siglo X," José Camón Aznar would claim that the buildings were more a reflection of local tradition than of Arab forms, and made a plea to change the terminology by which they were known.

In this generation Bango Torviso led the field of those seeking to redefine tenth-century architecture in the north, with his influential article "Arquitectura de la décima centuria: ¿Repoblación o mozárabe?" He refined the notion of the complex web of construction and patronage of northern building projects in the tenth century, and advocated

a scholarly separation from the term "Mozarabic." The arts of the north have begun to be seen as deriving from diverse kinds of patronage, and Mozarabs are no longer believed to be the sole source of Islamic aesthetic values.

In *Architecture and Ideology*, Dodds has separated out a group of buildings with evidence of Mozarabic patronage, which can be seen to have carried neo-Visigothic attitudes as well as Islamicized culture north from Cordoba. She also studies the impact of Mozarabic form on the Great Mosque of Cordoba, challenging the notion that appropriation always follows the rule of political and economic power. In "De Peñalba a San Baudelio de Berlanga," Milagros Guardia Pons has established closer relations between buildings like San Miguel de Celanova and the Great Mosque of Cordoba, and suggests that they, together with other northern buildings, share aulic connections. José María Mínguez Fernández has demonstrated that there was also an indigenous Islamic population in the north, which might have transmitted Islamic linguistic culture; see in particular his *España de los siglos VI al XIII*.

Meyer Schapiro's "From Mozarabic to Romanesque in Silos" has been fundamental for this part of our essay. It revolutionized the study of Spanish medieval art by showing two divergent, overlapping Christian cultures—Mozarabic and Romanesque—in a single monastic establishment, and distinguishing between the indigenous monastic culture and that of Roman reform, through an analysis of the aesthetic values of each. In general, scholars have been careful to distinguish the manuscript tradition often called "Mozarabic" from the Mozarabs as a group, and to associate them instead with the period of repopulation in the Duero basin and the north. The fundamental work on the Beatus manuscripts is John Williams, *The Illustrated Beatus*, which incorporates a distinguished body of William's previous publications. Williams has analyzed the relationship of the manuscripts to both northern monasticism and Mozarabic culture, and gives a careful, somewhat conservative account of the ideological statements toward Islam that might be contained in certain images. O. K. Werckmeister has shown that a conscious dialogue with Islamic forms in certain tenth-century manuscripts is powerful, in a series of articles that explore Mozarabic identity or an ideological response to Islam, including "Art of the Frontier: Mozarabic Monasticism," "Islamische Formen en spanischen Miniaturen des 10 Jahrhunderts und das Problem der mozarabischen Buchmalerei," and "The First Romanesque Beatus Manuscripts and the Liturgy of Death." Of particular importance to this narrative is his analysis "The Islamic Rider in the Beatus of Girona" and his work concerning the Biblia Hispalense.

For the advent of the Romanesque on the peninsula, we consulted the distinguished surveys of Bango Torviso and Joaquín Yarza, as well as Javier Castán Lanaspa's "Incorporación de Castilla a la Europa cristiana (siglos XI–XIV)." For the early eleventh century and the arts and architecture of Sancho the Great, we have relied on the essays and bibliography from Bango Torviso's *Edad de un reyno*, pages 426–431 of his *Arte prerrománico hispano*, and *Arte medieval navarro* by José Esteban Uranga Galdiano and Francisco Iñiguez Almech. Our understanding of Sancho's patronage was particularly advanced by an article of Janice Mann, "A New Architecture for a New Order: The Building Projects of Sancho el Mayor

(1004–1035)." Rose Walker's *Views of Transition* offers a deep look into manuscripts that chart the change from the Mozarabic to the Roman liturgy.

The brief survey of Romanesque monuments skims the surface of a substantial bibliography for the Romanesque arts of Castile and León. As a point of departure, *Arte románico*, the second volume of the *Historia del arte de Castilla y León*, sets the stage, along with Bango Torviso's *Arte románico en Castilla y León*, an important synthesis developing from geographical centers, with unusually beautiful photographic documentation. In "La part oriental dels temples de l'abat-bisbe Oliba," Bango Torviso traces the first impact of Cluny on the architecture of the north at Saint Michel de Cuxa, linking it to its patron's relationship with the monastery. Articles dedicated to the issues surrounding Cluny's impact are collected in volume 27 of *Gesta*, including John Williams's "Cluny and Spain," and O. K. Werckmeister's inspiring "Cluny III and the Pilgrimage to Santiago de Compostela." Finally, Williams has presented the historiography of Spanish Romanesque in "El románico en España: Diversas perspectivas."

For León we have also depended primarily on the work of Williams, in particular "León: The Iconography of a Capital," "San Isidoro in León: Evidence for a New History," "León and the Beginnings of Spanish Romanesque," and "Generationes Abrahae: Reconquest Iconography in León." For the patronage of Queen Urraca in León, we looked to an extremely valuable article by Therese Martin, in which Alfonso VI's daughter is found to be a powerful patron: "The Art of a Reigning Queen as Dynastic Propaganda in Twelfth-Century Spain."

The church of Santiago and the pilgrimage to Santiago de Compostela are not a focus of this study, but for our brief mention of the church we consulted Serafín Moralejo Alvarez's "Notas para unha revisión da obra de K. J. Conant," in his edition of Kenneth Conant's *Arquitectura románica da catedral de Santiago de Compostela* (*The Early Architectural History of the Cathedral of Santiago de Compostela*), as well as his "On the Road: The Camino de Santiago," in *The Art of Medieval Spain*. However, the study of Santiago has evolved in recent years, and has profited from the critical discussions of Bango Torviso, who has challenged the use of the term "Pilgrimage Roads Style," and thereby opened up the field of possible meanings for Santiago and its relationship to the arts of France and Spain. "Las llamadas iglesias de peregrinación," he concludes in his article of the same title, "no forman el grupo homogéneo que generalmente se le atribuye en la historiografía tradicional" (74). [The so-called churches of the Pilgrimage Roads do not form a homogeneous group as traditional historiography would have it.] He sees different interactions between patronage, construction, materials, liturgical needs, and economic limitations as "eslabones de una cadena experimental" (links in an experimental chain) that produce a plan type, circumstances that reach far beyond pilgrimage and relics. Annie Shaver-Crandell and Paula Gerson's translation of the "Pilgrim's Guide" and gazetteer of the monuments to be found on the road is an extremely useful reference.

Our discussion of the monastery of Santo Domingo de Silos was formed with constant gratitude for the vivid study of Schapiro, in conjunction with the longstanding lessons

of Fray Justo Pérez de Urbel and the publication of *El románico en Silos*, on the occasion of the nine-hundredth anniversary of the consecration of the church and cloister. More recently we have depended on a number of important specific studies, in particular those of Constancio Martínez del Alamo and Elizabeth Valdez del Alamo on architecture, sculpture, and the objects that formed part of the textured visual world of the monastery. Recent studies concerning the history of San Pedro de Cardeña have opened a window onto the monastery's participation in the creation of popular legend and the rewriting of history, in particular José Luis Senra's "En torno a la restauración de la memoria de la 'reconquista,'" and Francisco Javier Peña Pérez, "Los monjes de San Pedro de Cardeña y el mito del Cid."

Besides the studies of the Taifa period in Toledo mentioned below, our discussion of art and architecture in the Taifa period has relied on the extensive work of Christian Ewert, who has long been a scholar and beloved teacher in this field. More recently, the revelatory work of Cynthia Robinson concerning the Aljafería in Saragossa, *In Praise of Song: The Making of Courtly Culture in al-Andalus and Provence*, has traced the relationship of court culture, poetry, and art with such erudition and intimacy that it has fueled historical and literary studies as well as art historical ones, and set the standard for the integration of the arts and literature. Her "Arts of the Taifa Kingdoms," "Ubi Sunt: Memory and Nostalgia in Taifa Court Culture," and "Seeing Paradise: Metaphor and Vision in Taifa Palace Architecture" reframe the discussion for Taifa architecture, ever widening the prospects for future scholarship.

On the memory of the Umayyad glories in later Islamic art forms of the peninsula, particularly in the architecture of gardens and palaces, see the seminal work of Ruggles, who treats the subject most completely in *Gardens, Landscape, and Vision*. Her "Fountains and Miradors: Architectural Imitation and Ideology among the Taifas," "Historiography and the Rediscovery of Madinat al-Zahra," and "Arabic Poetry and Architectural Memory in al-Andalus" interweave text and monuments to show the invention of a new relationship with the past that resides at the heart of Taifa culture.

Our brief mention of Almohad and Almoravid traditions in architecture is indebted to Christian Ewert and Jens-Peter Wisshak's *Forschungen zur almohadischen Moschee* and Ewert's "Architectural Heritage of Islamic Spain in North Africa." For Seville we consulted Juan Clemente Rodríguez Estévez, *El alminar de Isbiliya: La Giralda en sus orígenes, 1184–1198*, and Henri Terasse, "La grande mosquée almohade de Séville." An invaluable book with studies that have informed our understanding of palaces and domestic architecture of all periods is Julio Navarro Palazón's *Casas y palacios de al-Andalus*. In particular, the following articles are key to comprehending the architecture of the Almoravid and Almohad periods: Navarro Palazón and Jiménez Castillo's "Casas y palacios de al-Andalus, XII–XIII," María Jesús Viguera Molins's "Ceremonias y símbolos soberanos en al-Andalus: Notas sobre la época almohade," and Rafael Manzano Martos's "Casas y palacios en la Sevilla almohade: Sus antecedentes hispánicos." Concerning Murcia in the thirteenth century, *Casas y palacios* once again is the central source, both in Navarro Palazón and Jiménez Castillo's article and in Navarro Palazón's "Palacio protonazarí en la Murcia del siglo XIII: Al Qasr al Sagir."

The volume compiled by Jonathan Bloom, *The Minbar from the Kutubiyya Mosque*, is a fas-

cinating and valuable study of which there are lamentably few examples. It sets the stage for an art held in high regard, but seldom studied in a synthetic way, providing technical and aesthetic analysis, as well as social, cultural, and political context. For the textiles of the Almoravid and Almohad period, we have relied on the fundamental references cited under caliphal arts, and in particular the overview of Cristina Partearroyo, "Almoravid and Almohad Textiles," as well as her individual entries in the *Al-Andalus* catalog. For the bell lamps, consult the entries by Abdellatif El Hajjami and Lhaj Moussa Aouni, also in *Al-Andalus: The Art of Islamic Spain*.

Bloom's *Minaret: Symbol of Islam* informed our discussion of the interaction between bell towers and minarets in form and meaning, as did the argument in Dodds's *Architecture and Ideology*. A new close reading of the ricocheting forms and meanings that in many ways supersede these two is found in John Tolan, "Affreux vacarme: Sons de cloches et voix de muezzins dans la polémique interconfessionelle en Péninsule Ibérique."

<div align="center">✳</div>

Regarding the appropriation and reuse of luxury arts of Islamic manufacture, we have relied on a number of illuminating studies. The notion of Spanish ivory caskets or textiles taken on as booty has been explored since the time of Rodrigo Amador de los Ríos and his *Trofeos militares de la reconquista: Estudio acerca de las enseñas musulmanas del real monasterio de las Huelgas (Burgos) y de la catedral de Toledo* of 1893. The twin attraction of beautifully crafted luxury goods on one hand, and the justifying triumphalist commodification of precious arts received as booty on the other, has been part of these studies from the beginning. Meyer Schapiro early introduced the ambivalence that inevitably exists toward an opulent work of art appropriated under the auspices of booty in "On the Aesthetic Attitude in Romanesque Art," and in "Le rôle de la reconquête de Tolède dans l'histoire monétaire de la Castille (1085–1174)" Gautier Dalché marked the practical and symbolic continuation of monetary forms between the reigns of Taifa and Castilian monarchs in Toledo. We recommend a lively survey of Oleg Grabar, "The Crusades and the Development of Islamic Art," which provoked our discussion of the twelfth-century metal peacock by "Abd al-Malik the Christian." Such studies urge the normalization of the notion that shared aesthetics that transcend differences in religion—rather than spoils of war—are likely responsible for more of the transmission of forms than many scholarly studies suggest. But even when spolia and appropriation are present, their meanings are multiple and ambivalent. For this notion we have depended on Dale Kinney's template for understanding the meaning of spolia: "Rape or Restitution of the Past? Interpreting *Spolia*."

Our study has profited enormously from Avinoam Shalem's *Islam Christianized: Islamic Portable Objects in the Medieval Church Treasuries of the Latin West*, which manages to both survey the objects in question and offer an abundance of new interpretations, as well as his "Objects as Carriers of Real or Contrived Memories in a Cross-Cultural Context." In "Muslim Ivories in Christian Hands: The Leire Casket in Context," Julie Harris has uncovered a specific matrix of meanings constructed around the so-called Leyre casket, the ivory box made

for Abd al-Malik that would house the relics of the Mozarabic martyrs in a politicized monastery in Navarre.

In *Museo de telas medievales: Monasterio de Santa María la Real de Huelgas*, Concha Herrero Carretero has cataloged the greatest concentration of textiles of Islamic manufacture in Castile. The meaning of clothing and textiles for the Castilian kings is the subject of Etelvina Fernández González's "Que los reyes vestiessen panos de seda, con oro, e con piedras preciosas: Indumentarias ricas en la Península Ibérica (1180–1300)" and of Manuela Marín's "Signos visuales de la identidad andalusí." Marín suggests at times constricted meanings in a useful volume that combines documentation and interpretation: *Tejer y vestir: De la antigüedad al islam.* María Judith Feliciano has made a valuable contribution in reaffirming this relationship between Islamic textiles and Castilian royal status in "Muslim Shrouds for Christian Kings?" and in incorporating those textiles into a notion of a shared aesthetic culture that crosses political and religious boundaries. However, her contention that "Christian consumers saw each piece of Andalusi fabric simply as the sum of its parts, which were often silver, gold, fine silk, difficult to obtain dyes, and the flawless execution of complex weaving techniques" and that the textiles "therefore, lacked any Islamic meaning to the Castilian consumers" (118) throws the infante out with his tiraz. If, as seems quite likely, "in their form, function and effect, Andalusi textiles conformed to Castilian notions of sartorial correctness," we also need to be ready to accept a poetics of dress that was at once shared and other, especially as long as the Castilians could not manufacture the coveted textiles themselves. Shared culture does not mean an erasure of difference; a consciousness of Arab or Islamic culture can exist alongside both shared visual languages and clear messages "of Castilian socio-political primacy" (118), and the way it is experienced will change markedly in each new time and place.

Concerning the pontificals of Jiménez de Rada, we depended on the study of María Socorro Mantilla de los Ríos y Rojas, *Vestiduras pontificales del arzobispo Rodrigo Ximénez de Rada (siglo XIII)*, and to its extraordinary place in the 2006 exhibition "La edad de un reyno: Las encrucijadas de la Corona y la Diócesis de Pamplona," which brought the remnants of the great man, in his silk pontificals, home to Navarre.

We only briefly discuss some of the richest image cycles in medieval art, those accompanying Alfonso X's *Cantigas de Santa María.* Our presentation of Cantiga 169 is deeply indebted to Joseph O'Callaghan's penetrating analysis of the dance between poem and history in *Alfonso X and the "Cantigas de Santa Maria": A Poetic Biography*, as well as in *The Learned King: The Reign of Alfonso X of Castile*, in which he creates an unforgettable personal link between the images and the ruler. These works also contain an extremely useful bibliography, which ought to be consulted for discussions of individual images. José Guerrero Lovillo's *Miniatura gótica castellana, siglos XIII y XIV* has long served as a background for study of the *Cantigas.* The facsimile edition of the richest of the manuscripts, now in the Escoriale (*Cantigas de Santa María: Edición facsimil del Códice T.I. 1 de la Biblioteca de San Lorenzo de El Escorial; Siglo XIII*) is valuable both for technical data and for accompanying essays. Of the many interpretive articles on the *Cantigas*, Francisco Prado-Vilar's "Gothic Anamorphic Gaze: Regard-

ing the Worth of Others" greatly influenced our thinking. Both moving and penetrating, it encourages us to explore the common ground not only between the devotional and emotive worlds of Muslims, Christians, and Jews in the *Cantigas*, but between those worlds and our own. Prado-Vilar finds not only interaction but the continuous transformation of identity we have hoped to trace here. Certain miniatures of the *Cantigas*, he tells us, "offer a glimpse into the conditions that facilitate an intercultural exchange held in the midst of a hybrid visual regime, where Christian images were discussed by Muslims and Muslim beliefs were pondered by the Christian population. In the socio-cultural mosaic of thirteenth-century Castile each social and religious group existed in constant contact with all the others . . . and was obliged to continually revise not only its image of them, but even its image of itself, thus rendering contingent ideas that went unchallenged in the rest of Christian Europe" (72).

✳

"[E]n la grande Era de la reconquista, período largo, difícil y glorioso, en que nace, se desarrolla y llega a colmada granazón el carácter nacional, ose señalaros entre todas las manifestaciones del arte cristiano cierto linaje de arquitectura reflejando de una manera inequívoca el estado intelectual de la grey española" (*El estilo mudéjar en arquitectura*, 6–7). [In the grand era of the reconquest, the long, difficult, and glorious period in which the national character is born, develops, and reaches germination, a certain architectural lineage dares to call your attention among all the manifestations of Christian art, unmistakably reflecting the intellectual state of the Spanish people.] With those words, from an extraordinary and much-cited lecture delivered before the Real Academia de Bellas Artes de San Fernando de Madrid, José Amador de los Ríos threw down the gauntlet that would forever incite architectural historians to struggle with those seasoned warriors, nationalism and plural identity. As early as 1857, Manual de Assas y Ereño had been using the term "Mudejar" in reference to architectural history, and Amador's lecture would mark the term's entry into scholarly language. Originally, Toledo's post-1085 buildings were termed Mudejar because they were thought to have been constructed by Muslims who were subjected to Christian rulers, or by the relic of an indigenous workforce, making the term descriptive of its creators. The earliest buildings were thought to be from the time of Alfonso VI, and so the architectural tradition thus became imbued with the romance of the "reconquest."

The power of Amador de los Ríos's characterization lay in the convergence he saw between style (situated in an Islamic construction tradition) and history (the circumstance of Muslims living under Christian rule). But it also produced a tension between the cherished idea that Mudejar was a uniquely Spanish kind of architecture and the more ambivalent idea that Mudejar instead disconnected Spain from ("classical") Europe. These are played out in the formidable scholarship of the legendary Islamicist Leopoldo Torres Balbás: "Mudéjar es, pues, el moro vasallo de los cristianos que conservó su religión y costumbres" (Mudejar is, then, the Moorish vassal of the Christians who held onto his

religion and customs), he said in his *Arte mudéjar* of 1949, and proceeded to situate Mudejar culture in an orientalist universe of license and lack of restraint that he posed as other to classical culture: "Una de las características fundamentales del arte mudéjar es su anticlasicismo, patente en el indisciplinado de expresión que muestra por toda norma. Incorrecto frecuentemente, con acento popular, es siempre expresivo. Su fecundidad de concepción va unida a la mayor licencia, y así pasa de los más inesperados aciertos a las mayores equivocaciones" (246). [One of the fundamental characteristics of Mudejar art is its anticlassicism, patent in the undisciplined expression shown by every norm. Frequently incorrect, with popular accents, it is always expressive. Its conceptual fruitfulness is accompanied by great license and so moves from the most unexpected successes to the greatest mistakes.]

In the world that looked culture through the lens of the reconquest, art or architecture was required to pronounce its allegiance, to cling to one or the other side of the religious frontier. Torres Balbás saw Mudejar as belonging to the category of Islamic art. And yet, to reconcile it with the notion of "anticlassicism" (the errant forms that separated Spain from Cartesian Europe), he would see Mudejar not as a style but as a "popular art," leaving space for this "undisciplined" expression outside the canonical arts of Castilian identity, both "Christian" and "Islamic." In this way he was able to amputate from Spanish identity the Islamic content that made it unique: to exteriorize it, without losing it altogether. And so, accepting Mudejar as a term that characterized all buildings of Christian patrons with "Islamic influence" (238), Torres Balbás also fiercely separated it from the Islamic "high" arts he studied. Thus he famously proclaimed that Alfonso VIII's chapel of the Claustrillas in Las Huelgas de Burgos and the synagogue of Santa María la Blanca were direct, unfiltered works of Almohad art rather than Mudejar (39–46).

Already in the early 1900s Vicente Lampérez y Romea had dislodged the term from the notion that a Mudejar building's workforce was entirely Muslim, pointing out that both Christians and Jews participated in construction. And yet he would situate the survival of Islamic form in workshop tradition, identifying it as ornamental in nature, and seeing Mudejar as a "Christian" style. Elie Lambert's "Art mudejar" went on to separate the idea of a Mudejar style from the notion of Islamic "influence": he saw Mudejar as a true synthesis of forms, and further estranged the term from the ethnicity or confession of its workforce. A building could be Mudejar, he submitted, even if the master mason was a Christian. And yet, though scholars have come to abandon the strictly confessional implications of a term now embraced for the sake of scholarly tradition, it has been hard for them to abandon the notion that Mudejar buildings are, by virtue of their liminal position between "Christian" and "Islamic" worlds, a group apart from the master narratives of both European medieval architecture and Spanish medieval culture.

In recent times, discomfort with the broad scope and ethnic source of the word "Mudejar" has expressed itself in disputes concerning terminology. In *Arte y arquitectura en España*, Yarza emphasized that Mudejar could not qualify as a style, and that its distinction from other contemporary buildings is manifest not only in ornament but in proportions as well. Gonzalo Borrás Gualis, a great early advocate of the study of Mudejar who has

documented scores of workshops, artists, and master masons, has published widely on the history and historiography of Mudejar architecture as a style and a workshop tradition, particularly in Aragon. Borrás Gualis sees Mudejar as a continuation of Islamic traditions—an Islamic aesthetic in Christian art—and emphasizes that a large number of those who constructed these churches and palaces had Arabic names, and called themselves Muslims. In *El arte mudéjar*, he favors seeing these buildings united as a category in Spanish architecture, analogous to existing political and chronological categories. Putting aside the issues of style he inquires: "¿Quién se plantea si el arte omeya es un estilo artístico? . . . ¿Por qué no se acepta que el mudéjar constituye un periodo artístico . . . ?" (49) [Who asks if Umayyad art is an artistic style? . . . Why not accept that Mudejar is an artistic period?]

That is a practical suggestion, and has been, indeed, the way we continue to speak of Mudejar today. It is also, significantly, the terminology through which Borrás Gualis has been at the vanguard and, at times heroically, has helped claim these extraordinary buildings from obscurity during the past quarter century. But though the buildings we call Mudejar across the peninsula share Christian patrons and workshops that grow from Islamic architectural traditions, we need now to begin to recognize that Mudejar is not a unified political period, and its patrons are not related as a group, apart from their majority religion. In fact, religion still carries too much of the burden in the recognition of Mudejar buildings. "El límite entre el arte musulmán y el mudéjar lo define el hecho histórico de la Reconquista cristiana" (The frontier between Muslim art and Mudejar art is defined by the historic fact of the Christian Reconquest), Borrás Gualis correctly observes in *El arte mudéjar: La estética islámica en el arte cristiano* (39), but there are many conquests, and those conquests are diverse, as are the cities conquered. The agendas of their political protagonists, the demographies, economies, and even ideologies were incredibly divergent for eleventh-century Barbastro, fourteenth-century Seville, thirteenth-century Murcia, or twelfth-century Toledo. Clearly, in the words of Yarza, "un estudio de este arte mudéjar ha de dividirse de acuerdo con el tiempo" (313) [the study of this Mudejar art must be divided chronologically].

If buildings as divergent as the Alcazar of Seville, the towers of Teruel, and the church of Santa Cruz in Toledo are all called Mudejar (because they share a process: Christian patrons who used a surviving construction tradition formed under Islamic rule), the distinguishing characteristic of the group is thus limited to a use of materials indigenous to the peninsula and to the fact of its hybridity. Recognizing the importance of this group has been the central work of the last scholarly generation. But today, to unify these buildings ahistorically, to classify them outside their specific political, chronological, and geographic contexts, is to suggest that they do not fit within the mainstream of the different geographical and political cultures within which they are found. It is to suggest that hybridity itself is anomalous to, for instance, mainstream Castilian identity.

In "El arte de construir en ladrillo en Castilla y León," Bango Torviso has questioned the emphasis placed on the theory of styles, and cautions against the tendency to rely on terminology to solve problems of meaning in architecture, given the fertile nature of

Mudejar to attract scholarly visions formed "bajo una óptica interesada" (from within a culturally interested point of view). These, he laments, include not just the "posturas clásicas de nuestra historiografía, lo cristiano y lo árabe, sino a los . . . moralizadores [que] hablan de un producto híbrido . . . se presentan como superadores de fanáticos antagonismos raciales" (113) [classic postures of our historiography, the Christian and the Arab, but the . . . moralizers who speak of a Mudejar hybrid product as if they were the vanquishers of fanatic racial antagonisms].

He goes on to show how a nineteenth-century restoration tradition tended to veil the basic connections, in New Castile, between brick churches called Mudejar and Romanesque churches constructed of stone: the organization of their interior space and wall articulation is the same. In essence, he does not deny Mudejar hybridity; he demonstrates that it is imbricated into mainstream Castilian values. It is not an exotic hothouse flower.

This discussion has become particularly interesting in reference to New Castile, where brick workshops construct Romanesque spaces with assorted wall systems and ornamentation that display varying levels of connection with workshops like those of Toledo. In *Arte mudéjar toledano*, Gómez Moreno separated the study of New Castile into two parts: Toledo, which he found profoundly connected to Islamic traditions, and the meseta, where taste was more directed toward Romanesque architecture. Lampérez y Romea found these churches to be composed of decorative workmanship with a "secondary" connection to Islamic workshops, and he called them "brick Romanesque" buildings (*Historia de la arquitectura cristiana española*, 699–719). Pérez Higuera's "Arquitectura mudéjar en los antiguos reinos de Castilla-León y Toledo" has shown that different urban centers generate different relationships between these Romanesque churches and Islamic, or Toledan, traditions. Her "Absides mudéjares con la moraña" is particularly clear-headed in this regard. This theme is also taken up by Manuel Valdés Fernández, in several publications, and his "Patronazgo señorial y arte mudéjar" is a valuable study of patronage patterns.

The problem, in the end, is not which buildings ought to be called Mudejar, and which Romanesque. The problems rests, rather, in the futile attempt to find a global term to cover architecture that springs from deeply diverse contexts: geographic, demographic, social, and political considerations need to be taken into account—in addition to the training of the workforce. The taste for Islamic form, the selection of a particular workshop, and the presence of Christians and Muslims in one place are not always the key factors in the creation of these buildings. To give all architecture that results from Christian patrons electing an indigenous workforce that builds in a style formed under Islamic practice and taste the same name—Mudejar—is to fetishize and marginalize it. It is to say, from our post-1492 point of view, that hybridity was an anomaly. And so, to marginalize Mudejar buildings as separate from other currents in Castilian architecture might be to miss the point altogether. Ruggles, in "Representation and Identity in Medieval Spain," even suggests that Mudejar as a style was seen not so much as "Islamic" but as "not French" in Aragonese and Castilian communities where the incursion of Romanesque and Gothic was experienced by contemporaries as part of a wider Gallic colonialism. (See also Geneviève Barbé,

"Mudejarismo en el arte aragonés del siglo XVI," who makes a similar point for Aragon.)

If we do not call buildings Mudejar for the religion of their artisans, and if we see that it is not possible to unify them all by claiming they grow from the same tradition or unified style, the pitfalls of classification are legion. Perhaps we need to see the Toledan buildings called Mudejar as one of the options within Castilian architecture, to cite Pérez Higuera in *Arquitecturas de Toledo*. Or, as Cynthia Robinson and Leyla Rouhi define its study in *Under the Influence*, "the term refers to the process of textual and artistic movement; . . . where origins are identified, this is done with a heightened consciousness that the product is greater than the sum of its parts" (5). Juan Carlos Ruiz Souza, lamenting scholars' insistence on a "theory of styles" that marginalizes the study of Mudejar, asks, "¿Cuánto tiempo debe pasar para que algo foráneo que fue incorporado a la tradición forme parte de ella misma?" ("Castilla y al-Andalus," 33) [How much time has to pass before a foreign element incorporated in a tradition becomes part of that tradition?]. Or, we might ask, how long does a Muslim, or a Mozarab, or an Arabized Jew have to work with Castilian patrons, secular and religious, before the buildings he constructs are seen simply as Castilian, and not as an exotic style set apart?

Perhaps the most important new synthesis of the problems and possibilities of the groups of buildings that have been traditionally called Mudejar is Ruiz Souza's article "Castilla y al-Andalus: Arquitecturas aljamiadas y otros grados de asimilación." He finds that it is the very tendency to speak in the language of "styles" that keeps us from understanding the nature of Castilian architecture: "Las construcciones medievales de la Corona de Castilla, se comprende mejor desde los baremos de tradición, asimilación e importación, que frente a otros que diferencian la arquitectura realizada en piedra o ladrillo, por cristianos o musulmanes, denominada mozárabe, de repoblación, románica, gótica, o mudéjar" (18). [The medieval constructions of the Crown of Castile are best understood from the accounting of tradition, assimilation, and appropriation, rather than from the point of view of those who separate architecture of stone or of brick, of Christians or of Muslims, that called Mozarabic, repopulation, Romanesque, Gothic, or Mudejar.] That is, we ought to seek the nature of Castilian architecture in its very plural quality, rather than try always to pull the warp and weft from its complex weave of construction, ornament, space, style, language, patronage, and religion. And he finds the conquest of Toledo an "essential" to understand the "assimilation and digestion" of the "Islamic monumental landscape" (21).

The discussion pursued here focuses on the churches of Castile and Toledo in particular, in the centuries following 1085, though the controversy surrounding the term, or of what a Mudejar architecture might be, exists for many of the brick traditions on the peninsula: for those of Aragon, for instance, for which Borrás Gualis provides a rich and varied field of documentation. There is also a lively discussion concerning Seville. Diego Angulo Iñiguez, in *Arquitectura mudéjar sevillana*, has called Sevillian Mudejar "hijo de dos estilos: el gotico importado por los castellanos y el almohade, vigoroso todavía entre los vencidos al tiempo de la Conquista" (6) [the son of two styles: the Gothic, imported by

the Castilians, and the Almohad, still vigorous among the vanquished at the time of the conquest], and Rafael Cómez Ramos has defined the Alfonsine style of church building where Gothic architecture absorbs the aniconic decorative strategies of Almohad tradition in *Arquitectura alfonsi* and in *Las empresas artísticas de Alfonso X el Sabio*.

In this volume we demur from abandoning the word "Mudejar" altogether for the twelfth- and thirteenth-century buildings of Toledo: we use it here as a traditional term that has a strong association with the buildings of Toledo in particular. Toledo's brick-based tradition, with its roots in Roman construction, and its ornamental strategies formed under Islamic rule, survived political change in the late eleventh century and became a powerful visual force in the city in the twelfth and thirteenth centuries, transforming and growing at every point in its history; melding with and stimulating Romanesque building as it went. "Toledan Mudejar" is both "one option" for Castilian patrons and an intrinsic part of Castilian culture in Toledo's rich and overlapping cultural stratigraphy. In this case "Toledan Mudejar" might be used, then, as a traditional term in which the strong ethnic and confessional implications are wholly abandoned, much as Gothic is used today.

But as a group, our community of scholars needs not so much to change the words with which we speak of the monuments of medieval Spain but to "change the very framework of knowledge production," as Ousterhout and Ruggles have proposed in "Encounters with Islam" (84). For the study of Mudejar, this demands exploration of the overly reductive way we use the term: its global application. Can "Aragonese Mudejar" mean Aragon's surviving tradition, without marginalizing it, linking it more closely to all the peninsula's hybrid styles than to its own history, thus privileging the notion of an assumed Christian/Muslim dichotomy in culture over acceptance of a naturally heteromorphous and protean cultural identity? Ever in our thoughts as we explored these territories have been Homi Bhabha's *Location of Culture*, Edward Said's *Culture and Imperialism*, and Edouard Glissant's *Nouvelle région du monde*.

When we turn to fourteenth-century architecture in Toledo and Seville—the synagogue of Samuel Halevi, the Alcazar of Seville, the palace of Tordesillas, and the other Nasrid and Castilian buildings to which they are intimately connected—we feel, with many of our contemporaries, disposed to abandon the term "Mudejar." Here, scholars ought probably to seek, from within the complex and interlocking history of the Castilians and the Nasrids, a term apart.

Rafael López Guzmán, in his dense and valuable survey of Mudejar architecture, presents a fascinating document of 1505, in which the count of Tendilla dictates his desires for the artistic work in the sepulcher of Cardinal Mendoza: "[M]i voluntad es que no se mezcle con la otra obra ninguna cosa francesa, ni alemana, ni morisca sino que todo sea romano" (17). [My desire is that no other work is mixed, neither the French, nor the German, nor the Morisco, but that everything should be Roman.] If "Morisco" corresponds to what we today call Mudejar, it would seem to argue for our partitioning its treatment in our texts, as a style separate from the more European styles used in Spain:

Romanesque or Gothic. But it is interesting to note that among the types of art the count lists—French, German, Roman—"Morisco" is the only Spanish one.

✳

Rodrigo Amador de los Ríos made his mark on the study of Toledo very early, and his *Monumentos arquitectónicos de España: Toledo* included archival and archaeological documentation that is still important today. Gómez Moreno, in *Arte mudéjar toledano*, structured the period's artistic history, a task refined by Torres Balbás and by Basilio Pavón Maldonado in *Arte toledano: Islámico y mudéjar*, who extended it geographically, and made a significant study of ornament.

For Toledo, a complete, brilliantly documented, and sumptuously produced reference of enormous importance is *Arquitecturas de Toledo*, volume 1, *Del romano al gótico*, edited by Rafael del Cerro Malagón in collaboration with María Jesús Sainz, Clara Delgado Valero, María Teresa Pérez Higuera, and María Angeles Franco Mata. The introductions to Islamic Toledo and Mudejar Toledo by Delgado Valero and Pérez Higuera are essential texts, as are their discussions of individual buildings, including plans, sections, and complete photographic documentation. And a key article by Cerro Malagón provides a valuable introduction to the city's urbanism.

This book is most deeply indebted to a series of scholars who have concentrated on Toledo's extraordinary urban fabric, and walked its rich historical and architectural maze. First among them is Pérez Higuera, whose scholarly, accessible *Paseos por el Toledo del siglo XIII* reproduces Castilian Toledo in a valuable book both rich and fascinating. We have profited enormously from this and other of her works, in particular, as regards Toledo, her contributions to *Arquitecturas de Toledo*, her *Mudejarismo en la baja edad media*, and her "Arquitectura mudéjar en los antiguos reinos de Castilla-León y Toledo." María Concepción Abad Castro's *Arquitectura mudéjar religiosa en el arzobispado de Toledo* has been another valuable resource, with historical, typological, and demographic information that deepens our understanding of Toledo's buildings. Her studies have brought her to evoke a series of new terms that help us appreciate the impulse to assimilate as a patron or within the collective consciousness of a society. And Balbina Martínez Caviro has advanced our studies of many Mudejar arts of Toledo, including ceramics, wooden ceilings, and architecture. For this study, we profited in particular from her *Mudéjar toledano: Palacios y conventos*.

For postconquest Toledo we are also indebted to the city's great chronicler, Clara Delgado Valero, whose work on Mudejar Toledo and the transition between the Taifa and Castilian city was fundamental to our understanding. See, in particular, "El mudéjar toledano y su área de influencia" and "El mudéjar: Una constante en Toledo entre los siglos XII y XV," including an introduction to the ample bibliography concerning Toledan architecture and arts not discussed here: woodwork and artesonado ceilings, plaster decoration, and metalwork. Finally, we owe much of our view of Islamic Toledo to her work as a pioneer not only in the close scholarly study of the fabric of the Islamic city but also in the understanding that to separate study of the arts of Christians and Muslims is destructive

to their true comprehension. Among these works, see *Toledo islámico: Ciudad, arte e historia*, *Regreso a Tulaytula: Guía del Toledo islámico (siglos VIII–XI)*, *Materiales para el estudio morfológico y ornamental del arte islámico en Toledo*, *Arte hispano-musulmán*, and her valuable contributions to *Arquitecturas de Toledo*. María Jesús Rubiera Mata's *Arquitectura en la literatura árabe* brings together useful descriptions from diverse primary sources.

Toledo's urbanism is further elucidated by Jean-Pierre Molénat, who wrests from the city its medieval past in "L'urbanisme à Tolède aux XIVe et XVe siècle," and "Places et marchés de Tolède au moyen âge (XIIe–XVIe s.)." In *Gardens, Landscape, and Vision*, Ruggles reevokes the palace of al-Mamun, as described by the historian al-Maqqari, for whom the fantastic crystal fountains built by Toledo's king explicitly recalled the wonders of Madinat al-Zahra. For evidence of Alfonso VI's love of the palaces of al-Mamun, and the specific palaces into which he moved, see the article by Manuel Valdés Fernández, "Patronazgo señorial y arte mudéjar en el reino de Castilla."

The integration of Jewish life and architecture into the urban fabric of Toledo has been studied with considerable care by Pilar León Tello in *Judíos de Toledo*, Julio Porres Martín Cleto in "Los barrios judíos de Toledo," and Ana María López Alvarez and Santiago Palomero Plaza of the Museo Sefardí. See also López Alvarez and Ricardo Izquierdo Benito, *Juderías y sinagogas de la Sefarad medieval*.

The classic study of our lamented colleague Christian Ewert concerning the mosque of Bab al-Mardum, "Die Moschee am Bab al-Mardum in Toledo: Eine 'Kopie' der Moschee von Cordoba," has lately been supplemented by those of the Arabist and architectural historian Susana Calvo Capilla. We have depended on her work, which, in its careful attention to both text and archaeology, has been extremely elucidating concerning the patronage of the mosque and the church, as well as the qubba of the palace of al-Mamun, and the issue of the conversion of mosques in Toledo as a wider topic. Revelatory in particular are "La mezquita de Bab al-Mardum y el proceso de consagración de pequeñas mezquitas en Toledo (s. XI–XIII)," "La capilla de Belén del Convento de Santa Fe de Toledo: ¿Un oratorio musulmán?" and "Reflexiones sobre la mezquita de Bab al-Mardum y la capilla de Belén de Toledo." Geoffrey King has chronicled the history of the mosque type in "The Mosque of Bâb al-Mardum and the Islamic Building Tradition." In "The Church of Santa Cruz and the Beginnings of Mudejar Architecture in Toledo," David Raizman brings his understanding of Toledo's painting traditions to bear on Santa Cruz, unifying studies of architecture and painting that have much too long remained separate. And finally, our new appreciation of the pseudo-Arabic inscriptions of Santa Cruz and San Román derives from a forthcoming article by Abigail Krasner Balbale.

The issue of conversions from mosques to churches has produced important work that has enriched this account. Calvo Capilla has discovered documentation that elucidates the transition between the mosque of Bab al-Mardum and the church of Santa Cruz, and has made an invaluable study of the conversion process in rural nuclei in "La mezquita de Bab al-Mardum y el proceso de consagración de pequeñas mezquitas en Toledo," and "Las mezquitas de pequeñas ciudades y núcleos rurales de al-Andalus," and in Cordoba in "El

entorno de la mezquita aljama de Córdoba antes y después de la conquista cristiana." A number of valuable case studies like these are greatly enriching our understanding of the process and its political and chronological variations, in particular, Eduardo Carrero Santamaría's "De mezquita a catedral: La seo de Huesca y sus alrededores entre los siglos XI y XV." The symbolic implications of mosque-to- church conversions within the discourse of the "reconquest" were studied by Julie Harris in her estimable "Mosque to Church Conversions in the Spanish Reconquest," and Heather Ecker has offered new observations in "The Conversion of Mosques to Synagogues in Seville: The Case of the Mezquita de la Judería," as well as in "How to Administer a Conquered City in al-Andalus: Mosques, Parish Churches, and Parishes."

The church of San Román has long been known in Toledo, and was published in 1845 by José Amador de los Ríos, in *Toledo pintoresco,* and by R. Ramírez de Arellano, in his venerable *Parroquias de Toledo.* Camón Aznar, in "La iglesia de San Román de Toledo," and in "Pinturas murales de San Román de Toledo," introduced its study with newly discovered paintings. See also Torres Balbás, "Por el Toledo mudéjar," and Walter William Cook and José Gudiol Ricart, *Pintura e imaginería románicas.* Pérez Higuera has most clearly defined its complex archaeology and history in *Arquitecturas de Toledo* and *Paseos por Toledo del siglo XIII,* correcting Torres Balbás's earlier chronology ("Por el Toledo mudéjar," 433). The ideas in our volume are developed more fully in Dodds's "Rodrigo, Reconquest, and Assimilation: Some Preliminary Thoughts about San Román."

A recent book for a general public by Abad Castro, *La iglesia de San Román de Toledo,* encapsulates its diverse history in an accessible and useful way, although the author hints at a chronology for the paintings that sees the decorative Islamic motifs as part of a preconquest cycle that is earlier than the figurative paintings. Carmen Rallo Gruss has shown that the paintings are, in fact, contemporary in her *Aportaciones a la técnica y estilística de la pintura mural en Castilla a final de la edad media.* In *Iglesia de San Martín de Valdilecha* Bango Torviso relates the paintings of San Román to Valdilecha.

In an exciting, comprehensive treatment of the monastery of Las Huelgas in Burgos, Gema Palomo Fernández and Juan Carlos Ruiz Souza have unraveled the puzzle of that intriguing and perplexing mixture of Gothic and Islamic forms. Their new chronology, which flows easily with what we know about history and deepens our understanding of its patrons, is an important contribution to the analysis of the kinds of relationships that can exist among monuments, cultural expression, and internal politics.

The court arts of fourteenth-century Castile, centering in the synagogue of Samuel Halevi in Toldeo and the Alcazar of Seville of Peter the Cruel, are increasingly treated outside the nomenclature of Mudejar, as their specific character is better understood, from within their historical and archaeological context. Such individual treatment is called for in "The Alcazar of Seville and Mudejar Architecture," a carefully reasoned article by Ruggles. Cynthia Robinson suggested a bold connection between Islamic and Christian devotion at Tordesillas that is intriguing, but still awaits resolution in "Mudéjar Revisited: A Prolegomena to the Reconstruction of Perception, Devotion, and Experience at the

Mudéjar Convent of Clarisas, Tordesillas, Spain (Fourteenth Century)." We are indebted to Carmen Rallo Gruss for her technical expertise throughout.

In understanding fourteenth-century architectural production and the close relationship—in terms of both patronage and workshops—with Nasrid Granada we have depended on the work of Ruiz Souza, in particular, whose close readings and meticulous chronologies of architecture during the reign of Peter the Cruel have transformed our understanding of the monuments and the moment in which they were made. The relationship is defined in his many studies of Tordesillas. In "El palacio de Comares de la Alhambra de Granada: Tipologías y funciones; Nuevas propuestas de estudio," Ruiz Souza disengages from a monolithic vision of Nasrid artistic production to suggest a lost portal at the Alhambra and the strong relationship between palatine spaces in Castilian and Nasrid palaces. His conclusions, notably in "Castilla y al-Andalus: Arquitecturas aljamiadas y otros grados de asimilación," that the Castilian and Nasrid use of this same style and many typologies are based in a notion of the unchallenged central state have profound implications for linking the formation of the Spanish nation-state to Castilian intimacy with al-Andalus. Besides the studies of Ruiz Souza, for the Alcazar of Seville, the documentation and reconstruction of Antonio Almagro Gorbea have been indispensable, as are his extraordinary digital animations of the interior of the Alcazar in different moments of its history. And the archaeological studies of Tabales Rodríguez are constantly challenging old assumptions in intriguing ways.

Foundation studies, including the translation of the inscriptions of the synagogue of Samuel Halevi, come from Francisco Cantera Burgos, *Sinagogas españolas, con especial estudio de la de Córdoba y la toledana de El Tránsito, Sinagogas de Toledo, Segovia y Córdoba*, and more recently from the studies of Ana María López Alvarez and collaborators. See also Dodds, "Mudejar Tradition and the Synagogues of Medieval Spain: Cultural Identity and Cultural Hegemony," and the valuable corrected chronology in Ruiz Souza, "Sinagogas sefardíes monumentales en el contexto de la arquitectura medieval hispana." His fourteenth-century date for the so-called synagogue of Santa María la Blanca in Toledo supersedes the proposals of Natascha Kubisch in *Die Synagoge Santa Maria la Blanca in Toledo: Eine Untersuchung zur maurischen Ornamentik*.

Concerning the Alhambra in general, we have rested both on the classic studies of Oleg Grabar and Antonio Fernández-Puertas and on more recent studies: Díez Jorge's *El palacio islámico de la Alhambra: Propuestas para una lectura multicultural*; Orihuela Uzal's *Casas y palacios nazaríes*; and the interpretive reconstructions of Ruiz Souza, in particular, "El palacio de Comares de la Alhambra de Granada: Tipologías y funciones; Nuevas propuestas de estudio" and "El Patio del Vergel del real monasterio de Santa Clara de Tordesillas y la Alhambra de Granada." These were augmented with the works brought together in Navarro Palazón's indispensable *Casas y palacios de al-Andalus*, and in Dodds, *Al-Andalus: The Art of Islamic Spain*. Our understanding of the meanings of the texts, architecture, and decoration of the Alhambra have been illuminated through the work of the philologist and art historian José Miguel Puerta Vílchez, in particular his *Códigos de utopía de la Alhambra de Granada*. And for its gardens, we turned as ever to Ruggles, in this case, "The Eye of Sovereignty: Poetry and Vision in

the Alhambra's Lindaraja Mirador" and "The Gardens of the Alhambra and the Concept of the Garden in Islamic Spain."

Languages and Literatures

In the 1850s the most influential Spanish public intellectual was José Amador de los Ríos. In June 1859, he gave his inaugural speech to the Real Academia de Bellas Artes de San Fernando in Madrid and ushered onto center stage the word *mudéjar* as a way of explaining monuments with which he had been grappling for decades. He called them "marriage of Christian and Arab architecture": "Hablo de aquel estilo, que tenido en poco, o visto con absoluto menosprecio por los ultraclásicos del pasado siglo, comienza a ser designado, no sin exactitud histórica y filosófica, con nombre de mudéjar" (*El estilo mudéjar en arquitectura*, 7). [I speak of that style, held in little regard or viewed with absolute scorn by the ultraconservatives of the past century, that is starting to be designated, not without historic or philosophical precision, by the name Mudejar.] See the 1965 critical edition, edited by Pierre Guenoun, which includes a helpful introduction and extensive notes on the variant manuscript and printed versions of Amador's text.

And yet, Amador was a scholar who worked in both literary and architectural history —beyond that he was also an artist, as well as a prominent player in the tumultuous public life of Spain at that moment. Amador was in fact the author of the most important literary history of the time, a work that long dominated how Spain's literary history was structured and perceived. His *Historia crítica de la literatura española* is a seven-volume work published between 1861 and 1865, that is, virtually immediately after he had delivered his Mudejar speech of 1859, and it seems logical to assume that he had already been working for some time on at least the early volumes, those that deal with medieval literature—the literature of the same period as the buildings he was about to bring to the public's attention. Amador's long-canonical (and, in many ways, still-influential) literary history is worth contemplating side by side with his seminal insights about architectural history, among other things because he fearlessly tackles the question of just who are the legitimate peoples and cultures that belong to the "historia de la literatura española." He begins with the Romans, from the earliest moments of their recorded writings in the peninsula; continues with the Christians of the Roman world; and after the fall of Rome, includes the Visigoths. This trajectory leads to Isidore and from there to the popular Latin poetry of the last years before the Islamic conquest. The first volume ends with the legendary materials concerning the last of the Visigoths and, without skipping a beat—or at all ignoring the overwhelming shifts in power and social structures and religions that follow—continues with the "escritores cristianos del Califato" (Christian writers of the caliphate). One might quarrel with the ideology that underpins this trajectory, which establishes that the Spaniards are defined first by geography and second by conversion to Christianity. But as with much else in Amador's work, it has the merit of defining the complex terms forcefully: it is not simply a matter of geography nor of a single language, but rather of a clear identity, unembarrassedly defined. Amador's work extended further still in its attempt to

cover all the peoples of the peninsula: a decade after the last volume of the literary history came out, Amador published his three-volume history of the Jews of Spain.

There is an enduring acuity—a revolutionary quality and a sense of surprise, both enhanced by our knowledge of his overt pieties and politics—in Amador's insights about the deep impressions, the primal imprinting, of the values of Spanish Islam that are vital to Castilian culture at its very beginnings. And Amador makes crystal clear in several extended passages in his address before what must have been a somewhat puzzled audience of Madrid's learned Catholic gentlemen, that while he chose to focus on the Islamicizing architectural style of the ascendant Castilians, the whole of medieval Castilian culture, as he saw it, was informed by the same fundamental principles of adaptation of Arabic and Islamic forms. These were made possible and attractive—rather than impossible or unattractive—by military victories and religious triumphalism: "Oriente y Occidente, templada, si no despuesta la Antigua ojeriza de los cristianos, comenzaban a enlazar con vínculos duraderos los frutos de la inteligencia. . . . Ni las ciencias, ni las letras, ni las artes de hebreos y mahometanos fueron ya sospechosas al rey [Alfonso X] (22). [East and West—the age-old spite of the Christians tempered, if not resolved—began to join the fruits of intelligence together with lasting bonds. . . . Neither the sciences, nor literature, nor the arts of the Jews and Muslims were ever suspicious to the king.] Key moments in Amador's speech, on the intertwining and shared values of aesthetic forms, for example—"Rara parecerá sin duda en aquellos días tan estrecha correspondencia entre artes y letras; pero no otra es la enseñanza que nos ministran los monumentos" (23) [Such close correspondence between arts and letters would undoubtedly seem rare in those days; but the lesson the monuments offer us is none other]—or on the ubiquity of the adaptations from the "mahometanos"—"Y no se había limitado por cierto este precioso legado a las esferas del arte de construir" (61) [And this precious legacy was certainly not limited to the spheres of the art of building]—might well have spawned rewritings of literary and intellectual history along Mudejar lines. But although Amador's deceptively radical reimagining of the nature of early Castilian culture provoked a new kind of dreaming of the past in architectural history, it would be nearly a century before a broader critical appreciation of what Mudejar might mean made its way into all the other cultural realms that Amador had rightly noted were inseparable from the architectural forms, and it remains rare enough in literary studies.

"Nada pués, más tangible que el solemne testimonio de los cuatro epitafios hispalenses respecto a un concepto político *que sólo puede llamarse 'mudéjar'* y que no se muestra concebible en ausencia de la fuerte peculiaridad del medioevo español." [Nothing is more tangible than the solemn testimony of the four Sevillian epitaphs with respect to a political concept *that can only be called "Mudejar"* and that proves to be inconceivable in the absence of the strong peculiarity of the Spanish medieval period.] This is the uncompromising description of an exhibition catalog titled *Mudejarismo: Las tres culturas en la creación de la identidad española*. The editor and principal essayist of the lovely volume is Francisco Márquez Villanueva, and he is describing the book's cover, a composite of the four language

inscriptions on the tomb of Ferdinand III of Castile. His description of that remarkable monument reveals the extent to which Mudejar, for the past half century or so, has been cultivated as something of a badge of honor for those who follow the path of Américo Castro. Castro was in most ways Spain's most influential—and provocative—twentieth-century literary historian and theoretician. Like many other intellectuals of his generation, he lived and worked in exile after the Spanish civil war. It was Castro who coined the term *convivencia* and made the whole notion of a universe of cultural syncretism a vital one—even when it is being disputed—for the study of Spanish culture in the Middle Ages and far beyond.

Castro's own use of *mudéjar* as regards literature—he calls it "mudejarismo literario"—is telling, and illuminates the perils of taking the confessional status of the individual builder as a starting point for a very broadly based cultural attitude and process. The great scholar's definition, as it appears most succinctly in a discussion of the *Libro de buen amor*, is formulaic: "Su arte consistió en dar sentido cristiano a hábitos y temas islámicos, y es así paralelo al de las construcciones mudéjares tan frecuentes en su tiempo" (*España en su historia*, 360). [Its art consisted of giving Christian meaning to Islamic habits and themes, and is thus parallel to that of the Mudejar buildings so frequent in their time.]

So just what would it mean, in the history of Castilian literature, to describe any work of literature as Mudejar? If it is, as Castro suggests, the adaptation of "Islamic" (or, in some cases more accurately, Arabic) motifs and styles or purposes—in poetry or prose—by authors who were not themselves Muslims, and who were writing in the new language of the Castilian empire, then it might be easier to itemize the works that are not Mudejar. From the *Calila e Dimna* to the *Conde Lucanor*, from Alfonso's *Cantigas*—performed on what we must then presumably call Mudejar instruments—to the *Libro de buen amor*, the rise of the vernacular as the language of belles-lettres and high culture is inseparable from the inevitable cultural *mudejarismo* of the historical moment in Spain. Aren't we setting apart, and exoticizing—with a term that if widespread in art history is far rarer and more exotic in literary studies—what is in fact, more simply, one of the several branches of Castilian letters (and, arguably, its dominant and triumphant one, through the middle of the fourteenth century)? Once again, we can protest with Ruiz Souza, "How much time has to pass before a foreign element incorporated in a tradition becomes part of that tradition?" And in literature the Mudejar label is potentially even more misleading since, among other reasons, the authors of what some would like to christen Mudejar literary works—beginning but not ending with Alfonso X himself—were hardly Mudejares, or any other marginal member of Castilian society.

Nevertheless, the Mudejar concept and terminology has for some years now been embraced by a small number of writers and literary scholars who use it to mean something more generally hybrid, and embracing of Arabic forms, than anything technical. Beyond Márquez Villanueva, and now eminent students of his such as Luis Girón Negrón, we note that Juan Goytisolo, for example, has long happily described himself as a Mudejar writer. One of Márquez Villanueva's books is dedicated to Goytisolo, and he has written

about him and his ideological and literary connections to the period of Castilian culture we explore here; see especially his "Lenguajes de ultratumba en Juan Goytisolo," as well as María Rosa Menocal's "'Spanish-Speaking Moor' of Marrakesh." Luce López-Baralt has used the term for many years now and also writes lovingly about Goytisolo and his mudejarismo in the last chapter of her 1985 *Huellas del islam*, titled "Hacia una lectura 'mudéjar' de *Makbara*," using the term not in any technical historical way, dependent on knowledge or perception of Mudejares as such, but as a metaphor, to mean what is hybrid in Spain, as she puts it in the subtitle of the original edition of the book, from Juan Ruiz to Juan Goytisolo.

The considerable problem, of course, is that this might suggest that the hybrid is unusual, rather than foundational, in Castilian letters. Furthermore, there is both irony and a certain obscuring involved in adopting this name that suggests that it was from the margins—those Muslims who stayed behind—rather than the center—the Castilians who consciously chose those aspects of Islamo-Arabic culture that pleased them or that they admired or that brought prestige or utility to their nascent culture. For these and other reasons we were tempted to use this study as the basis for an extended and explicit argument against the use of the term "Mudejar" in cultural studies of medieval Spain, but that impulse to proselytize was tempered, among other things, by the realization of how difficult it is to dislodge critical terminology, even when there is widespread recognition of its inadequacy. In Islamic and Arabic studies the classic case of this—and one of direct relevance to the problems posed by Mudejar—was the valiant attempt, by Marshall Hodgson, in *The Venture of Islam*, to replace "Islamic" with "Islamicate" since, much as in the case of Mudejar, he understood that the terminological association with the religion obscured the extent to which the cultural transcended the religious: "'Islamicate' would refer not directly to the religion, Islam, itself, but to the social and cultural complex historically associated with Islam and the Muslims, both the Muslims themselves and even when found among non-Muslims" (59). Another closely related attempt to replace or eliminate misleading monikers in medieval Spain is that of Thomas Burman, who spent some time and effort attempting to convince the scholarly community to replace "Mozarab" with "Andalusi Christian." Although art historians recently have begun to abandon use of the term "Mozarab," in other realms, Burman has not had the success he would have wanted; see his narrative of this on pages 7–9 of his *Religious Polemic and the Intellectual History of the Mozarabs*. The one area in which a change appears to be almost fully accomplished is in the linguistic realm. As Consuelo López-Morillas explains: "The time-honored name for the form of Hispano-Romance spoken in Muslim-held territory, 'Mozarabic,' now provokes dissatisfaction among some scholars . . . it has been objected that the term straddles ambiguously the realms of religion and language, and further implies, erroneously, that the dialect was spoken only by Christians" ("Language," 46–47). Increasingly common now is the term *romance andalusi* or "Andalusi Romance," although it needs to be understood, as López-Morillas points out, with various caveats, notably that it must not be imagined that this Romance was significantly different from those varieties of Romance spoken in Christian territories, although it would have had a higher proportion of Arabic loan-

words. In all these cases the difficulties are much the same, and rooted in the lack of complete correspondence between religion and other elements of identity—language, ethnicity, architectural styles, poetic tastes.

<p style="text-align: center">✳</p>

Michael Sells's dazzling translations of pre-Islamic poetry, and of the early suras of the Quran to which that poetry is linked, together provide the best introduction to the earliest traditions of poetry, as well as to that distinctive language-worship of Arabic culture. We are grateful to be able to quote from these, as well as from Sells's version of Ibn Zaydun's "Nuniyya." Readers wishing to explore the Quran beyond the "Early Revelations" might consult the highly accessible Ahmed Ali translation (which includes the Arabic original) or even the University of Southern California's web site "Compendium of Muslim Texts," which provides a line-by-line comparison of three major English-language translations of this fundamental text. A good introduction to the long and complex traditions of classical Arabic poetry may be found in Robert Irwin's narrated anthology *Night and Horses and the Desert*, while *An Introduction to Arab Poetics* (by one of the contemporary world's most distinguished poets of Arabic, Adonis) is an original and provocative presentation of the Arabic poetic traditions, reasonably accessible to scholars with limited knowledge of the Arabic literary tradition.

Translations of Hispano-Arabic poetry into English are limited. James T. Monroe's 1974 anthology with facing-page Arabic texts is still immensely useful, especially for its close relationship with the Arabic originals, and also provides a broad historical introduction to Arabic poetry in Spain. Translations into English based on García Gómez's Spanish translations from Andalusian Arabic poetry are among the best English renderings, despite the distance from the originals. These include Cola Franzen's highly regarded 1989 *Poems of Arab Andalusia* and the elegant *Andalusian Poems* by Christopher Middleton and Leticia Garza-Falcón from 1993. Both provide the reader with a distinct sense of the allure and grace of this poetry and we are grateful to be able to cite from these two collections. Additionally, selections from the thirteenth-century anthology by Ibn Said al-Maghribi (also first made widely accessible in editions and translations by García Gómez) known in English as *The Banners of the Champions* are available in James Bellamy and Patricia Owen Steiner's 1989 volume. This mid-thirteenth-century *diwan*, or poetic anthology, was the basis for García Gómez's seminal anthology, *Poemas arábigoandaluces*, a landmark work of translation from Arabic into Spanish that first appeared in 1930 and, like García Gómez's translation of Ibn Hazm's *Tawq al-hamama*, *El collar de la paloma*, of 1952, was highly influential for Spanish intellectuals and poets. The two English translations of Ibn Hazm's *Tawq* are infelicitous, although A. J. Arberry's is arguably preferable to A. R. Nykl's; both the García Gómez Spanish translation and now especially the beautiful new French translation—appropriately titled *De l'amour et des amants*—by the distinguished French Umayyadist Gabriel Martinez-Gros, would serve any reader far better. An excellent overview of Ibn Hazm's vast oeuvre in the historical context of his adventure-filled life is to be found in Eric Ormsby's essay in

the *CHAL*. García Gómez's enduring importance as anthologist and translator, and as the senior Spanish scholar of Hispano-Arabic poetry for so many years, cannot be underestimated. And as Ormsby points out, his translation *El collar de la paloma* became an important work in its own right in the canon of twentieth-century Spanish letters as, for that matter, did his *Poemas arábigoandaluces*.

A number of younger scholars in Spain have produced some exceptionally useful work in this area, and of special interest here are anthologies of translations, as well as general studies, aimed at making the poetry available to contemporary Spaniards. See especially Teresa Garulo's *Literatura árabe de al-Andalus*, an excellent synoptic history filled with fine translations. Her *Diwan de las poetisas de al-Andalus* is an invaluable round-up of the surviving verses, along with what relatively little is known, of the women poets of Islamic Spain; other contributors to this field include María Jesús Rubiera Mata. See also the charming and original 1995 volume titled *Taracea de poemas árabes* (lavishly published with the help of the Legado Andalusí), which includes Spanish translations of Arabic poems from al-Andalus in the context of the classics of Arabic poetry from other parts of the world (al-Mutanabbi and Abu Nuwas, for example) as well as modern Arabic poetry, with a special interest in poetry that reflects on the lost splendors of Spain, including an excerpt from the famous "Andalusian Ode" by the preeminent Palestinian poet Mahmoud Darwish.

The *CHAL* volume includes chapters on the poetry of Arabophone Spain, on which we rely, and which are of great use to the scholarly reader. See especially the chapter on the muwashshah, as well as articles on the preeminent Arabic poets who are centrally part of the canon at the heart of the Toledan poetic tradition: Ibn Hazm, Ibn Quzman, Ibn Zaydun. Other scholarly introductions to the Andalusian chapters of Arabic literary history are available in Jayyusi's *Legacy of Muslim Spain*. Jayyusi's own essays on the major poets and poetic themes are focused on the long-central question in this field of whether Andalusian poetry is just another branch of the classical Arabic traditions, displaced from the centers of the Arabic world but very little affected by the local geography or culture; or, instead, whether the poetry is distinctively Andalusi—what Jayyusi, with obvious skepticism, dubs "deterritorialised." She comes out decisively against this latter view, thus against a number of the canonical studies of the twentieth century and, indeed, against current prevailing opinion.

The classic work on the originality and particularity of the poetry of the Taifa period is Henri Pérès's great *Poésie andalouse en arabe classique au XI siècle* (originally published in 1937, second edition 1953), the very title of which reveals his view: that in the century after the collapse of the Umayyad caliphate Arabic poetry was shaped by the particularities of local conditions—and variations—as much as by the classical conventions. Pérès focuses both on the ethnic and cultural mélange that was al-Andalus by this point (and that was understood explicitly by Muslims) and on the departures from Arabic classicism in poetry these helped cause and sustain. Although many have since quarreled (and we might also do so) with one aspect or another of his presentation of Andalusian poetry in a context of nascent "nationalism"—that is, of local particularities in the forms, and especially in the themes, of a poetry that is thus distinctively local and Andalusian rather than Arabic that might

have been written anywhere else in the Arabophone world—the book remains an invaluable and in many ways unsurpassed introduction to the documentary evidence of the poetry of the period, inside its complex political universe.

In the years before the quarrels between Américo Castro and Claudio Sánchez Albornoz, Pérès presents something of a fusion of the two, avant la lettre: there is something exceptionally "Spanish" that transcends historical moments—once expressed in Latin, later to be articulated in Spanish—but the Islamic and the Arabic are also one of its central and shaping chapters. Among other things, Pérès makes clear that the abundant poetry of the Taifas was composed within a universe of Andalusian Muslim antagonism toward the ascendant Berbers of North Africa, that poetry itself—and the near obsession with it—was iconic of what the Andalusians believed to be their differences with (and superiority to) their coreligionists. Ruggles's "Arabic Poetry and Architectural Memory in al-Andalus" is an engaging supplement to these meditations, as well as an immensely useful inventory of the nostalgia of later Andalusian poets—such as Ibn Zaydun—for the glories of the lost Umayyad caliphate, symbolized by the gardens and splendors of Madinat al-Zahra. The excellent 1983 Spanish translation of Pérès's French original by Mercedes García-Arenal loses something of the directness of the title (*Esplendor de al-Andalus*) but little else, and adds an invaluable *apéndice bibliográfico*. Of historic interest is the review of the original book by Emilio García Gómez, written in the middle of Spain's searing civil war (annotated "Escrito en Valencia, 1938") and resonant with a sense of the various and in some cases overlapping levels of historic tragedies (as well as containing García Gómez's Auerbach-like statement about having had to write without any access to books). This appears in the single *Al-Andalus* volume that covers 1936–1939.

The quintessential Andalusian poetic invention has generated a vast bibliography since Samuel Stern's 1948 "discovery" of the bilingual muwashshahat (the plural form of the singular *muwashshah*, although we prefer to refer to the genre as "ring songs") but this is by and large for specialists only. Histories of the whole range of scholarly controversies are readily available in sources such as the articles by James Monroe in the Jayyusi volume and Tova Rosen's exemplary and comprehensive presentation in the *CHAL*. Several dedicated volumes of bibliography exist (Hitchcock; Hitchcock and López-Morillas) as well as an extended discussion in the bibliographic essays of Menocal's *Shards of Love*. A great deal of the research and scholarly writing on the muwashshahat is concerned exclusively with the matter of "origins" in ways that pose the question dichotomously, as if the Arabic speakers and the Romance speakers were from different universes (much as the scholars that work on those different languages are, most of the time, from very different academic divisions). A prominent exception is Monroe, far and away the leading scholar of the provocative and linguistically difficult poetry of Ibn Quzman. Monroe has stimulated a thorough rethinking of the conventional chronology of the mixed-language poetic forms with his work positing what is for many a counterintuitive relationship of muwashshah to zajal: that the zajal precedes the muwashshah, rather than the other way around. In other words, Monroe mantains that thoroughly vernacularized (and thus Romanized) Arabic lyric forms precede

the invention of what are then "classicizing" and in many ways nostalgic ring songs, with their separate stanzas in classical Arabic, on one hand, and the refrains in the vernacular, on the other. Ibn Quzman's poetic corpus—among the most important markers of how poetry continued to thrive under the in-principle antipoetry Almoravids and Almohads—comes down to us in one extant manuscript, first published by García Gómez in 1972, and it includes the muwashshah we present here, the single surviving exemplar of that form from Ibn Quzman's pen within his iconic body of zajals.

Recent studies by a growing number of scholars transcend purely philological questions—bypassing and trumping the damaging older and reductive dichotomy of is it Arabic versus is it Romance, or either one of them versus Hebrew, the language in which the muwashshahat first deciphered by Stern were composed. The best of these point explicitly instead to the broadly dialogic nature of this Andalusian innovation, and it is perhaps not surprising that the work of the principal students of the Hebrew poetic traditions is exemplary in this, as in other regards. Angel Saénz-Badillos has recently published an invaluable review of this body of scholarship in all its various languages. In English, a refined and yet accessible introduction by Dan Pagis is available in the collection of lectures titled *Hebrew Poetry of the Middle Ages and Renaissance*, and Raymond Scheindlin's highly useful anthologies of translations—*Wine, Women, and Death* and *The Gazelle*—with facing-page Hebrew texts, are now readily available as Oxford University Press paperbacks. We are fortunate to be able to quote from the extraordinary new volume of translations of Hebrew poetry from both Islamic and Christian Spain by Peter Cole, which takes its enchanting *Dream of the Poem* title from Mahmoud Darwish's "Andalusian Ode." Cole's various volumes have veritably transformed the field, making available a vast body of Spain's Hebrew poetry —with its profound intertwinement with the Arabic poetry of the moment—in stunningly evocative verse. On the intimacies of the Arabic-Hebrew symbiosis in the poetry of the peninsula, and on the resulting "golden age" of poetry, no scholar has contributed more to our understanding than Ross Brann, in his several books and in his encyclopedic, as well as specialized, articles. A newcomer to the field would probably want to approach the subject through Brann's panoramic pieces in the CHAL, on "The Arabized Jews" and on the most iconic of Andalusian poets, Judah Halevi. While Brann's insights here begin in a consideration of the Hebrew poetry of the Arabophone Jewish community, they are of great value to all students of this field, and help in understanding the complexities of the mixed-language forms, such as the muwashshah.

For innovative work among younger scholars, see Alexander Eben Elinson's 2001 article in *Medieval Encounters*, which puts the muwashshah into the classical Arabic context of *muarada* ("literary imitation")—or riffs—on an "original" and provides the structure for a dialogue between (in effect) tradition and innovation. Although Elinson's focus is on the variations of panegyrics (a vital part of the tradition of classical Arabic poetry everywhere, and for it in Spain, see Gruendler in the CHAL), his articulate insights here illuminate the issues of cultural admixtures and the ways Andalusian poetic forms made these focal points of the poetry itself. Vitally, he points out that what we are all-too-used to seeing as

different linguistic traditions are really "a single, multi-faceted literary culture. . . . The poets lived in the same place (al-Andalus), at the same time, spoke the same language (Arabic), and, to a large extent, shared a common literary background (at least as far as the Arabic literary tradition was concerned)" (195). Lourdes Alvarez's 2005 article "The Mystical Language of Daily Life" (as well as her forthcoming book, *Sufi Songs across an Andalusian Sky*) focuses on the thirteenth-century mystic Shushtari, relatively unknown in European scholarship and canon (especially in comparison to Ibn Arabi) precisely because of his use of Arabic vernacular and the great "popular" forms of al-Andalus, the muwashshah and the zajal. Her article provides an exemplary overview of the questions of those forms, their rise and nature in al-Andalus, and basic sources (see particularly pp. 7–9), as well as of the question far more rarely presented to European scholarly audiences, that of the relationship between classical Arabic and the Andalusian vernacular (for which see also the fine article by López-Morillas in the CHAL). Alvarez offers illuminating discussion of the bare survival of manuscripts of Andalusian poems, as well as on the matter of language, and presents the case of Shushtari in the underappreciated context of the privileging of a vernacular in Spain/Andalus: "Why would a man of noble background with an excellent education in letters and the religious sciences begin composing songs in vulgar Arabic, and more surprisingly, make a practice of singing them in the medieval equivalent of the red-light district? Does the choice of form or linguistic register reflect anything other than a subjective artistic choice or perhaps a literary fad?" (12).

The other vexed and perhaps finally nearly exhausted issue in this realm is that of the relationship between the lyric and song traditions of the Iberian Peninsula and the "troubadour" traditions that were long iconic of the earliest European culture. See Menocal's *Arabic Role in Medieval Literary History* for a detailed narrative of the scholarship on the subject; see also Américo Castro's brief note "Mozarabic Poetry and Castile" for an early and pointed meditation on why a lyric poetry never arose in Castilian, which ceded that ground to other languages. For an updated and comprehensive recounting of the dozens of scholarly debates and ruptures involved in this highly fraught area of the relationships among the various lyric traditions, see Cynthia Robinson's exhaustive *In Praise of Song: The Making of Courtly Culture in al-Andalus and Provence, 1005–1134 A.D.* Beyond her presentation of past and contemporary scholarship, Robinson's own contribution is to deal with the question in a satisfyingly broad and synthetic courtly context, bringing to bear considerations of architecture and luxury goods, as well as the usual poetry. She rightly brings home to readers from all disciplines the ways in which material culture and literary culture are ultimately inseparable from each other. This study is at the same time a tour de force on the deep and broad attractions that the Taifa court culture held for Christians both inside and outside the peninsula, creating a vivid picture of the nearly magical courtliness of Saragossa.

The historian George Beech has also produced invaluable work pinpointing the numerous historical ties that bound William of Aquitaine, legendary "first European poet" to the Saragossan court and the Iberian milieu in general, and we have relied on his

pathbreaking study "The Eleanor of Aquitaine Vase, William IX of Aquitaine, and Muslim Spain" for the details of that wonderful story. The role of the qiyan in the fallout from the taking of Barbastro is discussed in various sources, but for this, as well as for the wealth of connections of every sort between the Arabo-Islamic dominion in the peninsula and the various Christian polities, both south and north of the Pyrenees, and from virtually every century, we gratefully rely on Roger Boase's masterful studies, especially his 1976 book and his "Arab Influences on European Love-Poetry" in the Jayyusi volume. That same volume provides a meticulous overview by Owen Wright of the closely connected—indeed, at times inseparable—question of music, which includes instruments as well as the musical forms that we call poems, forms like the zajal and the ring song. The musical dimension is especially vexing since there is no way of reconstructing the melodies of this wide-ranging cultural phenomenon, which was both courtly and popular, and whose traces can be more difficult to recover. Here too the relationship between the Christian north and the Islamic south has long been disputed, although scholarship in recent decades largely favors the view that there were nothing like boundaries here—especially given the number of shared instruments, something highly visible in the illuminations of Alfonsine manuscripts. Dwight Reynolds's "Music" article in the *CHAL* is an excellent complement to the Wright piece, as is his informal but wide-ranging and highly engaging radio interview on "al-Andalus" published on the "Afropop" web site for world music (http://www.afropop.org/multi/interview/ID/57/Al-Andalus-Dwight+Reynolds). Here Reynolds makes the strongest possible case for the musical intertwinement of the various cultural spheres of the eleventh through thirteenth centuries: the Islamic Taifas and then Almoravid and Almohad polities, the courts of southern France, and the ascendant Castilian kingdom, which would eventually produce the *Cantigas*, whose manuscripts reveal the wealth of instruments from the Islamic world that had been fully adopted by that time. This perception of the profound interconnectedness of these musical traditions has filtered into the practices of a number of musical groups that specialize in the performance of early music, including the Boston Camerata and the Ivory Consort.

The optimistic scholar—and we count ourselves in this class—would suppose that twenty-first-century scholarship will proceed with the ever-more-widely shared assumption that there was a continuum of shared cultures among the Islamic courts of the Taifas and the new peninsular Christian courts, which, in the vital decades of the late eleventh and early twelfth centuries, were, like Toledo, at first little more than the Islamic spaces and cultural practices rather directly appropriated by Christian conquerors. Both of these were in turn connected to the universes of Langued'oc, the courts of what we call southern France or Provence or Aquitaine—none of which was any great distance, either linguistically or geographically. There is the occasional exception to the very general tendency to view this as a cultural continuum, and thus to understand the music and poetries of these areas as contiguous and at times overlapping. A curious recent example of this is J. A. Abu-Haidar's *Hispano-Arabic Literature and the Early Provençal Lyrics*, whose agenda is to deny both the role of Romance in the invention of the muwashshah and the role of the

Hispano-Arabic canon on that of Langued'oc, but this is an idiosyncratic study and an increasingly unusual scholarly posture.

Indeed, even beyond the purely scholarly domain, and in the bellelettristic universe, there is growing appreciation of the porousness of what we used to think of as boundaries, and the commensurate entanglement of the poetries; see, for example, the luminous presentation of the early Provençal poets (and their attraction for poets like Ezra Pound, as well as himself) in W. S. Merwin's half-autobiographical *Mays of Ventadorn*, from which we are pleased to quote the translation of the famous poem of that "first troubadour," William of Aquitaine. In the scholarly domain that deals with medieval French literature beyond Provençal poetry, a growing body of work dwells precisely on the pivotal and formative nature of these relationships—Aucassin and Nicolette, Floire and Blancheflor, most famously— depicted in many texts as "mixed" couples. What seems increasingly noteworthy is the self-consciousness about this intense and ambiguous relationship between a Muslim (or Arabized) universe and a Christian one, especially at the watershed moment when vernacular literatures and secular cultures were ascendant, and the complexity of vision—in the romances and epics—of the "Saracens" and their alluring culture. See, for example, the article by Sarah-Grace Heller, or the more extensive work of E. Jane Burns, both focused on the iconic importance of fashion and textiles in the representation of status and luxury; the essays by Catherine Sanok and Marla Segol, or the book by Lynn Ramey. Most recently, in her *Medieval Boundaries: Rethinking Difference in Old French Literature*, Sharon Kinoshita has taken on many of these different strands in a synthetic way, and understands the relationship to be foundational: "It is, I suggest, French contact with these lands [Spain]— familiar yet foreign, where the boundary between self and other was not always self-evident —that underlies many vernacular texts of the twelfth and early thirteenth centuries" (8).

<p style="text-align:center">✳</p>

"The finest Hebrew poetry of the period is the product of an age of translation. But translation, particularly in an age of translation, is not only what hired or inspired workers have rendered into another language; it is also what writers who read in multiple languages translate in thought alone—the force of which is brought to bear on the written language they use. This, granted, is simply influence; in this instance, however, it is influence born of a steady passage across linguistic and regional borders. . . . The Muslim and Jewish thinkers in Baghdad and Spain had at their disposal, in addition to a large body of original Arabic and Hebrew compositions, versions of over a hundred works by Galen, most of Aristotle, key books of Plato, Neoplatonic pseudo-Aristotelian texts, pseudo-Empedocles, Indian stories, Persian musical treatises, scientific collections of a diverse nature, mathematical studies of conics, spherics, and pneumatics, medical textbooks, and more" (Peter Cole, "An Andalusian Alphabet" prefatory to *Selected Poems of Solomon Ibn Gabirol*, 23–24).

There is little doubt that translation—conceived both broadly and technically—was one of the great engines of cultural development and change throughout the period, and in the cultures, encompassed in this book. And the concept of translation—or *traslatio*—

and the various ways language, empire, conversion, and the construction of cultural identity are related is one of the great topics of intellectual historians, and others, in recent decades. Thomas Greene, studying the Renaissance and its self-conscious association with the classical world, has written movingly about the translation and imitation of literature in *The Light in Troy*, and Walter Benjamin has also written extensively about translation, reproduction, and imitation, most famously in his essays "The Work of Art in the Age of Mechanical Reproduction" and "The Task of the Translator," both included in a much-reprinted translation edited by Hannah Arendt and titled *Illuminations*. Benjamin saw translation as a mode of transmitting some aspect of an immutable "original" in what is an inevitably changed form: "Translation is so far removed from being the sterile equation of two dead languages that of all literary forms it is the one charged with the special mission of watching over the maturing process of the original language and the birth pangs of its own" (73). There is no moment in European history that could plausibly compete with this one—Spain in the twelfth through fourteenth centuries—for the title of the age of translation, and as the singular moment when European cultural history was transformed thanks to translations of virtually every sort. And yet, this "steady passage across linguistic and regional borders" scarcely plays any role in the body of extensive theoretical musings about the nature of translations that are characteristic of our own critical age, from Benjamin himself to the iconic *After Babel* of George Steiner to a whole host of contemporary meditations provoked, among other things, by literary globalization and the rise of "world literature." Even a recent collection of studies such as *The Medieval Translator*—itself dedicated in great measure to correcting the larger picture in "translation studies," where the medieval world is largely ignored—is virtually oblivious to the centrality of the Arabic library, which, as it began to be translated in the twelfth century, transformed European culture.

On the Arabic library that arrived from Baghdad to Cordoba *Aristotle and the Arabs* by F. E. Peters remains an exceptionally useful overview, with its clear exposition of the Arabization of the philosophical tradition from the Greeks and the Hellenic world. Today the leading scholar on the translation movement from Greek into Arabic is Dimitri Gutas, and his work is especially helpful on the social and political dynamics of the antecedent and in certain ways parallel phenomenon in Baghdad that eventually made the Arabic-into-Latin project possible. His recent *Greek Thought, Arabic Culture* not only covers the intellectual aspects of the question but explores the often overlooked questions of local conditions and social causation: why did the Abbasids undertake the project? What were their resources to do so? Beyond these, many scholarly works focused on the later European project also provide prefatory narratives of this vast intellectual migration that, from the vantage point of the twelfth century, provided the basic materials for the Arabic-into-Latin translations.

This latter translation movement, whose products dominated and transformed intellectual life in western Europe during the twelfth and thirteenth centuries, is rarely treated as part of early Castilian cultural history and development. Instead, it is studied as a philosophical-historical project, with a focus on the history of textual transmissions, and as such it has an extensive body of scholarship, which we can only allude to here. A sampler

of the primary texts that were translated and widely disseminated is available in Arthur Hyman and James Walsh's *Philosophy in the Middle Ages*. Excellent starting points for a general picture of the translating activity itself include the first three chapters in Dorothee Metlitzki's classic *Matter of Araby in Medieval England*; the chapter "L'école des traducteurs" by Danielle Jacquart in *Tolède, XIIe–XIIIe*, edited by Louis Cardaillac; Richard Fletcher's brief and engaging narrative on the subject in his final book, *The Cross and the Crescent*; and, especially, Charles Burnett's contribution to the Jayyusi volume, "The Translating Activity in Medieval Spain," arguably the single best overview of the topic available. Burnett has in the last several decades become the eminent and most productive scholar in a field once dominated by the late Marie-Thérèse d'Alverny, whose life's work originally appeared principally in article form but is now recollected in a series of volumes edited by Burnett. Especially useful are *La transmission des textes philosophiques et scientifiques au moyen âge* and *La conaissance de l'islam dans l'Occident médiéval*, this latter devoted primarily to d'Alverny's essays on the translations and translators of the Quran.

The extent and importance of Burnett's own meticulous scholarship is such that it would be difficult and probably counterproductive to attempt to provide a full accounting of his work or of the indebtedness of everyone who reads or writes in this area. His overview in the Jayyusi volume includes a bibliographic review of his own contributions to the field (until 1992); one can also approach his work through either his collected articles in the volume somewhat misleadingly titled *Magic and Divination in the Middle Ages* (it is far broader than that) or his 1997 volume, which serves at the same time as an update and expansion to the material in Metlitzki's 1977 book. Beyond that we are especially grateful to be able to quote from his translation of Daniel of Morley, with which he opens one of his magisterial Panizzi lectures at the British Library, available now as *The Introduction of Arabic Learning into England*. Finally, despite his disagreement with many of our beliefs in this realm, Burnett has graciously contributed to the development of our view of the importance of the Toledan and Castilian environment—and the role of the Castilian monarchy in creating that environment—through productive argument, particularly in his reminder, both in personal conversation and as laid out in his "Translating Activity in Medieval Spain," of the transfer of the famously rich library of the Banu Hud from Saragossa to Toledo. The lack of direct involvement of the Castilian monarchy in the translation movement is not, perhaps, as telling for an overall assessment as is recognition of the extent to which they created a distinctive political culture: their version of the dhimma encouraged or made possible the fundamental conditions without which the Latin translation project, as we know it, could not have taken place.

Another prolific scholar in the field was Richard Lemay, closely associated with the *Annales* school, and his "Dans l'Espagne du XIIe siècle: Les traductions de l'arabe au latin" in particular provides a classic overview and periodization of the different stages of translation. And perhaps most prominently among the distinguished scholars who have contributed to this field we note Charles Homer Haskins, whose use of the expression "Renaissance" for the series of transformations in twelfth-century intellectual life derived

in part from his appreciation of the broad-based importance of the translation movement, to which he devoted attention beyond his 1927 landmark book; see especially the article "Translators from the Arabic in Spain." The chapter "The Translators from Greek and Arabic" in *The Renaissance of the Twelfth Century* was an adaptation of his work in *Studies in the History of Mediaeval Science*. There is, incidentally, a correspondingly large bibliography on the "Renaissance" of the twelfth century that Haskins made famous, although a great deal of it in recent years is about questioning the "reality" of it. As Stephen Jaeger recently put it, "The term 'twelfth-century renaissance' has proven usable against all opposition." Jaeger's elegant article provides not only an excellent bibliography on certain aspects of the subject but a salutary and sometimes gripping review of the pessimism of the age that label obscures. This, Jaeger finds, is ultimately at odds with the tendency of modern scholars to imagine it as a period of ongoing revival or even revolution. But this raises a number of questions and ironies, not least the fact that as in virtually every case since Haskins's own work, very little attention is paid to the conspicuous source of many specifics of the intellectual paradigmatic shift: the Arabized Christian universe of post-1085 Iberia. Indeed, it is something of a commonplace that the twelfth-century Renaissance bypassed Castile, a view of the moment sustainable only if one defines "Castile" or its culture very narrowly, as being what existed in its indigenous Latin culture, and excludes the new culture created by the complex Toledan adaptation of local Arabic culture. The work of several eminent Arabists complements that of Haskins, in its focus on the strongly "humanistic" nature of the classical Arabic culture whose library—and many of whose thinkers and writers—were at the heart of the new Latin library; see especially Joel Kraemer's *Humanism in the Renaissance of Islam* and George Makdisi's *Rise of Humanism in Classical Islam and the Christian West*.

More recently, other works of particular clarity and utility, especially in the effort to understand the local cultural context, include the always penetrating contributions of Thomas Glick. See especially his introduction to the *Convivencia* volume coedited with Mann and Dodds, which provides an excellent map of the intellectual landscape that was constructed out of the Arabic library, with special attention to the extensive and pivotal role played by Jews in the project; and his more recent "Interfaith Scholarly Interaction," where he explores the ways in which translation was one of the leading activities in which all three religious communities explicitly came together, not only intellectually, but also pragmatically, as an everyday matter, and as part of the teams that worked jointly. Indeed, the translation movement, which so often involved members of the different faiths working intimately with each other—not to mention with the texts of major thinkers of the other religious traditions—was a central part of the intermingling of the faith communities. Perhaps no scholar has contributed more richly to our understanding of the complexity of that interaction than Thomas Burman, whose fundamental work on the Mozarabs has been vital for this project, and whose article "Michael Scot and the Translators" is the best available résumé of the translation activity in Sicily. But we have especially relied here on his recent and ongoing work on the translations of the Quran, work in the process of fundamentally altering our received opinions about the quality of the first and most famous of

those—that of Robert of Ketton, commissioned by Peter the Venerable of Cluny—as well as about the ambivalent attitudes toward Islam and Arabic culture that can be gleaned from the work of all of the translators, even when they were working toward explicitly polemical ends. On Peter and his project, James Kritzeck's *Peter the Venerable and Islam* is still an invaluable source and of special interest here also is Walter Cahn's discussion in "The 'Portrait' of Muhammad in the Toledan Collection." On Mark of Toledo, the later translator of the Quran working at the time of Rodrigo Jiménez de Rada, the work of d'Alverny remains indispensable, although now very helpfully contextualized, in terms of the evolving ideology of reconquest of the archbishop Rodrigo, by John Tolan in his "Traducciones y la ideología de la reconquista." Tolan is also the authority to turn to for Petrus Alfonsi and the *Disiciplina*; his wonderful *Petrus Alfonsi and His Medieval Readers* is an excellent introduction to the intellectual ambience of the times, as well as to the major works of this pivotal and mysterious figure.

Until recently, little work has been done on what could profitably be called the "local conditions," that is, on the "Toledan" or "Castilian" context of the Latin-into-Arabic translations, for a host of seemingly good reasons: most of the known translators were not natives of the region but rather scholars from Latin Christendom, and in any event the two written languages involved, Arabic and Latin, as well as the nature of the texts that passed from the former to the latter, are by and large not the focal point of early Castilian literary studies. A Latin chronicle tied to the story of the Cid may well enter centrally into a discussion of early Castilian texts, but a treatise on algebra in Arabic turned into Latin by a native of Cremona might seem peripheral at best to the concerns of students of Castilian culture as such. And the scholars who work on the Arabic-Latin textual traditions are a rare breed of Arabist-Latinist whose own languages and interests mostly lie far afield from the local conditions of twelfth-century Castile. In any event, the content of most of the works translated at this time—overwhelmingly philosophical and scientific (or what we would dub "pseudo-scientific")—tend to lead to more abstract discussions about the migration and development of ideas. But several recent scholarly efforts support our notion that "the translation movement is a more Spanish event than we like to admit," as the young scholar Dag Hasse noted in a presentation at a recent conference, now available in the invaluable 2006 volume edited by Speer and Wegener, with its dozens of articles on nearly every aspect of the Arabic library's presence in Latin Europe in the Middle Ages.

What was there in Arabic for the Latins to receive? Gutas poses this question in his breakthrough study in the same volume, thus bringing to bear on the Latin project of Toledo the same kinds of questions about local cultural needs and resources asked in his earlier work on the translation of Greek texts into Arabic in Baghdad. Here, Gutas focuses with particular clarity on the distinct Andalusianness of this project, as opposed to imagining it as an exclusively intellectual ambition, which might have led the Latins to seek texts in other parts of the Mediterranean to which they had access and did travel and where they would, indeed, have found far more advanced scientific texts: "The translators of the twelfth century, then, looked for their Arabic manuscripts in al-Andalus and were influenced by Andalusian tastes and biases in their selection of works to translate. This would

indicate to me that one of the reasons, if not the main reason, that they engaged in this translation movement was to imitate the Andalusians and appropriate their knowledge—become like them, essentially. That this was among their motivations rather than any desire to improve their scientific knowledge or 'advance science' is also indicated by the fact that they selected outdated works to translate and did not look around the Islamic world for the latest developments in the sciences concerned. . . . *Thus the translation movement of the twelfth century in Spain appears to have been a local affair, with local concerns and ideological motivations*" (11; emphasis ours). All of this brings to bear on the discussion of the Latin translation movement vital manifestations of "local" pride and desire inextricable from the Castilian attitudes—including what we might call Umayyad envy—that transform Toledo from a culturally flourishing Taifa to the center of invigorated Christian intellectual life, via the conversion of the local library. And two vital guidebooks to that library turn out to be distinct manifestations of the Andalusian-centric view of the universe that so affected local conditions, both before and after 1085: Ibn Hazm's "The Excellence of al-Andalus," and "The Categories of Nations" by Said al-Andalusi, which, according to Gutas, "presents a very interesting picture of the cultural history of the world from the point of view of Islamic Toledo: according to Said, the march of civilization proceeds from its beginnings with Chaldeans, ancient Persians and Hindus, successively through the Greeks, the Romans, the Egyptians, and the Abbasid Muslims, until it culminates with the Andalusian Muslims and Jews in Toledo in the eleventh century (7)."

<div align="center">✳</div>

López-Morillas provides an outstanding linguistic portrait of the peninsula in her "Language" chapter in the *CHAL*, introducing readers to the fundamental questions, and dealing with Arabic and Hebrew as well as Latin and Romance: who spoke which languages, how those languages interacted with each other, the differences between written and spoken varieties of the "same" languages, and a great deal more, including a bibliography of the fundamental work done in these various areas. On the linguistic development of Castilian, the canonical source, since it first appeared in 1987, is Paul Lloyd, *From Latin to Spanish*. See the essentially freestanding section on Castilian (pp. 172–180), which goes into the external history as it shapes the so-called internal history of the language, and especially his comments on the stamping of the earlier and distinct character of Castilian through its complex relationship with Basque: "That is, during the period in which the Basques were ceasing to think of themselves as Basques, and were taking Romance as their language, there were undoubtedly many who still kept some feature of Basque in their pronunciation of the evolving Castilian dialect" (179). Equally pertinent are his remarks on self-conscious frontierism: "Group solidarity would then be expressed in certain features of their dialect that came to be thought of as distinctively Castilian, serving to identify Castilians as a group with a certain ethos, a certain way of looking at the world" (177). On the various languages of the Mozarabs—their use of both Arabic and Romance before and after the conquest of 1085—see the invaluable article by Francisco Hernández.

On the question we might vulgarly restate as "when is Latin no longer Latin, but rather (one of) the new Romance languages?" it is safe to say that a single scholar, Roger Wright, has thoroughly transformed our understanding and cast it as one of a very specific kind of perception; we have quoted the late Colin Smith's relatively recent résumé "The Vernacular" (which Wright had a hand in editing after Smith's untimely death), which has the added merit of providing a broad European context, of the complex argument made in Wright's now classic *Late Latin and Early Romance* of 1982. What is sobering in reflecting on the historic "development" of the vernaculars from Latin is to understand how vast the "measurable" or "objective" linguistic differentiation can be—lack of inflected endings and commensurate reliance on word order, new vocabulary, major shifts in pronunciation, and so forth—while the consciousness of speaking the same, older language remains intact and probably largely unquestioned within the community of speakers. Of course, those who know Arabic may well read descriptions about the pre-Carolingian reform situation in Latin—"elisions and lack of synthetic case-endings and abundant post-classical vocabulary"—and recognize the essentials of the situation in classical Arabic, whose regional and vernacular differences have long existed, and are widely recognized and studied, but where the notion that any of those vernaculars might be a different "language" would seem peculiar and ultimately unacceptable.

Wright's work has allowed us to see precisely that this was the situation in Latin until, ironically, the Carolingian reforms made that belief untenable. And Wright's position is that what were long cited (and still are in many quarters) as the "earliest documents" in the history of the vernaculars—notations on Latin works such as the famous "Glosas Emilianenses" (from the monastery of San Millán de la Cogolla, and thus a vital icon in the hagiographic version of the history of Castilian)—do not reveal any consciousness of a new language that merits writing but something like the opposite, being local pronunciation guides for Latin; see also now Wright's "Latin Glossaries in the Iberian Peninsula." Most recently, in his 2006 "Language and Religion in Early Medieval Spain," this eminent philologist takes on the question of the diversity of languages of this period, and the anachronism of assuming that the members of the different religious communities were separated by different languages. Noting that in linguistic terms, as well as in others, "the cultures were not neatly delimited," Wright goes on to debunk the notion that the inhabitants of the peninsula would have principally identified themselves in religious terms: "That is, we can suspect that if we had been able to ask individual inhabitants what they were, they could well have answered 'Cordoban', or 'gardener', or 'old woman', or some other category, rather than, or before, 'Christian', 'Muslim' or 'Jew'" (120).

Brian Dutton is the distinguished editor of the *Obras completas* of Berceo, and his editions constitute an excellent introduction to the original texts and their linguistic and cultural setting (as well as of the very widespread notion that the region of the Rioja is the "cradle" of Castilian). Berceo was a near contemporary of Rodrigo Jiménez de Rada, and his traditional status as the "first Spanish poet" has been the subject of scholarly discussion in recent years, especially as the long-canonical direct equivalence between Castilian and

Spanish has come under increasing scrutiny; on this, see the provocative contribution to the recent and immensely useful *Cambridge History of Spanish Literature* (edited by David Gies) by John Dagenais, "Medieval Spanish Literature in the Twenty-First Century." At something like a polar extreme in the same volume is "The Poetry of Medieval Spain" by Andrew Beresford, which provides a straightforward and informative thumbnail of Berceo's life and works, especially valuable in the context of the anonymous Castilian poetry that precedes him and what follows, which Beresford dubs "a literary crisis characterized by stagnation and decay" (82)—a characterization predicated on nearly all the assumptions about what constitutes the Spanish medieval canon questioned by Dagenais. We are grateful to be able to quote from the translation into English of Berceo's *Milagros* by Richard Terry Mount and Annette Grant Cash, *Miracles of Our Lady*. In her *Conflict and Coexistence* Lucy Pick makes a convincing case for attributing authorship of the *Auto de los reyes magos*, the fragmentary drama from the early thirteenth century, to the archbishop Rodrigo Jiménez de Rada; for a more traditional consideration, in the framework of the dramatic traditions of the peninsula, as well as further bibliographic guidance, see Charlotte Stern's chapter in the *Cambridge History of Spanish Literature*.. We have drawn the text and translations cited from the excellent web site of Dr. Jeremy Lawrance of the University of Manchester's Department of Spanish, Portuguese, and Latin American Studies, http://www.art.man.ac.uk/SPANISH/ug/documents/AUTRRMAG_002.pdf, which includes an image of the sole surviving manuscript, as well as Lawrance's transcription, and translations into modern Spanish and English.

We are grateful to be able to quote from W. S. Merwin's graceful verse translation of the *Poem of the Cid*, by far the most literary rendering into English. Novice readers may also want to consult the prose translation in the facing-page bilingual edition prepared by Rita Hamilton, Janet Perry, and Ian Michael, which remains readily available in paperback. On the life and times of Rodrigo Díaz of Vivar, Fletcher's *Quest for El Cid* is an excellent account, and includes a particularly useful central chapter (pp. 89–104) on the variety of medieval sources that speak to the Cid's exploits and early mythologization. Some of those sources are made available in collections such as *The World of El Cid: Chronicles of the Spanish Reconquest*, a volume of selected sources translated and annotated by Simon Barton and Richard Fletcher, or in anthologies such as *Christians and Moors in Spain* (see especially volume 1, which covers the period 711–1150, and volume 3, dedicated to Arabic sources). Additional historical contextualization and commentary on this pivotal moment and iconic figure from which we have especially profited include the vast body of Reilly's work, as well as Wasserstein's now classic *Rise and Fall of the Party-Kings*.

Scholarship on this singular epic poem from the Spanish medieval period is a veritable industry. The useful volume titled *El Cid: De la materia épica a las crónicas caballerescas*, edited by Carlos Alvar, Fernando Gómez Redondo, and Georges Martin, was produced at the ninth centenary of the death of the Cid, a conference held in Alcalá de Henares in 1999; a vigorous debate held in 2002 on the subject of history versus mythology in the Cid poem and Cid studies is recorded in the volume *Memoria, mito y realidad en la historia medieval*, edited by José Ignacio de la Iglesia Duarte; more recently *La Corónica* published a "critical cluster"

focused on "contemporary critical tendencies" in literary Cid scholarship. This collection of articles is edited and introduced by Oscar Martín, to whom we are also personally indebted for guidance on contemporary Cid studies. Traditionally much of the writing on the poem is sharply partisan on the question of whether the single (and mutilated) surviving manuscript of the epic poem represents an orally composed or a written text, and (thus) what its temporal relationship is to the events narrated. Whether it is an oral composition, with its first performances roughly contemporaneous to the events narrated over a century later, or whether, quite to the contrary, it is a composition by a learned individual, writing well over a century after the Cid's death in 1099—or some compromise or combination of these views—are the considerable range of choices available to students of medieval Castilian literature. In the sometimes rancorous debates over the learned versus popular origins of the epic poem (a conflict that, much like the one between Américo Castro and Claudio Sánchez Albornoz over the nature of the "Spaniards," has shaped much of the field's basic theoretical and historical questions), two canonical works remain: *La España del Cid*, by the great Spanish scholar and champion of the theory of oral composition and transmission, Ramón Menéndez Pidal, and Colin Smith's 1983 *Making of the "Poema de mio Cid,"* which took few prisoners in its challenge to the near-sainted Menéndez Pidal's views, and details Smith's own vision of a legally trained writer who had studied abroad and was influenced by his knowledge of French epic materials. There are also what are, in effect, dueling editions of the text by these scholars.

Much of the most provocative work on the poem addresses the matter of the relationship between literary text and historical context: what was the ideological and political slant of the poem when it was first performed, if we believe it to have been an oral performance text? The most canonical of such studies is that of María Eugenia Lacarra; the superb study by Joseph Duggan offers a series of insights about the Castilian culture from which the poem emerges—circa 1200—and emphasizes the poem's focus on the creation and distribution of wealth, as well as the poem's dance around issues of the legitimacy of the Cid himself. Or do we believe it to have been "a sort of recruiting poster," circa 1207, for the battle of Las Navas de Tolosa, a poem that reflects the legal and political concerns of the court of Alfonso VIII, or the ideological ones in the prowar circles around Rodrigo Jiménez de Rada? For a detailed laying out, and subtle dismantling, of those views, one can do no better than chapter 10 of Linehan's *History and the Historians of Medieval Spain*. If there is increasing agreement among scholars on any topic in this area, it is that the still-popular caricature of the Cid as a "reconquest" hero is the product of the starkly romantic and nationalist mythology of the Cid, cultivated in the context of nineteenth- and twentieth-century Spain by Menéndez Pidal, and that the text, like the historical record, in fact depicts (at best) a more ambiguous hero.

The legend of the Cid's entry into Toledo, and his horse's recognition of the burning flame of Christianity underneath the little mosque of Bab al-Mardum, may have contributed to the later naming of the site "Cristo de la Luz" and in the nineteenth century was made famous by the Romantic writer Gustavo Adolfo Bécquer. Curiously, the publicity

materials for the recently restored (and museum-ized) "Mezquita Cristo de la Luz" recasts the legend slightly, eliminating the Cid and replacing him with Alfonso VI himself as the rider of the horse that discovers Christianity's flame still lit, buried beneath the Islamic house of worship.

<div align="center">✳</div>

For Alfonso's languages, and his education in general, we have relied on various authorities, especially O'Callaghan's *Learned King*, and the very extensive body of work by Márquez Villanueva on what he felicitously calls the "concepto cultural alfonsí" (the Alfonsine cultural concept), itself inseparable from Alfonso's "mudejarismo." Márquez Villanueva first developed this paradigm for understanding the historical moment and its transformations in his own contribution to a symposium in 1984 on the seven-hundredth anniversary of the death of Alfonso. The article, which appears in the symposium proceedings Márquez Villanueva edited with Carlos Vega, gives an excellent and succinct overview in English, and was later more fully developed as the Spanish monograph published in 1994. Márquez Villanueva understands Alfonso's life and education as a young man as being the apotheosis of *mudejarización*, a term he believes we need to just learn to deal with, as he somewhat impatiently notes in his provocative "Meditación de las otras Alhambras": "No habrá que decir que Alfonso el Sabio, nacido en Toledo y ligado por su vida, primero a Murcia y después a Sevilla, encarnaba en su persona la más completa *mudejarización* (*acostumbrémonos a la terminología*)" (266). [It goes without saying that Alfonso the Wise, born in Toledo and linked throughout his life first to Murcia and then to Seville, personally embodied the most complete *mudejarización* (*let's get used to the terminology*).] And most of all we rely on H. Salvador Martínez's magisterial new biography, whose chapter "Educación del príncipe" is now the indispensable guide to the subject. A more concise overview of Alfonso's life and impact is available in Julio Valdeón Baruque's *Alfonso X el Sabio: La forja de la España moderna* (Valdeón Baruque has also written wonderful synthetic and analytical histories of the watershed cultural moments during the reigns of Abd al-Rahman and Peter the Cruel). Unfortunately, John Ersten Keller's brief 1967 biography, among the only introductions in English to the life and times and works, is now seriously out of date.

On the question of Alfonso's own studies in Murcia and whether he studied Arabic at the madrasa of al-Riquti, and on his later establishment of a royal studium there, we are indebted to Benjamin Liu, whose forthcoming article on Arabic language mastery in thirteenth-century Spain is generally illuminating and also explores the delicate question of whether al-Riquti's famous multifaith school taught Arabic to Jews and Christians (as well as Muslims) or instead taught to each group in its own language. Diego Catalán, in his collected studies on the *Estoria de España*, one of the great histories of the Alfonsine period, is also exceptionally helpful on the "forma nueva" in which Alfonso and his siblings were educated, and on the impact this education had on Alfonso's conviction that his own role required his becoming an educator to his people. Catalán directly defuses the older notion that the translations began to be made in Castilian because it was the intermediary

language, and because it was preferred by the Jewish translators, who did not know or want to be involved with Latin, the language of the church. This is an argument not unlike the one still made from time to time about Mudejar—that it was what the workmen knew and preferred, rather than what the Castilian patrons really wanted—whereas in fact the turn to Castilian was explicitly a part of Alfonso's vision, derived directly from the adab works of his education. In his brave new world Alfonso was intent on becoming the leader of a cultural empire that left the Latin one aside, an ideology later carried forward by Don Juan Manuel. As Catalán puts it: "Pero el aspecto más renovador de su organizado esfuerzo fue el 'espaladinar' los saberes en castellano, en lengua vulgar. Ello supone que los 'ladinos' a quien Alfonso se proponía instruir con una tan vasta producción científica no constituían un privilegiado círculo de letrados, pues, segun el propio don Juan Manuel nos hace ver, los libros que se hacen o mandan hacer en romance 'es señal que se fazen para los legos que non son muy letrados.' Los destinatarios de los libros alfonsíes y no sus productores son la justificación" (15–16). [But the most renewing aspect of his organized effort was the "examination" of knowledge in Castilian, in the vulgar language. It supposes that the "Ladinos" Alfonso proposed to instruct with such a vast scientific production did not constitute a privileged circle of literate men, but, as Don Juan Manuel himself has us see, the books made or ordered made in Romance "are a sign that they're made for the laymen who are not all that literate." Those for whom the Alfonsi books were destined—and not their producers—were the justification.] On the historiographical writing of the period, see also the work of Inés Fernández Ordóñez, whose *Estorias de Alfonso el Sabio* provides a comprehensive account of both primary texts and scholarly work done on them. Finally, for a characteristically thorough and stimulating overview of the enterprise of writing history in the vernacular, one of the monumental achievements of the Alfonsine court, see Linehan's "From Chronicle to History: Concerning the *Estoria de España* and Its Principal Sources."

A fuller version of the argument about adab and its role in the establishment of Castilian is available in Menocal's "To Create an Empire: Adab and the Creation of Castilian Culture." On the establishment of the protouniversities in the early thirteenth century, all the above sources provide narratives and basic information about the brief heyday of Palencia as a studium; see also the illuminating discussion in O'Callaghan's *Learned King* of the slightly later but ultimately more successful venture at Salamanca, which might have withered permanently but for Alfonso's own reinvigoration of its charter in 1254. In this context it is fascinating to return to the canonical Haskins, *The Renaissance of the Twelfth Century* ("The Beginnings of Universities" is the closing chapter) and then to Makdisi, *The Rise of Colleges: Institutions of Learning in Islam and the West*, a book in significant ways written as a response or supplement to Haskins; see especially chapter 4, "Islam and the Christian West." The early Castilian texts associated with the art of learning and education that comprised Alfonso's Castilian library are readily available in several different sources. The standard edition of the *Libro de Alexandre* is by Jesús Cañas; we have benefited enormously from the insights about the *Alexandre* itself, as well as its place in the intellectual and political universe of mester de clerecía, and its role in the education of the Castilian princes, in the

excellent recent book by Julian Weiss, to whom we are personally indebted for sharing parts of this study before its appearance. The *Doce sabios* exists in a useful edition by Jack Walsh; the *Libro de las animalias que caçan* was the subject of a number of studies by Dennis Seniff (who was also the editor of the *Libro de la montería* of Alfonso XI), now available in the collection *Noble Pursuits: Literature and the Hunt*, which places the work in the context of the whole tradition of hunting books of the Middle Ages.

The standard and extremely usefully annotated standard edition of the *Calila e Dimna* is by María Jesús Lacarra and J. M. Cacho Blecua. Lacarra is also the author of *Orígenes de la prosa* (with Francisco López Estrada) and *Cuentística medieval en España*, fundamental reference books and studies on the development of early Castilian prose with its beginnings in the translations of collections of framed tales out of Arabic. These are at the same time the best sources of information on the *Sendebar*, relatively little studied, although Alan Deyermond's "*Libro de los engaños*: Its Social and Literary Context" explores in some depth the various philological and historical puzzles the text presents. The *Conde Lucanor*, in contrast, has long commanded considerable scholarly attention, much of it reviewed in Menocal's 1995 article, which focuses on reading this framed-tale collection within the strong Arabic tradition. It is worth noting that in 1993 one of the most distinguished of Don Juan Manuel scholars, Reinaldo Ayerbe-Chaux, published *Yo, don Juan Manuel*, a fictional "memoir" of the novelistic life of this most canonical medieval author; this somewhat idiosyncratic work also provides a thorough bibliography of both primary and secondary sources. Indeed, the relationship between the life and times, on one hand, and the extensive body of work written by Alfonso's nephew, on the other, has an enduring hold on the imagination of scholars who work in this field, and with good reason. The most thorough exploration of the topic is David Flory's *El Conde Lucanor: Don Juan Manuel en su contexto histórico* but see also, for example, Peter Dunn's study "Don Juan Manuel: The World as Text"; Vincente Cantarino's remarkable "Ese autor que llaman Don Juan Manuel," intent on establishing that Don Juan Manuel's life cannot have prepared him intellectually to write the works attributed to him; and Ciriaco Morón Arroyo's study of Don Juan Manuel's Jewish physician and advisor, instrumental in the composition of the *Conde Lucanor*.

More recently the fundamental two-volume study by Fernando Gómez Redondo, *Historia de la prosa medieval castellana*, has become the standard history and reference, and he demonstrates in no uncertain terms the centrality of translations from Arabic into Castilian to the development of a Castilian prose style. The *Kalila* circulated extensively in Europe, in numerous different versions and languages, in the vernaculars as well as in Latin, the latter principally in the translation by Juan de Capua, one of the eminent converted Jews working as a translator at Alfonso's court, and working from the Hebrew. Another Latin version by Raymond de Béziers, translated from the Spanish, was presented as an illuminated "royal book" to King Phillip the Fair of France, and the detailed history of this deluxe version that passed into the library of the French royal family is wonderfully told by Nancy Regalado, with fine appreciation for the value of the text as one to educate rulers; the eminent French Arabist André Miquel produced an exceptionally readable and

useful of the Arabic text into modern French. In *Under the Influence* Luis Girón Negrón contributes a fine study of the complex history of translations in and out of Arabic, Hebrew, Latin, and Castilian, all prompted by Alfonso's youthful interest. In contemporary English there are two very different choices: a modern version very self-conscious about the processes of adaptation rather than straight translation, the *Kalila and Dimna: Selected Fables of Bidpai* "retold" by Ramsay Wood, with an illuminating introduction by Doris Lessing; and the Irving translation into straightforward English, *Kalilah and Dimnah: An English Version of Bidpai's Fables Based upon Ancient Arabic and Spanish Manuscripts*, a text combining both the Ibn al-Muqaffa Arabic text and its Castilian adaptation.

Beyond these matters of Alfonso's education and his earliest efforts at producing Castilian versions of Arabic texts, there is a vast bibliography on virtually every aspect of the massive cultural revolution provoked by the king's transformation of Castilian into the new Latin, the language of his realm and, he hoped, of his new cultural empire. Among these we especially rely on and recommend the following: the older but still excellent study by Evelyn Procter, *Alfonso X of Castile: Patron of Literature and Learning*, as well as the classic study of the methods of vernacular translation by Gonzalo Menéndez Pidal, "Cómo trabajaron las escuelas alfonsíes," and Hans-Josef Niederehe's *Alfonso X el Sabio y la lingüística de su tiempo*, a fundamental study of Alfonso and the vernacular. Two important collections of papers edited by Father Robert I. Burns, the 1985 *Worlds of Alfonso the Learned and James the Conqueror* and the 1990 *Emperor of Culture: Alfonso X the Learned and His Thirteenth-Century Renaissance*, each include a wide range of useful studies. Another, rather different collection of studies on the "learned king" arose from one of the numerous celebrations of Alfonso's life that took place in 1984, the seven-hundredth anniversary of his death. Edited by Márquez Villanueva and Carlos Vega, the volume includes several studies on the *Cantigas*.

We have also benefited from the work on Castilian as the emerging language of literacy in a recent article by María Teresa Echenique Elizondo in the volume *The Dawn of the Written Vernacular in Western Europe*, as well as the considerable body of work by the eminent Spanish philologist and Arabist Alvaro Galmés de Fuentes; see especially his *Influencias sintácticas y estilísticas del árabe en la prosa medieval castellana*, and the chapter "Alfonso X el Sabio y la creación de la prosa literaria castellana" in his volume of collected essays titled *Romania Arabica*. See also the relatively recent collection *La escuela de traductores de Toledo*, edited by Ana María López Alvarez, especially the article by Márquez Villanueva, with its emphasis on the centrality of Toledo's local vernacular, "In Lingua Tholetana," and that of Julio Samsó (one of the most authoritative Spanish scholars on the translation of scientific and pseudo-scientific texts from Arabic into both Latin and Castilian; see, for example, his *Ciencias de los antiguos en al-Andalus* and *Islamic Astronomy and Medieval Spain*) with its systematic and chronological overview of the translation enterprise, its consideration of the relationship and transition between the Latin and Castilian translations, and especially its meditation on the paradoxical need to translate Castilian texts into Latin, when it became obvious that Alfonso's imperial aspirations had failed, and thus that his ambition to have Castilian become the new lingua franca of the Holy Roman empire had also foundered.

Arguably, the most famous and important text in this "backwards" move—the translation into Latin of Castilian translations, an implicit acknowledgment of the continuing role of Latin, rather than a vernacular, as the language of an international culture—is the so-called *Liber scalae*, or the "Book of the Ladder of Muhammad," first translated into Castilian from Arabic, and then from the Castilian (which has been lost) into Latin and Old French. An overview of the many philological and historical controversies provoked by the suggestion that Dante was aware of this text, which is part of the apocryphal narrative tradition called *miraj* in Arabic, and translated at Alfonso's court, will appear in Menocal's "Dante and Islam." See also Ana Echevarría's highly instructive contextualization of the text within religious polemics of the moment, in her "Eschatology or Biography: Alfonso X, Muhammad's Ladder and a Jewish Go-Between," published in Robinson and Rouhi's *Under the Influence*, as well as Harvey's "Alfonsine School of Translators," focused on the (for him, hard-to-understand) polemical and misrepresented views of Islam emerging from a court at which so many Muslims, and Islamic texts, were available. Invaluable in understanding the Alfonsine court's role in cultural transformations in other corners of Europe is Julia Bolton Holloway's brilliant "Road through Roncesvalles: Alfonsine Formation of Brunetto Latini and Dante—Diplomacy and Literature," published in Burns's *Emperor of Culture*. See also the description of Brunetto's visit to Alfonso's court in Seville, in the old Alcazar, in Martínez's biography of Alfonso, beginning on page 171, and in that context we note that in fact, Seville, as the center of the Castilian cultural transformation, was a remarkable crossroads. Prado-Vilar has argued convincingly in "The Gothic Anamorphic Gaze: Regarding the Worth of Others" that the *Cantigas*, which were intended to be sung on the feast of the Virgin in the church where Alfonso would be buried, were thus performed in the cathedral of Seville, the converted Almohad mosque.

On the *Cantigas*, see the discussion above, in "Architecture and Art," for the secondary sources focused on the extraordinary miniatures of the lavishly illustrated collection of Alfonso's Galician-language songbook, which we have cited in English in the translation of Kathleen Kulp-Hill. Although we scarcely touch on the musical aspects of this multimedia work, we acknowledge the exceptional importance to the general theses of this book of Julián Ribera's *Música de las cantigas: Estudio sobre su origen y naturaleza*, as well as Ramón Menéndez Pidal's classic *Poesía juglaresca y juglares*. Each of these venerable Spanish scholars established, in his own way, the continuum of musical genres in the Arabic and Romance traditions, and each understood the oral traditions—including the lyrical and the musical—as being those most likely to cross linguistic "frontiers." Additionally, we recommend the overview provided in another collection of studies arising from a 1984 conference, this one titled *Alfonso X el Sabio y la música*, as well as the lovely study by Luis Girón Negrón, "El canto del ave: Música y éxtasis en la Cantiga de Santa María 103." Israel Katz provides an excellent examination of the history of musicological scholarship in his conference paper published in Márquez Villanueva and Vega's *Alfonso X of Castile*, touching especially on the foundational work of Higinio Anglés, and Katz's "Study and Performance of the CSM" further updates his survey of the scholarship.

Perhaps the most difficult question in the study of the Alfonsine cultural revolution is that concerning the language of the *Cantigas*: why did the man who so purposefully transformed Castilian into the new language of empire choose Galician-Portuguese when he went to write this remarkable body of lyric poetry? Although the subject has been much discussed by critics over the years, nothing like a consensus has ever been reached. Among discredited older arguments are those that claim that Alfonso's choice was dictated by Galician's more "lyrical" qualities, and Sánchez Albórnoz's notion that Galician developed earlier and more authoritatively as a lyric language because of the greater distance from the (Castilian) centers of reconquest. But more recently many scholars—and we along with them, throughout this book—have tended to understand the linguistic variations of the peninsula not as strictly tied to political entities or ethnic or religious groups, and the overall population and its societies as plurilingual. The work of Hans-Josef Niederehe in particular has clarified that the choice of specific languages was a pragmatic one, often dependent on the cultural realm in which a given language would be used, something more like a style or a register—and the choice of Galician-Portuguese is a choice in favor of the language in which the lyric genre had flourished in the peninsula. This argument is also made by Joseph Snow, whose extensive scholarship on the *Cantigas* further examines Alfonso's presentation of himself as the Lady's troubadour. Snow has provided the field indispensable bibliographies of work done in Alfonsine scholarship focused on the lyric, and those wanting to read further on the topic can do no better than to begin with his series of annotated surveys.

Santob de Carrión's authoritative editor, translator, and exegete in our times is T. A. Perry. We are grateful to be able to rely not only on his edition and his translation of the *Proverbios morales* but on the excellent introductions and commentaries that are an integral part of these two volumes, as well as on the comprehensive bibliography on this largely underappreciated figure in early Castilian letters. Perry's eloquent characterization of the man speaks volumes: "Nurtured in rabbinic patterns of thought and an accomplished master of Hebrew poetry, both liturgical and profane, Rabbi Santob nevertheless chose the vernacular of the majority culture as the vehicle for his autobiographical magnum opus and addressed it to the Christian King of Castile. Indeed, his *Proverbios morales* is a literary masterpiece and the dialogue it sustains between two cultures has few parallels" (*Moral Proverbs*, 4).

Bibliography

Primary Works

Abelard, Peter. *A Dialogue of a Philosopher with a Jew and a Christian*. Translated by Pierre J. Payer. Toronto: Pontifical Institute of Medieval Studies, 1979.

Adonis. *An Introduction to Arab Poetics*. Translated by Catherine Cobham. Austin: University of Texas Press, 1990.

Albar, Paul. *Indiculus luminosus*. Edited by Juan Gil. 2 vols. Madrid, 1973.

Alfonso X. "Astromagia." Edited by Alfonso d'Agostino. Naples: Liguori, 1992.

———. *Cantigas*. Edited by Jesús Montoya. 3rd ed. Madrid: Cátedra, 2002.

———. *Cantigas de Santa María: Edición facsímil de Códice T.I. 1 de la Biblioteca de San Lorenzo de El Escorial; Siglo XIII*. 2 vols. Madrid: Edilan, 1979.

———. *El libro de los doce sabios o Tractado de la nobleza y lealtad*. Edited by John K. Walsh. Madrid: Real Academia de la Lengua Española, 1975.

———. *Primera crónica general*. Edited by Ramón Menéndez Pidal. Madrid, 1955.

———. *Setenario*. Edited by Kenneth Vanderford. Barcelona: Crítica, 1984.

———. *Las siete partidas*. Translated by Samuel Parsons Scott. Edited by Robert Ignatius Burns. 5 vols. Philadelphia: University of Pennsylvania Press, 2001.

———. *Las siete partidas del rey Don Alfonso el Sabio*. Edited by Real Academia de la Historia. 3 vols. Madrid: Imprenta Real, 1801.

———. *Las siete partidas glosadas por el licenciado Gregorio López*. Salamanca: Andrea Portonariis, 1555.

———. *Songs of Holy Mary of Alfonso X, the Wise: A Translation of the "Cantigas de Santa Maria."* Translated by Kathleen Kulp-Hill. Tempe: Arizona Center for Medieval and Renaissance Studies, 2000.

Alfonso X, and Gregorio López. *Las siete partidas del sabio rey Don Alfonso el Nono*. Madrid: Boletín Oficial del Estado, 1974.

"Anales toledanos I, II, III." In *España sagrada: Theatro geográphico-historico de la iglesia de España; Origen, divisiones, y limites de todas sus provincias, antiguedad, translaciones, y estado antiguo y presente de sus sillas, con varias dissertaciones de las provincias antiguas de estos reinos*, edited by Enrique Flores, 23:381–401. Madrid: Antonio Marin, 1754.

Asín Palacios, Miguel, and Julián Ribera. *Manuscritos árabes y aljamiados de la Biblioteca de la Junta*. Madrid, 1912.

Barton, Simon, and Richard Fletcher, eds. *The World of El Cid: Chronicles of the Spanish Reconquest*. Manchester: Manchester University Press, 2000.

Bécquer, Gustavo Adolfo. *Historia de los templos de España*. Edited by José R. Arboleda. Barcelona: Puvill, 1857.

Bellamy, James A., and Patricia Owen Steiner, eds. *The Banners of the Champions: An Anthology of Medieval Arabic Poetry from Andalusia and Beyond*. Madison: Hispanic Seminary of Medieval Studies, 1989.

Berceo, Gonzalo de. *Los Milagros de Nuestra Señora: Estudio y edición crítica*. Edited by Brian Dutton. London: Tamesis, 1971.

———. *Miracles of Our Lady*. Translated by Richard Terry Mount and Annette Grant Cash. Lexington: University Press of Kentucky, 1997.

———. *La "Vida de San Millán de la Cogolla" de Gonzalo de Berceo: Estudio y edición crítica*. Edited by Brian Dutton. London: Tamesis, 1967.

———. *La Vida de Santo Domingo de Silos: Estudio y edición crítica*. Edited by Brian Dutton. London: Tamesis, 1978.

Bonnaz, Yves, ed. *Chroniques asturiennes (fin IXe siècle)*. Paris: Centre National de la Recherche Scientifique, 1987.

Cañas, Jesús, ed. *Libro de Alexandre*. Madrid: Cátedra, 1988.

Chronica Adefonsi Imperatoris. Edited by Luis Sánchez Belda. Madrid, 1950.

Chronica Naierensis. Edited by Juan A. Estévez Sola. Turnhout: Brepols, 1995.

The Chronicle of San Juan de la Peña: A Fourteenth Century Official History of the Crown of Aragón. Translated by Lynn H. Nelson. Philadelphia: University of Pennsylvania Press, 1991.

Chronique latine des rois de Castille jusqu'en 1236. Edited by Georges Cirot. Bordeaux: Feret et Fils, 1913.

Cole, Peter. *The Dream of the Poem: Hebrew Poetry from Muslim and Christian Spain*. Princeton: Princeton University Press, 2007.

————, trans. *Selected Poems of Shmuel HaNagid*. Princeton: Princeton University Press, 1996.

————, trans. *Selected Poems of Solomon Ibn Gabirol*. Princeton: Princeton University Press, 2001.

Constable, Olivia Remie, ed. *Medieval Iberia: Readings from Christian, Muslim, and Jewish Sources*. Philadelphia: University of Pennsylvania Press, 1997.

Crónica de Alfonso III. Edited by Zacarias García Villada. Madrid: Sucesores de Rivadeneyra, 1918.

Crónica de Alfonso X. Edited by Manuel Gónzales Jiménez. Murcia: Real Academia Alfonso X el Sabio, 1998.

Crónica de San Juan de la Peña. Edited by Antonio Ubieto Arteta. Valencia: Anubar, 1961.

"Crónica del rey don Alfonso X." In *Biblioteca de autores españoles*, 3–66. Madrid: Rivadeneyra, 1875.

"Crónica del rey don Alfonso XI." In *Biblioteca de autores españoles*, 173–392. Madrid: Rivadeneyra, 1875.

"Crónica latina de los reyes de Castilla." Edited by Maria Desamparados Cabanés Pecourt. Valencia, 1964.

Crónica latina de los reyes de Castilla. Edited by Luis Charlo Brea. Cádiz: Universidad de Cádiz, 1984.

Crónica najerense. Edited by Antonio Ubieto Arteta. Valencia: Anubar, 1966.

Falque Rey, Emma. *Historia compostellana*. Turnhout: Brepols, 1988.

Flores, Enrique. "Inscripciones que existen en Sevilla en el altar del santo rey D. Fernando y no se han publicado hasta hoy." In *España sagrada: Theatro geográphico-historico de la iglesia de España; Origen, divisiones, y limites de todas sus provincias, antiguedad, translaciones, y estado antiguo y presente de sus sillas, con varias dissertaciones de las provincias antiguas de estos reinos*, 2:2–25. Madrid: Antonio Marin, 1754.

Franzen, Cola. *Poems of Arab Andalusia*. San Francisco: City Lights, 1989.

García Gómez, Emilio, ed. *Las jarchas romances de la serie árabe en su marco: Edición en caracteres latinos, versión española en calco rítmico y estudio de 43 moaxajas andaluzas*. Madrid: Sociedad de Estudios y Publicaciones, 1965.

————, ed. *El libro de las banderas de los campeones de Ibn Sa'id al-Magribi*. Madrid: Instituto de Valencia de Don Juan, 1942.

————, ed. *Poemas arábigoandaluces*. Madrid: Espasa-Calpe, 1943.

————. *al-Shi'r al-andalusi: Bahth fi tatawwurihi wa-kasa'isih*. Translated by Husayn Munis. Cairo: Maktabat al-Nahdah al-Misriyah, 1952.

————. *Todo Ben Quzmán*. Madrid: Gredos, 1972.

García Morenos, Pilar. *Libro de ajedrez, dados y tablas de Alfonso X el Sabio*. Madrid: Patrimonio Nacional, 1977.

Garulo, Teresa. *Diwan de las poetisas de al-Andalus*. Madrid: Hiperión, 1986.

————. *La literatura árabe de al-Andalus durante el siglo XI*. Madrid: Hiperión, 1998.

Guillén Robles, Francisco. *Leyendas de Jose, hijo de Jacob y de Alejandro Magno sacadas de dos manuscritos moriscos de la Biblioteca Nacional de Madrid*. Saragossa: Imprenta del Hospicio Provincial, 1888.

————. *Leyendas moriscas*. 3 vols. Madrid: Sufi, 1889 [reprinted 1993].

Hillenbrand, Carole, trans. *The History of al-Tabari: Volume 26, The Waning of the Umayyad Caliphate*. Albany: State University of New York Press, 1989.

al-Himyari, Muhammad ibn Abd Allah. *La Péninsule Ibérique au moyen-âge d'après le Kitab al-rawd al-mitar fi khabar al-aqtar d'Ibn Abd al-Mu'nim al-Himyari*. Translated and edited by Evariste Lévi-Provençal. Leiden: Brill, 1938.

"Historia compostelana." In *España sagrada: Theatro geográphico-historico de la iglesia de España; Origen, divisiones, y limites de todas sus provincias, antiguedad, translaciones, y estado antiguo y presente de sus sillas, con varias dissertaciones de las provincias antiguas de estos reinos*, edited by Enrique Flores, 20:1–598. Madrid: Antonio Marin, 1754.

Historia silense. Edited by Justo Pérez de Urbel and Atilano González Ruiz-Zorrilla. Madrid, 1959.

Ibn Bassam al-Shantarini, Ali. *al-Dhakhira fi mahasin ahl al-jazira*. Edited by Ihsan Abbas. Tunis: al-Dar al-Arabiyah lil-Kitab, 1975.

Ibn Buluggin, Abd Allah. *The Tibyan: Memoirs of Abd Allah b. Buluggin, Last Zirid Amir of Granada*. Translated by Amin T. Tibi. Leiden: Brill, 1986.

Ibn Hayyan, Abu Marwan Hayyan ibn Khalaf. *Crónica de los emires al-Hakam I y 'Abdarrahman II entre los años 796 y 847 (Almuqtabis II-1)*. Translated by Mahmud Ali Makki and F. Corriente. Saragossa: Instituto de Estudios Islámicos y del Oriente Próximo, 2001.

———. *Crónica del califa Abdarrahman III an-Nasir entre los años 912 y 942 (al-Muqtabis V)*. Translated by María Jesús Viguera and F. Corriente. Saragossa: Anubar, Instituto Hispano-Arabe de Cultura, 1981.

———. *Al-Muqtabas min anba ahl al-Andalus*. Edited by Mahmud Ali Makki. Beirut: Dar al-Kitab al-Arabi, 1973.

———. *Al-Muqtabis (al-juz al-khamis)*. Edited by P. Chalmeta and F. Corriente. Madrid: al-Mahad al-Isbani al-Arabi lil-Thaqafah, 1979.

———. *Muqtabis II: Anales de los emires de Córdoba Alhaquém I (180–206 H./796–822 J.C.) y Abderramán II (206–232/822–847)*. Edited by Joaquín Vallvé Bermejo. Madrid: Real Academia de la Historia, 1999.

———. *La primera década del reinado de al-Hakam I, según el Muqtabis II, de Ben Hayyan de Córdoba (m. 469 h./1076 J.C.)*. Translated by Joaquín Vallvé and F. Ruiz Girela. Madrid: Real Academia de la Historia, 2003.

Ibn Hazm, Ali ibn Ahmad. *A Book Containing the Risala Known as the Dove's Neck-ring, about Love and Lovers*. Translated by A. R. Nykl. Paris: Librairie Orientaliste Paul Geuthner, 1931.

———. *El collar de la paloma: Tratado sobre el amor y los amantes*. Translated by Emilio García Gómez. Madrid: Sociedad de Estudios y Publicaciones, 1952.

———. *De l'amour et des amants: Tawq al-hamâma fî-l-ulfa wa-l-ullâf (Collier de la colombe sur l'amour et les amants)*. Translated by Gabriel Martinez-Gros. Paris: Sindbad, 1992.

———. *Jamharat ansab al-'arab*. Misr: Dar al-Maarif, 1948.

———. *The Ring of the Dove: A Treatise on the Art and Practice of Arab Love*. Translated by A. J. Arberry. London: Luzac, 1953.

Ibn Idhari, Muhammad. *Histoire de l'Afrique du Nord et de l'Espagne musulmane, intitulée Kitab al-bayan al-mugrib, et fragments de la chronique de Arib*. Translated by G. S. Colin and Evariste Lévi-Provençal. 2 vols. Leiden: Brill, 1948.

———. *Kitab al-bayan al-mughrib*. Edited by G. S. Colin and Evariste Lévi-Provençal, based on the version by R. Dozy. Beirut: Dar Assakafa, 1948.

Ibn Khaldun, Abd al-Rahman. *Histoire des Berberes et des dynasties musulmanes de l'Afrique septentrionale*. Translated by Baron de Slane. 4 vols. Paris, 1852–1856.

———. *The Muqaddimah: An Introduction to History*. Translated by Franz Rosenthal. Edited and abridged by N. J. Dawood. Princeton: Princeton University Press, 1967.

Ibn al-Khatib, Muhammad ibn Abd Allah. *Histoire de l'Espagne musulmane (Kitab amal al-alam)*. Beirut: Dar al-Makshush, 1956.

Ibn al-Muqaffa, Abd Allah. *Le livre de Kalila et Dimna*. Translated by André Miquel. Paris: Klincksieck, 1957.

Ibn Umirah al-Dabbi, Ahmad. *Bughyat al-multamis fi tarikh rijal ahl al-andalus*. Madrid, 1884.

Iglesia, Ramón. *Baraja de crónicas castellanas del siglo XIV*. [Mexico]: Séneca, 1940.

Irving, Thomas Ballantine. *Kalilah and Dimnah: An English Version of Bidpai's Fables Based upon Ancient Arabic and Spanish Manuscripts*. Newark, Del.: Juan de la Cuesta, 1980.

Irwin, Robert. *Night and Horses and the Desert: An Anthology of Classical Arabic Literature*. London: Penguin, 1999.

Jiménez de Rada, Rodrigo. "De rebus Hispaniae." In *Opera*, edited by Francisco Lorenzana, 1–208. Madrid, 1793.

———. "Historia arabum." In *Opera*, edited by Francisco Lorenzana, 242–283. Madrid, 1793.

———. *Opera*. Edited by Francisco Lorenzana. Madrid, 1793.

———. *Roderici Ximenii de Rada, Historia De rebus Hispaniae sive Historia Gothica*. Edited by Juan Fernández Valverde. Turnhout: Brepols, 1987.

Lacarra, María Jesús. *Sendebar*. Madrid: Cátedra, 1989.

Lacarra, María Jesús, and J. M. Cacho Blecua, eds. *Calila e Dimna*. Madrid: Castalia, 1984.

The Latin Chronicle of the Kings of Castile. Tempe: Arizona Center for Medieval and Renaissance Studies, 2002.

Lawrance, Jeremy. *Auto de los reyes magos (c. 1200)*. http://www.art.man.ac.uk/SPANISH/ug/documents/AUTRRMAG_002.pdf.

Lévi-Provençal, Evariste. *Inscriptions arabes d'Espagne avec quarante-quatre planches en phototypie*. Leiden: Brill, 1931.

Liu, Benjamin M., and James T. Monroe. *Ten Hispano-Arabic Strophic Songs in the Modern Oral Tradition*. Berkeley: University of California Press, 1989.

López Serrano, Matilde, ed. *Cantigas de Santa María de Alfonso X el Sabio, rey de Castilla*. Madrid: Patrimonio Nacional, 1974.

Lucas of Túy. *Crónica de España*. Edited by Julio Puyol. Madrid, 1926.

Manuel, Juan. *The Book of Count Lucanor and Patronio*. Translated by John E. Keller and L. Clark Keating. Lexington: University Press of Kentucky, 1977.

———. *El conde Lucanor o Libro de los enxiemplos del conde Lucanor et de Patronio*. Madrid: Castalia, 1969.

al-Maqqari, Ahmad ibn Muhammad, and Ibn al-Khatib. *The History of the Mohammedan Dynasties in Spain; Extracted from the Nafhu-t-tíb min ghosni-l-Andalusi-r-rattíb wa táríkh Lisánu-d-Dín Ibni-l-Khattíb*. Translated by Pascual de Gayangos. London: Printed for the Oriental translation fund of Great Britain and Ireland, sold by W. H. Allen and Co., 1840.

Martínez Montávez, Pedro, ed. *Taracea de poemas árabes*. Granada: Fundación Rodriguez-Acosta, 1995.

Melville, Charles, and Ahmad Ubaydli, eds. *Christians and Moors in Spain*. Vol. 3, *Arabic Sources, 711–1501*. Warminster: Aris and Phillips, 1992.

Menéndez Pidal, Ramon. *Poema de mio Cid*. 1911. Madrid: Espasa-Calpe, 1971.

Merwin, W. S. *The Mays of Ventadorn*. Washington, D.C.: National Geographic Society, 2002.

Middleton, Christopher, and Leticia Garza-Falcón, trans. *Andalusian Poems*. Boston: David R. Godine, 1993.

Monroe, James T. *Hispano-Arabic Poetry: A Student Anthology*. Berkeley: University of California Press, 1974.

Nebrija, Antonio de, Antonio Quilis, and Manuel Alvar. *Gramática de la lengua castellana*. 3 vols. Madrid: Ediciones de Cultura Hispánica, 1992.

Pagis, Dan. *Hebrew Poetry of the Middle Ages and Renaissance*. Berkeley: University of California Press, 1991.

Pérez González, Maurilio. *Crónica del emperador Alfonso VII*. [León]: Universidad de León, Secretariado de Publicaciones, 1997.

Perry, T. A. *The Moral Proverbs of Santob de Carrión: Jewish Wisdom in Christian Spain*. Princeton: Princeton University Press, 1987.

Poem of the Cid. Translated by W. S. Merwin. New York: Meridian, 1959.

The Poem of the Cid. Translated by Rita Hamilton and Janet Perry. Edited by Ian Michael. London: Penguin, 1975.

Prelog, Jan, ed. *Die Chronik Alfons' III: Untersuchungen und kritische Edition der vier Redactionen*. Frankfurt: Peter Lang, 1980.

Al-Qur'an: A Contemporary Translation. Translated by Ahmed Ali. Princeton: Princeton University Press, 1984.

Rubiera Mata, María Jesús, ed. *Poesía femenina hispanoárabe*. Madrid: Castalia, 1990.

Ruiz, Juan, Arcipreste de Hita. *Libro de buen amor*. Madrid: Austral, 1994.

Santob de Carrión. *Proverbios morales*. Edited by Theodore A. Perry. Madison: Hispanic Seminary of Medieval Studies, 1986.

Scheindlin, Raymond P. *The Gazelle: Medieval Hebrew Poems on God, Israel, and the Soul*. Philadelphia: Jewish Publication Society, 1991.

———. *Wine, Women, and Death: Medieval Hebrew Poems on the Good Life*. Philadelphia: Jewish Publication Society, 1986.

Sells, Michael A., ed. *Approaching the Qur'án: The Early Revelations*. Ashland: White Cloud, 1999.

———, trans. *Desert Tracings: Six Classic Arabian Odes by 'Alqama, Shánfara, Labíd, 'Antara, Al-A'sha, and Dhu al-Rúmma*. Middletown: Wesleyan University Press, 1989.

———. *Stations of Desire: Love Elegies from Ibn 'Arabi and New Poems*. Jerusalem: Ibis, 2000.

al-Shushtari, Abu al-Hasan. *Songs of Love and Devotion*. Translated by Lourdes María Alvarez. New York: Paulist, forthcoming.

Smith, Colin, ed. *Christians and Moors in Spain*. Vol. 1, *711–1150*. Warminster: Aris and Phillips, 1988.

———, ed. *Christians and Moors in Spain*. Vol. 2, *1195–1614*. Warminster: Aris and Phillips, 1989.

———. *Poema de mio Cid*. Oxford: Clarendon, 1972.

Wood, Ramsay. *Kalila and Dimna: Selected Fables of Bidpai*. New York: Knopf, 1980.

Secondary Works

Abad Castro, María Concepción. *Arquitectura mudéjar religiosa en el arzobispado de Toledo*. Toledo: Caja de Ahorro de Toledo, 1991.

————. *La iglesia de San Román de Toledo*. Madrid: El Viso, 2005.

Abu-Haidar, J. A. *Hispano-Arabic Literature and the Early Provençal Lyrics*. Richmond, Surrey: Curzon, 2001.

Aguilar, M. D., ed. *Mudéjar iberoamericano: Una expresión cultural de dos mundos*. 2 vols. Vol. 1. Granada: Universidad de Granada, 1993.

Alfonso X: Toledo 1984 (Catalog of Exposition, Museo de Santa Cruz, June–Sept. 1984). Toledo: Ministerio de Cultura, Dirección General de Bellas Artes y Archivos, 1984.

Almagro Gorbea, Antonio. "El palacio de Pedro I de Tordesillas: Realidad y hipótesis." *Reales Sitios: Revista del Patrimonio Nacional* 163 (2005): 2–13.

————. "El Patio del Crucero de los Reales Alcázares de Sevilla." *Al-Qantara* 20, no. 2 (1999): 331–376.

————. *Planimetría del Alcázar de Sevilla*. Seville: Ayuntamiento, Patronato del Real Alcázar, 2000.

————. "La recuperación del jardín medieval del Patio de las Doncellas." *Apuntes del Alcázar de Sevilla* 7 (2005): 45–67.

Alvar, Carlos, Fernando Gómez Redondo, and Georges Martin, eds. *El Cid: De la materia épica a las crónicas caballerescas* (Actas del Congreso Internacional "IX Centenario de la muerte del Cid," celebrado en la Universidad de Alcalá de Henares los días 19 y 20 de noviembre de 1999). Alcalá de Henares: Servicio de Publicaciones de la Universidad de Alcalá, 2002.

Alvarez, Lourdes María. "The Mystical Language of Daily Life: Vernacular Sufi Poetry and the Songs of Abu al-Hasan al-Shushtari." *Exemplaria* 17, no. 1 (2005): 1–32.

————. *Sufi Songs across an Andalusian Sky*. New York: Palgrave, forthcoming.

————. "'This Still Flickering Light': Reading and Teaching the Women Poets of al-Andalus." *La Corónica* 32, no. 1 (2003): 79–87.

Amador de los Ríos, José. *El estilo mudéjar en arquitectura*. 1859. Introduction, edition, and notes by Pierre Guenoun. Paris: Centre de Recherches de l'Institut d'Etudes Hispaniques, 1965.

————. *Historia crítica de la literatura española*. 7 vols. Madrid: José Rodríguez, 1861–1865.

————. *Historia social, política y religiosa de los judíos de España y Portugal*. 3 vols. Madrid: Aguilar, 1875–1876.

————. *Mezquita de Bib al Mardun, hoy ermita de Sto. Cristo de la Cruz y Nuestra Señora de la Luz*. Toledo, 1905.

————. *Toledo pintoresco o Descripción de sus más célebres monumentos*. Madrid: Ignacio Boix, 1845.

Amador de los Ríos, Rodrigo. *Monumentos arquitectónicos de España: Toledo*. Madrid: E. Martín y Gamoneda, 1905.

————. *Trofeos militares de la reconquista: Estudio acerca de las enseñas musulmanas del real monasterio de las Huelgas (Burgos) y de la catedral de Toledo*. Madrid: Fortanet, 1893.

Anderson, Glaire D. "The Suburban Villa (Munya) and Court Culture in Umayyad Cordoba." PhD dissertation, Massachusetts Institute of Technology, 2005.

Anglés, Higinio. *La música de las Cantigas de Santa María del rey Alfonso el Sabio: Facsímil, transcripción y estudio crítico*. 3 vols. Barcelona: Diputación Provincial de Barcelona, 1943–1964.

Angulo Iñiguez, Diego. *Arquitectura mudéjar sevillana de los siglos XIII, XIV y XV*. Seville: Servicio de Publicaciones del Ayuntamiento de Sevilla, 1983.

Arié, Rachel. *L'Espagne musulmane au temps des Nasrides (1232–1492)*. Paris: E. de Boccard, 1973.

————. *España musulmana (siglos VIII–XV)*. Vol. 3 of *Historia de España*. Edited by Manuel Tuñón de Lara. 10 vols. Madrid: Labor, 1984.

Arquitecturas de Toledo. Edited by Rafael del Cerro Malagón, María Jesús Sainz, Clara Delgado Valero, María Teresa Pérez Higuera, and M. Angeles Franco Mata. Toledo: Junta de Comunidades de Castilla–La Mancha, 1991.

El arte mudéjar: La estética islámica en el arte cristiano. Vienna: Electa, 2000.

Assas y Ereño, Manuel de. "Dia 8 de noviembre de 1857." *Semanario pintoresco español* (1857).

Ayerbe-Chaux, Reinaldo. *Yo, don Juan Manuel: Apología de una vida*. Madison: Hispanic Seminary of Medieval Studies, 1993.

Baer, Yitzhak. *History of the Jews in Christian Spain*. Translated by Louis Schoffman. Philadelphia: Jewish Publication Society, 1966.

Baldwin, M. W., and K. M. Setton, eds. *A History of the Crusades: The First Hundred Years*. Philadelphia: University of Pennsylvania Press, 1955.

Bango Torviso, Isidro Gonzalo. "Arquitectura de la décima centuria: ¿Repoblación o mozárabe?" *Goya* 122 (1974): 68–75.

———. "El arte de construir en ladrillo en Castilla y León durante la alta edad media, un mudéjar inventado en el siglo XIX." In *Mudéjar iberoamericano: Una expresión cultural de dos mundos*, 109–123. Granada: Universidad de Granada, 1993.

———. *Arte prerrománico hispano: El arte en la España cristiana de los siglos VI al XI*. Madrid: Espasa-Calpe, 2001.

———. *El arte románico en Castilla y León*. Madrid: Banco de Santander, 1997.

———, ed. *El camino de Santiago*. Madrid: Espasa-Calpe, 1998.

———. "El camino jacobeo y los espacios sagrados durante la alta edad media en España." In *Viajeros, peregrinos, mercaderes en el Occidente medieval (XVIII Semana de Estudios Medievales, Estella, 22 a 26 de julio de 1991)*, edited by Isidro Gonzalo Bango Torviso, Manuel Núñez Rodríguez, and José Manuel García Iglesias, 121–155. Pamplona: Gobierno de Navarra, Departamento de Educación y Cultura, 1999.

———. "Crisis de una historia del arte medieval a partir de la teoría de los estilos." *Cuadernos Secc. Artes Plásticas Monumentales*, no. 15 (1996): 15–28.

———. "De la arquitectura visigoda a la arquitectura asturiana: Los edificios ovetenses en la tradición de Toledo y frente a Aquisgran." In *L'Europe héritière de l'Espagne wisigothique: Colloque international du C.N.R.S., tenu à la Fondation Singer-Polignac (Paris, 14–16 mai 1990)*, edited by Jacques Fontaine and Christine Pellistrandi, 303–313. Madrid: Rencontres de la Casa de Velázquez, 1992.

———. *La edad de un reyno: Las encrucijadas de la Corona y la Diócesis de Pamplona*. 2 vols. Pamplona: Baluarte de Pamplona, 2006.

———. *Iglesia de San Martín de Valdilecha (Madrid)*. Madrid: Servicios de Extensión Cultural y Divulgación, Diputación Provincial de Madrid, 1981.

———. "Las llamadas iglesias de peregrinación o arquetipo de un estilo." In *El camino de Santiago, camino de estrellas*, 11–75. Madrid: Fundación Caixa Galicia, 1994.

———. *Maravillas de la España medieval: Tesoro sagrado y monarquía*. 2 vols. León: Junta de Castilla y León, Caja España, 2001.

———, ed. *Memoria de Sefarad (Toledo, Centro Cultural San Marcos, octubre 2002–enero 2003)*. Madrid: Sociedad Estatal para la Acción Cultural Exterior, 2002.

———. "El neovisigotismo artístico de los siglos IX y X: La restauración de ciudades y templos." *Revista de Ideas Estéticas* 148 (1979): 319–338.

———. "La part oriental dels temples de l'abat-bisbe Oliba." *Quaderns d'Estudis Medievals* 23–24 (1988): 51–66.

———, ed. *Remembering Sepharad: Jewish Culture in Medieval Spain*. Washington, D.C.: State Corporation for Spanish Cultural Action Abroad, 2003.

Bango Torviso, Isidro Gonzalo, Joan Sureda Pons, Joaquín Yarza, Javier Castán Lanaspa, Amelia Gallego de Miguel, and Alfonso Alvarez Mora. *Historia del arte de Castilla y León*. Vol. 2, *Arte románico*. Valladolid: Ambito, 1994.

Barbé, Geneviève. "Mudejarismo en el arte aragonés del siglo XVI." In *Actas del I Simposio Internacional de Mudejarismo*, 155–176. Madrid: Consejo Superior de Investigaciones Científicas, 1981.

Barletta, Vincent. *Covert Gestures: Crypto-Islamic Literature as Cultural Practice in Early Modern Spain*. Minneapolis: University of Minnesota Press, 2005.

Barral I Altet, Xavier. *La alta edad media: De la antigüedad tardía al año mil*. Madrid: Taschen, 1998.

Barrucand, Marianne, and Achim Bednorz. *Moorish Architecture in Andalusia*. New York: Taschen, 2002.

Barton, Simon. *The Aristocracy in Twelfth-Century León and Castile*. Cambridge: Cambridge University Press, 1997.

———. "From Mercenary to Crusader: The Career of Alvar Pérez de Castro (d. 1239) Re-examined." In *Church, State, Vellum, and Stone: Essays on Medieval Spain in Honor of John Williams*, edited by Therese Martin and Julie A. Harris, 111–129. Leiden: Brill, 2005.

———. *A History of Spain*. New York: Palgrave MacMillan, 2004.

———. "Traitors to the Faith? Christian Mercenaries in al-Andalus and the Maghrib, c. 1100–1300." In *Medieval Spain: Culture, Conflict and Coexistence; Studies in Honour of Angus MacKay*, edited by Roger Collins and Anthony Goodman, 23–45. London: Palgrave, 2002.

Beckwith, John. *Caskets from Cordoba*. London: Victoria and Albert Museum, H. M. Stationery Office, 1960.

Bécquer, Gustavo Adolfo. "Una calle de Toledo: La iglesia de San Román." *La Ilustración de Madrid* (1870).

Beech, George T. "The Eleanor of Aquitaine Vase, William IX of Aquitaine, and Muslim Spain." *Gesta* 32, no. 1 (1993): 3–10.

———. "Troubador Contacts with Muslim Spain and Knowledge of Arabic: New Evidence Concerning William IX of Aquitaine." *Romania* 113, no. 1–2 ([1992–]1995): 14–42.

Beinart, Haim. *The Expulsion of the Jews from Spain.* Translated by Jeffrey M. Green. Oxford: Littmann Library of Jewish Civilization, 2002.

Benjamin, Walter. *Illuminations.* Edited by Hannah Arendt. New York: Schocken, 1968.

Beresford, Andrew M. "The Poetry of Medieval Spain." In *The Cambridge History of Spanish Literature,* edited by David T. Gies, 75–94. Cambridge: Cambridge University Press, 2004.

Bernabé-Pons, Luis F. "La asimilación cultural de los musulmanes de España: Lengua y literatura de mudéjares y moriscos." In *Chrétiens et musulmans à la Renaissance: Actes du 37e colloque international du CESR* (1994), edited by Bartolomé Bennassar and Robert Sauzet, 317–335. Paris: Honoré Champion, 1998.

———. *Bibliografía de la literatura aljamiado-morisca.* Madrid: Universidad de Alicante, 1992.

Bhabha, Homi K. *The Location of Culture.* London: Routledge, 1994.

Biale, David, ed. *Cultures of the Jews: A New History.* New York: Schocken, 2002.

Bishko, Charles J. "Fernando I y los orígenes de la alianza castellano-leonesa con Cluny." *Cuadernos de Historia de España* 47–48 (1969): 50–116.

———. "The Spanish and Portuguese Reconquest, 1095–1492." In *A History of the Crusades: The Fourteenth and Fifteenth Centuries,* edited by Harry W. Hazard and Kenneth M. Setton, 396–456. Madison: University of Wisconsin Press, 1977.

Bisson, Thomas N. *The Medieval Crown of Aragon: A Short History.* Oxford: Clarendon, 1986.

Blair, Sheila S., and Jonathan Bloom. "The Mirage of Islamic Art: Reflections on the Study of an Unwieldy Field." *Art Bulletin* 85, no. 1 (2003): 153–184.

Bloom, Jonathan. *Minaret: Symbol of Islam.* Oxford: Oxford University Press, 1989.

———. "The Revival of Early Islamic Architecture by the Umayyads of Spain." In *The Medieval Mediterranean: Cross-Cultural Contacts,* edited by Marilyn Joyce Segal Chiat and Kathryn Reyerson, 35–42. St. Cloud: North Star, 1988.

Bloom, Jonathan, and Sheila Blair. *Islam: A Thousand Years of Faith and Power.* New Haven: Yale University Press, 2002.

Bloom, Jonathan M., Ahmed Toufiq, Stefano Carboni, Jack Soultanian, Antoine M. Wilmering, Mark D. Minor, Andrew Zawacki, and El Mostafa Hbibi. *The Minbar from the Kutubiyya Mosque.* New York: Metropolitan Museum of Art, 1998.

Boase, Roger. "Arab Influences on European Love-Poetry." In *The Legacy of Muslim Spain,* edited by Salma Khadra Jayyusi, 457–482. Leiden: Brill, 1992.

———. "The Morisco Expulsion and Diaspora: An Example of Racial and Religious Intolerance." In *Cultures in Contact in Medieval Spain: Historical and Literary Essays Presented to L. P. Harvey,* edited by David Hook and Barry Taylor, 9–28. London: King's College London Medieval Studies, 1990.

———. *The Origin and Meaning of Courtly Love: A Critical Study of European Scholarship.* Manchester: Manchester University Press, 1976.

Bonet Correa, Antonio. *Arte pre-románico asturiano.* Barcelona: Polígrafa, 1967.

Borrás Gualis, Gonzalo M. *El arte mudéjar.* Teruel: Instituto de Estudios Turolenses, 1990.

———, ed. *El arte mudéjar.* Saragossa: Unesco-Ibercaja, 1996.

———. *Arte mudéjar aragonés.* Saragossa: Guara, 1978.

———. *El arte mudéjar en Teruel y su provincia.* Teruel: Instituto de Estudios Terulenses, 1987.

———. "El mudéjar como constante artística." In *Actas del 1 Simposio Internacional de Mudejarismo,* 29–40. Madrid: Consejo Superior de Investigaciones Científicas, 1981.

Bosch, Lynette M. F. *Art, Liturgy and Legend in Renaissance Toledo: The Mendoza and the Iglesia Primada.* University Park: Pennsylvania State University Press, 2000.

Bosch Vilá, Jacinto. *Los almorávides: Historia de Marruecos.* Tetuán: Marroquí, 1956.

———. *Historia de Sevilla: La Sevilla islámica, 711–1248.* Seville: Universidad de Sevilla, 1984.

Bosch Vilá, Jacinto, and Emilio Molina López. *Los almorávides.* Granada: Universidad de Granada, 1998.

Boswell, John. *The Royal Treasure: Muslim Communities under the Crown of Aragon in the Fourteenth Century.* New Haven: Yale University Press, 1977.

Brann, Ross. "The Arabized Jews." In *The Cambridge History of Arabic Literature: The Literature of al-Andalus,* edited by María Rosa Menocal, Raymond P. Scheindlin, and Michael Sells, 435–454. Cambridge: Cambridge University Press, 2000.

———. *The Compunctious Poet: Cultural Ambiguity and Hebrew Poetry in Muslim Spain*. Baltimore: Johns Hopkins University Press, 1991.

———. "Judah Halevi." In *The Cambridge History of Arabic Literature: The Literature of al-Andalus*, edited by María Rosa Menocal, Raymond P. Scheindlin, and Michael Sells, 265–281. Cambridge: Cambridge University Press, 2000.

———, ed. *Languages of Power in Islamic Spain*. Bethesda: CDL Press, 1997.

———. *Power in the Portrayal: Representations of Jews and Muslims in Eleventh- and Twelfth-Century Islamic Spain*. Princeton: Princeton University Press, 2002.

Brann, Ross, and Adam Sutcliffe, eds. *Renewing the Past, Reconfiguring Jewish Culture: From al-Andalus to the Haskalah*. Philadelphia: University of Pennsylvania Press, 2004.

Bulliet, Richard W. *Conversion to Islam in the Medieval Period: An Essay in Quantitative History*. Cambridge: Harvard University Press, 1979.

Burman, Thomas E. "Cambridge University Library MS Mm. v. 26 and the History of the Study of the Qur'an in Medieval and Early Modern Europe." In *Religion, Text and Society in Medieval Spain and Northern Europe: Essays in Honor of J. N. Hillgarth*, edited by Thomas E. Burman, Mark D. Meyerson, and Leah Shopkow, 335–363. Toronto: Pontifical Institute of Medieval Studies, 2002.

———. "Michael Scot and the Translators." In *The Cambridge History of Arabic Literature: The Literature of al-Andalus*, edited by María Rosa Menocal, Raymond P. Scheindlin, and Michael Sells, 404–411. Cambridge: Cambridge University Press, 2000.

———. "Polemic, Philology, and Ambivalence: Reading the Qur'an in Latin Christendom." *Journal of Islamic Studies* 15, no. 2 (2004): 181–209.

———. *Religious Polemic and the Intellectual History of the Mozarabs, c. 1050–1200*. Leiden: Brill, 1994.

———. "Tafsir and Translation: Traditional Arabic Qur'an Exegesis and the Latin Qur'ans of Robert of Ketton and Mark of Toledo." *Speculum* 73 (1998): 703–732.

Burman, Thomas E., Mark D. Meyerson, and Leah Shopkow, eds. *Religion, Text and Society in Medieval Spain and Northern Europe: Essays in Honor of J. N. Hillgarth*. Toronto: Pontifical Institute of Medieval Studies, 2002.

Burnett, Charles. "The Coherence of the Arabic-Latin Translation Program in Toledo in the Twelfth Century." *Science in Context* 14, no. 1–2 (2001): 249–288.

———. *The Introduction of Arabic Learning into England*. London: British Library, 1997.

———. *Magic and Divination in the Middle Ages*. Brookfield: Variorum, 1996.

———. "The Translating Activity in Medieval Spain." In *The Legacy of Muslim Spain*, edited by Salma Khadra Jayyusi, 1036–1062. Leiden: Brill, 1992.

Burns, E. Jane. *Courtly Love Undressed: Reading through Clothes in Medieval French Culture*. Philadelphia: University of Pennsylvania Press, 2002.

———. "Saracen Silk and the Virgin's Chemise: Cultural Crossings in Cloth." *Speculum* 81 (2006): 365–397.

Burns, Robert I., ed. *Emperor of Culture: Alfonso X the Learned and His Thirteenth-Century Renaissance*. Philadelphia: University of Pennsylvania Press, 1990.

———. *Muslims, Christians and Jews in the Crusader Kingdom of Valencia: Societies in Symbiosis*. Cambridge: Cambridge University Press, 1984.

———. "Muslims in the Thirteenth-Century Realm of Aragon: Interaction and Reaction." In *Muslims under Latin Rule, 1100–1300*, edited by James M. Powell, 57–102. Princeton: Princeton University Press, 1990.

———, ed. *The Worlds of Alfonso the Learned and James the Conqueror: Intellect and Force in the Middle Ages*. Princeton: Princeton University Press, 1985.

Burns, Robert I., and Paul E. Chevedden. *Negotiating Cultures: Bilingual Surrender Treaties in Muslim-Crusader Spain under James the Conqueror*. Leiden: Brill, 1999.

Buturovic, Amila. "Ibn Quzman." In *The Cambridge History of Arabic Literature: The Literature of al-Andalus*, edited by María Rosa Menocal, Raymond P. Scheindlin, and Michael Sells, 292–305. Cambridge: Cambridge University Press, 2000.

Cagigas, Isidro de las. *Los mozárabes: Minorías étnico-religiosas de la edad media española*. Madrid: Instituto de Estudios Africanos, 1947.

———. *Los mudéjares: Minorías étnico-religiosas de la edad media española*. Madrid: Instituto de Estudios Africanos, 1948–1949.

Cahn, Walter B. "The 'Portrait' of Muhammad in the Toledan Collection." In *Reading Medieval Images*, edited by Elizabeth Sears and Thelma K. Thomas, 51–60. Ann Arbor: University of Michigan Press, 2002.

Calvo Capilla, Susana. "La capilla de Belén del convento de Santa Fe de Toledo: ¿Un oratorio musulmán?" *Tulaytula* 11 (2004): 31–74.

———. "El entorno de la mezquita aljama de Córdoba antes y después de la conquista cristiana." In *Catedral y ciudad medieval en la Península Ibérica*, edited by Eduardo Carrero Santamaría and Daniel Rico, 9–34. Murcia: Nausícaä, 2004.

———. "La mezquita de Bab al-Mardum y el proceso de consagración de pequeñas mezquitas en Toledo (s. XII–XIII)." *Al-Qantara* 20, no. 2 (1999): 299–330.

———. "Las mezquitas de pequeñas ciudades y núcleos rurales de al-Andalus." *Revista de Ciencias de las Religiones, Anejos* 10 (2004): 39–63.

———. "Reflexiones sobre la mezquita de Bab al-Mardum y la capilla de Belén de Toledo." In *Entre el califato y la taifa: Mil años de Cristo de la Luz (Actas del Congreso Internacional, Toledo, 1999)*, 335–346. Toledo: Asociación de Amigos del Toledo Islámico, 2000.

Camón Aznar, José. "Arquitectura española del siglo X: Mozárabe y de la repoblación." *Goya* 52 (1963): 206–219.

———. "La iglesia de San Román de Toledo: Cronología." *Al-Andalus* 6 (1941): 451–459.

———. "Pinturas murales de San Román de Toledo." *Archivo Español de Arte* 15 (1942): 50–58.

Cantarino, Vincente. *Entre monjes y musulmanes: El conflicto que fue España*. Madrid: Alhambra, 1978.

———. "Ese autor que llaman Don Juan Manuel." *Actas del VIII Congreso de la Asociación Internacional de Hispanistas* 1 (1986): 329–338.

Cantera Burgos, Francisco. *Sinagogas de Toledo, Segovia y Córdoba*. Madrid: Instituto Arias Montana, Consejo Superior de Investigaciones Científicas, 1973.

———. *Sinagogas españolas, con especial estudio de la de Córdoba y la toledana de El Tránsito*. Madrid: Instituto Arias Montana, Consejo Superior de Investigaciones Científicas, 1984.

Cardaillac, Louis, ed. *Tolède, XIIe–XIIIe: Musulmans, chrétiens et juifs; Le savoir et la tolérance*. Paris: Autrement, 1991.

———, ed. *Toledo, siglos XII–XIII: Musulmanes, cristianos y judíos; La sabiduría y la tolerancia*. Madrid: Alianza, 1992.

Caro Baroja, Julio. *Los moriscos del reinado de Granada*. Madrid: Istmo, 2000.

Carrero Santamaría, Eduardo. "De mezquita a catedral: La seo de Huesca y sus alrededores entre los siglos XI y XV." In *Catedral y ciudad en la Península Ibérica*, edited by Eduardo Carrero Santamaría and Daniel Rico, 35–75. Murcia: Nausícaä, 2004.

Carrete Parrondo, Carlos, Marcelo Dascal, Francisco Márquez Villanueva, and Angel Sáenz-Badillos, eds. *Encuentros and Desencuentros: Spanish Jewish Cultural Interaction throughout History*. Tel Aviv: University Publishing Project, 2000.

Castán Lanaspa, Javier. "Incorporación de Castilla a la Europa cristiana (siglos XI–XIV)." In *Historia de una cultura: La singularidad de Castilla*, edited by Agustín García Simón, 61–102. Valladolid: Junta de Castilla y León, 1995.

Castro, Américo. *Cervantes y los casticismos españoles y otros estudios cervantinos*. Madrid: Trotta, 2002.

———. "El enfoque histórico y la no hispanidad de los visigodos." *Nueva Revista de Filología Hispánica* 3, no. 3 (1949): 217–263.

———. *España en su historia: Cristianos, moros y judíos*. Barcelona: Crítica, 2001.

———. *Español, palabra extranjera: Razones y motivos*. Madrid: Cuadernos Taurus, 1970.

———. "Mozarabic Poetry and Castile: A Rejoinder to Mr. Leo Spitzer." *Comparative Literature* 4, no. 2 (1952): 188–189.

———. *El pensamiento de Cervantes y otros estudios cervantinos*. Madrid: Trotta, 2001.

———. *La realidad histórica de España*. Mexico: Porrúa, 1954.

———. *Santiago de España*. Buenos Aires: Emecé, 1958.

———. *The Spaniards: An Introduction to Their History*. Translated by Willard F. King and Selma Margaretten. Berkeley: University of California Press, 1971.

———. *The Structure of Spanish History*. Translated by Edmund L. King. Princeton: Princeton University Press, 1954.

Catalán, Diego. *La "Estoria de España" de Alfonso X: Creación y evolución*. Valencia: Fundación Ramón Menéndez Pidal, Universidad Autónoma de Madrid, 1990.

Catlos, Brian A. "Contexto y conveniencia en la corona de Aragón: Propuesta de un modelo de interaccíon entre grupos etno-religiosos minoritarios y mayoritarios." In *Los mudéjares valencianos y peninsulares*, edited by Manuel Ruzafa. Valencia: Revista D'Historia Medieval, 2001–2002.

———. "Mohamet Abenadalill: A Muslim Mercenary in the Service of the Kings of Aragon (1290–1291)." In *Jews, Muslims and Christians in and*

around the Crown of Aragon: Essays in Honour of Professor Elena Lourie, edited by Harvey J. Hames, 257–302. Leiden: Brill, 2004.

———. "'Secundum suam zunam': Muslims in the Laws of the Aragonese 'Reconquista.'" Mediterranean Studies 7 (1998): 13–26.

———. The Victors and the Vanquished: Christians and Muslims of Catalonia and Aragon, 1050–1300. Cambridge: Cambridge University Press, 2004.

Cheddadi, Abdesselam. "A propos d'une ambassade d'Ibn Khaldun auprès Pierre le Cruel." Hesperis-Tamuda 20–21 (1982–1983): 5–23.

Cohen, Mark R. Under Crescent and Cross. Princeton: Princeton University Press, 1994.

Colbert, Edward P. The Martyrs of Córdoba (850–859): A Study of the Sources. Washington, D.C.: Catholic University of America Press, 1962.

Collins, Roger. The Arab Conquest of Spain, 710–797. Oxford: Blackwell, 1989.

———. "Continuity and Loss in Medieval Spanish Culture: The Evidence of MS Silos, Archivo Monástico 4." In Medieval Spain: Culture, Conflict and Coexistence; Studies in Honour of Angus MacKay, edited by Roger Collins and Anthony Goodman, 1–22. London: Palgrave, 2002.

———. Early Medieval Spain: Unity in Diversity, 400–1000. 2nd ed. New York: St. Martin's, 1995.

Collins, Roger, and Anthony Goodman, eds. Medieval Spain: Culture, Conflict and Coexistence; Studies in Honour of Angus MacKay. London: Palgrave, 2002.

Cómez Ramos, Rafael. Arquitectura alfonsi. Seville: Publicaciones de la Excma. Diputación Provincial de Sevilla, 1974.

———. Los constructores de la España medieval. Seville: Universidad de Sevilla, 2001.

———. Las empresas artísticas de Alfonso X el Sabio. Seville: Publicaciones de la Excma. Diputación Provincial de Sevilla, 1979.

———. Imagen y símbolo en la edad media andaluza. Seville: Universidad de Sevilla, 1990.

———. "Tradición e innovación artísticas en Castilla en el siglo XIII." Alcantare 3 (2002–2003): 135–164.

Constable, Olivia Remie. Trade and Traders in Muslim Spain: The Commercial Realignment of the Iberian Peninsula, 900–1500. Cambridge: Cambridge University Press, 1994.

Cook, Walter William, and José Gudiol Ricart. Pintura e imaginería románicas. Vol. 6 of Ars Hispaniae: Historia universal del arte hispánico. Madrid: Plus Ultra, 1980.

Cressier, Patrice. "Los capiteles islámicos de Toledo." In Entre el califato y la taifa: Mil años de Cristo de la Luz (Actas del Congreso Internacional, Toledo, 1999), 169–196. Toledo: Asociación de Amigos del Toledo Islámico, 2000.

Creswell, K. A. C. Early Muslim Architecture. Oxford: Oxford University Press, 1969.

Cutler, Anthony. The Craft of Ivory: Sources, Techniques, and Uses in the Mediterranean World, A.D. 200–1400. Washington, D.C.: Dumbarton Oaks Research Library and Collection, 1985.

Dagenais, John. "Medieval Spanish Literature in the Twenty-First Century." In The Cambridge History of Spanish Literature, edited by David T. Gies, 39–57. Cambridge: Cambridge University Press, 2004.

d'Alverny, Marie-Thérèse. La connaissance de l'islam dans l'Occident médiéval. Edited by Charles Burnett. Aldershot: Variorum, 1994.

———. Etudes sur le symbolisme de la Sagesse et sur l'iconographie. Edited by Charles Burnett. Aldershot: Variorum, 1993.

———. La transmission des textes philosophiques et scientifiques au moyen âge. Edited by Charles Burnett. Aldershot: Variorum, 1994.

d'Alverny, Marie-Thérèse, and Charles Burnett. Pensée médiévale en Occident: Théologie, magie et autres textes des XIIe–XIIIe siècles. Edited by Charles Burnett. Aldershot: Variorum, 1995.

Delgado Valero, Clara. Arte hispano-musulmán: Artículos; Homenaje a Clara Delgado Valero. Madrid: Universidad Nacional de Educación a Distancia, 2001.

———. Materiales para el estudio morfológico y ornamental del arte islámico en Toledo. Toledo: Consejería de Educación y Cultura, 1987.

———. "El mudéjar toledano y su área de influencia." In El mudéjar iberoamericano: Del islam al nuevo mundo, edited by Ignacio Henares Cuéllar, 111–126. Barcelona: Lunwerg, 1995.

———. "El mudéjar: Una constante en Toledo entre los siglos XII y XV." In Mudéjar iberoamericano: Una expresión cultural de dos mundos, edited by M. D. Aguilar, 79–107. Granada: Universidad de Granada, 1993.

———. Toledo islámico: Ciudad, arte e historia. Toledo: Caja de Toledo, 1987.

Delgado Valero, Clara, [et al.]. *Regreso a Tulaytula: Guía del Toledo islámico (siglos VIII–XI)*. Toledo: Junta de Comunidades de Castilla–La Mancha, 1999.

Deyermond, Alan. "The *Libro de los engaños*: Its Social and Literary Context." In *The Spirit of the Court: Selected Proceedings of the Fourth Congress of the International Courtly Literature Society*, edited by Glyn S. Burgess and Robert A. Taylor, 158–167. Cambridge: D. S. Brewer, 1985.

Díaz Martín, Luis Vicente. *Pedro I, 1350–1369*. Palencia: Diputación Provincial de Palencia, Editorial la Olmeda, 1995.

Díaz y Díaz, Manuel C. "La historiografía hispana desde la invasión árabe hasta el año 1000." In *De Isidoro al siglo XI: Ocho estudios sobre la vida literaria peninsular*, edited by Manuel C. Díaz y Díaz, 203–234. Barcelona: El Albir Universal, 1976.

Díez Jorge, Maria Elena. *El arte mudéjar: Expresión estética de una convivencia*. Granada: Universidad de Granada, Instituto de Estudios Turolenses, 2001.

———. *El palacio islámico de la Alhambra: Propuestas para una lectura multicultural*. Granada: Universidad–La General, 1998.

Dodds, Jerrilynn D., ed. *Al-Andalus: The Art of Islamic Spain*. New York: Metropolitan Museum of Art, 1992.

———. *Architecture and Ideology in Early Medieval Spain*. University Park: Pennsylvania State University Press, 1990.

———. "The Arts of al-Andalus." In *The Legacy of Muslim Spain*, edited by Salma Khadra Jayyusi, 599–620. Leiden: Brill, 1992.

———. "Entre Roma i el romànic: El mite d'Occident." In *Catalunya a l'època carolingia: Art i cultura abans del romànic (segles IX i X)*, 147–155. Barcelona: Museu Nacional d'Art de Catalunya, 1999. Translated in same volume as "Between Rome and Romanesque: Architecture and the Myth of the West."

———. "The Great Mosque of Cordoba." In *Al-Andalus: The Art of Islamic Spain*, edited by Jerrilynn D. Dodds, 10–25. New York: Metropolitan Museum of Art, 1992.

———. "Hunting for Identity." In *Imágenes y promotores en el arte medieval: Miscelánea en homenaje a Joaquín Yarza Luaces*, edited by Maria Luisa Melero Moneo, Francesca Español Bertrán, Anna Orriols I Alsina, and Daniel Rico Camps, 89–100. Barcelona: Universitat Autònoma de Barcelona, 2001.

———. "Islam, Christianity, and the Problem of Religious Art." In *The Art of Medieval Spain, A.D.*
500–1200, edited by Jerrilynn Dodds, Charles Little, Serafin Moralejo, and John Williams, 27–37. New York: Metropolitan Museum of Art, 1993.

———. "Mudejar Tradition and the Synagogues of Medieval Spain: Cultural Identity and Cultural Hegemony." In *Convivencia: Jews, Muslims, and Christians in Medieval Spain*, edited by Vivian B. Mann, Thomas F. Glick, and Jerrilynn D. Dodds, 113–132. New York: George Braziller in association with the Jewish Museum, 1992.

———. "The Mudejar Tradition in Architecture." In *The Legacy of Muslim Spain*, edited by Salma Khadra Jayyusi, 592–597. Leiden: Brill, 1992.

———. "Rodrigo, Reconquest, and Assimilation: Some Preliminary Thoughts about San Román." *Studies in Iconography* (forthcoming).

Dodds, Jerrilynn, Charles Little, Serafin Moralejo, and John Williams, eds. *The Art of Medieval Spain, A.D. 500–1200*. New York: Metropolitan Museum of Art, 1993.

Drews, Wolfram. "'Sarazenen' als Spanier? Muslime und kastilisch-neogotische Gemeinschaft bei Rodrigo Jiménez de Rada." In *Wissen über Grenzen: Arabisches Wissen und lateinisches Mittelalter*, edited by Andreas Speer and Lydia Wegener, 259–281. Berlin: Walter de Gruyter, 2006.

Duggan, Joseph J. *The Cantar de mio Cid: Poetic Creation in Its Economic and Social Contexts*. Cambridge: Cambridge University Press, 1989.

Dunn, Peter N. "Don Juan Manuel: The World as Text." *MLN* 106, no. 2 (1991): 223–240.

Echenique Elizondo, María Teresa. "Nivellement linguistique et standardisation en espagnol (castillian) médiéval." In *The Dawn of the Written Vernacular in Western Europe*, edited by Michele Goyens and Werner Verbeke, 337–350. Leuven: Leuven University Press, 2003.

Echevarría, Ana. "Eschatology or Biography? Alfonso X, Muhammad's Ladder and a Jewish Go-Between." In *Under the Influence: Questioning the Comparative in Medieval Castile*, edited by Cynthia Robinson and Leyla Rouhi, 133–152. Leiden: Brill, 2005.

Ecker, Heather L. *Caliphs and Kings: The Art and Influence of Islamic Spain*. Washington, D.C.: Smithsonian Institution, 2004.

———. "The Conversion of Mosques to Synagogues in Seville: The Case of the Mezquita de la Judería." *Gesta* 36, no. 2 (1997): 190–207.

————. "How to Administer a Conquered City in al-Andalus: Mosques, Parish Churches and Parishes." In *Under the Influence: Questioning the Comparative in Medieval Castile*, edited by Cynthia Robinson and Leyla Rouhi, 45–65. Leiden: Brill, 2005.

Elinson, Alexander Eben. "Contrapuntal Composition in the *Muwashshah* Family, or Variations on a Panegyric Theme." *Medieval Encounters* 7, no. 2 (2001): 174–196.

Ellis, Roger, and Ruth Evans, eds. *The Medieval Translator 4*. Binghamton: Medieval and Renaissance Texts and Studies, State University of New York, 1994.

Entre el califato y la taifa: Mil años de Cristo de la Luz (Actas del Congreso Internacional, Toledo, 1999). Toledo: Asociación de Amigos del Toledo Islámico, 2000.

Epalza, Mikel de. "Mozarabs: An Emblematic Christian Minority in Islamic Al-Andalus." In *The Legacy of Muslim Spain*, edited by Salma Khadra Jayyusi, 149–170. Leiden: Brill, 1992.

Ettinghausen, Richard, Oleg Grabar, and Marilyn Jenkins-Madina. *Islamic Art and Architecture, 650–1250*. New Haven: Yale University Press, 2001.

Ewert, Christian. "The Architectural Heritage of Islamic Spain in North Africa." In *Al-Andalus: The Art of Islamic Spain*, edited by Jerrilynn D. Dodds, 85–95. New York: Metropolitan Museum of Art, 1992.

————. "El Cristo de la Luz: Una copia de la mezquita de Córdoba." In *Entre el califato y la taifa: Mil años de Cristo de la Luz (Actas del Congreso Internacional, Toledo, 1999)*, 11–52. Toledo: Asociación de Amigos del Toledo Islámico, 2000.

————. "Die Moschee am Bab al-Mardum in Toledo: Eine 'Kopie' der Moschee von Cordoba." *Madrider Mitteilungen* 18 (1977): 287–354.

————. *Spanisch-Islamische Systeme sich kreuzenden Bögen*. Berlin: Madrider Forschungen Band 2, 1968.

————. "Tradiciones omeyas en la arquitectura palatina de la época de los taifas: La Aljafería de Zaragoza." In *Actas del XXIII Congreso Internacional de Historia del Arte: Entre el Mediterráneo y el Atlántico, Granada, 1973*, 62–75. Granada: Universidad de Granada, 1976.

Ewert, Christian, and Jens-Peter Wisshak. *Forschungen zur almohadischen Moschee*. Mainz: P. von Zabern, 1981.

Feliciano, María Judith. "Muslim Shrouds for Christian Kings? A Reassessment of Andalusi Textiles in Thirteenth Century Castilian Life and Ritual." In

Under the Influence: Questioning the Comparative in Medieval Castile, edited by Cynthia Robinson and Leyla Rouhi, 101–131. Leiden: Brill, 2005.

Fernández González, Etelvina. "Que los reyes vestiessen panos de seda, con oro, e con piedras preciosas: Indumentarias ricas en la Península Ibérica (1180–1300)." Forthcoming.

Fernández Ordoñez, Inés. *Estorias de Alfonso el Sabio*. Madrid: Istmo, 1992.

Fernández y González, Francisco. *Estado social y político de los mudéjares de Castilla*. Madrid: Hiperión, 1985.

Fernández-Puertas, Antonio. "Alhambra: Urbanismo del barrio castrense de la Alcazaba." In *Casas y palacios de al-Andalus*, edited by Julio Navarro Palazón, 255–268. Barcelona: Lunwerg, 1995.

————. *The Alhambra: From Muhammad V (1354) to the Present Day (1995)*. London: Saqi Books, 2007.

————. *The Alhambra: The Ninth Century to Yusuf I*. London: Saqi Books, 2001.

————. *La fachada del palacio de Comares*. Granada: Patronato de la Alhambra y Generalife, 1980.

Ferrando, Ignacio. "El árabe, lengua del Toledo islámico." In *Entre el califato y la taifa: Mil años de Cristo de la Luz (Actas del Congreso Internacional, Toledo, 1999)*, 107–124. Toledo: Asociación de Amigos del Toledo Islámico, 2000.

Fletcher, Richard. *The Cross and the Crescent*. New York: Viking, 2003.

————. *Moorish Spain*. Berkeley: University of California Press, 1992.

————. *The Quest for El Cid*. New York: Oxford University Press, 1989.

————. "Reconquest and Crusade in Medieval Spain c. 1050–1150." *Transactions of the Royal Historical Society* 37 (1987): 31–47.

Flood, Finbarr B. *The Great Mosque of Damascus: Studies on the Makings of an Umayyad Visual Culture*. Leiden: Brill, 2001.

Flory, David A. *El Conde Lucanor: Don Juan Manuel en su contexto histórico*. Madrid: Pliegos, 1995.

Fontaine, Jacques. "La literatura mozárabe 'extremadura' de la latinidad cristiana antigua." In *Arte y cultura mozárabe*, 101–138. Toledo: Instituto de Estudios Visigótico-Mozárabes, 1979.

Galmés de Fuentes, Alvaro. *Influencias sintácticas y estilísticas del árabe en la prosa medieval castellana*. Madrid: Real Academia Española, 1956.

————. *Los moriscos (desde su misma orilla)*. Madrid: Instituto Egipcio, 1993.

————. *Romania Arabica II: Estudios de literatura comparada árabe y romance*. Madrid: Real Academia de la Historia, 2000.

García de Cortázar y Ruiz de Aguirre, José Angel. *La época medieval*. Vol. 2 of *Historia de España alfaguara*. Madrid: Alianza, 1973.

García Gallo, Alfonso. "Los fueros de Toledo." *Anuario de Historia del Derecho Español* 45 (1975): 407–458.

García Gómez, Emilio, ed. *Cinco poetas musulmanes: Biografías y estudios*. Madrid: Espasa-Calpe, 1944.

————. "Una obra importante sobre la poesía arábigoandaluza: Reseña del libro del prof. H. Pérès." *Al-Andalus: Revista de las Escuelas de Estudios Arabes de Madrid y Granada* 4 (1936–1939): 283–316.

García Sánchez, E. "Botánica y agronomía en Tulaytula." In *Entre el califato y la taifa: Mil años de Cristo de la Luz (Actas del Congreso Internacional, Toledo, 1999)*, 135–152. Toledo: Asociación de Amigos del Toledo Islámico, 2000.

Gautier Dalché, Jean. "L'histoire castillane dans la première moitié du XIVe siècle." *Anuario de Estudios Medievales* 7 (1970–1971): 239–252.

————. *Historia urbana de León y Castilla en la edad media*. Madrid: Siglo Ventiuno de España, 1979.

————. "Le rôle de la reconquête de Tolède dans l'histoire monétaire de la Castille (1085–1174)." In *Homenaje al profesor Juan Torres Fontes*, 613–622. Murcia: Universidad de Murcia, 1987.

Gerber, Jane S. *The Jews of Spain: A History of the Sephardic Experience*. New York: Free Press, 1992.

Gerli, E. Michael. *Medieval Iberia: An Encyclopedia*. New York: Routledge, 2003.

Gies, David T., ed. *The Cambridge History of Spanish Literature*. Cambridge: Cambridge University Press, 2004.

Girón Negrón, Luis. "El canto del ave: Música y éxtasis en la Cantiga de Santa María 103." In *Literatura y espiritualidad: Actas del seminario internacional (Universitat de Barcelona, 3–4 abril 2000)*, edited by María Pilar Manero, 35–59. Barcelona: Universitat de Barcelona, 2003.

————. "How the Go-Between Cut Her Nose: Two Ibero-Medieval Translations of a *Kalilah wa Dimnah* Story." In *Under the Influence: Questioning the Comparative in Early Medieval Castile*, edited by Cynthia Robinson and Leyla Rouhi, 231–259. Leiden: Brill, 2005.

Glick, Thomas F. "Convivencia: An Introductory Note." In *Convivencia: Jews, Muslims, and Christians in Medieval Spain*, edited by Vivian B. Mann, Thomas F. Glick, and Jerrilynn D. Dodds, 1–9. New York: George Braziller in association with the Jewish Museum, 1992.

————. *From Muslim Fortress to Christian Castle: Social and Cultural Change in Medieval Spain*. Manchester: Manchester University Press, 1995.

————. "Interfaith Scholarly Interaction." In *Jews, Muslims and Christians in and around the Crown of Aragon: Essays in Honour of Professor Elena Lourie*, edited by Harvey J. Hames, 157–182. Leiden: Brill, 2004.

————. *Islamic and Christian Spain in the Early Middle Ages*. Revised and expanded ed. Leiden: Brill, 2005.

————. "Tribal Landscapes of Islamic Spain." In *Inventing Medieval Landscapes*, edited by John Howe and Michael Wolf, 113–145. Gainesville: University of Florida, 2002.

Glick, Thomas F., and Oriol Pi-Sunyer. "Acculturation as an Explanatory Concept in Spanish History." *Comparative Studies in Society and History* 11 (1969): 136–154.

Glissant, Edouard. *Une nouvelle région du monde*. Paris: Gallimard, 2006.

Gómez Moreno, Manuel. *El arte árabe hasta los almohades: Arte mozárabe*. Vol. 3 of *Ars Hispaniae: Historia universal del arte hispánico*. Madrid: Plus Ultra, 1954.

————. *Arte mudéjar toledano*. Madrid: L. de Miguel, 1916.

————. *Iglesias mozárabes: Arte español de los siglos IX–XI*. Madrid: Centro de Estudios Históricos, 1919.

Gómez Redondo, Fernando. *Historia de la prosa medieval castellana*. 2 vols. Madrid: Cátedra, 1998.

Gómez-Martínez, José Luis. *Américo Castro y el origen de los españoles: Historia de una polémica*. Madrid: Gredos, 1975.

Goñi Gaztambide, José. *Historia de la bula de la cruzada en España*. Vitoria: Editorial del Seminario, 1958.

González González, Julio. *Repoblación de Castilla la Nueva*. 2 vols. Madrid: Universidad Complutense, 1975–1976.

González Palencia, Angel. *Los mozárabes de Toledo en los siglos XII y XIII*. 4 vols. Madrid: Instituto de Valencia de Don Juan, 1926–1930.

Gonzálvez, Ramón. "The Persistence of the Mozarabic Liturgy in Toledo after 1080." In *Santiago, Saint-Denis, and Saint Peter: The Reception of the Roman Liturgy*

in León-Castile in 1080, edited by Bernard F. Reilly, 157–186. New York: Fordham University Press, 1985.

Grabar, Oleg. *The Alhambra*. 2nd, revised ed. Sebastapol: Solipsist Press, 1992.

———. "The Crusades and the Development of Islamic Art." In *The Crusades from the Perspective of Byzantium and the Muslim World*, edited by Angeliki E. Laiou and Roy Mottahedeh, 235–245. Washington D.C.: Dumbarton Oaks, 2001.

———. *The Dome of the Rock*. New York: Rizzoli, 1996.

———. *The Formation of Islamic Art*. Revised and enlarged ed. New Haven: Yale University Press, 1987.

———. "La grande mosquée Omeyyade de Damas et les origines architecturales de la mosquée." In *Synthronon: Art et archéologie de la fin de l'antiquité et du moyen âge*, edited by André Grabar. Paris: Klincksieck, 1968.

———. "The Meaning of the Dome of the Rock in Jerusalem." In *Studies in Arab History*, edited by Derek Hopwood, 151–163. London: Macmillan, 1990.

———. *The Mediation of Ornament*. Princeton: Princeton University Press, 1992.

Grabar, Oleg, Mohammad Al-Asad, Abeer Audeh, and Said Nuseibeh. *The Shape of the Holy: Early Islamic Jerusalem*. Princeton: Princeton University Press, 1996.

Greene, Thomas M. *The Light in Troy: Imitation and Discovery in Renaissance Poetry*. New Haven: Yale University Press, 1982.

Gruendler, Beatrice. "The Qasida." In *The Cambridge History of Arabic Literature: The Literature of al-Andalus*, edited by María Rosa Menocal, Raymond P. Scheindlin, and Michael Sells, 211–232. Cambridge: Cambridge University Press, 2000.

Guardia Pons, Milagros. "De Peñalba a San Baudelio de Berlanga: La pintura mural de los siglos X y XI en el reino de León y en Castilla; ¿Un espejo de al-Andalus?" In *El legado de al-Andalus: El arte andalusí en los reinos de León y Castilla durante la edad media*, edited by Manuel Valdés Fernández. Forthcoming.

Guerrero Lovillo, José. *Miniatura gótica castellana, siglos XIII y XIV*. Madrid: Laboratorio de Arte de la Universidad de Sevilla, Instituto Diego Velázquez del Consejo Superior de Investigaciones Científicas, 1956.

Guichard, Pierre. *Al-Andalus: 711–1492*. Paris: Hachette Litteratures, 2000.

———. *De la expansión árabe a la reconquista: Esplendor y fragilidad de al-Andalus*. Granada: Legado Andalusí, 2000.

Gutas, Dimitri. *Greek Thought, Arabic Culture*. London: Routledge, 1998.

———. "What Was There in Arabic for the Latins to Receive? Remarks on the Modalities of the Transmission of Knowledge." In *Wissen über Grenzen: Arabisches Wissen und lateinisches Mittelalter*, edited by Andreas Speer and Lydia Wegener, 3–21. Berlin: Walter de Gruyter, 2006.

Hames, Harvey J., ed. *Jews, Muslims and Christians in and around the Crown of Aragon: Essays in Honour of Professor Elena Lourie*. Leiden: Brill, 2004.

———. "Reason and Faith: Inter-Religious Polemic and Christian Identity in the Thirteenth Century." In *Religious Apologetics: Philosophical Argumentation*, edited by Yossef Schwartz and Volkhard Krech, 267–284. Tübingen: Mohr Siebeck, 2004.

Harris, Julie A. "Mosque to Church Conversions in the Spanish Reconquest." *Medieval Encounters* 3 (1997): 158–172.

———. "Muslim Ivories in Christian Hands: The Leire Casket in Context." *Art History* 18 (1995): 213–221.

———. "Redating the Arca Santa of Oviedo." *Art Bulletin* 77, no. 1 (1995): 83–93.

Harvey, L. P. "The Alfonsine School of Translators: Translations from Arabic into Castilian Produced under the Patronage of Alfonso the Wise of Castile (1221-1252-1284)." *Journal of the Royal Asiatic Society* (1977): 108–117.

———. *Islamic Spain, 1250–1500*. Chicago: University of Chicago Press, 1990.

———. "The Literary Culture of the Moriscos: A Study Based on the Extant Manuscripts in Arabic and Aljamia." PhD dissertation, Oxford University, 1958.

———. "The Mudejars." In *The Legacy of Muslim Spain*, edited by Salma Khadra Jayyusi, 176–187. Leiden: Brill, 1992.

———. *Muslims in Spain, 1500 to 1614*. Chicago: University of Chicago Press, 2005.

Haskins, Charles Homer. *Michael Scot in Spain*. Madrid, 1930.

————. *The Renaissance of the Twelfth Century*. Cambridge: Harvard University Press, 1927.

————. *Studies in the History of Mediaeval Science*. Cambridge: Harvard University Press, 1924.

Hasse, Dag Nikolaus. "The Social Conditions of the Arabic- (Hebrew-)Latin Translation Movements in Medieval Spain and in the Renaissance." In *Wissen über Grenzen: Arabisches Wissen und lateinisches Mittelalter*, edited by Andreas Speer and Lydia Wegener, 68–86. Berlin: Walter de Gruyter, 2006.

Heller, Sarah-Grace. "Fashion in French Crusade Literature: Desiring Infidel Textiles." In *Encountering Medieval Textiles and Dress: Objects, Texts, Images*, edited by Désirée G. Koslin and Janet E. Snyder, 103–120. New York: Palgrave Macmillan, 2002.

Hernández, Francisco J. "Language and Cultural Identity: The Mozarabs of Toledo." *Boletín Burriel* 1 (1989): 29–48.

Hernández Giménez, Felix, and Antonio Fernández-Puertas. *Madinat al-Zahra: Arquitectura y decoración*. Granada: Patronato de la Alhambra, 1985.

Herrero Carretero, Concha. *Museo de telas medievales: Monasterio de Santa María la Real de Huelgas*. Madrid: Patrimonio Nacional, 1988.

Hillenbrand, Robert. *Studies in Medieval Islamic Architecture*. 2 vols. London: Pindar, 2001.

Hillgarth, J. N. *The Spanish Kingdoms, 1250–1516*. 2 vols. Oxford: Clarendon, 1976.

Hitchcock, Richard. *The Kharjas: A Critical Bibliography*. London: Grant and Cutler, 1977.

Hitchcock, Richard, and Consuelo López-Morillas. *The Kharjas: A Critical Bibliography*. Supplement no. 1. London: Grant and Cutler, 1996.

Hodgson, Marshall G. S. *The Venture of Islam: Conscience and History in a World Civilization*. Vol. 1, *The Classical Age of Islam*. Chicago: University of Chicago Press, 1974.

Holod, Renata. "Luxury Arts of the Caliphal Period." In *Al-Andalus: The Art of Islamic Spain*, edited by Jerrilynn D. Dodds, 41–48. New York: Metropolitan Museum of Art, 1992.

Hyman, Arthur, and James J. Walsh, eds. *Philosophy in the Middle Ages: The Christian, Islamic, and Jewish Traditions*. 2nd ed. Indianapolis: Hackett, 1973.

Iglesia Duarte, José Ignacio de la, ed. *Memoria, mito y realidad en la historia medieval*. Logroño: Gobierno de La Rioja, Instituto de Estudios Riojanas, 2003.

Jackson, Gabriel. *The Making of Medieval Spain*. Norwich: Harcourt Brace Jovanovich, 1972.

Jacquart, Danielle. "L'école des traducteurs." In *Tolède, XIIe–XIIIe: Musulmans, chrétiens et juifs; Le savoir et la tolérance*, edited by Louis Cardaillac, 177–191. Paris: Autrement, 1991.

Jaeger, C. Stephen. "Pessimism in the Twelfth-Century 'Renaissance.'" *Speculum* 78 (2003): 1151–1183.

Jayyusi, Salma Khadra. *The Legacy of Muslim Spain*. Leiden: Brill, 1992.

Jenkins, Marilyn. "Capital and Base of Engaged Column (Catalog Entry)." In *The Art of Medieval Spain, A.D. 500–1200*, edited by Jerrilynn Dodds, Charles Little, Serafín Moralejo, and John Williams, 92. New York: Metropolitan Museum of Art, 1993.

Katz, Israel. "Higinio Anglés and the Melodic Origins of the 'Cantigas de Santa Maria': A Critical View." In *Alfonso X of Castile, the Learned King, 1221–1284: An International Symposium, Harvard University, 17 November 1984*, edited by Francisco Márquez-Villanueva and Carlos Alberto Vega, 46–75. Cambridge: Department of Romance Languages and Literatures of Harvard University, 1990.

————. "The Study and Performance of the CSM: A Glance at Recent Musicological Literature." *Cantigueros de Santa María* 1 (1987): 51–60.

Kehew, Robert, ed. *Lark in the Morning: The Verses of the Troubadors*. Chicago: University of Chicago Press, 2005.

Keller, John Ersten. *Alfonso X, El Sabio*. New York: Twayne, 1967.

Khoury, Nuha N. N. "The Meaning of the Great Mosque of Cordoba in the Tenth Century." *Muqarnas* 13 (1996): 80–98.

King, David A. *Astronomy in the Service of Islam*. Aldershot: Variorum, 1993.

King, Geoffrey. "The Mosque of Bâb al Mardum and the Islamic Building Tradition." In *Entre el califato y la taifa: Mil años de Cristo de la Luz (Actas del Congreso Internacional, Toledo, 1999)*, 269–286. Toledo: Asociación de Amigos del Toledo Islámico, 2000.

King, P. D. *Law and Society in the Visigothic Kingdom*. London: Cambridge University Press, 1972.

Kinney, Dale. "Rape or Restitution of the Past? Interpreting Spolia." *Papers in Art History from Pennsylvania State University* 9 (1995): 53–67.

Kinoshita, Sharon. *Medieval Boundaries: Rethinking Difference in Old French Literature*. Philadelphia: University of Pennsylvania Press, 2006.

Kraemer, Joel L. *Humanism in the Renaissance of Islam: The Cultural Revival during the Buyid Age.* Leiden: Brill, 1986.

Kritzeck, James. *Peter the Venerable and Islam.* Princeton: Princeton University Press, 1964.

Kubisch, Natascha. *Die Synagoge Santa Maria la Blanca in Toledo: Eine Untersuchung zur maurischen Ornamentik.* Frankfurt: Peter Lang, 1995.

———. "La influencia del arte almohade en Toledo." In *Entre el califato y la taifa: Mil años de Cristo de la Luz* (*Actas del Congreso Internacional, Toledo, 1999*), 243–268. Toledo: Asociación de Amigos del Toledo Islámico, 2000.

Kühnel, Ernst, and Adolph Goldschmidt. *Die islamischen Elfenbeinskulpturen, VIII–XIII Jahrhundert.* Berlin: Deutscher Verlag für Kunstwissenschaft, 1971.

Lacarra, José María. *Aragón en el pasado.* Madrid: Espasa-Calpe, 1972.

Lacarra, María Eugenia. *El poema de mio Cid: Realidad histórica e ideología.* Madrid: J. Porrúa Turanzas, 1980.

Lacarra, María Jésus. *Cuentística medieval en España: Los orígenes.* Saragossa: Universidad de Zaragoza, 1979.

Lacarra, María Jesús, and Francisco López Estrada. *Orígenes de la prosa.* Edited by Ricardo de la Fuente. Vol. 4 of *Historia de la literatura española.* Madrid: Júcar, 1993.

Ladero Quesada, Miguel Angel. *Granada: Historia de un país islámico* (*1232–1571*). Madrid: Gredos, 1989.

———. *Los mudéjares de Castilla y otros estudios de historia medieval andaluza.* Granada: Universidad de Granada, 1989.

———. "La population mudéjar, état de la question et documentation chrétienne en Castille." *Revue du Monde Musulman et de la Mediterranée* 63–64, no. 1–2 (1992): 131–142.

Lagardère, Vincent. *Les Almoravides: Le djihad andalou* (*1106–1143*). Paris: L'Harmattan, 1998.

———. *Les Almoravides jusqu'au règne de Yusuf B. Ta?fin* (*1039–1106*). Paris: L'Harmattan, 1989.

Lambert, Elie. "L'art mudejar." *Gazette des Beaux Arts* 9 (1933): 17–33.

Lampérez y Romea, Vicente. *Historia de la arquitectura cristiana española en la edad media según el estudio de los elementos y los monumentos.* Barcelona, 1909.

Laursen, John Christian, and Cary J. Nederman. *Beyond the Persecuting Society: Religious Toleration before the Enlightenment.* Philadelphia: University of Pennsylvania Press, 1997.

Lemay, Richard. "Dans l'Espagne du XIIe siècle: Les traductions de l'arabe au latin." *Annales* 18 (1963): 639–665.

León Tello, Pilar. *Judíos de Toledo.* Madrid: Consejo Superior de Investigaciones Científicas, Instituto "B. Arias Montano," 1979.

Lévi-Provençal, Evariste. *Histoire de l'Espagne musulmane.* 3 vols. Paris: Maisonneuve et Larose, 1950.

Lewis, Bernard. *The Jews of Islam.* Princeton: Princeton University Press, 1984.

Linehan, Peter. "From Chronicle to History: Concerning the *Estoria de España* and Its Principal Sources." In *Historical Literature in Medieval Iberia*, edited by Alan Deyermond, 7–33. London: Department of Hispanic Studies, Queen Mary and Westfield College, 1996.

———. *History and the Historians of Medieval Spain.* Oxford: Clarendon, 1993.

———. "The Toledo Forgeries c. 1150–c. 1300." In *Falschungen im Mittlealter*, vol. 1, *Kongreßdaten und Festvoträge: Literatur und Fälschung*, 643–674. Hannover: Hahnsche Buckhandlung, 1988.

Linehan, Peter, and Janet L. Nelson, eds. *The Medieval World.* London: Routledge, 2001.

Liu, Benjamin. "Martí, Llull, al-Riquti: Arabic Language Mastery in 13th-Century Spain." Forthcoming.

Lloyd, Paul M. *From Latin to Spanish.* Philadelphia: American Philosophical Society, 1987.

Lomax, Derek W. *The Reconquest of Spain.* London: Longman, 1978.

Lombard, Maurice. *Les textiles dans le monde musulman du VIIe au XIIe siècle.* Paris: Mouton, 1978.

López Alvarez, Ana María. *Catálogo del Museo Sefardí.* Madrid: Ministerio de Cultura, 1986.

———, ed. *La escuela de traductores de Toledo.* Toledo: Diputación Provincial de Toledo, 1996.

———. "La galería de mujeres de la sinagoga de el Tránsito." *Sefarad* 47, no. 2 (1987): 301–314.

López Alvarez, Ana María, and Ricardo Izquierdo Benito, eds. *Juderías y sinagogas de la Sefarad medieval: En memoria de José Luis Lacave Riaño.* Cuenca: Ediciones de la Universidad de Castilla–La Mancha, 2003.

López Alvarez, Ana María, María Luisa Menéndez Robles, and Santiago Palomero Plaza. "Inscripciones árabes halladas en las excavaciones de la sinagoga del Tránsito, Toledo." *Al-Qantara* 16, no. 2 (1995): 433–448.

López Alvarez, Ana María, Santiago Palomero Plaza, and Yasmina Alvarez Delgado. "Nuevos datos sobre la historia de la sinagoga del Tránsito." *Sefarad* 52, no. 2 (1992): 473–500.

López Gómez, Margarita. "The Mozarabs: Worthy Bearers of Islamic Culture." In *The Legacy of Muslim Spain*, edited by Salma Khadra Jayyusi, 171–175. Leiden: Brill, 1992.

López Guzmán, Rafael. *Arquitectura mudéjar: Del sincretismo medieval a las alternativas hispanoamericanas.* Madrid: Cátedra, 2000.

López-Baralt, Luce. *Huellas del islam en la literatura española: De Juan Ruiz a Juan Goytisolo.* Madrid: Hiperión, 1985.

———. *Islam in Spanish Literature: From the Middle Ages to the Present.* Translated by Andrew Hurley. Leiden: Brill, 1992.

———. "The Moriscos." In *The Cambridge History of Arabic Literature: The Literature of al-Andalus*, edited by María Rosa Menocal, Raymond P. Scheindlin, and Michael Sells, 472–487. Cambridge: Cambridge University Press, 2000.

López-Morillas, Consuelo. "Language." In *The Cambridge History of Arabic Literature: The Literature of al-Andalus*, edited by María Rosa Menocal, Raymond P. Scheindlin, and Michael Sells, 33–59. Cambridge: Cambridge University Press, 2000.

———. *The Qur'an in Sixteenth-Century Spain: Six Morisco Versions of Sura 79.* London: Tamesis, 1982.

Lourie, Elena. "Anatomy of Ambivalence: Muslims under the Crown of Aragon in the Late Thirteenth Century." In *Crusade and Colonisation: Muslims, Christians, and Jews in Medieval Aragon*, edited by Elena Lourie. Aldershot: Variorum, 1990.

———. "The Confraternity of Belchite, the *Ribat*, and the Temple." In *Crusade and Colonisation: Muslims, Christians, and Jews in Medieval Aragon*, edited by Elena Lourie, 159–176. Aldershot: Variorum, 1990.

MacKay, Angus. *Spain in the Middle Ages: From Frontier to Empire, 1000–1500.* London: Macmillan, 1977.

Makdisi, George. *The Rise of Colleges: Institutions of Learning in Islam and the West.* Edinburgh: Edinburgh University Press, 1981.

———. *The Rise of Humanism in Classical Islam and the Christian West: With Special Reference to Scholasticism.* Edinburgh: Edinburgh University Press, 1990.

Makki, Mahmoud. "The Political History of Al-Andalus." In *The Legacy of Muslim Spain*, edited by Salma Khadra Jayyusi, 3–87. Leiden: Brill, 1992.

Mann, Janice. "A New Architecture for a New Order: The Building Projects of Sancho el Mayor (1004–1035)." In *The White Mantle of Churches: Architecture, Liturgy, and Art around the Millennium*, edited by Nigel Hiscock, 233–249. Turnhout: Brepols, 2003.

———. "San Pedro at the Castle of Loarre, a Study in the Relation of Cultural Forces to the Design, Decoration and Construction of a Romanesque Church." PhD dissertation, Columbia University, 1991.

Mann, Vivian B., Thomas F. Glick, and Jerrilyn D. Dodds, ed. *Convivencia: Jews, Muslims, and Christians in Medieval Spain.* New York: George Braziller in association with the Jewish Museum, 1992.

Mantilla de los Ríos y Rojas, María Socorro. *Vestiduras pontificales del arzobispo Rodrigo Ximénez de Rada (siglo XIII): Su estudio y restauración.* Madrid: Ministerio de Cultura, 1995.

Manzano Martos, Rafael. "Casa y palacios en la Sevilla almohade: Sus antecedentes hispánicos." In *Casas y palacios de al-Andalus*, edited by Julio Navarro Palazón, 315–352. Barcelona: Lunwerg, 1995.

Marín, Manuela, ed. *Tejer y vestir: De la antigüedad al islam.* Madrid: Consejo Superior de Investigaciones Científicas, 2001.

———. "Los ulemas de Toledo en los siglos IV–V y X–XI." In *Entre el califato y la taifa: Mil años de Cristo de la Luz (Actas del Congreso Internacional, Toledo, 1999)*, 67–96. Toledo: Asociación de Amigos del Toledo Islámico, 2000.

Márquez Villanueva, Francisco. "The Alfonsine Cultural Concept." In *Alfonso X of Castile, the Learned King, 1221–1284: An International Symposium, Harvard University, 17 November 1984*, edited by Francisco Márquez Villanueva and Carlos Alberto Vega, 76–109. Cambridge: Department of Romance Languages and Literatures of Harvard University, 1990.

———. *El concepto cultural alfonsí.* Madrid: Mapfre, 1994.

———. "Hispano-Jewish Cultural Interactions: A Conceptual Framework." In *Encuentros and Desencuentros: Spanish Jewish Cultural Interaction throughout History*, edited by Carlos Carrete Parrondo, Marcelo Dascal, Francisco Márquez Villanueva, and Angel Sáenz-Badillos. Tel Aviv: University Publishing Project, 2000.

———. "In Lingua Tholetana." In *La escuela de traductores de Toledo*, edited by Ana María López Alvarez, 23–34. Toledo: Diputación Provincial de Toledo, 1996.

———. "Los lenguajes de ultratumba en Juan Goytisolo." *Cuadernos Hispanoamericanos*, no. 618 (2001): 93–108.

———. "Meditación de las otras Alhambras." In *Pensar la Alhambra*, edited by José Antonio González Alcantud and Antonio Malpica Cuello, 261–273. Granada: Diputación Provincial de Granada, 2001.

———. *El problema morisco (desde otras laderas)*. Madrid: Al Qibla, 1991.

———. *Santiago: Trayectoria de un mito*. Barcelona: Bellaterra, 2004.

Márquez Villanueva, Francisco, and Juan Goytisolo. *Mudejarismo: Las tres culturas en la creación de la identidad española*. Cordoba: Fundación Tres Culturas del Mediterráneo, 2003.

Márquez Villanueva, Francisco, and Carlos Alberto Vega. *Alfonso X of Castile, the Learned King, 1221–1284: An International Symposium, Harvard University, 17 November 1984*. Cambridge: Department of Romance Languages and Literatures of Harvard University, 1990.

Martín, José-Luis. *Claudio Sánchez-Albornoz*. Valladolid: Junta de Castilla y León, Consejería de Educación y Cultura, 1986.

———. *La península en la edad media*. Barcelona: Teide, 1976.

Martín, Oscar. "Introducción: A Critical Cluster on the *Poema de mio Cid*." *La Corónica* 33, no. 2 (2005): 7–12.

Martin, Therese. "The Art of a Reigning Queen as Dynastic Propaganda in Twelfth-Century Spain." *Speculum* 80 (2005): 1134–1171.

Martínez, H. Salvador. *Alfonso X, el Sabio: Una biografía*. Madrid: Polifemo, 2003.

Martínez Caviro, Balbina. *Mudéjar toledano: Palacios y conventos*. Madrid: Vocal Artes Gráficas, 1980.

Martínez del Alamo, Constancio. "El sepulcro-altar del cuerpo santo en la antigua iglesia de Silos: Intento de reconstrucción." *Studia Silensia* 28 (2003): 543–556.

Martinez-Gros, Gabriel. "Enjeux espagnols: L'historiographie d'al-Andalus au XIXe siècle." In *Histoire de l'Andalousie: Mémoire et enjeux*, edited by François Zabbal and José Antonio Alcantud, 266–274. Paris: L'Archange Minotaure, 2001.

———. *Identité andalouse*. Paris: Actes Sud, 1997.

———. *L'idéologie Omeyyade: La construction de la légitimité du califat de Cordoue (Xe–XIe siècles)*. Madrid: Casa de Velázquez, 1992.

May, Florence Lewis. *Silk Textiles of Spain: Eighth to Fifteenth Century*. New York: Hispanic Society of America, 1957.

Mayer, Leo A. *Islamic Astrolabists and Their Works*. Geneva: Albert Kundig, 1956.

Menéndez Pidal, Gonzalo. "Cómo trabajaron las escuelas alfonsíes." *Nueva Revista de Filología Hispánica* 5 (1951): 363–380.

Menéndez Pidal, Ramón. *La España del Cid*. Madrid: Plutarco, 1929.

———. *Poesía juglaresca y juglares*. Madrid: Espasa-Calpe, 1991.

———. "Repoblación y tradición en la cuenca del Duero." In *Enciclopedia lingüística hispánica*, edited by Manuel Alvar, xxix–lvii. Madrid: Consejo Superior de Investigaciones Científicas, 1960.

Menocal, María Rosa. *The Arabic Role in Medieval Literary History: A Forgotten Heritage*. Philadelphia: University of Pennsylvania Press, 1987.

———. "The Castilian Context of the Arabic Translation Movement: Imagining the Toledo of the Translators." In *Wissen über Grenzen: Arabisches Wissen und lateinisches Mittelalter*, edited by Andreas Speer and Lydia Wegener, 119–125. Berlin: Walter de Gruyter, 2006.

———. "The Culture of Translation." In *Words without Borders: The Online Magazine for International Literature*, 2005.

———. "Dante and Islam." *Dante Studies* (forthcoming).

———. "Life Itself: Storytelling as the Tradition of Openness in the *Conde Lucanor*." In *Oral Tradition and Hispanic Literature: Essays in Honor of Samuel G. Armistead*, edited by Mishael M. Caspi, 469–495. New York: Garland, 1995.

———. *Ornament of the World: How Muslims, Jews and Christians Created a Culture of Tolerance in Medieval Spain*. New York: Little, Brown, 2002.

———. *Shards of Love: Exile and the Origins of the Lyric*. Durham: Duke University Press, 1994.

———. "Signs of the Times: Self, Other and History in *Aucassin et Nicolette*." *Romanic Review* 80, no. 4 (1989): 497–511.

———. "The 'Spanish-Speaking Moor' of Marrakesh." *Descant* 114 32, no. 3 (2001): 98–108.

———. "To Create an Empire: Adab and the Creation of Castilian Culture." *Maghreb Review* 31, no. 3–4 (2006): 194–202.

Menocal, María Rosa, Raymond P. Scheindlin, and Michael Sells, eds. *The Cambridge History of Arabic Literature: The Literature of al-Andalus.* Cambridge: Cambridge University Press, 2000.

Menocal, Narciso C. "The Date of the Dedication of San Juan de Baños de Cerrato." *Studies in Medieval Culture* 5 (1975): 21–24.

Metlitzki, Dorothee. *The Matter of Araby in Medieval England.* New Haven: Yale University Press, 1977.

Miles, George Carpenter. *The Coinage of the Umayyads of Spain.* New York: American Numismatic Society in cooperation with the Hispanic Society of America, 1950.

Miller, H. D. "According to Christian Sunna: Mozarabic Notarial Culture in Toledo, 1085–1300." PhD dissertation, Yale University, 2003.

Miller, H. D., and Hanna E. Kassis. "The Mozarabs." In *The Cambridge History of Arabic Literature: The Literature of al-Andalus,* edited by María Rosa Menocal, Raymond P. Scheindlin, and Michael Sells, 417–434. Cambridge: Cambridge University Press, 2000.

Mínguez Fernández, José María. *La España de los siglos VI al XIII: Guerra, expansión y transformaciones; En busca de una frágil unidad.* 2nd ed. San Sebastián: Nerea, 2004.

Miranda Calvo, José. *La reconquista de Toledo por Alfonso VI.* Toledo: Instituto de Estudios Visigótico-Mozárabes de San Eugenio–Toledo, 1980.

Molénat, Jean-Pierre. "Places et marchés de Tolède au moyen âge (XIIe–XVIe s.)." In *"Plazas" et sociabilité en Europe et Amérique latine: Colloque des 8 et 9 mai 1979,* edited by Lino Alvarez Reguillo, 43–59. Paris: Diffusion de Boccard, 1982.

———. "L'urbanisme à Tolède aux XIVe et XVe siècle." In *La ciudad hispánica durante los siglos XIII al XVI: Actes du colloque tenu à La Rábida et Séville du 14 au 19 septembre 1981,* 1105–1111. Madrid: Universidad Complutense, 1985.

———. "Y a-t-il en des mozarabes à Tolede du VIIIe au XI siècle?" In *Entre el califato y la taifa: Mil años de Cristo de la Luz (Actas del Congreso Internacional, Toledo, 1999),* 97–106. Toledo: Asociación de Amigos del Toledo Islámico, 2000.

Moneo, Maria Luisa Melero, Francesca Español Bertrán, Anna Orriols I Alsina, and Daniel Rico Camps, eds. *Imágenes y promotores en el arte medieval: Miscelánea en homenaje a Joaquín Yarza Luaces.* Barcelona: Universitat Autònoma de Barcelona, 2001.

Monroe, James T. "Ibn Quzman on I'rab: A zéjel de juglaría in Arab Spain?" In *Hispanic Studies in Honor of Joseph H. Silverman,* edited by Joseph Ricapito, 45–56. Newark, Del.: Juan de la Cuesta, 1988.

———. *Islam and the Arabs in Spanish Scholarship: Sixteenth Century to the Present.* Leiden: Brill, 1970.

———. "Poetic Quotation in the Muwa??aha and Its Implications: Andalusian Strophic Poetry as Song." *La Corónica* 14, no. 2 (1986): 230–250.

———. "Zajal and Muwa??aha: Hispano-Arabic Poetry and the Romance Tradition." In *The Legacy of Muslim Spain,* edited by Salma Khadra Jayyusi, 398–419. Leiden: Brill, 1992.

Moralejo Alvarez, Serafín. "La imagen arquitectónica de la catedral de Santiago de Compostela." In *II Pellegrino a Santiago de Compostela e la letteratura jacopea,* 35–59. Perugia: Atti del Convegno Internazionale di Studi, 1985.

———. "Notas para unha revisión da obra de K. J. Conant." In *Arquitectura románica da catedral de Santiago de Compostela (The Early Architectural History of the Cathedral of Santiago de Compostela),* edited by Kenneth John Conant, 89–117. Santiago de Compostela: Colexio Oficial de Arquitectos de Galicia, 1983.

———. "On the Road: The Camino de Santiago." In *The Art of Medieval Spain, A.D. 500–1200,* edited by Jerrilynn Dodds, Charles Little, Serafin Moralejo, and John Williams, 175–183. New York: Metropolitan Museum of Art, 1993.

Morales, Alfredo J. "El arte mudéjar como síntesis de culturas." In *El mudéjar iberoamericano: Del islam al nuevo mundo,* edited by Ignacio Henares Cuéllar, 59–65. Barcelona: Lunwerg, 1995.

Morón Arroyo, Ciriaco. "Practical Intelligence: Don Juan Manuel." In *Languages of Power in Islamic Spain,* edited by Ross Brann, 197–210. Bethesda: CDL Press, 1997.

Moxó, Salvador de. *Repoblación y sociedad en la España cristiana medieval.* Madrid: Rialp, 1979.

El mudéjar iberoamericano: Del islam al nuevo mundo. Edited by Ignacio Henares Cuéllar. Barcelona: Lunwerg, 1995.

Navarro Palazón, Julio. "El Alcázar de Guadalajara: Noticias de las excavaciones realizadas durante el año 2005." *Castillos de España* 141 (2006): 15–23.

———, ed. *Casas y palacios de al-Andalus.* Barcelona: Lunwerg, 1995.

———. "Un palacio protonazarí en la Murcia del siglo XIII: Al Qasr al Sagir." In *Casas y palacios de al-Andalus,* edited by Julio Navarro Palazón, 177–206. Barcelona: Lunwerg, 1995.

Navarro Palazón, Julio, and Pedro Jiménez Castillo. "Casas y palacios de al-Andalus, XII–XIII." In *Casas y palacios de al-Andalus*, edited by Julio Navarro Palazón, 17–32. Barcelona: Lunwerg, 1995.

———. "El castillejo de Monteagudo: Qasr Ibn Sa'd." In *Casas y palacios de al-Andalus*, edited by Julio Navarro Palazón, 63–104. Barcelona: Lunwerg, 1995.

Nederman, Cary J. *Worlds of Difference: European Discourses of Toleration, c. 1100–c. 1550*. University Park: Pennsylvania State University Press, 2000.

Niederehe, Hans-Josef. "Alfonso el Sabio y la fisionomía lingüística de la Península Ibérica de su época." In *La lengua y la literatura en tiempos de Alfonso X: Actas del Congreso Internacional, Murcia, 5–10 marzo 1984*, edited by Fernando Carmona and Francisco J. Flores, 415–436. Murcia: Departamento de Literaturas Románicas, Universidad de Murcia, 1985.

———. *Alfonso X el Sabio y la lingüística de su tiempo*. Madrid: Sociedad General Española de Librería, 1987.

———. *Die Sprachauffassung Alfons des Weisen: Studien zur Sprach- und Wissenschaftsgeschichte*. Tübingen: M. Niemeyer, 1975.

Nieto Cumplido, Manuel. *Corpus mediaevale cordubense*. Cordoba: Monte de Piedad y Caja de Ahorros de Córdoba, 1979.

———. *Historia de la iglesia en Córdoba: Reconquista y restauración, 1146–1326*. Cordoba: Monte de Piedad y Caja de Ahorros de Córdoba, 1991.

Nieto Cumplido, Manuel, and C. Luca de Tena. *La mezquita de Córdoba: Planos y dibujos*. Cordoba: Colegio Oficial de Arquitectos de Andalucía, 1992.

Nieto Soria, José Manuel. *Iglesia y génesis del estado moderno en Castilla (1369–1480)*. Madrid: Complutense, 1993.

Nirenberg, David. *Communities of Violence: Persecution of Minorities in the Middle Ages*. Princeton: Princeton University Press, 1996.

———. "Enmity and Assimilation." *Common Knowledge* 9, no. 1 (2003): 137–155.

———. "Love between Muslim and Jew in Medieval Spain: A Triangular Affair." In *Jews, Muslims and Christians in and around the Crown of Aragon: Essays in Honour of Professor Elena Lourie*, edited by Harvey J. Hames, 127–155. Leiden: Brill, 2004.

———. "Muslims in Christian Iberia, 1000–1526: Varieties of Mudejar Experience." In *The Medieval World*, edited by Peter Linehan and Janet L. Nelson, 60–76. London: Routledge, 2001.

Novikoff, Alex. "Between Tolerance and Intolerance in Medieval Spain: An Historiographic Enigma." *Medieval Encounters* 11, no. 1–2 (2005): 7–36.

Núñez Rodríguez, Manuel. *Arquitectura prerrománica*. Santiago de Compostela: Coag, 1982.

O'Callaghan, Joseph F. *Alfonso X and the "Cantigas de Santa Maria": A Poetic Biography*. Leiden: Brill, 1998.

———. *A History of Medieval Spain*. Ithaca: Cornell University Press, 1975.

———. *The Learned King: The Reign of Alfonso X of Castile*. Philadelphia: University of Pennsylvania Press, 1993.

———. "The Mudejares of Castile and Portugal in the 12th and 13th Centuries." In *Muslims under Latin Rule, 1100–1300*, edited by James M. Powell, 11–56. Princeton: Princeton University Press, 1990.

———. *Reconquest and Crusade in Medieval Spain*. Philadelphia: University of Pennsylvania Press, 2003.

Orcástegui Gros, Carmen, and Esteban Sarasa Sánchez. *Sancho Garcés el Mayor (1004–1035): Rey de Navarra*. Iruña, 1991.

Orihuela Uzal, A. *Casas y palacios nazaríes: Siglos XIII–XV*. Barcelona: Lunwerg, 1996.

Orlandis, José. *Historia del reino visigodo español: Los acontecimientos, las instituciones, la sociedad, los protagonistas*. Madrid: Rialp, 2003.

Ormsby, Eric. "Ibn Hazm." In *The Literature of al-Andalus*, edited by María Rosa Menocal, Raymond P. Scheindlin, and Michael Sells, 237–251. Cambridge: Cambridge University Press, 2000.

Ousterhout, Robert, and D. Fairchild Ruggles. "Encounters with Islam: The Medieval Mediterranean Experience: Art, Material Culture, and Cultural Interchange." *Gesta* 43, no. 2 (2004): 83–85.

Palol, Pedro de. *Arqueología cristiana de la España romana, siglos IV–VI*. Madrid: Consejo Superior de Investigaciones Científicas, 1967.

———. *Arte hispánico de la época visigoda*. Barcelona: Polígrafa, 1968.

———. *La basílica de San Juan de Baños*. Palencia: Diputación, 1988.

Palomo Fernández, Gema, and Juan Carlos Ruiz Souza. "Nuevas hipótesis sobre Las Huelgas de Burgos: Escenografía funeraria de Alfonso X para

un proyecto inacabado de Alfonso VIII y Leonor Plantagenêt." *Goya* 316–317 (2007): 21–44.

Partearroyo, Cristina. "Almoravid and Almohad Textiles." In *Al-Andalus: The Art of Islamic Spain*, edited by Jerrilynn D. Dodds, 105–113. New York: Metropolitan Museum of Art, 1992.

———. "Los tejidos de al-Andalus entre los siglos IX al XV (y su prolongación en el siglo XVI)." In *España y Portugal en las rutas de seda: Diez siglos de producción y comercio entre Oriente y Occidente*, 58–73. Barcelona: Universitat de Barcelona, 1996.

Pavón Maldonado, Basilio. *Arte toledano: Islámico y mudéjar*. Madrid: Ministerio de Asuntos Exteriores, Instituto Hispano-Arabe de Cultura, 1973.

Pays d'islam et monde latin: Xe–XIIIe siècle (Textes et documents). Lyon: Presses Universitaires de Lyon, 2000.

Pearce, Sarah. "Era Dhu l-Qarnain, que su nombre era al-Iskandar: Notes on the Morisco Alexander-roman." Senior essay, Yale University, 2005.

Peña Pérez, Francisco Javier. "Los monjes de San Pedro de Cardeña y el mito del Cid." In *Memoria, mito y realidad en la historia medieval*, edited by José Ignacio de la Iglesia Duarte, 331–344. Logroño: Gobierno de La Rioja, Instituto de Estudios Riojanas, 2003.

Pérès, Henri. *Esplendor de al-Andalus: La poesía andaluza en árabe clásico en el siglo XI, sus aspectos generales, sus principales temas y su valor documental*. Translated by Mercedes García-Arenal. Madrid: Hiperión, 1983.

———. *La poésie andalouse en arabe classique au XIe siècle: Ses aspects généraux, ses principaux thèmes et sa valeur documentaire*. 2nd, revised ed. Paris: Adrien-Maisonneuve, 1953.

Pérez de Urbel, Justo. *El claustro de Silos*. Burgos: Ediciones de la Institución Fernán González, 1975.

———. *El románico en Silos: IX centenario de la consagración de la iglesia y claustro, 1088–1988*. Burgos: Abadía de Silos, 1990.

Pérez Higuera, María Teresa. "Absides mudéjares con la moraña (Avila): Su relación con modelos de Castilla la Vieja y León." In *Originalidad, modelo y copia en el arte medieval hispánico*, edited by José Joaquín Yarza Luaces and Francesca Español Bertrán, 289–296. Barcelona: Congreso Español de Historia del Arte, 1987.

———. "Al-Andalus y Castilla: El arte de una larga coexistencia." In *Historia de una cultura: La singularidad de Castilla*, edited by Agustín García Simón, 9–59. Valladolid: Junta de Castilla y León, 1995.

———. "Arquitectura mudéjar en los antiguos reinos de Castilla-Léon y Toledo." In *El arte mudéjar*, edited by Gonzalo M. Borrás Gualis, 31–61. Saragossa: Unesco-Ibercaja, 1996.

———. "La mezquita de Córdoba." In *El esplendor de los omeyas cordobeses: La civilización musulmana de Europa occidental*, edited by Maria Jesús Viguera Molins and Concepción Castillo, 372–379. Granada: Consejería de Cultura de la Junta de Andalucía, 2001.

———. "El mudéjar, una opción artística en la corte de Castilla y León." In *Historia del arte en Castilla y León*, 129–222. Valladolid: Ambito, 1994.

———. *Mudejarismo en la baja edad media*. Madrid: La Muralla, 1987.

———. *Objetos e imágenes de al-Andalus*. Barcelona: Lunwerg, 1994.

———. *Paseos por el Toledo del siglo XIII*. Toledo: Ministerio de Cultura, 1984.

———. "El primer mudéjar castellano: Casas y palacios." In *Casas y palacios de al-Andalus*, edited by Julio Navarro Palazón, 303–314. Barcelona: Lunwerg, 1995.

Peters, F. E. *Aristotle and the Arabs: The Aristotelian Tradition in Islam*. New York: New York University Press, 1968.

———. *The Children of Abraham: Judaism, Christianity, Islam*. Princeton: Princeton University Press, 2004.

———. *The Monotheists: Jews, Christians, and Muslims in Conflict and Competition*. 2 vols. Princeton: Princeton University Press, 2003.

Pick, Lucy K. *Conflict and Coexistence: Archbishop Rodrigo and the Muslims and Jews of Medieval Spain*. Ann Arbor: University of Michigan Press, 2004.

———. "Rodrigo Jiménez de Rada and the Jews: Pragmatism and Patronage in Thirteenth-Century Toledo." *Viator* 28 (1997): 203–222.

Porres Martín Cleto, Julio. "Los barrios judíos de Toledo." In *Simposio "Toledo Judaico" (Toledo, 20–22 abril 1972)*, 45–76. Toledo: Publicaciones del Centro Universitario de Toledo, 1973.

———. *Historia de Tulaytula*. 2nd ed. Toledo: Ledoria/Junta de Comunidades de Castilla–La Mancha, 2004.

Porter, Arthur Kingsley. "'Spain or Toulouse?' and Other Questions." *Art Bulletin* 7, no. 1 (1924): 2–25.

Powell, James M., ed. *Muslims under Latin Rule, 1100–1300*. Princeton: Princeton University Press, 1990.

———. "The Papacy and the Muslim Frontier." In *Muslims under Latin Rule, 1100–1300*, edited by James M. Powell, 175–204. Princeton: Princeton University Press, 1990.

Powers, James F. "Frontier Municipal Baths and Social Interaction in Thirteenth-Century Spain." *American Historical Review* 84, no. 3 (1979): 649–667.

Prado-Vilar, Francisco. "Circular Visions of Fertility and Punishment: Caliphal Ivory Caskets from al-Andalus." *Muqarnas* 14 (1997): 19–41.

———. "The Gothic Anamorphic Gaze: Regarding the Worth of Others." In *Under the Influence: Questioning the Comparative in Medieval Castile*, edited by Cynthia Robinson and Leyla Rouhi, 67–100. Leiden: Brill, 2005.

Procter, Evelyn S. *Alfonso X of Castile: Patron of Literature and Learning*. Oxford: Clarendon, 1951.

Puerta Vílchez, José Miguel. *Los códigos de utopía de la Alhambra de Granada*. Granada: Diputación Provincial de Granada, 1990.

———. *Historia del pensamiento estético árabe: Al-Andalus y la estética árabe clásica*. Madrid: Akal, 1997.

———. "El vocabulario estético de los poemas de la Alhambra." In *Pensar la Alhambra*, edited by José Antonio González Alcantud and Antonio Malpica Cuello, 69–88. Granada: Diputación Provincial de Granada, 2001.

Rabat, Nasser. "The Meaning of the Umayyad Dome of the Rock." *Muqarnas* 6 (1989): 12–21.

———. "The Palace of the Lions in the Alhambra and the Role of Water in Its Conception." *AARP/Environmental Design*, no. 2 (1985): 64–73.

———. "The Transcultural Meaning of the Dome of the Rock." In *The Open Veins of Jerusalem*, edited by Munir Akash and Fouad Moughrabi, 71–107. Syracuse: Jusoor Books, distributed by Syracuse University Press, 2005.

Raizman, David. "The Church of Santa Cruz and the Beginnings of Mudejar Architecture in Toledo." *Gesta* 38, no. 2 (1999): 128–141.

———. "Prayer, Patronage and Piety at Las Huelgas: New Observations on the Later Morgan Beatus (M. 429)." In *Church, State, Vellum, and Stone: Essays on Medieval Spain in Honor of John Williams*, edited by Therese Martin and Julie A. Harris, 235–273. Leiden: Brill, 2005.

———. "A Rediscovered Illuminated Manuscript of St. Ildefonsus's *De Virgintate Beatae Mariae* in the Biblioteca Nacional in Madrid." *Gesta* 26, no. 1 (1987): 37–46.

Rallo Gruss, Carmen. *Aportaciones a la técnica y estilística de la pintura mural en Castilla a final de la edad media: Tradición e influencia islámica*. Madrid: Fundación Universitaria Española, 2002.

Rallo Gruss, Carmen, and Juan Carlos Ruiz Souza. "El palacio de Ruy López dá Valos y sus bocetos inéditos en la sinagoga del Tránsito: Estudio de sus yeserías en el contexto artístico de 1361 (I)." *Al-Qantara* 20, no. 2 (1999): 275–301.

———. "El palacio de Ruy López dá Valos y sus bocetos inéditos en la sinagoga del Tránsito: Estudio de sus yeserías en el contexto artístico de 1361 (II)." *Al-Qantara* 21, no. 1 (2000): 143–154.

Ramey, Lynn Tarte. *Christian, Saracen and Genre in Medieval French Literature: Imagination and Cultural Interaction in the French Middle Ages*. New York: Routledge, 2001.

Ramirez de Arellano, R. *Parroquias de Toledo*. Toledo: Instituto Provincial de Investigaciones y Estudios Toledanos, 1921.

Ray, Jonathan. "Beyond Tolerance and Persecution: Reassessing Our Approach to Medieval *Convivencia*." *Jewish Social Studies* 11, no. 2 (2005): 1–18.

———. *The Sephardic Frontier: The Jewish Community in Medieval Iberia*. Ithaca: Cornell University Press, 2006.

Regalado, Nancy Freeman. "Kalila et Dimna, Liber regius: The Tutorial Book of Raymond de Béziers (Paris, BNF MS Lat. 8504)." In *Satura: Essays on Medieval Satire and Religion in Honor of Robert Raymo*, edited by Ruth Sternglantz and Nancy Reale, 102–123. Stamford, U.K.: Paul Watkins, 2001.

Reilly, Bernard F. "The Chancery of Alfonso VI of Léon-Castile (1065–1109)." In *Santiago, Saint-Denis, and Saint Peter: The Reception of the Roman Liturgy in León-Castile in 1080*, edited by Bernard F. Reilly, 1–40. New York: Fordham University Press, 1985.

———. *The Contest of Christian and Muslim Spain: 1031–1157*. Oxford: Blackwell, 1992.

———. *The Kingdom of Leon-Castilla under King Alfonso VI, 1065–1109*. Princeton: Princeton University Press, 1988.

———. *The Kingdom of Leon-Castilla under King Alfonso VII, 1126–1157*. Philadelphia: University of Pennsylvania Press, 1998.

———. *The Kingdom of Leon-Castilla under Queen Urraca, 1109–1126*. Princeton: Princeton University Press, 1982.

———. *The Medieval Spains*. Cambridge: Cambridge University Press, 1993.

————, ed. *Santiago, Saint-Denis, and Saint Peter: The Reception of the Roman Liturgy in León-Castile in 1080*. New York: Fordham University Press, 1985.

Reynolds, Dwight. "Music." In *The Literature of al-Andalus*, edited by María Rosa Menocal, Raymond P. Scheindlin, and Michael Sells, 60–82. Cambridge: Cambridge University Press, 2000.

Ribera, Julián. *La música de las cantigas: Estudio sobre su origen y naturaleza*. Madrid: Revista de Archivos, 1922.

Rivera Recio, Juan Francisco. *El arzobispo de Toledo Don Bernardo de Cluny (1086–1124)*. Rome: Iglesia Nacional Española, 1962.

————. *La iglesia de Toledo en el siglo XII (1086–1208)*. Vol. 1. Rome: Instituto Español de Historia Eclesiástica, 1966.

————. *La iglesia de Toledo en el siglo XII (1086–1208)*. Vol. 2. Toledo: Diputación Provincial, 1976.

Robinson, Cynthia. "Arts of the Taifa Kingdoms." In *Al-Andalus: The Art of Islamic Spain*, edited by Jerrilynn D. Dodds, 49–61. New York: Metropolitan Museum of Art, 1992.

————. *In Praise of Song: The Making of Courtly Culture in al-Andalus and Provence, 1005–1134 A.D.* Boston: Brill, 2002.

————. "Mudéjar Revisited: A Prolegomena to the Reconstruction of Perception, Devotion, and Experience at the Mudéjar Convent of Clarisas, Tordesillas, Spain (Fourteenth Century)." *Res* 43 (2003): 51–78.

————. "Seeing Paradise: Metaphor and Vision in Taifa Palace Architecture." *Gesta* 36, no. 2 (1997): 145–155.

————. "*Ubi Sunt*: Memory and Nostalgia in Taifa Court Culture." *Muqarnas* 15 (1998): 20–31.

Robinson, Cynthia, and Leyla Rouhi, eds. *Under the Influence: Questioning the Comparative in Medieval Castile*. Leiden: Brill, 2005.

Rodríguez Estévez, Juan Clemente. *El alminar de Isbiliya: La Giralda en sus orígenes, 1184–1198*. Seville: Ayuntamiento de Sevilla, 1998.

Rojas, J. M., and J. R. Villa. "Las casas islámicas toledanas." In *Entre el califato y la taifa: Mil años de Cristo de la Luz (Actas del Congreso Internacional, Toledo, 1999)*, 197–242. Toledo: Asociación de Amigos del Toledo Islámico, 2000.

Rosen, Tova. "The Muwashshah." In *The Literature of al-Andalus*, edited by María Rosa Menocal, Raymond P. Scheindlin, and Michael Sells, 165–189. Cambridge: Cambridge University Press, 2000.

Rubiera Mata, María Jesús. *La arquitectura en la literatura árabe*. Madrid: Editora Nacional, 1981.

————. *Bibliografía de la literatura hispano-árabe*. Alicante: Universidad de Alicante, 1988.

Rucquoi, Adeline, ed. *Génesis medieval del estado moderno: Castilla y Navarra (1250–1370)*. Valladolid: Ambito, 1987.

Ruggles, D. Fairchild. "The Alcazar of Seville and Mudejar Architecture." *Gesta* 43, no. 2 (2004): 87–98.

————. "Arabic Poetry and Architectural Memory in al-Andalus." *Ars Orientalis* 23 (1993): 171–178.

————. "The Eye of Sovereignty: Poetry and Vision in the Alhambra's Lindaraja Mirador." *Gesta* 36, no. 2 (1997): 180–189.

————. "Fountains and Miradors: Architectural Imitation and Ideology among the Taifas." In *Künstlerischer Austausch*, edited by Thomas W. Gaehtgens, 391–406. Berlin: Akademie Verlag, 1992.

————. *Gardens, Landscape, and Vision in the Palaces of Islamic Spain*. University Park: Pennsylvania State University Press, 2000.

————. "The Gardens of the Alhambra and the Concept of the Garden in Islamic Spain." In *Al-Andalus: The Art of Islamic Spain*, edited by Jerrilynn D. Dodds, 163–171. New York: Metropolitan Museum of Art, 1992.

————. "Historiography and the Rediscovery of Madinat al-Zahra." *Islamic Studies* 30, no. 1–2 (1991): 129–140.

————. "The Mirador in Abbasid and Hispano-Umayyad Garden Typology." *Muqarnas* 7 (1990): 73–82.

————. "Mothers of a Hybrid Dynasty: Race, Genealogy, and Acculturation in al-Andalus." *Journal of Medieval and Early Modern Studies* 34, no. 1 (2004): 65–94.

————. "Representation and Identity in Medieval Spain: Beatus Manuscripts and the Mudejar Churches of Teruel." In *Languages of Power in Islamic Spain*, edited by Ross Brann, 76–106. Bethesda: CDL Press, 1997.

Ruiz, Teofilo F. *From Heaven to Earth: The Reordering of Castilian Society, 1150–1350*. Princeton: Princeton University Press, 2004.

Ruiz Souza, Juan Carlos. "Architectural Languages, Functions and Spaces: The Crown of Castile and al-Andalus." *Medieval Encounters* 12, no. 3 (2006): 360–387.

———. "Capillas reales funerarias catedrálicas de Castilla y León: Nuevas hipótesis interpretativas de las catedrales de Sevilla, Córdoba y Toledo." *Anuario del Departamento de Historia y Teoría del Arte (UAM)* 18 (2006): 9–29.

———. "Castilla y al-Andalus: Arquitecturas aljamiadas y otros grados de asimilación." *Anuario del Departamento de Historia y Teoría del Arte (UAM)* 16 (2004): 17–43.

———. "El palacio de Comares de la Alhambra de Granada: Tipologías y funciones; Nuevas propuestas de estudio." *Cuadernos de la Alhambra*, no. 40 (2004): 77–102.

———. "El Patio del Vergel del real monasterio de Santa Clara de Tordesillas y la Alhambra de Granada: Reflexiones para su estudio." *Al-Qantara* 19, no. 2 (1998): 315–337.

———. "La planta centralizada en la Castilla bajomedieval: Entre la tradición martirial y la qubba islámica; Un nuevo capítulo de particularismo hispano." *Anuario del Departamento de Historia y Teoría del Arte (UAM)* 13 (2001): 9–36.

———. "Santa Clara de Tordesillas: Nuevos datos para su cronología y estudio; La relación entre Pedro I y Muhammad V." *Reales Sitios: Revista del Patrimonio Nacional* 130 (1996): 32–40.

———. "Sinagogas sefardíes monumentales en el contexto de la arquitectura medieval hispana." In *Memoria de Sefarad* (Toledo, Centro Cultural San Marcos, octubre 2002–enero 2003), edited by Isidro Bango Torviso, 229–232. Madrid: Sociedad Estatal para la Acción Cultural Exterior, 2002.

Sachar, Howard M. *Farewell España: The World of the Sephardim Remembered.* New York: Knopf, 1994.

Sáenz-Badillos, Angel. "El estudio de la poesía y la prosa hispanohebrea en los últimos cincuenta años." *Miscelanea de Estudios Arabes y Hebraicos* 50 (2001): 133–161.

———. "Hacia una valoración global de la presencia judía en España." In *Judíos entre árabes y cristianos: Luces y sombras de una convivencia*, edited by Angel Sáenz-Badillos, 169–186. Cordoba: El Almendro, 2000.

———. *Judíos entre árabes y cristianos: Luces y sombras de una convivencia.* Cordoba: El Almendro, 2000.

Safran, Janina M. "From Alien Terrain to the Abode of Islam: Landscapes in the Conquest of al-Andalus." In *Inventing Medieval Landscapes: Senses of Place in Western Europe*, edited by John Howe and Michael Wolfe, 136–149. Gainesville: University of Florida Press, 2002.

———. "Identity and Differentiation in Ninth-Century al-Andalus." *Speculum* 76 (2001): 573–598.

———. *The Second Umayyad Caliphate: The Articulation of Caliphal Legitimacy in al-Andalus.* Cambridge: Harvard University Press, 2000.

Said, Edward. *Culture and Imperialism.* New York: Vintage Books, 1993.

Samsó, Julio. *Ciencias de los antiguos en al-Andalus.* Madrid: Mapfre, 1992.

———. *Islamic Astronomy and Medieval Spain.* Aldershot: Variorum, 1994.

———. "Las traducciones toledanas en los siglos XII–XIII." In *La escuela de traductores de Toledo*, edited by Ana María López Alvarez, 17–22. Toledo: Diputación Provincial de Toledo, 1996.

Sánchez Albornoz, Claudio. "El aula regia y las asambleas políticas de los godos." *Cuadernos de Historia de España* 5 (1946): 5–110.

———. *Despoblación y repoblación del valle del Duero.* Buenos Aires: Instituto de Historia de España, 1966.

———. *España, un enigma histórico.* 2 vols. Buenos Aires: Editorial Sudamericana, 1956.

———. *Orígenes de la nación española: Estudios críticos sobre la historia del reino de Asturias.* 3 vols. Oviedo: Instituto de Estudios Asturianos, 1972–1975.

———. *Ruina y extinción del municipio romano en España e instituciones que le reemplazan.* Buenos Aires: Facultad de Filosofía y Letras, 1943.

———. "Sede regia y solio real en el reino asturoleonés." In *Asturiensia medievalia*, 75–86. Oviedo: Universidad de Oviedo, 1979.

———. *Spain, a Historical Enigma.* Translated by Colette Joly Dees and David Sven Reher. Madrid: Fundación Universitaria Española, 1975.

Sanok, Catherine. "Almoravides at Thebes: Islam and European Identity in the *Roman de Thèbes*." *Modern Language Quarterly* 64, no. 3 (2003): 277–298.

Scales, Peter C. *The Fall of the Caliphate of Córdoba: Berbers and Andalusis in Conflict.* Leiden: Brill, 1994.

Schapiro, Meyer. "From Mozarabic to Romanesque in Silos." In *Romanesque Art: Selected Papers* 1, 28–101. New York: Braziller, 1977.

———. "On the Aesthetic Attitude in Romanesque Art." In *Romanesque Art: Selected Papers* 1, 1–28. New York: Braziller, 1977.

Schlunk, Helmut. *Arte visigodo, arte asturiano*. Vol. 2 of *Ars Hispaniae: Historia universal del arte hispánico*. Madrid: Plus Ultra, 1947.

Schlunk, Helmut, and Theodor Hauschild. *Die Denkmäler der frühchristlichen und westgotischen Zeit, Hispania antiqua*. Mainz: P. v. Zabern, 1978.

Schwartz, Stuart. *In Their Own Law: Salvation and Religious Tolerance in the Iberian Atlantic World*. New Haven: Yale University Press, forthcoming.

Segol, Marla. "Medieval Cosmopolitanism and the Saracen-Christian Ethos." *CLCWeb: Comparative Literature and Culture; A WWWeb Journal* 6, no. 2 (2004).

Sells, Michael. "Love." In *The Literature of al-Andalus*, edited by María Rosa Menocal, Raymond P. Scheindlin, and Michael Sells, 126–158. Cambridge: Cambridge University Press, 2000.

Seniff, Dennis P. *Noble Pursuits: Literature and the Hunt*. Edited by Diane M. Wright and Connie L. Scarborough. Newark, Del.: Juan de la Cuesta, 1992.

Senra, José Luis. "En torno a la restauración de la memoria de la 'reconquista': Un escenario martirial en el contexto de la expulsión morisca." *Quintana*, no. 3 (2004): 89–106.

Serjeant, R. B. *Islamic Textiles: Materials for a History up to the Mongol Conquest*. Beirut: Librairie du Liban, 1972.

Shalem, Avinoam. *Islam Christianized: Islamic Portable Objects in the Medieval Church Treasuries of the Latin West*. Frankfurt: Peter Lang, 1996.

———. "Objects as Carriers of Real or Contrived Memories in a Cross-Cultural Context: The Case of Medieval Diplomatic Presents." In *Migrating Images: Producing, Reading, Transporting, Translating*, edited by Petra Stegmann and Peter C. Seel, 36–52. Berlin: Haus der Kulturen der Welt, 2004.

———. *The Oliphant: Islamic Objects in Historical Context*. Leiden: Brill, 2004.

Shaver-Crandell, Annie, and Paula Gerson, eds. *The Pilgrim's Guide to Santiago de Compostela: A Gazetteer*. London: Harvey Miller, 1995.

Simonet, Francisco Javier. *Historia de los mozárabes de España*. Vols. 1–4. Madrid: Turner, 1867.

Smith, Colin. *The Making of the "Poema de mio Cid."* Cambridge: Cambridge University Press, 1983.

———. "The Vernacular." In *The New Cambridge Medieval History*, vol. 5, c. 1198–c. 1300, edited by David Abulafia, 71–83. Cambridge: Cambridge University Press, 1999.

Smith, Damian. "'Soli Hispani'? Innocent III and Las Navas de Tolosa." *Hispania Sacra* 51 (1999): 487–513.

Snow, Joseph T. "Current Status of Cantigas Studies." In *Studies on the Cantigas de Santa María: Art, Music, Poetry; Proceedings of the International Symposium on the Cantigas de Santa María of Alfonso X, el Sabio (1221–1284) in Commemoration of Its 700th Anniversary Year*—1981, edited by Israel J. Katz and John E. Keller, 475–486. Madison: Hispanic Seminary of Medieval Studies, 1987.

———. "An Overview of Recent Studies Devoted to the CSM." *Cantigueros de Santa María* 1 (1987): 5–10.

———. *The Poetry of Alfonso X, el Sabio: A Critical Bibliography*. London: Grant and Cutler, 1977.

———. "Trends in Scholarship on Alfonsine Poetry." *La Corónica* 11, no. 2 (1983): 248–257.

Soldevila, Ferran. *Historia de España*. Vol. 1. Barcelona: Crítica, 1995.

Southern, R. W. *Western Views of Islam in the Middle Ages*. Cambridge: Harvard University Press, 1962.

Speer, Andreas, and Lydia Wegener, eds. *Wissen über Grenzen: Arabisches Wissen und lateinisches Mittelalter*. Berlin: Walter de Gruyter, 2006.

Steiner, George. *After Babel: Aspects of Language and Translation*. 2nd ed. Oxford: Oxford University Press, 1992.

Stern, Charlotte D. "The Medieval Theater: Between *scriptura* and *theatrica*." In *The Cambridge History of Spanish Literature*, edited by David T. Gies, 115–134. Cambridge: Cambridge University Press, 2004.

Stern, Samuel Miklos. "Les vers finaux en espagnol dans les muwa??aha hispano-hebraiques." *Al-Andalus* 13 (1948): 299–346.

Stewart, Devin. "Ibn Zaydun." In *The Literature of al-Andalus*, edited by María Rosa Menocal, Raymond P. Scheindlin, and Michael Sells, 306–317. Cambridge: Cambridge University Press, 2000.

Stillman, Norman A. *The Jews of Arab Lands: A History and Source Book*. Philadelphia: Jewish Publication Society of America, 1979.

Subirats, Eduardo, and Juan Goytisolo. *Américo Castro y la revisión de la memoria: El islam en España*. Madrid: Ediciones Libertarias, 2003.

Surtz, Ronald E., Jaime Ferrán, and Daniel P. Testa, eds. *Américo Castro: The Impact of His Thought*. Madison: Hispanic Seminary of Medieval Studies, 1988.

Symposium *Alfonso X el Sabio y la música: Ponencias, comunicaciones y coloquios celebrados en 1984.* Madrid: Sociedad Española de Musicología, 1987.

Tabales Rodríguez, M. A. *El Alcázar de Sevilla: Primeros estudios sobre estratigrafía y evolución constructiva.* Seville: Junta de Andalucía, Consejería de Cultura, 2002.

———. "Investigaciones arqueológicas en el Patio de las Doncellas: Avance de resultados de la primera campaña (2002)." *Apuntes del Alcázar de Sevilla* 4 (2003): 7–25.

Terasse, Henri. "La grande mosquée almohade de Séville." In *Mémorial Henri Basset: Nouvelles études nordafricaines et orientales, publiées par l'Institut des Hautes-Etudes Marocaines,* 249–266. Paris: Librairie Orientaliste Paul Geuthner, 1928.

Terrasse, Michel. *Islam et Occident méditerranéen: De la conquête aux Ottomans.* Paris: Comité des Travaux Historiques et Scientifiques, 2001.

Thompson, E. A. *The Goths in Spain.* Oxford: Clarendon, 1969.

Tolan, John. "Affreux vacarme: Sons de cloches et voix de muezzins dans la polémique interconfessionnelle en Péninsule Ibérique." In *Guerre, pouvoirs et idéologies dans l'Espagne chrétienne aux alentours de l'an mil,* edited by T. Deswartes and Philippe Sénac, 51–64. Turnhout: Brepols, 2005.

———. "Esgrimiendo la pluma: Polémica y apologética religiosa entre judíos, cristianos y musulmanes (siglos XIII al XV)." In *L'esplendor de la Mediterrània medieval (segles XIII–XV),* 243–259. Barcelona: IMED, 2004.

———. *Medieval Christian Perceptions of Islam: A Book of Essays.* New York: Routledge, 1996.

———. *Petrus Alfonsi and His Medieval Readers.* Gainesville: University of Florida Press, 1993.

———. *Saracens: Islam in the Medieval European Imagination.* New York: Columbia University Press, 2002.

———. "Las traducciones y la ideología de reconquista: Marcos de Toledo." In *Musulmanes y cristianos en Hispania durante las conquistas de los siglos XII y XIII,* edited by Miquel Barcelo and José Martínez Gazquez, 79–85. Bellaterra: Universitat Autònoma de Barcelona, 2005.

Torres Balbás, Leopoldo. *Arte mudéjar.* Vol. 4 of *Ars Hispaniae: Historia universal del arte hispánico.* Madrid: Plus Ultra, 1949.

———. *Ciudades hispanomusulmanas.* Madrid: Instituto Hispano-Arabe de Cultura, 1985.

———. "Por el Toledo mudéjar: El Toledo aparente y oculto." *Al-Andalus* 23 (1958): 424–445.

Torres Fontes, Juan. "La cultura murciana en el reinado de Alfonso X." *Murgetana* 14 (1960): 57–89.

———. "Los mudéjares murcianos en el siglo XIII." *Murgetana* 17 (1961): 57–81.

Uranga Galdiano, José Esteban, and Francisco Iñíguez Almech. *Arte medieval navarro.* 5 vols. Pamplona: Aranzadi, 1971.

Valdeavellano, Luis G. de. *Historia de España: De los orígenes a la baja edad media.* Madrid: Revista de Occidente, 1952.

Valdeón Baruque, Julio. *Abderramán III y el califato de Córdoba.* Madrid: Debate, 2001.

———. *Alfonso X el Sabio: La forja de la España moderna.* Madrid: Temas de Hoy, 2003.

———. *Pedro I, el Cruel y Enrique de Trastámara: ¿La primera guerra civil española?* Madrid: Aguilar, 2002.

Valdés Fernández, Manuel. *Arquitectura mudéjar en León y Castilla.* León: Colegio Universitario de León, Institución Fray Bernardino de Sahagún, 1981.

———. "Patronazgo señorial y arte mudéjar en el reino de Castilla." In *Imágenes y promotores en el arte medieval: Miscelánea en homenaje a Joaquín Yarza Luaces,* edited by Maria Luisa Melero Moneo, Francesca Español Bertrán, Anna Orriols I Alsina, and Daniel Rico Camps, 645–652. Barcelona: Universitat Autònoma de Barcelona, 2001.

Valdez del Alamo, Elizabeth. "The Saint's Capital, Talisman in the Cloister." In *Decorations for the Holy Dead: Visual Embellishments on Tombs and Shrines of Saints,* edited by Stephen Lamia and Elizabeth Valdez del Alamo, 111–128. Turnhout: Brepols, 2002.

Valdez del Alamo, Elizabeth, and Constancio Martínez del Alamo. "Caja relicario de marfil con esmaltes." In *De Limoges a Silos: Biblioteca Nacional, Espace Culturel BBL, Monasterio de Santo Domingo de Silos: Madrid, Bruselas, Santo Domingo de Silos: 15 de noviembre de 2001, 28 de abril de 2002,* 312–315. Madrid: Sociedad Estatal para la Acción Cultural Exterior, 2001.

Valencia, Rafael. "Islamic Seville: Its Political, Social and Cultural History." In *The Legacy of Muslim Spain,* edited by Salma Khadra Jayyusi, 136–148. Leiden: Brill, 1992.

Vallejo Triano, Antonio. *Madinat al-Zahra: El salon de 'Abad al-Rahman III.* Cordoba: Junta de Andalucía, Consejería de Cultura, 1995.

———. "Madinat al-Zahra: The Triumph of the Islamic State." In *Al-Andalus: The Art of Islamic Spain*, edited by Jerrilynn D. Dodds, 27–40. New York: Metropolitan Museum of Art, 1992.

Vann, T. M. "The Town Council of Toledo during the Minority of Alfonso VIII (1158–1169)." In *Medieval Iberia: Essays on the History and Literature of Medieval Spain*, edited by Donald J. Kagay and Joseph T. Snow, 44–57. New York: Peter Lang, 1997.

Viguera, María Jesús. *Los reinos de taifas y las invasiones magrebíes (al-Andalus del XI al XIII)*. Madrid: Mapfre, 1992.

———, ed. *El retroceso territorial de al-Andalus: Almorávides y almohades, siglos XI al XIII*. Madrid: Espasa-Calpe, 1997.

———. "La taifa de Toledo." In *Entre el califato y la taifa: Mil años de Cristo de la Luz (Actas del Congreso Internacional, Toledo, 1999)*, 53–66. Toledo: Asociación de Amigos del Toledo Islámico, 2000.

Viguera Molins, María Jesús. "Ceremonias y símbolos soberanos en al-Andalus: Notas sobre la época almohade." In *Casas y palacios de al-Andalus*, edited by Julio Navarro Palazón, 105–116. Barcelona: Lunwerg, 1995.

Villalon, L. J. Andrew. "Pedro the Cruel: Portrait of a Royal Failure." In *Medieval Iberia: Essays on the History and Literature of Medieval Spain*, edited by Donald J. Kagay and Joseph T. Snow, 205–216. New York: Peter Lang, 1997.

Walker, Rose. *Views of Transition: Liturgy and Illumination in Medieval Spain*. London: British Library, 1998.

Wasserstein, David. *The Caliphate in the West: An Islamic Political Institution in the Iberian Peninsula*. Oxford: Clarendon, 1993.

———. *The Rise and Fall of the Party-Kings: Politics and Society in Islamic Spain, 1002–1086*. Princeton: Princeton University Press, 1985.

Watt, W. Montgomery, and Pierre Cachia. *A History of Islamic Spain*. 2nd ed. New York: Anchor Books, 1967.

Weiss, Julian. *"Mester de Clerecía": Intellectuals and Ideologies in Thirteenth Century Castile*. Woodbridge: Tamesis, 2006.

Werckmeister, O. K. "Art of the Frontier: Mozarabic Monasticism." In *The Art of Medieval Spain, A.D. 500–1200*, edited by Jerrilynn Dodds, Charles Little, Serafín Moralejo, and John Williams, 121–132. New York: Metropolitan Museum of Art, 1993.

———. "Cluny III and the Pilgrimage to Santiago de Compostela." *Gesta* 27, no. 1–2 (1988): 103–112.

———. "Die Bilder der drei Propheten in der Biblia Hispalense." *Madrider Mitteilungen* 4 (1963): 141–188.

———. "The First Romanesque Beatus Manuscripts and the Liturgy of Death." In *Actas del simposio para el estudio de los códices del "Comentario al Apocalypsis de Beato de Liebana,"* 167–192. Madrid: Joyas Bibliográficas, 1980.

———. "The Islamic Rider in the Beatus of Girona." *Gesta* 36, no. 2 (1997): 101–106.

———. "Islamische Formen en spanischen Miniaturen des 10 Jahrhunderts und das Problem der mozarabischen Buchmalerei." *Settimane di Studi del Centro Italiano di Studi sull'Alto Medioevo* 12 (1965): 933–967.

Wheeler, B. W. "Conflict in the Mediterranean before the First Crusade: The Reconquest of Spain before 1095." In *A History of the Crusades: The First Hundred Years*, edited by M. W. Baldwin and K. M. Setton, 31–39. Philadelphia: University of Pennsylvania Press, 1955.

Williams, John. "Cluny and Spain." *Gesta* 27, no. 1–2 (1988): 93–101.

———. "Generationes Abrahae: Reconquest Iconography in León." *Gesta* 16, no. 2 (1977): 3–14.

———. *The Illustrated Beatus: A Corpus of the Illustrations of the Commentary on the Apocalypse*. 5 vols. London: Harvey Miller, 1994.

———. "León: The Iconography of a Capital." In *Cultures of Power: Lordship, Status and Process in Twelfth-Century Europe*, edited by Thomas N. Bisson, 231–259. Philadelphia: University of Pennsylvania Press, 1995.

———. "León and the Beginnings of Spanish Romanesque." In *The Art of Medieval Spain: A.D. 500–1200*, edited by Jerrilynn Dodds, Charles Little, Serafín Moralejo, and John Williams, 167–173. New York: Metropolitan Museum of Art, 1993.

———. "El románico en España: Diversas perspectivas." In *Actas del II Curso de Cultura Medieval: Alfonso VIII y su epóca*, 9–12. Aguilar de Campoo: Fundación Santa María la Real, 1990.

———. "San Isidoro in León: Evidence for a New History." *Art Bulletin* 55, no. 2 (1973): 170–184.

———. "Spain or Toulouse? A Half Century Later Observations on the Chronology of Santiago de Compostela." In *Actas del XXIII Congreso Internacional de Historia de Arte*, 557–567. Granada, 1976.

Wolf, Kenneth Baxter. *Christian Martyrs in Muslim Spain.* Cambridge: Cambridge University Press, 1988.

———. "Christian Views of Islam in Early Medieval Spain." In *Medieval Christian Perceptions of Islam: A Book of Essays,* edited by John Tolan, 85–108. New York: Routledge, 1996.

———. *Conquerors and Chroniclers of Early Medieval Spain.* 2nd ed. Liverpool: Liverpool University Press, 1999.

———. "Eulogius of Cordoba." In *Medieval Iberia: An Encyclopedia,* edited by E. Michael Gerli, 312. New York: Routledge, 2003.

Wright, Owen. "Music in Muslim Spain." In *The Legacy of Muslim Spain,* edited by Salma Khadra Jayyusi, 555–579. Leiden: Brill, 1992.

Wright, Roger. "Language and Religion in Early Medieval Spain." In *Language of Religion—Language of the People: Medieval Judaism, Christianity and Islam,* edited by Ernst Bremer, Jörg Jarnut, Michael Richter, and David J. Wasserstein, 115–126. Munich: Willem Fink Verlag, 2006.

———. *Late Latin and Early Romance (in Spain and Carolingian France).* Liverpool: Francis Cairns, 1982.

———. *Latin and the Romance Languages in the Early Middle Ages.* London: Routledge, 1991.

———. "Latin Glossaries in the Iberian Peninsula." In *Insignis Sophiae Arcator: Medieval Latin Studies in Honour of Michael Herren on His 65th Birthday,* edited by Gernot R. Wieland, Carin Ruff, and Ross G. Arthur, 216–236. Turnhout: Publications of the Journal of Medieval Latin 6, 2006.

Yarza, Joaquín. *Arte y arquitectura en España, 500–1200.* Madrid: Cátedra, 1979.

Zohar, Zion, ed. *Sephardic and Mizrahi Jewry: From the Golden Age of Spain to Modern Times.* New York: New York University Press, 2005.

Zozaya, Juan. *Alarcos '95: El fiel de la balanza.* Toledo: Junta de Comunidades de Castilla–La Mancha, 1995.

———. "The Fortifications of al-Andalus." In *Al-Andalus: The Art of Islamic Spain,* edited by Jerrilynn D. Dodds, 63–73. New York: Metropolitan Museum of Art, 1992.

———. "Islamic Fortifications in Spain: Some Aspects." *British Archaeological Report* 193 (1984): 636–673.

———. "Las torres y otras defensas." *Arevacon* 14 (1988): 6–9.

Index

Text Credits

Excerpts from *Poem of the Cid*, translated by W. S. Merwin. Copyright © 1959 by W. S. Merwin. Reprinted by permission of the author.

Treaty of Tudmir, from Olivia Remie Constable, *Medieval Iberia: Readings from Christian, Muslim, and Jewish Sources*, pp. 37–38. Copyright © 1997 by the University of Pennsylvania Press. Reprinted by permission of the University of Pennsylvania Press.

Ibn Zaydun, excerpts from "From al-Zahra," Ibn Quzman, "Disparagers of love," and Al-Mutamid, "You are abandoned by a friend," from *Andalusian Poems*, translated from the Arabic by Christopher Middleton and Leticia Garza-Falcón. Copyright © 1993 by Christopher Middleton and Leticia Garza-Falcón. Reprinted by permission of David R. Godine, Publisher, Inc.

Wallada, "If you did justice to our love," from Devin Stewart, "Ibn Zaydun"; Abd al-Rahman, "A palm tree stands in the middle of Rusafa," from D. F. Ruggles, "Madinat al-Zahra' and the Umayyad Palace"; Ibn Zaydun, excerpts from "The Nuniyya," from Michael Sells, "To al-Andalus, Would She Return the Greeting"; and Ibn Quzman, "I said what I had in mind," from Amila Buturovic, "Ibn Quzman," all in *The Cambridge History of Arabic Literature: The Literature of al-Andalus*. Copyright © 2000 by Cambridge University Press. Reprinted by permission of Cambridge University Press.

Ibn Hazm, "Split My Heart," and Al-Mutamid, "The Prisoner in Aghmat Speaks to His Chains," from Cola Franzen, *Poems of Arab Andalusia*. Copyright © 1989 by Cola Franzen. Reprinted by permission of the author.

Labid, excerpts from "The Mu'állaqa," from Michael Sells, *Desert Tracings*. Copyright © 1989 by Michael Sells. Reprinted by permission of Wesleyan University Press.

William of Aquitaine, "With the sweetness of the new season," from W. S. Merwin, *The Mays of Ventadorn*. Text copyright © 2002 by W. S. Merwin. Reprinted by permission of the author.

Al-Mutamid, "On Being Exiled from Seville," from Rafael Valencia, "Islamic Seville: Its Political, Cultural and Social History," in *The Legacy of Islamic Spain*, edited by Salma Khadra Jayyusi. Copyright © 1992 by E. J. Brill. Reprinted by permission of E. J. Brill.

Ibn Arabi, excerpt from "Gentle now, doves," from Michael Sells, *Stations of Desire*. Copyright © 2000 by Michael Sells. Reprinted by permission of Ibis Editions.

Judah Halevi, "If Only I Could Give," Todros Abulafia, "Before the King" and "I Take Delight in My Cup and Wine," from *The Dream of the Poem*, translated, edited, and introduced by Peter Cole. Copyright © 2007 by Princeton University Press. Reprinted by permission of Princeton University Press.

Ibn Quzman, "My life is spent in dissipation and wantonness!" from James T. Monroe, *Hispano-Arabic Poetry: An Anthology*. Copyright © 2004 by Gorgias Press LLC. Reprinted by permission of Gorgias Press.

Gonzalo de Berceo, excerpt from "The Chasuble of Saint Ildephonsus," from *Miracles of Our Lady*, translated by Richard Terry Mount and Annette Grant Cash. Copyright © 1997 by the University Press of Kentucky. Reprinted by permission of the University Press of Kentucky.

Excerpt from *The Songs of Holy Mary of Alfonso X, the Wise: A Translation of the "Cantigas de Santa Maria,"* translated by Kathleen Kulp-Hill. MRTS volume 173 (Tempe, Arizona, 2000), pp. 204–5. Copyright © Arizona Board of Regents for Arizona State University. Reprinted with permission.

Excerpt from T. A. Perry, *The Moral Proverbs of Santob de Carrión*. Copyright © 1987 by Princeton University Press. Reprinted with permission of Princeton University Press.

Ibn Zamrak, "I am the garden," from Oleg Grabar, *The Alhambra*. Copyright © 1992 by Solipsist Press. Reprinted with permission of the author.

Illustration Credits

All photographs by the authors, except those that follow.

Adler Planetarium & Astronomy Museum:
p. 207: Latin astrolabe and Hebrew astrolabe courtesy of Adler Planetarium & Astronomy Museum, Chicago, Illinois

American Numismatic Society:
p. 190: Toledan dinar of Alfonso X courtesy of the American Numismatic Society, New York, New York

Archivo Fotográfico Oronoz, Madrid:
p. 11: Crown of Recceswinth (Museo Arqueológico Nacional, Madrid)
p. 19: Codex Conciliorum Albeldense (Biblioteca de la Real Monasterio de San Lorenzo de El Escorial, Madrid, MS T.I.1, sig. D.I.i.)
p. 20: al-Mughira casket (Louvre, Paris, France)
p. 99: Santiago de Compostela, capital with image of Alfonso VI
p. 174: Heavenly court from the Gerona Beatus (Gerona Cathedral)
p. 198: Bell lamps in the Qarawiyyin mosque in Fez
p. 198: Lamp from the Qarawiyyin mosque in Fez
p. 223: Cantiga 169 (Biblioteca de la Real Monasterio de San Lorenzo de El Escorial, Madrid, MS T.I.1)
p. 225: Cantiga 187 (Biblioteca de la Real Monasterio de San Lorenzo de El Escorial, Madrid, MS T.I.1)
p. 230: Chess game, *Libro de ajedrez, dados y tablas de Alfonso X* (Biblioteca de la Real Monasterio de San Lorenzo de El Escorial, Madrid, MS T.I.6)
p. 233: Muslim and Christian sing, from the *Cantigas* of Alfonso X (Biblioteca de la Real Monasterio de San Lorenzo de El Escorial, Madrid, MS T.I.1)
pp. 246–247: View of the Alhambra, Granada
p. 268: Cathedral of Cordoba, interior

Art Resource, New York:
p. 75: "Muslim Rider" from the Gerona Beatus (Gerona Cathedral, MS 7, fol. 134v)
p. 87: The Feast of Baltassar. From "Commentary on the Apocalypse," by Beatus de Liebana (The Pierpont Morgan Library, New York, New York, m.644, f.255v.) The Pierpont Morgan Library/Art Resource, New York
p. 161: Peacock aquamanile (Louvre, Paris, France) photographed by Hervé Lewandowski. Réunion des Musées Nationaux/Art Resource, New York
p. 182: The Whore of Babylon and the Kings. From "Commentary on the Apocalypse," by Beatus de Liebana (The Pierpont Morgan Library, New York, New York, m.644, f.194v.) photographed by David Loggie. The Pierpont Morgan Library/Art Resource, New York

George Beech:
p. 109: Eleanor vase (Louvre, Paris, France)

Biblioteca Medicea Laurenziana:
p. 76: Annunciation to Mary, from Saint Ildefonsus's Treatise on the Virginity of Mary, A.D. 1067 (Biblioteca Medicea Laurenziana, Florence, m. Ashb. 17, fol. 66r)

Biblioteca Nacional de España:
p. 178: *Notule de primatu* (Biblioteca Nacional, Madrid, BN MS Vitr. 15-5, fol. 4r)

Biblioteca Universitaria de Zaragoza:
p. 102: "Mozarabic" antiphonary (Biblioteca Universitaria de Zaragoza, Saragossa, Spain, ms. 418)

Bibliothèque nationale de France:
p. 57: Celestial globe (Bibliothèque nationale de France, Département des Cartes et Plans)

Bodleian Library, University of Oxford:
p. 244: Kennicott Bible (The Bodleian Library, Oxford, England, Ms Kennicott 13)

British Library:
p. 244: Sister Haggadah (B.L. Or. MS.2884)

Cincinnati Art Museum:
p. 90: Photograph of the falconer painting from San

Baudelio de Berlanga with permission of the
Cincinnati Art Museum, Cincinnati, Ohio

Pep Escoda:
p. 240: Synagogue of Samuel Halevi, stucco detail
p. 243: Synagogue of Samuel Halevi, interior
p. 243: Synagogue of Samuel Halevi, detail from
Women's Gallery
p. 255: Synagogue of Samuel Halevi, stucco detail

Germanisches Nationalmuseum:
p. 207: Arabic astrolabe, Germanisches
Nationalmuseum, Nuremberg

Charles Gifford:
p. 97: San Millán de la Cogolla, interior
p. 97: San Millán de la Cogolla, arcade

The Metropolitan Museum of Art:
p. 49: Taifa antependium (Museu Episcopal de Vic,
Barcelona) photographed by Sheldan Collins.
Photograph © 1992 The Metropolitan Museum of
Art
p. 55: Capital from the Palace of al-Mamun (Museo
Taller de Moro, Toledo, Depósito de la Parroquia de
Santo Tomé) photographed by Bruce White.
Photograph © 1992 The Metropolitan Museum of
Art
p. 55: Relief from the Palace of al-Mamun (Museo
de Santa Cruz, Toledo) photographed by Bruce
White. Photograph © 1992 The Metropolitan
Museum of Art
p. 70: Pamplona casket (Museo de Navarra,
Comunidad Foral de Navarra, Pamplona) pho-
tographed by Sheldan Collins. Photograph © 1992
The Metropolitan Museum of Art
Pamplona casket, detail, photographed by Sheldan
Collins. Photograph © 1992 The Metropolitan
Museum of Art
p. 71: Palencia casket (Museo Arqueológico
Nacional, Madrid) photographed by Bruce White.
Photograph © 1992 The Metropolitan Museum of
Art
Palencia casket, detail, photographed by Bruce
White. Photograph © 1992 The Metropolitan
Museum of Art
p. 72: Reliquary casket of Santo Domingo de Silos
(Museo de Burgos) photographed by Bruce White.
Photograph © 1993 The Metropolitan Museum of
Art
p. 74: Lining of reliquary casket of Saint Pelagius
(Real Colegiata de San Isidoro, León) photographed
by S. Collins. Photograph © 1993 The Metropolitan
Museum of Art
p. 90: Pamplona casket, detail: carving of a falconer

(Museo de Navarra, Comunidad Foral de Navarra,
Pamplona) photographed by Sheldan Collins.
Photograph © 1992 The Metropolitan Museum of
Art
p. 107: Pillowcase of Berenguela (Patriomonio
Nacional, Museo de Telas Medievales, Monasterio
de Santa María la Real de Huelgas, Burgos) pho-
tographed by Sheldan Collins. Photograph © 1992
The Metropolitan Museum of Art
p. 160: Bilingual funerary slab (Museo Taller del
Moro, Toledo; property of the Parroquia de Santas
Justa y Rufina, Toledo) photographed by Bruce
White. Photograph © 1993 The Metropolitan
Museum of Art
p. 187: Robe of Jiménez de Rada (Monasterio de
Santa María, Santa María la Real de Huerta, Soria)
photographed by Sheldan Collins. Photograph ©
1992 The Metropolitan Museum of Art
Robe of Jiménez de Rada, detail, photographed by
Sheldan Collins. Photograph © 1992 The
Metropolitan Museum of Art
p. 264: Filigree necklace from the Nasrid period
(The Metropolitan Museum of Art) Gift of
J. Pierpont Morgan, 1917 (17.190.161) pho-
tographed by Bruce White. Photograph © 1992
The Metropolitan Museum of Art

Julio Navarro Palazón:
p. 221: Photograph courtesy of Julio Navarro
Palazón, from Casas y palacios de al-Andalus (Barcelona:
Lunwerg, 1995)

Real Academia de la Historia:
p. 102: "Roman" antiphonary (Real Academia de la
Historia, Madrid, Sig. Cod-45)

Maps by Cynthia Poulton:
p. 10: Map of Iberia, 711–1031
p. 46: Map of Iberia, 1065
p. 48: Map of Taifa Tulaytula after Julio Porres
Martín Cleto
p. 132: Map of Castilian Toledo after Julio González
González
p. 192: Map of Iberia, 1212
p. 242: Map of Iberia, 1492